The Anatomical Works of George Stubbs

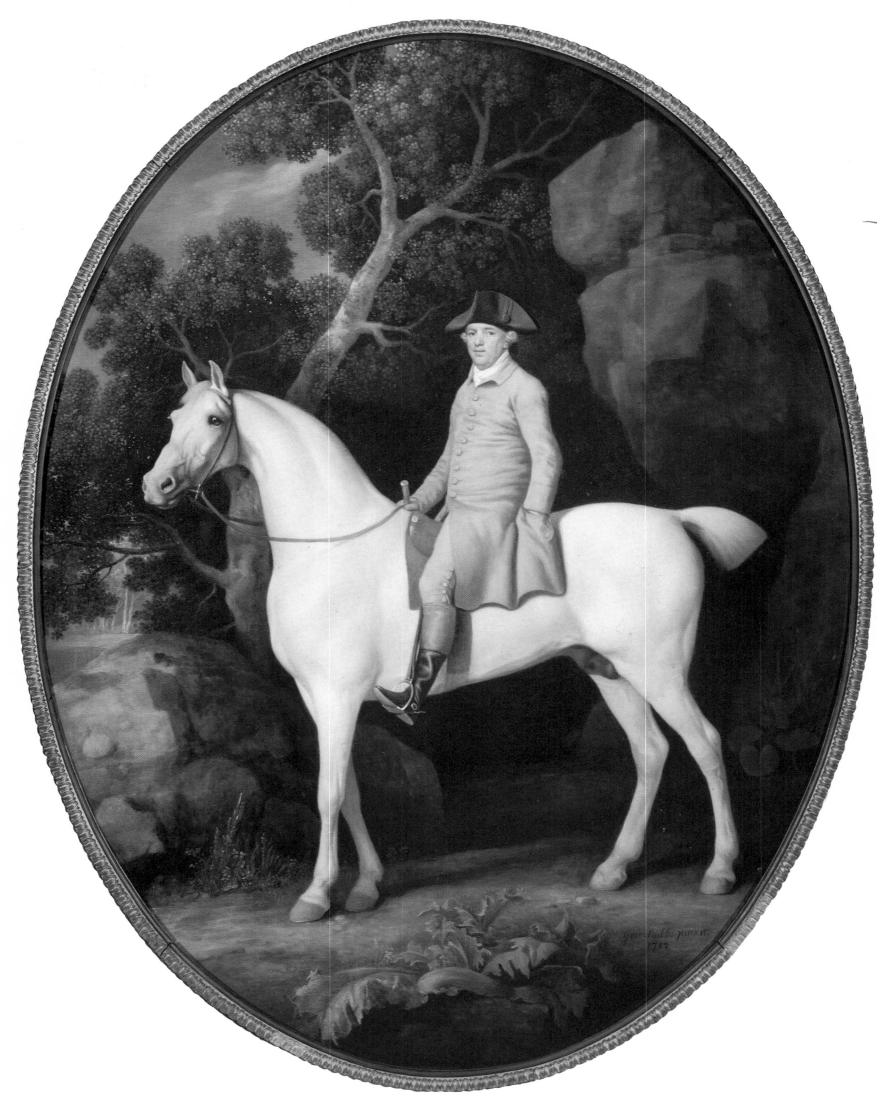

George Stubbs, *Self-portrait on horseback*, 1782. *See p. 280*

The
Anatomical Works
of
GEORGE STUBBS

Terence Doherty

David R. Godine
Publisher
Boston

First published in America 1975 by

David R. Godine

306 Dartmouth Street, Boston

Massachusetts 02116

Copyright © Terence Doherty 1974

ISBN: 0-87923-117-3

LCC No: 74-15259

Designed by Ruari McLean Associates,

Dollar, Scotland

Printed in Great Britain by Westerham Press Limited

Bound by Webb Son and Company Limited

To My Parents

Foreword

The anatomical works of George Stubbs, for which this book is intended as an introduction, have not been previously published as a whole. Only *The Anatomy of the Horse* has been generally available, and indeed until the rediscovery of the drawings for the *Comparative Anatomical Exposition* at the Free Public Library of Worcester, Massachusetts, in 1957, followed by the re-emergence of twenty-four additional drawings for *The Anatomy of the Horse* at the Royal Academy in 1963, only the anatomical illustrations published in Stubbs's lifetime and the eighteen anatomical drawings of the horse were known. The reappearance of the lost drawings has made it possible to assess Stubbs's position and technique as an anatomist, although the amount of available original material still remains tantalisingly small and most of one's conclusions must remain speculative.

Stubbs's reputation has continued to increase during this century, as is clearly indicated by the astonishing rise in the saleroom prices, now equalling the highest ever realised by an English painter. His paintings are much more accessible to the appreciation of the public than the drawings, partly because there are so few of the latter and partly because the bulk of these are of dissections, which tend to repel most people not familiar with the fascinations of anatomy. In his dual role as painter and anatomist, Stubbs is unique in English art; and his full stature as an artist can be appreciated properly only when his achievement as an anatomist is understood.

My first contact with George Stubbs came as a pleasant relief from many tedious weeks spent in sexing a small black beetle called *Phaedon cochlearae*, which preys on mustard plants. I was given a calendar illustrating a group of Stubbs's paintings by my friend John Hussey, together with his enthusiastic praise of the artist. I was not immediately overwhelmed. Later, when I was browsing in Michael Ayrton's library, I found the 1957 catalogue of the exhibition of Stubbs's work at the Whitechapel Gallery and began to ask questions. Through Michael Ayrton I was led to admire the one true classical artist that England had produced, a man whose virtues had been overshadowed by the apparent banality of his subject matter. In the further discussion I was introduced to an essay by Geoffrey Grigson published in *Signature*, which made the first serious advance in the study of Stubbs, and to the numerous important works on the artist by Basil Taylor. Gradually, my initial half-heartedness gave way to considerable enthusiasm and in this excited state I began to consider a serious study of Stubbs's work. I began to model an anatomical horse based on Stubbs's First Table and eventually to study Stubbs's work as an anatomist, the result of which now forms the introduction to this book.

During my researches I have become indebted to many people who have freely given of their time and help. I must first thank the Phoenix Trust, without whose generous grant it would have been impossible to travel in

search of material or to obtain essential references and photographs for study. I am equally grateful to Elisabeth and Michael Ayrton, who not only provided the initial impetus for this work, but have continually and consistently encouraged, cajoled, criticised and unfailingly helped me through many difficulties. Amongst those who have spent their time and efforts on my behalf are Mr Peter Croft of Sotheby & Co., who advised me on problems connected with Stubbs's handwriting; Mr Gerald Leach who pointed out some valuable references to articles on Stubbs's scientific connections and Mr C. Hugh Hildesley of the Parke-Bernet Galleries, New York, whose aid in obtaining material in the United States was absolutely invaluable. I have had numerous helpful discussions with Miss Jessie Dobson of the Hunterian Museum of the Royal College of Surgeons; Miss Constance-Anne Parker of the Library of the Royal Academy; my old tutor Dr N. B. Eales of Reading University; Mr Michael Rosenthal and Mr Basil Taylor. Dr Richard Hunt of Oxford and Dr Neil McKendrick of Cambridge have both supplied me with valuable information and The Honble. Robert Erskine who loaned me his first edition of *The Anatomy of the Horse*. Amongst the owners of material I have wished to reproduce I must thank Her Majesty The Queen; The Royal Academy of Arts; The Worcester Free Public Library and The Worcester Museum of Massachusetts, who have allowed me to publish much material for the first time; The Walker Art Gallery and the Picton Library of Liverpool; The British Museum; The National Portrait Gallery; The Lady Lever Art Gallery; The Royal College of Surgeons; The Mellon Foundation; The Cole Library of the University of Reading; The Wellcome Foundation; The Wedgwood Museum; and the Courtauld Institute of Art.

Finally, I would like to give my most grateful thanks to the designer of this book, Mr Ruari McLean, and to my publisher, Mr T. G. Rosenthal, whose aid and patience have been exceptional.

Colne Engaine, Essex, 1973.

Contents

I. Introduction

Stubbs's early life

When, on August 25th 1724, George Stubbs was born, King George I had been reigning for ten years. The country, despite the alarums of the first Jacobite uprising in 1715, was beginning to settle into a period of great internal peace and expansion, and under the rule of Sir Robert Walpole manufacture, trade, and wealth were steadily increasing. Stubbs's birthplace, the port of Liverpool, was rapidly overtaking Chester as a centre of vital industry; a wet dock had been added to its harbour, and trading had been increased by the industrial development of its hinterland—the textile industries of Lancashire and Yorkshire and the iron-smelting of Cumberland. Already rivalling Bristol in its share of Welsh and Irish trade, and of importation of tobacco and slaves, by 1760 Liverpool was the second port of the kingdom.

George Stubbs was one of seven children born to John and Mary Stubbs.* John Stubbs was a currier, or leather dresser, in Dele Street, which was and remains one of the principal thoroughfares from the waterfront to the heart of the city. His father's tanyards and the slaughterhouses from which the hides were procured must have been entirely familiar to Stubbs from his earliest years. They cannot have made a pleasant environment. The development of humane killing lay far in the future, and the screams of panic-stricken animals, the blood-stained floors of the abattoir, and the heaps of entrails beneath the suspended carcases would have presented a scene of terror to any child not totally absorbed in the goings-on. Paradoxically, the boy brought up in the stench and shambles of the slaughterhouse, in a context of violent cruelty and callousness, was as an adult able to produce some of the most orderly classical art of eighteenth-century England.

By the age of eight, Stubbs was making drawings of the bones and organs of animals, and soon afterwards began to carry out dissection of dogs and hares. No doubt this early work was crudely done, but it is remarkable that a boy of that age should attempt the work at all, and at a period when the formal teaching of anatomy in the medical schools was poor, and practical dissections by student doctors almost unknown. Stubbs's early passion for drawing was not actively discouraged by his father, but he was prudently persuaded to enter the family business, which would provide a more secure future than that of an artist. However, when in 1740 his father died, Stubbs, then aged sixteen, became—apparently with his mother's support—an assistant to the painter Hamlet Winstanley, a copyist employed by Lord Derby at Knowsley. Through this work Stubbs was brought into contact with the only large collection of fine painting within the vicinity of Liverpool. Winstanley, however, proved a bad mentor, deliberately frustrating Stubbs's efforts to learn by copying the Knowsley paintings. After only three months, Stubbs quit his service, vowing that henceforth he would learn from nature alone. He returned to his home in Liverpool and spent the next three or four years drawing and studying anatomy, financially supported by his mother. At the age of nineteen he moved to Wigan and then to Leeds, where he earned his living painting portraits. Finally, in 1743, Stubbs settled in York.

*Compared with that concerning his contemporaries, Reynolds and Gainsborough, the amount of surviving original material dealing with Stubbs's life is small. The most important source is the manuscript Memoir by Ozias Humphry and its two transcripts in the Picton Library in Liverpool. This work was probably largely dictated by Stubbs, with some additions by his companion, Mary Spencer. The Memoir is disjointed and anecdotal, with no clear chronology, but it contains the only contemporary account of Stubbs's anatomical working methods. In addition, there are a number of references to Stubbs in the letters of Josiah Wedgwood, which give an insight into his attitude to his work, but apart from these, little of significance exists.

Eighteenth-century York was an important provincial centre. A wave of development had added to its medieval core notable modern buildings, among them the Assembly Rooms built by Lord Burlington in 1730–32, an advanced and severe manifestation of Palladianism. This splendid start was followed by a theatre, the Mansion House—designed by John Carr—and many private dwellings of considerable distinction. The importance of York was based on its function as a market town, as the seat of an archbishop, and as the social capital of the north-east. The city was also a centre for the practice and teaching of medicine, and in some respects was more advanced than London in the treatment of the poor and insane.

In York, Stubbs made contact with various doctors, among them the surgeon Charles Atkinson, by whom he was employed. Atkinson was able to procure for him a human cadaver for dissection, which Stubbs studied to such advantage that he was soon engaged to give anatomical lectures to private pupils in the hospital. A more important patron, whose influence was to have the profoundest effect on Stubbs's later development, was Dr John Burton (1710–71). Burton was a man of wide learning and culture, for in addition to his primary occupation as a Doctor of Medicine he was also interested in antiquarian activities, particularly of the Middle Ages in York, and in the political problems of his own time, with which he was soon to become dangerously involved. He was educated at St John's College, Cambridge, and at Leyden in Holland, where he studied under Hermann Boerhaave, the greatest teacher of medicine in Europe at that time. Burton's sojourn in Holland exposed him to the most active school of anatomical research in the early eighteenth century, for the anatomists working at Leyden at that time included Sylvius, Bidloo, de Pau, and Ruysch. On his return to England Burton established himself at York as a physician, becoming a founder member of York County Hospital in 1740. There he became the most prominent accoucheur outside London at a time when obstetrics was only beginning to be the province of the qualified male practitioner. These 'men-midwives', as they were called, had to overcome the prejudices of their patients and the ridicule and hostility of the public whilst they developed efficient new techniques of delivery and aftercare.

Dr Burton was soon to become embroiled in more than medical controversies, however. On July 23, 1745 Charles Edward Stuart landed on the isle of Eriskay and raised the Highland clans in revolt against the Hanoverian Settlement. He met the English commander, Sir John Cope, at Prestonpans on September 21, routed him, and began at march on London, spreading alarm through the northern counties. Burton, an active Tory suspected of Jacobite sympathies, was unwise enough to choose this time to visit some of his property in the West Riding, at Settle, a town which lay in the direct path of Charles Edward's advance. When Burton returned to York he was accused of trafficking with the rebels. The instigator of this accusation was Dr Jacques Sterne, whom Burton had previously defeated in a local election. Jacques Sterne was Precentor of the Cathedral and uncle of the novelist Laurence Sterne, at that time the obscure thirty-two-year-old vicar of Sutton, eight miles outside York. Burton was further charged with drinking a disloyal oath in the company of his colleague Dr Drake and he was imprisoned for a year. Laurence Sterne pursued the attack on Burton by later satirising him in the novel *Tristram Shandy*, which was published in 1780. Burton appears in the book in the character of Dr Slop, a ludicrous man-midwife, ill-mannered, bad-tempered, and a vulgar Papist—a crude travesty of the real man.

Stubbs's work for Burton's Midwifery

On regaining his freedom, Burton began work on a book on midwifery. In 1751 his *An Essay Towards a Complete New System of Midwifery* was published, illustrated with eighteen etched tables by Stubbs, and marking an important stage in the development of the subject. The science of obstetrics was only just beginning to make headway against the ignorance which enveloped all matters to do with pregnancy and birth. As recently as 1726 there had

been a furore over the supposed delivery by Mary Tofts of Godalming of a whole series of rabbits, both dead and alive. The affair received enormous publicity until the leading authority, Sir Richard Manningham, after a public investigation instigated by Queen Caroline, proved the case to be a fraud. Manningham was the first doctor to set aside beds for the lying-in of expectant women, at the St James Infirmary in 1739. His work was advanced by Burton in York and by the Scot, William Smellie, in London—both men celebrated for their use of specially designed forceps as an aid in difficult deliveries. Like other men-midwives of the time, Smellie and Burton were forced by the modesty of their patients to adopt women's clothing during delivery, and sometimes to carry out their work in highly difficult circumstances, while their patients remained decorously wrapped in bed-clothes throughout their labour.

Although Burton's work on midwifery coincided with a period of rapid advance in the provision of maternity hospitals, where in London five were established between 1748 and 1757, the series of dissections which Stubbs undertook for the illustration of Burton's book earned him a 'vile reputation'. In his Memoir of the artist, Ozias Humphry says that 'fourteen or sixteen miles from York, a female subject was found singularly favourable for the purpose of these studies and brought to York by Stubbs's pupils, where it was concealed in a garrett, and all the necessary dissections made. This passionate pursuit of knowledge by the most direct means was one of Stubbs's enduring characteristics and imposed itself upon the minds of his contemporaries. His obituary in *The Gentleman's Magazine* of October 1806 says that 'when a young man so ardent was his thirst for acquiring experience by practical dissection that he very frequently braved those dangers from putridity &c. which would have appalled the most experienced practitioners'. *The Sporting Magazine* of July 1808 remarks, 'To dissect the human body was also his diligent pursuit, inasmuch that (as I have heard a relative declare) to procure subjects for his improvement, Mr Stubbs has, an hundred times, run into such adventures as might subject anyone with less honourable motives to the greatest severity of the law.' The fact that Stubbs was prepared to lay himself open to opprobrium and even imprisonment in the pursuit of scientific ends and was to continue to accept these risks even when he could have made a comfortable living as an animal painter indicates both his courage and his will.

All early anatomists laboured under severe restrictions with regard to the availability of human subjects for their work; even the most eminent metropolitan anatomists could use only one or two bodies a year and were thus forced to rely on 'resurrectionists' for extra specimens. The great John Hunter, with whom Stubbs was later to be associated, descended to bribery and subterfuge in order to get hold of the corpse of Byrne, the famous Irish giant, and once he had reduced the body to a skeleton waited for two years before revealing it to the public.

The production of the plates for Burton's work was Stubbs's first attempt at etching. He had obtained advice from a house-painter at Leeds, who showed him the technique of waxing copper plates before attacking them with the acid. He demonstrated the method of cutting through the wax ground to the metal, by using a sewing-needle stuck into a wooden skewer and working on the surface of a halfpenny. Stubbs had to modify his technique; he found that the bitten line was not sufficiently distinct and had to be reinforced by going over it with a graving tool, which he borrowed from a York clockmaker. He seems to have been dissatsified with the work, and he is not acknowledged in the book as the author of the illustrations.

Working with Burton, Stubbs must have had access to a wide range of medical and anatomical texts, for in his book Burton quotes some seventy-six references to other works, mostly dating from the seventeenth century onwards, and it is fair to presume that these volumes were in his possession at the time. Stubbs based his own plates on Albinus's *Tables of the Gravid Uterus* and Astruc's *The Diseases of Women*. His style, apart from the obvious pleasure in delineating fully rounded forms, shows little deviation from that current in contemporary anatomical books. Stubbs's plates show the pelvic region of the female

skeleton, the female genitalia, embryos in positions of normal and incorrect presentation, embryonic malformations, and a variety of obstetric instruments.

The Italian journey

After his collaboration with Burton, Stubbs remained in York until some time in 1754, when he moved for a short period to Hull. In 1754 he took ship for Italy, to make the tour which was then an essential part of the education of an artist. Ozias Humphrey in his Memoir states that Stubbs's Italian journey was carried out with the purpose of convincing himself of the superiority of Nature over Art as a source of inspiration. This attitude seems to have been a desired conviction on the part of Stubbs, rather than a basic assumption underlying his work, and an examination of his paintings as well as of his anatomical studies reveals numerous instances of the influence of earlier works of art and science. It is highly probable that the theme of a lion attacking a horse, which had an obsessive fascination for the artist, originated from contact with a much-restored Roman copy of a Hellenistic sculpture of this subject, which still stands in the garden of the Palazzo dei Conservatori in Rome, and which had been painted by Jan Weenix in the seventeenth century and Pannini in the eighteenth century. The Classical frieze, with its arrangement of forms parallel to the surface, also had a strong influence on his numerous paintings of mares and foals, while the landscapes of Claude, Gaspard Poussin, Vernet, and Salvator Rosa affected his treatment of the backgrounds of his paintings. Whatever the deeper influence of Italy, Stubbs apparently made no effort to paint or draw his surroundings or works of art while he was there. Stubbs's reaction to Italy is in strong contrast to that of other British artists who were there during the same period. These included Wilson, Chambers, Reynolds, and Robert Adam—men who were, from the 1760s to 80s, to revolutionise the arts of painting and architecture in England and direct English taste away from provincial and towards European sources. This redirection was both in its essentials and outward forms towards Italian and Classical art, and demanded many direct quotations from Roman and Renaissance works. Stubbs seems to have resisted these powerful influences in extreme form; his images are quintessentially English in feeling as in subject; but, despite his avowed rejection of Art as a guide and his protested reliance upon Nature alone, they do show a grasp of the deeper implications of Classical Italian art, its order, clarity, and idealised realism.

Stubbs began his journey home in 1755. According to a story originating in *The Sporting Magazine* in 1808, he broke his voyage at Cueta in Morocco, where he witnessed an encounter between a lion and a horse—an account which is most probably fiction based on then extant paintings. Stubbs returned to Liverpool and remained there for some eighteen months, painting portraits and pursuing his studies of anatomy. When, in 1757, his mother died, Stubbs spent another year and a half in Liverpool, settling her affairs and presumably making some arrangements with his brother and sisters about the family business, though no clear account of his activities at this time is available. Some time in 1758 Stubbs went to Hull and thence to Lincolnshire to complete a commission for Lady Nelthorpe, and in the same year he began the preparatory dissections for *The Anatomy of the Horse*.

Though we know little of Stubbs's life and work at this period it is still possible to form an opinion of the character and strength of the artist. From the evidence of his work on the horse, and the self-imposed isolation and iron will which he would have needed to keep to his task, it is clear that he was a man of strong constitution and singleness of purpose. Though he was continually exposed to the dangers of dissection in an age without anti-septics, and to death 'of a putrid miasma' (septicaemia) he seems never to have suffered any serious illness. Indeed, his physical strength became legendary. It was said that he could carry a horse on his back up a flight of stairs, and that on the day before he died he walked eight or nine miles and returned in very good spirits. He seems, too, to have been a keen

observer of nature, who, when his interest was engaged, was tenacious and persevering in the pursuit of his ends. He lacked that urge to theorise, which was such a feature of Reynolds, nor did he suffer the mercurial sensibility of Gainsborough. His industry and patience were quite outstanding. All the work on the engraving of the plates for *The Anatomy of the Horse* was done in time left free from commissions, as were his later researches into the formulation of pigments for enamel painting. His natural gifts, moulded and influenced by his contact with men of science and the voyage to Italy, provided the knowledge and skill to undertake the formidable task of unaided research into the anatomy of the horse.

The Anatomy of the Horse : the historical background

Before dealing in detail with Stubbs's work on the anatomy of the horse, it is essential to give some idea of the development of anatomy before his time. By the middle of the eighteenth century, the science was well established, and numerous, often brilliantly illustrated works on both human and animal subjects had been published. The first detailed records of animals are Greek. Aristotle's descriptions of various vertebrate and invertebrate types indicate that he must have practised or had access to knowledge of animal dissection. That human dissection was practised by the Greeks from the fourth century onwards implies a profound alteration in their attitude to the sanctity of the human body. After the death of Alexander the Great the centre of the study of anatomy shifted from Athens to Alexandria. Though frowned on by the Romans, human dissection continued at Alexandria until the second century A.D.

The first surviving treatise on anatomical procedure was written by the Roman Galen, whose views dominated medicine and anatomy until the sixteenth century. Although Galen was for a time surgeon to the gladiators, Roman abhorrence of human dissection forced him to base his work on studies of the Barbary Ape, the results of which were long-perpetuated errors about human anatomical structure. Galen dissected and described various other animals including the dog, fox, sheep, ox, horse, and elephant, but these studies did not develop further in the succeeding centuries. The triumph of Christianity, with its belief in the sanctity of the human body and in corporeal resurrection, effectively prevented further advances, and indeed led to a positive regression in anatomical knowledge for almost nine hundred years. As early as the sixth century the whole Classical tradition had withered and become corrupted under the double impact of Christianity and Barbarism.

It was left to Arabic scholars to preserve the original Greek and Roman anatomical texts in their own language, until, in the eleventh century, these began to be translated back into Latin by the Italians. Between 1266 and 1275 post-mortem examinations led to a revival of human dissection in Bologna, but its use was restricted to the verification of Roman and Arabic authorities. Few of the Scholastic anatomists descended from their chairs to operate, preferring to leave practical matters to menial demonstrators. The first post-Classical work devoted wholly to anatomy is the 'Anothomia of Mundinus' by Mondino de Luzzi, which appeared in 1316.

The first contemporary illustration of an actual dissection which survives is in the form of a miniature in an early-fourteenth-century manuscript now in the Bodleian Library at Oxford. Henri de Mondeville, *c.* 1270–1320, trained at Bologna and taught at Montpellier, where he used large diagrams to illustrate his lectures, reduced copies of which survive in the Bibliothèque Nationale in Paris. These diagrams are very schematic and show only the viscera of the thoracic and abdominal cavities. Such illustrations were typical of the text figures used until the sixteenth century. There were usually five and sometimes six basic figures, a number traditional since the sixth century A.D. These represented bones, muscles, arteries, veins, nerves, and sometimes the male and female reproductive parts. The Scholastic anatomists placed emphasis on verbal or written descriptions of structure, and they viewed illustrations with disfavour. But while anatomical knowledge continued to

advance during the fourteenth and fifteenth centuries, it was not evident in the illustrative material, which continued to represent not what was seen and known but what tradition required to be seen and known.

The revival of naturalism in the visual arts which occurred in Italy during the Renaissance instigated a parallel revival of interest in anatomy, and artists began to carry out their own dissections in order to obtain a deeper knowledge of structure. Donatello, Signorelli, Pollaiuolo, Verrocchio—who was Leonardo da Vinci's master—and Michelangelo are all known or presumed to have engaged in dissection. Apart from Leonardo, however, the anatomical studies of artists were largely confined to the superficial musculature, blood vessels, and skeleton—that is, to those parts of the body which determined the proportions, form, and modulations of the body surface. Sculptors and painters would have had no use for a knowledge of the viscera, deeper muscles, or the nervous system, since these parts do not appear to affect the outward appearance of the body. Since their aim as artists was accuracy of representation, they were not concerned with the organisational significance of the various parts.

Leonardo da Vinci occupies a rather isolated position in the field of anatomy and its relationship to the visual arts. While he produced anatomical drawings which have never been excelled in beauty and which were fifty years in advance of those of his contemporaries in the correct observation and interpretation of many structures, his impact on this science was minimal. His intention to complete and publish his work on anatomy was never carried out, and the drawings were not in fact disseminated in printed form until 1796, when John Chamberlaine published his *Imitations of Original Designs by Leonardo da Vinci*, thirty years after Stubbs's publication of *The Anatomy of the Horse*. Though Leonardo's work is a pinnacle of artistic achievement in the representation of anatomy, it contributed little to the development of the subject, and had no immediate influence and no direct heirs.

The naturalism of Renaissance art led to the gradual replacement of conceptual by objective illustration in the published anatomical works. The anatomists began to employ artists to produce drawings directly from dissections under their guidance. An enormous impetus was given to the science by the invention of printing and the improvement of woodcut techniques for the production of prints. The study of anatomy is peculiarly dependent upon direct observation, and in default of tangible specimens, attempts at understanding the subject can only be frustrated by inaccurate diagrams or simple written descriptions. Communication between scholars at a distance is even more liable to error and misunderstanding in the absence of accurate visual information. Once reliable diagrams could be produced comparatively cheaply and on a large scale the whole subject was revolutionised.

The collaboration of anatomist, artist, and printer is epitomised by the publication in 1543 of the most famous work of Renaissance anatomy, *De Humani Corporis Fabrica* of Andreas Vesalius, illustrated through a great series of woodcuts by artists probably connected with Titian's studio, among them Jan van Calcar, to whom the work is usually attributed. The fame of this book owes much to the size and brilliance of the plates in which the human body progressively disintegrates under the anatomist's hands, the whole work resembling a scientific sermon on mortality. The figures are posed before a continuous landscape which has been shown to represent the Euganean Hills, south-west of Padua. The illustration of the unsupported body is a *tour de force* of reconstructed knowledge, as it shows the impossible situation of a living, gesturing cadaver, and the work speaks as much for the learning of the artist as of the anatomist. A number of other sixteenth-century anatomical works were produced—notably those of Eustachius—but they have been overshadowed by the reputation of the *Fabrica*.

An interest in the structure of animals was also increasing. Leonardo had made carefully measured drawings of horses from life for the abortive Sforza monument at Milan, and he may have been preceded in this field by Donatello in his preparations for the Gattamelata monument at Padua. Leonardo also made some beautiful drawings of the dissected foot of

6

a bear, showing the mechanism of the retraction of the claws. Even more important were his comparative studies of the hind legs of a horse and the legs of a man. Probably the first example of a deliberate comparison of human and animal structures, its implications place it among the most extraordinary of Leonardo's insights. It was followed in 1555 by Pierre Belon's *L'Histoire de la Nature des Oyseaux*, which contained the first printed figures showing the comparative anatomy of a man and a bird.

The most important of the early zootomists was Volcher Coiter (1534–76), a Frisian who studied in Italy and settled in Nuremberg. He dissected many animals and published plates of the skeletons of a wide range of reptiles, birds, and mammals. These illustrations are accurate and beautifully engraved, but they are crowded together on the page and show little sense of design. This form of anatomical illustration, combining the maximum of information with little aesthetic appeal, became usual in the natural sciences, and with few exceptions persists to the present.

In 1598 Carlo Ruini, a Bolognese senator and an amateur anatomist, published a monograph on the horse entitled *Dell' Anotomia et dell' Infirmità del Cavallo*. This work was significant on two counts: as the first detailed study of the horse and as the first work to be devoted entirely to a single animal other than man. Ruini imitated Vesalius in his treatment of the horse. The style of the woodcut plates is that of the *Fabrica*, the anatomised beast adopting a series of rather Baroque postures before a pastoral landscape. The *Anotomia* is divided into five books, each with its own series of engravings, covering the entire structure in the following order:

Book I Animal Parts—mouth, tongue and teeth, brain, major sense organs, skull.
Book II Spiritual Parts—Neck, thorax, structures of the neck, heart, lungs, diaphragm.
Book III Nutritive Parts—Abdomen, gut, liver, spleen, kidneys.
Book IV Generative Parts—Genitalia, reproductive organs of both sexes, a gravid uterus with placenta and foetus.
Book V Outlying Parts—The limbs with their bones, muscles, and blood vessels.

Added to these parts are figures summarising the more important features of the skeleton, veins, arteries, and muscles.

In the following year, 1599, Jean Heroard published *Hippostologie, c'est à dire Discours des Os du Cheval*. This was prepared quite independently of Ruini and deals fully only with the skeleton, Heroard having lost the material he had gathered on the rest of the structure. Apart from this fragment, between the period of Ruini and that of Stubbs no important original work in the field of equine anatomy seems to have been carried out or published. Ruini's book went through fifteen editions between 1598 and 1769, and it was accompanied by a series of bare-faced plagiarisms in which the plates were copied by inferior hands and disfigured by superfluous ornaments. These plagiaries included Andrew Snape's *An Anatomy of the Horse*, 1683; J. de Saunier's *La Parfaite Connoissance des Chevaux*, 1734; and William Cavendish's *A General System of Horsemanship*, 1743. A curiosity outside this series of copies is *Markham's Maister-peece* of 1631, a treatise on farriery, with illustrations of an almost incredible crudity, in which the skeleton of the horse seems to be composed of barely articulated wooden segments.

Though no advance was made in the study of the horse between 1598 and 1766, the science of anatomy continued to progress in the accumulation of material and in its interpretation. The centre of medical and biological research shifted from Italy to Holland, England, and France during the seventeenth century, a period which saw the invention of the microscope and the use of injections to expose the pathways of vascular structures. The microscope tended to divert the attention of biologists to the newly revealed world of minute organisms, and brilliant dissections were made of insects by Swammerdam and by Malpighi, who first developed the use of mercury injections to show the tracheal system of bees. However, the great virtuoso in the field of injection was Frederick Ruysch, Professor

of Anatomy at Amsterdam, who thrust his syringe into every organ of the body, revealing vascular systems even in the periosteum of the auditory ossicles.

Improvements also came in methods of preservation. Smaller specimens were stored in alcohol and larger ones injected with arsenical compounds, or carefully dried and impregnated with wax. Anatomical museums began to be established, the indefatigable Ruysch producing a veritable necropolis in which the specimens were arranged as a vast sermon on the inevitability of death, rather than as a logical display of organic development.

Bernhard Siegfried Albinus, Professor of Anatomy and Surgery at Leyden from 1721 to 1770, pioneered a new epoch in the study of human anatomy, particularly in osteology and myology. His most important works were the *Historia Musculorum Hominis* of 1734, which contained eight plates depicting the muscles of the hand, and the great *Tabulae Sceleti et Musculorum Corporis Humani* of 1747, which was translated into English in 1749. Albinus employed the artist Jan Wandelaar to make preliminary drawings and to engrave the large, elaborate, and extremely beautiful plates. This work is of cardinal importance for the study of Stubbs's *Anatomy of the Horse* and his later *Comparative Anatomical Exposition*; both plainly owed an enormous debt to it. The English edition of Albinus's book of 1749 has a long preface by the author, describing very exactly his working methods and the problems he encountered and overcame in producing the plates, together with his reasons for adopting certain features in the finished work, such as the backgrounds and separate key figures.

Albinus began his work in 1724, and it was virtually a fresh examination of human anatomy from the direct observation of his own and his students' dissections. He began by making drawings directly from the body, beginning with the surface and proceeding inwards. As he progressed, he found great difficulty making accurate drawings of the parts, since there was no fixed point of reference on which to base the outlines of the muscles, which were continually being disturbed by deeper dissection. He therefore decided to prepare a skeleton and make extremely accurate, measured drawings and engravings of this, the one stable part of the anatomy. He produced a fresh skeleton with all the tendons, ligaments, and cartilages attached and preserved these from decay by soaking them in vinegar. This skeleton was arranged in a natural posture and held upright with tensed cords attached at salient points such as the spine, girdles, and limbs, with the pelvis resting on a metal tripod. Several days were spent in adjusting the posture by tightening or relaxing the cords until all was perfect. Albinus overcame the problem of obtaining correct proportions between the parts of the body in his drawings by using a series of grids or quadrats made of cords strung on frames and placed at selected intervals between the observer and the skeleton. One was placed almost in contact, the second at a distance of four feet, and the third at a distance of forty feet from the model. The artist Jan Wandelaar made general drawings of the whole skeleton at the greatest distance and then moved closer to it to verify the finer details. At the same time a live nude model stood by in the same attitude as the posed skeleton. The completed drawings were reduced and engraved on copper, and prints were taken with the greatest care to avoid distortion in the press. The printed skeleton outlines were then used as the basis for a large series of drawings of the muscles, which were made from demonstration dissections in the anatomy schools. After corrected drawings of the layers of muscles had been made, the plates were engraved and printed for the finished work.

The whole of this undertaking occupied some twenty years between 1725 and 1747. The plates are exquisitely engraved and show the body in much less rhetorical postures than in Vesalius's work. The landscape backgrounds usually include some animal or architectural fragment, and were chosen—according to Albinus—in order to enhance the chiaroscuro of the figures and give them a greater illusion of three-dimensional reality. He did not obscure these highly wrought figures with reference numbers or labels, but produced separate outlines on which were added key figures referring to the printed descriptions accompanying the plates. Many of these features were adopted by Stubbs when he published *The Anatomy of the Horse*.

When Stubbs began to dissect horses at Horkstow in Lincolnshire in 1758 he had a considerable background of scientific knowledge upon which to draw. The initial impetus for undertaking this arduous and difficult piece of work seems to have come from his colleagues at York, who had promised him material and financial assistance, which was not, in the event, forthcoming. Stubbs selected an isolated farmhouse, no doubt to avoid the curiosity and odium which was attached to the practice of dissection. It is probable that the house was found for or loaned to him by his patroness, Lady Nelthorpe, who lived in the county.

The horses which Stubbs used for his dissection were killed by bleeding from the jugular vein, a process which avoided damaging the carcase. The vascular system was then injected with warm tallow to preserve the course of the vessels and make them more visible as the dissection proceeded. These preliminaries complete, the carcase was then slung from the roof-beams by iron hooks fixed to a bar of the same metal and thrust through the rib-cage below the spine on the side opposite the one to be dissected. The iron bar was attached to a tackle (or 'teagle' as Humphry calls it) and suspended so that the horse's feet just touched the ground and the anatomist could have ready access to all parts. Dissection began with the abdominal muscles and worked down to the membranes of the peritoneum and pleura covering the gut and lungs, at which point the viscera were discarded. The head and the rest of the musculature were then attacked, and drawings with written notes and descriptions made at each stage.

Work on each specimen apparently occupied between six and seven weeks, and in one instance eleven weeks, but no mention is made of the method of preservation. No doubt Stubbs did most of his dissecting during the colder months of the year, or he may have used vinegar as a crude method of arresting decay, but the work can never have been easy or pleasant. The size of the animal and the enormous care needed for accurate dissection and drawing at each stage would have made work very slow, and inevitably a powerful stench could not have been avoided. The instruments Stubbs used would have been very like those still current for anatomy, as can be verified from contemporary illustrations.

The drawings which Stubbs made for *The Anatomy of the Horse* are at the Royal Academy Library in Burlington House. They were acquired in 1879 as a bequest from Charles Landseer, Keeper of the Royal Academy and brother of the painter Sir Edwin Landseer, who had himself originally owned them. Until 1963 the Royal Academy were only aware that they had eighteen drawings for Stubbs's *Anatomy of the Horse*, but in that year a parcel was found containing a battered portfolio in which were twenty-four more drawings. These rediscovered drawings appear to have been kept separate because they were less finished than those which were already known, the latter having been mounted at some time and used in the teaching of the Academy's students.

The Royal Academy's drawings fall into two groups. The first are working drawings done directly from dissections. They are of varying dimensions and have been done in several media: pencil, red and black chalk, and coloured ink, the bulk of them bearing evidence of a traced or pounced outline. The second group are highly finished pencil studies of uniform dimension, from which the plates for the book were engraved. This second group consists essentially of refined generalisations of the anatomy based upon the more numerous working drawings. The working studies show that Stubbs followed Albinus's method as set out in the 1749, English, edition, of his *Tabulae Sceleti et Musculorum Corporis Humani*. The drawings of the muscles from the dissection were added to previously prepared outlines of the skeleton, which Stubbs had accurately measured and whose proportions acted as a standard of reference throughout the work. There are three drawings (R.A. Nos. 34, 35, and 36) of outline skeletons with careful measurements of the proportions. The final drawing of this group, a lateral view from the left, has a note to the effect that it was the skeleton of an old mare, fifteen hands high. These measured skeletons appear to have been used for the highly finished final studies and not for the working outlines, since they differ materially in appearance from the latter.

Stubbs states in the preface to his book that he based the system of measurement and proportion on the length of the skull from the occipital crest to the ends of the incisor teeth. One of the working drawings (R.A. No. 22), a frontal view, has been squared. This might have been done for purposes of reduction or enlargement, but since the posture is markedly different from the final frontal views, this seems unlikely. It may indicate that Stubbs attempted Albinus's system of using quadrats at various distances for determining the relationships between the parts and the whole. All the working drawings of the anterior and posterior views differ markedly from the finished studies; the angle is more oblique and the distortion in the length of the nearest limbs is very noticeable. This distortion may well be due to the fact that Stubbs was having to work at rather close quarters to the animal and could not get far enough away to produce a balanced view.

Stubbs evidently produced another set of skeleton outlines for his working studies, and this would almost certainly have been the first task he undertook at Horkstow. The bones in these skeleton outlines are often numbered, particularly those of the spine, to help in the correct observation of the origin and insertion of the various muscles. The different media used in the studies also helped to distinguish the muscles, nerves, and blood vessels. Stubbs's drawing technique varies from very free sketching to the style of the highly finished final studies. Working notes are often added round the margins, and in many cases these have become difficult to decipher due to fading. The elaborate final studies for the engravings are very remarkable and beautiful, both as lucid representations of anatomy and as independent works of art. Only occasionally may faint traces of a preparatory outline be seen, but it is evident that these drawings, like those of Albinus, are generalised studies based upon a series of observations of individual specimens. They avoid the individual distortions of particular structures which always occur in nature. The pencil work is of the greatest delicacy, the forms are modelled by shading, indicating a lighting from the left, though the degree of contrast between light and dark is never extreme. Stubbs used a complex of hatchings, stippling, and rather longer strokes, which in some cases follow the forms and in others the direction of the muscle fibres. When he came to make the engravings, Stubbs followed the minute variations in the pencilling of the drawings with great fidelity, making only occasional modifications.

Humphry says that Stubbs's drawings were not only of the entire horse but included diagrams of individual parts as well, such as the limbs and sense organs. No drawings of this kind survive. It is possible that Stubbs had not completed all the highly finished drawings for the plates or that he was contemplating a more extensive work covering the complete anatomy in the style of Ruini. It is also remarkable that apart from a single drawing of the head and neck of a fowl there are no fragmentary drawings or studies in the later material prepared for the *Comparative Anatomical Exposition*, all being of entire animals or men.

The preparatory work for *The Anatomy of the Horse* was completed by the production of a numbered key for each figure, accompanied by notes. These notes were also a great contribution to the anatomical knowledge of the time and were a more extensive and complete description of the detailed structure of the horse than any that had preceded them. Such notes obviously required much original observation, combined with the profound knowledge of human anatomy which Stubbs would have needed to assist in his interpretation of equine structures, since he would have had no other contemporary horse anatomy to guide him.

With all the preliminary work complete, Stubbs left Horkstow for London some time in 1759 and settled in Somerset Street, off Oxford Street, on a site now occupied by Selfridges store. He attempted to obtain professional help in engraving the plates for publication, and approached Grignion and Pond, leading engravers of the time. Both refused the work on the grounds that it was too difficult for them to interpret the drawings because of their ignorance of anatomy. In default of specialist help, Stubbs undertook the work of engraving himself, and had to proceed with it in the time left free from his professional activities as a painter, with which he was increasingly occupied during the 1760s.

Eighteenth-century books were usually illustrated by copper-engravings. The leading country for their production was France, where it was usual for book illustrations to be designed by an artist and thereafter for the plate to be independently engraved by a specialist in the work, although the artist might occasionally see the whole process through to publication himself. The commonest technique was a mixture of etching and engraving, the main outlines of the composition being often lightly etched as a guide to the engraver, who then worked over the plate with a burin or graver, the engraved line standing up to the pressure of printing better than an etched one. As the eighteenth century advanced, techniques tended to change. Attempts were made to reproduce the tonal subtleties of painting both in the reproduction of paintings and in original prints. In England, particularly in the latter part of the century, when English books began to equal French ones in the quality of their engraving, mezzotint and aquatint were often combined with etching and line-engraving, and there was a frequent use of mixed methods to create a great variety of effects. Although Stubbs used several different methods in his later work as a printmaker, he employed a linear technique for the plates of *The Anatomy of the Horse*, thereby allowing the greatest clarity of detail—a necessity in a scientific work where the information imparted by the plate must be a prime consideration.

Stubbs's use of line in *The Anatomy of the Horse* is wholly his own. Little trace remains of those outside influences which marked his work for Burton. He had mastered the medium and subjugated it completely to express his ends. The engravings show a great variety of strokes, from stippling to the most complex cross-hatching; the line is employed to indicate contour, texture, mass, and chiaroscuro. Bones are usually shown with a delicate linear stipple to differentiate them from muscle, which is described by a more continuous line following the contour of the organs and, at the same time, indicating their fibrous nature. Nerves are simply bounded by a continuous line and left white, while the blood vessels are given a spiralling contour. Shadows and those parts which are reproduced in depth are made darker by cross-hatching, which increases in intensity to produce a continuous black where required. On the whole, Stubbs followed his pencil drawings closely. Frequently the engraved line faithfully reproduces the effect of the pencil, most noticeably in the texture of the muscles, but the nerves and blood vessels have a more linear quality in the plates. Small details such as the precise course of a vein or the angle of the ears differ in the drawings and the plates. Often the latter show a greater definition, and Stubbs may well have referred to working details as well as to the highly finished drawings while he was at work on the engraving. The completed work is a masterly display of knowledge and organisation; the horse is shown in a vital but un-rhetorical posture, with an appearance so fully realised as to appear almost sculptural. The form, within which the detail clearly stands out, is established without destroying the overall unity of the design. *The Anatomy of the Horse* has both scientific and artistic importance, and it enjoys, with the anatomical works of Vesalius and Albinus, an esteem far beyond the special area of learning for which it was designed.

Stubbs advertised the *Anatomy* in the London press, offering a price of four guineas for subscribers to the book and five guineas for non-subscribers. The date of publication was March 4th 1766, and it was distributed through four London booksellers, Dodsley in Pall Mall, Nourse in the Strand, Owen at Temple Bar, and Newberry at St Paul's Churchyard.

The establishment of Stubbs's reputation and his relations with Josiah Wedgwood
In 1760, when Stubbs established himself in London, George III had just succeeded his grandfather as King. Pitt and Newcastle were coming to the end of an uneasy partnership as heads of Government, and were soon to be succeeded by the King's favourite, Bute. Though the reign was frequently marked by political upheaval, the country enjoyed a period of remarkable social stability and continually increasing industrial, agricultural, and mercantile prosperity. In 1760 the country's imports amounted to eleven million pounds and her

exports to sixteen million pounds. The population was between six and a quarter and six and three-quarter millions—a figure which had been stable for some time but was soon to rise and continue to do so, due to the fall in the death rate and rise in the birth rate, the result of a continued improvement in both the quantity and diversity of food and the slow but appreciable effects of an increasingly scientific practice of medicine.

The social and intellectual life of London dominated the rest of the country. Although local affairs preoccupied most men's minds in the provinces, new ideas and new habits were invariably generated in, and filtered through from, the capital. In choosing to settle in Somerset Street, Stubbs deliberately selected a part of the town where he would find his future patrons. Georgian London began to develop rapidly after the Hanoverian Settlement, particularly the estates of the Russells, Grosvenors, and Cavendishes north of Oxford Street. While the City remained the centre of commerce, law, and medicine, the expansion to the north and west of Westminster had begun to make this area, as it remains today, the social and fashionable centre of metropolitan life.

Stubbs's arrival in London meant that he had to find employment for his talents. He was completing the engraving of the plates for *The Anatomy of the Horse*, and he was soon occupied as a painter of horses and other animals. Among these were hunting and racing scenes and conversation pieces, in which the human subjects are almost invariably associated with horses, or in which horse-drawn vehicles predominate. Among the earliest of these pictures are the series which he painted for the Duke of Richmond at Goodwood between 1760 and 1761. The first of these paintings is probably the one showing a hunting party of the Duke, his brother Lord George Lennox, and General Jones. The composition is rather naïve, with the human figures disproportionately elongated, and a number of the hounds rather weakly drawn. The quality of the painting seems to indicate that Stubbs was uncertain at this stage how to handle a large and complex composition, but what is more interesting (from our point of view) is the rather inept handling of the human and animal anatomy.

Stubbs seems, in this early work, to have paid closer attention to the style of pictures made by his much less masterly predecessors than to his own hard-won anatomical knowledge. Nor does he follow his avowed principle of applying himself solely to the study of nature as a guide for his work. In this particular instance he may well have felt it advisable to bow to precedent and the expectations of his patron, although no doubt simple lack of experience contributed to the style of the work. The other Richmond paintings show a much greater control of composition and, particularly in the painting of the Duke and Duchess of Richmond watching their horses at exercise (1760–61), beging the wonderful series of anonymous portraits of grooms and stable boys which give such insight into eighteenth-century life and character. The culmination of this first phase of his activity is the magnificent *Grosvenor Hunt* (1763), a painting still in the estate of the original owners. Here Stubbs shows a complete control of design, accuracy of representation, and anecdotal conviction. Almost two-thirds of the canvas is occupied by a group of riders and hounds moving to the kill. Poised over the dying stag, and framed by the curving trunk of a tree, is the Earl of Grosvenor, patron of both the hunt and the artist. The whole scene is balanced by a single huntsman blowing his horn on the far left of the picture.

In 1770 Stubbs began to exhibit pictures executed in enamel on copper. According to Humphry, Stubbs was persuaded to adopt this form of painting at the suggestion of Richard Cosway, whose work in enamel had been commissioned by a foreign patron. Once Stubbs's interest in the technique was aroused he spent almost all his free time in experimenting on the colours to be used in enamelling, finally producing nineteen different tints. The largest copper plate which could be satisfactorily fired was ten by fifteen inches and this Stubbs found to be inadequate for his conception. He therefore applied to Josiah Wedgwood to make him some ceramic plaques which would serve equally well for enamel painting, but which could be made in much larger sizes than the copper plates.

In the letters of Josiah Wedgwood to his partner Thomas Bentley there are several references to George Stubbs which are extremely valuable since, apart from the Humphry

Memoir, they represent the only extensive and contemporary record of the thoughts and activities of the artist.

The first mention of Stubbs in the Wedgwood–Bentley correspondence occurs in a letter, dated October 1777, in which Wedgwood commented, 'I am afraid Mr. Stubs [*sic*] will find our pallet of Queen's Ware too heavy for his hand.' This apparently refers to some pallettes which were probably never made. On November 4th 1777 Wedgwood wrote, 'My compliments to Mr. Stubbs. He shall be gratified but large tablets are not the work of a day.' Wedgwood evidently then began to carry out some serious research into the problem. He started with trials on small plaques and gradually increased their size, but experienced difficulty in preventing them from disintegrating in the kiln. On October 17th 1778 he wrote to Bentley, 'When you see Mr. Stubbs pray tell him how hard I have been labouring to furnish him with the means of adding immortality to his very excellent pencil. . . . My first attempt has failed, & I cannot well succeed in my experiments 'till we lay by work for Xmass when our kilns will be at liberty for my trials.' It was not until May 30th in the following year, 1779, that Wedgwood was able to report any real success. On that day he wrote to Bentley:

I wrote to you by post this morning, but wish to say a word or two concerning Mr. Stubbs and his tablets.

We shall be able now to make them with certainty and success of the size of the 3 in this invoice and I hope soon to say as far as thirty inches, perhaps ultimately up to 36 inches by 24, but at present in the offing, and I would not mention to Mr. Stubbs beyond 30 at present.

If Mr. Stubbs succeeds he will be followed by others to which he does not seem to have the least objection, but rather wishes for it; and if the oil painters too should use them they may become a considerable object.

At present I think we should give Mr. Stubbs every encouragement to proceed and establish the fashion. He wishes, you know, to do something for us by way of setting off against the tablets. My picture and Mrs. Wedgwood's in enamel will do something. Perhaps he may take your governess and you by the same means. I should have no objection to a family piece, or rather two, perhaps, in oil, if he should visit us this summer at Etruria. These things will go very much beyond his present trifling debt to us. Now I wish you to see Mr. Stubbs, and if the idea meets your approbation, to tell him that if it is convenient for him to pay in money for what he has hitherto had, it will pay something towards the kilns, and alterations in kilns we have made, and the other expences we have been at in our essays, and the next 100 or £150 in tablets, perhaps more, shall be work and work. We will take the payment in paintings.

The two family pieces I have hinted at above I mean to contain the children only, and grouped perhaps in some manner as this.

Sukey playing upon her harpsichord, with Kitty singing to her which she often does, and Sally and Mary Ann upon the carpet in some employment suitable to their ages. This to be one picture. The pendant to be Jack standing at a table making fixable air [CO_2] with the glass apparatus etc.; and his two brothers accompanying him. Tom jumping up and clapping his hands in joy and surprise at seeing the stream of bubbles rise up just as Jack has put a little chalk to the acid. Joss with the chemical dictionary before him in a thoughtful mood, which actions will be exactly descriptive of their respective characters.

My first thought was to put these two pictures into Mr. Wright's hands; but other ideas took place and remembering the labourers, and cart in the exhibition, with paying for tablets etc. I ultimately determined in favour of Mr. Stubbs, and have mentioned a fire piece to Mr. Wright in a letter I wrote to him the last week to tell him I should be glad to see him here in a fortnight or 3 weeks. But what shall I do about having Mr. S. and Mr. W. here at the same time; will they draw kindly together think you.

I. Introduction
The establishment of
Stubbs's reputation

In the summer of the following year, 1780, Stubbs went to Wedgwood's home at Etruria where he worked between August and October on family portraits and the modelling of a relief. Wedgwood's own ideas for the pictures, which he had so carefully described to his partner, evidently did not appeal to the artist, who produced instead a large group-portrait of Wedgwood with his wife and children, four of whom are on horseback. He also painted three single portraits, of Wedgwood, of his wife, and of his father, Richard Wedgwood. Stubbs was paid £236. 17s. 6d. for the family group, £26. 5s. od. for the portrait of Richard Wedgwood, and £19. 13s. 9d. for the portrait of Sarah Wedgwood. Stubbs based the subject of the relief plaque which he modelled on the engraving of *A horse frightened by a lion*, which he had first published in 1777.

In further letters to Bentley, Wedgwood continues the description of Stubbs's activities at Etruria.

7th August, 1780
. . . We have been considering, and reconsidering some subjects besides tablets for Mr. Stubbs to paint in enamel and we are now making some large jarrs for that purpose. The present idea is to cover them over with painting, with the ground, figures, trees and sky without any border or divisions, in short to consider the whole surface as one piece of canvas and cover it accordingly, and under this idea we find a simple jarr form the best for our purpose, and they will come cheap enough which, as times are, may be something in their favour.

This morning we are going for the second time to the works to see the jarrs turned and to prepare some clay tablets for modeling upon, and we shall then dine with the good parson of Newcastle so that this day is fully provided for only we must find time for a lecture upon perspective, which science Mr. Stubs has kindly engaged to teach my boys.

Mr. Stubs, it seems has been a drawing master amongst other things, at Heath academy, though he followed that profession but a short time. He began by teaching perspective to his pupils, which he believes to be just as rational a method in drawing as learning the letters first is acquiring the art of reading and he would have the learner to copy nature and not drawings. . . .

13th August, 1780
We make but little progress with the family piece at present, but Mr. S. talks of laying to in good earnest soon. He has fixed upon his subject for modelling, the lion and horse from his own engraving. He objected to every other subject so I gave it up, and he is now laying in the horse whilst I am writing a few letters this good Sunday morning. He does very well so far, and with a little practise will probably be as much master of his modeling tools as he is of his pencils. I will write you farther as we proceed.

Our three little lasses and their coach are just put into colours, and the characters of the children are hit off very well. I have given him one sitting, and this is all we have done with the picture. The stable is preparing, and the horses are to sit this week. . . .

21st August, 1780
On Monday last I took Mr. Stubs to Trentham to look at the fine view there. Lord Gower was polite enough to ride with us through the park and grounds. This morning we spent in mere viewing of the finest scenes, Mr. S. says, he ever saw, and the remainder of the day in feasting the body and mind in his lordships mansion.

Our picture proceeds very slowly, but we have begun to make the horse sit this morning, and I write this by Mr. Stubs in the new stable, which is to be my new study whilst he is painting there.

14th September, 1780
Our picture goes on very slowly, but we report some progress and I think the likenesses promise to be strong, but I do not know what to say upon this subject because the

likeness in those that approach towards being finished grow weaker as the painting increases. Mr. Stubs says the likeness will come in and go off many times before finishing, so I can say nothing to this matter at present, only that the first sketches were very strong likenesses, and the after touches have made them less so, but I dare say he will bring them about again before he takes his final leave of the picture.

25th September, 1780
Mr. Stubs came to us again last night after finishing a portrait of Mr. Swinnerton which is much admired, and I think deservedly so by all who have seen it, and I hope this, with our family picture and some others which he will probably paint before he leaves us, will give him a character which will be entirely new to him here, for nobody suspects Mr. Stubs of painting any thing but horses and lions, or dogs and tigers, and I can scarcely make any body believe that he ever attempted a human figure.

I find Mr. S. repents much his having established this character for himself. I mean that of horse painter, and he wishes to be considered as an history and portrait painter. How far he will succeed in bringing about the change at his time of life I do not know. The exhibition may do wonders for him.

21st October, 1780
Mr. Stubs is now drawing to a conclusion and talks of going to Liverpool in a few days; but I think he is not quite so near a finish as he seems to apprehend. He thinks he has finished six of the children, the horses and the little carriage. The children are most of them strong, but not very delicate likenesses—Some parts are either a little caricatured, or my own eyes and those of many of my friends are much decieved. He certainly has not observed Mrs Montague's maxim respecting her model, but I will not say any more upon this subject at present, and this is only to yourself, as it would be hardly fair 'till the picture is turned out of his hands as completely finished, and besides he has promised to compare the originals and copies carefully together and give any last touches which may be found wanting as soon as he has brought my wife, my daughter Susan and my self up with the rest. I think he has not been so happy in hitting off the likenesses of the two former as he has in the others. I have been sitting the great part of the day but cannot report much progress.

Time and patience in large doses are absolutely necessary in these cases, and methinks I would not be a portrait painter upon any condition whatever. We are all heartily tired of the business, and I think the painter has more reason than any of us to be so.

These letters give an insight into Stubbs's avowed and actual attitudes to his art and are in some ways more valuable than the contrived apologetics of the Humphry Memoir. The regret that Stubbs manifested to Wedgwood about his limited reputation as 'a mere horse painter' is belied by his determination to modify his patron's very decided wishes about the family group, introducing horses where none had been intended, and in his very stubborn refusal to model any but his chosen and favourite theme of the lion and the horse.

The Wedgwood letters also give us some idea of the milieu in which Stubbs moved and was accepted during this time. It is obvious that he was treated by Wedgwood with considerable respect as a fellow worker in the arts and a man of intellectual curiosity and seriousness. Wedgwood was one of a provincial group, many of whom were members of the Lunar Society of Birmingham, which represented the most active and advanced aspect of mid-eighteenth-century intellectual life. Those men included Joseph Priestley, Matthew Boulton, James Watt, and Erasmus Darwin, whose family was to be linked by marriage with Wedgwood's. The interests of these men were very wide in range, but they were also intensely practical and predominantly scientific. Such a group would have welcomed Stubbs, whose contribution to the study of anatomy was by then celebrated, and the artist would have received from these talented men a reciprocal stimulus and an affirmation of his

I. Introduction
*The establishment of
Stubbs's reputation*

own personal predilections. These were advantages which his acquaintance with other artists could not provide, and he seems to have been often uneasy in their society.

Stubbs and the Hunter brothers

Amongst Stubbs's more important patrons in London were the brothers William and John Hunter, the former the successor to Dr Smellie as the leading metropolitan man-midwife and the accoucheur of Queen Charlotte, and the latter the greatest comparative anatomist in Europe in the second half of the eighteenth century. William was a devoted collector of coins, books, and pictures. He commissioned a portrait from Allan Ramsay and bought several paintings from Chardin, which are still part of the Hunterian Collection of the University of Glasgow. From Stubbs he purchased four pictures of animals; a Pigmy Antelope, a moose, a Nylghau, and a spotted cavy. Of these the last has disappeared. The painting of the Pigmy Antelope is unfinished and shows clearly Stubbs's method of first painting the animal before completing the background. The initial paintwork is very thin, and he was obviously at pains to perfect the contour.

John Hunter was less concerned with his own social advancement and with the aesthetic satisfactions of collecting than his elder brother, William. He was passionately engaged in the study of comparative anatomy and in the advancement of surgery. He amassed an immense collection of prepared specimens and dissections at his house in Leicester Square and had a private menagerie at another establishment at Earl's Court. After his death, John Hunter's collection was carefully preserved by his assistant William Clift until it was bought by the Royal College of Surgeons, where a large part of it was tragically destroyed by bombing in the Second World War. But the paintings Hunter obtained from Stubbs survive. Like those at Glasgow they are of animals—an Indian rhinoceros, a yak, and a baboon with an albino Macaque monkey.

The painting of the rhinoceros is the first really accurate representation of this animal to be executed in oils. Dürer had produced a woodcut in 1515, from sketches done in Portugal of an Indian rhinoceros which was being delivered to the Pope. This woodcut is impressive but wildly fanciful since Dürer transformed the hide into the semblance of Gothic horse-armour and, to correlate it with a Classical description of a two-horned rhinoceros by Martial, added an extra horn between the shoulder blades. Dürer's image, however, proved to be a most potent one and persisted, with the inevitable distortions resulting from copies, until the eighteenth century, even being incorporated into the arms of the Society of Apothecaries in 1621.

Stubbs apparently made several studies of Hunter's rhinoceros and nine of the animal in different attitudes were recorded at the sale of Stubbs's effects. But only one of these studies, in pencil, has come to light. The drawing, which is now in the possession of Mr Basil Taylor, shows the rhinoceros recumbent on the ground facing to the left, unlike the painting in which it is seen standing facing in the same direction.

Stubbs's relationship with John Hunter is not recorded, but the latter's attitude to the study of anatomy, especially his insistence on the importance of tracing the relationships of organs through a series of comparative specimens, must have been a powerful influence on Stubbs's last published work. Hunter's lifelong interest was the practice and teaching of surgery and anatomy, and his ambition was to investigate and display in the museum which he began in 1763 the anatomy and physiology of the whole animal kingdom. Hunter was not an articulate man and he left no clearly written statement of his general ideas, but the way in which he organised the museum shows a trend of thought which was unique in a pre-Darwinian age. He arranged the specimens to show the general anatomy of various selected animals, followed by detailed preparations to demonstrate the various vital functions such as locomotion, digestion, and the operation of the vascular system. The collection was completed by a series of preparations showing the organs of reproduction.

By these means Hunter was able to present comparative anatomy in an orderly and scientific manner and to demonstrate through a series of animals the developmental changes in various organs which had taken place, a demonstration which by implication alone was clearly evolutionary in intention.

Stubbs's later life and his work on the Comparative Anatomical Exposition
Stubbs's activities between the publication of *The Anatomy of the Horse* in 1766 and the preliminary work for the *Comparative Anatomical Exposition*, which he began in 1795, were devoted to painting and to his researches into the properties and technical application of enamel pigments. Although he was continually occupied with the production of pictures of animals, he does not seem to have been able to give much time to the detailed dissections of his subjects. However, his interest in this branch of study did not altogether diminish. There is a story told in the Humphry Memoir that one evening at about ten o'clock a visitor called at his house in Upper Seymour Street to tell him that a tiger had just expired at Pidcock's Menagerie in the Strand. According to the story, Stubbs 'flew towards the well known place and presently entered the den where the dead animal lay extended: this was a precious moment; three guineas were given to the attendant, and the body was instantly conveyed to the painter's habitation, where in the place set apart for his muscular pursuits, Mr. S. spent the rest of the night in carbonading the once tremendous tyrant of the Indian Jungle.'

Although Stubbs's first ten years in London had been enormously productive and financially rewarding, as the century advanced the demand for his work began to decline—a situation possibly brought about by the general shift in taste as the official ideals of the new Royal Academy became more firmly established. Stubbs's problems were not eased by his development of enamel painting. His works in enamel were generally light in tone, and the application of the pigment was smooth, delicate, and extremely subtle. Moreover, the later enamels on Wedgwood plaques were in an unfamiliar oval format. These enamel paintings failed to please the public, and though a few were commissioned twenty-six remained in his studio unsold at the time of his death. His oil painting was influenced by his enamel technique and became markedly thinner and more delicate. Stubbs's personal relations with the Royal Academy were unhappy. He had been elected an A.R.A. in 1780 and advanced to full membership in 1781, but he refused for some reason to submit the obligatory Diploma work. His appointment was not, therefore, completed and was allowed to lapse after three years. Stubbs also suffered a severe setback in the early 1790s when a series of paintings specially commissioned for the *Turf Review* failed to sell. In the last decade of his life he was in straitened circumstances, and he became dependent on the financial help of Miss Isabella Saltonstall, whom he had painted in 1782 in the character of Una in Spenser's *Faerie Queen*, an enamel recently acquired by the Fitzwilliam Museum.

When Stubbs turned his mind once more to a large-scale anatomical work he may have been feeling a sense of understandable disillusionment with the pursuit of pure painting and a strong desire to immerse himself again in those activities on which his initial reputation had been founded. Whatever the motive, the work he undertook was both highly original in conception and extensive in scope. Stubbs's close association with John Hunter probably provided the initial idea of producing a work of comparative anatomy. His book, entitled, *A Comparative Anatomical Exposition of the Human Body with that of a Tiger and a Common Fowl*, was to be the first major illustrated study of a comparative nature yet produced. Although this work was published in an incomplete form, due to the artist's death, there is a greater surviving bulk of preparatory material made for it than for the much more widely known *Anatomy of the Horse*. While the Royal Academy have thirty-nine drawings for *The Anatomy of the Horse*, there are one hundred and twenty-four drawings for the *Comparative Anatomical Exposition* in the collection of the Worcester Museum in Massachusetts, consti-

tuting the largest single surviving group of Stubbs drawings. The drawings at Worcester are accompanied by four volumes of manuscript text, partly in French and partly in English. This material passed to Mary Spencer after Stubbs's death. In 1817 when she died they passed to Thomas Bell, a dental surgeon and anatomist. Bell sold the Stubbs material some time in the 1850s to Dr John Green of Worcester, Massachusetts. In 1859 Dr Green offered his entire library of seven thousand volumes to form the nucleus of the Free Public Library of Worcester, and the Stubbs material bears the Library's accession date of January 1 1863. Since that date they remained virtually hidden from public view until they were rediscovered in May 1957, when the Library began to recatalogue its collection. They were exhibited in October 1957 in Worcester and in 1958 at the Arts Council's gallery in London. A selection of the drawings was later shown in an exhibition of Stubbs's graphic work at Aldeburgh and the Victoria and Albert Museum in 1969.

The relationship between the Worcester drawings and the published plates of the *Comparative Anatomical Exposition* issued during Stubbs's life and immediately after his death is complicated, and a comparison between them and the drawings for *The Anatomy of the Horse* is of great interest. From a technical point of view the Worcester drawings, many of which are mounted on card, fall into three groups, those made on thick cartridge paper, those on laid paper, and those on thin paper. Stubbs used three different media for the work—pencil, red chalk, and ink. In some instances he squared the drawings for transfer or enlargement. Stubbs does not seem to have arranged them according to any clear scheme, or if he did the original order has been disturbed and new classification must be imposed. Few of the Worcester drawings seem to be made directly from one of Stubbs's actual dissections, unlike a number of the drawings for *The Anatomy of the Horse*. They seem to be refinements of direct studies—which, it must be presumed, were lost or destroyed by the artist—made with a view to clarifying and generalising the anatomy, and designing a drawing suitable for engraving. Apart from the anecdote about the tiger we have no other evidence of Stubbs's working on dissection for the *Comparative Anatomical Exposition*. It would have been easy for him to obtain fowls, but the dissection of a human body on his own premises would have posed a serious problem. Although the situation regarding human dissection was becoming easier at the end of the eighteenth century, it would have been virtually impossible for an unqualified private person to carry out such work at his own home, except in conditions of considerable secrecy and risk, and to publish the results of such illicit activity would only have increased the danger. It is more probable that Stubbs used his connection with John Hunter to gain access to the anatomy rooms in one of the London teaching hospitals, where he could perform dissections himself, or else observe the demonstration dissections made for the students.

Stubbs's method of preparing the work for publication was little different from that which he adopted for *The Anatomy of the Horse*. As in the previous work, he made a highly finished plate of the subject with no intrusion of keys, labels, or backgrounds to obscure its clarity. This was accompanied by an outline key figure without modelling, whose legend could be related to the printed explanatory text. The plates of the *Comparative Anatomical Exposition* incorporate one important technical innovation in that they make use of the stippling technique of engraving. During his working life Stubbs had produced a number of prints either based on his paintings or of original subjects. In these works he had developed a highly personal method in which he was able to reproduce changes in tones by employing a great variety of engraving tools and techniques. Because it was essential to obtain the maximum clarity in his anatomy plates, Stubbs did not use the complex tonal variations found in his later prints but confined himself to stipple, which allowed him to preserve the delicate modelling of the forms with no loss of definition. In stipple engraving the tone is produced by minute dots varying in density according to the amount of light and shadow. These were produced both by etching and by direct working on the plate with a burin, and the results are extraordinarily impressive. The plates lose almost nothing of the delicacy and beauty of the splendid finished drawings, and they give a more immediately tactile

impression of the bones and tissues displayed than do the plates of *The Anatomy of the Horse*. They are a triumphant consummation of his lifelong devotion to anatomy.

There is only the scantiest record of Stubbs's work on the preparations for the *Comparative Anatomical Exposition*. He evidently began in earnest in 1795 when he was seventy-one and probably spent the next five years involved with the dissections, although some of this may have been done in the years before the project finally crystallised. Much of the drawing and engraving was probably completed by 1802, since Stubbs advertised the work for publication in that year and on July 17th 1802 the Council of the Royal Academy resolved to subscribe to it. In a note in the Humphry Memoir at Liverpool, William Upcott states that in 1803 he and Samuel Daniell, nephew of Thomas Daniell, R.A., paid a visit to Stubbs. The visitors found the artist 'engaged in engraving his series of anatomical plates, of which he had just completed his first number. This day he will have attained his seventy-ninth year, and still enjoys so much health and strength that, he says, within the last month having missed the stage coach he has walked two or three times from his house in Somerset Street to the Earl of Clarendon's at the Grove between Watford and Tring, a distance of sixteen miles, carrying a small portmanteau in his hand.'

In January and December 1804 the Royal Academy received the first two numbers of the *Comparative Anatomical Exposition*, consisting of the first ten tables and their linear key diagrams. These tables showed the three views of the human skeleton, the tiger skeleton, the fowl skeleton, the three views of the complete human body, the skinned tiger, and the plucked fowl. Although these tables had their key figures, they were apparently not accompanied by a printed text. At this juncture the remaining plates to be engraved were Tables IX to XV (Table XI being printed in error as II). These tables were probably printed during Stubbs's lifetime, although they were not obtained by the Royal Academy until later. They do, however, exist in other collections. The complete work as planned by Stubbs remained unfinished at his death on July 10th 1806, although he seems to have finished the preliminary work. *The Gentleman's Magazine* in its obituary of the artist said, 'At the time of his death he had completed all the anatomical preparations and prepared the finished drawings for an elaborate work which he had very much at heart and of which he lived to publish only three parts out of six, under the title of A Comparative Anatomical Exposition of the Structure of the Human Body, with that of a Tiger, and a Common Fowl, in Thirty Tables. The first number contained an explanation of the Skeleton; the Second, a view of the External Parts of the Human Body, and an enumeration of the parts lying under them, with a description of the Common Integuements; and the Third the Common Integuements taken off, with the Membrana, Adiposa and Fat. In the Fourth, Fifth and Sixth Numbers, Mr. Stubbs meant to have described the first, second and third lays of the muscles taken off.'

When Mary Spencer died in 1817, Stubbs's preparatory drawings and manuscripts were sold. Later in 1817 an edition of the completed tables, accompanied by a text, was published by Edward Orme. There is considerable confusion about the compilation of this particular publication. It carries two titles, the first being 'The Anatomy of the Human Body particularly adapted to the use of artists the whole executed by George Stubbs, Esq. RA. author of the Anatomy of the Horse accompanied with fifteen large folio engravings'; the second title occurs on page 260 and is 'A Comparative Anatomical Exposition of the Tiger and Fowl exemplified on twelve large Folio engravings, the whole executed by George Stubbs, Esq. RA.'. These two titles seem to imply that there were twenty-seven plates to illustrate the book, fifteen for the human body and twelve for the tiger and the fowls; though in fact there are only fifteen in all, together with the outline key figures. The text of the Orme book cannot be clearly related to the present Worcester manuscript. While the former is in English, some parts of the Worcester manuscript dealing with Orme's published text are in French and some in English. This implies either that some sections in English are missing from the manuscript or that Orme had the relevant parts of the French text translated. The confusion about the number of the plates may be due to Orme's possible intention of engraving and

publishing some of the highly finished drawings now in the Worcester collection.

Stubbs had initially announced that the work was to be in thirty tables. In addition to the fifteen that were published, there are amongst the Worcester drawings seven ready for engraving and directly related to those published, together with four finished drawings of human skeletons, which might also have been ready for engraving. Possibly Orme obtained all the relevant material at Phillips's sale of Mary Spencer's effects and used it for the compilation of his 1817 publication, since there are indications that the Worcester collection is not complete. It is also possible that Orme destroyed or mislaid some of the drawings and part of Stubbs's original text while they were in his hands. Though there are seven drawings surviving which could have been engraved, a further eight would be needed to complete the fifteen which Stubbs proposed in his advertisement of the work.

The manuscript text now in the Worcester collection is written in pencil, probably in Stubbs's own hand, and bound in four volumes in green quarter calf. The first volume is written in French and consists of 257 leaves of laid paper $9\frac{7}{8}'' \times 7\frac{3}{4}''$, watermarked Magnay and Pickering 1800. Only 159 of the pages are written on, the text consisting of the following parts:

Des Os de l'Homme, vu de front.
Des Os de l'Homme, vu par derrière.
Des Muscles &c. d'un Homme, vu de front.
Des Muscles &c. d'un Homme, vu par derrière.
Des Muscles &c. d'un Oiseau, vu lateralement.
Des Muscles &c. d'un Oiseau, vu lateralement.
Des Muscles &c. du Tigre, vu lateralement.
Des Muscles &c. d'un Tigre, vu lateralement.
Des Muscles &c. d'un Oiseau, vu lateralement.

The second volume which is labelled 2A consists of 254 leaves of laid paper $13'' \times 7\frac{3}{4}''$, watermarked with a crown and the date 98 (*i.e.* 1798); 176 pages are occupied by a text written in English in the following parts:

The Anatomy of the Human Body, viewed anteriorly.
The Anatomy of the Human Body, viewed posteriorly.
The Anatomy of the Human Body, viewed laterally.
The Anatomy of the Human Body, viewed anteriorly.
The Anatomy of the Human Body, viewed posteriorly.
The Anatomy of the Human Body, viewed laterally.

The third volume is labelled 2B. Like the first volume it is written in French and consists of 98 leaves of laid paper $13'' \times 7\frac{3}{4}''$, watermarked with a crown and the date 96 (*i.e.* 1796). The text occupies 57 pages in the following parts:

Des Muscles &c. du Tigre, vu lateralement.
Des Muscles &c. du Tigre, vu lateralement.
Des Muscles &c. du Tigre, vu lateralement.
Des os du Tigre, vu lateralement.
Des os de l'Homme, vu lateralement.
Des os des Oiseaux, vu lateralement.

The fourth and final volume is written in English and consists of 233 leaves of laid paper $13'' \times 7\frac{3}{4}''$, watermarked with a crown and the date 98 (*i.e.* 1798); the text occupies 167 pages in the following parts:

The Anatomy of the Human Body, viewed anteriorly.
The Anatomy of the Human Body, viewed anteriorly.
The Anatomy of the Human Body, viewed posteriorly.
The Anatomy of the Human Body, viewed laterally.
The Anatomy of the Body of a Fowl, viewed laterally.
The Anatomy of the Body of a Fowl, viewed laterally.
The Anatomy of the Body of a Fowl, viewed laterally.

The Anatomy of the Body of a Tiger, viewed laterally.
The Anatomy of the Body of a Tiger, viewed laterally.
The Anatomy of the Body of a Tiger, viewed laterally.

The first volume has the bookplate of Dr Thomas Bell, and its flyleaf carries Bell's initials and a note in his hand that 'This was the intended title of this unpublished Work by Geo. Stubbs, an eminent Animal Painter and Anatomist. At his Death, in 1806, he left prepared these 124 Plates, with Three Parts (in Manuscript) of the Six, of which he intended the Work to consist.' Some of the plates are coloured. Fourteen are on bookboard and the remainder on drawing paper. Each volume also carries a bookplate indicating that it was the gift of Dr John Green to the Worcester Free Public Library. The fact that the paper in the manuscript volumes is watermarked with dates ranging from 1796 to 1800 does not necessarily mean that they were written consecutively according to those dates. Stubbs may well have bought them at the same time or had them about him before he began to write in them. It is more probable that the writing was all done at one time from preliminary notes made while he was dissecting with the aid of printed sources.

The fact that part of the surviving text at Worcester is in French presents a further problem. It seems probable that Stubbs was contemplating an edition in French of the *Comparative Anatomical Exposition*; there was a flourishing school of comparative anatomists in France at that time and, no doubt, despite the difficulties entailed by the Napoleonic wars, such a work would have been welcomed. However, part of the French text does not duplicate the English version, and vice-versa. It may be that the whole work was completed in both languages and some parts were subsequently lost, or that Stubbs was never able to complete the entire work. We know that Stubbs was fluent in French since Humphry says that he studied French and fencing when he arrived in York as a young man. He was also probably able to read some other languages since many of his references were written in Latin or a modern European language. The manuscript is written in the same careful hand throughout, and this has been authenticated as Stubbs's autograph. It is remarkable for its clarity and compares more than favourably with the fragments of his writing that survive from earlier dates. Stubbs very probably made earlier drafts of the text before carefully preparing the surviving manuscript, but there is no evidence to support this, and it must remain a supposition.

The drawings which survive at Worcester cannot all be related directly to either of the published works. Of the three subjects which Stubbs studied, the human body, tiger, and fowl, there are drawings of a distinctly different kind from the ones which form an obvious basis for the tables. In the case of the human body, there are a set of drawings of the skeleton, which has already been mentioned, showing the skeleton in different postures. Two of these are of a standing skeleton in anterior and posterior view, with the right leg supported on a box and the right arm extended with its hand hanging downwards, the effect being reminiscent of the pose of an academy nude. The other two drawings show the skeleton in a pronograde posture with the neck flexed back so that the face is forward. In one drawing the arms and hands are advanced, while in the other they are held closer to the legs. These drawings show an attempt to demonstrate the normally upright or orthograde human skeleton in a position comparable to that of a pronograde, quadrupedal mammal, and as such are highly original in conception. They carry the comparison between different organisms much further than had been attempted by previous anatomists. In the case of the tiger there are two sets of drawings of large cats which are obviously made from different specimens than that published in the tables. One of these, of which there are nine drawings, is of a tiger of similar proportions to the one published but differing in the position of the head—which is tilted slightly to the right and has the eyes open—and of the feet and claws. The other animal does not seem to be a tiger at all but is probably a leopard. It is much more slender, with a small head held well forwards and the limbs are drawn to show the animal as running. There is also a pair of drawings of a tiger lying on its left side with the belly towards the spectator. The partly dissected right hind leg is raised in the air, and the right foreleg is

extended; the tail is curled over the left hind leg, parallel with the belly. Finally in this group is a rather sketchy drawing of a tiger in an upright posture standing on its hind legs with its forelegs extended. This, like the drawings of the crouching human skeleton, has an analogical purpose.

Of the drawings devoted to the fowl, there are five which differ from those published. The bird shown in this group is a Dorking Hen, which has an extra non-functional digit in its right foot—a condition characteristic of the Dorking breed and known as hyperdactyly. One of the drawings of the skeleton of this bird is very carefully finished, which seems to indicate that Stubbs intended to engrave a plate from it. Three further drawings remain which are quite separate from the others, two of these are of an owl, plucked except for the main flight feathers of the wings and posed in an upright posture similar to that of the human body and the sketch of the tiger. One of these drawings is much more carefully executed than the other. The third drawing is of a monkey, and has been tentatively identified as a Barbary Ape. It is standing upright with the right arm lowered and the left raised with its fingers extended. The specimen seems to have been partly dissected. The skin is missing, there are no eyes, and the facial muscles have been removed. From its appearance it seems that it may have been a dried or mummified animal. The drawing is in ink and not very close in style to the rest of the collection.

The possibility that the collection of drawings at Worcester is incomplete and that it contains drawings which are not related to the tables published during and after Stubbs's lifetime leads one to speculate on his intentions. We know that he had proposed to publish thirty tables and succeeded in producing fifteen. Thus fifteen more were to be engraved. Of the surviving drawings the largest number are related to the published plates, and amongst these those dealing with the human body include four that can with some certainty be regarded as ready for engraving. These drawings are two anterior views showing progressively advanced states of dissection; a posterior view at the same stage as the first of the anterior views; and a lateral view at the same stage as the second of the anterior views. There is a single drawing of the abdominal viscera *in situ* carefully finished in pencil with the rest of the body in outline. If the scheme adopted in the published plates was followed giving three plates of the human body to every one of the tiger and the fowl, it would seem likely that Stubbs would have needed at least three more stages in the dissection of the human body to fully demonstrate its anatomy. This means that nine tables would have been required to show each stage from the three selected viewpoints of the body. The remaining six tables would then be devoted to three views of the later stages of dissection of the tiger and of the fowl. There are two drawings of the tiger which are highly finished and ready for engraving and one of the fowl in a similar condition. In this way, the drawings give some strong indications of the probable appearance of the unpublished plates, but not a complete record of what they were to be.

The other drawings which are unrelated to the published work present a further problem. Why did Stubbs carry so many to such a highly finished state if he did not intend to engrave them? Did he, in fact, have a larger scheme in mind which he was forced to abandon for some reason such as increasing age or lack of funds? There is some tenuous evidence that he did indeed have larger intentions for his work. A memoir of Stubbs in *The Sporting Magazine* of July 1808 says ' . . . he most cheerfully began his Comparative Anatomy, after the plan of Professor Blumenbach, at the period of 80, promising a complete classification of the animal world.' There is also a note in the Humphry Memoir by Mary Spencer, his lifelong companion, that 'The last exertion of this truly great man was a Comparative anatomy, showing the analogy between the Human frame and the Quadruped and the fowl; giving also an accurate description of the bones, cartilages, muscles, fascias, ligaments &c &c which he intended to carry on to the vegetable world.' The drawings of the leopard(?), monkey, Dorking Hen, and owl do seem to bear out, if only to a limited extent, these statements that he intended a larger work, although there is no evidence of any close study of the plant kingdom. The Worcester drawings give a clear insight into Stubbs's

22

method of preparing his work for publication, but their incompleteness is tantalising; they point to certain possible intentions which, without documentary evidence, must remain in doubt.

George Stubbs died suddenly on July 10th 1806. Though George Dance the architect, who made a fine pencil portrait of the artist in 1794, had remarked to Joseph Farington, R.A., in 1804 how old and shrunken Stubbs had become, he seems to have remained healthy and active to the end. There is a moving description of his last hours in the notes by Mary Spencer in the Humphry Memoir.

> . . . Within an hour of his death he sayed to his surronding friends 'perhaps I am going to die,' but continued he 'I fear not death, I have no particular wish to live. I had indeed hoped to have finished my Comparative Anatomy eer I went, but for other things I have no anxiety.' Here then do we see an example of the mind in the most trying period of human existence, rising superior to the selfish ideas incident to such moments, Anxious only to promote the knowledge, & welfare, of his fellow creatures. He accustomed himself to long walks by way of excercise, and on the 9th of July 1806, he as usual walked eight or nine miles; and returned in very good Spirits, went to bed at about nine o'Clock and at three on the following morning awoke, as well he said, as ever he was in his life. On getting up in bed, he was struck with a most excrusiating pain in his breast, and by the moaning he made was heard by his female friend (who slept in the adjoining room) on interrogation, he said the pain would kill him, at four o'clock he arose & Dressed himself, went down stairs, and up again several times, to Arange some papers his friends, who were assembled, all thought him a great deal better, he left them at breakfast and returned to his bedroom one of the party immediately followed him, and her screams soon brought up the rest of the company who found him sitting in an Arm Chair, another chair he had placed so as to rest his legs upon, wrapt himself up in his Gown, and the moment she arrived breathed his last. Thus on the 10th of July 1806, at 9 o'Clock in the morning, Closed the career of this celebrated Artist a genius unexampled in the annals of history: in his profession unequaled, in his private Life exemplary for honour, honesty, integrity, and temperance (his beverage water, his food simple) possessed of a firm and manly spirit, yet with a heart, overflowing with the milk of human kindness beloved by his friends, fared by his enemies and esteemed by all who knew him. By the multiplicity and excellence of his works, he has raised a monument to himself, that will Vie with time.

Mary Spencer's affirmation of her belief in Stubbs's posthumous fame was not immediately borne out, and he suffered neglect until the enthusiasm of Joseph Mayer and Sir Walter Gilbey in the last quarter of the nineteenth century revived an interest, which grew until he is now valued as highly as any of his great contemporaries.

If the essence of Stubbs's life and work is to be found it is in his unswerving independence of all influences which might seriously divert or alter his personal attitude to the problems which engaged his deepest artistic convictions. It is true that he expressed a desire to be seriously considered as a portrait painter and that elements of history painting, neoclassicism, and romanticism are embodied in his work. These tendencies are manifest in many of his later paintings, particularly in those dealing with the themes of a lion attacking a horse and in the beautiful series of pastoral scenes of harvesting, but they are marginal to his central concern. This concern was with the scrupulous observation of natural facts in which each organism, human, animal, or plant, was considered as an individual entity, and all were composed with the most rigorous thought and exacting taste into coherent and stable designs.

Stubbs does not seem to have been torn by any conflict between his artistic and scientific pursuits. In his easy combination of the two interests, which have often since the early nineteenth century been thought to conflict, he was unique in his own time and has not been approached since. He was primarily a painter, and though always active as an

anatomist, he was prevented from fully exploiting this side of his work by the demands of earning his living. Though *The Anatomy of the Horse* and the *Comparative Anatomical Exposition* made an important contribution, they were not crucial to the advance of the science of his period. They are essentially works of painstaking observation in which the element of visual representation is paramount. Apart from his investigations into the properties of enamel pigments, Stubbs was not an experimenter. He made no discoveries of fundamental importance, but added to the clarification of that which was already known. Like any worker in the arts and sciences he was subject to the influences of his predecessors and contemporaries. Of these the work of Albinus was crucial to the manner in which he produced *The Anatomy of the Horse* and is an important element in the *Comparative Anatomical Exposition* as well. In the second work the influence of John Hunter must have been a prime factor in his selection of the theme, though he may have been hoping to emulate the Leonardo drawings at Windsor. It is in the design and engraving of the plates for these works that Stubbs stands out from his contemporaries. The absence of backgrounds focuses attention on the organisms, which are quite without any element of the dramatic and macabre which had seduced so many anatomical illustrators from Vesalius onwards. Instead, Stubbs maintained a cool detachment to the potential horrors of the subject. But, and in this he resembles Vesalius, he infused them with an intense vitality so that they seem to live, dissected, upon the page. Stubbs's plates are the sum of extraordinary efforts consistently maintained, in circumstances which most people would find unbearably repellent. The countless observations made during dissection are refined and co-ordinated until only the essentials remain, clear and unmistakable.

II. Engravings for the tables illustrating Dr John Burton's *An Essay Towards a Complete New System of Midwifery*, London, 1751

These eighteen tables were Stubbs's first published anatomical illustrations. He was not satisfied with their quality and he is not acknowledged in the work. They show the anatomy of the female skeleton in the pelvic region, the uterus, placenta, various embryos, and the instruments used in delivery.

NOTES ON THE TABLES

II. Engravings for the tables illustrating Dr John Burton's *An Essay Towards a Complete New System of Midwifery*, **London, 1751**

TABLE 13

Engraving, $7\frac{3}{4} \times 4\frac{1}{4}$ inches.
Another table demonstrating faulty positions of presentation, in this case the embryo's buttocks and abdomen are facing the opening of the cervix.

TABLE 14

Engraving, $7\frac{3}{4} \times 4\frac{1}{4}$ inches.
This table also shows faulty presentations of the embryo. In the upper figure the embryo has the abdomen towards the cervix, the head is forced backwards, and the umbilical cord is twisted round over the shoulder. In the lower figure the head has been forced back and part of the umbilical cord has protruded through the cervix.

35 TABLE 15

Engraving, $8\frac{1}{8} \times 4\frac{3}{8}$ inches.
The first figure shows the head being forced through the cervix into the vagina by a contraction of the uterus, whilst the second shows an incorrect delivery with the right arm protruding into the vagina.

TABLE 16 35

Engraving, $7\frac{1}{2} \times 4\frac{1}{2}$ inches.
This rather crowded plate shows two embryos and an array of various instruments used in delivery. The first figure shows twins within the uterus; the other figure of an embryo shows an instrument being used to correct its position.

TABLE 17 36

Engraving, $7\frac{3}{4} \times 4\frac{1}{8}$ inches.
A number of malformed embryos, and below, an array of instruments used for extracting embryos which cannot be delivered.

TABLE 18 36

Engraving, $7\frac{3}{8} \times 4\frac{1}{2}$ inches.
A group of delivery forceps with some dimensions and their parts lettered. These forceps had been improved by Burton as a result of his own experience in delivery.

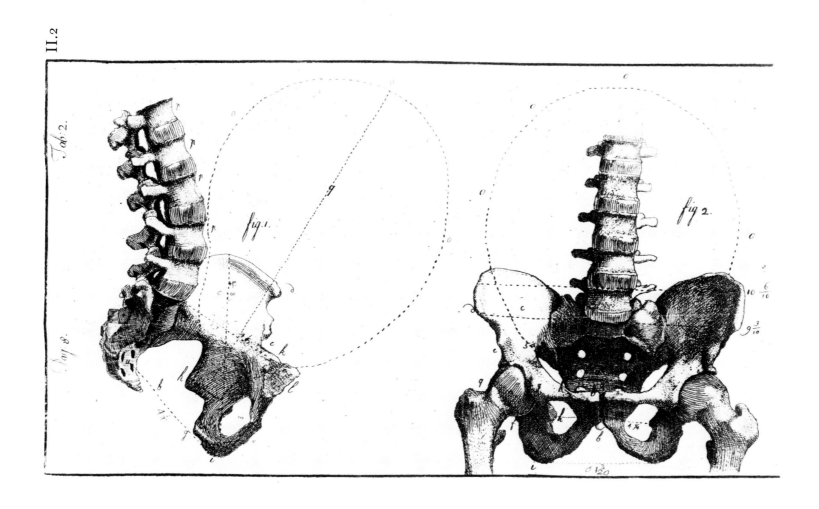

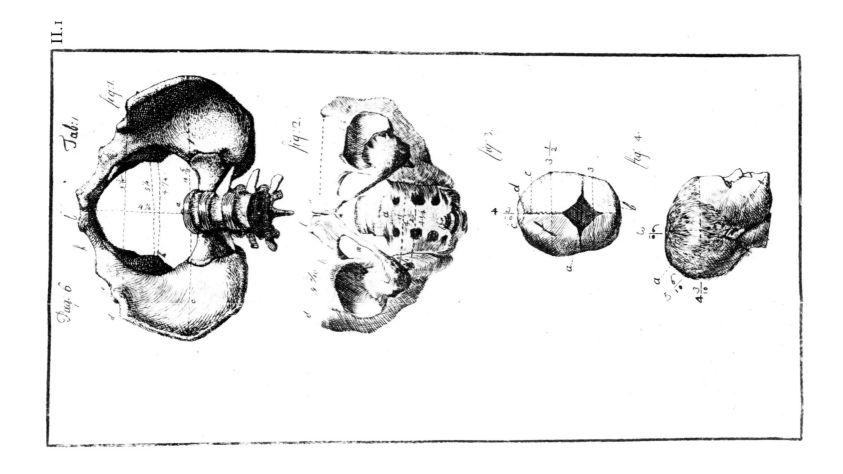

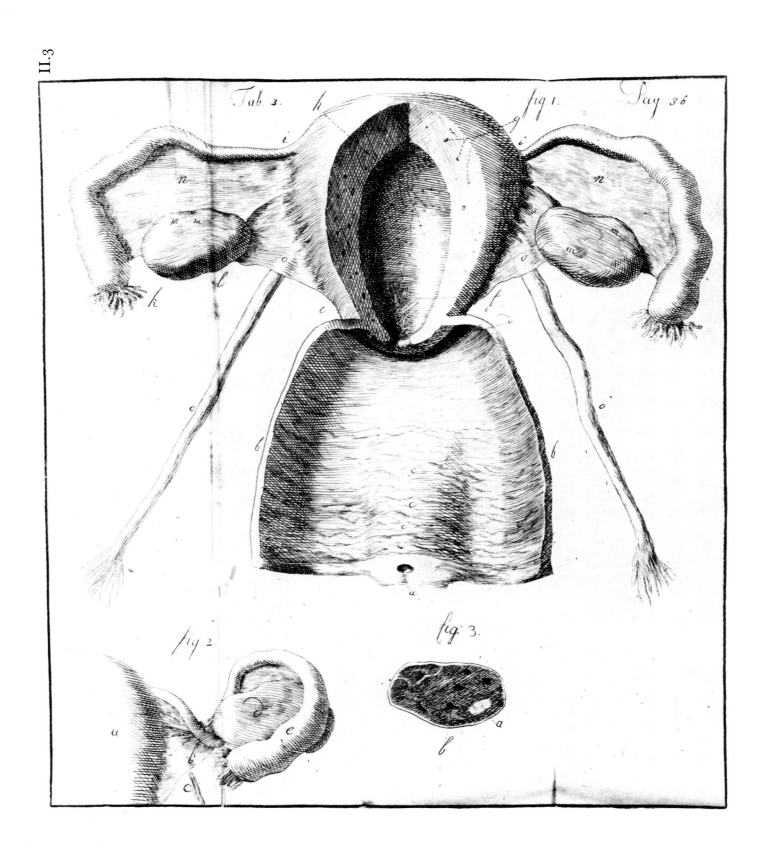

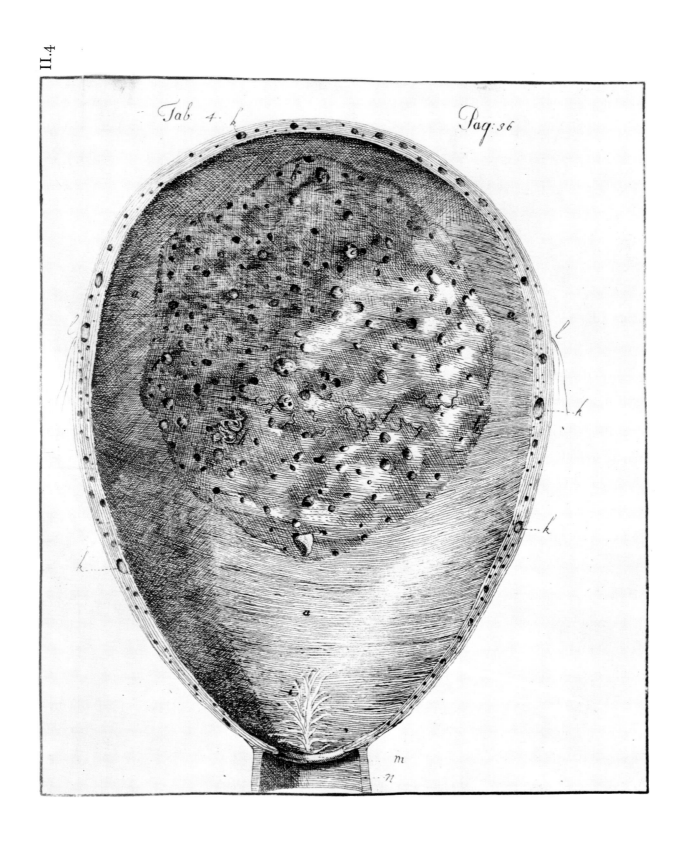

Tab. 4. k Pag: 36

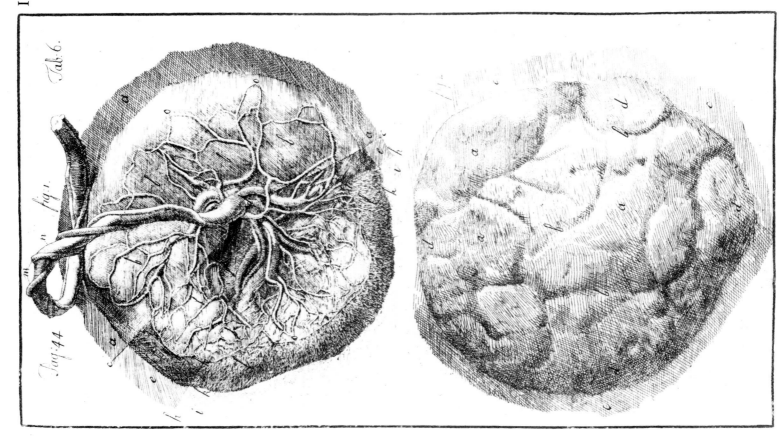

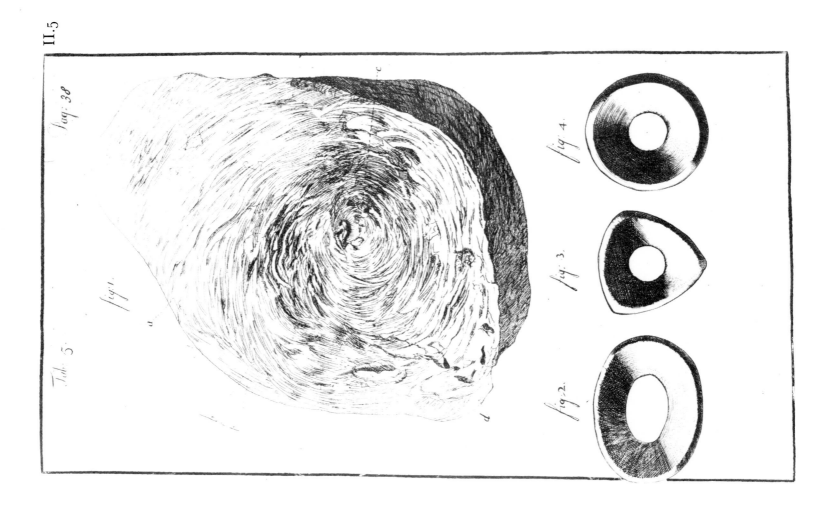

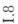

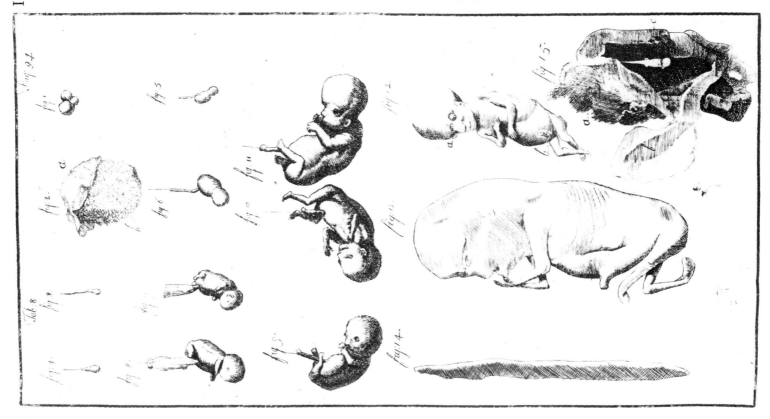

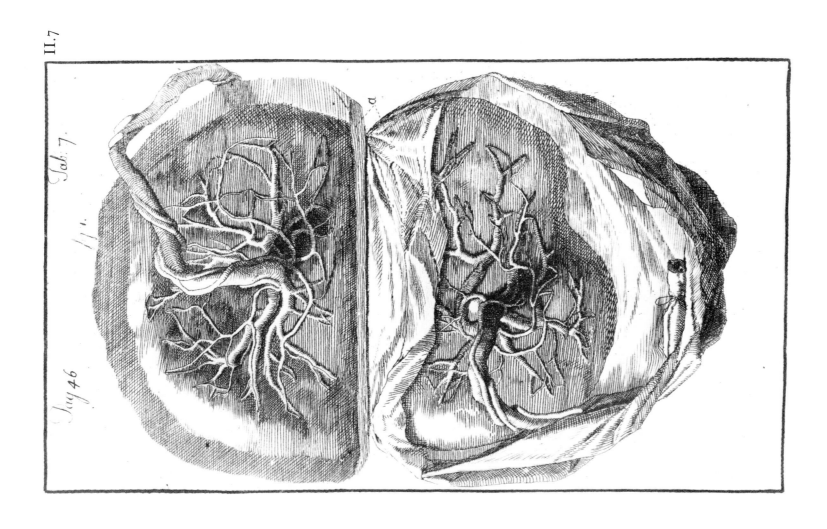

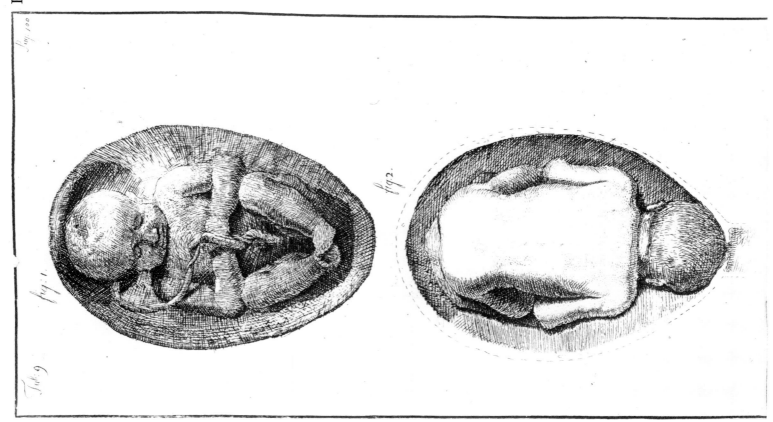

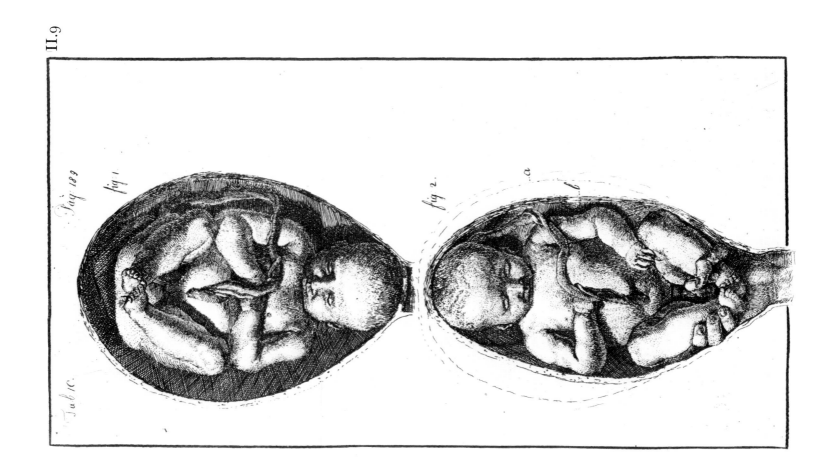

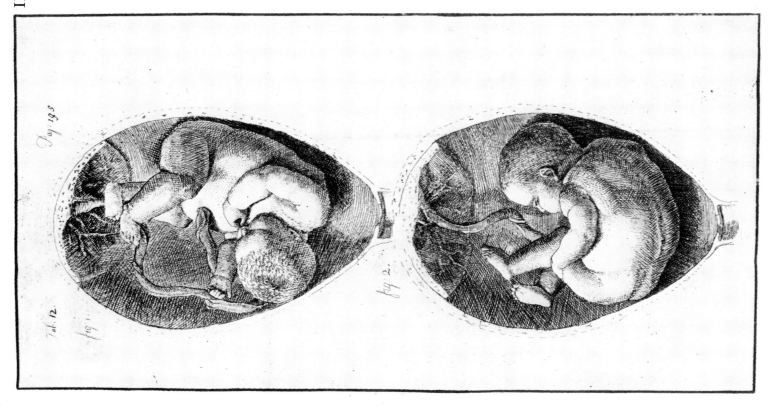

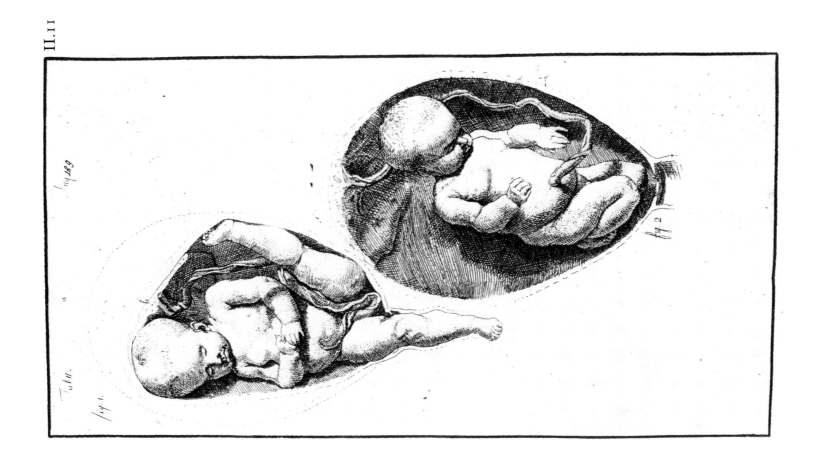

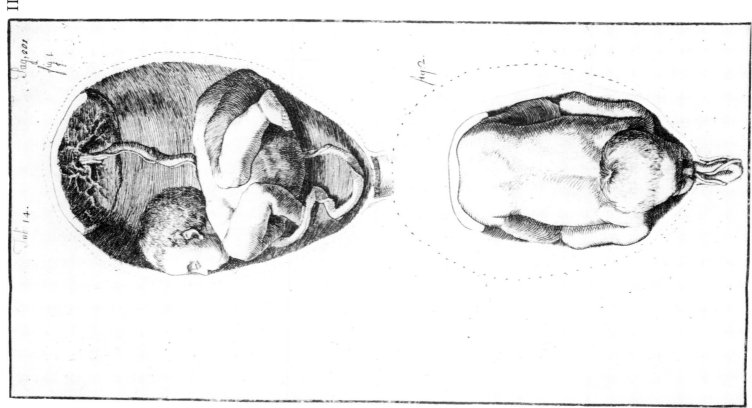

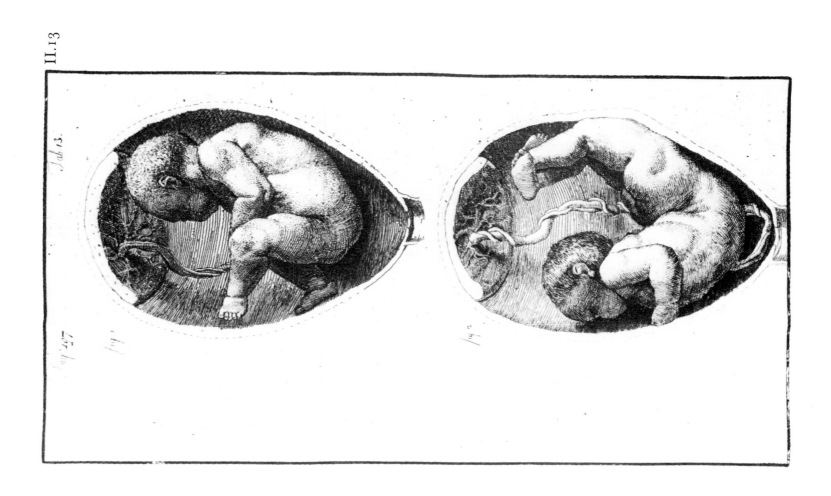

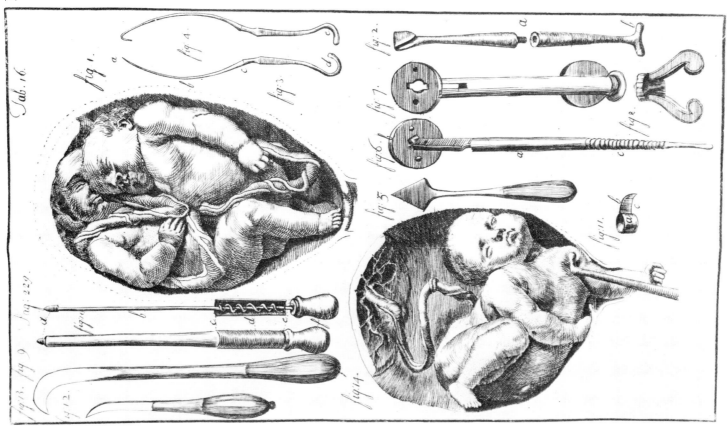

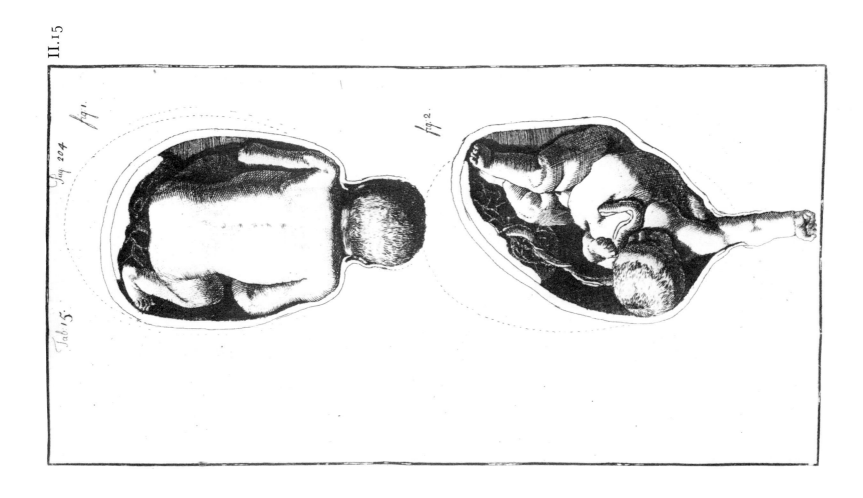

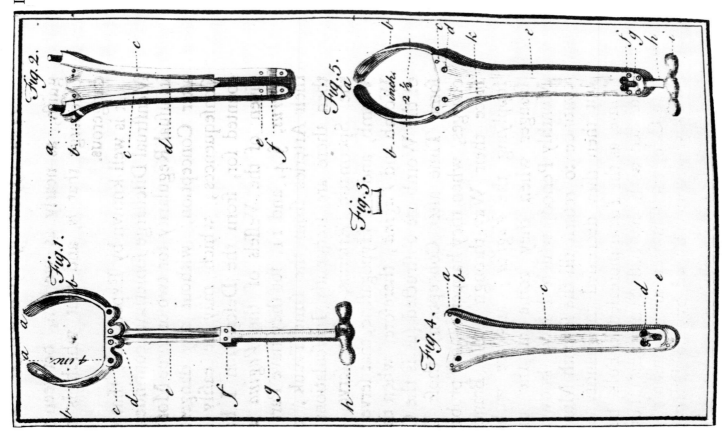

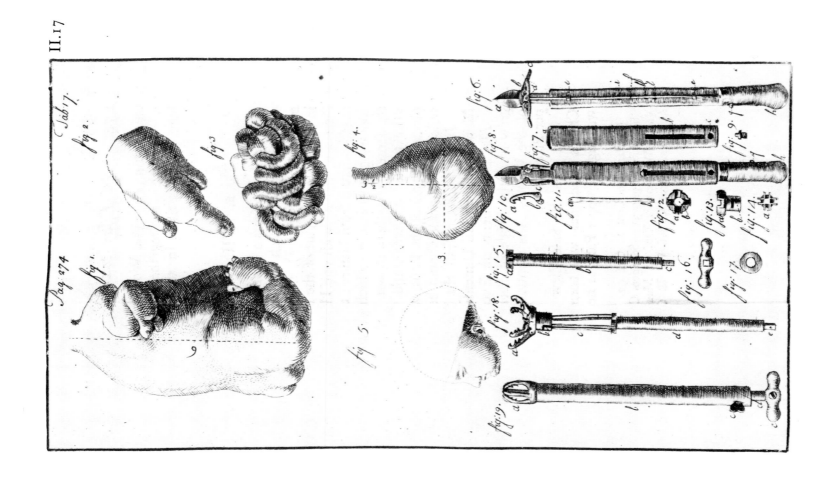

III. Drawings for *The Anatomy of the Horse,* London, 1766

Forty-one drawings were made by Stubbs in preparation for the engraving of the tables for *The Anatomy of the Horse,* and all of these are in the possession of the Royal Academy at Burlington House. These drawings remained in Stubbs's studio until his death, when they passed to Mary Spencer. They were purchased at an unknown date by Sir Edwin Landseer from the dealer Colnaghi, who had himself bought them from Mary Spencer's estate in 1817. Landseer bequeathed them to his brother, Charles Landseer, Keeper of the Royal Academy Schools, in 1873. On Charles Landseer's death in 1879 he made a large financial bequest to the Royal Academy and also left them the Stubbs drawings. In 1880 it was reported by the Inspectors of Property of the Royal Academy that the Stubbs drawings had been moved to the Library so that they could be used for reference by the students. It seems that at this time a selection of eighteen drawings, the finished studies from which the tables were engraved, were mounted and kept for reference while the less perfect working drawings were relegated to a cupboard and lost to view. These neglected drawings were happily rediscovered in 1963 when a search was being made of material for an exhibition of the treasures of the Royal Academy. The existing drawings can be divided into two groups: firstly, the highly finished studies made as a preliminary to engraving and, secondly, the working drawings made by Stubbs from skeletons and dissections. This second group is of great interest since they are the only surviving drawings which can with any certainty be said to have been made directly from Stubbs's dissections at Horkstow. In making the drawings Stubbs used a variety of media, including pencil, ink in various colours, and red chalk; there is also some variation in the size of paper used.

NOTES ON THE DRAWINGS

page 43 1. FINISHED STUDY FOR THE FIRST SKELETON TABLE (R.A. No. 5)

Pencil on paper, $14\frac{1}{4} \times 19$ inches.
The completed pencil study for the first of the three tables dealing with the skeleton. It is a lateral view of the animal facing to the left. As with all the engraved tables the position is reversed in printing. The tail in this study is noticeably more elevated than in the other drawings of the lateral view, with the single exception of the measured outline-drawing of the skeleton (R.A. No. 36).

44 2. FINISHED STUDY FOR THE SECOND SKELETON TABLE (R.A. No. 10)

Pencil on paper, $14 \times 7\frac{1}{4}$ inches.
An anterior view of the skeleton slightly to the right of centre so that the right side is concealed by the raised right foreleg, whilst the left side of the spine and rib-cage can be seen highly foreshortened. Stubbs has given some shaded indication of the ground surface which he later eliminated from the engraving.

3. FINISHED STUDY FOR THE THIRD SKELETON TABLE (R.A. No. 18) 45

Pencil on paper, 14×7 inches.
A posterior view of the skeleton some way to the left of centre so that the left side of the rib-cage is strongly foreshortened and the sternum is partly hidden by the bent knee of the left hind leg. As in the previous drawing, there is an indication of the ground surface.

4. FINISHED STUDY FOR THE FIRST ANATOMICAL TABLE (R.A. No. 4) 46

Pencil on paper, $14\frac{1}{2} \times 19\frac{1}{2}$ inches.
A lateral view of the horse with the skin and subcutaneous fat removed. The course of some of the blood vessels, particularly on the head, neck, shoulders, and ventral part of the thorax, can be seen. The tail is held at a lower angle than in the first skeleton drawing.

5. FINISHED STUDY FOR THE SECOND ANATOMICAL TABLE (R.A. No. 3) 47

Pencil on paper, $14\frac{1}{2} \times 19\frac{1}{2}$ inches.
The superficial connective tissue overlying the

muscles has been removed so that the form of the surface muscles is clear. The hooves have been partly cut away on the side to the spectator revealing the bone beneath. The drawing has suffered slightly from rubbing.

48 6. FINISHED STUDY FOR THE THIRD
ANATOMICAL TABLE (R.A. No. 28)

Pencil on paper, 14½ × 19¾ inches.
The upper layers of muscles have been removed; this is particularly noticeable in the region of the scapula and its joint with the humerus and in the area over the rib-cage. The tendons of the plantaris and gemellus muscles can be seen in the hind legs standing clear of the other tissues and attached to the calcaneum.

49 7. FINISHED STUDY FOR THE FOURTH
ANATOMICAL TABLE (R.A. No. 29)

Pencil on paper, 14 × 19½ inches.
The deeper muscles have been exposed by the removal of most of the powerful limb musculature. The head has been considerably dissected, the ears removed. The eyeballs are exposed in their sockets and the form of the skull is apparent. The hooves of the fore limbs are unfinished.

50 8. FINISHED STUDY FOR THE FIFTH
ANATOMICAL TABLE (R.A. No. 30)

Pencil on paper, 14¼ × 20 inches.
This is the final stage in the dissection. The abdominal viscera have been removed, although the lungs remain. The great ligamentum colli joining the back of the skull to the anterior spines of the thoracic vertebrae can be seen. As in the previous drawing the ears have been removed, although Stubbs replaced them in the engravings of the Fourth and Fifth Anatomical Tables. Again, the hooves of the fore limbs remain incomplete.

51 9. FINISHED STUDY FOR THE SIXTH
ANATOMICAL TABLE (R.A. No. 14)

Pencil on paper, 14 × 7 inches.
The first of the dissections from the anterior view. The skin and subcutaneous connective tissue have been removed. The course of the cephalic branches of the jugular veins can be seen running from the base of the neck down the length of the fore limbs.

52 10. FINISHED STUDY FOR THE SEVENTH
ANATOMICAL TABLE (R.A. No. 13)

Pencil on paper, 14 × 7½ inches.
Here the muscles have been cleared of surface tissue. At the base of the neck are the prominent lymph glands, from beneath which run the cephalic veins seen in the previous drawing. On either side of the nasal bones can be seen the long nasal muscles which have a common origin in a tendon inserted on the upper lip.

11. FINISHED STUDY FOR THE EIGHTH 53
ANATOMICAL TABLE (R.A. No. 9)

Pencil on paper, 14 × 7¼ inches.
The surface muscles have been dissected away revealing parts of the underlying skeleton. The ribs, left scapula, and the crest of the sternum are visible, while at the base of the neck the two jugular veins with a number of small branches can be seen. The complex insertions of the tendons over the joints is evident.

12. FINISHED STUDY FOR THE NINTH 54
ANATOMICAL TABLE (R.A. No. 8)

Pencil on paper, 13½ × 7¼ inches.
Here only the deepest muscles remain. The shoulder joints and the rib-cage are exposed and from the top of the latter the intercostal muscles can be seen. The jugular veins in the neck have been cut away to show the carotid arteries running up the sides of the trachea. In the head the eyelids have been removed, exposing the eyeballs in their sockets.

13. FINISHED STUDY FOR THE TENTH 55
ANATOMICAL TABLE (R.A. No. 17)

Pencil on paper, 14 × 7¾ inches.
Nearly all the muscles have been removed. Some of the ligaments at the joints remain and the nerves supplying the fore limbs, shoulders, and neck can be seen rising high up on the sides of the trachea.

14. FINISHED STUDY FOR THE ELEVENTH 56
ANATOMICAL TABLE (R.A. No. 11)

Pencil on paper, 14½ × 7¾ inches.
This drawing is the first of the posterior views of the horse. A fragment of the traced outline which Stubbs used to obtain uniformity between the various studies can be seen at the end of the tail extending its curve downwards. This drawing also clearly shows the pencil shading following the course of the muscle fibres.

15. FINISHED STUDY FOR THE TWELFTH 57
ANATOMICAL TABLE (R.A. No. 1)

Pencil on paper, 18½ × 11½ inches.
Here the massive muscles of the haunches which give power to the hind limbs are exposed, and the strong tendon of the plantar muscle can be seen emerging from the muscles above it and descending to its point of insertion on the heel.

16. FINISHED STUDY FOR THE THIRTEENTH
ANATOMICAL TABLE (R.A. No. 7)

Pencil on paper, $13\frac{1}{2} \times 7\frac{1}{2}$ inches.
Some of the large muscles have been removed and
the relationship between the head of the femur and
its muscles is clear in the left leg, where the muscles
are tensed over the joint. The sciatic nerve can be
seen passing over the gemellus muscle.

59 17. FINISHED STUDY FOR THE FOURTEENTH
ANATOMICAL TABLE (R.A. No. 15)

Pencil on paper, $14\frac{1}{2} \times 7\frac{1}{2}$ inches.
The major muscles have been dissected away,
revealing the femur and the muscles and ligaments
which attach it to the pelvic girdle. The paths of the
nerves and blood vessels supplying the hind limbs
are made clear.

60 18. FINISHED STUDY FOR THE FIFTEENTH
ANATOMICAL TABLE (R.A. No. 16)

Pencil on paper, $14\frac{1}{4} \times 7\frac{1}{2}$ inches.
This is the final drawing in the series of finished
studies for the tables. In this drawing only the very
deepest muscles remain and the ligaments binding
the bones at the joints are seen. This drawing is an
excellent example of Stubbs's enormous talent for
rendering extremely complex detail with the
utmost clarity.

Working drawings
This group of drawings was made by Stubbs during
the preparation of the skeleton and the execution
of the dissections of the horses. Some of the drawings
from the lateral view use the same skeleton outline
as in the finished studies, while others from the same
position are markedly different. All the drawings
from the anterior and posterior positions, with the
exception of the two showing measured skeletons, are
very different from the finished studies of the same
positions. The first three drawings are of measured
skeletons which the artist used as the basis of the
outlines employed in the finished studies; they seem
to have been kept by him as a group since they all
have similar well-worn transverse folds and show
marked signs of wear and tear.

61 19. MEASURED WORKING DRAWING FOR THE
FIRST SKELETON TABLE (R.A. No. 36)

Pencil and brown ink on paper, $14\frac{1}{4} \times 7\frac{1}{2}$ inches.
This is one of the most important of the drawings
made by Stubbs in his preparatory work. The bones
have been measured, as have the distances between
the various salient points on the skeleton. Stubbs
based his scale of proportion on the length of the
line from the end of the nasal bone to the crest of the
occipital bone at the top of the skull. There is a note

in pencil at the top of the drawing which reads as
follows:
> Proportions taken from the skeleton of an old
> mare about 13 hands high From the joining of
> the 2nd with the 3rd to the joining of the 7th
> with the 1st of ye back N.B. the point of fusion
> in the junctures of the vertebrae of the neck
> lies directly betwixt the anterior and inferior
> part of the bodies and posterior extremities of
> the descending oblique processes in a line
> drawn from the inferior parts of those two
> places.

20. MEASURED WORKING DRAWING FOR THE 62
SECOND SKELETON TABLE (R.A. No. 35)

Brown ink on paper, $14\frac{1}{4} \times 9\frac{3}{4}$ inches.
Like the previous drawing, this is a carefully
measured skeleton. The paper has been damaged
near the right knee and there is evidence of rubbing
on the femur.

21. MEASURED WORKING DRAWING FOR THE 63
THIRD SKELETON TABLE (R.A. No. 34)

Brown ink on paper, $14\frac{1}{4} \times 9\frac{3}{4}$ inches.
The last of the series of measured working drawings.
The line linking the salient points of the skeleton are
particularly clear and some variation in the
intensity of the ink is apparent.

22. OUTLINE DRAWING POSSIBLY FOR THE 64
FIRST SKELETON TABLE (R.A. No. 37)

Black ink on paper, $19 \times 23\frac{1}{2}$ inches.
An unadorned skeleton drawn in ink over a pencil,
outline traces of which remain below the area of the
supra-scapular cartilage. The thoracic and lumbar
vertebrae and the ribs have been numbered in
pencil. The drawing has been squared very faintly
in pencil, and since this is a replica of the skeleton
outline used in the final studies it is probable that
this squaring was done with a view to transferring
the drawing to a plate, rather than as an aid in
determining the relationship of the parts during
dissection.

23. WORKING DRAWING OF THE MUSCLES FOR 65
THE FIRST ANATOMICAL TABLE
(R.A. No. 26)

Pencil, red chalk, and brown ink on paper,
$18\frac{3}{4} \times 23\frac{3}{4}$ inches.
This drawing and the group of similar studies which
follow are significantly different from those shown
previously. It is made over a larger pencil outline of
the skeleton with the tail drooping downwards,
although Stubbs has altered this in the overlying
drawing. It demonstrates Stubbs's method of
building up his drawings of the muscles over an
established base which provides a constant frame-

III. Drawings for
*The Anatomy of the
Horse*, London,
1766

work of reference. This and the following studies were almost certainly made directly from the dissections. Slight shading is used to indicate the relation of the feet to the ground.

66 24. WORKING DRAWING OF THE MUSCLES FOR
THE SECOND ANATOMICAL TABLE
(R.A. No. 31)

Pencil, red chalk, and brown ink on paper,
18½ × 24 inches.
This shows the first layer of muscles, together with some of the blood vessels in the head, neck, and limbs. Most of the structures have been carefully realised, but the area round the abdomen is more lightly sketched in, and Stubbs has left its outline rather vague.

67 25. WORKING DRAWING OF THE MUSCLES FOR
THE THIRD ANATOMICAL TABLE
(R.A. No. 27)

Pencil, red chalk, and brown ink on paper,
18¾ × 23¾ inches.
There are some differences between this drawing and the finished study for the same table. The exposed parts of the skeleton are left unmodelled, the serratus major muscle, which fans out from the scapula over the ribs, is more clearly defined, while the muscles from the pelvis over the surface of the abdomen have been omitted.

68 26. WORKING DRAWING OF THE MUSCLES FOR
THE FOURTH ANATOMICAL TABLE
(R.A. No. 32)

Pencil, red chalk, and brown ink on paper,
18½ × 23½ inches.
This is much less complete than the final version. Stubbs has concentrated his attention on the deeper muscles of the neck and the hind limbs, only sketching in those of the back.

69 27. WORKING DRAWING OF THE MUSCLES FOR
THE FIFTH ANATOMICAL TABLE
(R.A. No. 33)

Pencil, red chalk, and brown ink on paper,
18½ × 24 inches.
This, the last of the series of working studies from the lateral viewpoint, is only a tentative statement; none of the parts has been worked up and much of the anatomy appearing in the published table has not been recorded here.

70 28. WORKING DRAWING OF THE BLOOD
VESSELS FOR THE FIRST ANATOMICAL
TABLE (R.A. No. 40)

Pencil, red chalk, and yellow ink on paper,
14¼ × 29¾ inches.

In the following group of five studies of blood vessels, Stubbs used the outline of the skeleton which he adopted for the finished drawings. It is possible that these studies were made after the actual work of dissection from notes taken at the time. This particular drawing shows the vascular supply to the superficial muscles. Across the top of the drawing is a note in Stubbs's hand as follows:

These nerves are accompanied with arteries and lie between the membrana carnosus and fasciculata and are to be seen the same in Table the 2d. They arise from between the intercostals betwixt the sacrolumbalis and longissimus dorsi. They are nerves all accompanied with small arteries some with an artery on each side.

29. WORKING DRAWING OF THE BLOOD 71
VESSELS FOR THE SECOND ANATOMICAL
TABLE (R.A. No. 38)

Pencil, red chalk, and yellow ink on paper,
14¼ × 19¾ inches.
In this study the vessels have been carefully numbered or lettered and the outlines of the major muscles have been indicated to show their relationship to the blood supply.

30. WORKING DRAWING OF THE BLOOD 72
VESSELS FOR THE THIRD ANATOMICAL
TABLE (R.A. No. 39)

Pencil, red chalk, and yellow ink on paper,
14½ × 19 inches.
There are slight alterations in the outline marking the progress of the dissection, the ears have been removed and details such as the larynx and trachea inserted.

31. WORKING DRAWING OF THE BLOOD 73
VESSELS FOR THE FOURTH ANATOMICAL
TABLE (R.A. No. 41)

Pencil, red chalk, and yellow ink on paper,
14¼ × 19 inches.
This is a very detailed study of the blood vessels and nerves supplying the abdomen, pelvic girdle, and hind limbs, the vascular supply of the head, neck, and fore limbs has been omitted.

32. WORKING DRAWING OF THE BLOOD 74
VESSELS FOR THE FIFTH ANATOMICAL
TABLE (R.A. No. 42)

Pencil and yellow ink on paper, 14¼ × 19 inches.
This drawing, which is the last in the series of studies of blood vessels, is incomplete, showing only the supply to the upper parts of the hind limbs. In the finished version Stubbs described the anterior supply as well.

75 33. WORKING DRAWING OF THE MUSCLES FOR
THE SEVENTH ANATOMICAL TABLE
(R.A. No. 6)

Pencil on paper, 18½ × 11½ inches.
This is the first of the working drawings of the
anterior view of the horse, there is no surviving
drawing for the Sixth Table. The drawings from
the anterior and posterior made from the dissections
are very different from Stubbs's finished studies:
they are strongly foreshortened, and the angle of
the animal in relation to the spectator differs so that
more of the left side is exposed. This difference in
position is probably due to the fact that Stubbs had
to work in a confined space in the dissecting room,
too close to the specimen to give a view which
would have allowed a more correct representation
of the proportions.

76 34. WORKING DRAWING OF THE MUSCLES FOR
THE EIGHTH ANATOMICAL TABLE
(R.A. No. 19)

Pencil, red chalk, and red ink on paper,
19 × 12 inches.
Although there is a figure eight at the top of the
sheet, the stage of dissection shown in this drawing
is somewhere between the Seventh and the Eighth
Tables. Stubbs has paid most attention to the
muscles of the chest and fore limbs, leaving the
muscles of the trunk and hind limbs only lightly
sketched. Notes on the sheet in Stubbs's hand read:
> Arises from the sternum A B D pectoralis & the
> part wh turns after to a membrane down the
> inside of the cubit F the part which crosses in
> a membranous and runs upon the outside of ye
> cubit D the part inserted into the top of ye
> humerus along with the levator humeri
> proprius & it may be called the transversalis
> from its position regarding the rest of the
> pectoralis.

77 35. WORKING DRAWING OF THE MUSCLES FOR
THE NINTH ANATOMICAL TABLE
(R.A. No. 20)

Pencil, red chalk, and ink on paper, 18¾ × 12 inches.
This cannot be very closely related to the Ninth
Table, which shows the dissection in a more
advanced state. The drawing has notes in Stubbs's
hand which read:
> A part of the pectoralis inserted into the inside
> of ye humerous and forms a ligament that binds
> down the head of ye biceps.
> B C D what I think analogous to the serratus
> minor anticus arises at D from the sternum &
> part of the first rib or collar bone and from the
> 2d 3d & 4th ribb under their joins to the sternum
> is inserted into the shoulder blade and tendi-
> nous surfaces of the supraspinatus scapula A &
> C.

36. WORKING DRAWING OF MUSCLES FOR THE
NINTH ANATOMICAL TABLE (R.A. No. 21)

Pencil and black ink on paper, 19 × 12 inches.
Although this drawing is distinctly labelled ten at
the top of the sheet, the muscles depicted do not
appear in the tenth finished drawing but can be seen
in the Ninth Anatomical Table. The drawing is very
sketchy, the muscles of the back being only roughly
indicated by a mass of hatching following their
general outline.

37. WORKING DRAWING OF THE MUSCLES FOR 79
THE TENTH ANATOMICAL TABLE
(R.A. No. 22)

Pencil and black ink on paper, 18¼ × 11¼ inches.
This drawing is of considerable interest since it is
the only one of the series taken from the dissection
to have been squared with a grid. In fact, two grids
have been drawn: a larger and clearer one numbered
from eight down to two on the left, and a smaller,
fainter grid below it, numbered from twelve to two
on the same left-hand side. The presence of these
two grids may indicate that Stubbs used Albinus's
technique of placing strung quadrats in front of the
dissection in order to maintain correct proportions
between the parts as he worked. It seems unlikely
that the grids on this drawing were used for transfer
to a plate since it does not correspond to the
published outlines or the final studies.

38. WORKING DRAWING OF THE MUSCLES FOR 80
THE THIRTEENTH ANATOMICAL TABLE
(R.A. No. 2)

Pencil and red chalk on paper, 18½ × 11½ inches.
This is the first of the four surviving studies of the
posterior view of the horse taken during dissection.
These studies are quite unlike the skeleton outlines
Stubbs actually published; the viewpoint is higher
and the right hind leg is extremely elongated
compared with the rest of the skeleton. Although
this study is not numbered, it seems to be most
closely related to the Thirteenth Table, though the
dissection is in a rather more advanced state than in
the published plate.

39. WORKING DRAWING OF THE MUSCLES FOR 81
THE FOURTEENTH ANATOMICAL TABLE
(R.A. No. 23)

Pencil, red chalk, and red ink on paper,
18¾ × 11½ inches.
This drawing is numbered nine, but cannot possibly
relate to that table since the published plate is an
anterior view while this drawing is from the
posterior. The deep muscles exposed are clearly

III. Drawings for
The Anatomy of the
Horse, London,
1766

those shown in the Fourteenth Table. There is a note in Stubbs's hand which reads:

> A B omini C obturator internus D obturator externus E quadratus F G H adductor magnus H gracilis L gluteus internus M plantaris N O popliteus P iliacus internus.

82 40. WORKING DRAWING OF THE MUSCLES
PROBABLY FOR THE FIFTEENTH
ANATOMICAL TABLE (R.A. No. 24)

Pencil and red ink on paper, 19 × 12¼ inches.
This shows a late stage in dissection. The muscles depicted occur in both the Fourteenth and Fifteenth Tables, although the stage reached is closer to that shown in the Fifteenth Table. A note on the sheet in Stubbs's hand reads:

> A B ye gemini C quadratus D pectineus E adductor brevis F adductor longus G the tendon of ye illiacus internus and psoas magnus H iliacus internus I musculus parvus in articulation femorissitus h origin of ye rectus.

41. WORKING DRAWING OF THE MUSCLES FOR 83
THE FIFTEENTH ANATOMICAL TABLE
(R.A. No. 25)

Pencil and red ink on paper, 18¾ × 11¾ inches.
This is labelled Table Eleven but is not related to that table as published. This is a rather sketchy study; Stubbs has concentrated his attention on the tendons and ligaments of the lower parts of the legs. There is a brief note in Stubbs's hand which reads:

> F illiacus intermedius magnus B the tendon along with the psoas.

42

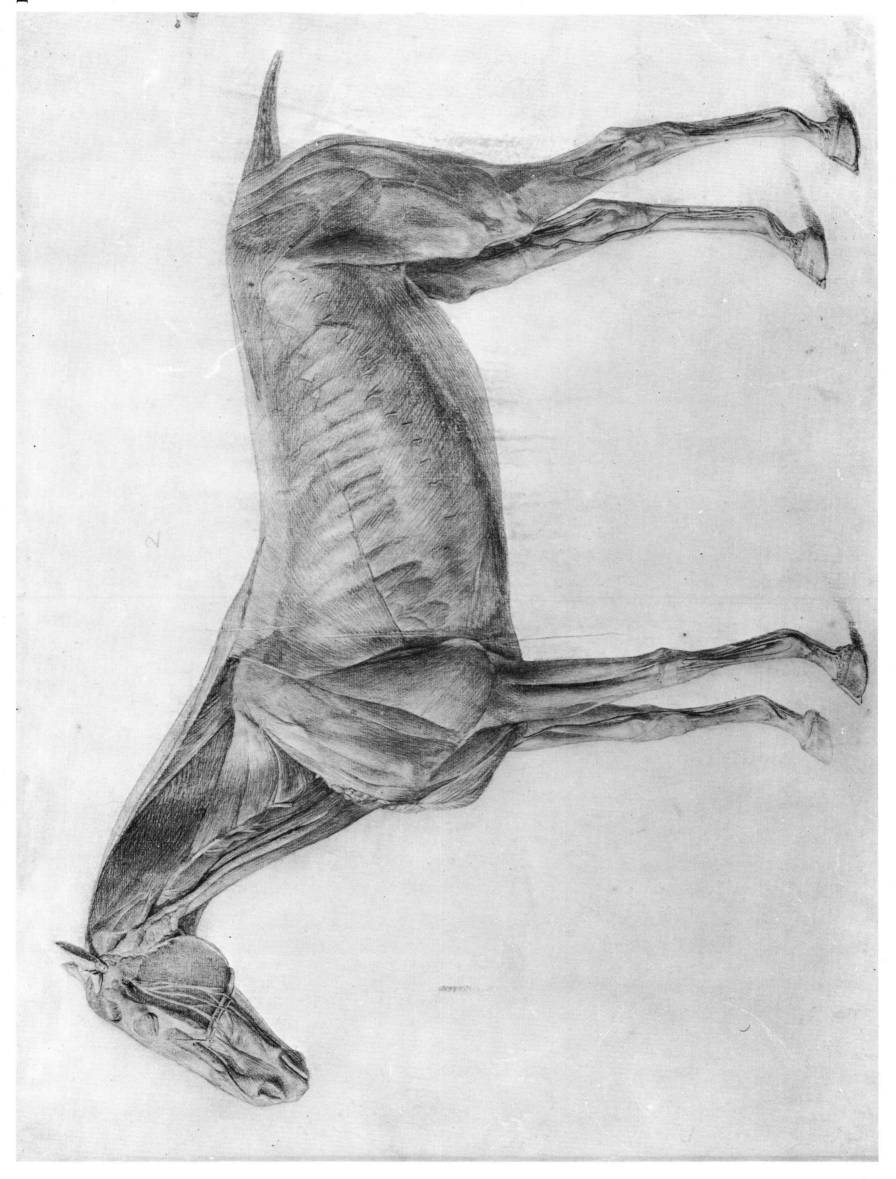

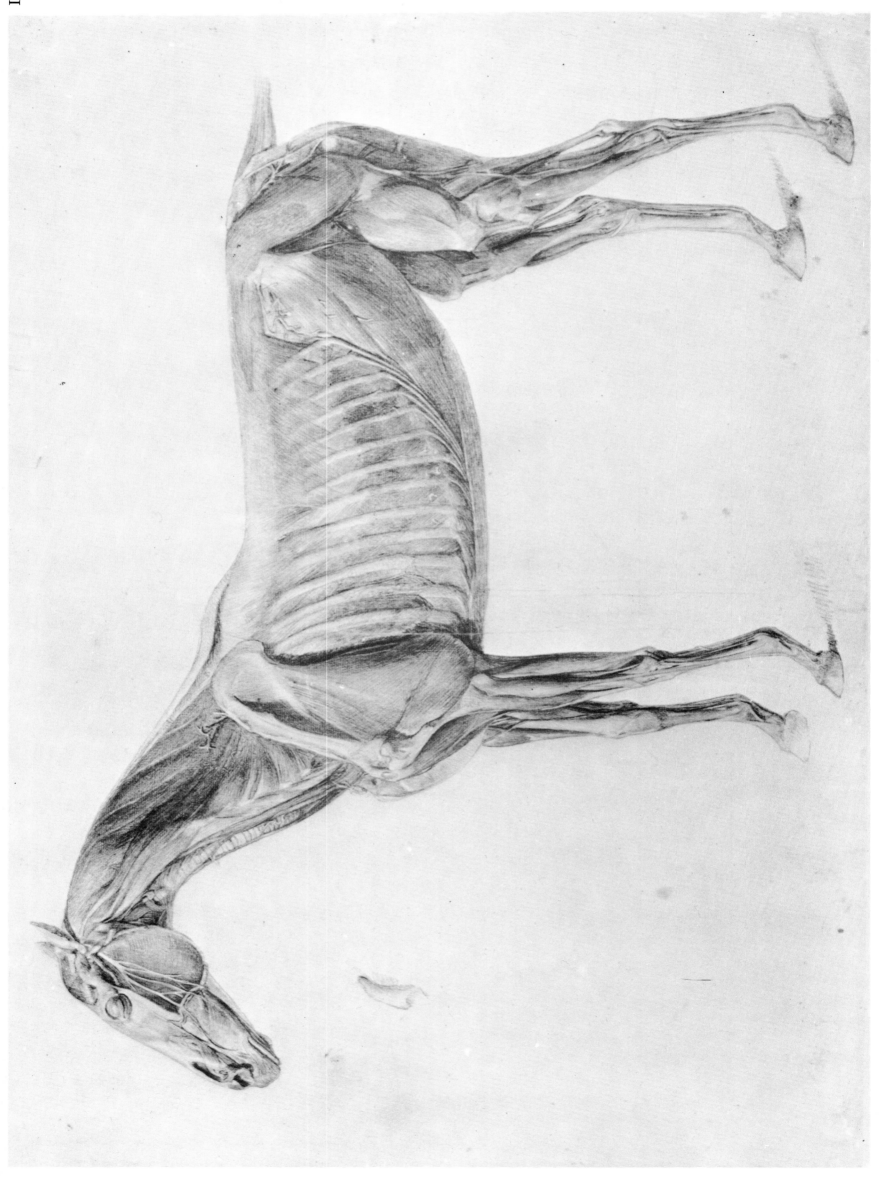

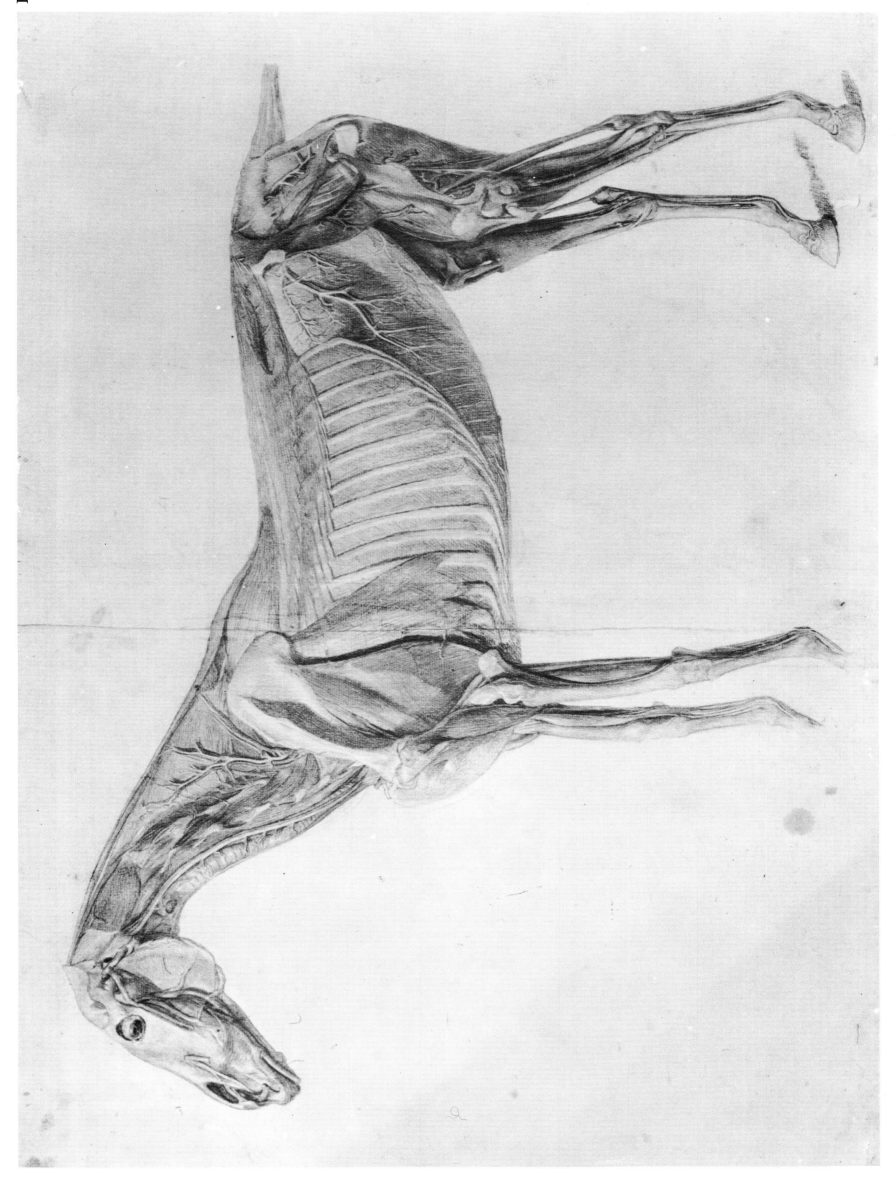

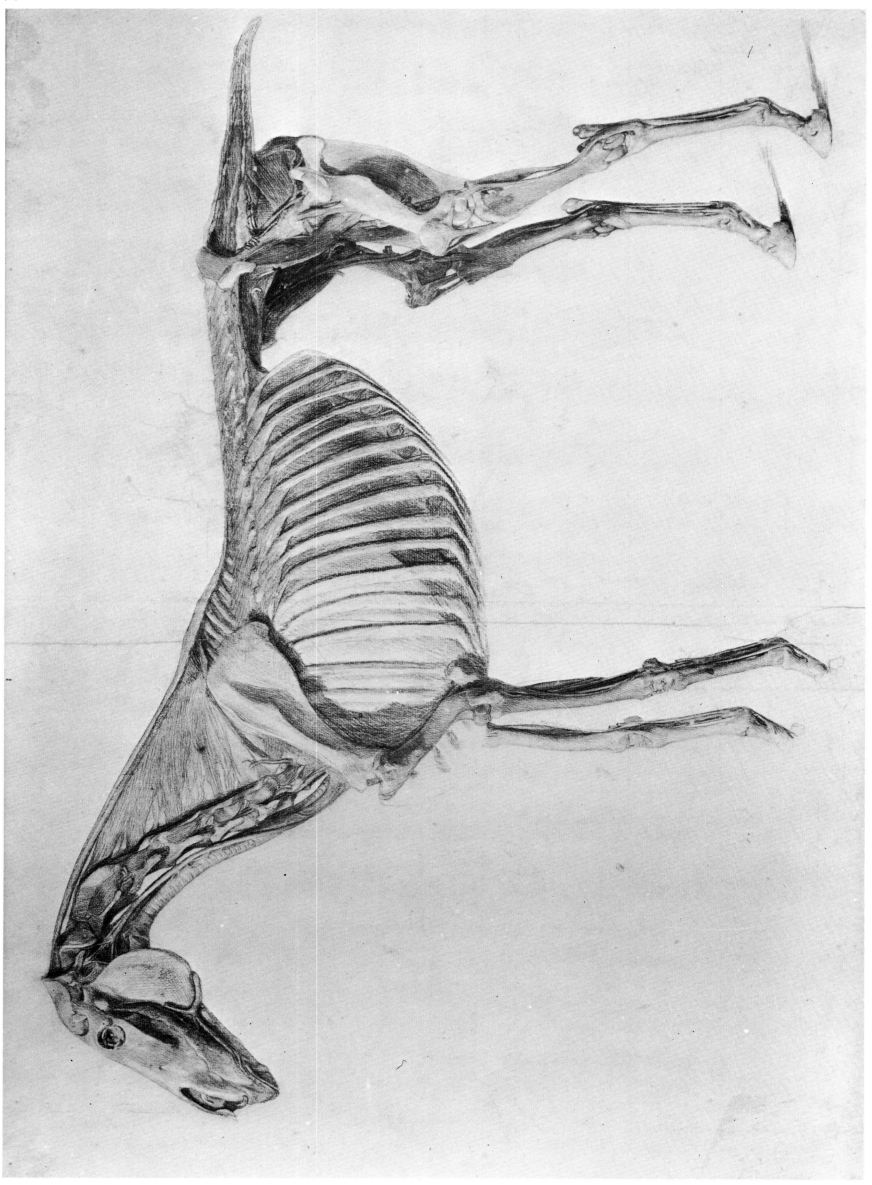

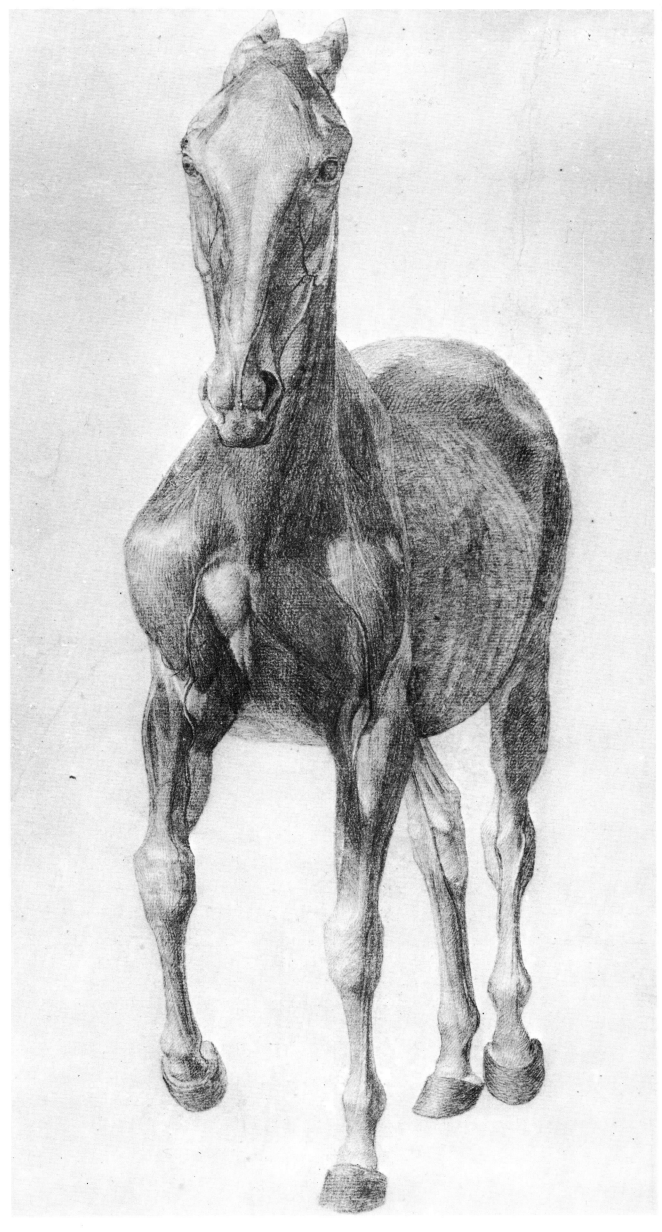

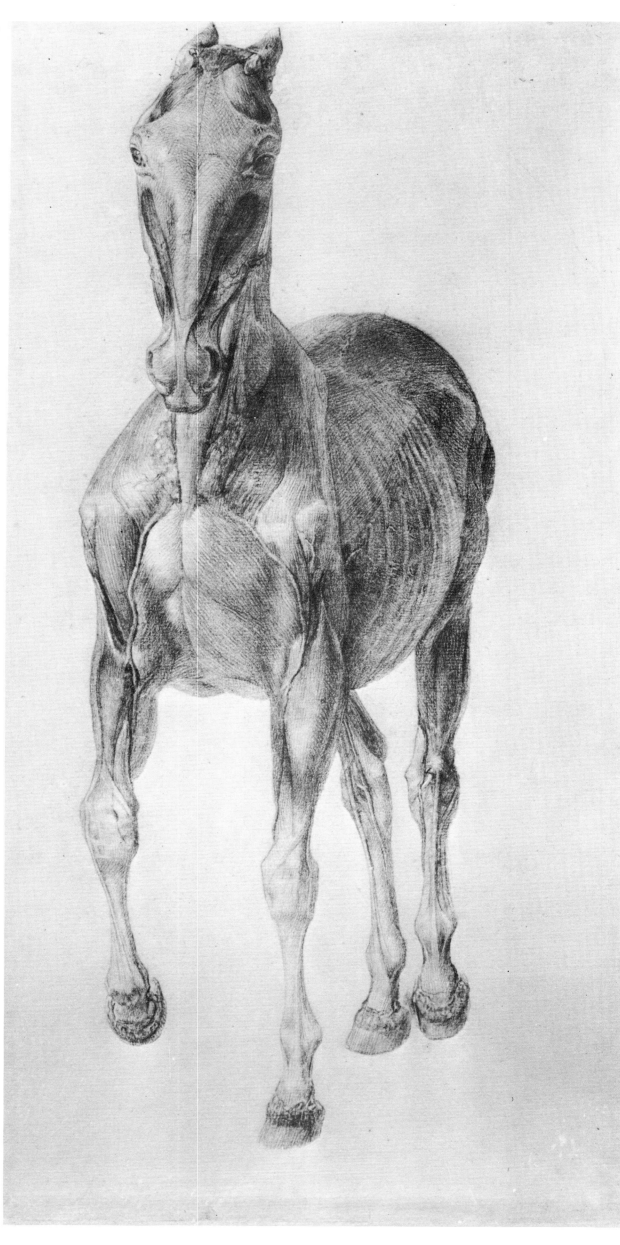

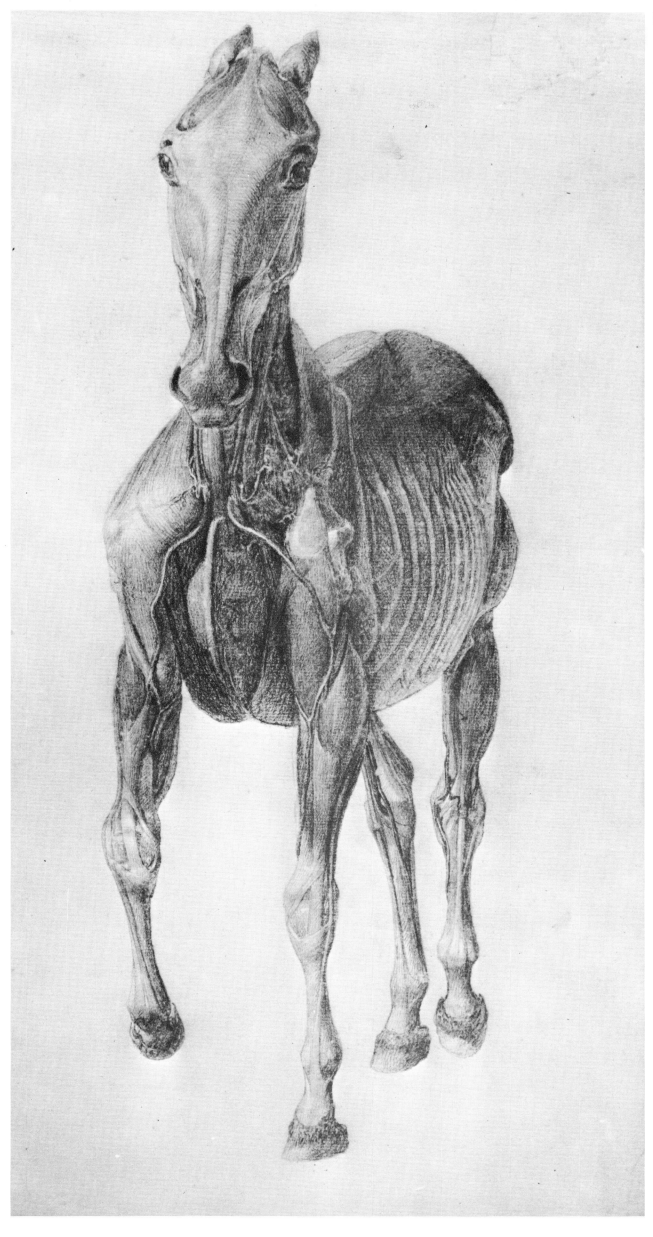

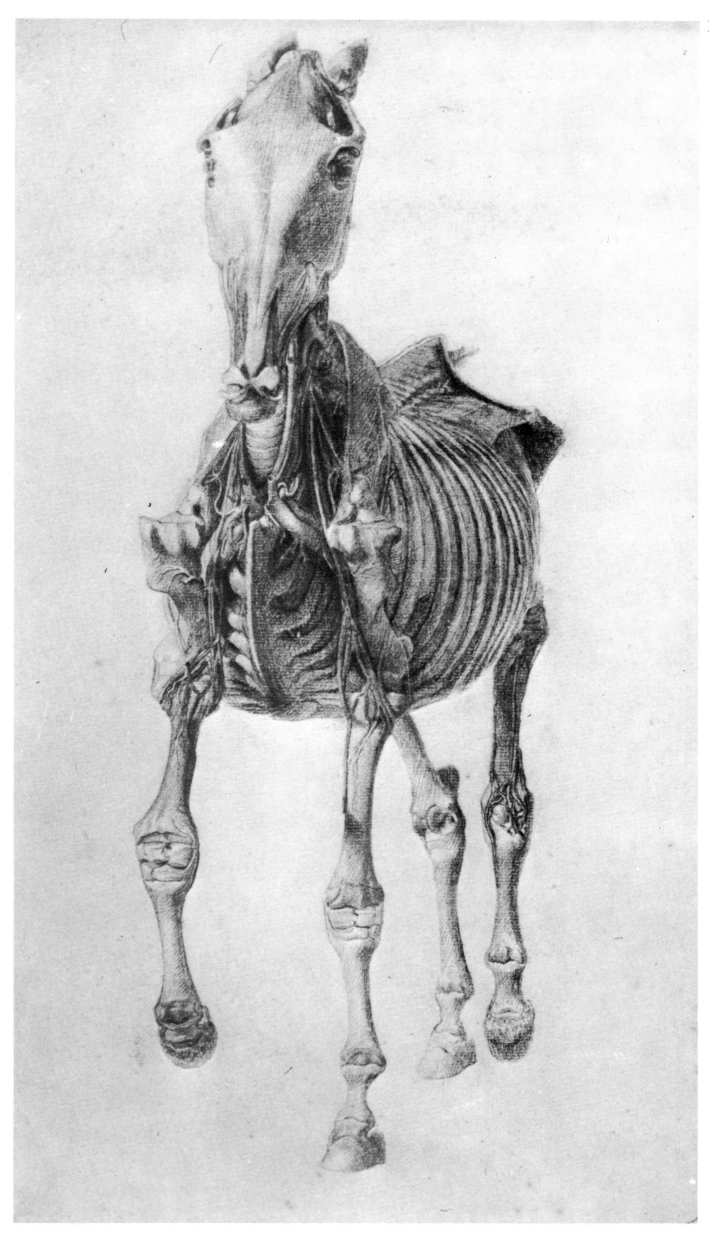

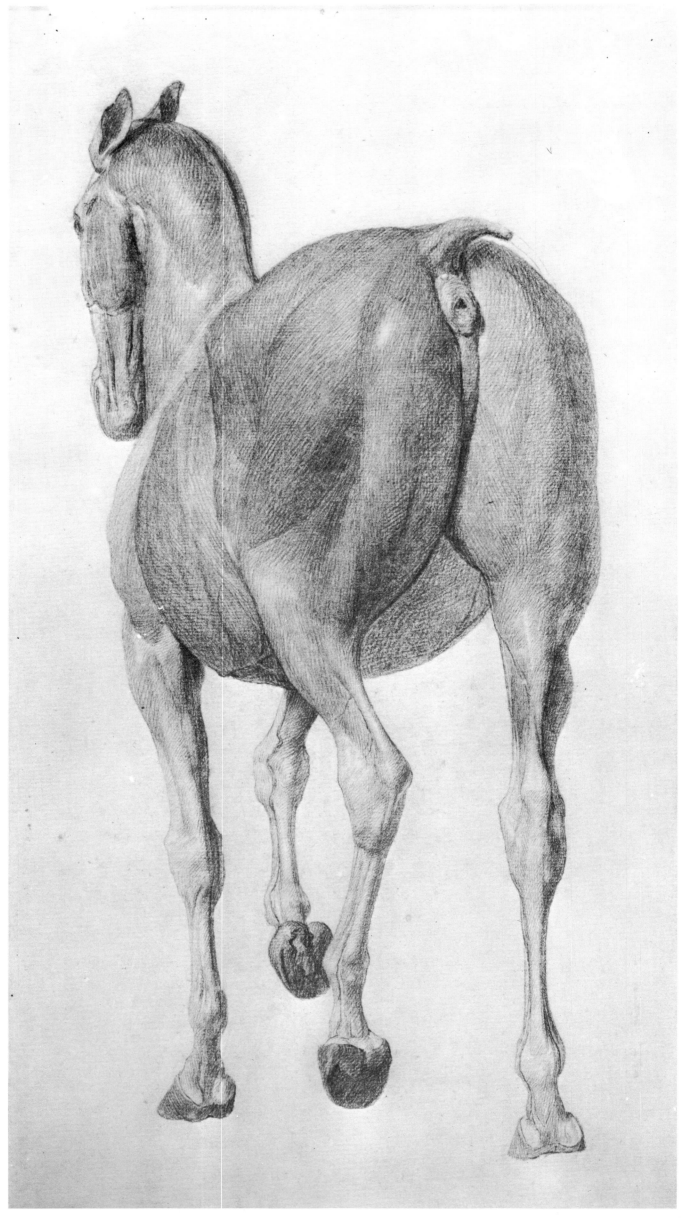

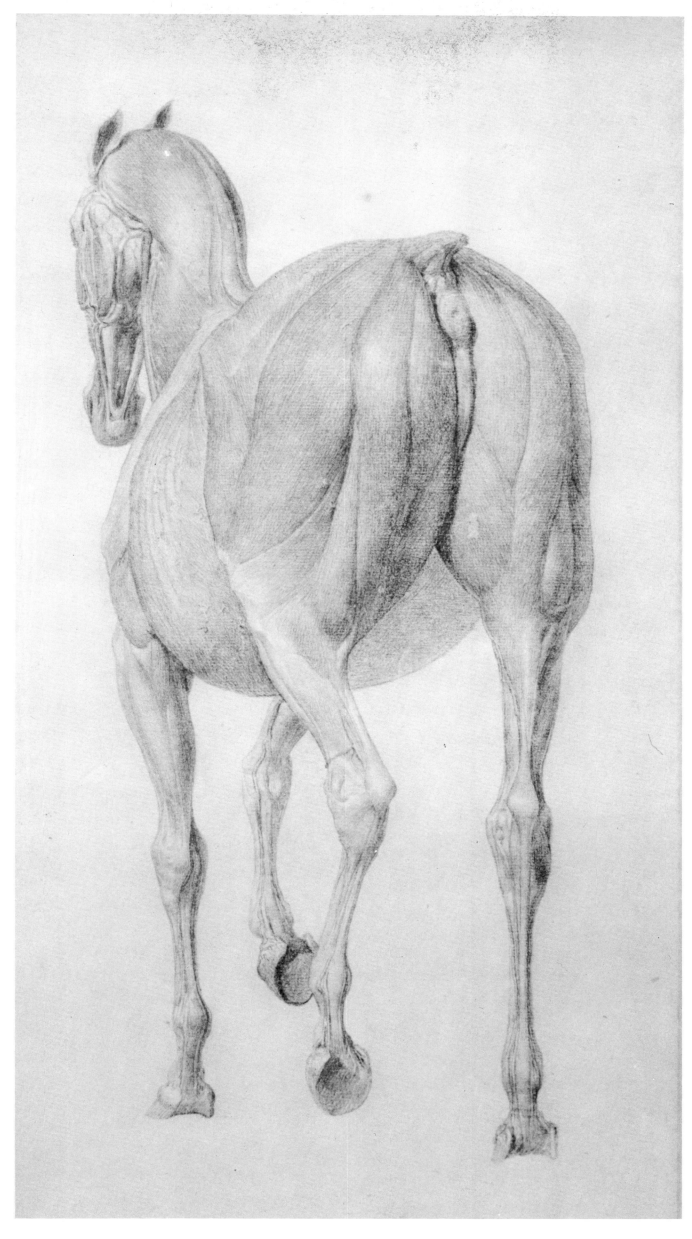

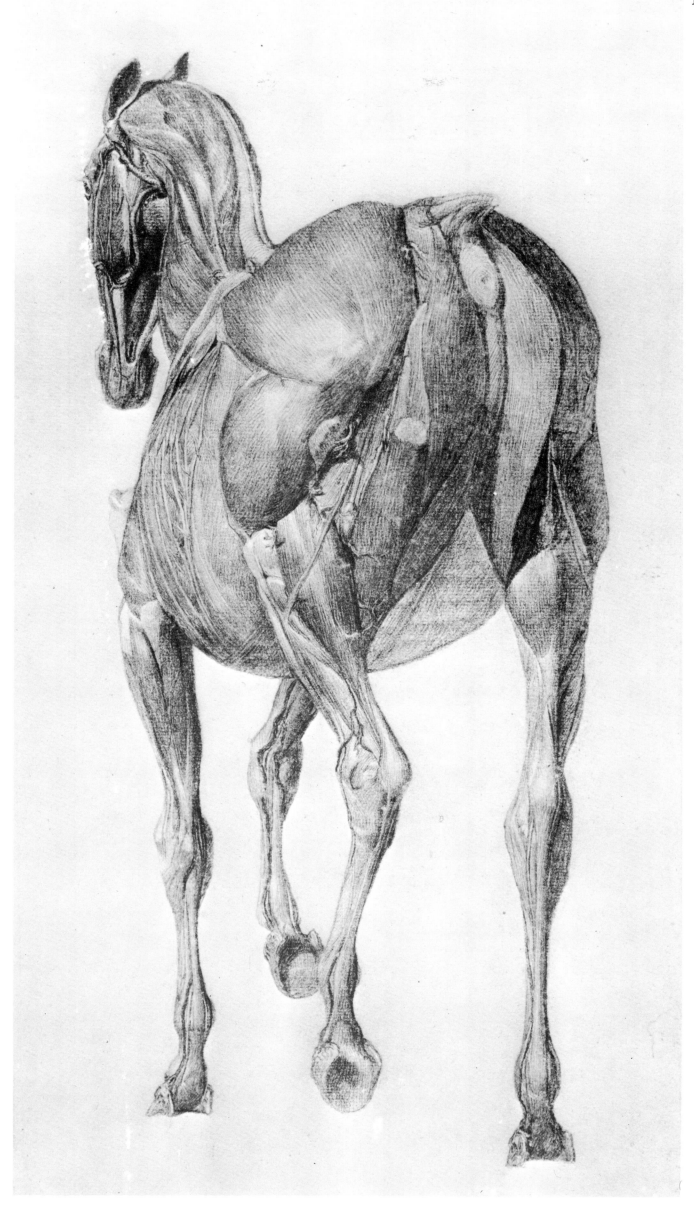

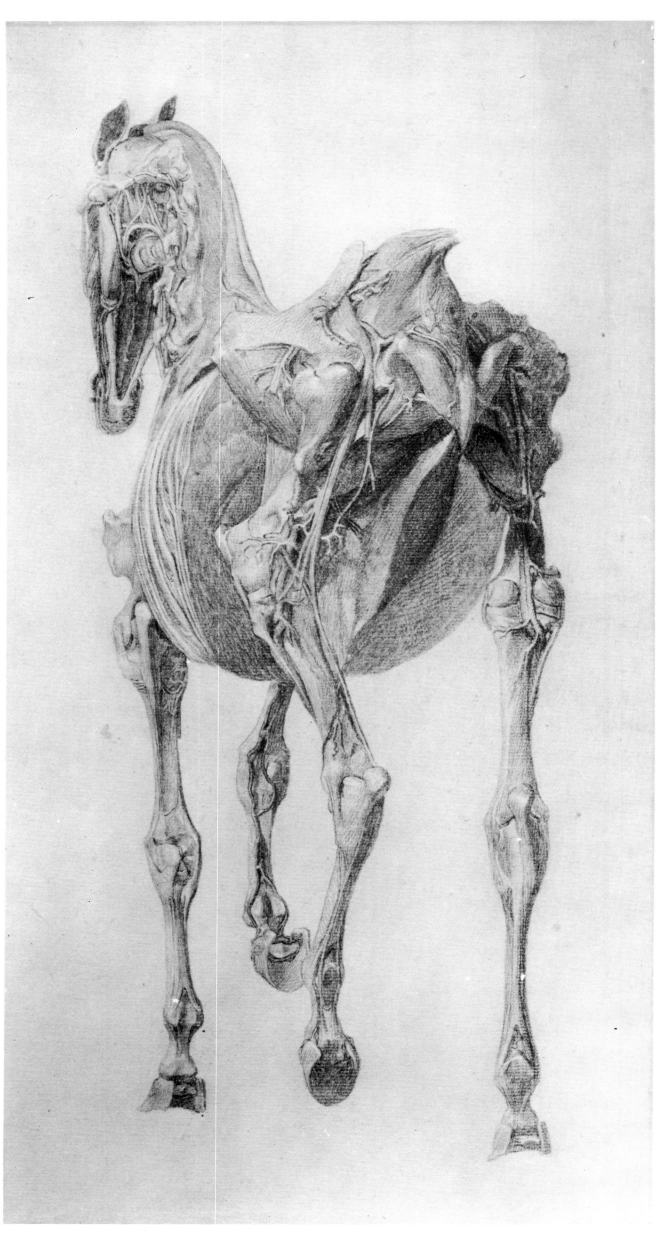

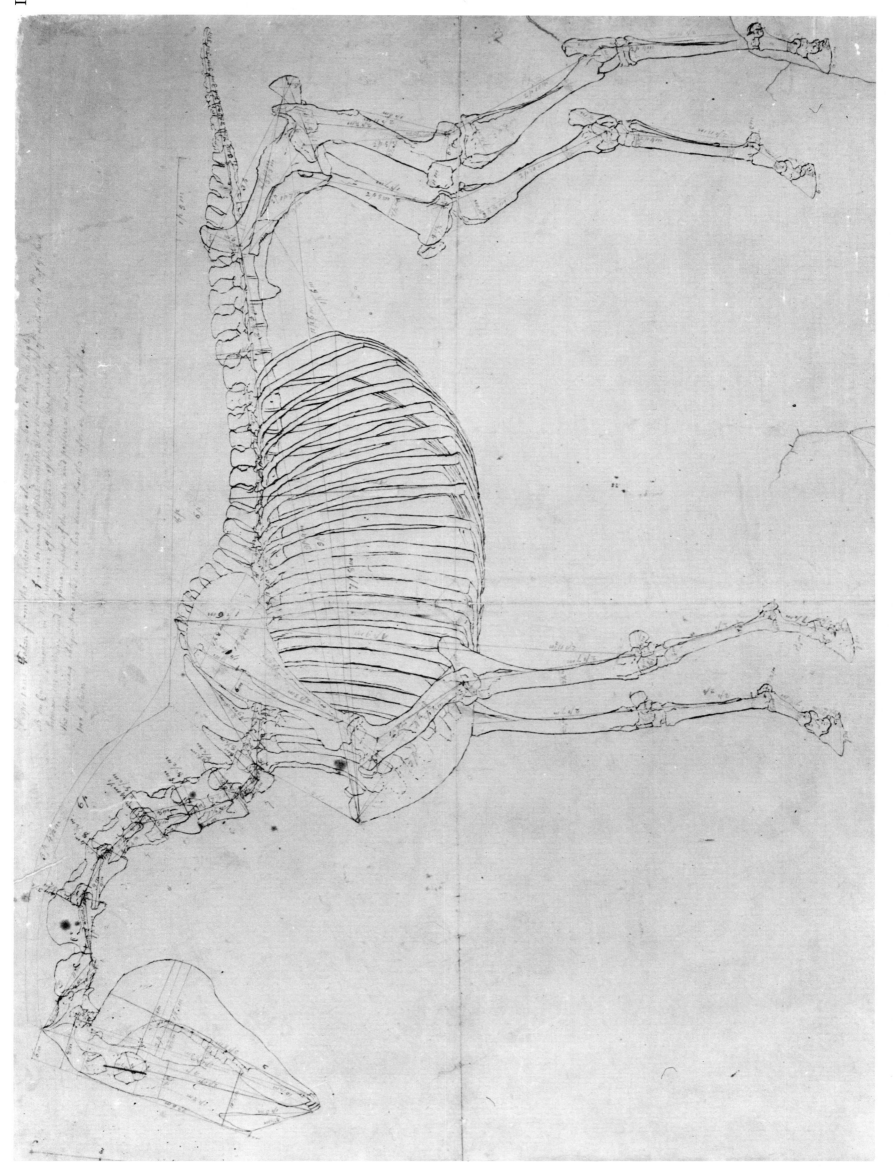

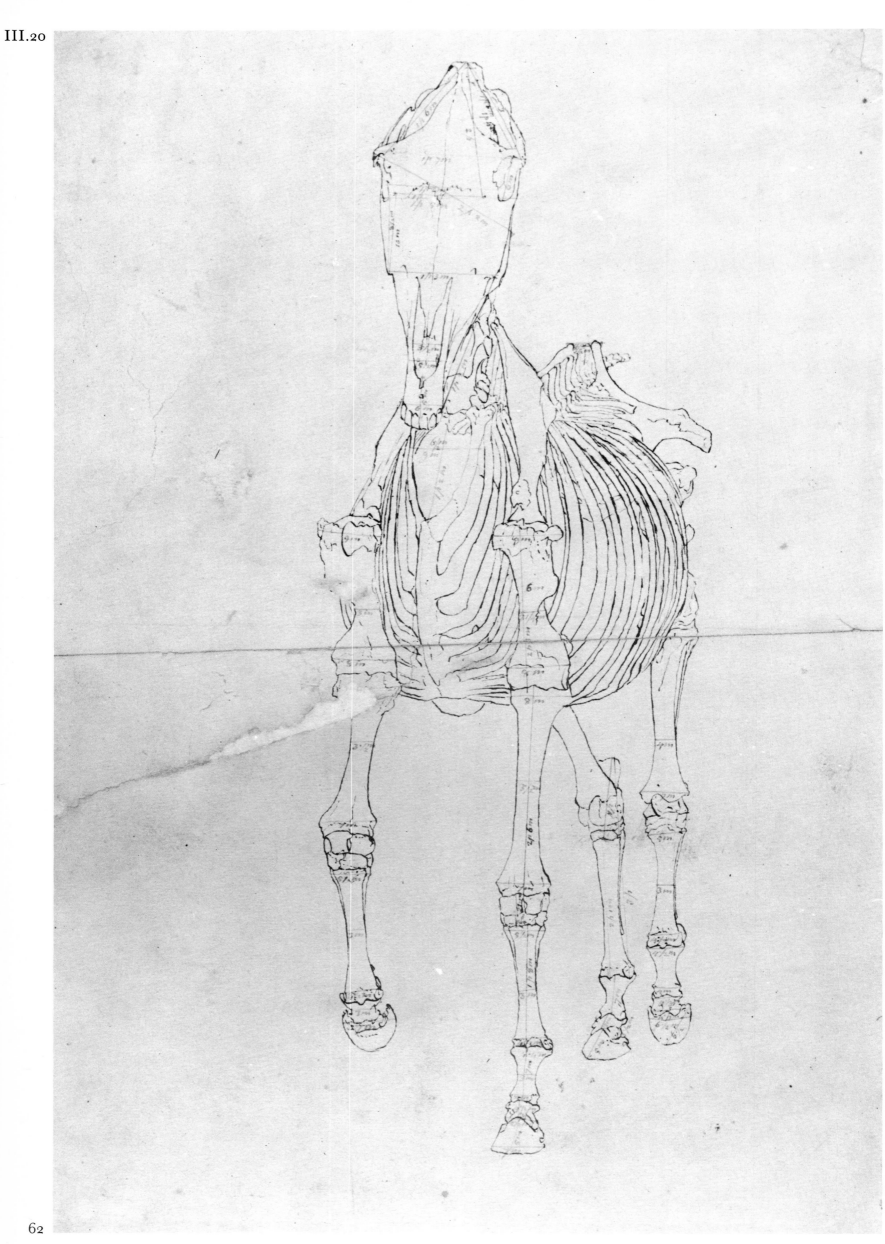

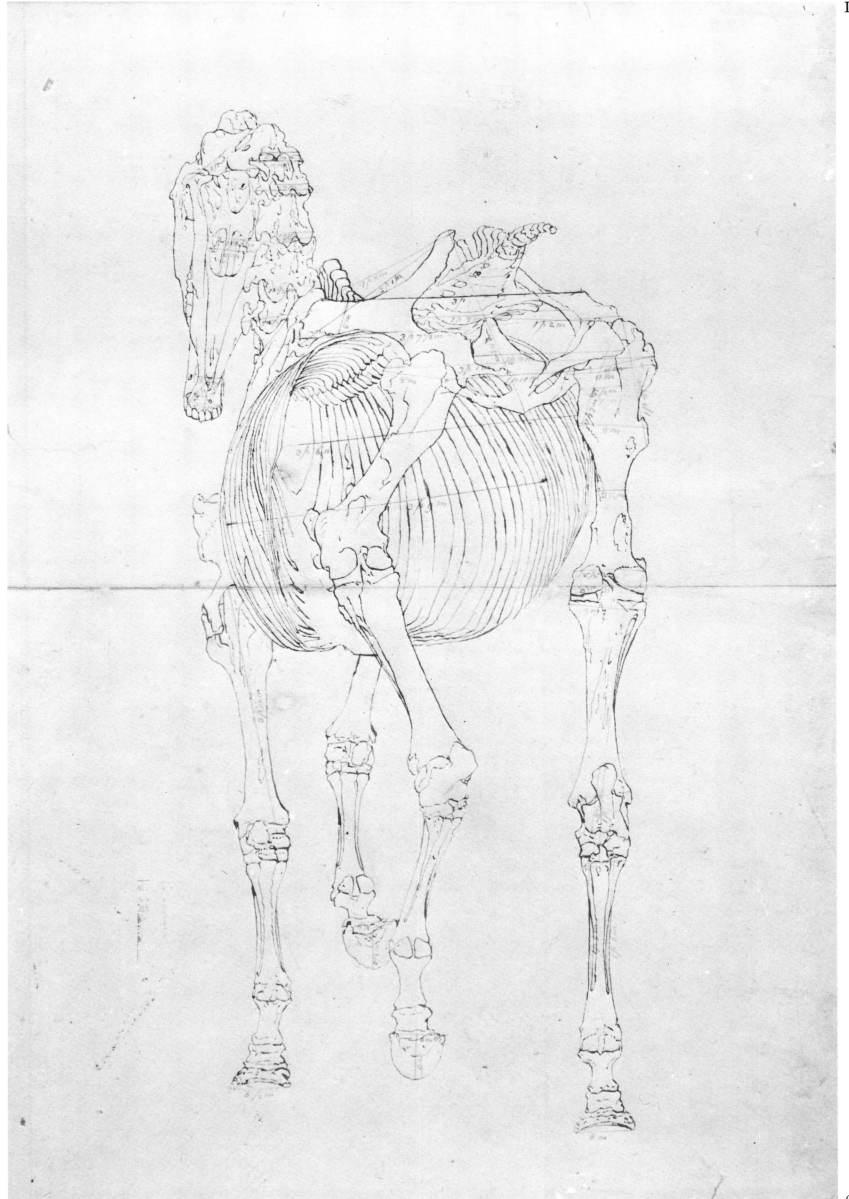

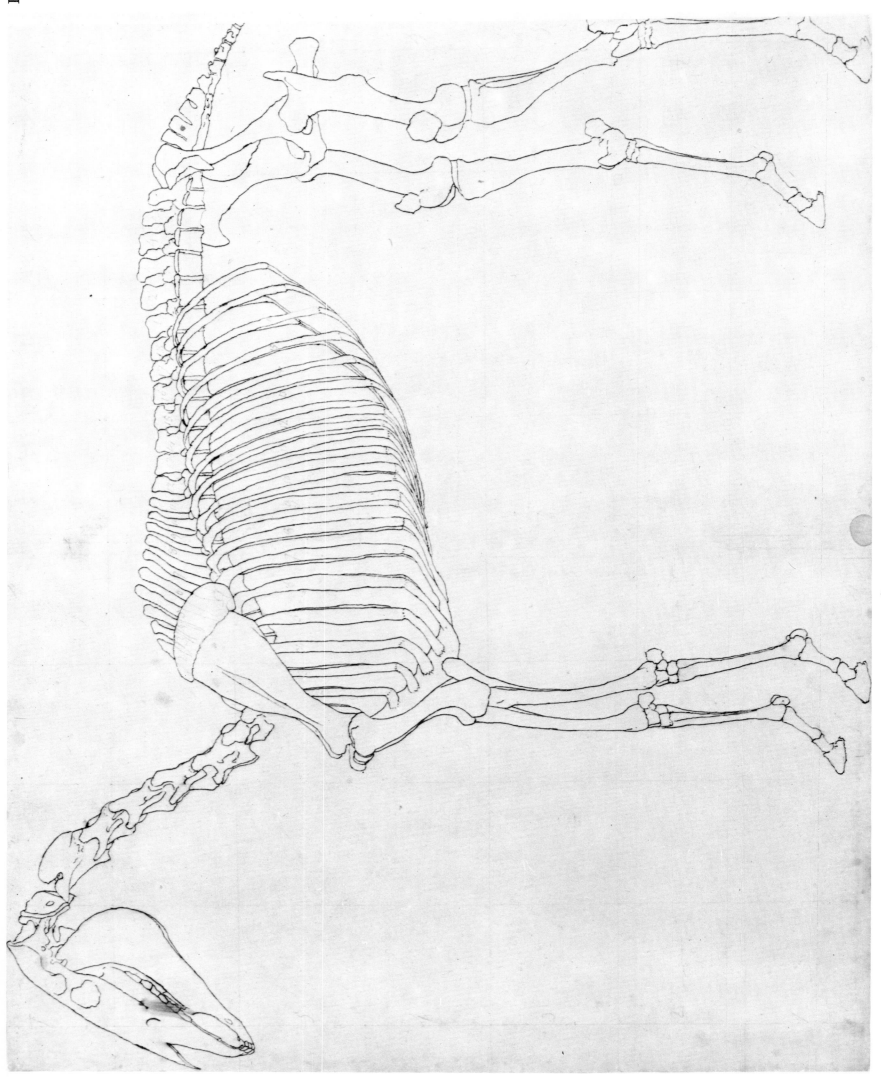

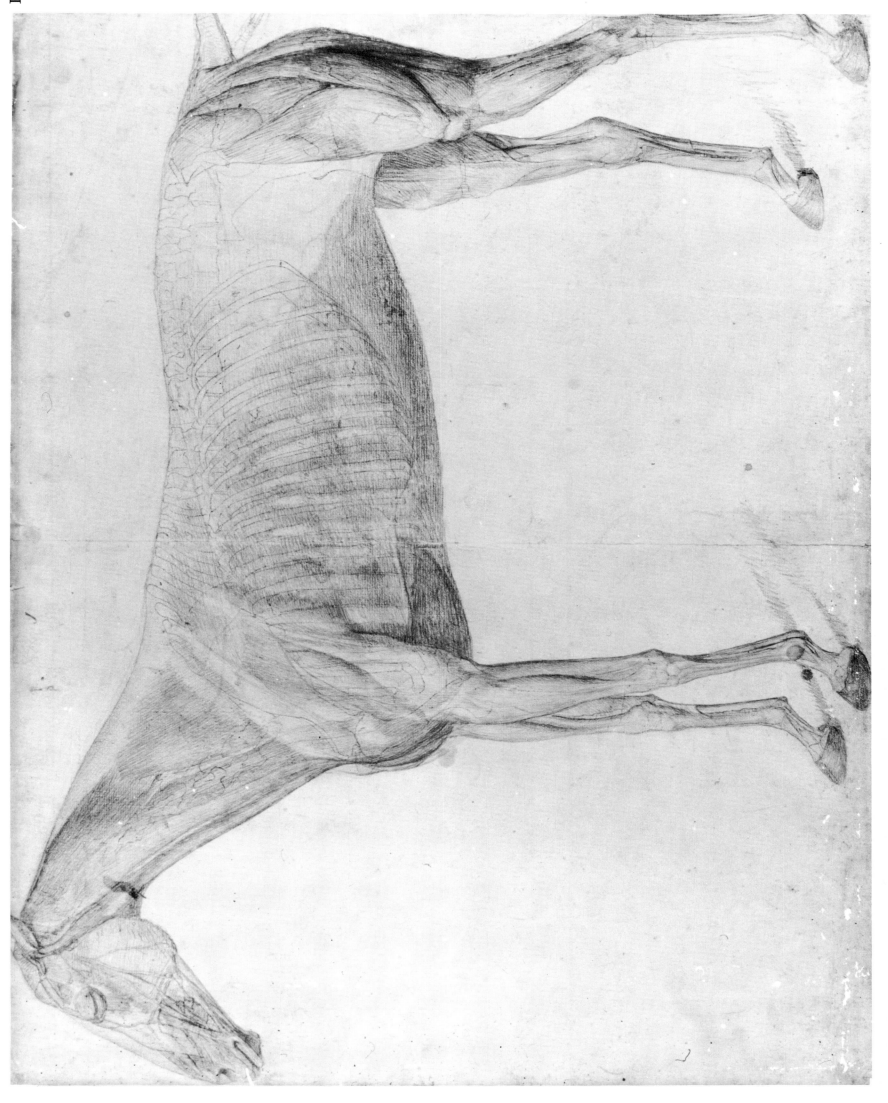

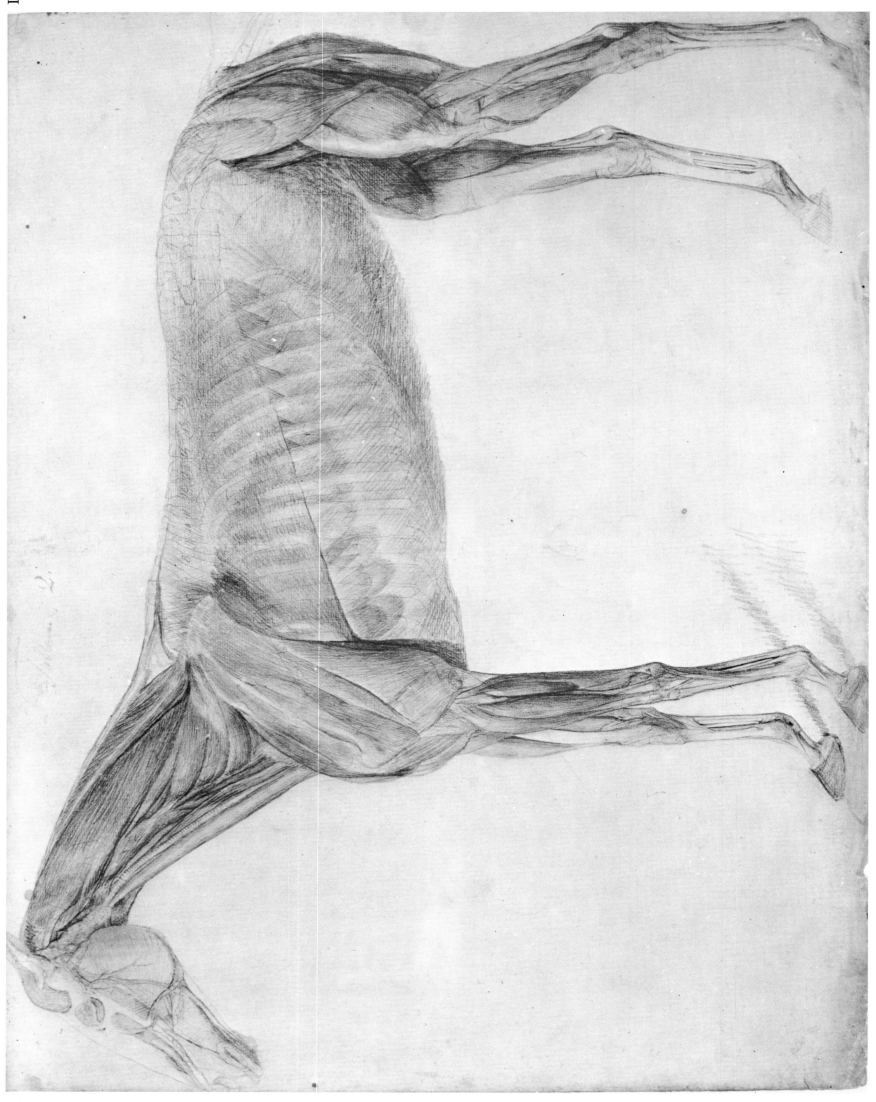

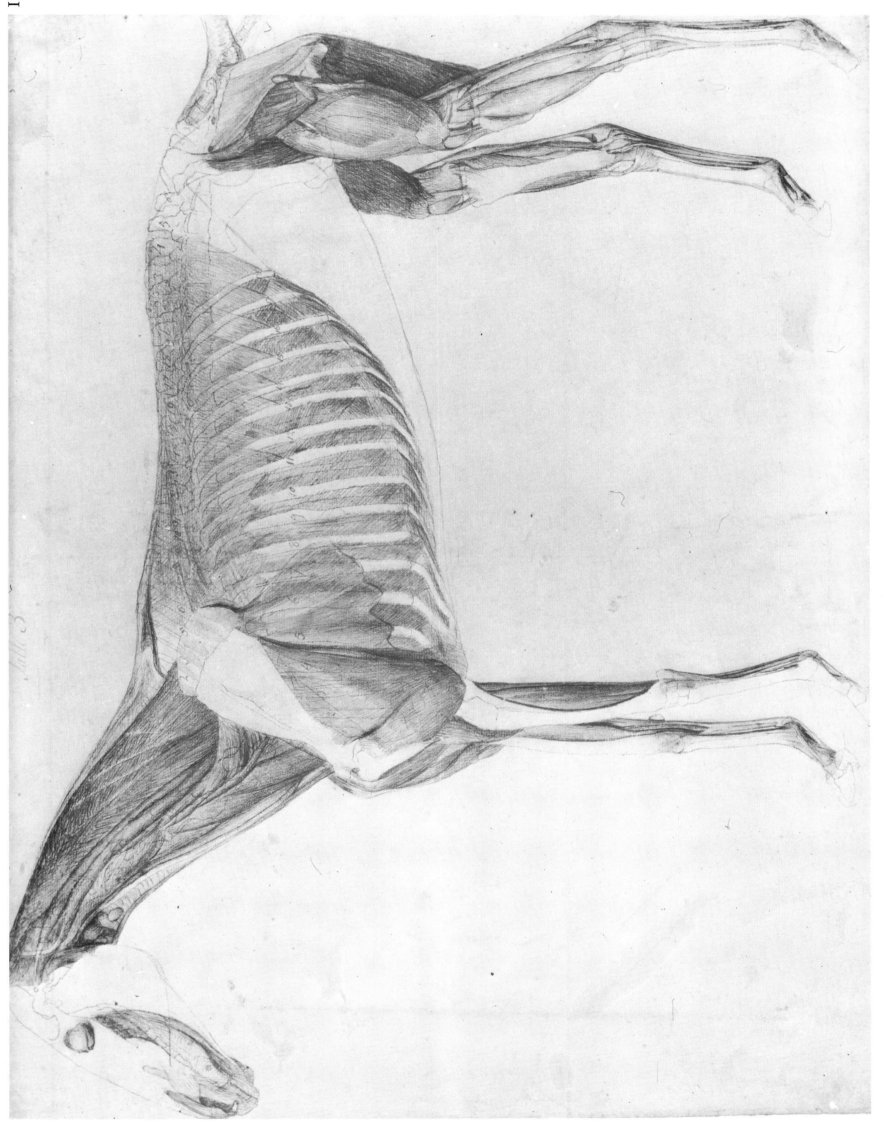

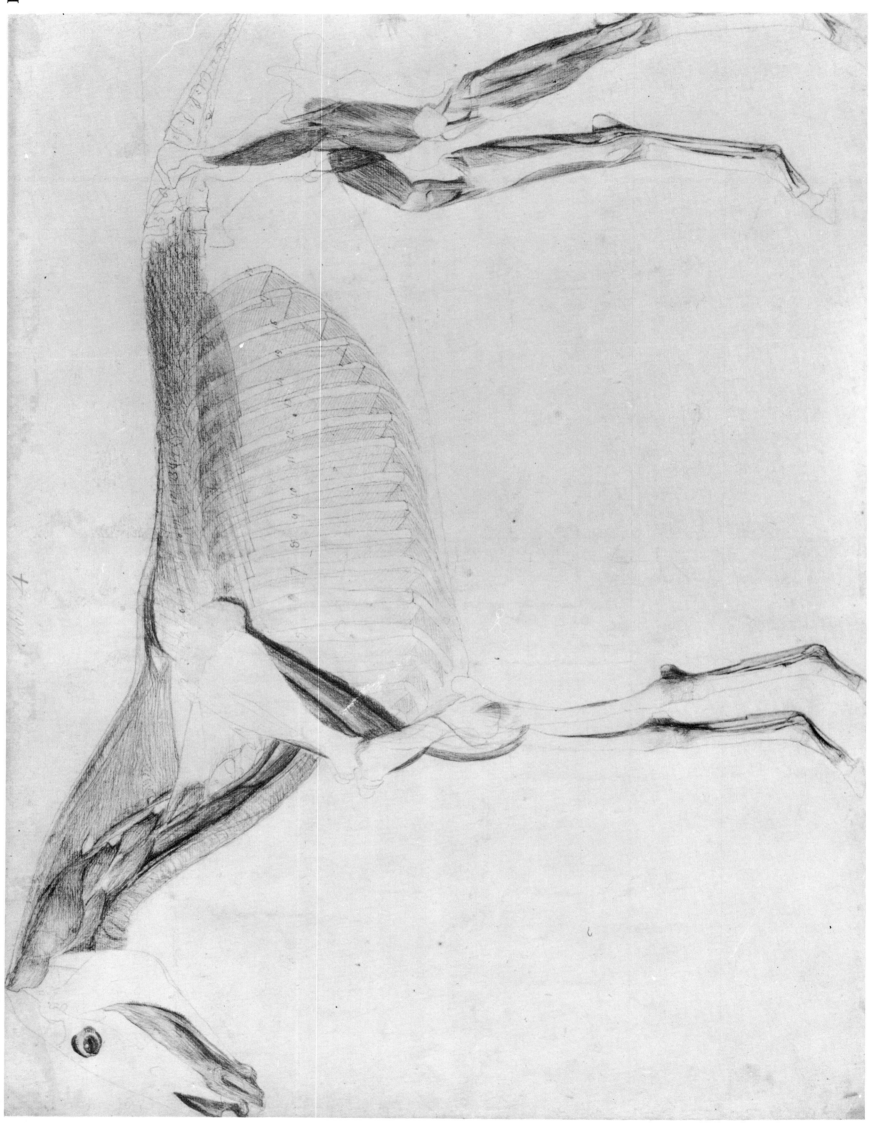

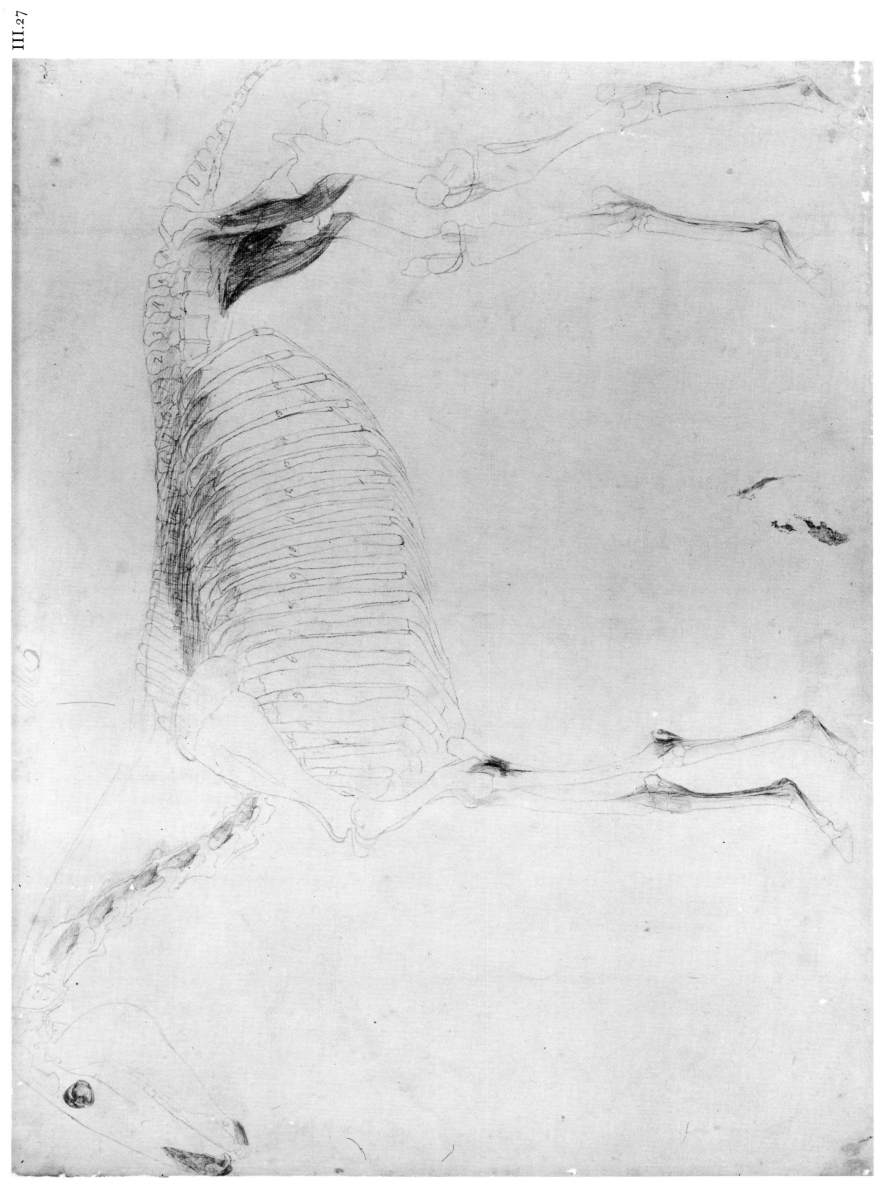

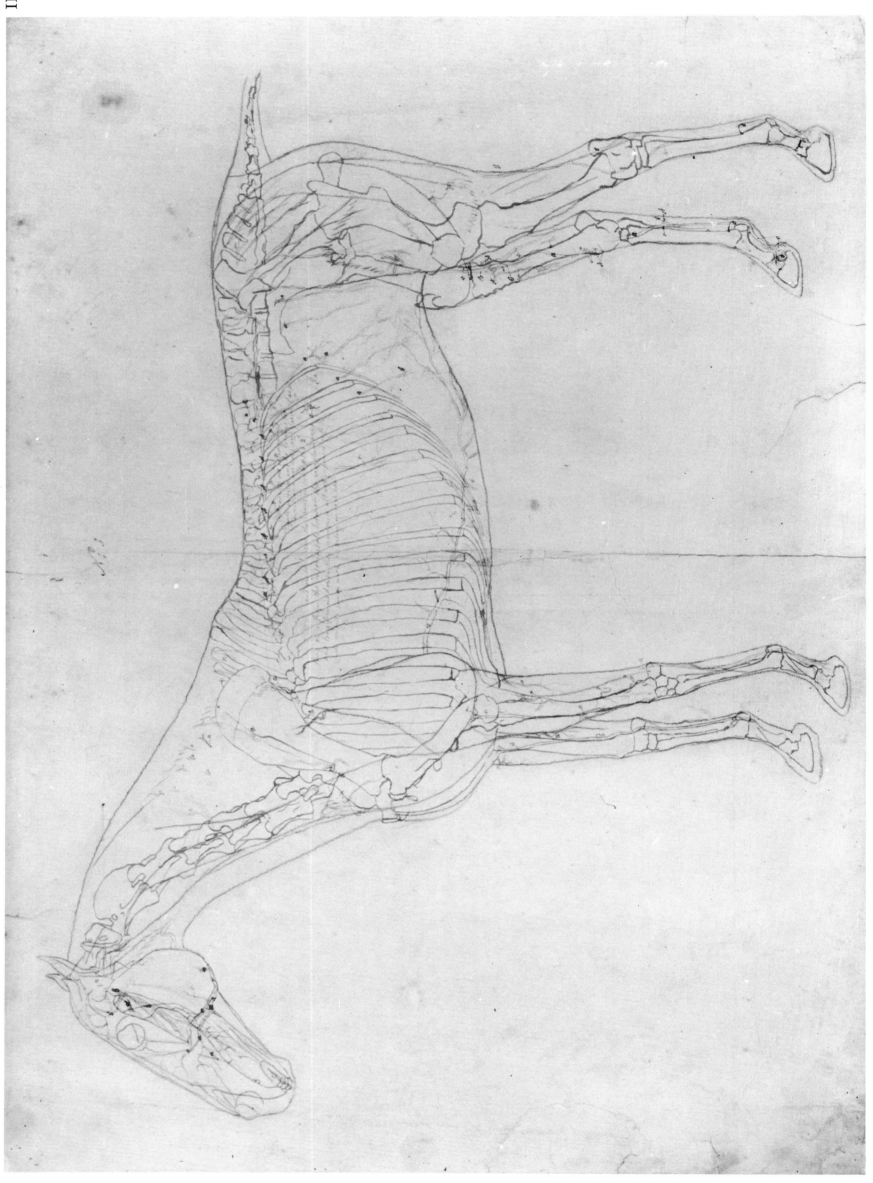

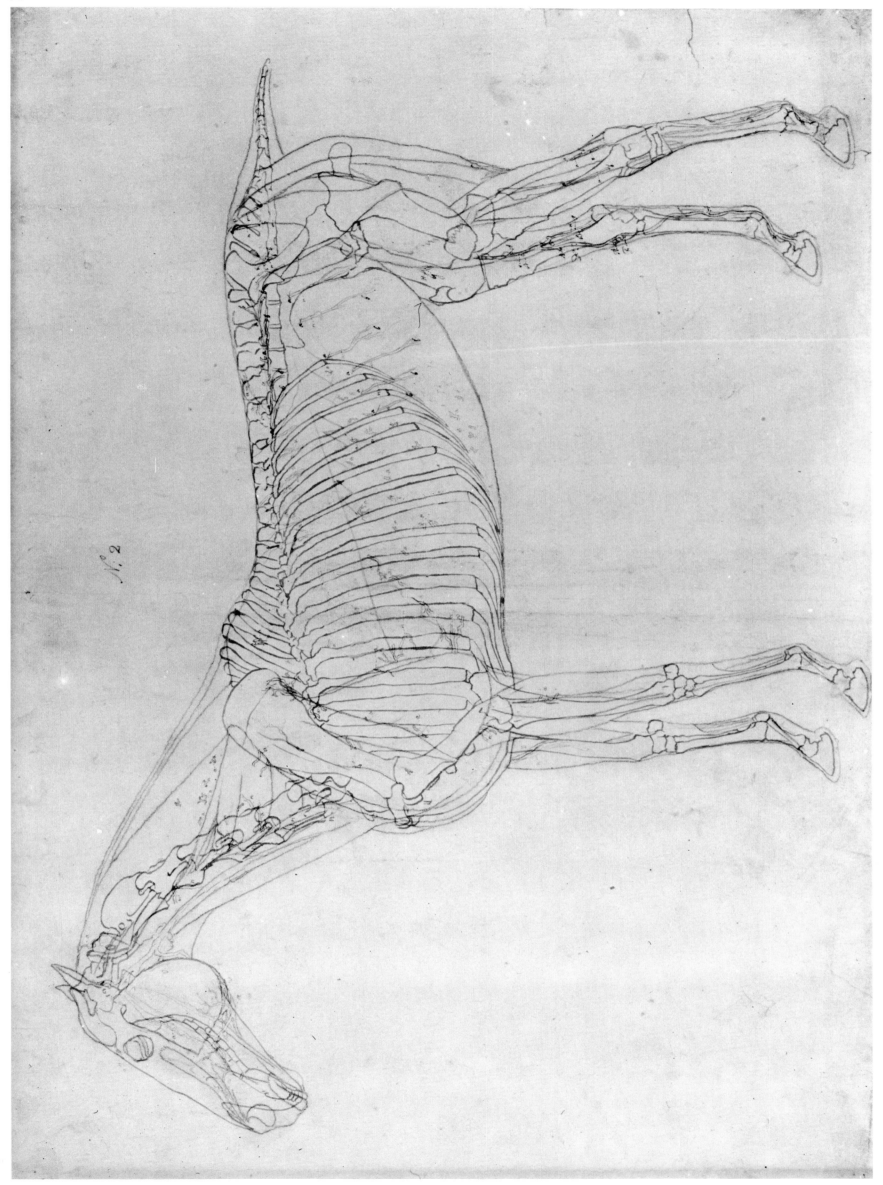

N.º 2

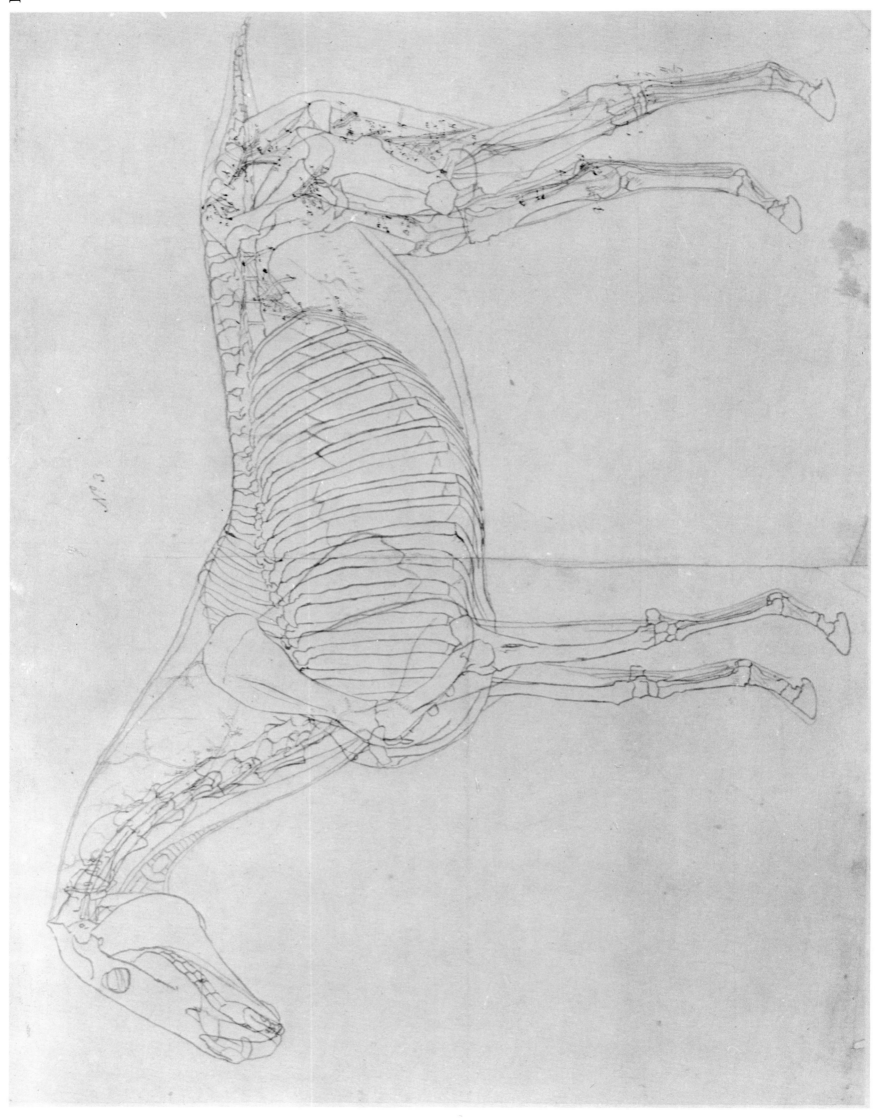

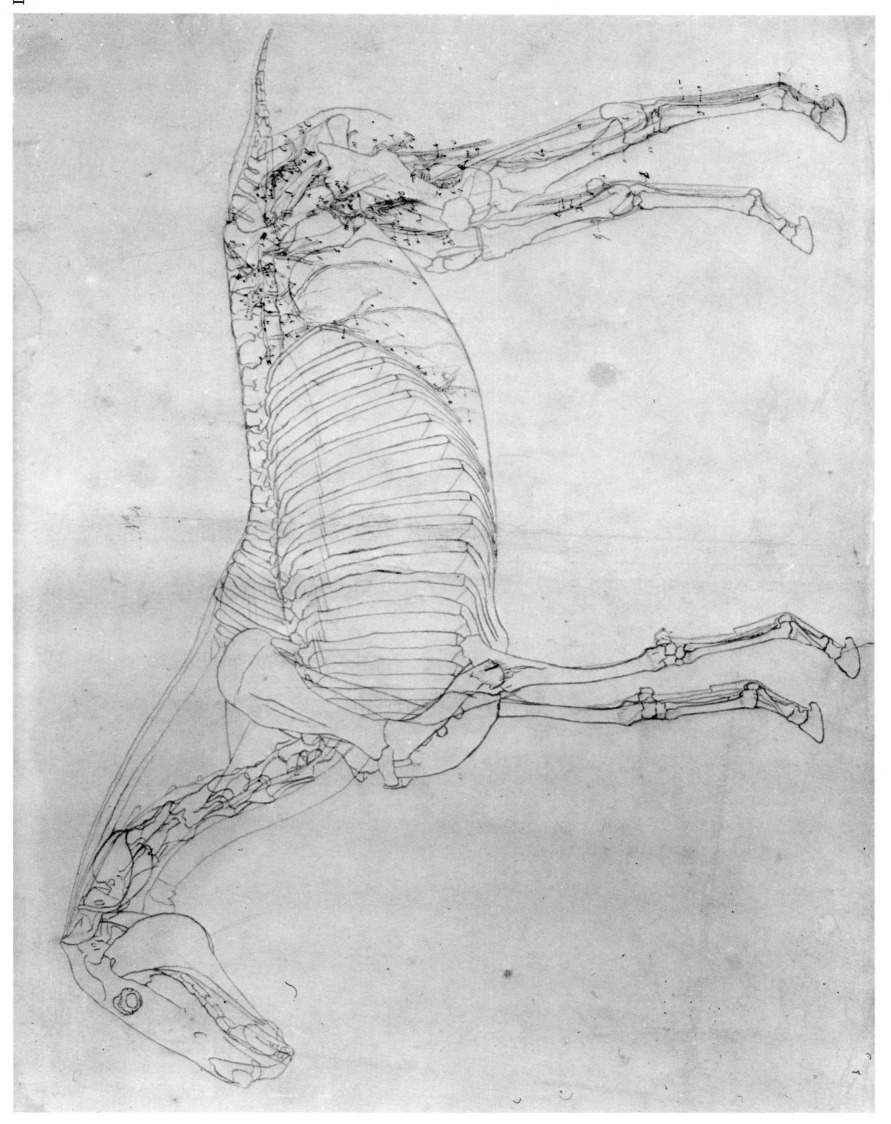

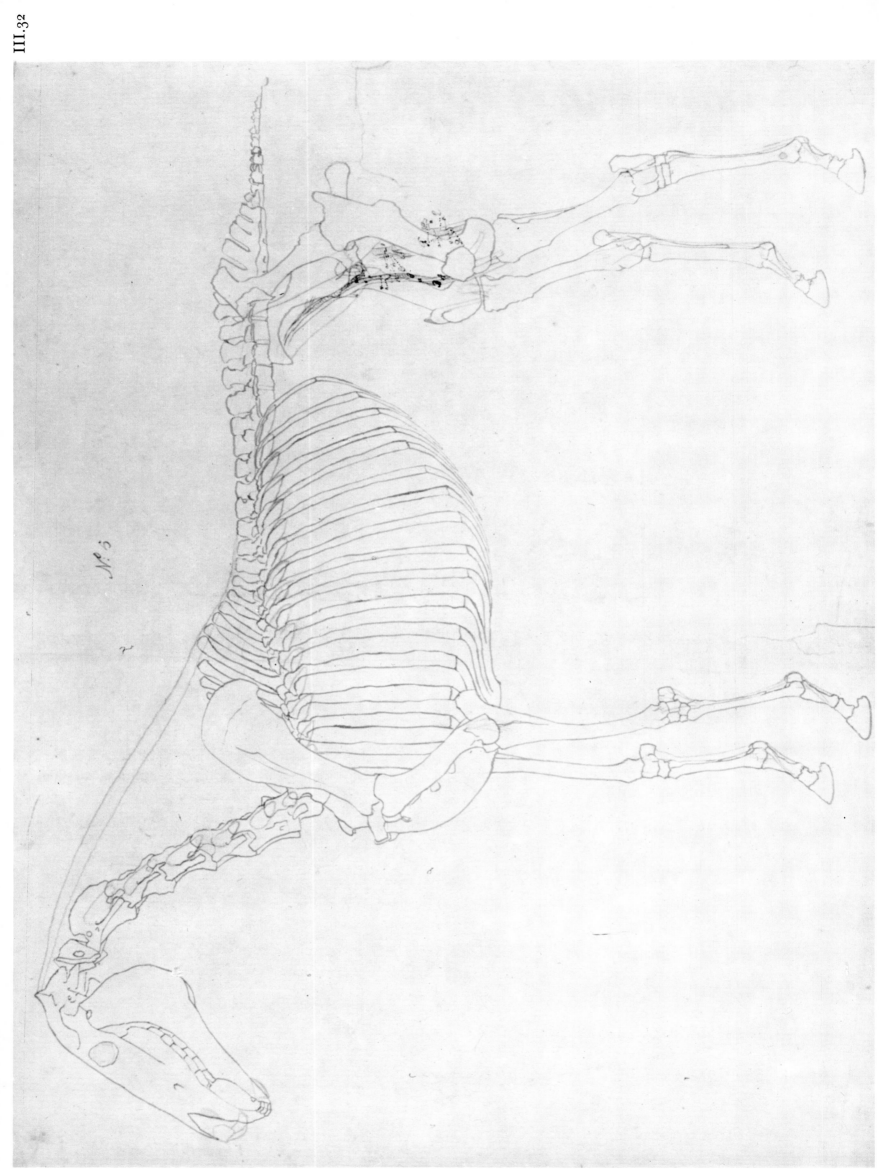

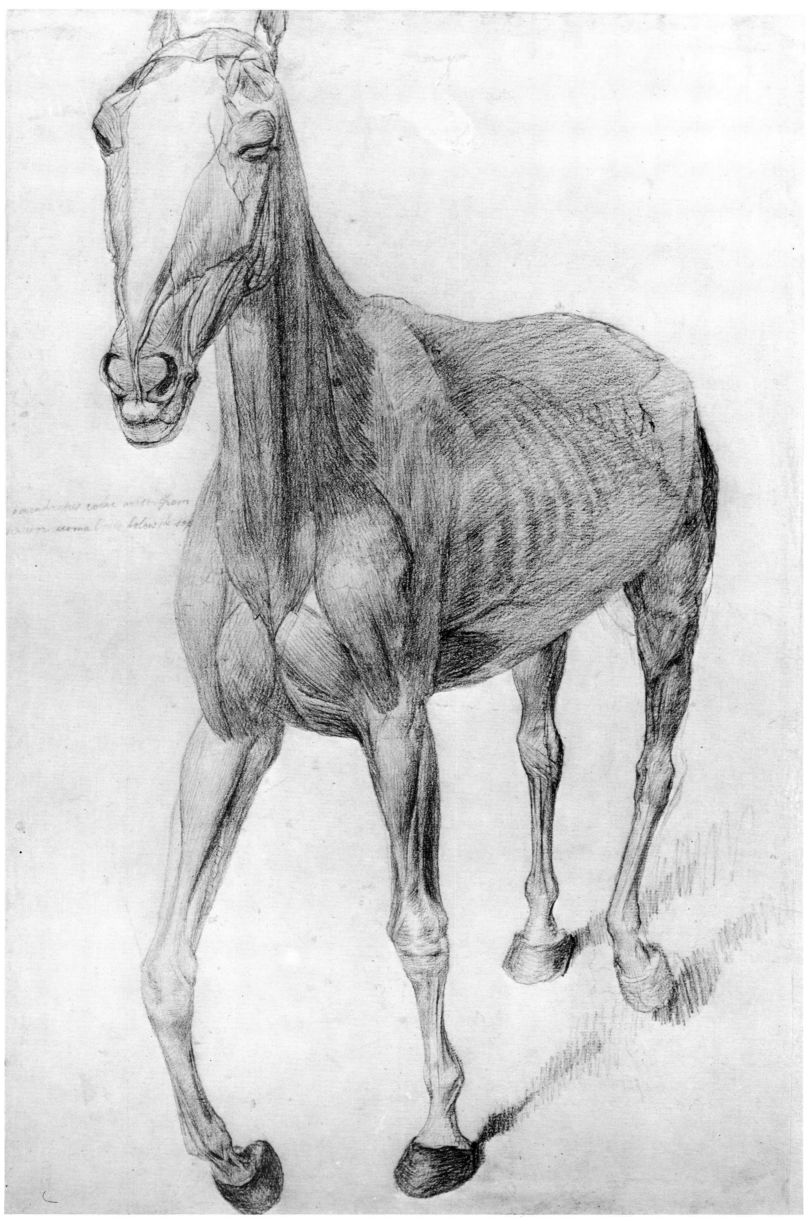

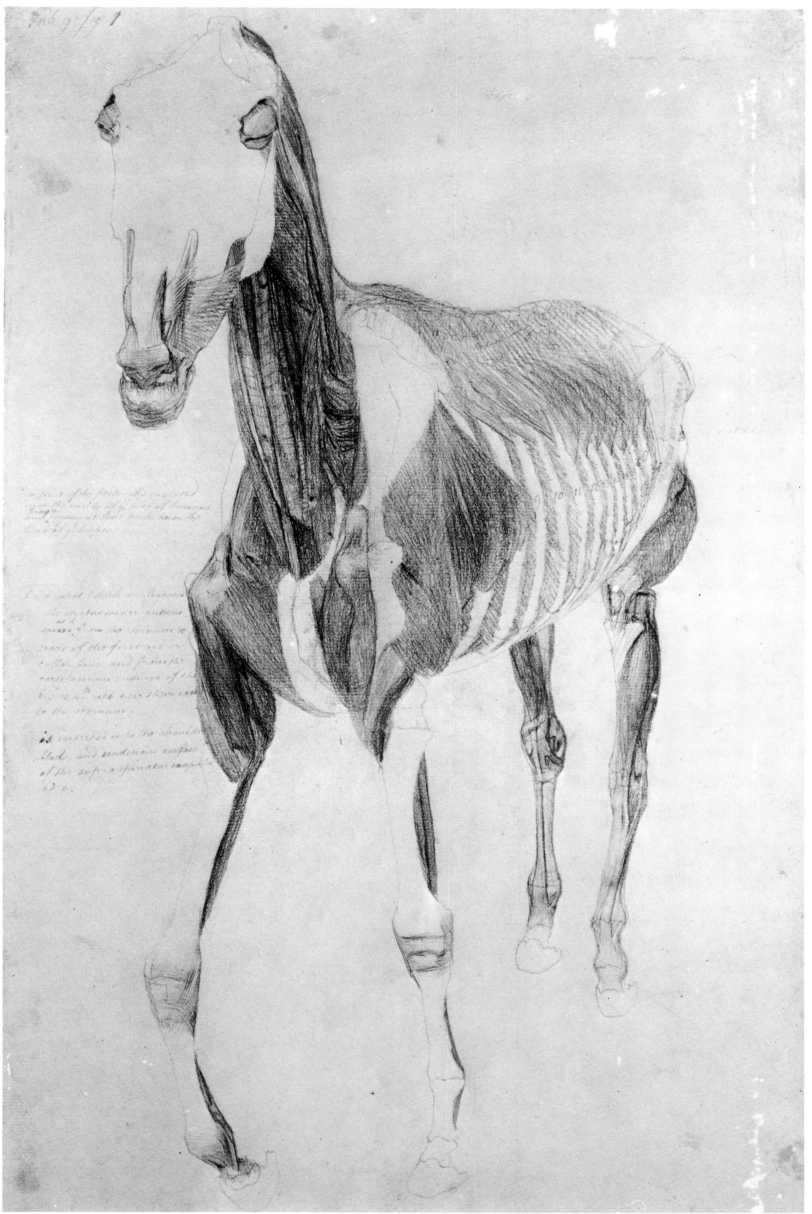

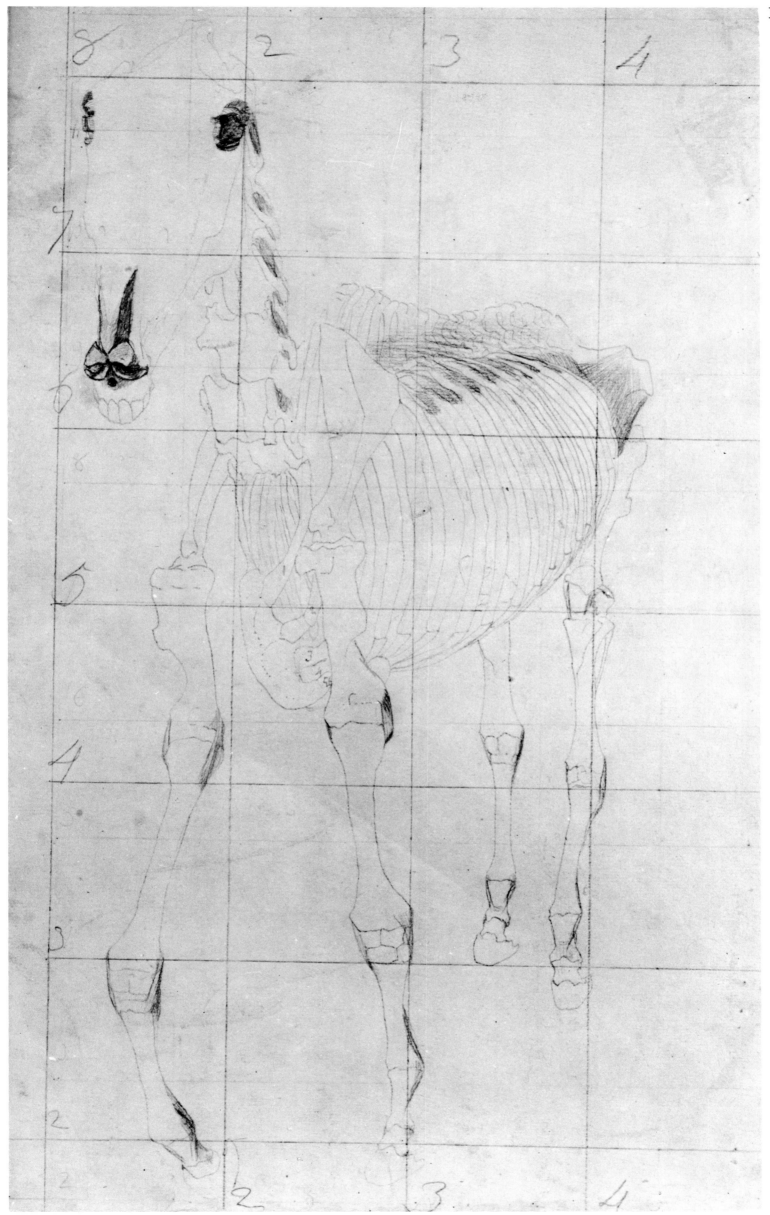

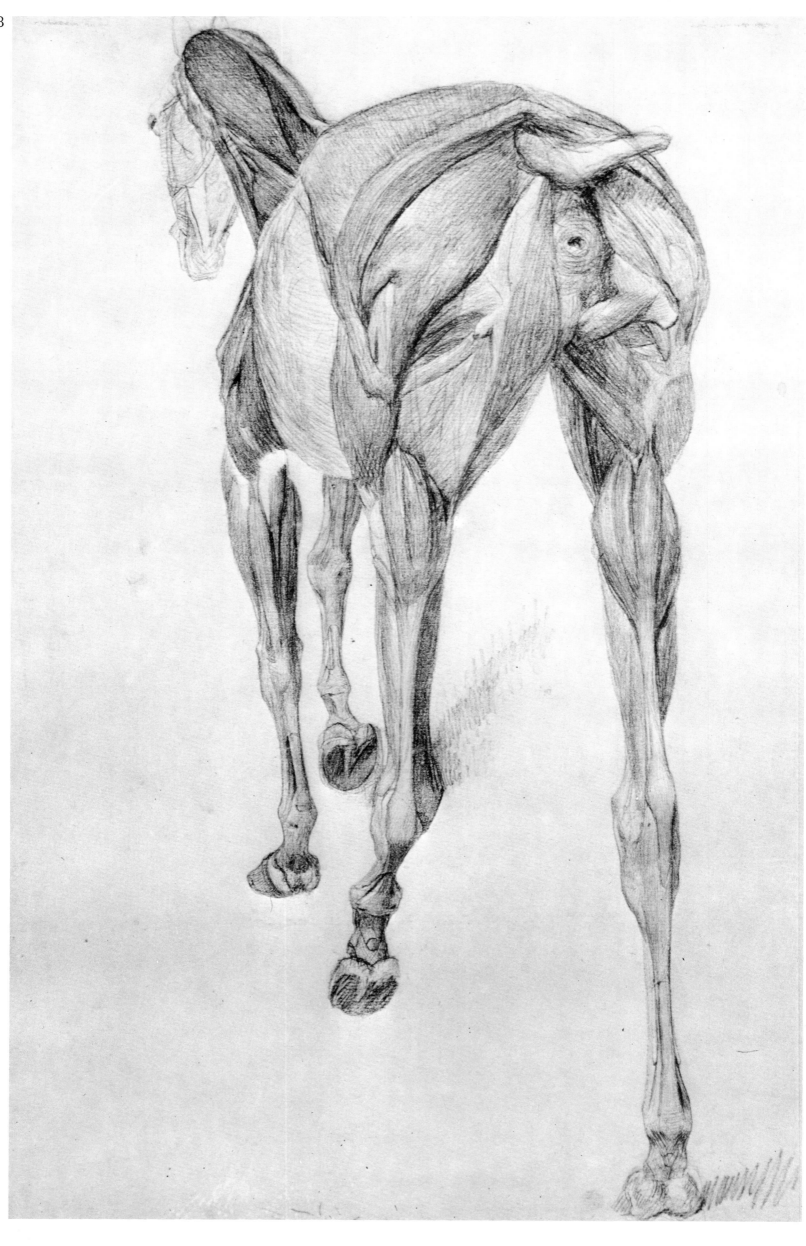

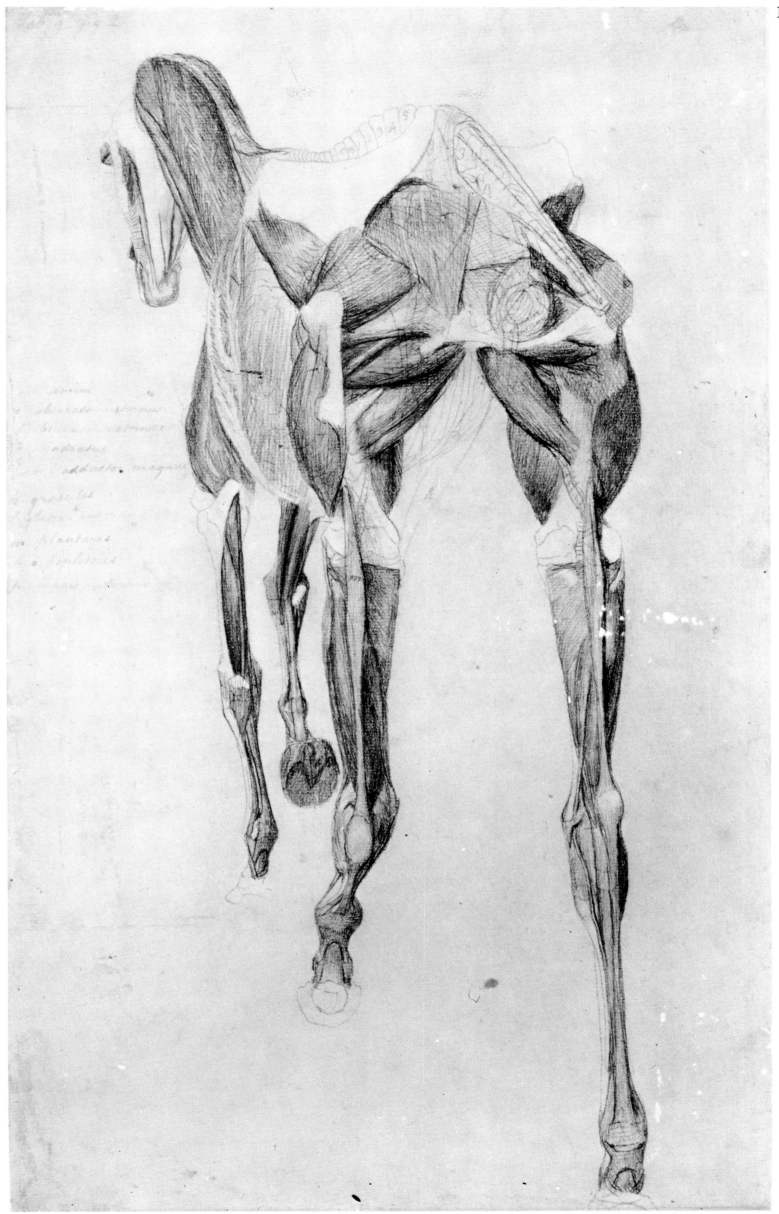

a b & 2 gemini
c quadratus
d pectineus
e adductor brevis
f adductor longus
g the tendon off of illiacus internus
and psoas magnus

h illiacus internus
i musculus parous in articulation of inferior situs
k vastus internus

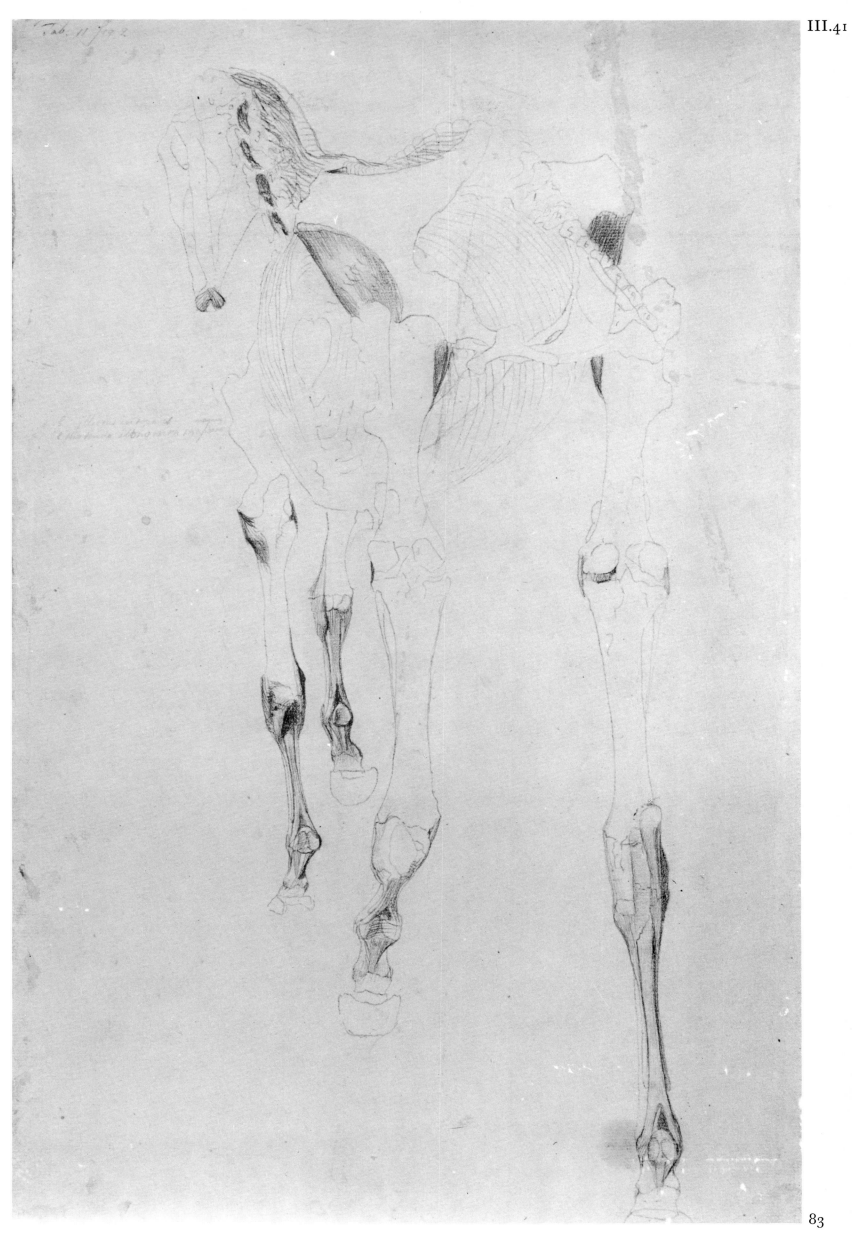

IV. Engravings for *The Anatomy of the Horse,* London, 1766

This series of tables was the first work which Stubbs acknowledged, and its publication established his reputation. There are eighteen tables showing the skeleton or the anatomy, accompanied by key figures—printed on separate sheets in the case of the lateral views of the horse, but on the same sheet as the unadorned figure in the case of the anterior and posterior views. The tables may be divided into four groups, these tables of the skeleton with separate key figures (I–III), five tables of the lateral view with separate key figures (I–V), five tables of the anterior view (VI–X), with key figures on the same sheet and five tables of the posterior view (XI–XV), again with key figures on the same sheet. The total number of plates that Stubbs engraved for *The Anatomy of the Horse* thus amounts to twenty-four. Stubbs published the following proposals for subscriptions to the work:

> PROPOSALS for Publishing by Subscription, THE ANATOMY OF THE HORSE INCLUDING a particular Description of the Bones, Cartilages, Muscles, Fascias, Ligaments, Nerves, Arteries, Veins and Glands. Represented in Eighteen Tables, all done from Nature. By GEORGE STUBBS, Painter.
> CONDITIONS
> The Tables engraved on Plates 19 inches by 15. The Explanation of the Tables will be printed on a Royal Paper answerable to the Plates, each of which will be printed upon a half Sheet of Double Elephant. The Price of the Book to Subscribers will be 4l. 4s. one Half to be paid at the Time of Subscribing, the other Half when the Book is delivered. The Price to Nonsubscribers will be 5l. 5s. The Names of the Subscribers will be printed at the Beginning of the Work.
> N.B. The Plates being all finished and the whole Work in the Press, it will be published as soon as 150 Subscribers have in their Names; which will, together with their subscriptions, be received by the following Booksellers, viz. Mr. Dodsley, in Pallmall; Mr. Nourse, in the Strand; Mr. Owen, at Temple Bar; Mr. Newberry, in St. Paul's Churchyard; and by all other Booksellers in Great Britain and Ireland. Subscriptions are likewise received by Mr. Stubbs at his House in Somerset Street, opposite North Audley Street, Oxford Road.
> This Work being the Result of many Years actual Dissections, in which the utmost accuracy has been observed, the Author hopes, that the more expert Anatomists will find it a useful Book as a Guide in Comparative Anatomy; and all Gentlemen who keep Horses, will by it, be enabled not only to judge of the Structure of the Horse more scientifically, but also to point out the Seat of Diseases, or Blemishes, in that Noble Animal, so as frequently to facilitate their Removal, by giving proper Instructions to the more illiterate Practitioners of the Veterinarian art into whose Hands they may accidently fall.
> RECeived the Day of 1765 Of
> 2l. 2s. being Half the Subscription Money for one BOOK of the Anatomy of the Horse.
> Geo. Stubbs.

Although Stubbs quotes the dimensions of the tables as being 19 by 15 inches, none of them actually reaches this size, but all are very slightly smaller, either due to the contraction of the paper after printing or to slight variations in the sizes of the individual copper plates used in the engraving.

NOTES ON THE ENGRAVINGS

1. FIRST SKELETON TABLE, LATERAL VIEW

Engraving, $14\frac{7}{8} \times 18\frac{3}{4}$ inches.
In this table Stubbs deals with the bones of the head, the vertebrae of the neck and spine, the thorax and shoulder blades, the right upper limb, the left upper limb, the pelvis, and the lower limbs. The key is printed separately.

89 2. THE SECOND SKELETON TABLE, ANTERIOR VIEW

Engraving, $14\frac{7}{8} \times 18\frac{7}{8}$ inches.
This table, like the other anterior and posterior views, has the key figure on the same plate. It deals with the head, spine, thorax and shoulder blades, the pelvis, the upper limbs, and the lower limbs.

90 3. THE THIRD SKELETON TABLE, POSTERIOR VIEW

Engraving, $14\frac{7}{8} \times 18\frac{7}{8}$ inches.
Here the parts are dealt with in the same order as in the Second Table.

91 4. THE FIRST ANATOMICAL TABLE, LATERAL VIEW

Engraving, $15 \times 18\frac{7}{8}$ inches.
The superficial muscles. Stubbs describes the structures in the head, the muscles of the outer ear, in the neck, the shoulder and trunk, and the muscles of the fore limb as they appear below the superficial connective tissue. The description is then completed by dealing with the external and internal views of the lower limbs.

93 5. THE SECOND ANATOMICAL TABLE, LATERAL VIEW

Engraving, $14\frac{7}{8} \times 18\frac{7}{8}$ inches.
This shows some of the upper layer of muscles removed. The description deals with the head, neck, the muscles inserted from the neck and trunk into the scapula; the muscles inserted into the humerus and cubit; and the muscles of the trunk, right upper limb, right lower limb, interior of the left lower limb, and the left upper limb.

95 6. THE THIRD ANATOMICAL TABLE, LATERAL VIEW

Engraving, $14\frac{7}{8} \times 18\frac{7}{8}$ inches.
In this table some of the larger groups of muscles in the neck and round the shoulders and pelvic girdle have been removed. The parts thus exposed and described are those of the head, neck, shoulder, and trunk; the cubit and right upper extremity, the right lower limb, the interior of the left lower limb, and the interior of the left upper limb.

7. THE FOURTH ANATOMICAL TABLE, LATERAL VIEW

Engraving, $15 \times 18\frac{7}{8}$ inches.
Here, in the penultimate stage of dissection, much of the vascular system and many of the main nerves are brilliantly displayed. The order of description is head, neck, shoulder, trunk, right lower limb, left lower limb, right upper limb, and left upper limb.

8. THE FIFTH ANATOMICAL TABLE, LATERAL VIEW

Engraving, $15 \times 18\frac{7}{8}$ inches.
This is the final stage of dissection displayed from the lateral viewpoint. Only the deepest muscles, blood vessels, and nerves survive; the trachea has been left intact. The parts are described as follows: the head, neck, trunk, right lower limb, interior of the left lower limb, right upper limb, and interior of the left upper limb.

9. THE SIXTH ANATOMICAL TABLE, ANTERIOR VIEW

Engraving, $14\frac{7}{8} \times 18\frac{3}{4}$ inches.
This is the first of the anterior views and shows the first stage of dissection with the skin removed. Stubbs's description deals with the head, neck, breast, shoulders, and trunk, and is completed by a description of the upper and lower limbs.

10. THE SEVENTH ANATOMICAL TABLE, ANTERIOR VIEW

Engraving, $14\frac{3}{4} \times 18\frac{7}{8}$ inches.
The superficial connective tissue has been removed and the muscles of the shoulders and trunk are displayed. The description deals with the head, the ear, neck, shoulders, and trunk, and the upper and lower limbs.

11. THE EIGHTH ANATOMICAL TABLE, ANTERIOR VIEW

Engraving, $14\frac{3}{4} \times 18\frac{3}{4}$ inches.
At this stage the upper layers of muscle have been removed and the position of the skeleton, particularly at the shoulders and limb joints is revealed. The parts are described as follows: the head, neck, trunk, shoulders and upper limbs, and the lower limbs.

12. THE NINTH ANATOMICAL TABLE, ANTERIOR VIEW

Engraving, $14\frac{7}{8} \times 18\frac{7}{8}$ inches.
In this, as in the Fourth and Fourteenth Tables, most of the muscles have been dissected exposing blood vessels and nerves. The parts described are: the head, neck, trunk, shoulders and upper limbs, and the lower limbs.

IV. Engravings for
The Anatomy of the Horse, London,
1766

13. THE TENTH ANATOMICAL TABLE,
ANTERIOR VIEW

Engraving, 14⅞ × 18⅞ inches.
Here only a few very deep muscles, some ligaments, and the nerves and blood vessels to the deeper parts remain. The intricate network of the blood vessels over the shoulders and hooves is beautifully displayed. The description deals with the head, neck and trunk, the shoulders and upper limbs, and the lower limbs.

106 14. THE ELEVENTH ANATOMICAL TABLE,
POSTERIOR VIEW

Engraving, 14¾ × 18¾ inches.
This is the first of the posterior views. Much of the detailed structure of the muscles is obscured by the subcutaneous connective tissue. The parts are described by Stubbs as follows: the head, the neck, shoulders and trunk, the upper extremities or anterior limbs, and the lower or posterior limbs.

107 15. THE TWELFTH ANATOMICAL TABLE,
POSTERIOR VIEW

Engraving, 14⅞ × 18¾ inches.
Although close in appearance to the preceding table, the contours of the main groups of muscles as they appear at the surface is clear and the branches of the jugular vein as they traverse the surface of the jaw are prominent. The parts described are: the head, the shoulder and trunk, the upper limbs, and the lower limbs.

108 16. THE THIRTEENTH ANATOMICAL TABLE,
POSTERIOR VIEW

Engraving, 14¾ × 18¾ inches.
Here the dissection has been carried furthest in the neck, shoulder, and pelvic region, the semitendinous muscle has been partly cut, and its severed end with the lower part of the muscle can be seen. The parts are described as follows: the head, the neck, the trunk, the upper limbs, and the lower limbs.

17. THE FOURTEENTH ANATOMICAL TABLE, 109
POSTERIOR VIEW

Engraving, 14¾ × 18¾ inches.
Nearly all the major groups of muscles have been dissected, exposing the skeleton in some parts and many of the nerves and blood vessels. As in all the tables showing the later stages of dissection the complex forms of the various structures heightens the dramatic quality of the engraving. The parts described are: the head and wind-pipe, the neck, the trunk, the upper limbs, and the lower limbs.

18. THE FIFTEENTH ANATOMICAL TABLE, 110
POSTERIOR VIEW

Engraving, 14⅞ × 18⅞ inches.
This is the last of the posterior views and the final table in *The Anatomy of the Horse*. The principal structures displayed are the nerves and blood vessels and the ligaments remaining at the joints. Stubbs's description is in the following order: the head and neck, the trunk, the upper limbs, and the lower limbs.

Tab.I. IV.i

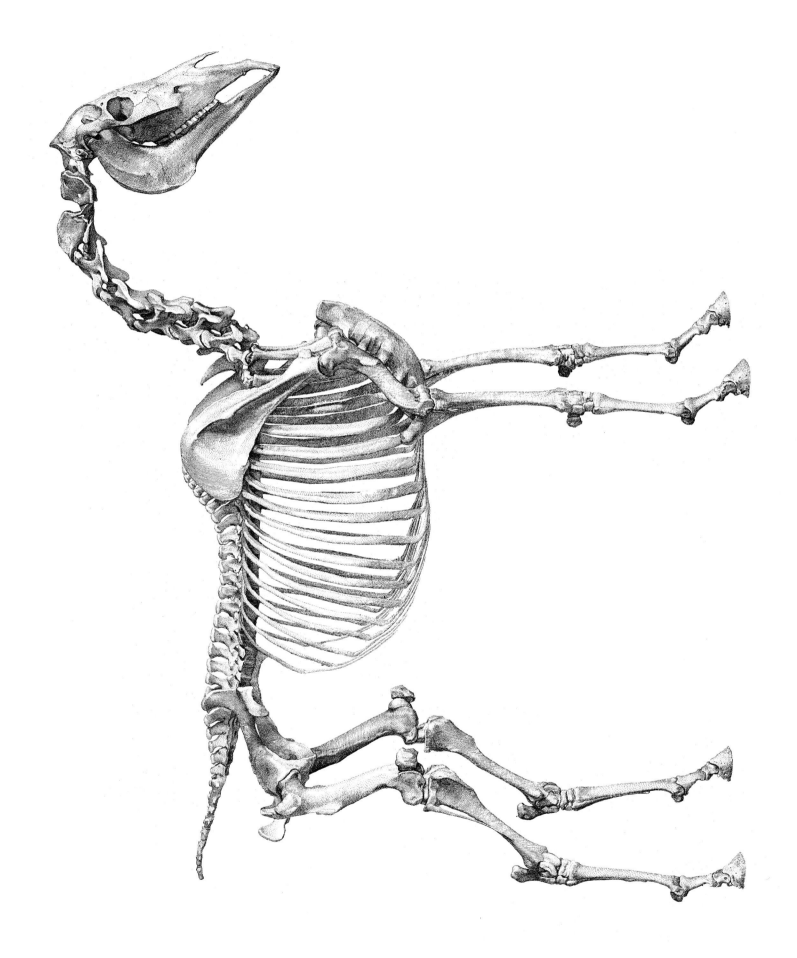

TAB. I.

Tab. II. **IV.2**

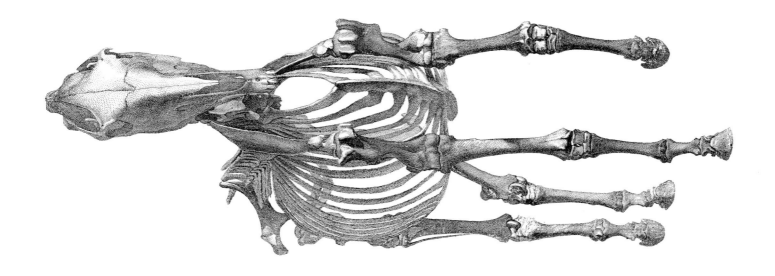

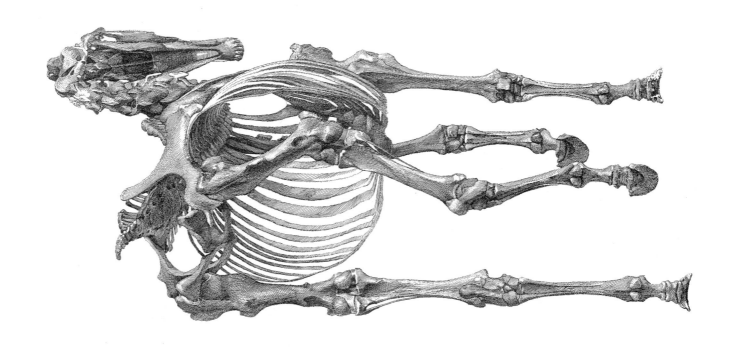

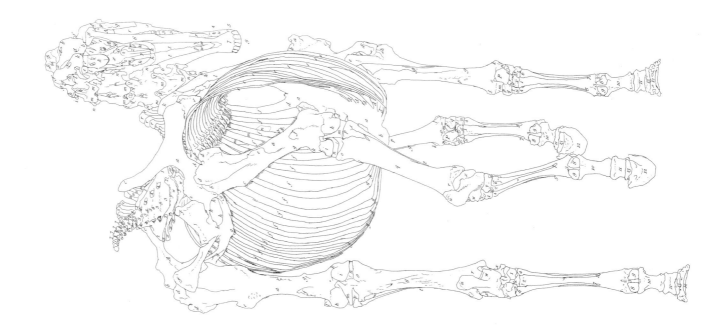

TAB. I. IV.4

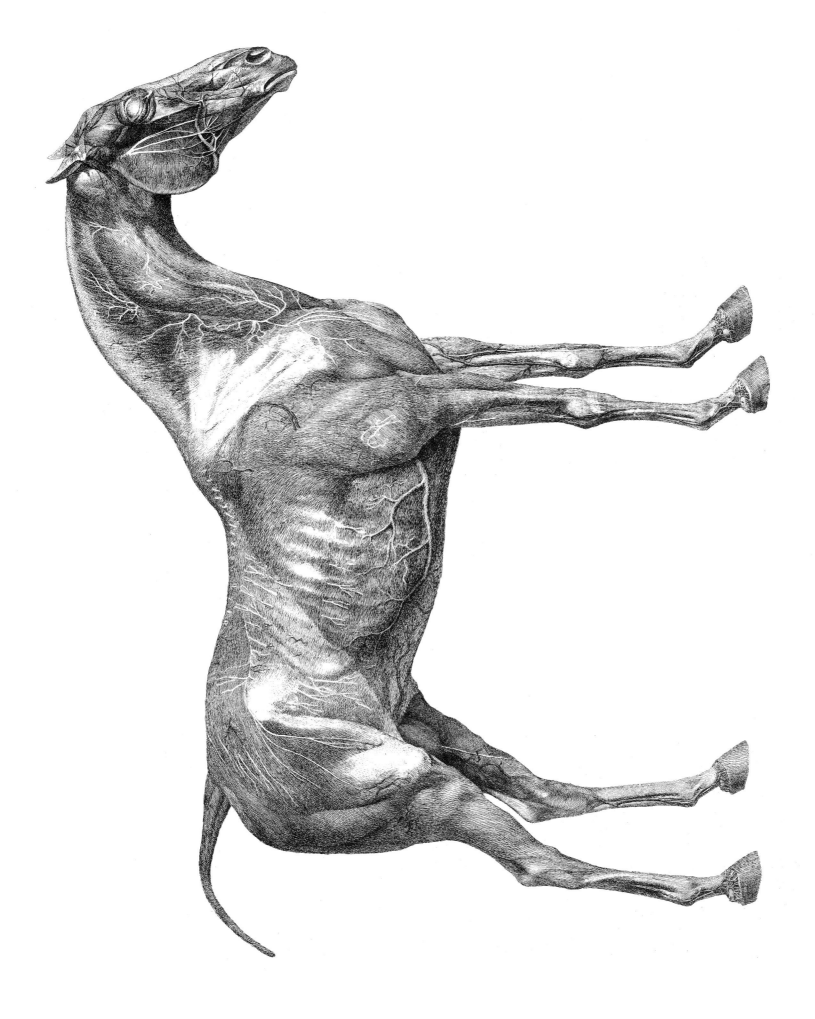

TAB.I.

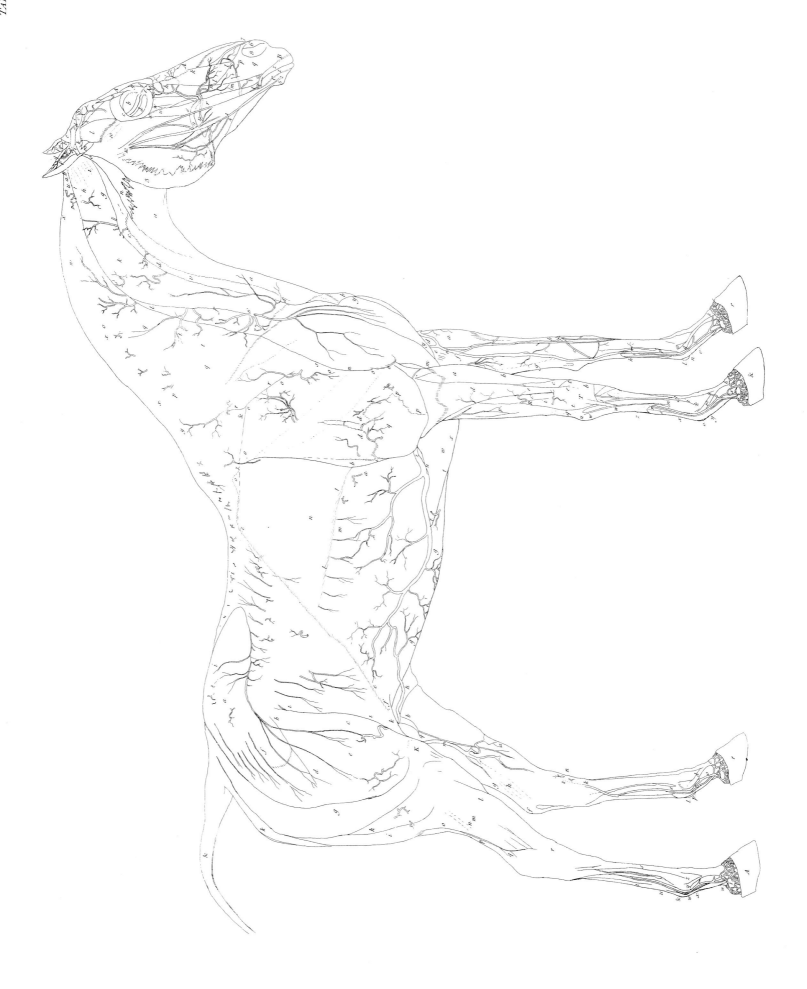

TAB. II. IV.5

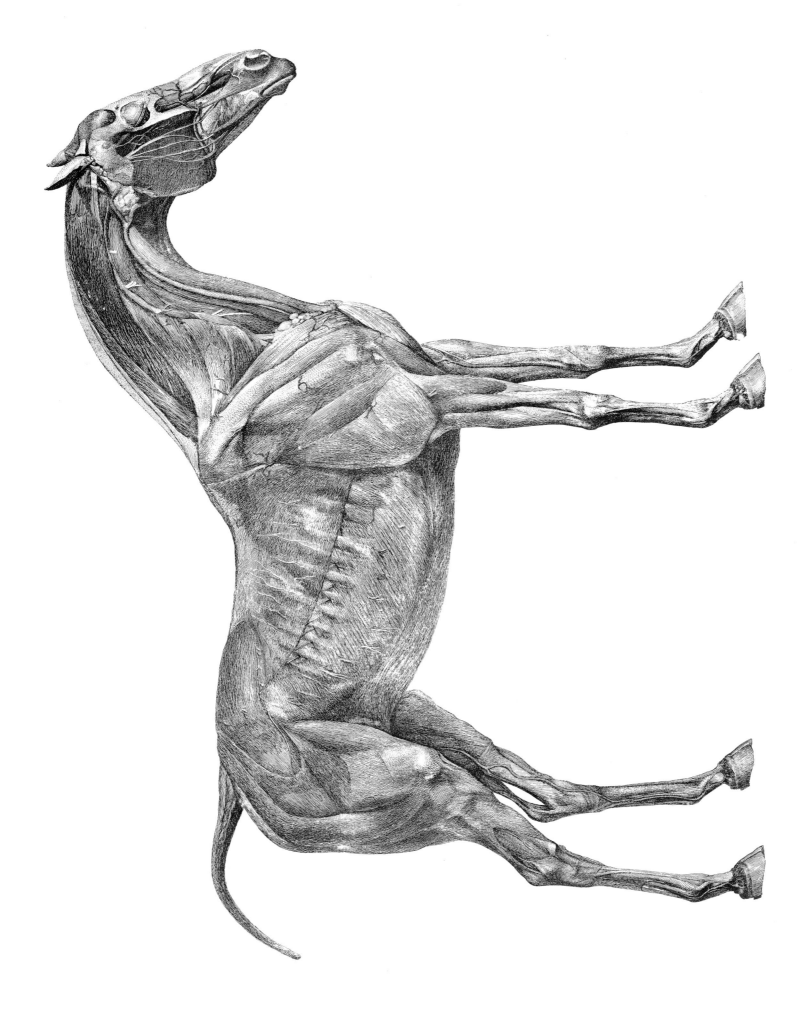

TAB. II.

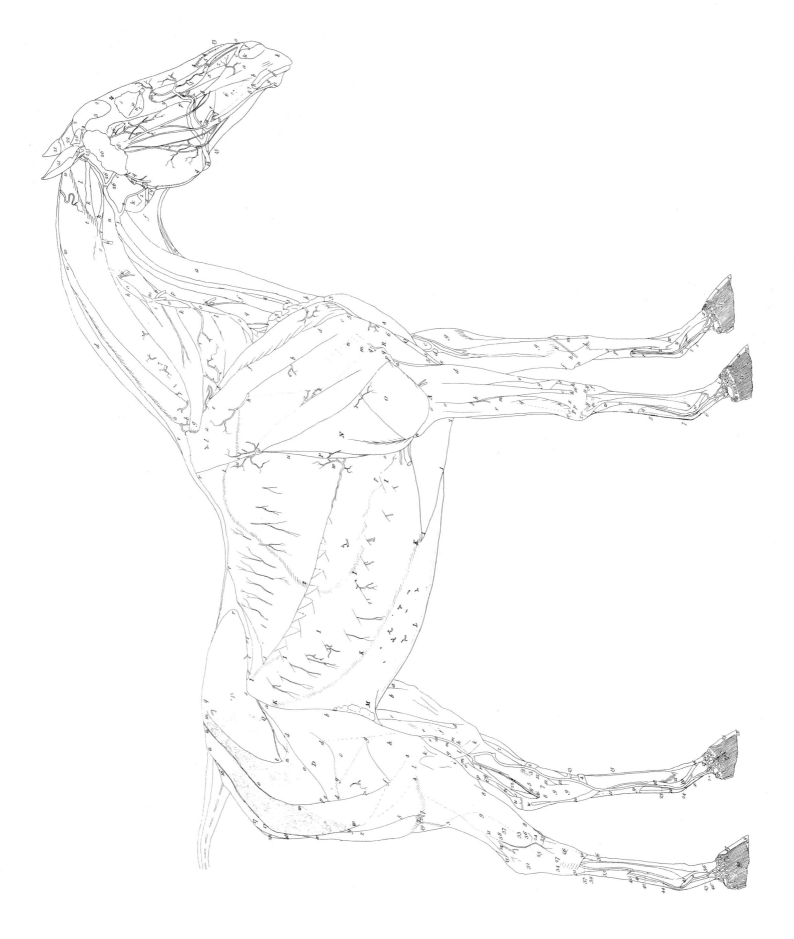

TAB. III. IV.6

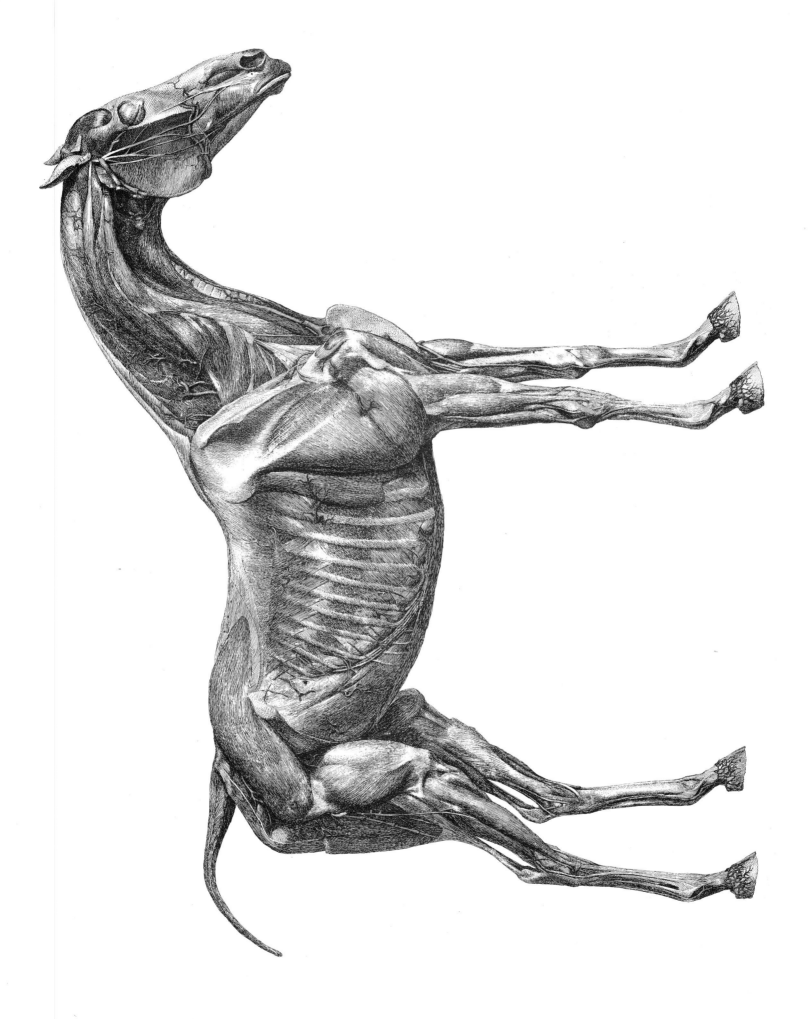

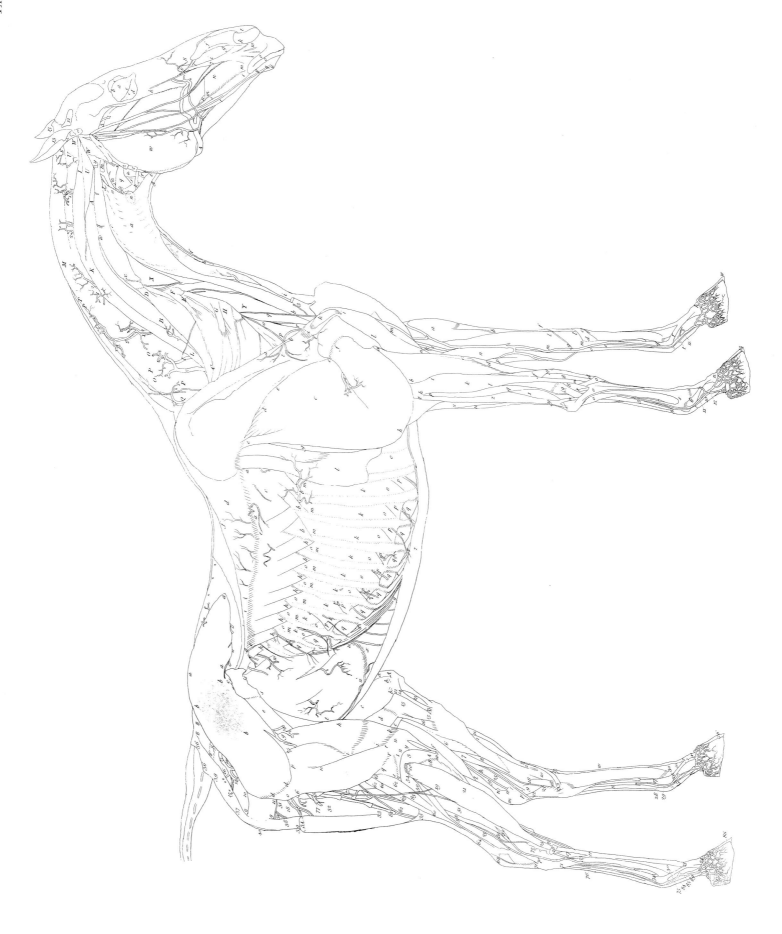

TAB. III.

TAB.IV. IV.7

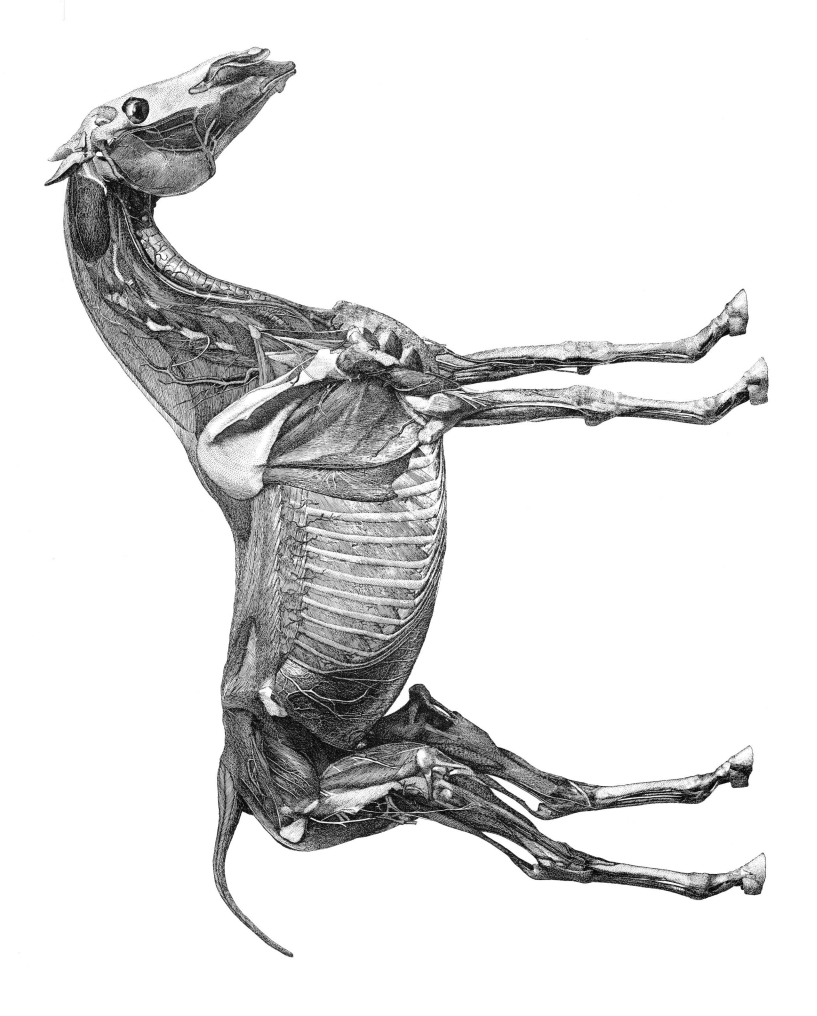

TAB. IV.

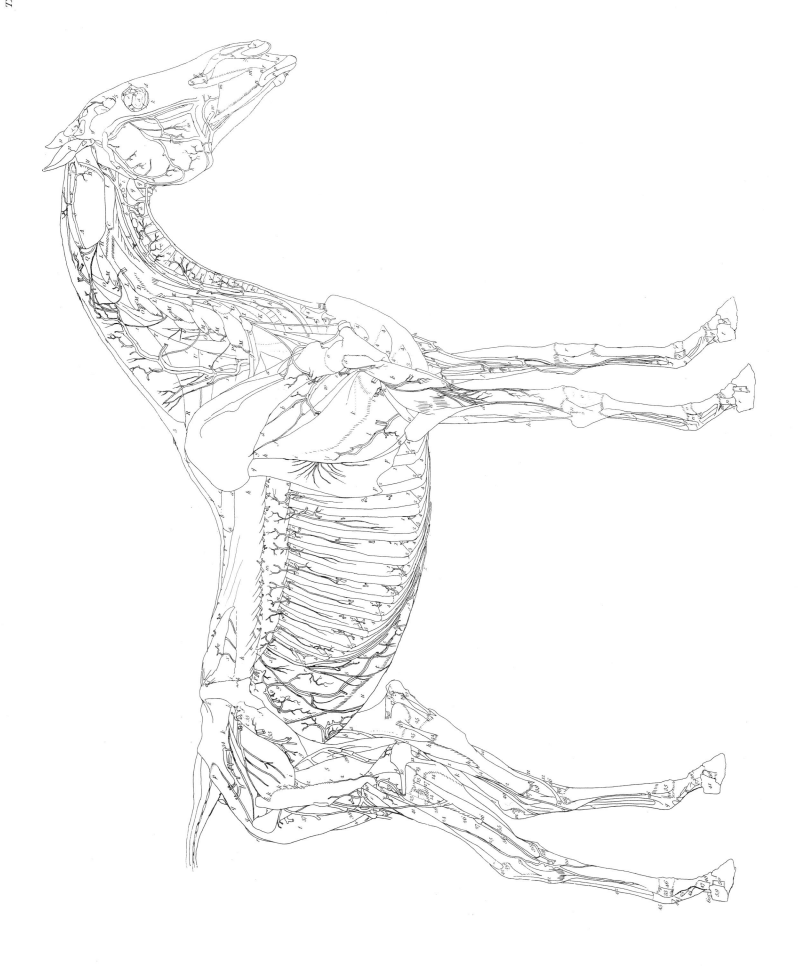

TAB. V. IV.8

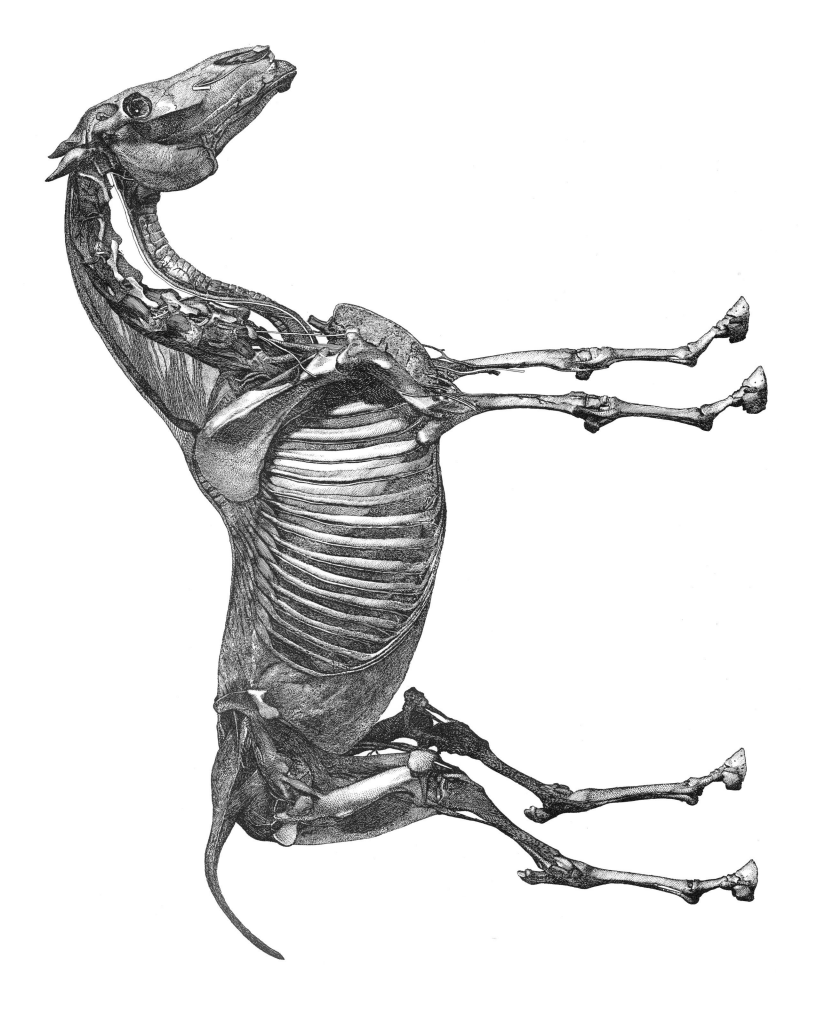

TAB. V.

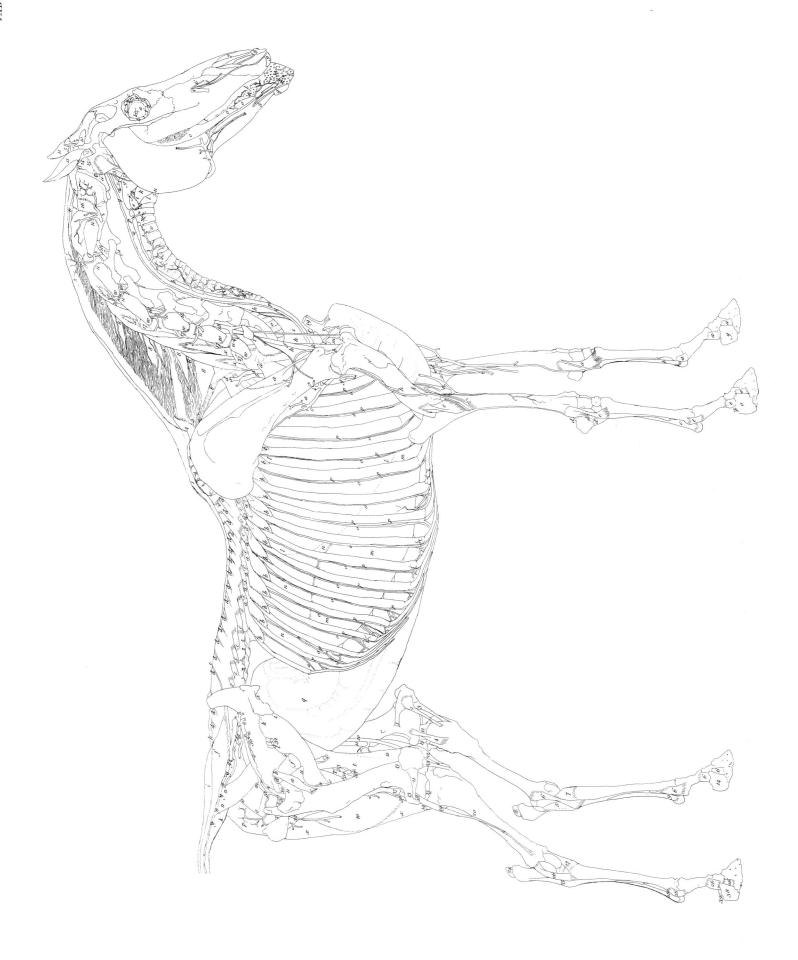

TAB. VI. IV.9

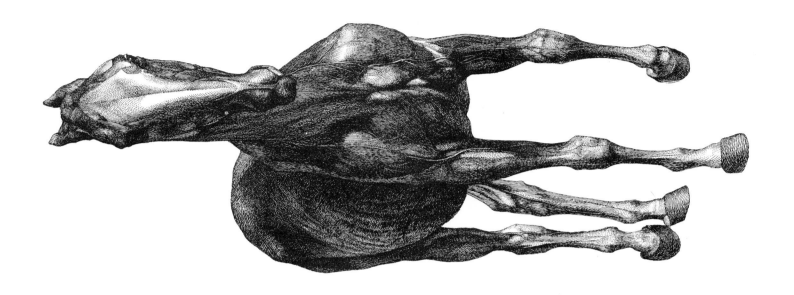

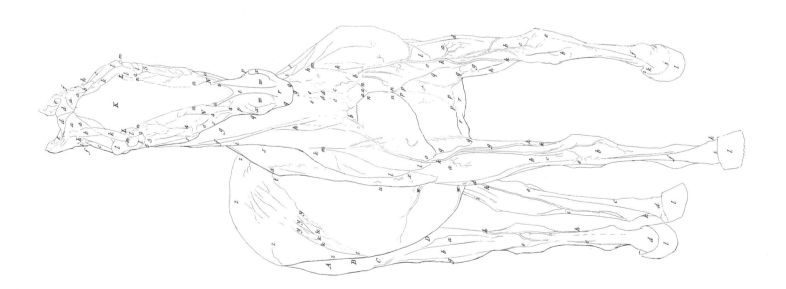

TAB.VII. IV.10

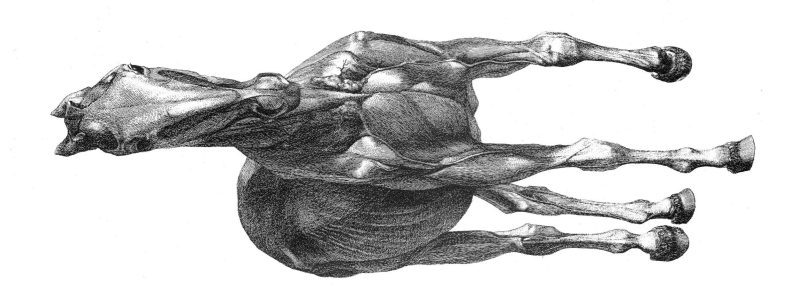

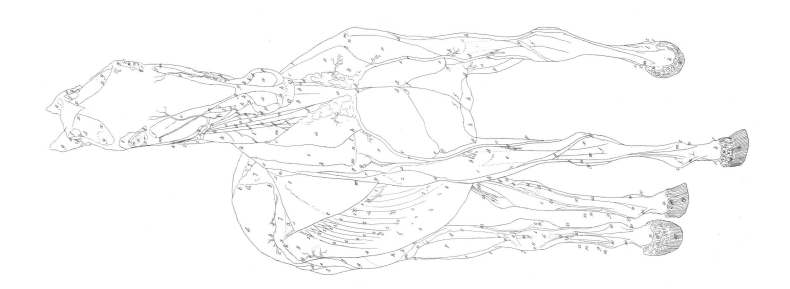

TAB.VIII. IV.11

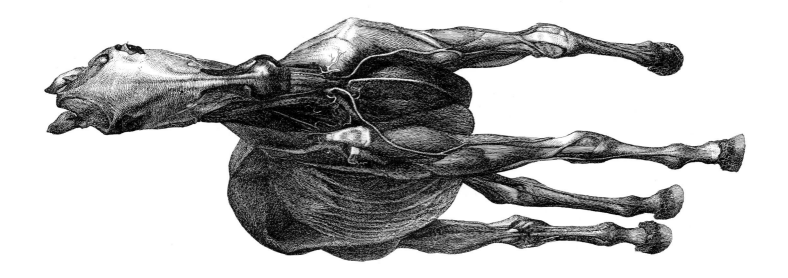

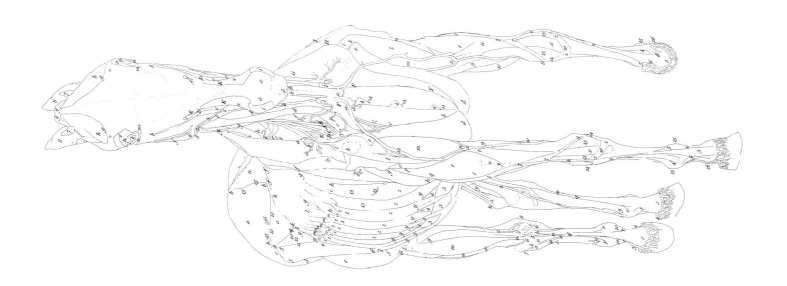

TAB.IX. **IV.12**

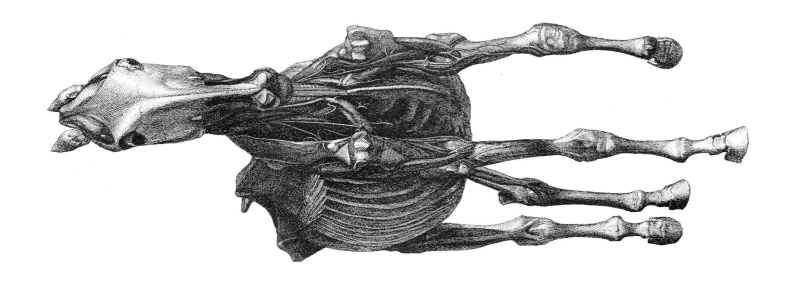

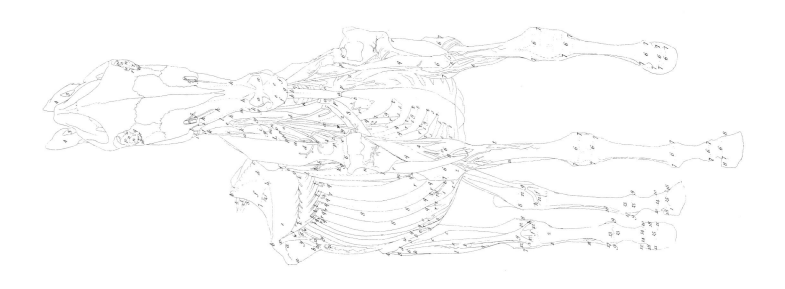

TAB.I IV.13

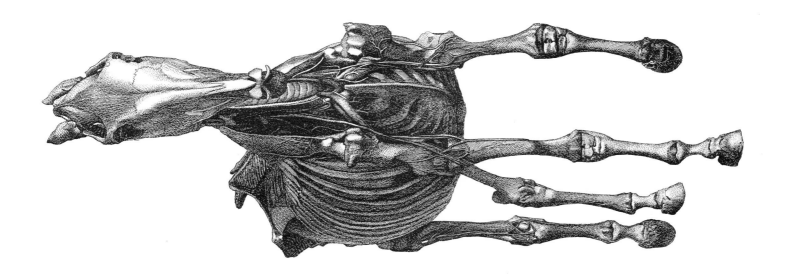

TAB.XI. IV.14

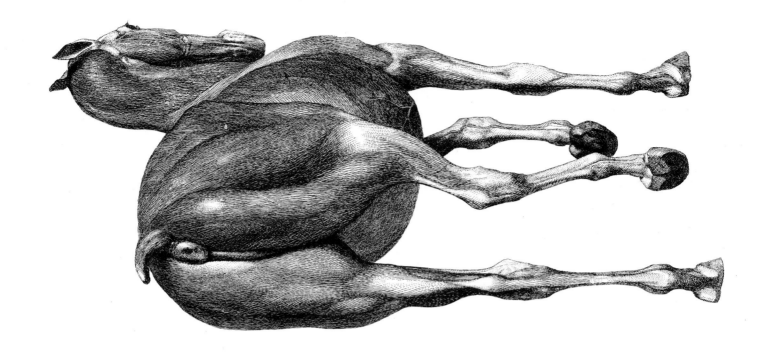

TAB. XII IV.15

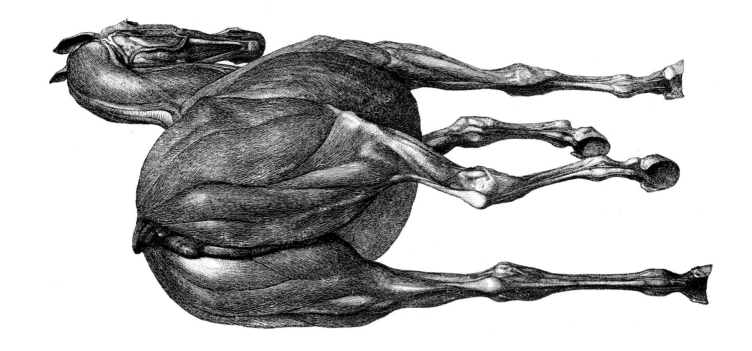

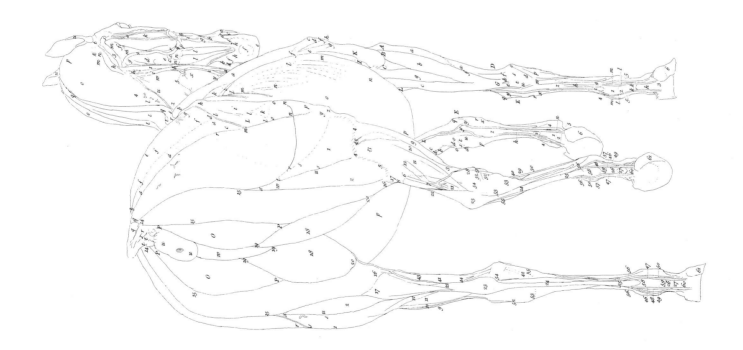

TAB.XIII IV.16

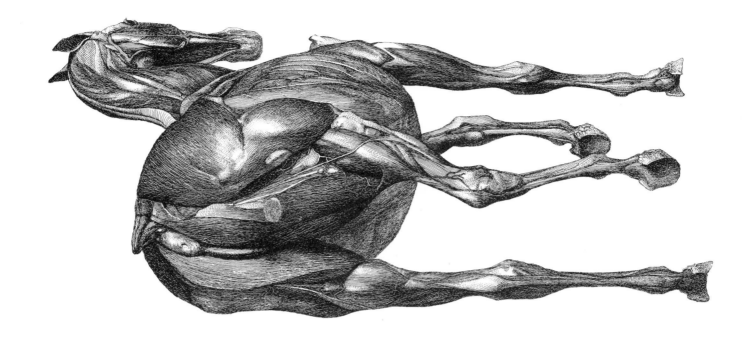

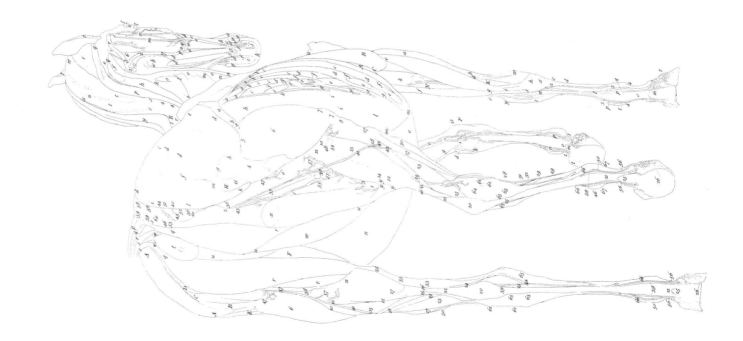

TAB. XIV. IV.17

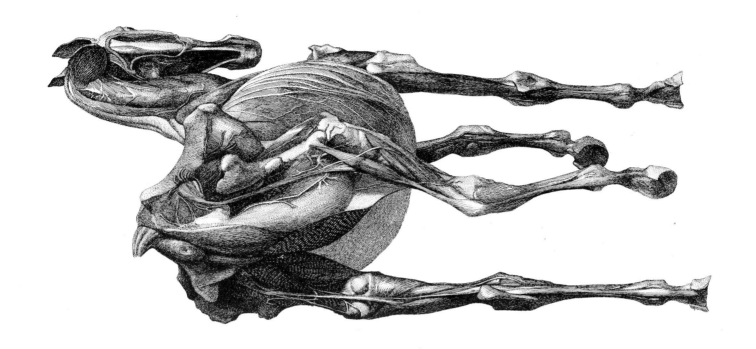

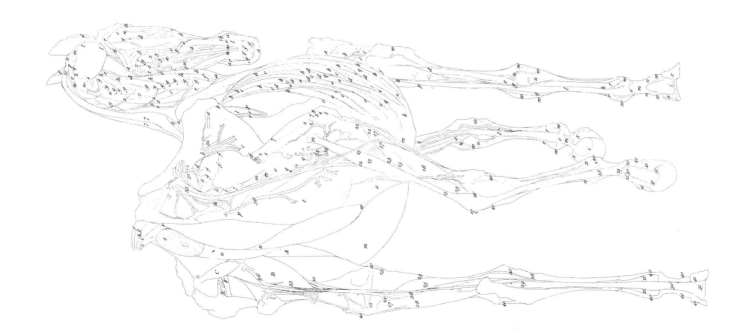

TAB.XV. IV.18

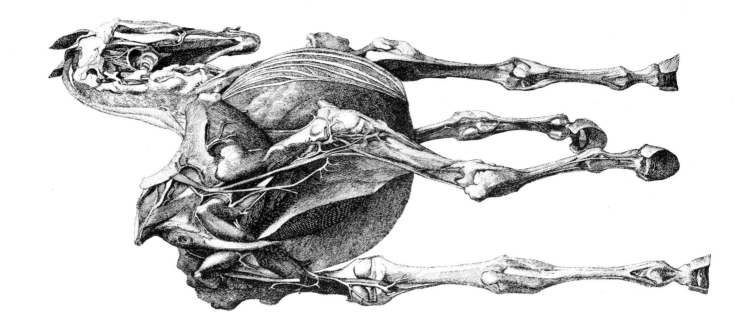

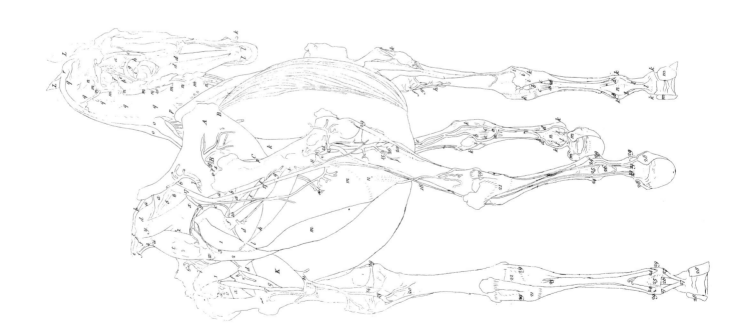

V. Drawings for *A Comparative Anatomical Exposition of the Human Body with that of a Tiger and a Common Fowl*, London, 1804–6

These drawings which exist as a single group in the collection of the Worcester Museum in Massachusetts, U.S.A., show certain similarities with the earlier group of studies Stubbs made for *The Anatomy of the Horse*, and also some important differences. The bulk of these drawings can be related to the fifteen published stipple engravings of the *Comparative Anatomical Exposition* produced during Stubbs's lifetime. This larger group is of finished studies based on a uniform set of skeleton or body outlines and is directly related to the engraved work. Unlike the drawings for *The Anatomy of the Horse* they do not appear to include studies made directly from the dissections Stubbs must have undertaken in preparation for the work. A smaller group of the Worcester drawings are of specimens not illustrated in the published tables. These include another tiger, a large cat which is probably a leopard, a Dorking Hen, an owl, a monkey, and views of the human skeleton—both standing and in a pronograde posture. These drawings may represent further studies for a larger version of the work which, due to Stubbs's death, was never completed. In other cases they may simply be studies made by Stubbs in his general pursuit of anatomy and included with the rest by Mary Spencer when she disposed of the drawings.

NOTES ON THE DRAWINGS

page 122 1. FINISHED STUDY FOR TABLE I
(Arts Council Cat. 3)*

Pencil on cartridge paper, 21¼ × 16 inches.
This is the first of the group of fifteen finished drawings for the engraved tables which were completed and issued. It is a frontal view of the human skeleton, very delicately finished with the most subtle shading.

123 2. FINISHED STUDY FOR TABLE II
(Arts Council Cat. 4)

Pencil on cartridge paper, 21 × 16 inches.
Posterior view of the human skeleton. The thumb and associated wrist bones have been left unmodelled.

124 3. FINISHED STUDY FOR TABLE III
(Arts Council Cat. 6)

Pencil on cartridge paper, 21¼ × 16 inches.
Lateral view of the human skeleton seen from the

left. This differs from the first two drawings in that the skeleton is shown running. The choice of a radically different posture for the lateral view was probably made to enhance the comparison with the two animal skeletons and other anatomies in the series.

4. FINISHED STUDY FOR TABLE IV 125
(Arts Council Cat. 8)

Pencil on cartridge paper, 16 × 21¼ inches.
Lateral view of the skeleton of the tiger viewed from the left. The quality of the modelling varies; on the left hind leg and pelvic girdle the bones are modelled with rather coarse hatching while in other parts such as the scapula individual pencil strokes are indistinguishable.

5. FINISHED STUDY FOR TABLE V 126
(Arts Council Cat. 10)

Pencil on cartridge paper, 20¼ × 16 inches.
Lateral view of the skeleton of a fowl viewed from the left. This is one of the finest of the drawings in the Worcester collection. The complex relationships between the bones of the wing, pectoral girdle, and thorax which result from Stubbs's choice of a drooping position for the wing are rendered with beautiful clarity.

*Numbers in parentheses refer to drawings reproduced in the Art Council's 1958 catalogue: *George Stubbs. Rediscovered Anatomical Drawings*.

V. Drawings for
*A Comparative
Anatomical
Exposition of the
Human Body with
that of a Tiger and a
Common Fowl,*
London, 1804–6

6. FINISHED STUDY FOR TABLE VI
(Arts Council Cat. 11)

Pencil on cartridge paper, $21\frac{1}{4} \times 16$ inches.
Frontal view of the entire human figure. Note the unrhetorical pose chosen by Stubbs. It is obviously drawn from an individual model; no alteration has been made in order to conform to an ideal proportion. The head is noticeably small and the shoulders are sloping. The fingers are held in a slightly extended position.

128 7. FINISHED STUDY FOR TABLE VII
(Arts Council Cat. 12)

Pencil on cartridge paper, $21\frac{1}{2} \times 16$ inches.
Posterior view of the entire human figure. There are very slight alterations in the posture. The arms are held a little more widely and the angle of the hands and feet has been altered to reveal the fingers and toes.

129 8. FINISHED STUDY FOR TABLE VIII
(Arts Council Cat. 12a)

Pencil on cartridge paper, $21\frac{1}{2} \times 16$ inches.
Lateral view of the entire human figure from the left. The drawing has been damaged by rubbing around the lower part of the abdomen and the genitalia.

130 9. FINISHED STUDY FOR TABLE IX
(Arts Council Cat. 13)

Pencil on cartridge paper, 16×21 inches.
Lateral view of the body of the tiger from the left. The skin and superficial connective tissue have been removed exposing the surface muscles and their blood supply. The blood vessels have been emphasised by very fine outline contours. This is the first drawing of the body of the tiger, and Stubbs did not include an earlier stage showing the skin intact.

131 10. FINISHED STUDY FOR TABLE X
(Arts Council Cat. 14)

Pencil on cartridge paper, $21\frac{1}{2} \times 16$ inches.
Lateral view of the body of the fowl from the left. The bird has been plucked except for the tail and the flight feathers, which have been cut leaving the stumps of the quills. The papillae of the plucked feathers can be seen running in tracts on the skin. The swelling at the base of the tail is the preen gland.

132 11. FINISHED STUDY FOR TABLE XI
(Arts Council Cat. 15)

Pencil on cartridge paper, $21\frac{1}{4} \times 16$ inches.
Frontal view of the human body with the skin and superficial connective tissue removed. The forms of main groups of muscles are revealed at this stage and are similar to the traditional écorché figures used in the teaching of anatomy to artists from the Renaissance onwards.

12. FINISHED STUDY FOR TABLE XII 133
(Arts Council Cat. 16)

Pencil on cartridge paper, 21×16 inches.
Posterior view of the human body with the skin and superficial connective tissue removed. This is similar in treatment to the previous drawing. The toes of the left foot are incomplete.

13. FINISHED STUDY FOR TABLE XIII 134
(Arts Council Cat. 17)

Pencil and red chalk on thin paper, $19 \times 15\frac{1}{2}$ inches.
Lateral view of the human body from the right with the skin and superficial connective tissue removed. This drawing does not conform to the others in the series of completed studies. The dimensions are smaller, the media differ—red chalk being used in addition to pencil—and the drawing is on thin paper. However, this is the only finished study of the human body at this stage of dissection in the collection. The posture is simply a reversal of the usual view to the left and was probably done by a reversed tracing. There are similar less complete studies, and Stubbs may have intended this to be traced directly on to a plate for engraving.

14. FINISHED STUDY FOR TABLE XIV 135
(Arts Council Cat. 18)

Pencil on cartridge paper, 16×21 inches.
Lateral view of the body of the tiger from the left, with the connective tissue overlying the muscles removed. The muscles are clearly revealed and the jugular vein running down the side of the neck is exposed. The removal of the connective tissue from the tail has shown the position of the caudal vertebrae.

15. FINISHED STUDY FOR TABLE XV 136
(Arts Council Cat. 20)

Pencil on cartridge paper, $21\frac{1}{2} \times 16$ inches.
Lateral view of the body of the fowl with the skin and superficial tissue removed. The wattles have been cut away from the head and the blood vessels supplying the head, neck, and legs can be seen. The quills of the flight feathers are still in the wings, and the preen gland at the base of the tail can be seen.

Studies for the anatomy of the human body other than those finished for the published tables
There are fifty-one of these drawings, and they can be divided into two major groups. First are draw-

ings which relate to the published plates and show various stages in the preparation of the drawings; as has been said, none of these appears to have been made directly from the dissections. In this first group are twelve studies from the anterior viewpoint, twelve from the posterior, and nineteen from the lateral position. The second major group are drawings of the skeleton in a variety of positions, none of these related to the published plates. They occur in pairs, one of each being a highly finished drawing comparable to those made for the published plates and the other an ink outline of the same pose. In this second set Stubbs makes the comparative exposition clearer, particularly in those drawings which show the skeleton in the pronograde position, where he makes a parallel between the posture of the tiger and that of the human skeleton. The high degree of finish of the pencil studies indicates that these drawings were made with a view to publication.

137 16. STUDY OF THE HUMAN FIGURE,
 ANTERIOR VIEW

Red chalk on thin paper, 20 × 13⅝ inches.
This is an outline drawing for Table VI. A slight amount of modelling is indicated by hatching. The features differ slightly from those of the table.

138 17. STUDY OF THE HUMAN FIGURE,
 ANTERIOR VIEW

Pencil on cartridge paper, 21⅛ × 16 inches.
This is an outline figure over a tracing of the skeleton, in which the skull and vertebral column are only slightly described. Lettering is used to indicate some parts. This drawing is probably related to Table XI.

139 18. HUMAN FIGURE, ANTERIOR VIEW
 (Arts Council Cat. 21)

Pencil on cartridge paper, 21¼ × 16⅛ inches.
This is a finished study showing the connective tissue removed and exposing the upper layers of the muscles and the blood vessels. It is obviously a drawing intended for a plate that was never published.

140 19. HUMAN FIGURE, ANTERIOR VIEW

Pencil and red chalk on cartridge paper,
21 × 15⅞ inches.
This drawing is largely in outline and is similar to the preceding study. The rectus abdominis muscles descending from the sternum to the pubes and the obliquus externus abdominis which support the gut have been carefully modelled in red chalk.

20. HUMAN FIGURE, ANTERIOR VIEW

Pencil on cartridge paper, 21⅛ × 15⅞ inches.
This is an outline drawing of the body and skeleton, the head very faintly indicated, with a very carefully modelled study of the abdominal viscera *in situ* showing the liver, stomach, spleen, and intestines. The bile duct can be seen running from the liver over the pyloric end of the stomach to the duodenum. This drawing is interesting in that it indicates Stubbs's intention to deal with the viscera as well as the muscles and skeleton—a much more detailed exploration of the anatomy than he had attempted in *The Anatomy of the Horse*.

21. HUMAN FIGURE, ANTERIOR VIEW 142
 (Arts Council Cat. 22)

Pencil on cartridge paper, 21¼ × 15⅞ inches.
This is a finished study of the final stage of the dissection of the human body, only a few muscles remain. The kidneys, ureters, and bladder are exposed, and the aorta and posterior vena cava can be seen dividing to form the iliac veins and arteries supplying the legs.

22. HUMAN FIGURE, ANTERIOR VIEW 143

Pencil and ink on cartridge paper,
20⅞ × 16 inches.
An outline figure with the muscles lettered. It relates to the previous drawing and is made for the outline key which would have accompanied the table. The excretory organs which were shown in the previous drawing have been omitted.

23. HUMAN SKELETON, ANTERIOR VIEW 144

Pencil and ink on thin paper, 19 × 13 inches.
This is a numbered and lettered drawing of the skeleton with measured dotted lines linking salient points to establish the proportions. This and the following four drawings are almost identical in character and were probably made by Stubbs in order to firmly establish the basic outline and proportions of the skeleton from the anterior position. This was then used as a framework on which were made the rest of the studies of the skeleton and body from this view.

24. HUMAN SKELETON, ANTERIOR VIEW 145

Pencil on thin paper, 19½ × 14 inches.
Almost identical to the previous study. The outline is slightly less carefully made and the rear part of the rib-cage has been faintly shaded.

25. HUMAN SKELETON, ANTERIOR VIEW

Pencil on thin paper, 19½ × 13⅞ inches.
Another numbered and lettered study of the skeleton, the skull and neck very faint.

26. HUMAN SKELETON, ANTERIOR VIEW
(verso of the above)

This is a study of the skull and cervical vertebrae without key letters.

148 27. HUMAN SKELETON, ANTERIOR VIEW

Pencil and ink on thin paper, 20 × 13½ inches.
This is the final study of the anterior view of the skeleton. The outline of the body has been omitted and it lacks lines of proportion. The sheet has been folded and damaged and then pasted down on a support.

149 28. HUMAN BODY, POSTERIOR VIEW

Ink on thin paper, 19⅛ × 12¾ inches.
This is an outline drawing for Table VII, probably made for the key figure.

150 29. HUMAN FIGURE, POSTERIOR VIEW

Pencil on cartridge paper, 19¾ × 13⅜ inches.
This is almost identical to the finished drawing for Table XII and shows the body with the skin and superficial connective tissue removed. However, the handling of this drawing is rather coarser and more emphatic, and the outlines of the muscle groups and the blood vessels, particularly in the legs, are much heavier than in the finished study.

151 30. HUMAN FIGURE, POSTERIOR VIEW

Red chalk on cartridge paper, 21 × 13¼ inches.
This is an outline drawing for the key figure to Table XII, although it lacks the numbers and letters.

152 31. HUMAN FIGURE, POSTERIOR VIEW

Pencil on cartridge paper, 21⅛ × 16 inches.
Another outline drawing for the key figure to Table XII. In this case the numbers and letters of the parts have been added. One slight difference is the indication of the neural crests of the vertebrae and an extremely faint outline of the skeleton below the muscles.

153 32. HUMAN FIGURE, POSTERIOR VIEW

Pencil and ink on thin paper, 19¼ × 13 inches.
A further study for Table XII. Although the neural crests are shown, the underlying skeleton is absent.

33. HUMAN FIGURE, POSTERIOR VIEW 154
(Arts Council Cat. 23, Plate II)

Pencil on cartridge paper, 21⅜ × 16 inches.
This is a finished study for an unpublished plate. The upper layers of muscles have been dissected, most obviously in the areas of the shoulders and buttocks.

34. HUMAN FIGURE, POSTERIOR VIEW 155

Pencil on cartridge paper, 21⅛ × 15⅞ inches.
This is an outline drawing for the key figure of an unpublished plate. There is no modelled drawing related to this outline. It is close to the previous study, although dissection has been carried further into the deeper layers of muscles, and the blood supply to the limbs is indicated.

35. HUMAN FIGURE, POSTERIOR VIEW 156

Pencil on thin paper, 19⅞ × 14 inches.
An outline drawing for a key figure showing the final stage of dissection of the body from the posterior. Again, no modelled drawing of this stage of dissection survives. Scarcely any muscles remain, and only the blood supply to the legs is shown.

36. HUMAN FIGURE, POSTERIOR VIEW 157

Pencil on cartridge paper, 21⅛ × 16 inches.
This is a partly lettered and numbered drawing of the skeleton. The outline of the figure has been left unfinished round the bones of the hands.

37. HUMAN SKELETON, POSTERIOR VIEW 158

Ink on thin paper, 18⅞ × 12½ inches.
This is a carefully drawn outline of the skeleton, numbered and lettered with measured lines of proportion from the salient points of the skeleton. It relates to Table II.

38. HUMAN SKELETON, POSTERIOR VIEW 159

Pencil on cartridge paper, 18⅞ × 14¾ inches.
This drawing is almost identical to the previous study. Extra numbering has been added to the feet, and lines of proportion to the skull. This, like other drawings of the skeleton in the series, was probably an early study on which the proportions of the skeleton were established for the drawings of the muscles.

39. HUMAN SKELETON, POSTERIOR VIEW 160

Pencil on thin paper, 18⅞ × 10½ inches.
A numbered and lettered outline of the skeleton, folded and later pasted down on a support. Perhaps the first of the studies of the skeleton.

161 40. HUMAN FIGURE, LATERAL VIEW
 (Arts Council Cat. 30)

Pencil on cartridge paper, 21⅜ × 16 inches.
This drawing is a preliminary draft for the final study for Table VIII. There are slight differences in the expression of the face and the arrangement of the hair. It shows Stubbs's method of first indicating the general disposition of the forms by rather rough hatching, which was then presumably worked over and refined.

162 41. HUMAN FIGURE, LATERAL VIEW

Ink on thin paper, 19⅝ × 14¼ inches.
This is an outline study in reverse of Table VIII, probably prepared for transfer to a plate to be used for the key figure to the table.

163 42. HUMAN FIGURE, LATERAL VIEW

Pencil on cartridge paper, 21 × 16 inches.
A lettered and numbered drawing of the muscles for the key figure to Table XIII. This is in the position of the published table, whereas the finished drawing for the same plate is in reverse.

164 43. HUMAN FIGURE, LATERAL VIEW
 (Arts Council Cat. 24)

Pencil on cartridge paper, 21⅜ × 16 inches.
This is almost identical to the previous drawing. It lacks numbers and letters, the hatching over the abdomen is slightly coarser, and some of the muscles are drawn in greater detail.

165 44. HUMAN FIGURE, LATERAL VIEW

Pencil on thin paper, 19 × 15¾ inches.
This is related to Table XIII and is a detailed study of the blood vessels supplying the muscles, which are particularly prominent in the head, thorax, back, abdomen, and arms.

166 45. HUMAN FIGURE, LATERAL VIEW

Ink on thin paper, 18¼ × 15¼ inches.
This is a reversed variant of the previous drawing, and was prepared for transfer to the plate of the key figure to Table XIII.

167 46. HUMAN FIGURE, LATERAL VIEW
 (Arts Council Cat. 24)

Pencil on cartridge paper, 21¼ × 16 inches.
This is a finished study for an unpublished table and represents the last stage in the dissection. Only a few muscles in the limbs and thorax remain. The kidneys and bladder have been left, together with the main blood vessels to the legs.

47. HUMAN FIGURE, LATERAL VIEW

Pencil on cartridge paper, 21⅛ × 16 inches.
This is a numbered and lettered outline study for the key figure to the previous drawing. There are very slight differences: the cartilages of the nose, larynx, and trachea, as in the drawing have been included.

48. HUMAN SKELETON, LATERAL VIEW

Pencil and ink on thin paper, 21⅜ × 16 inches.
This is a study for a key figure to an unpublished table showing the abdominal viscera, which have been lettered. No drawing related to this key figure survives.

49. HUMAN SKELETON, LATERAL VIEW

Pencil and red chalk on cartridge paper, 21¼ × 16 inches.
This may be related to the previous drawing. The outline of the abdominal muscles is clearly indicated and there are fainter outlines of the genital organs and the muscles of the right leg.

50. HUMAN SKELETON, LATERAL VIEW

Pencil on cartridge paper, 21¾ × 16 inches.
This highly finished drawing is very close to the final study for Table III but differs in detail. The skull is longer and the cranial sutures more clearly indicated. The proportions of the rib-cage and pelvic girdle are different, and the hatching used to model the form of the bones is rather more emphatic. It is difficult to see why Stubbs prepared this drawing to such an advanced state; he may have rejected it as a model for engraving because he was dissatisfied with the general proportions.

51. HUMAN SKELETON, LATERAL VIEW

Pencil on thin paper, 18 × 14½ inches.
This is a numbered and lettered outline of the skeleton for the key figure to Table III. It has been squared—possibly for transfer to a plate—and subsequently pasted down on a support.

52. HUMAN SKELETON, LATERAL VIEW

Pencil on cartridge paper, 21⅜ × 16 inches.
A numbered and lettered drawing of the skeleton with the measurements of the bones and lines of proportion linking the salient points. This study was probably used as the basis for the other skeleton drawings and figure outlines that were used.

V. Drawings for *A Comparative Anatomical Exposition of the Human Body with that of a Tiger and a Common Fowl*, London, 1804–6

169

170

171

172

173

V. Drawings for
A Comparative Anatomical Exposition of the Human Body with that of a Tiger and a Common Fowl, London, 1804–6

53. HUMAN SKELETON, LATERAL VIEW

Ink on thin paper, $17\frac{3}{4} \times 14$ inches.
This is similar to the previous drawing; the outline of the body has been added as a dotted line and the line of proportion in front of the skull omitted.

54. HUMAN SKELETON, LATERAL VIEW

Pencil on cartridge paper, $18\frac{7}{8} \times 14\frac{3}{4}$ inches.
Apart from the different medium and some alterations in the numbers and letters, this is identical to the previous drawing.

176 55. HUMAN SKELETON, LATERAL VIEW

Ink on thin paper, $16\frac{1}{4} \times 10\frac{5}{8}$ inches.
This is a rather coarsely drawn study of the skeleton with some numbers and letters. It has been squared and pasted down on a support.

177 56. HUMAN SKELETON, LATERAL VIEW

Pencil on cartridge paper, $19 \times 14\frac{7}{8}$ inches.
This is an unadorned outline of the skeleton and may have been initially prepared for use as a key figure to Table III but later abandoned. The beautiful clarity of its line gives an excellent demonstration of Stubbs's powers as a draughtsman.

178 57. HUMAN FIGURE, LATERAL VIEW

Ink on cartridge paper, 21×16 inches.
This and the following drawing are difficult to place. Both the continuous outline of the figure and the dotted outline of the skeleton within its boundary are given equal prominence. It is possible that this was an early study, made by Stubbs to establish the outlines of the figure in relation to the skeleton as a basis for the subsequent detailed drawings of the anatomy from the lateral view.

179 58. HUMAN FIGURE, LATERAL VIEW

Pencil on thin paper, $19\frac{5}{8} \times 15\frac{5}{8}$ inches.
Although much fainter, this is almost identical to the previous drawing—the major difference being the head, where the bones of the skull have been left out and the hair lacks definition.

180 59. HUMAN SKELETON, ANTERIOR VIEW
(Arts Council Cat. 35)

Pencil on cartridge paper, $17\frac{3}{4} \times 11$ inches.
This is a finished study for an unpublished table and is the first of eight drawings which Stubbs made introducing different postures into the human skeleton to emphasise the comparison between the human body and that of the tiger and the fowl. The posture in this and the similar posterior view is typical of the stance adopted in teaching academies

and is also reminiscent of some of the plates in Albinus's anatomy of the human body.

60. HUMAN SKELETON, ANTERIOR VIEW 181

Ink on thin paper, $17\frac{1}{4} \times 10\frac{3}{4}$ inches.
This is identical to the previous drawing, although the box on which the right leg is resting is more clearly indicated.

61. HUMAN SKELETON, POSTERIOR VIEW 182

Pencil on cartridge paper, $17\frac{7}{8} \times 11$ inches.
This is a finished study for an unpublished table, identical in posture to the first two drawings.

62. HUMAN SKELETON, POSTERIOR VIEW 183

Ink on thin paper, $17\frac{1}{4} \times 10\frac{1}{4}$ inches.
Identical to the previous drawing except for the difference in the medium employed. The modelling of the bones has been reduced to a minimum.

63. HUMAN SKELETON, LATERAL VIEW 184
(Arts Council Cat. 39)

Pencil on thin paper, $11 \times 17\frac{5}{8}$ inches.
This is a finished study for an unpublished table. It shows the human skeleton crawling forward in a pronograde position. This and the companion pair of studies showing the skeleton crouching are the most original drawings Stubbs made for the *Comparative Anatomical Exposition*. They make an explicit comparison between man and the tiger and are the earliest known drawings which show such a direct comparison. In a sense they imply an evolutionary relationship.

64. HUMAN SKELETON, LATERAL VIEW 185
(Arts Council Cat. 38, Fig. P.4)

Ink on thin paper, $10\frac{1}{2} \times 17\frac{1}{8}$ inches.
This is identical to the previous drawing.

65. HUMAN SKELETON, LATERAL VIEW 186
(Arts Council Cat. 37)

Pencil on cartridge paper, $17\frac{1}{2} \times 11\frac{1}{8}$ inches.
This is a finished study for an unpublished table and shows the human skeleton crouching in a pronograde posture. The neck is bent back to hold the head so that it faces forwards.

66. HUMAN SKELETON, LATERAL VIEW 187
(Arts Council Cat. 36)

Ink on thin paper, $16\frac{3}{4} \times 9\frac{7}{8}$ inches.
This is close to, but not absolutely identical with, the previous drawing. There are slight variations in the outline of the bones, particularly in the region of the pelvic girdle.

V. Drawings for
*A Comparative
Anatomical
Exposition of the
Human Body with
that of a Tiger and a
Common Fowl,*
London, 1804–6

*Studies of the anatomy of the tiger other than those
finished for the published tables*

There are thirty-five drawings of large cats, most of
which are of tigers, though there is a small group of
another animal, most probably a leopard. The
drawings can be divided into five distinct groups.
The first of eighteen are related to the published
tables; the second—a group of nine—are of a
different tiger, a slightly larger animal, though in
the same posture as the first, the third group of five
drawings is of another large cat, probably a leopard,
which is shown running rather than walking as in
the previous groups. The fourth group of two,
almost identical, drawings shows a tiger lying on its
side with the ventral surface exposed and the left
leg raised in the air. The final group is a single
drawing of a standing tiger in the same posture as a
man.

188 67. TIGER SKELETON, LATERAL VIEW

Pencil on cartridge paper, 16 × 21¼ inches.
This is a highly finished study for Table IV. It has
the same dimensions as the final drawing for the
table and is almost identical in quality, differing
only in the depth of shading of the bones.

189 68. TIGER SKELETON, LATERAL VIEW

Pencil on cartridge paper, 15 × 19⅞ inches.
This and the following drawing are identical
outlines of the skeleton and may have been made
for use in preparing studies of the muscles or as the
key figure to Table IV.

190 69. TIGER SKELETON, LATERAL VIEW

Pencil on cartridge paper, 16 × 21 inches.
Identical, except in dimensions and minor points of
handling, to the previous drawing.

191 70. TIGER SKELETON, LATERAL VIEW
 (Arts Council Cat. 31)

Ink and pencil on thin paper, 15 × 20¼ inches.
This is a numbered and lettered study for the key
figure to Table IV.

192 71. TIGER SKELETON, LATERAL VIEW
 (Arts Council Cat. 40)

Ink over red chalk on thin paper, 9⅝ × 14⅝ inches.
Although similar in appearance to the other outline
skeleton drawings, this drawing is smaller in overall
proportions and shows considerable differences in
all the minor details. The drawing is very faintly
squared.

72. TIGER SKELETON, LATERAL VIEW

Pencil on cartridge paper, 14½ × 19⅞ inches.
This is a carefully measured study of the skeleton
with the salient points of the skeleton joined by
measured lines and the contours of the body
indicated by a dotted outline. This was probably
the master study of the skeleton which established
the proportions used in the other drawings of the
tiger.

73. TIGER SKELETON, LATERAL VIEW 194

Ink on thin paper, 12¾ × 19½ inches.
A reversed version of the previous study with the
numbers and letters omitted.

74. TIGER BODY, LATERAL VIEW 195

Pencil on thin paper, 15⅞ × 21 inches.
A careful outline study of the surface blood supply.
Prepared for the key figure to Table IX, it is close to
the final drawing for the table but shows the blood
vessels in even finer detail.

75. TIGER BODY, LATERAL VIEW 196

Pencil on cartridge paper, 15⅞ × 21⅛ inches.
This is a numbered and lettered study of the muscles
for the key figure to Table IX.

76. TIGER BODY, LATERAL VIEW 197

Pencil on cartridge paper, 16 × 21 inches.
A numbered and lettered study of the upper layers
of muscles and their blood supply prepared for the
key figure to Table XIV.

77. TIGER BODY, LATERAL VIEW 198

Pencil on cartridge paper, 15¾ × 20⅞ inches.
A careful outline drawing similar to the previous
study for Table XIV.

78. TIGER BODY, LATERAL VIEW 199

Pencil and ink on thin paper, 14 × 20¾ inches.
This is identical to the previous drawing, but in
reverse, and was probably prepared for transfer to
a plate for engraving.

79. TIGER BODY, LATERAL VIEW 200
 (Arts Council Cat. 25)

Pencil on cartridge paper, 16 × 21¼ inches.
This is a finished drawing for an unpublished table.
It shows the third stage in dissection with the surface
muscles removed to expose deeper layers. The bones
of the skull, pectoral girdle, and fore legs are also
exposed.

V. Drawings for
*A Comparative
Anatomical
Exposition of the
Human Body with
that of a Tiger and a
Common Fowl,*
London, 1804–6

80. TIGER BODY, LATERAL VIEW

Pencil on cartridge paper, 16 × 21⅛ inches.
This is the numbered and lettered outline study for the key figure to the previous drawing.

81. TIGER BODY, LATERAL VIEW
(Arts Council Cat. 26)

Pencil on cartridge paper, 16 × 21⅛ inches.
An unadorned outline drawing of the third stage of the dissection of the tiger, comparable to the two preceding studies.

203 82. TIGER BODY, LATERAL VIEW

Pencil on cartridge paper, 16 × 21¼ inches.
This is a study for an unpublished table and shows a late stage in dissection. The abdominal viscera have been exposed and can be seen *in situ*. Stubbs seems to have gone over the outlines of some of the bones, notably the ribs and femurs.

204 83. TIGER BODY, LATERAL VIEW

Pencil on cartridge paper, 16 × 21⅛ inches.
A numbered and lettered outline drawing for the key figure to the previous study.

205 84. TIGER BODY, LATERAL VIEW

Pencil on cartridge paper, 15¾ × 21⅛ inches.
An unadorned outline drawing similar to the two previous studies.

206 85. TIGER BODY, LATERAL VIEW
(Arts Council Cat. 42)

Pencil on laid paper, 9 × 12⅞ inches.
This is the first of nine drawings of another specimen of tiger. It is slightly heavier in build than the animal Stubbs used in the tables and the position of the head is different, although the overall attitude of the body is the same. This study shows the skin removed.

207 86. TIGER BODY, LATERAL VIEW
(Arts Council Cat. 43)

Red chalk and ink on thin paper, 10 × 14¾ inches.
This is similar to the previous drawing, but has been much more highly wrought. The relief of the muscles has been accentuated by ink shading in a system of dots and short, hatched lines.

208 87. TIGER BODY, LATERAL VIEW

Red chalk on thin paper, 10¼ × 13¾ inches.
This is a numbered and lettered study of the surface muscles exposed by the removal of the superficial connective tissue. It has been squared, possibly for transfer.

88. TIGER BODY, LATERAL VIEW 209

Ink on thin paper, 15⅞ × 21¼ inches.
This is an outline study of the surface muscles and their blood supply and was probably made for a key figure.

89. TIGER BODY, LATERAL VIEW 210

Red chalk on thin paper, 10⅝ × 14⅜ inches.
This drawing shows the third stage in dissection, some of the surface muscles have been removed, chiefly in the neck and shoulders. The quality of the line is rather tentative, except in the feet where the artist seems to have reinforced and clarified the outline.

90. TIGER BODY, LATERAL VIEW 211

Ink on thin paper, 15½ × 21 inches.
This is an outline drawing similar to the previous study, but giving a much clearer definition of the muscles and probably made as the basis for a key figure.

91. TIGER BODY, LATERAL VIEW 212

Red chalk on thin paper, 9¼ × 12¼ inches.
This is a numbered and lettered study of the muscles exposed at the third stage of dissection and has been squared for transfer.

92. TIGER BODY, LATERAL VIEW 213

Red chalk on thin paper, 10¼ × 13⅛ inches.
A study of the fourth stage of dissection showing the deeper muscles, the scapula has been exposed. The drawing has been numbered and lettered and squared, the squares also being numbered for reference.

93. TIGER BODY, LATERAL VIEW 214

Ink on thin paper, 16 × 21⅛ inches.
An outline drawing identical to the previous study, prepared for a key figure.

94. LEOPARD BODY, LATERAL VIEW 215
(Arts Council Cat. 44, Plate IV)

Red chalk and pencil on thin paper, 9¾ × 13¾ inches.
This is the first of five studies of another large cat. It is generally more slender in proportion than the previous animals depicted. This is particularly noticeable in the structure of the skull, which suggests that it is probably a leopard rather than a tiger. It has been drawn as if running, a much more active attitude than Stubbs used for the other studies. In this respect it is closer to the lateral views of the human figure, which is also shown running. This drawing shows the animal with the skin removed.

216 95. LEOPARD BODY, LATERAL VIEW

Red chalk on thin paper, 9¾ × 13⅞ inches.
This is almost identical to the previous study, but
the handling is harder and more incisive. Although
this makes the outlines of the muscles clearer, some
loss of quality is apparent. The outline of the skull
round the nose and jaws can be seen.

217 96. LEOPARD BODY, LATERAL VIEW

Red chalk on thin paper, 9 × 14⅛ inches.
A numbered and lettered study identical to the
previous two drawings but with only the most
cursory modelling.

218 97. LEOPARD BODY, LATERAL VIEW

Ink over red chalk on thin paper, 10⅛ × 15¾ inches.
This drawing shows a later stage in dissection: the
superficial connective tissue has been removed and
the ears taken off. It shows clearly the proportions
of the skull, which is shorter and more rounded than
that of the tiger.

219 98. LEOPARD BODY, LATERAL VIEW
 (Arts Council Cat. 45)

Ink over red chalk on thin paper, 9⅛ × 12¼ inches.
This shows the same stage in dissection as the
previous study, but is unique among the series of
lateral views in that it has been drawn from a three-
quarters position, rather than strictly laterally, and
enhances the impression of movement. The choice
of this aspect is puzzling since Stubbs made no
attempt to use it in any of the published tables of the
tiger. It is possible that these studies of the leopard
were produced before work on the *Comparative
Anatomical Exposition* was begun and are part of
Stubbs's experiments with various viewpoints.

220 99. TIGER BODY, RECUMBENT, VIEWED
 VENTRALLY (Arts Council Cat. 53)

Pencil on thin paper, 9 × 12⅜ inches.
This and the following, almost identical, drawing
are the only studies of an animal in this position. The
dissection is quite advanced and the position of
right fore and hind limbs, which are both stretched,
displays the muscles.

221 100. TIGER BODY, RECUMBENT, VIEWED
 VENTRALLY

Pencil and red chalk on thin paper, 9¼ × 13⅓ inches.
Apart from the addition of red chalk and a rather
hard quality of line, this is identical to the previous
drawing. The more incisive line clarifies the
structure of the abdominal muscles and feet.

101. TIGER BODY, STANDING IN HUMAN
 POSTURE (Arts Council Cat. 52)

Pencil on thin paper, 10¾ × 9½ inches.
This rather rough sketch is of great interest since it
is the most explicit attempt made by Stubbs to draw
a parallel between the tiger and the human body.

*Studies of the anatomy of the fowl other than those finished
for the published tables*
There are twenty-two of these drawings which fall
into two groups. The first group of seventeen
drawings depicts a cockerel and is directly related
to the three published tables. The second group of
five drawings is of a Dorking Hen. These are on a
slightly smaller scale and are in some respects
comparable to the studies of the leopard in the
previous group of drawings.

102. FOWL SKELETON, LATERAL VIEW 223

Pencil on thin paper, 19 × 13⅜ inches.
This is an outline drawing of the skeleton prepared
for the key figure to Table V.

103. FOWL SKELETON, LATERAL VIEW 224

Ink and pencil on thin paper, 20 × 14½ inches.
This is a numbered and lettered study for the key
figure to Table V. Although close to the previous
drawing, there is a considerable clarification of fine
detail and some modelling and shading of the bones
has been inked in in a simple linear style.

104. FOWL SKELETON, LATERAL VIEW 225

Pencil on thin paper, 20⅜ × 13⅞ inches.
This is a carefully measured study of the skeleton,
with salient points drawn and measured and the
outline of the body showed by a dotted line. This is
probably the basic study of the proportions of the
fowl skeleton used for the preparation of the other
drawings.

105. FOWL SKELETON, LATERAL VIEW 226

Pencil on thin paper, 20½ × 14¼ inches.
This is identical to the previous drawing. There are
signs of rubbing on the cervical vertebrae.

106. FOWL SKELETON, LATERAL VIEW 227

Pencil on thin paper, 20¼ × 14⅜ inches.
An outline drawing of the skeleton, probably made
for further additions.

107. FOWL SKELETON, LATERAL VIEW 228

Pencil on thin paper, 20¼ × 15½ inches.
Identical to the previous drawing, apart from the
most minor details of shading.

V. Drawings for
*A Comparative
Anatomical
Exposition of the
Human Body with
that of a Tiger and a
Common Fowl,*
London, 1804–6

V. Drawings for
*A Comparative
Anatomical
Exposition of the
Human Body with
that of a Tiger and a
Common Fowl,*
London, 1804–6

108. FOWL SKELETON, LATERAL VIEW

Pencil on thin paper, 20⅝ × 14¾ inches.
Another outline drawing of the skeleton, with the addition of a dotted contour showing the body of the fowl.

109. FOWL SKELETON, LATERAL VIEW

Pencil on thin paper, 20¼ × 15½ inches.
Similar to the previous study. The rendering of the skeleton and body outlines have been reversed, the former now dotted while the latter is a continuous line.

231 110. FOWL BODY, LATERAL VIEW

Ink on thin paper, 21 × 15⅛ inches.
A numbered and lettered study of the plucked fowl, prepared for the key figure to Table X.

232 111. FOWL BODY, LATERAL VIEW

Pencil on thin paper, 20¼ × 14 inches.
Identical to the previous drawing but reversed and the numbers and letters omitted. This was probably prepared for transfer to the plate for engraving the key figure to Table X.

233 112. FOWL BODY, LATERAL VIEW

Pencil on thin paper, 20 × 15 inches.
This is a study related in reverse to the finished drawing for Table XV. It is unlike the other drawings in the group in the quality of its handling and was probably prepared for transfer to the plate for the engraving of Table XV. It shows the skin and superficial connective tissue removed.

234 113. FOWL BODY, LATERAL VIEW

Pencil on thin paper, 20⅜ × 15½ inches.
This is a numbered and lettered study for the key figure to Table XV. Although close to the previous drawing, some details of the blood vessels, particularly in the legs and neck, have been clarified by further dissection.

235 114. FOWL BODY, LATERAL VIEW

Pencil on thin paper, 20¾ × 15 inches.
An outline drawing of the body and skeleton, with a detailed study of the blood vessels, which are particularly elaborate over the neck and crop. This drawing shows how Stubbs used the outlines he had prepared for the addition of details of particular anatomical features. Like the three previous drawings, it is related to Table XV.

115. FOWL BODY, LATERAL VIEW 236
(Arts Council Cat. 27, Plate III)

Pencil on cartridge paper, 21¼ × 16 inches.
A highly finished study for an unpublished table. It shows the last stage in dissection. Almost all the muscles have been removed, and the abdominal viscera are exposed within the body cavity.

116. FOWL BODY, LATERAL VIEW 237

Pencil on thin paper, 21⅛ × 16 inches.
A numbered, lettered, and annotated drawing for a key figure to the previous drawing. Stubbs has only labelled the muscles and blood vessels. The viscera which were shown in the previous drawing have been omitted.

117. FOWL BODY, LATERAL VIEW 238

Pencil on thin paper, 21⅛ × 15⅞ inches.
An outline of the skeleton, with the adductor muscles from the pelvic girdle to the femur, together with their blood vessels drawn and lettered. It is related to the previous three drawings.

118. FOWL HEAD AND NECK, LATERAL VIEW 239
(Arts Council Cat. 51)

Pencil and ink on thin paper, 10⅛ × 8⅛ inches.
This is much larger in scale than the other drawings, although the overall dimensions of the paper are smaller. It is a study of the muscles of the throat and larynx, and these have been annotated in Stubbs's hand.

119. DORKING HEN SKELETON, 240
LATERAL VIEW (Arts Council Cat. 48)

Pencil on cartridge paper, 11 × 15½ inches.
A finished study for an unpublished table. This breed of hen is anatomically interesting since it shows the condition known as hyperdactyly, in which extra digits are formed. In this particular instance there is an additional toe on the right foot.

120. DORKING HEN SKELETON, 241
LATERAL VIEW
(Arts Council Cat. 47, Fig. P.2)

Ink and pencil on thin paper, 10½ × 12½ inches.
An outline drawing of the skeleton close to the previous study. It has been numbered and lettered, and the contour of the neck muscles have been drawn very faintly in pencil. Probably prepared for an unpublished key figure.

121. DORKING HEN BODY, LATERAL VIEW 242
(Arts Council Cat. 50)

Red chalk and pencil on thin paper, 14 × 10⅜ inches.
The hen with skin and superficial connective tissues removed. The first toe of the left foot has been rubbed and is almost invisible.

243 122. DORKING HEN BODY, LATERAL VIEW
 (Arts Council Cat. 49)

Ink, pencil, and red chalk on thin paper,
10⅛ × 12⅝ inches.
This outline drawing of the muscles is related to the
previous study. Many of the muscles have been
named in Stubbs's hand. In the top right-hand
corner of the paper can be seen a very faint outline
of the bird viewed from above.

244 123. DORKING HEN BODY, LATERAL VIEW

Pencil on thin paper, 10½ × 12⅝ inches.
A study of the muscles of the body and limbs at a
later stage of dissection. They have been numbered
and lettered.

Drawings not directly related to the Comparative
Anatomical Exposition.
There are three of these drawings—two almost
identical ones of an owl and one of some species of
monkey. The animals depicted are shown standing
upright, and in this respect are comparable to the
drawing of the standing tiger and the standing
human figure. As in the drawing of the tiger, here
Stubbs's interest to make a comparison with the
human posture is evident.

245 124. OWL STANDING, ANTERIOR VIEW
 (Arts Council Cat. 54, Plate I)

Pencil on thin paper, 15⅜ × 10⅝ inches.
A delicate study of a partly plucked owl, shown
standing with its wings folded back. It bears a
resemblance to the plate of a skeleton of a bird
published by Belon in his *L'Histoire de la Nature des
Oyseaux* in 1555, where the bird is directly compared
with a human skeleton, the first such printed
comparison.

125. OWL STANDING, ANTERIOR VIEW

Pencil on thin paper, 14¾ × 9⅞ inches.
This is close to the other study of an owl, but is much
more poorly drawn, the bird being rendered
schematically. The head in particular seems to be
that of a hen rather than an owl.

126. MONKEY STANDING, ANTERIOR VIEW
 (Arts Council Cat. 55)

Ink on laid paper, 11¼ × 13¼ inches.
This is curiously unlike any of the other drawings.
The animal has been identified as the Barbary
Ape, but this is far from certain. It seems to have
been mummified and the skull partly dissected. It is
difficult to tell whether Stubbs intended the ink
hatching to indicate the fur or simply to model
the forms of the muscles. The posture is obviously
intended to be compared with that of man.

V. Drawings for
*A Comparative
Anatomical
Exposition of the
Human Body with
that of a Tiger and a
Common Fowl*,
London, 1804–6

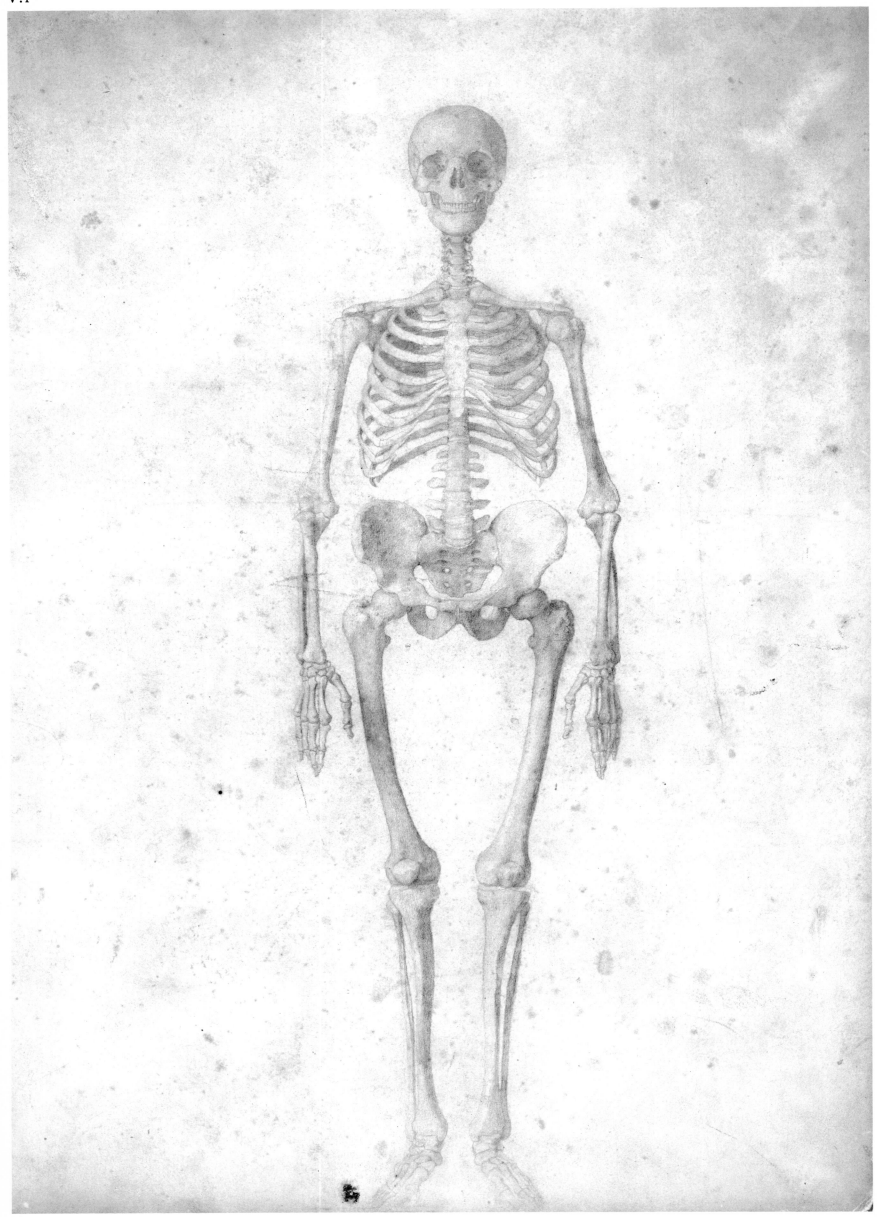

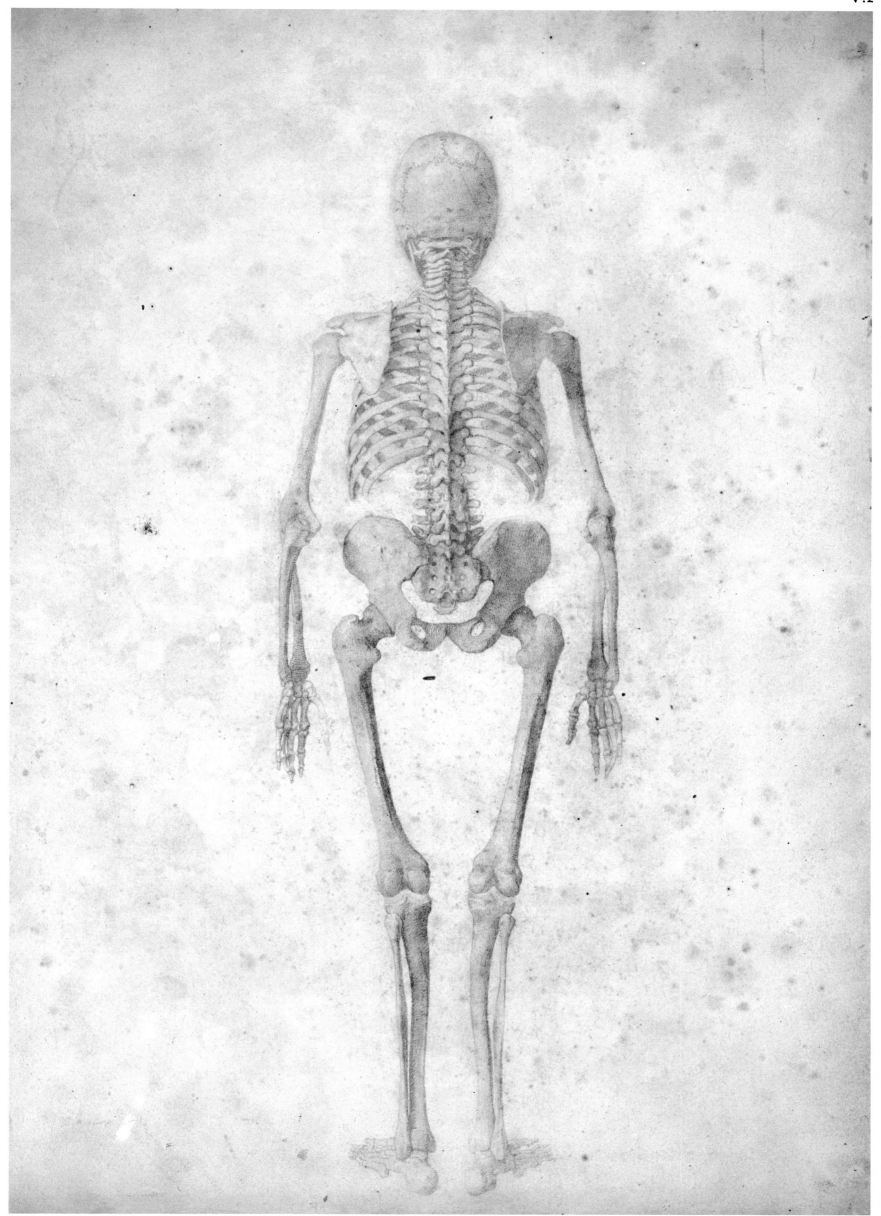

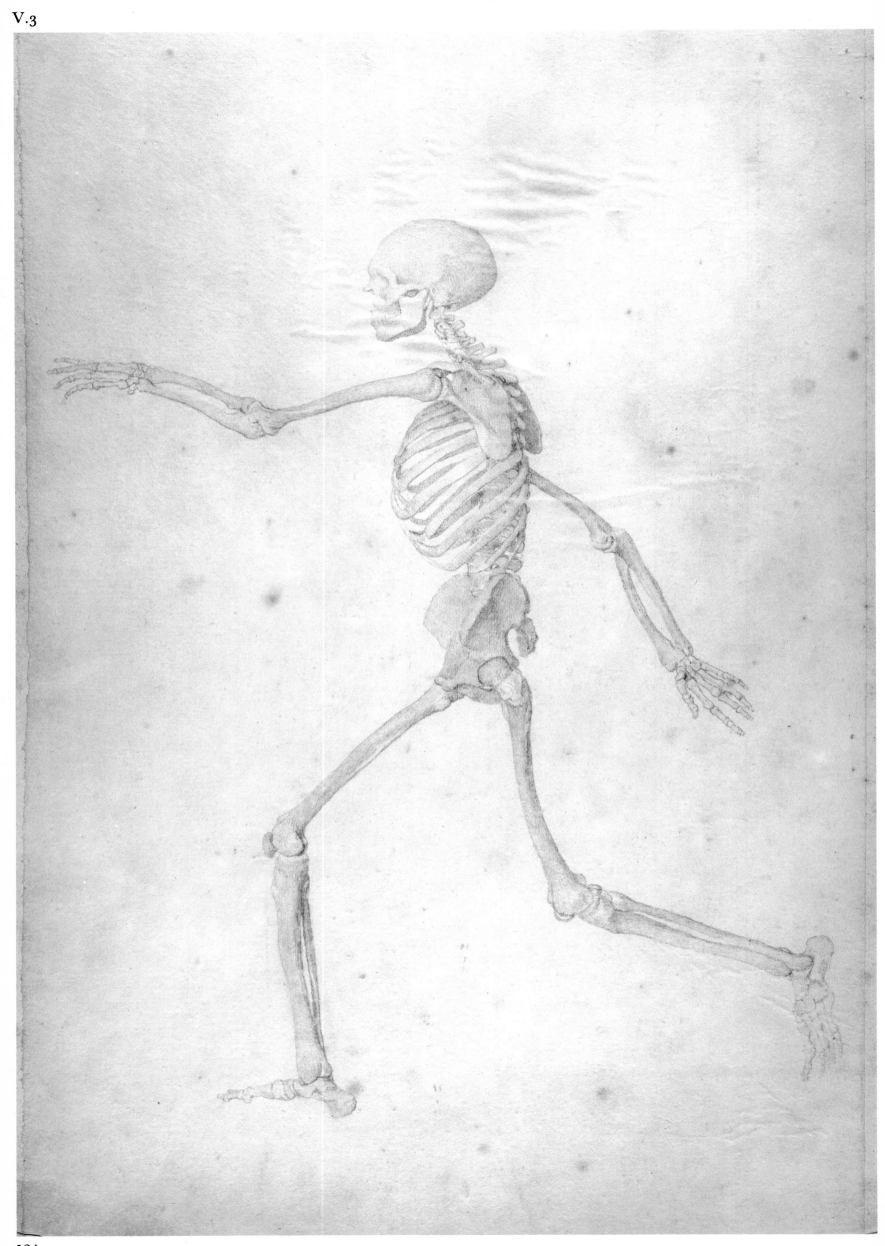

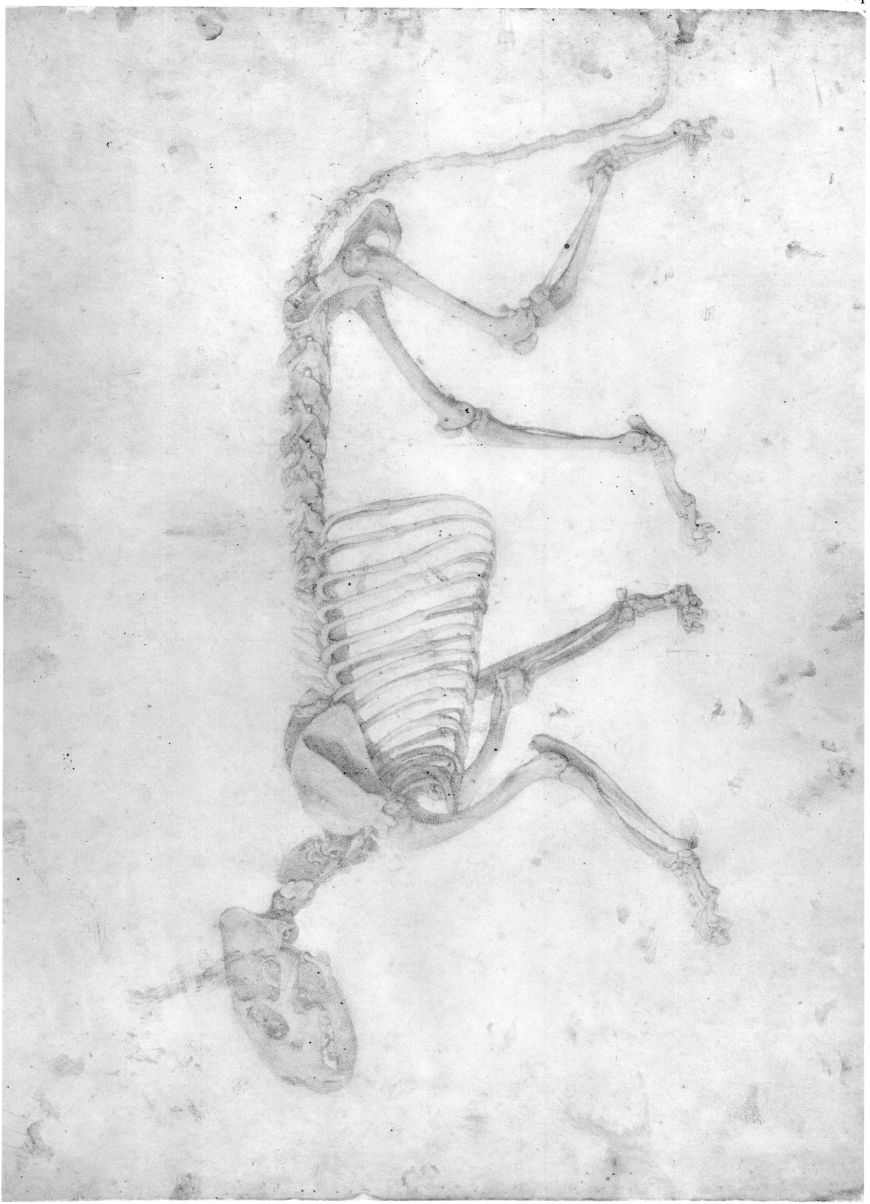

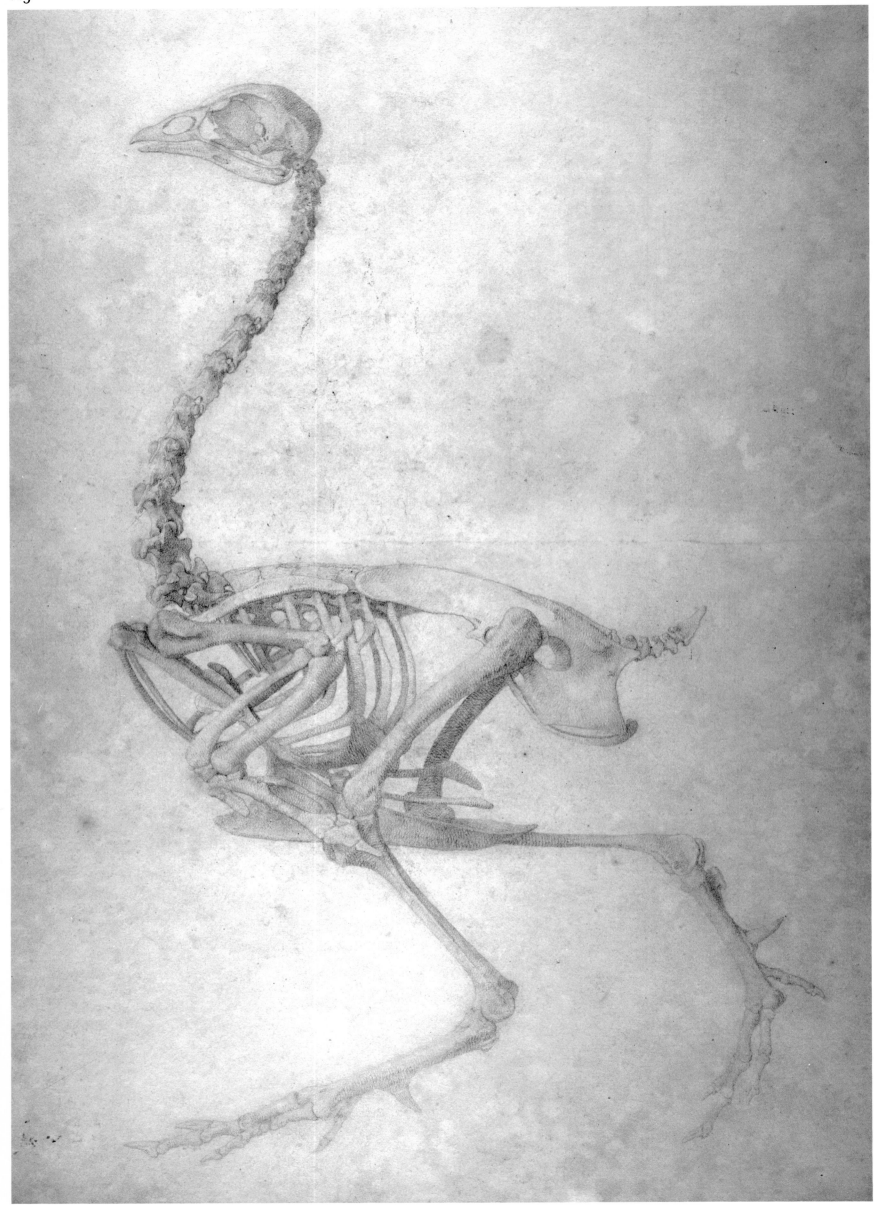

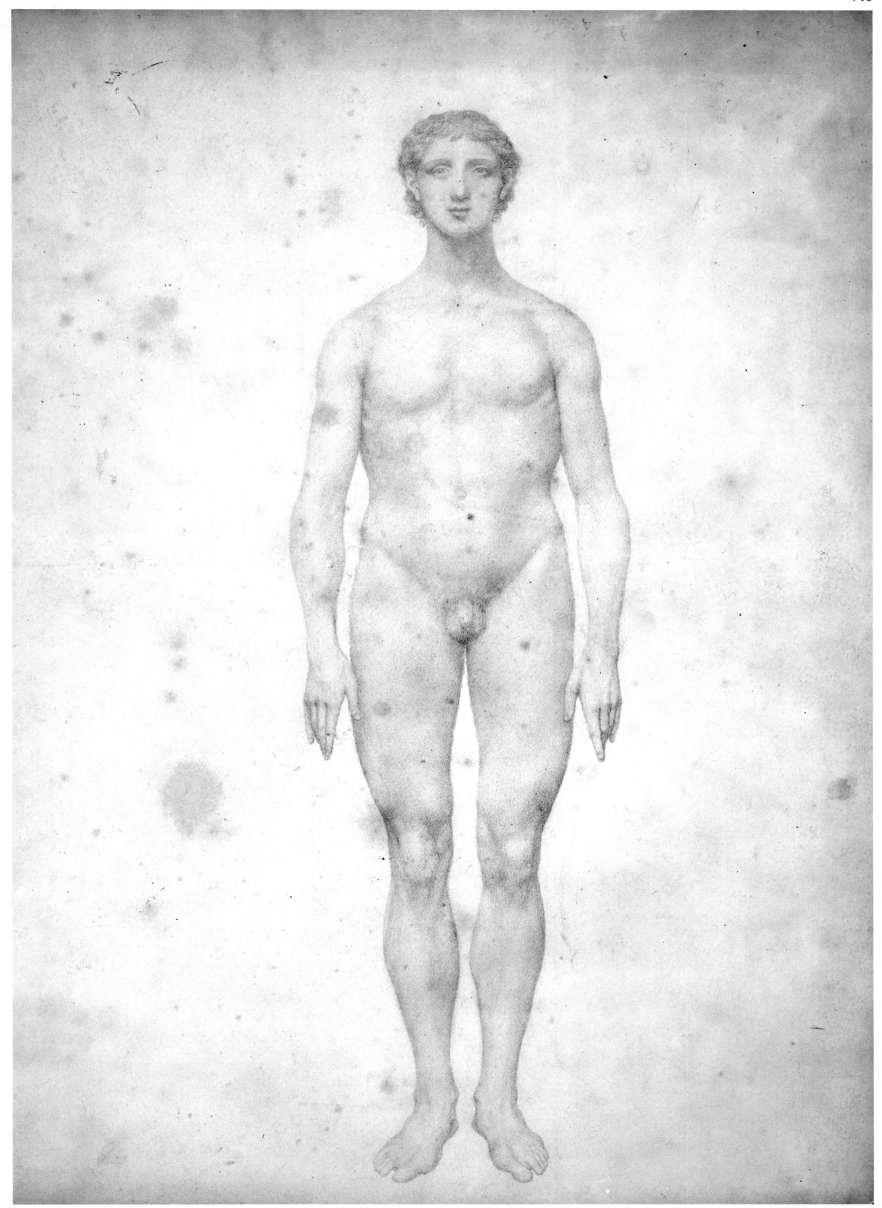

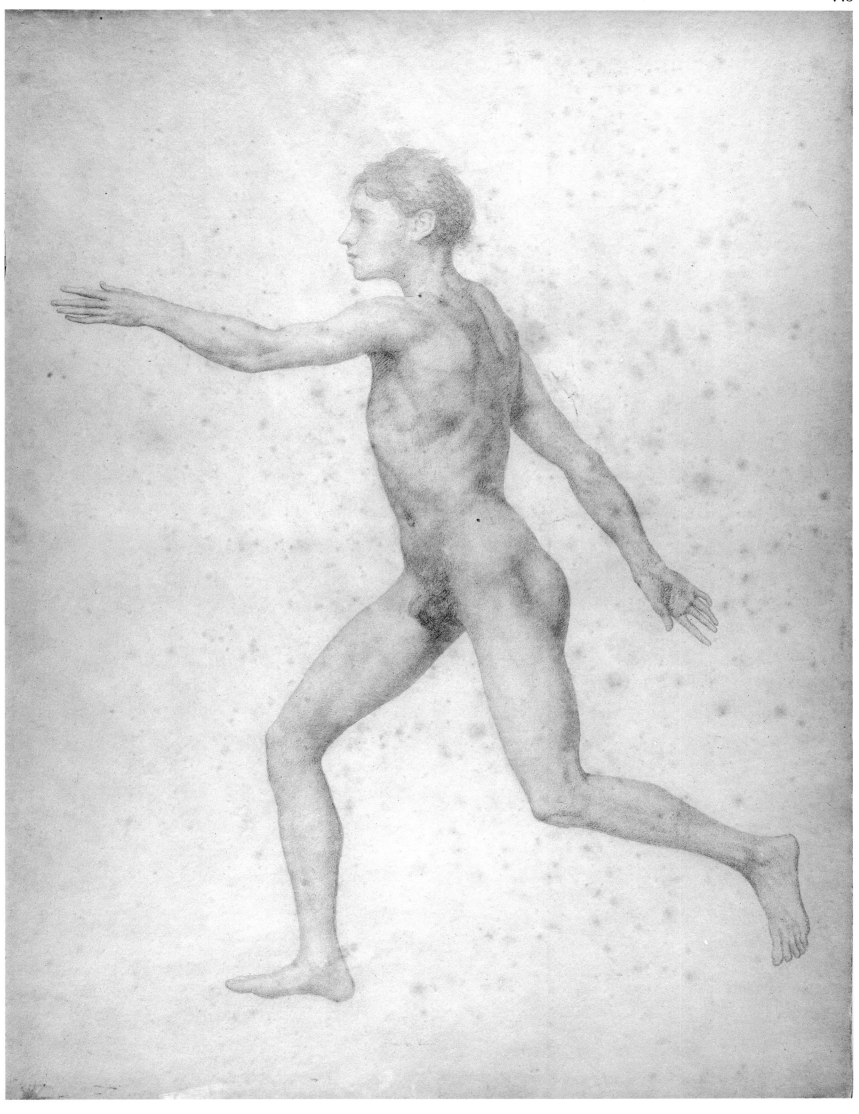

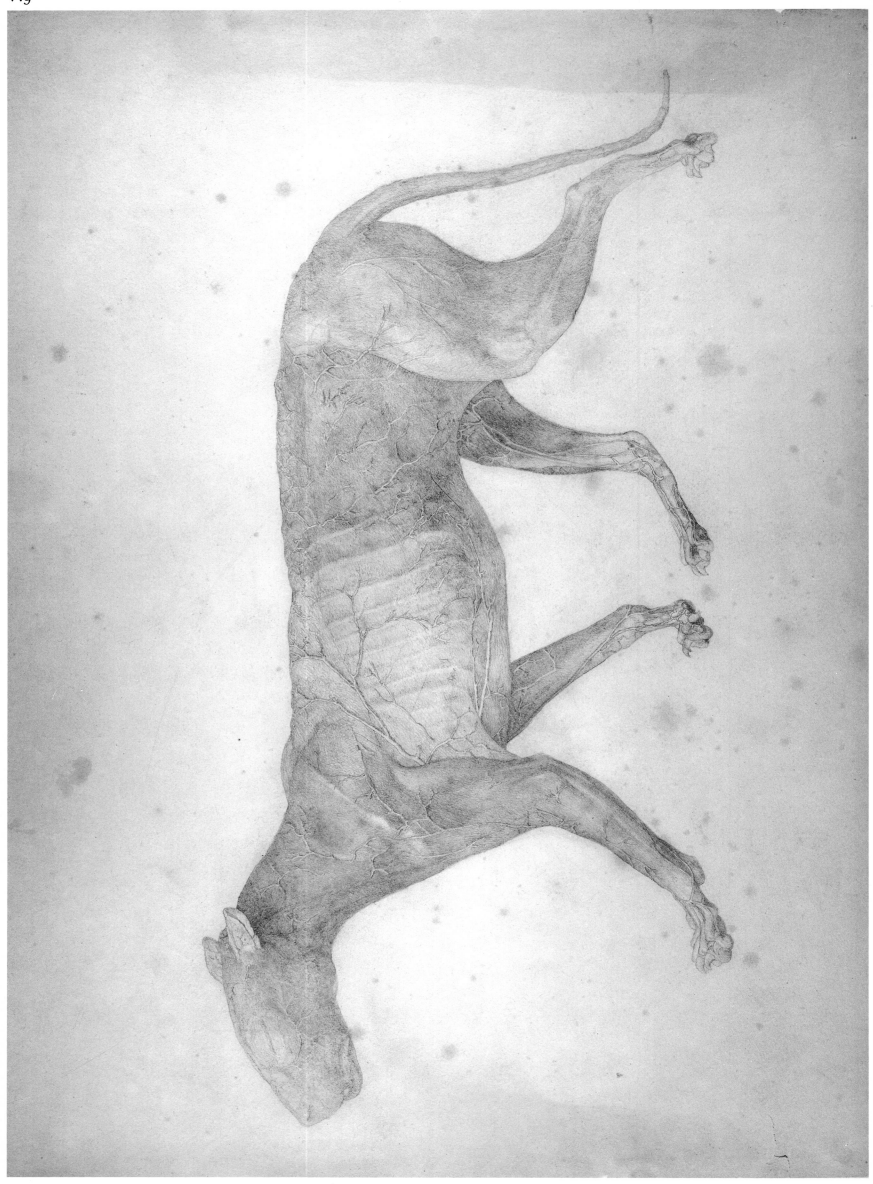

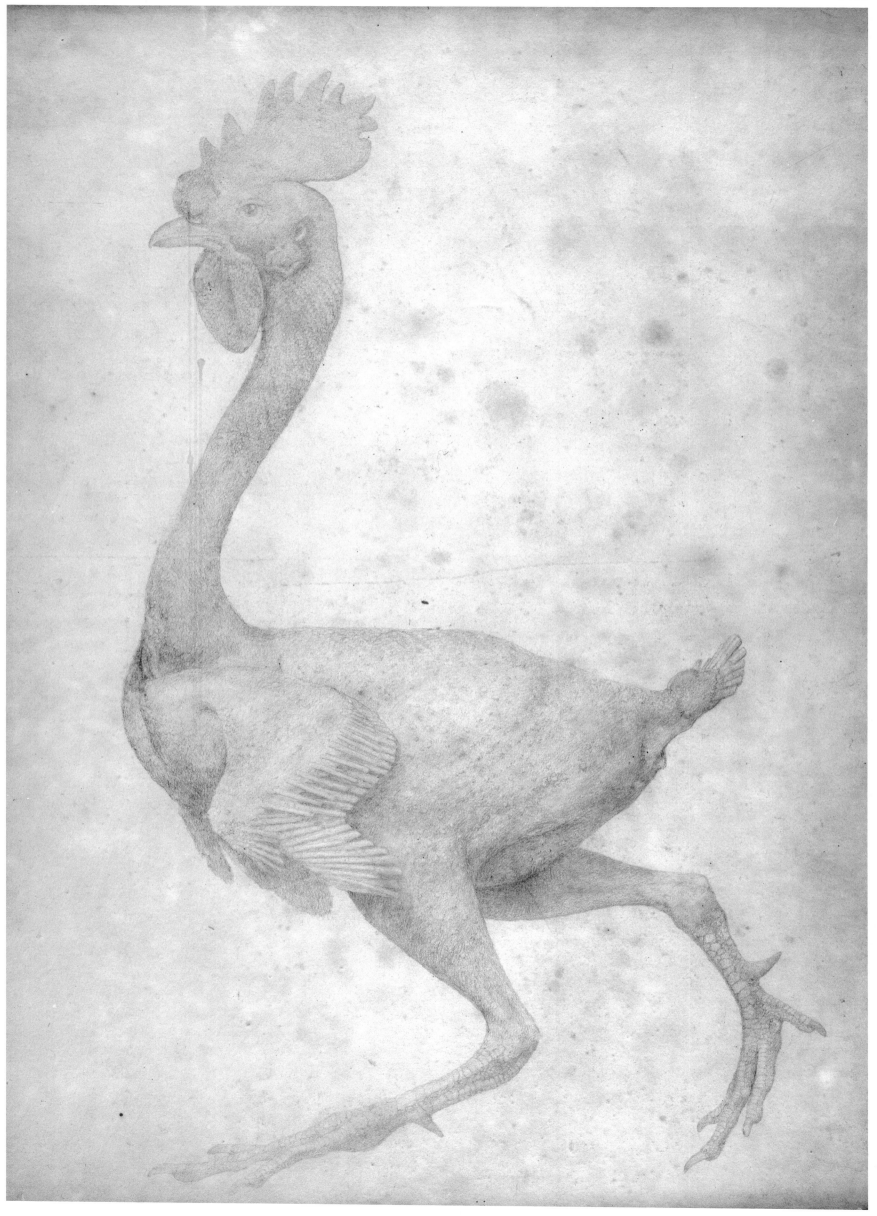

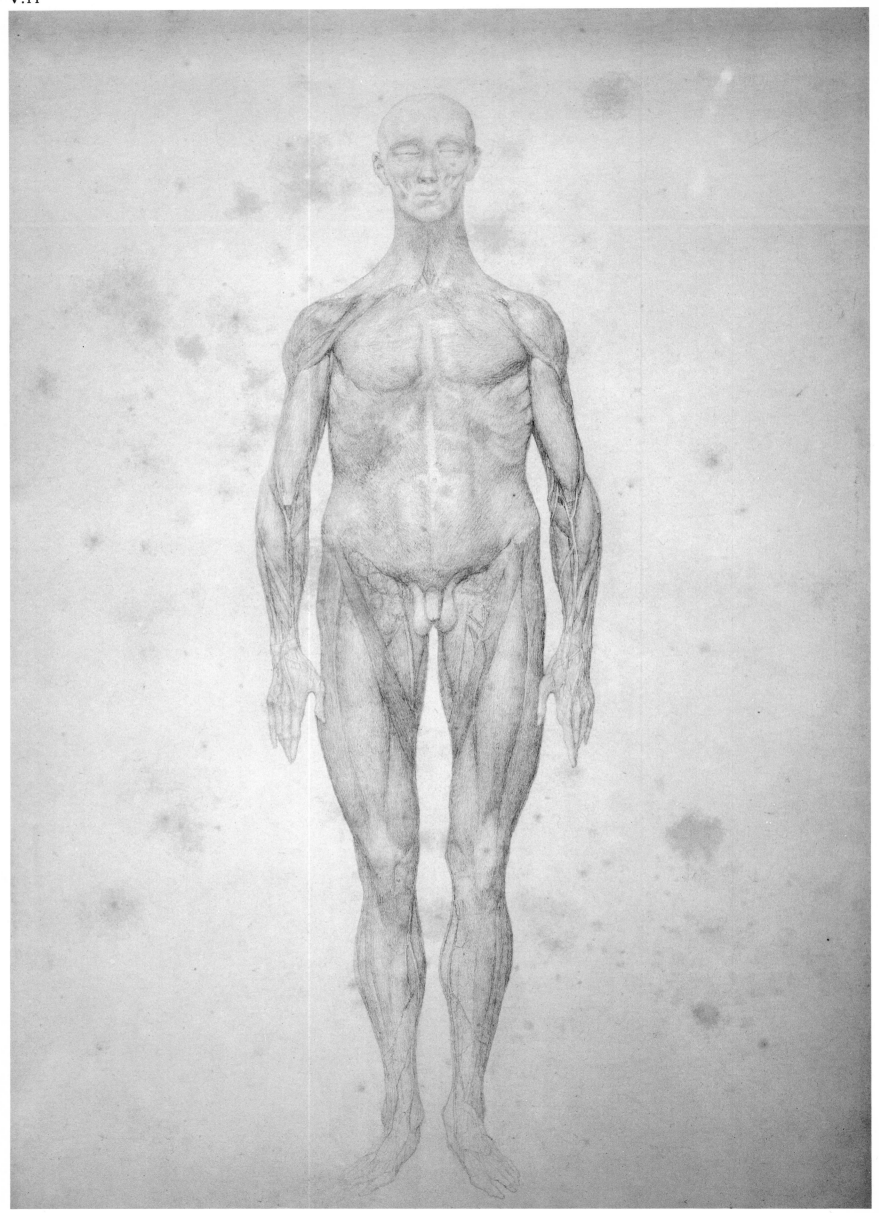

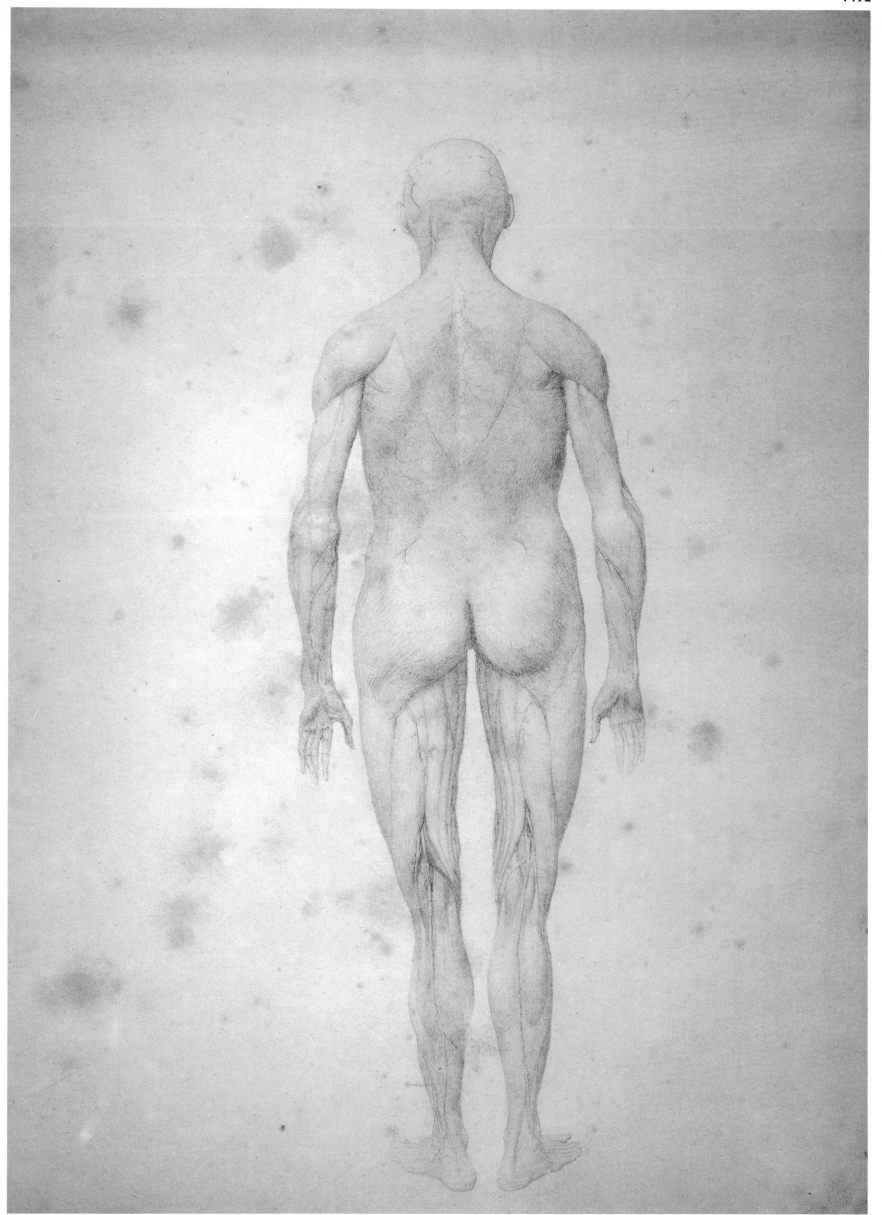

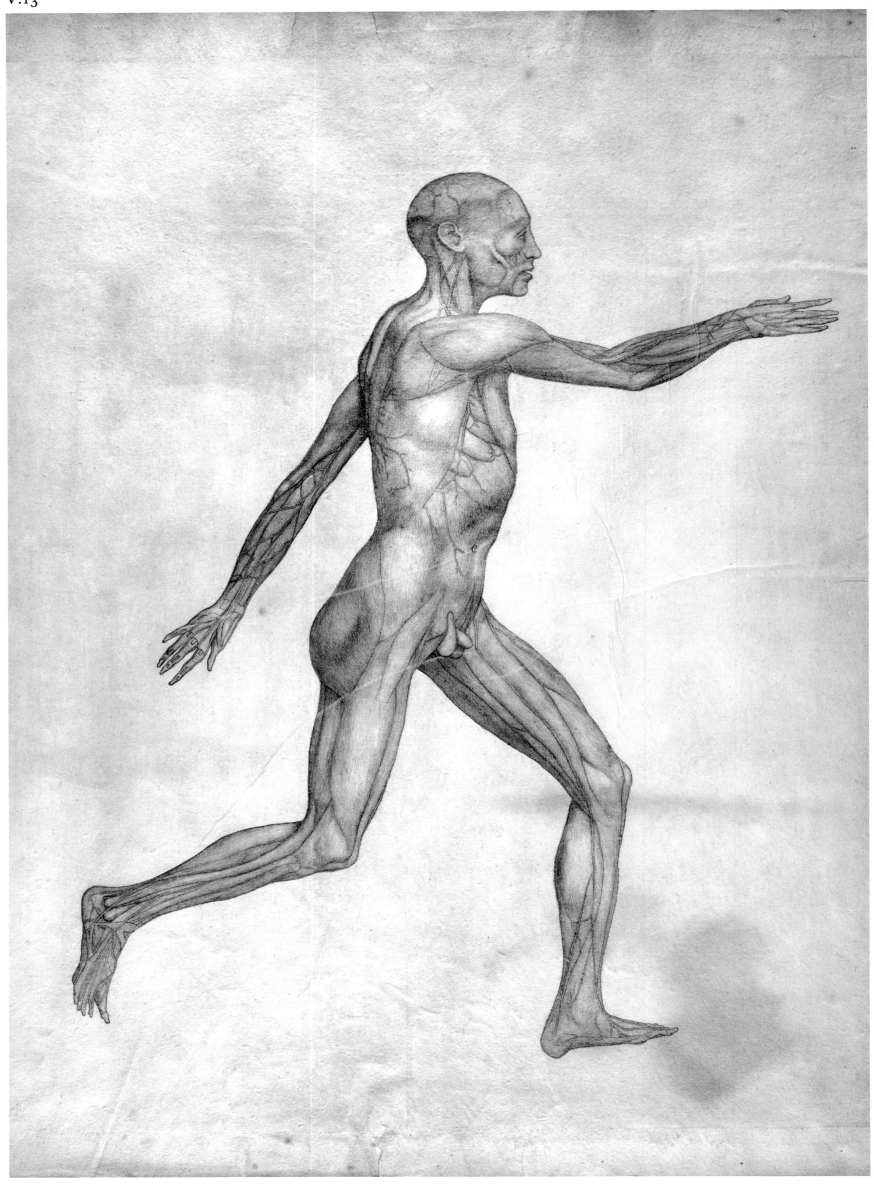

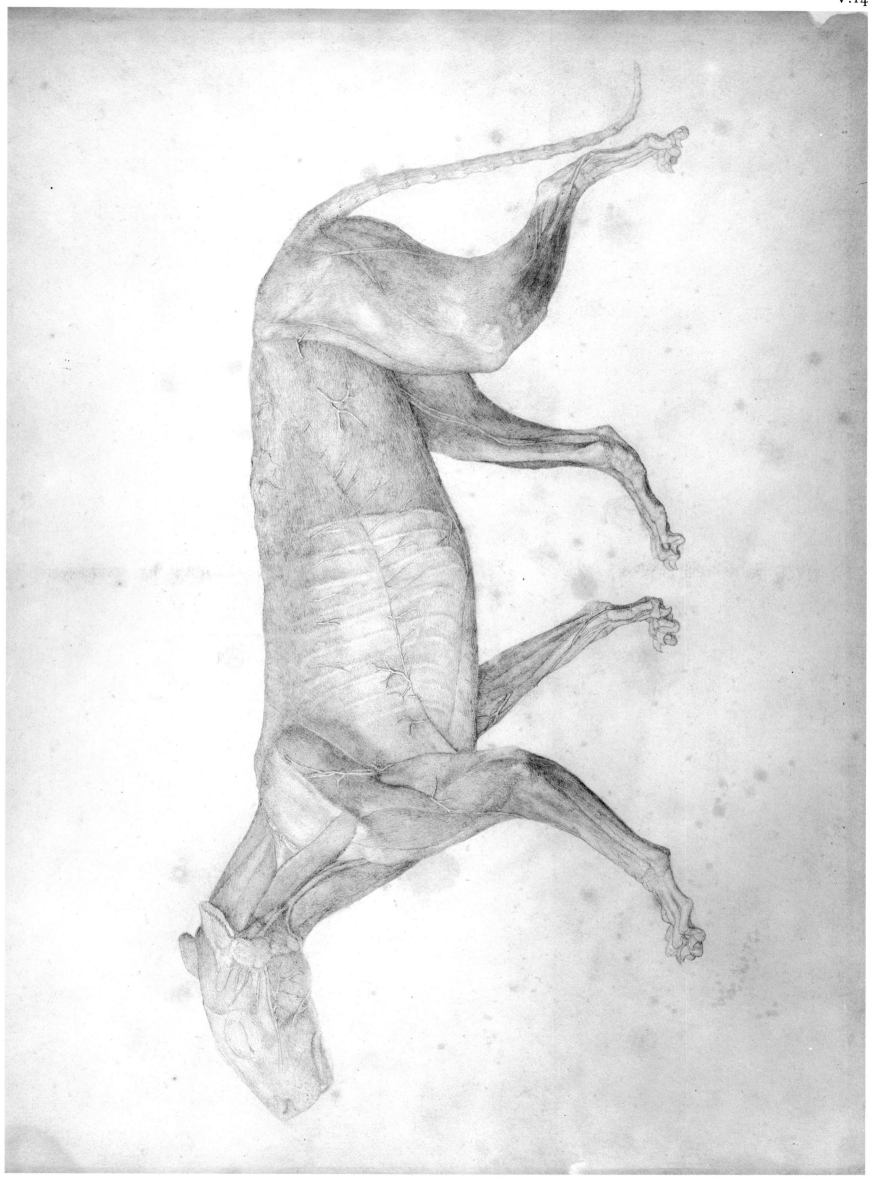

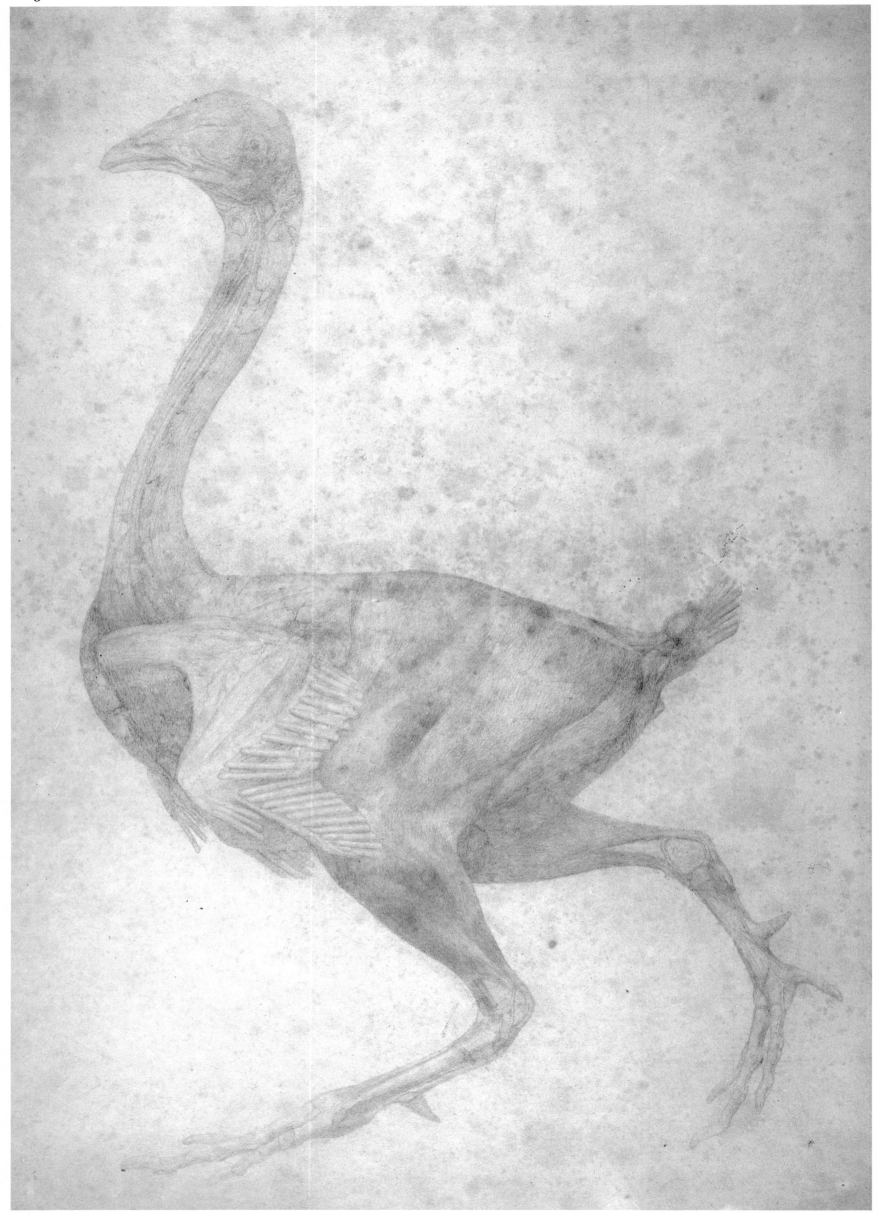

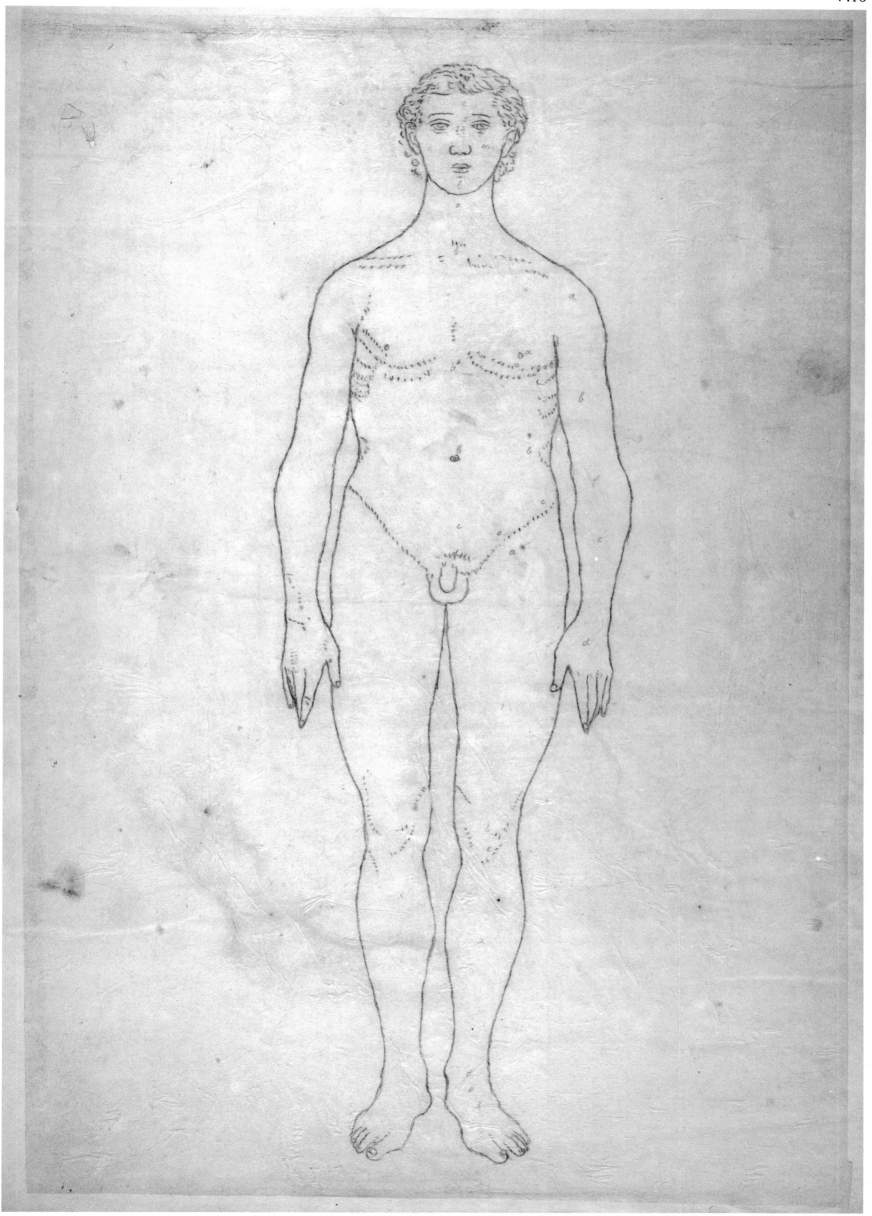

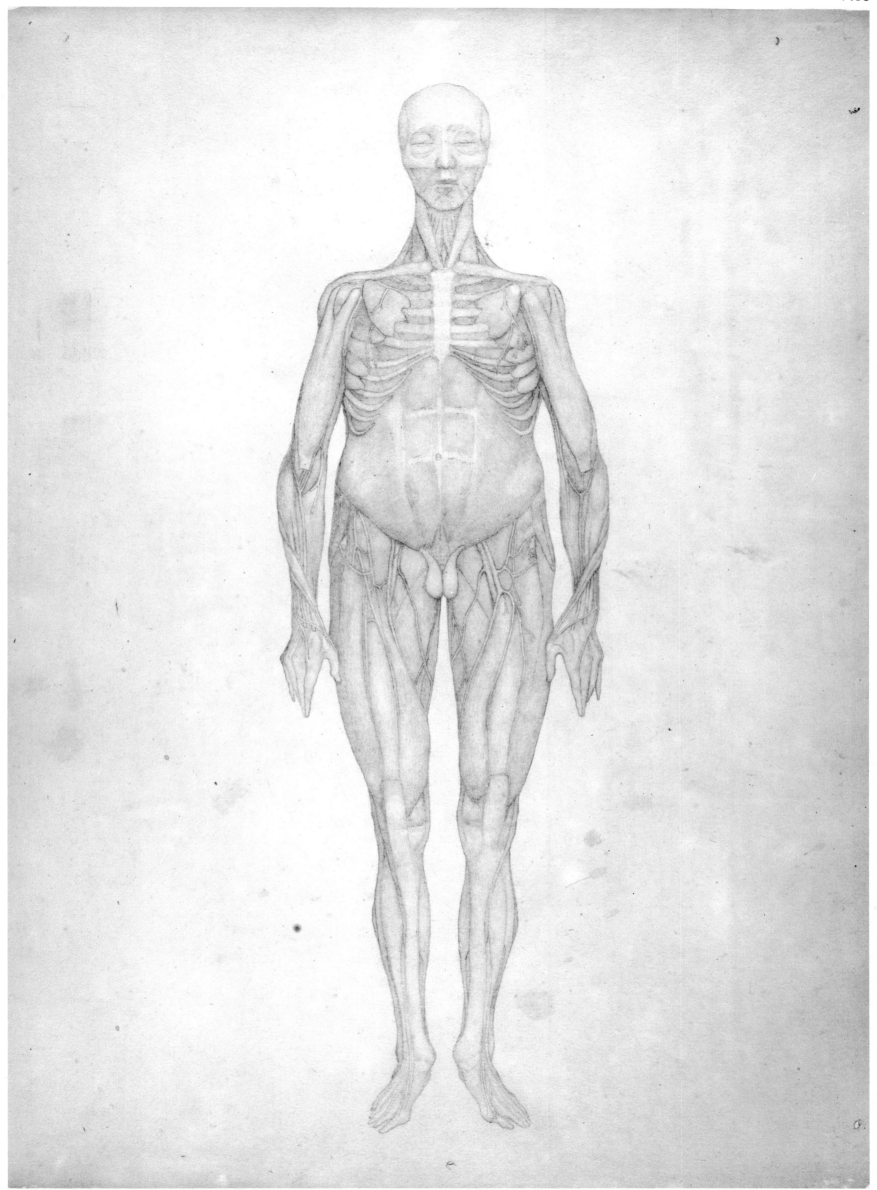

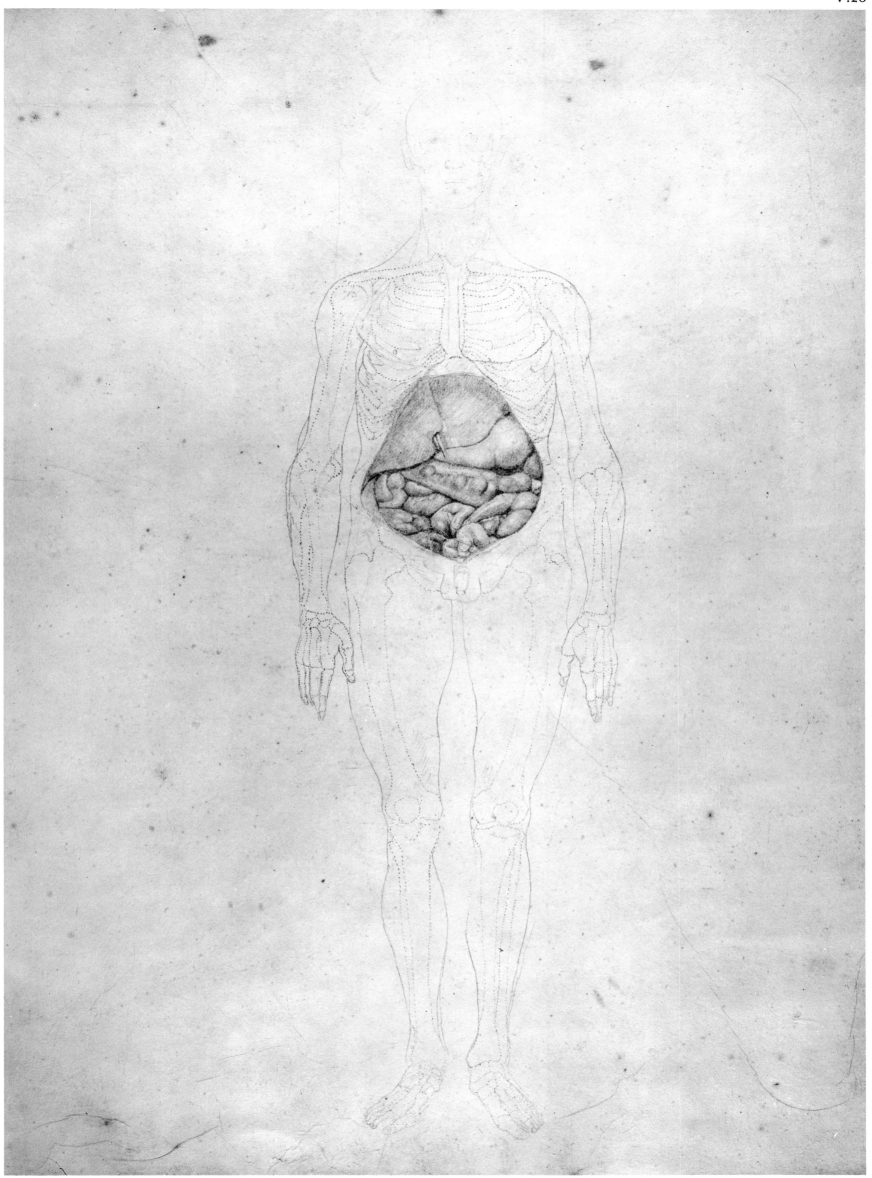

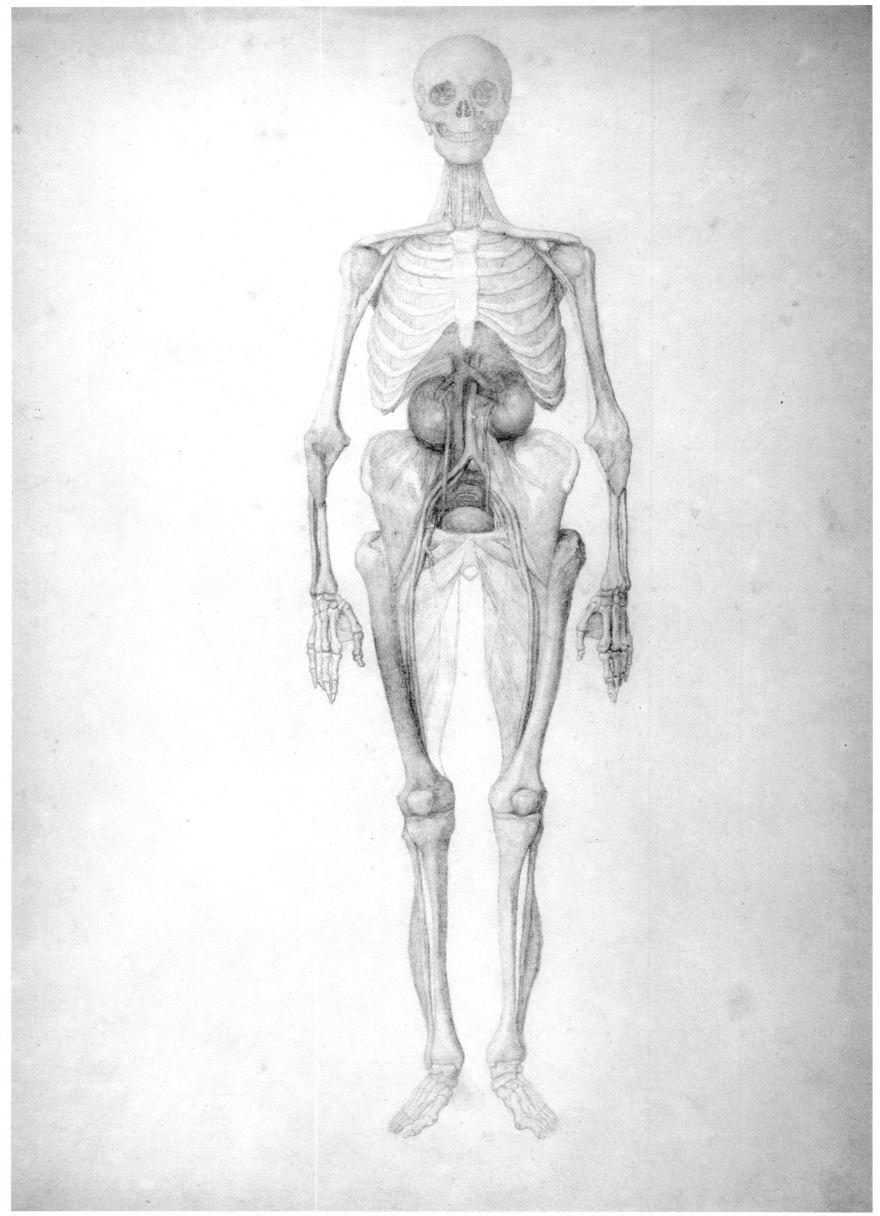

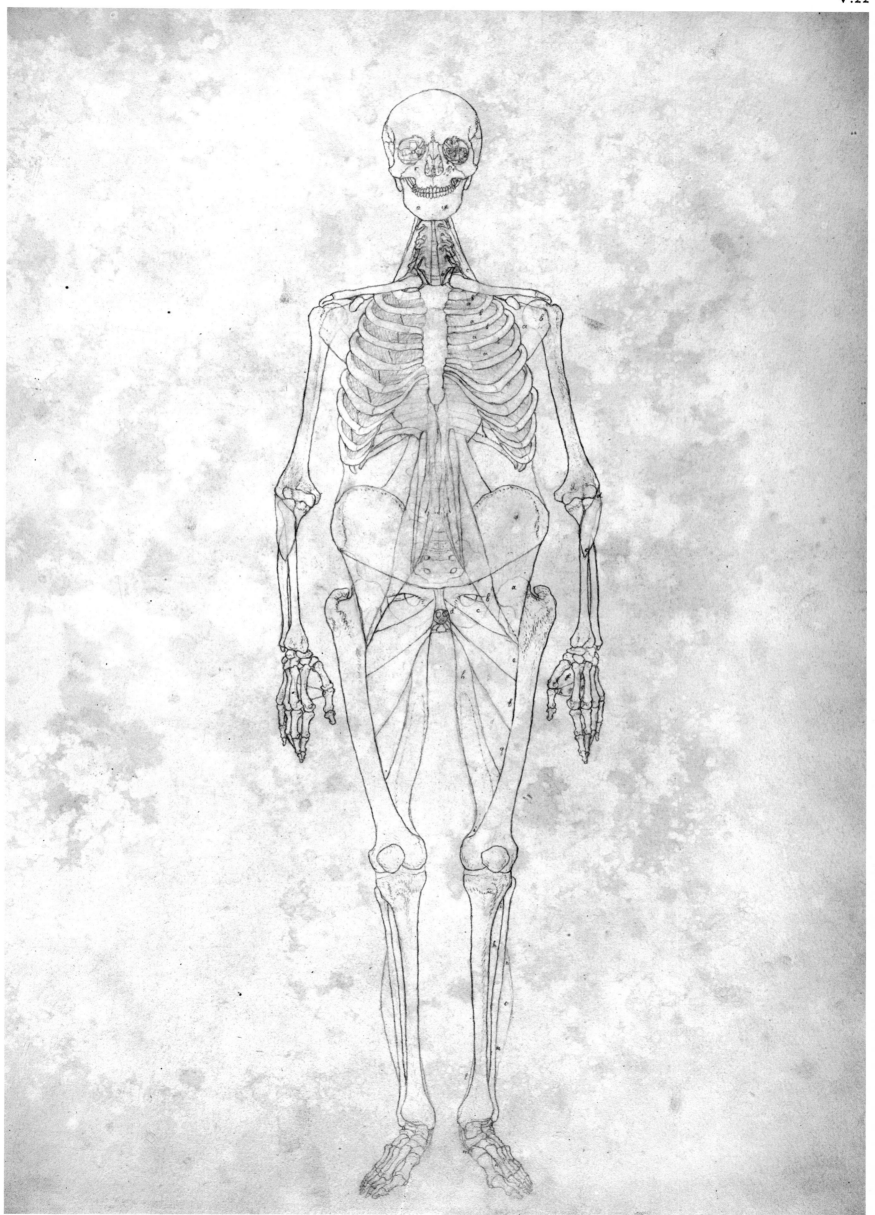

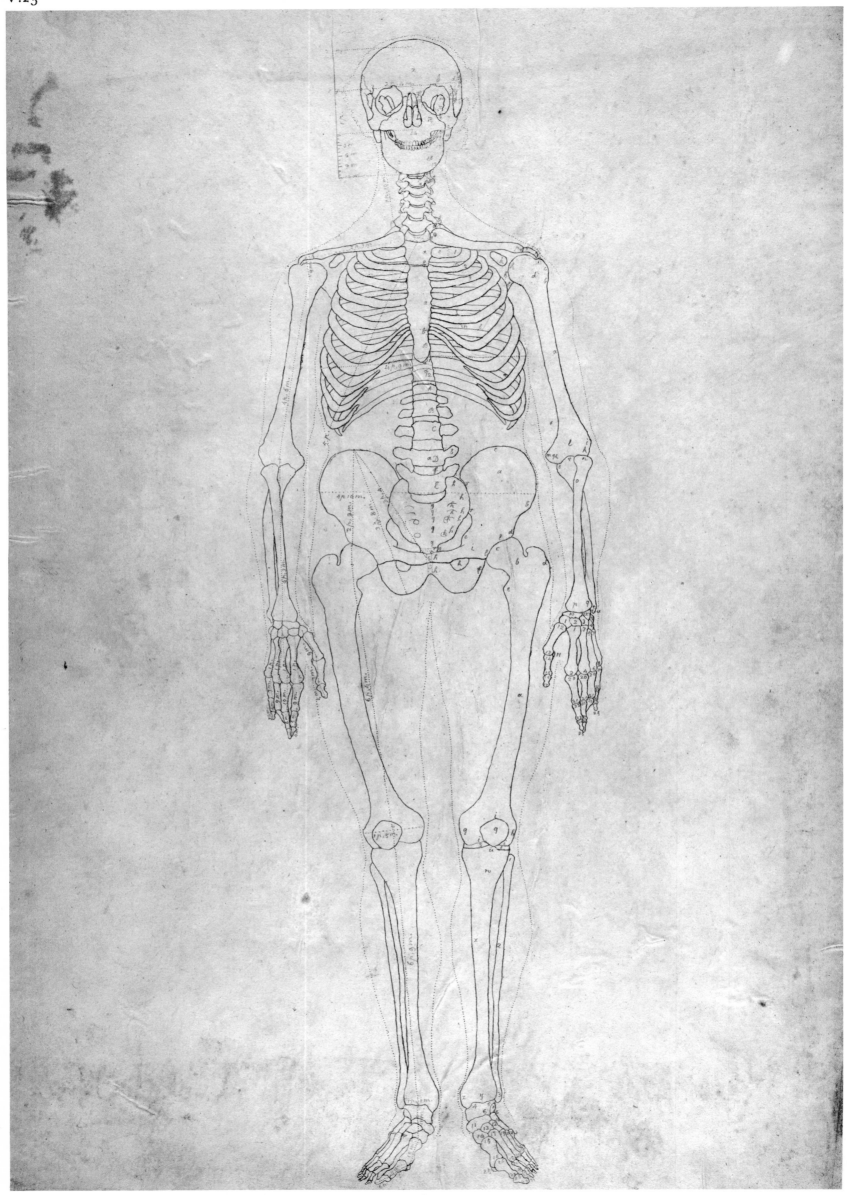

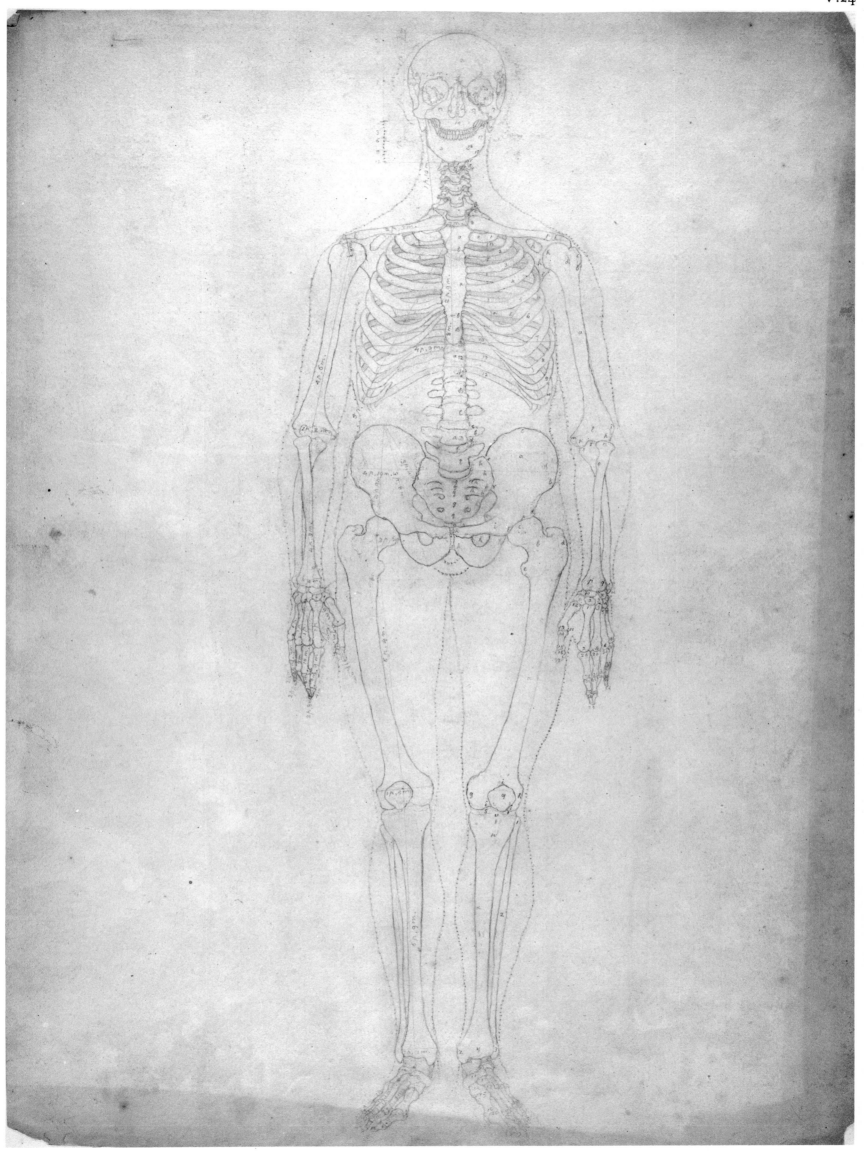

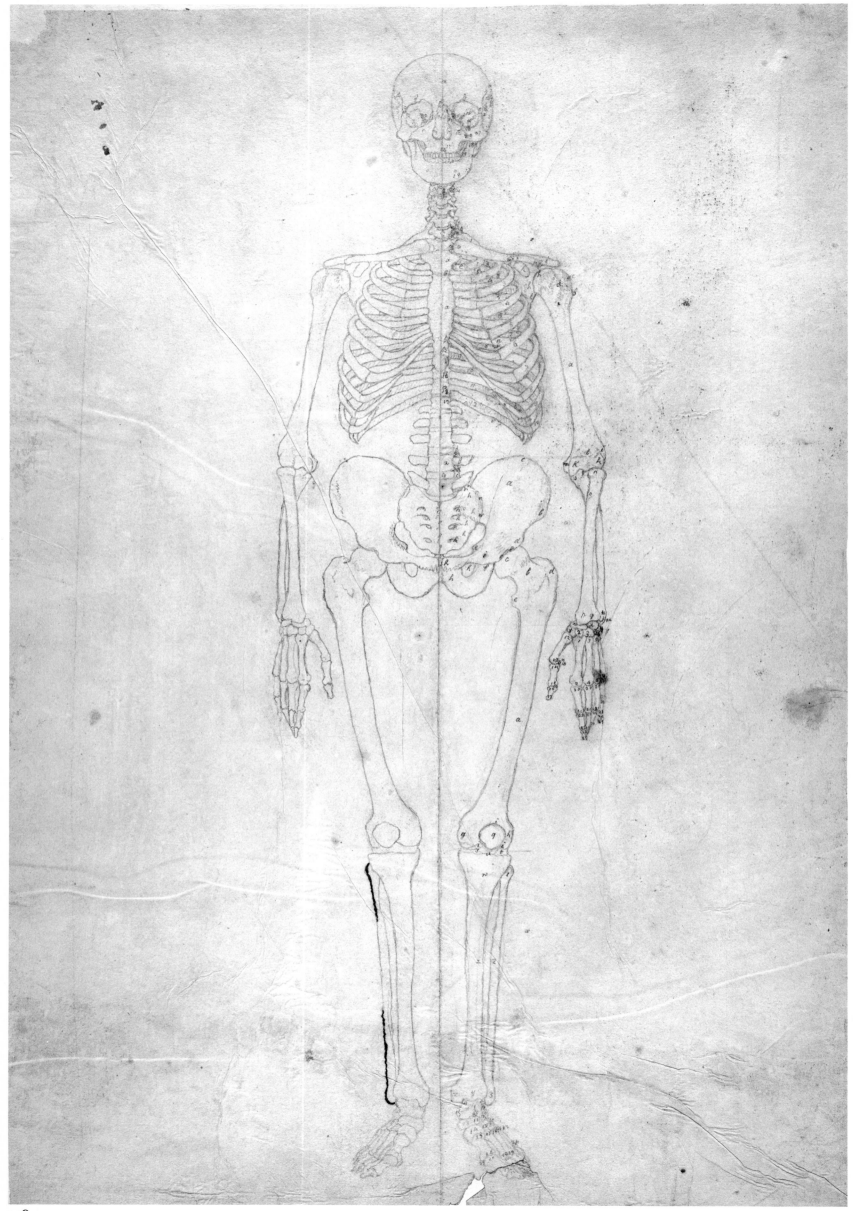

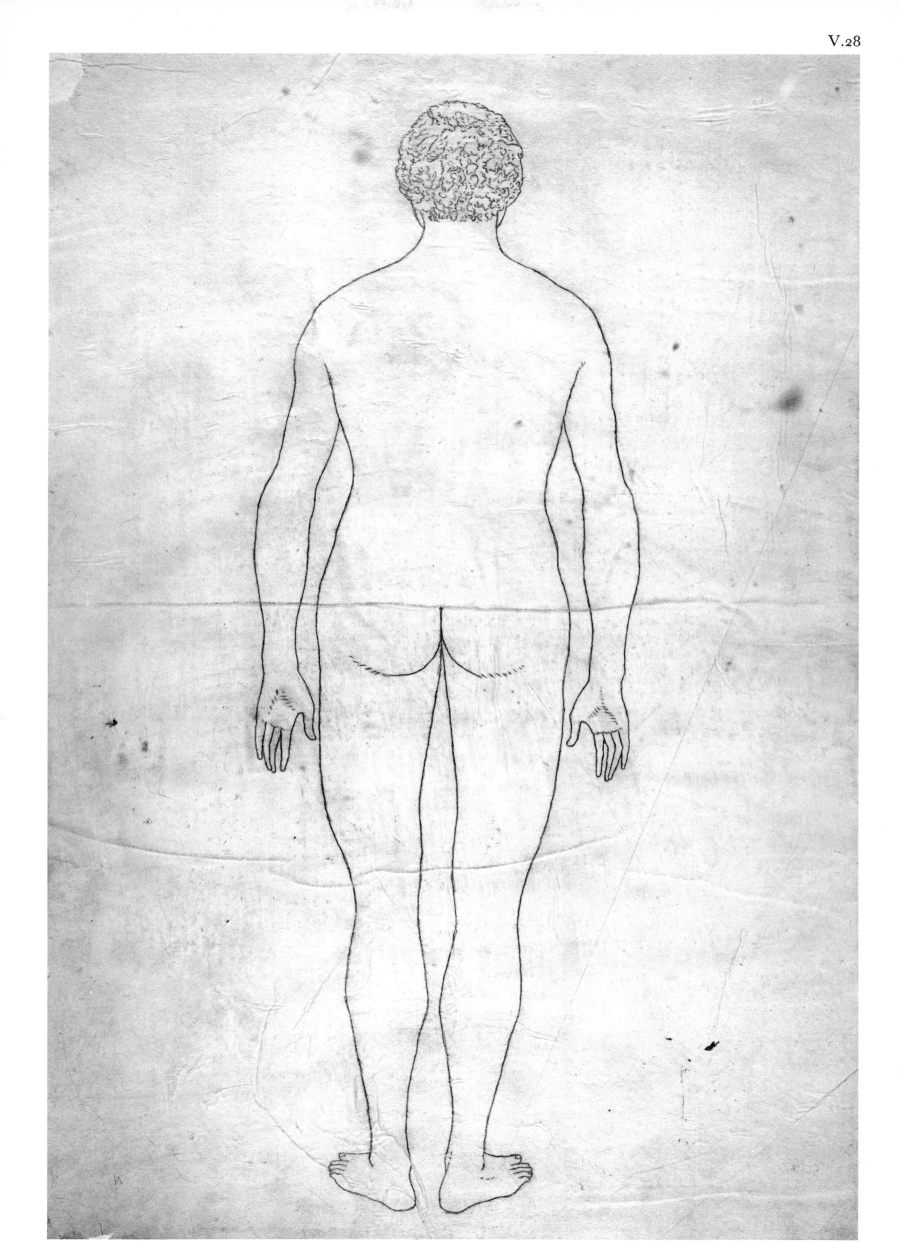

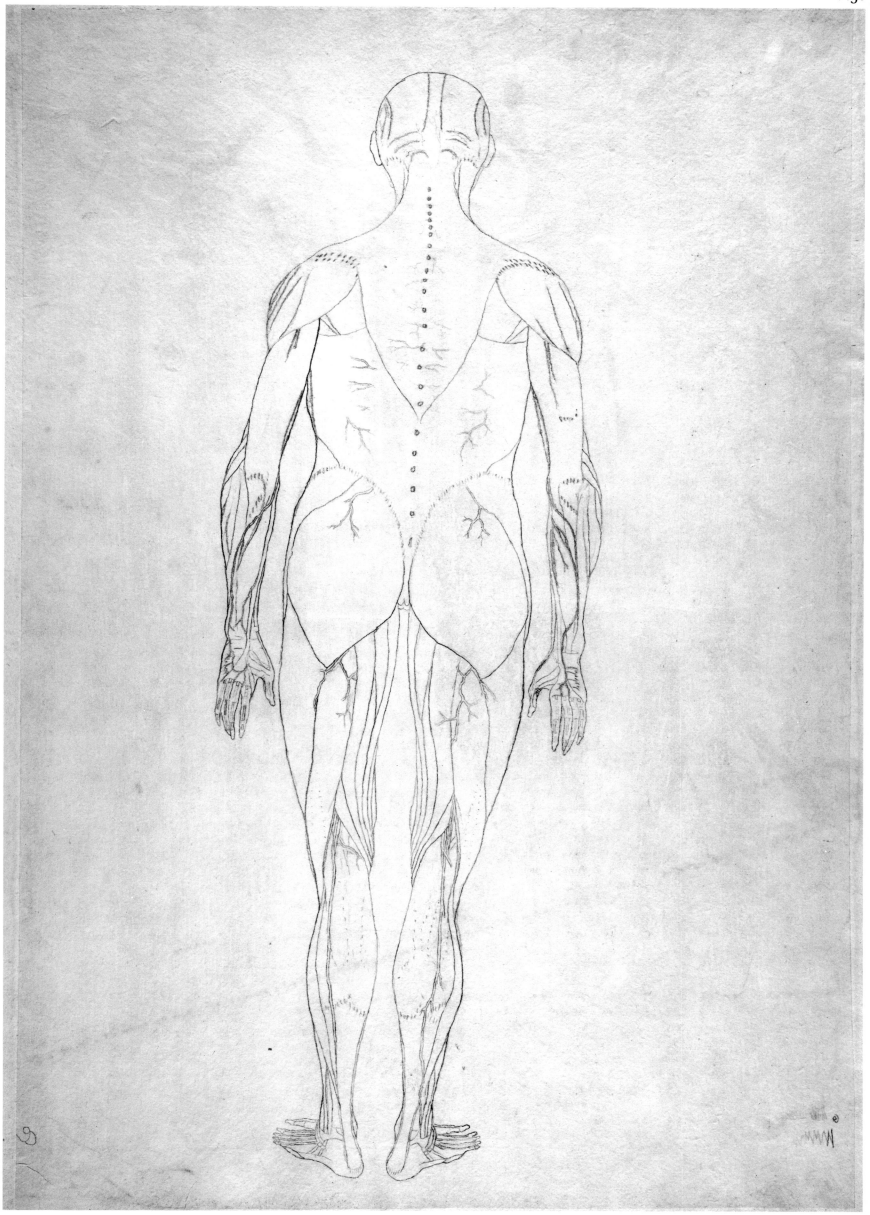

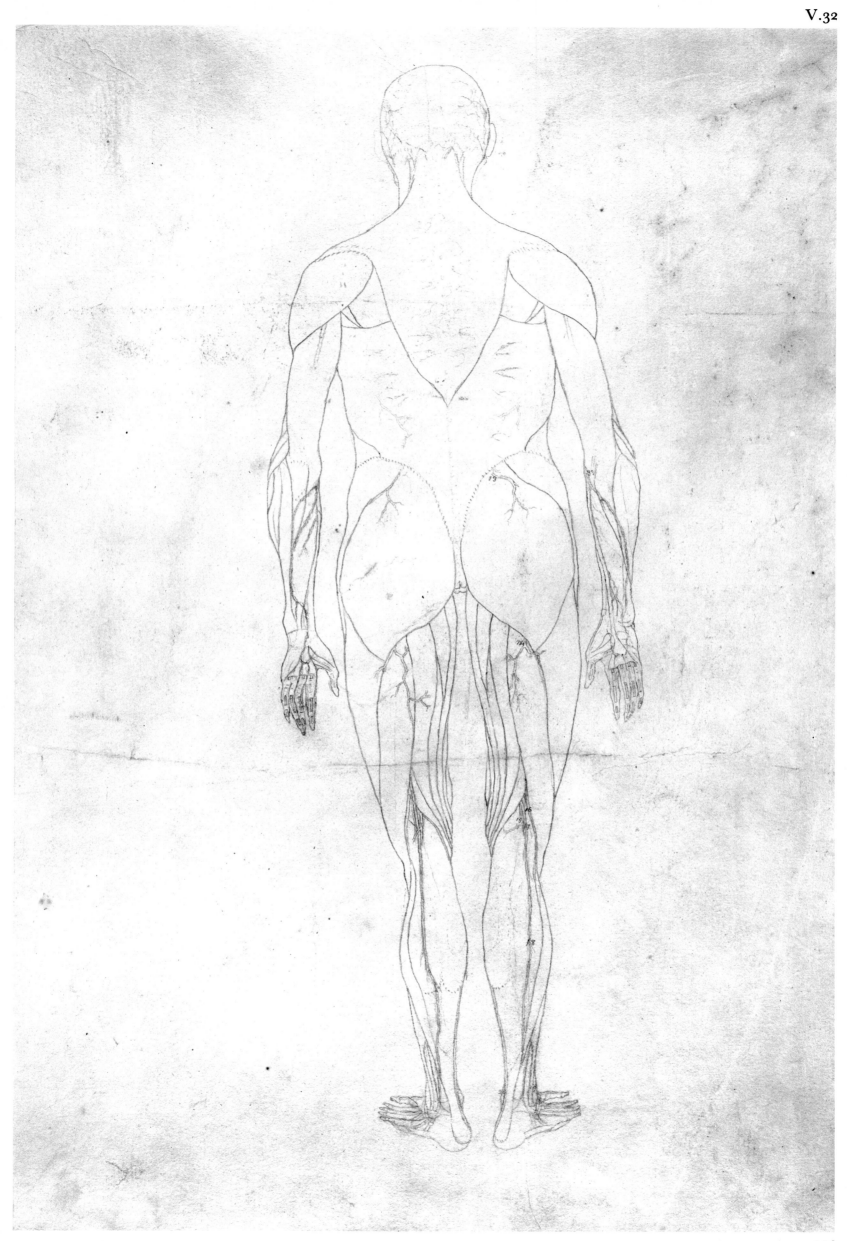

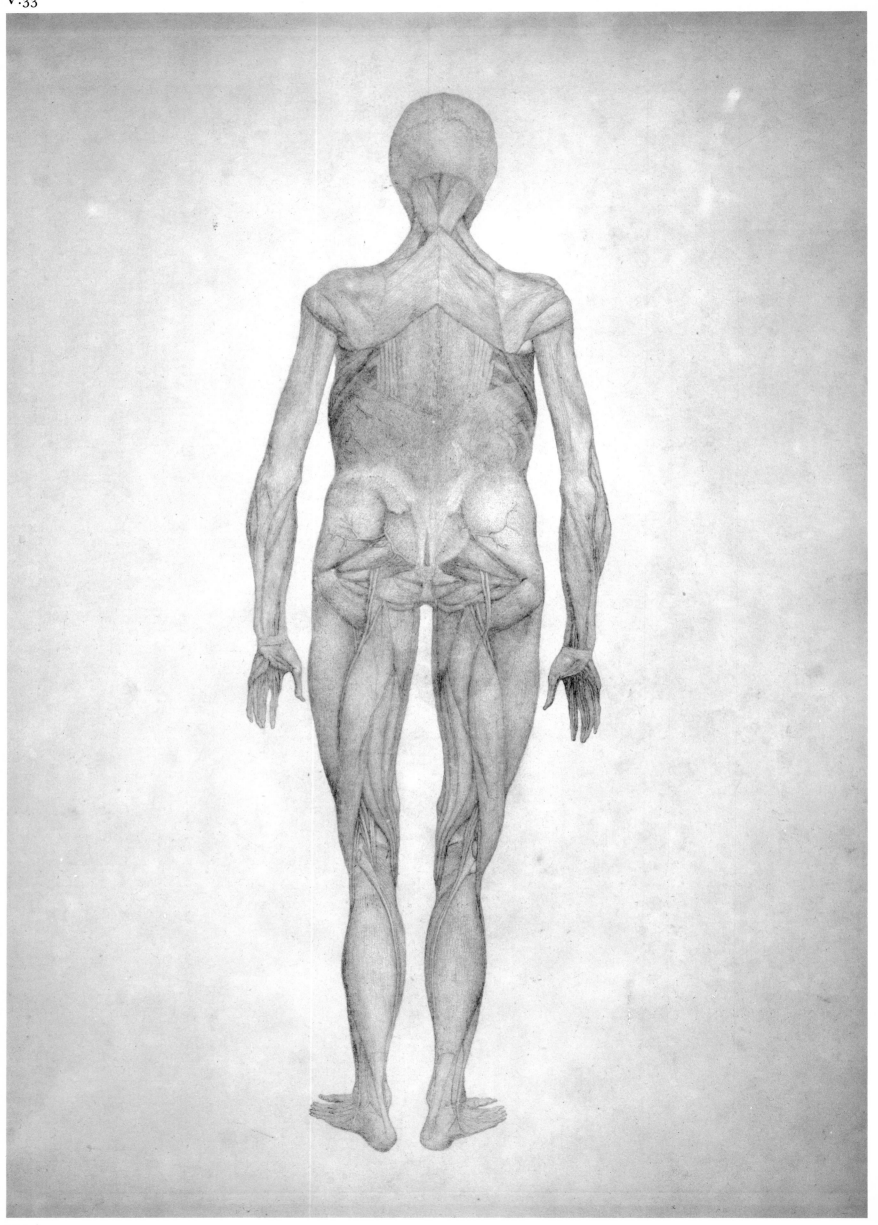

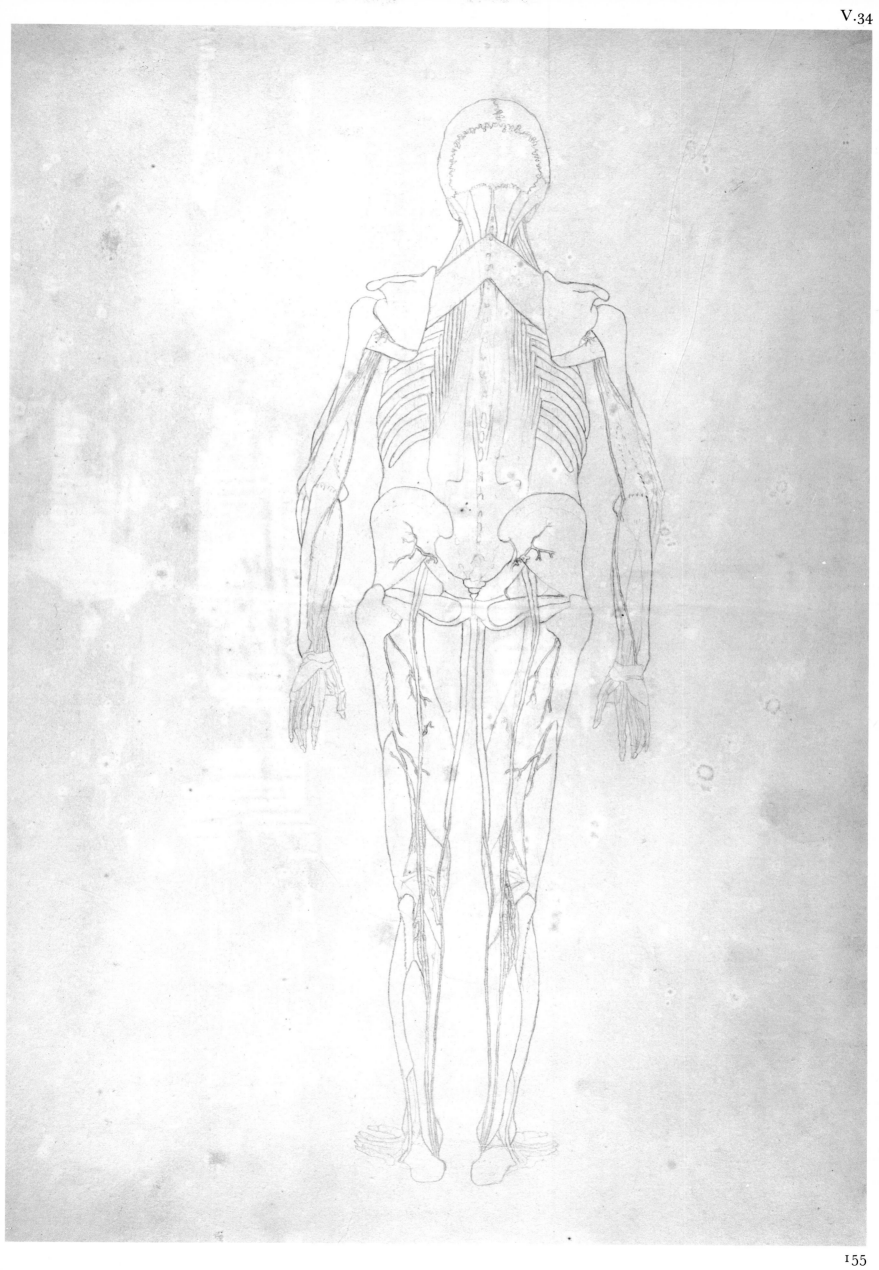

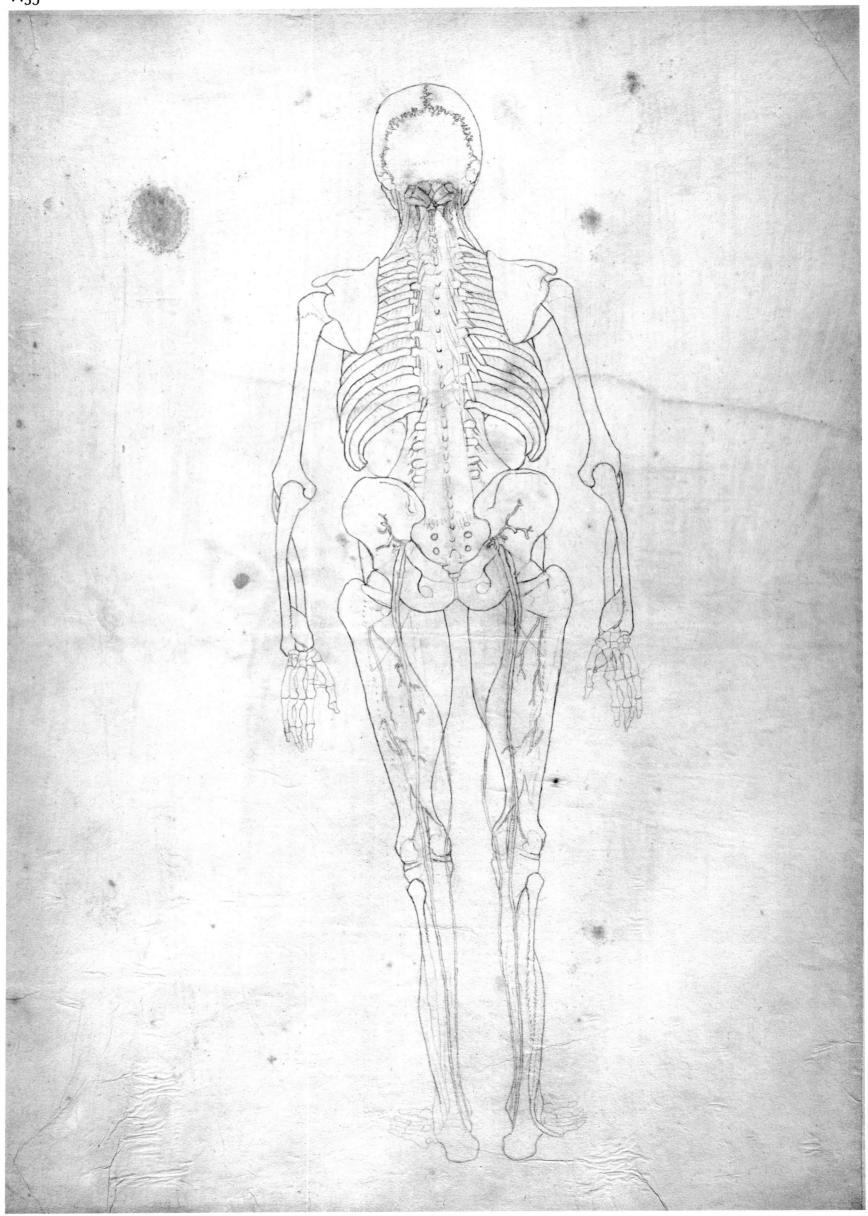

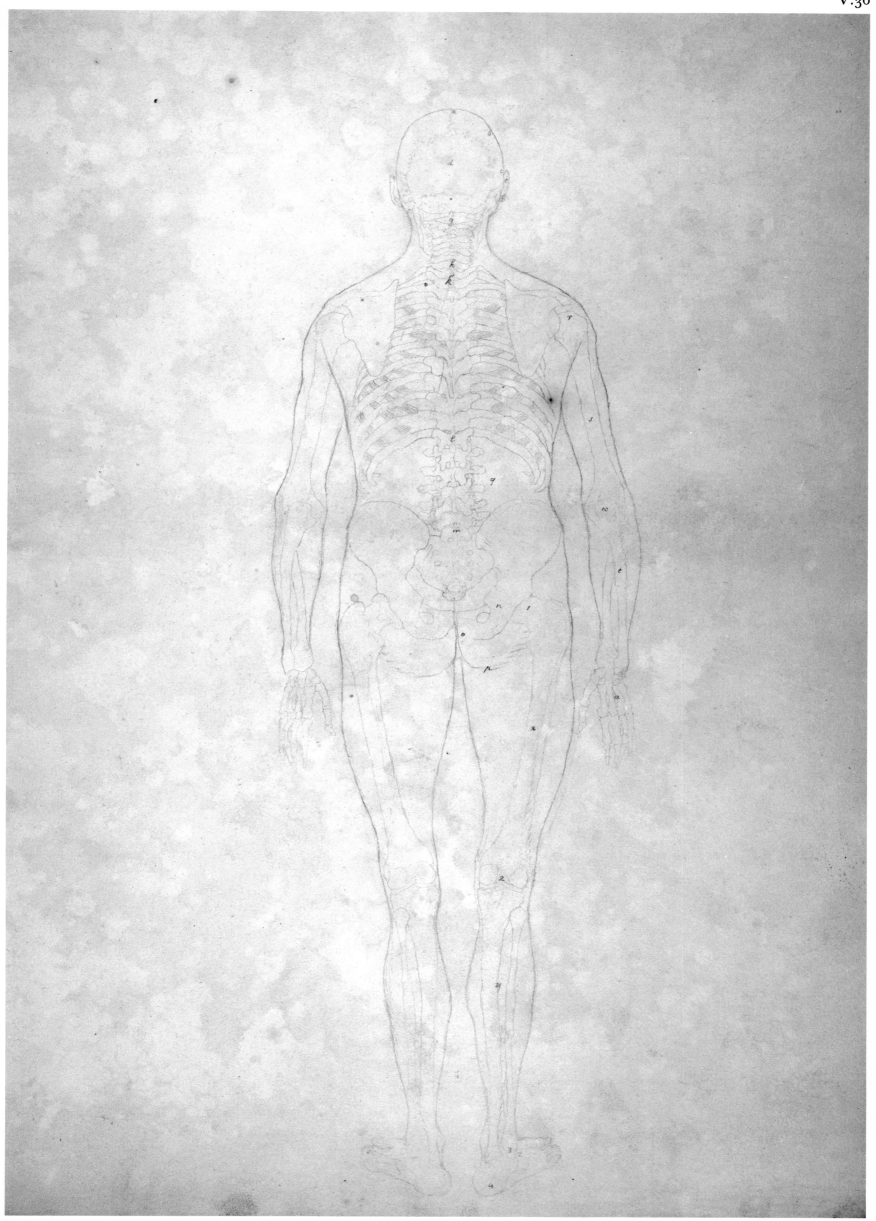

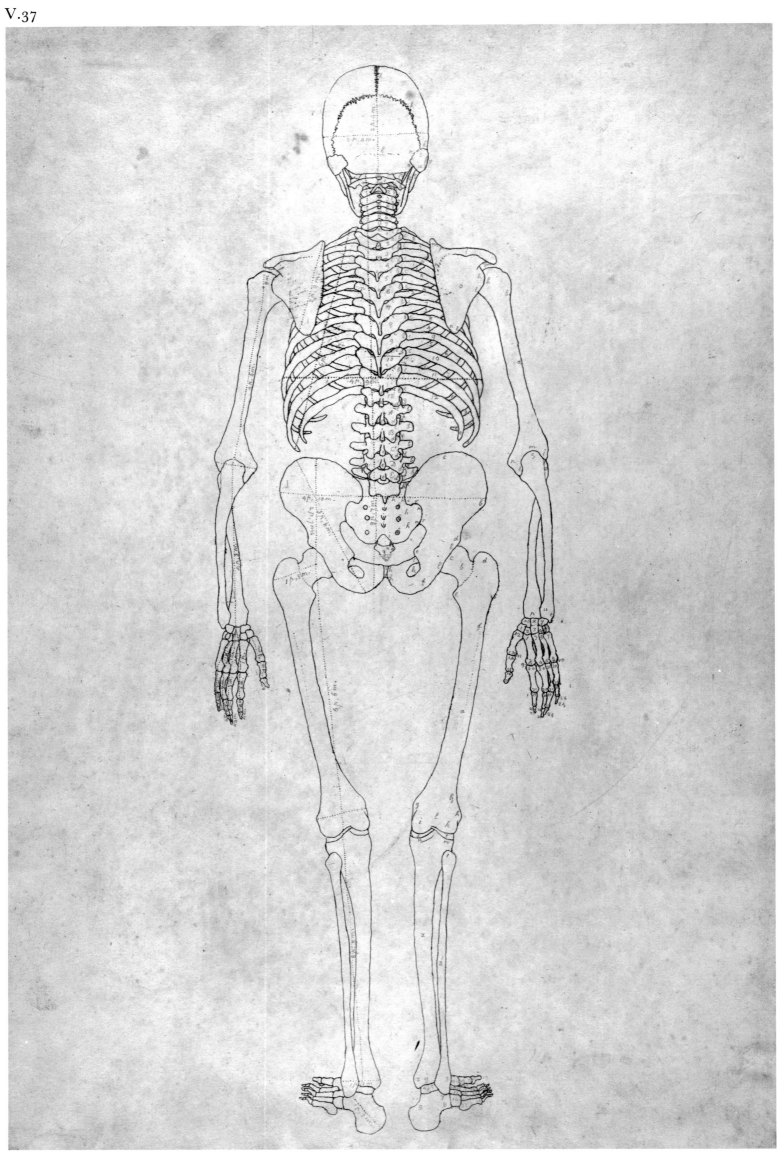

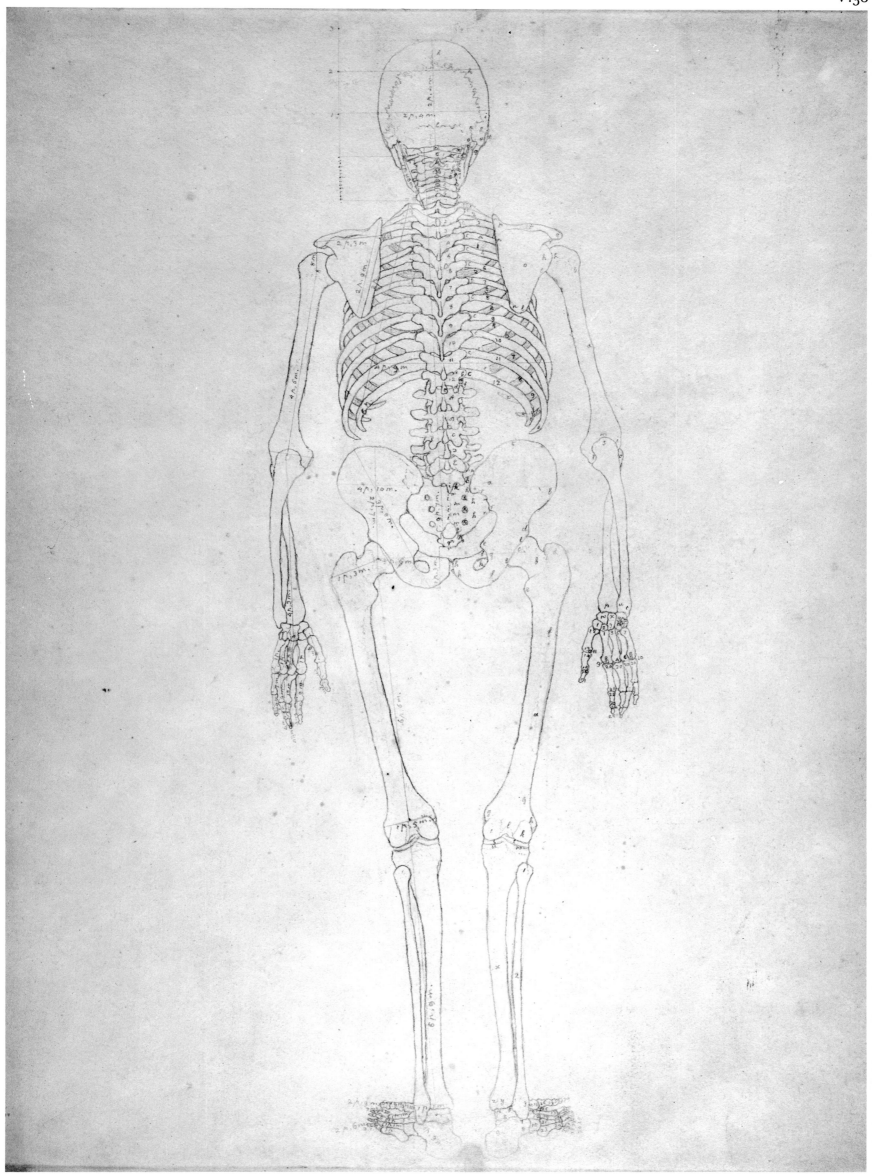

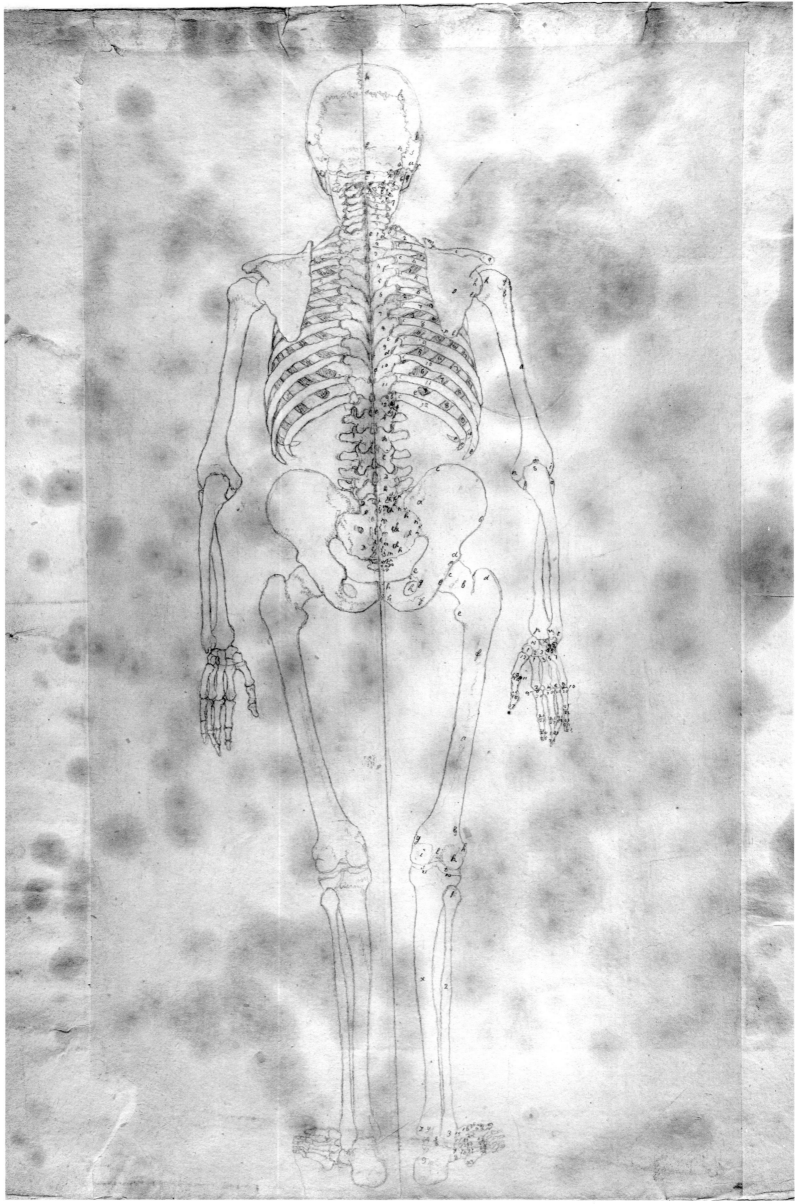

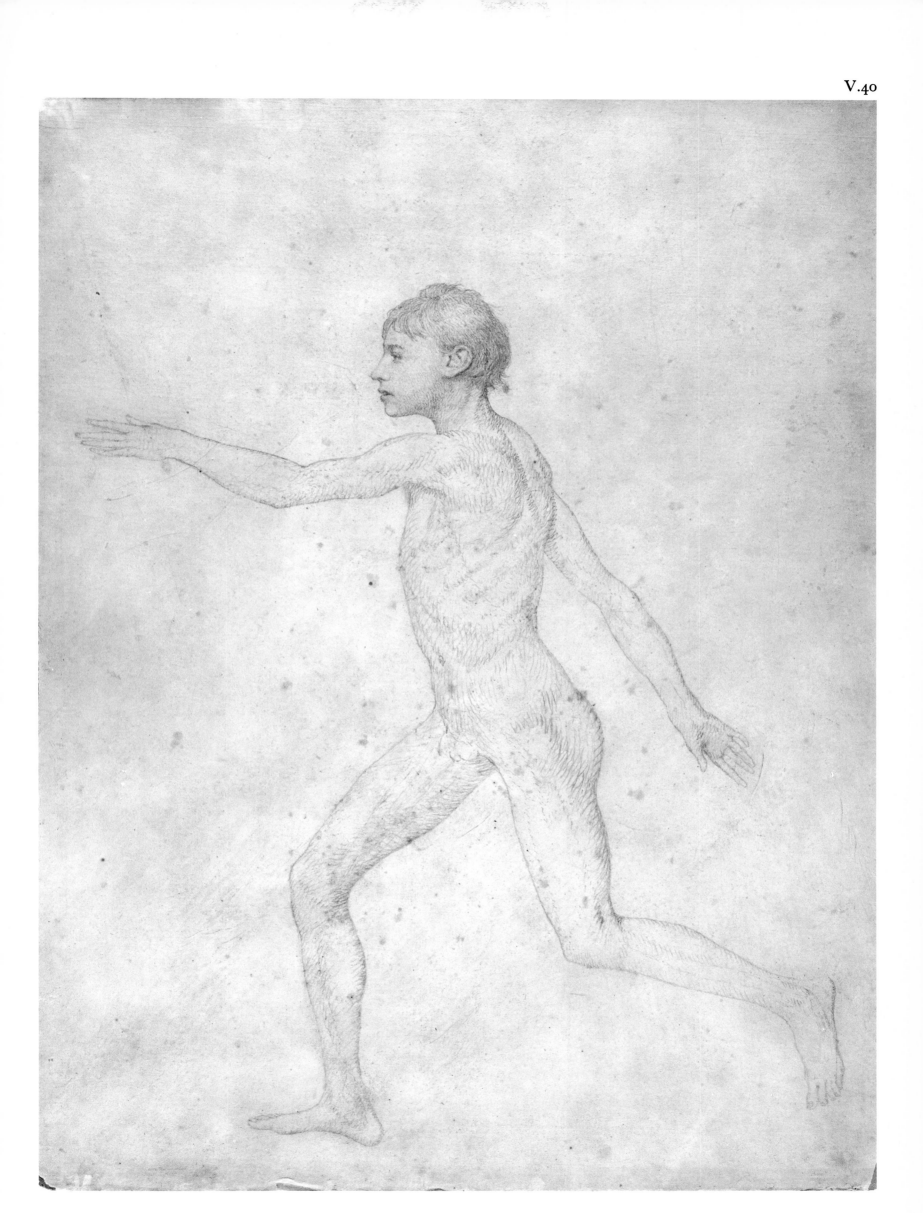

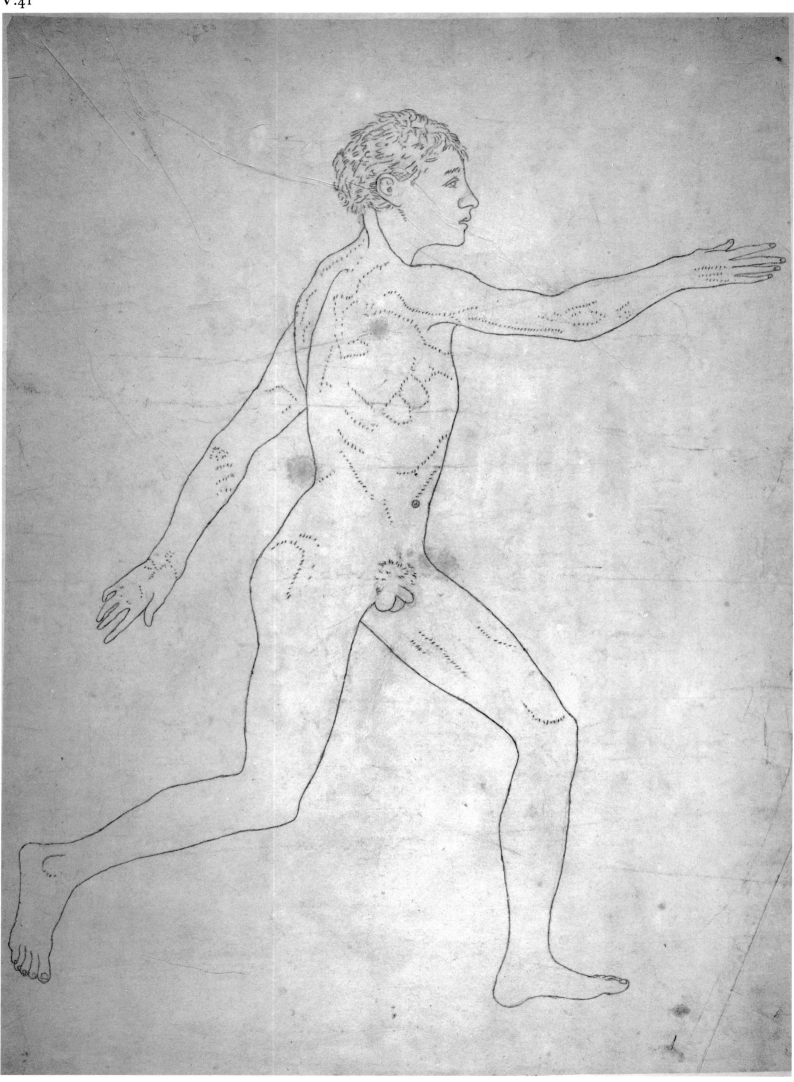

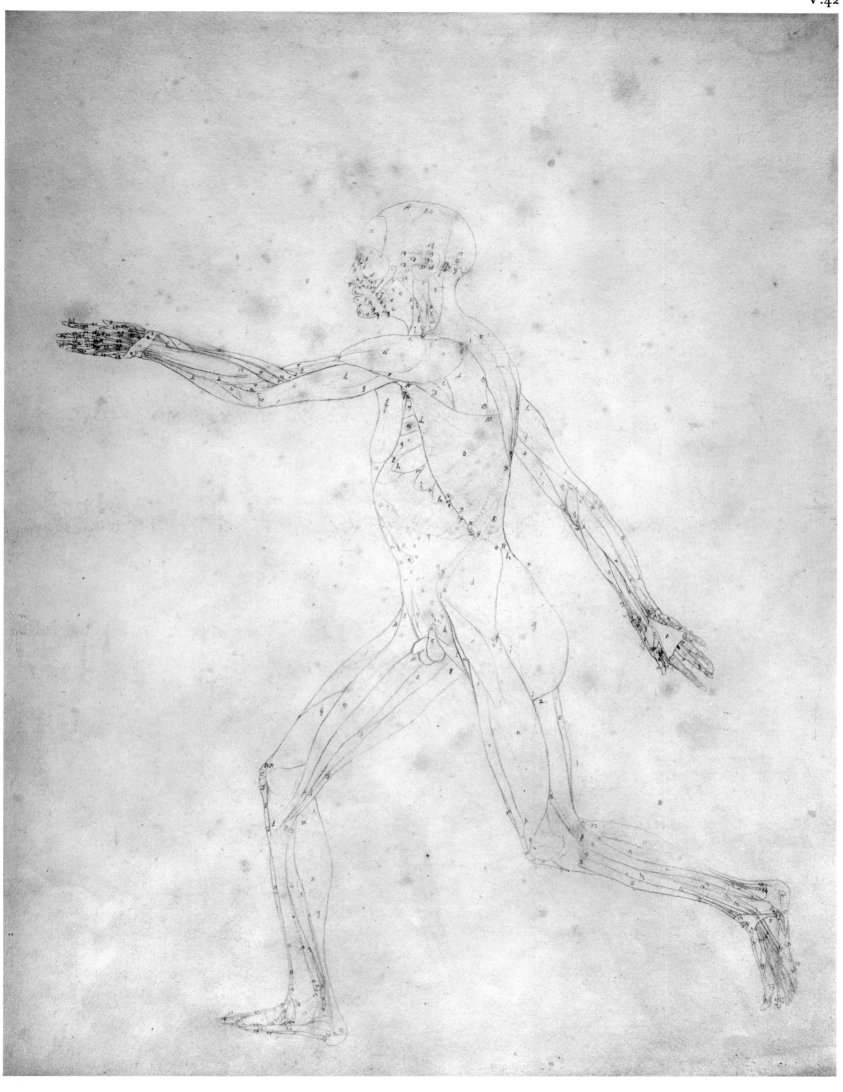

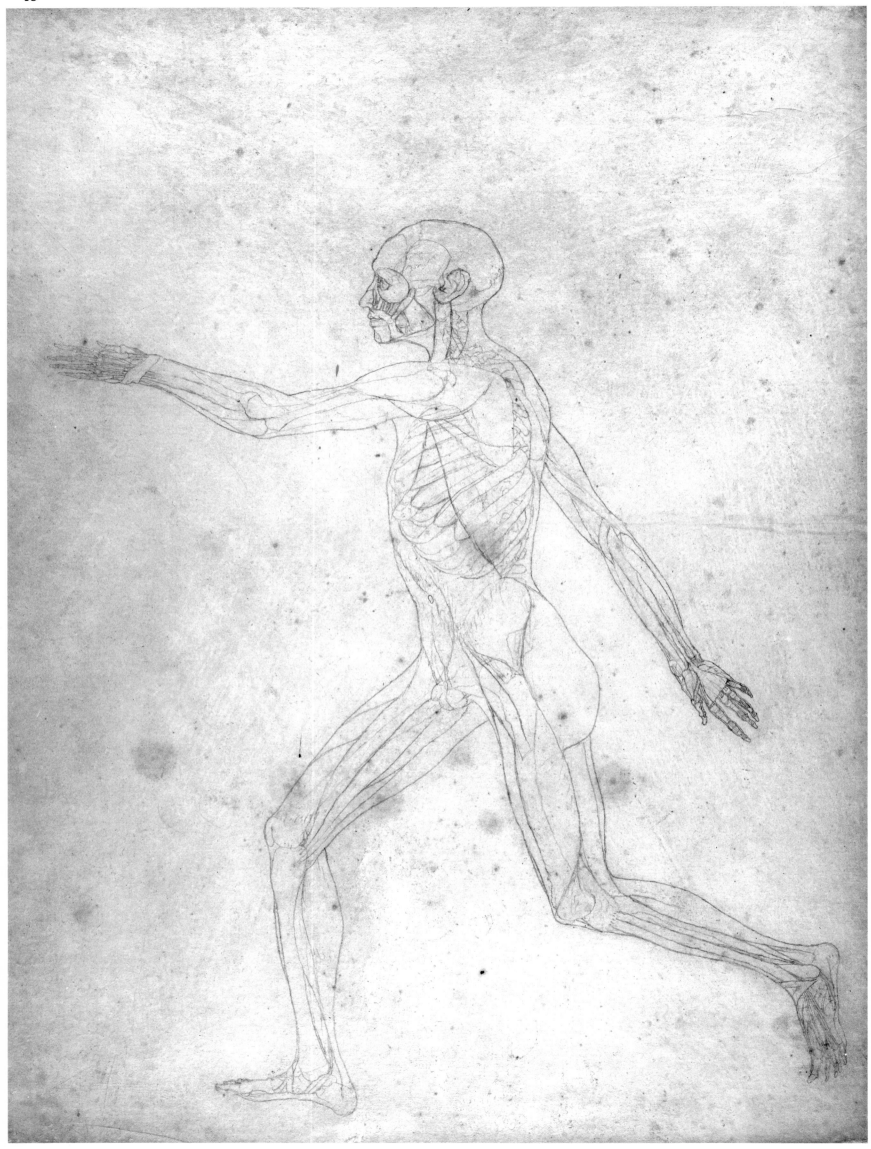

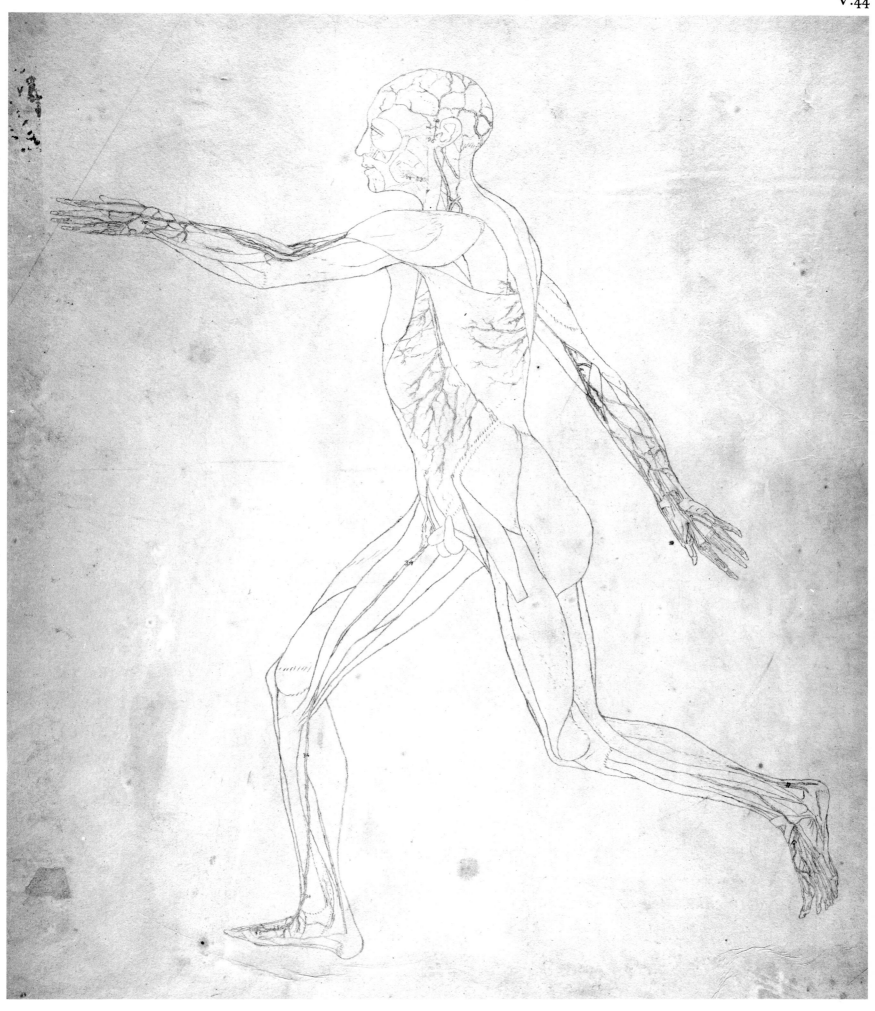

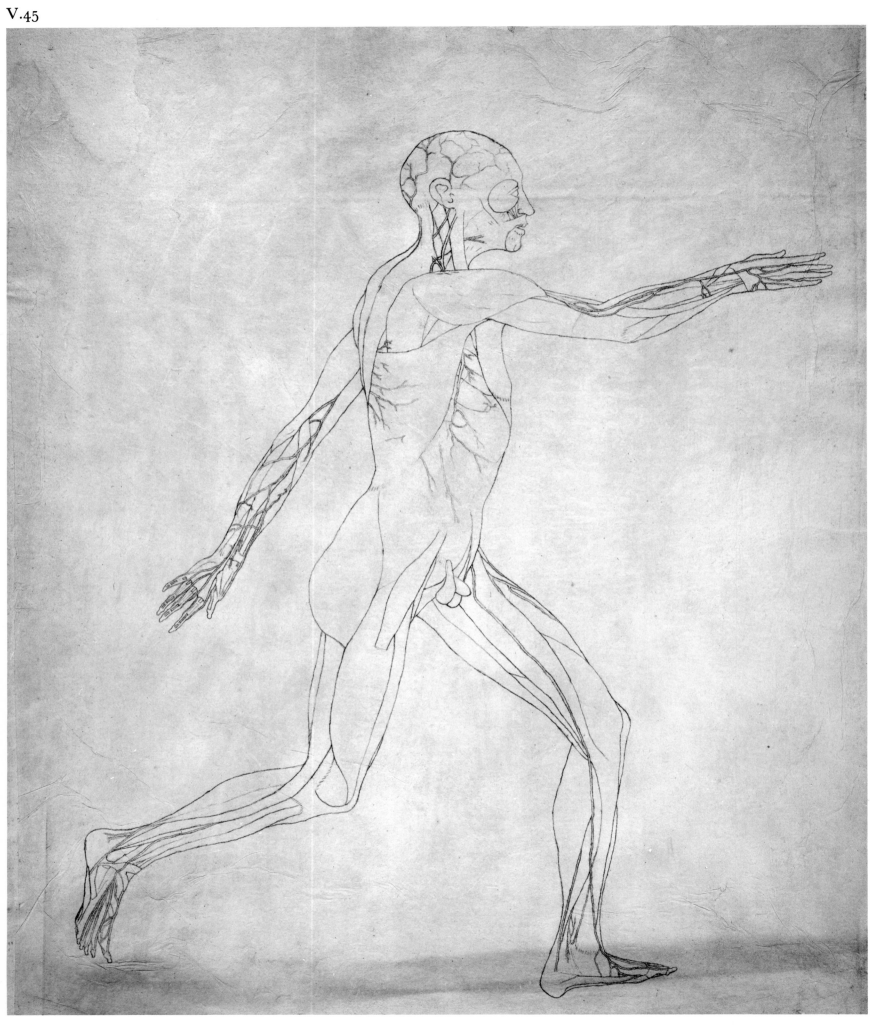

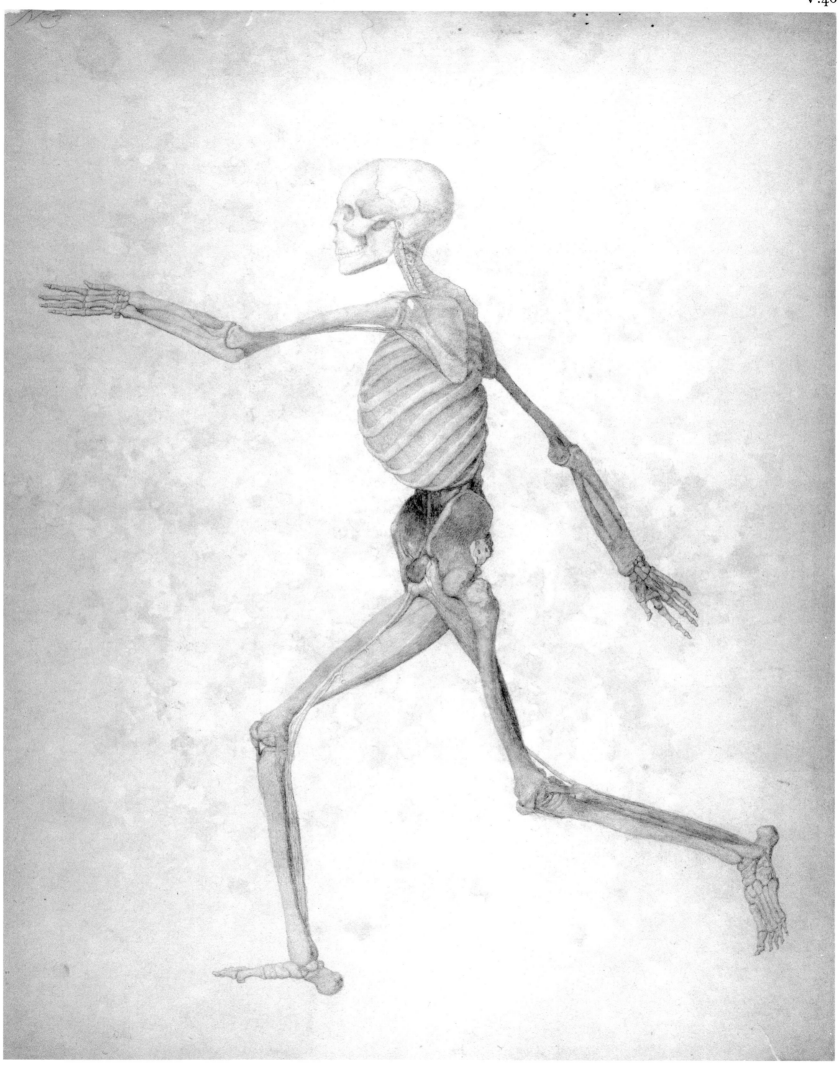

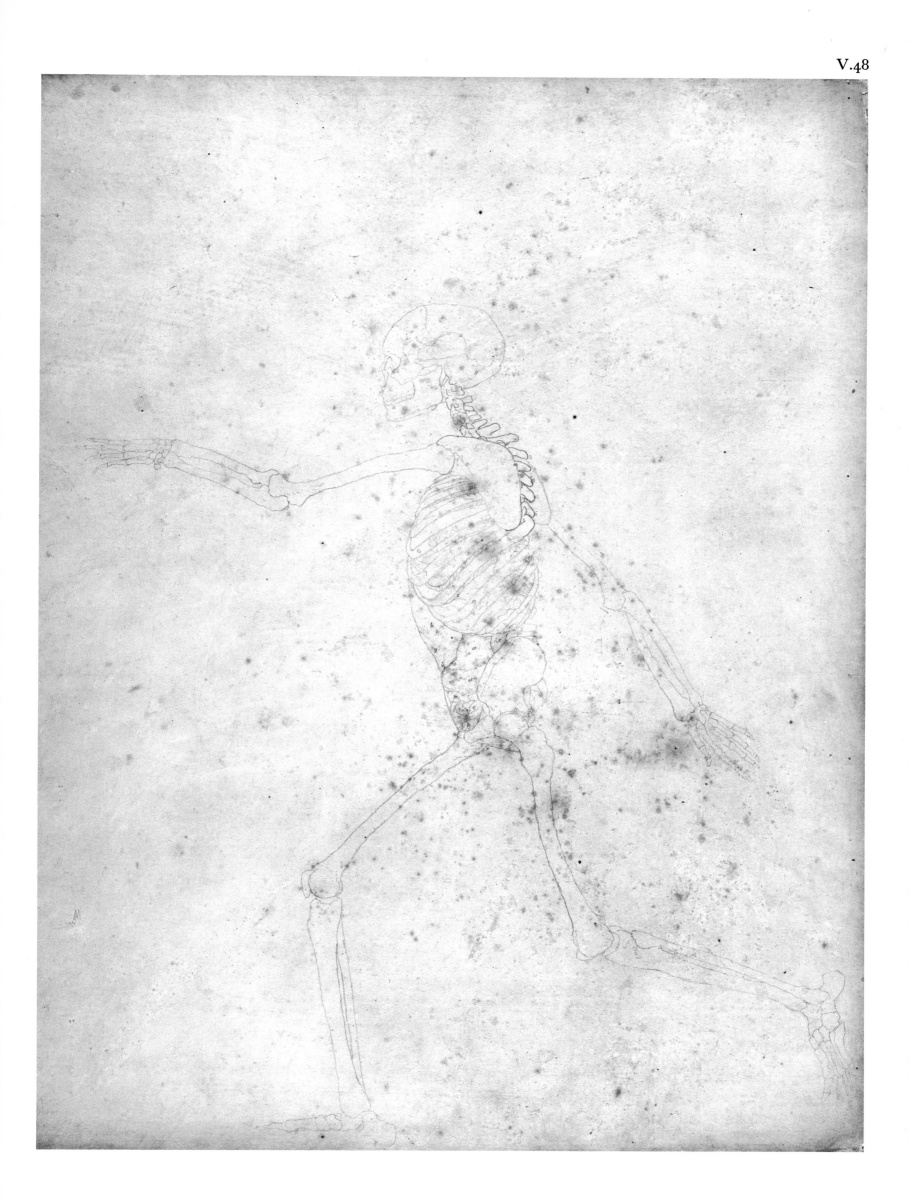

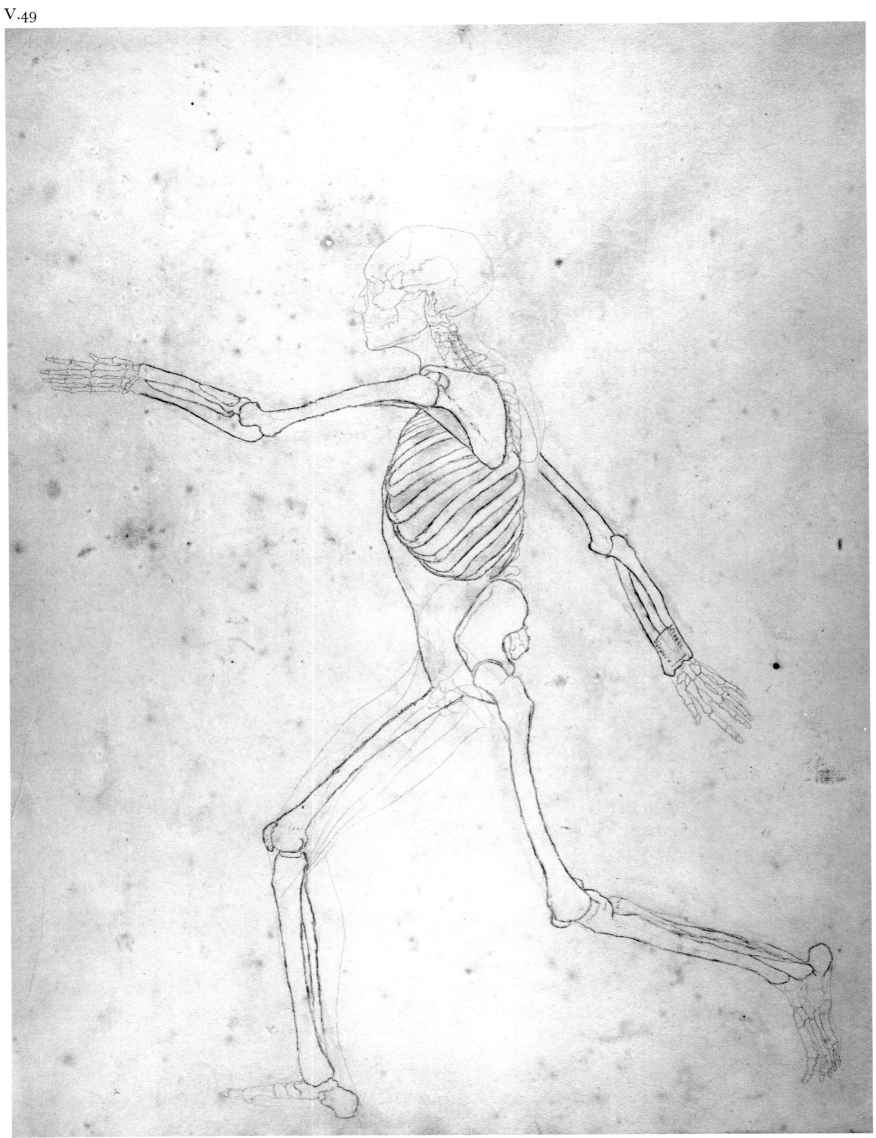

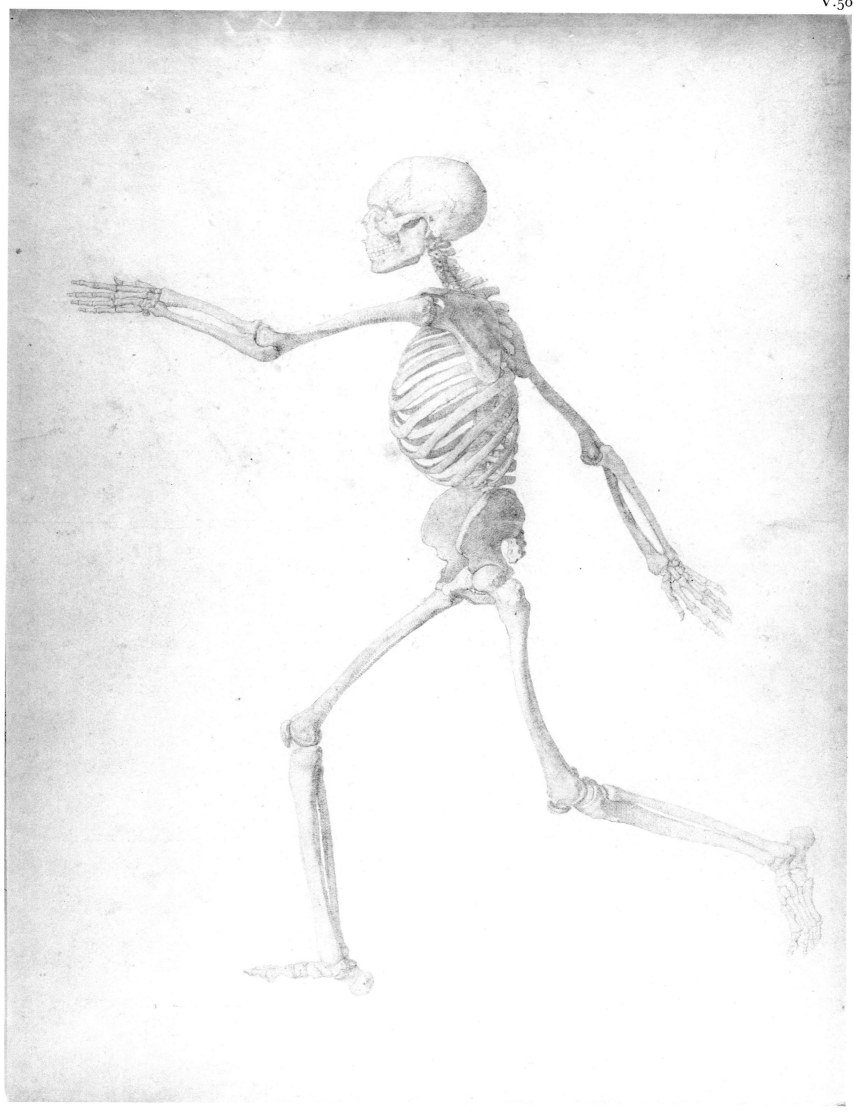

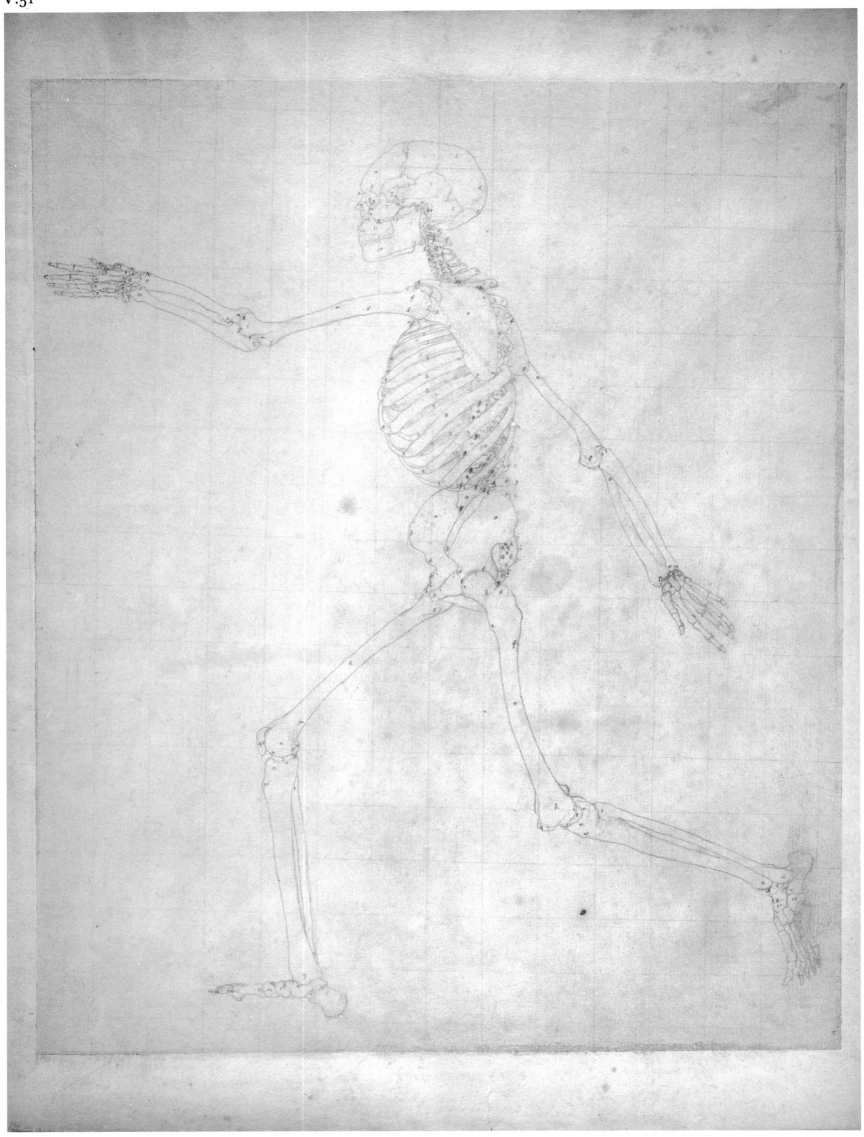

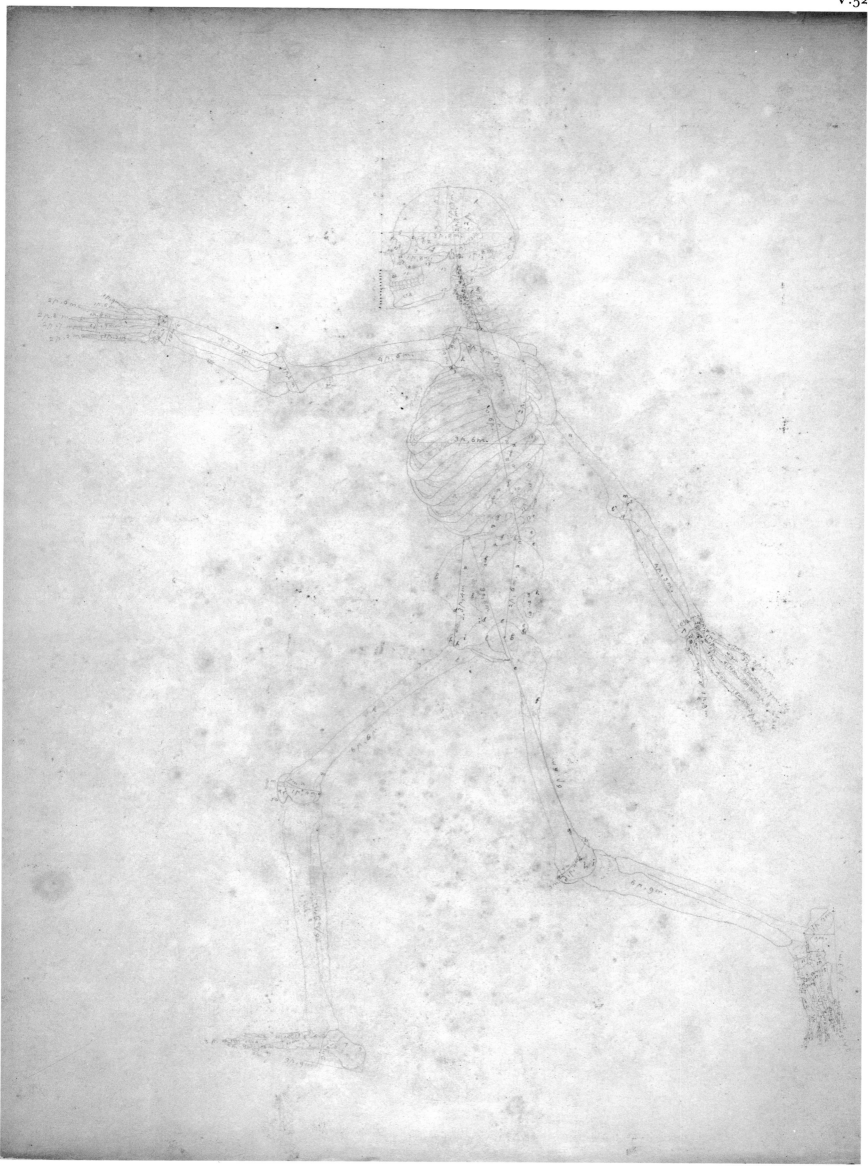

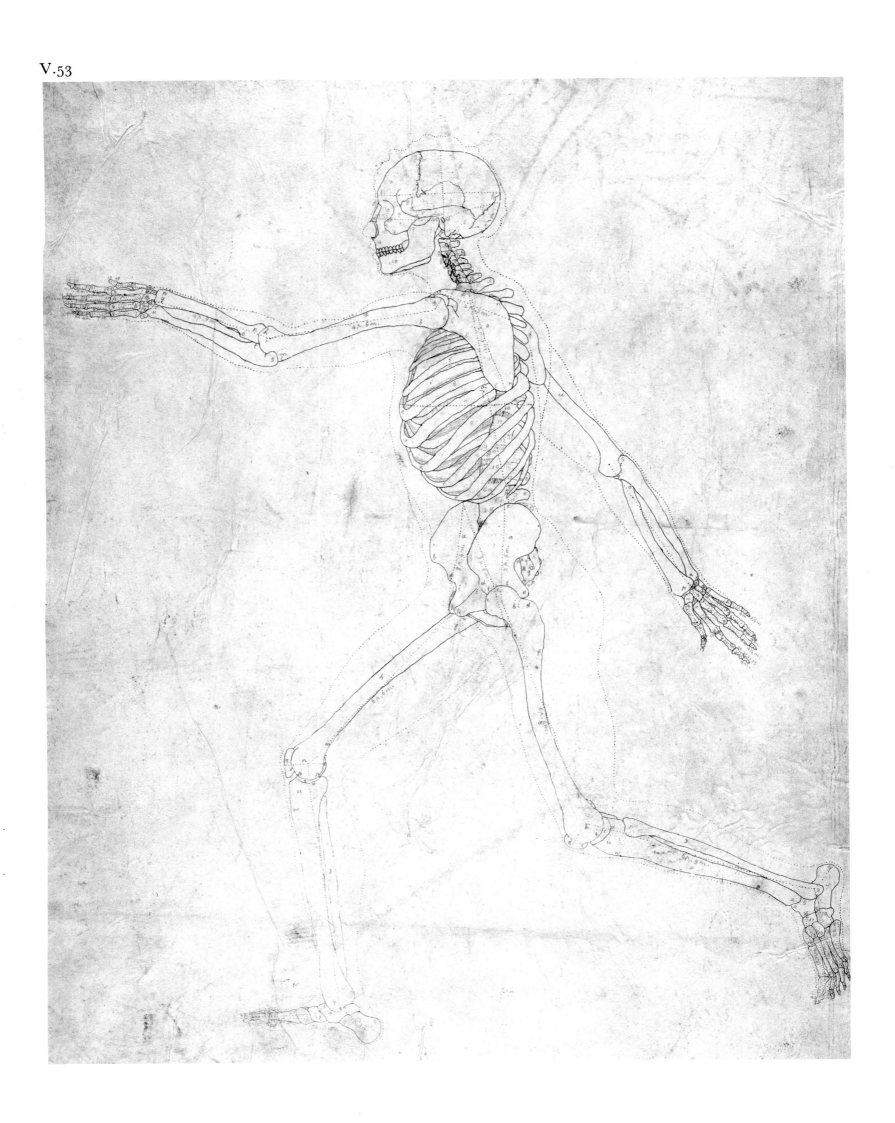

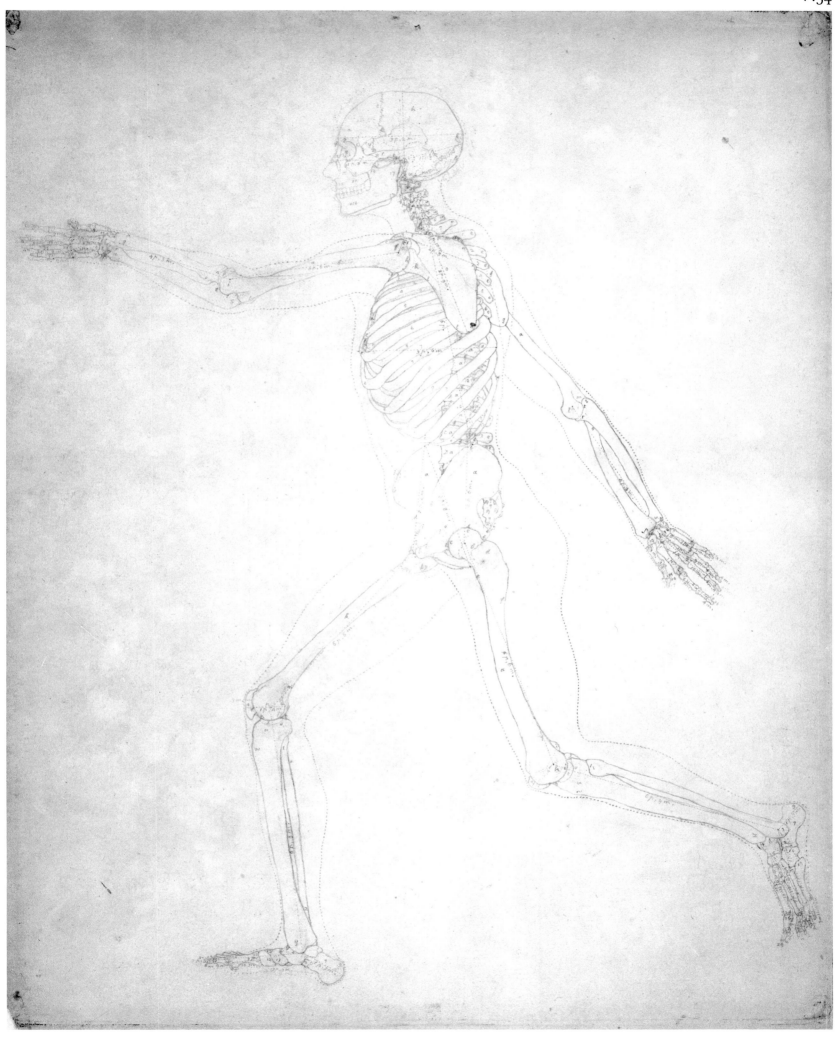

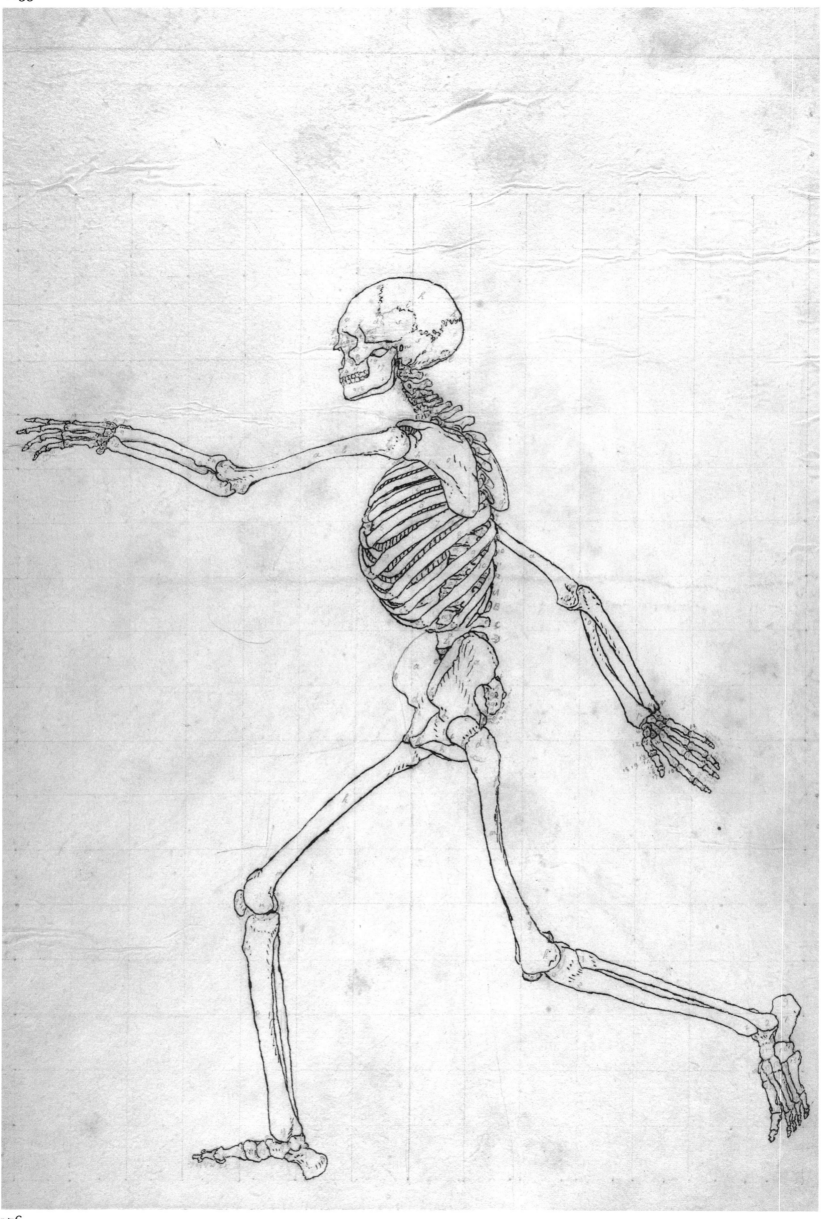

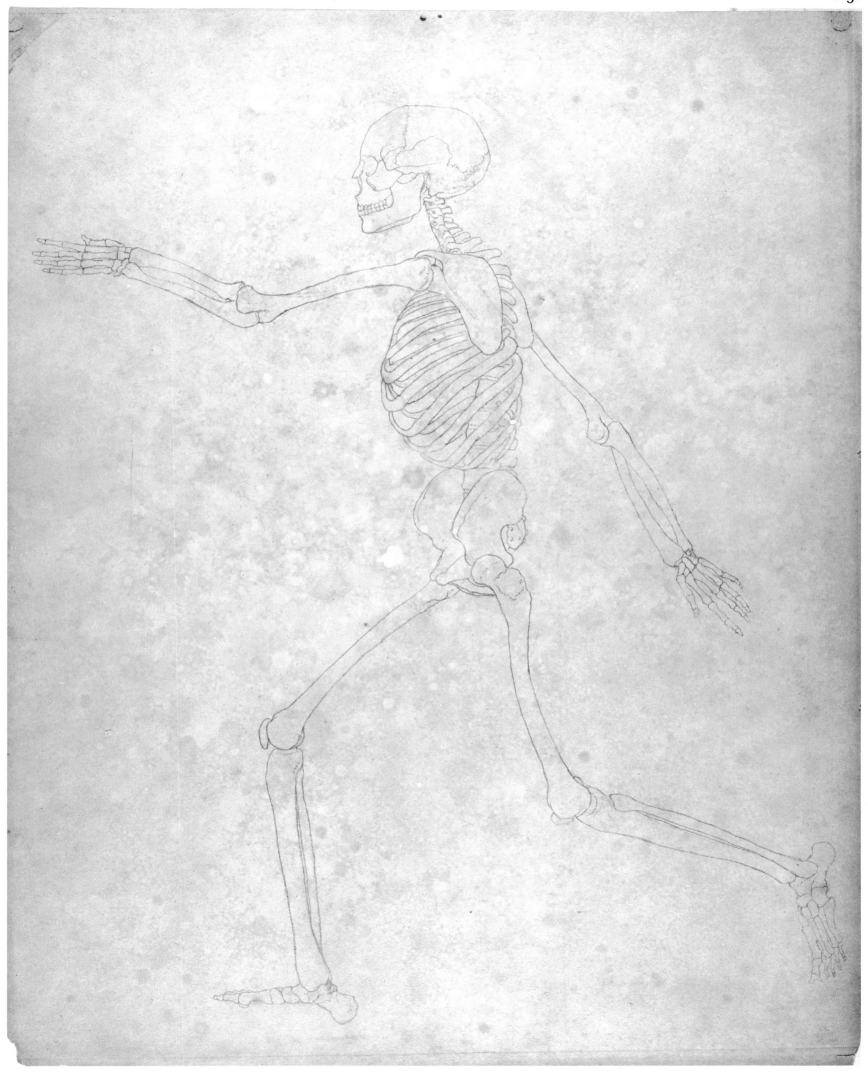

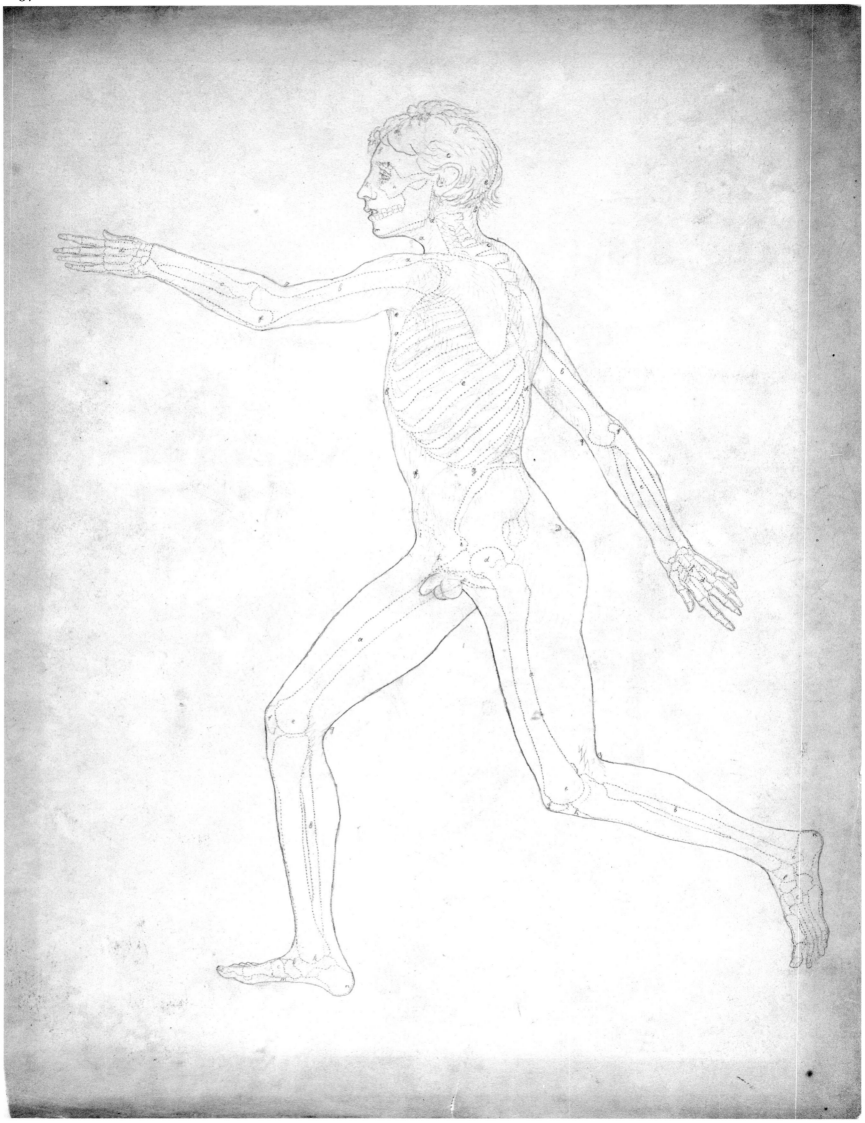

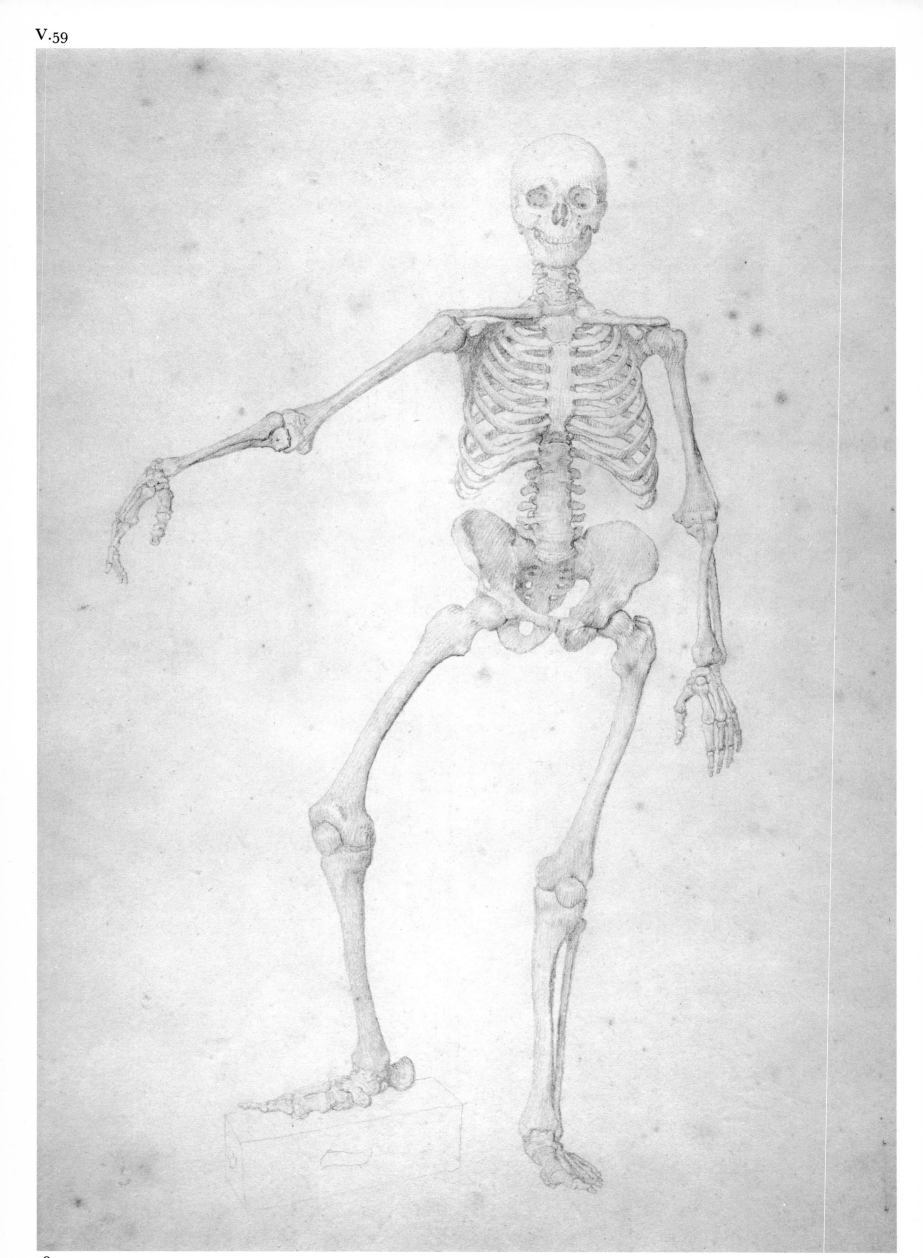

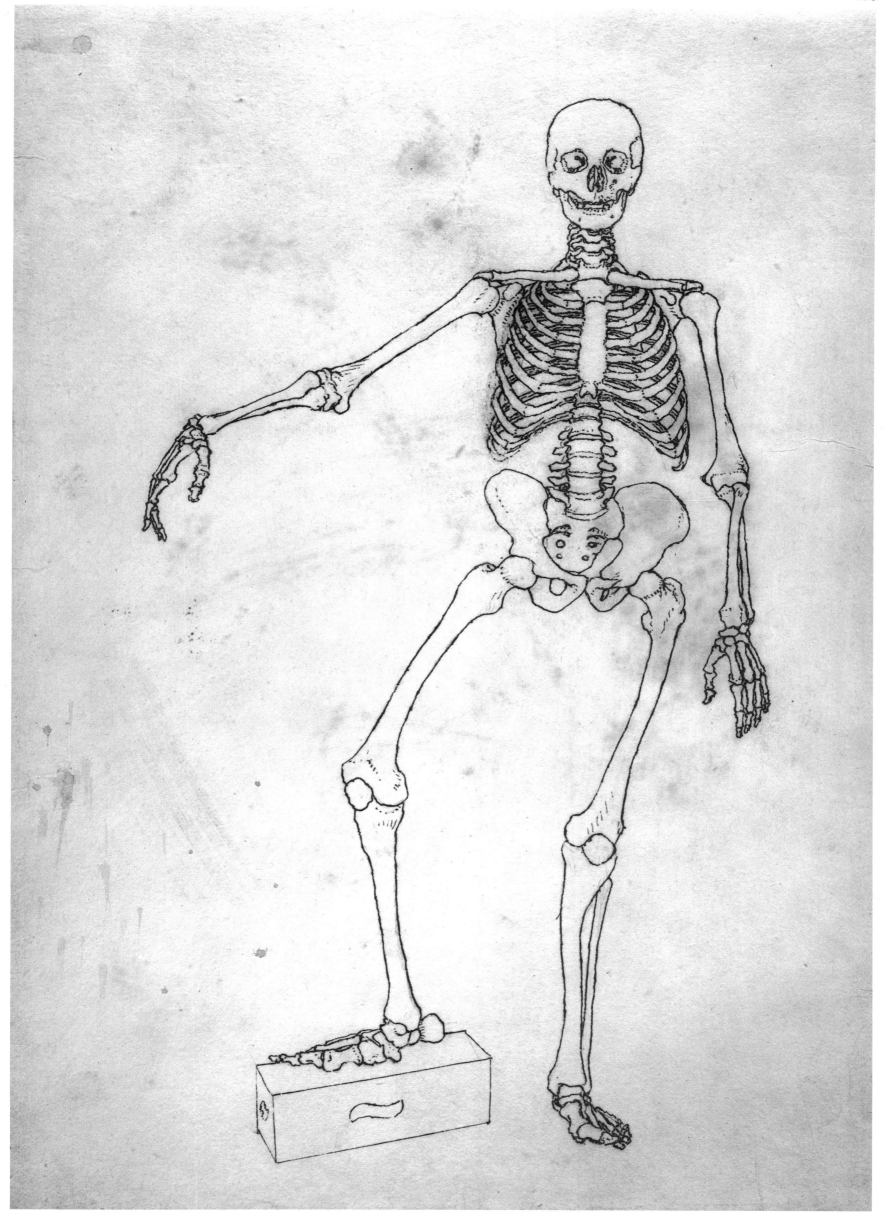

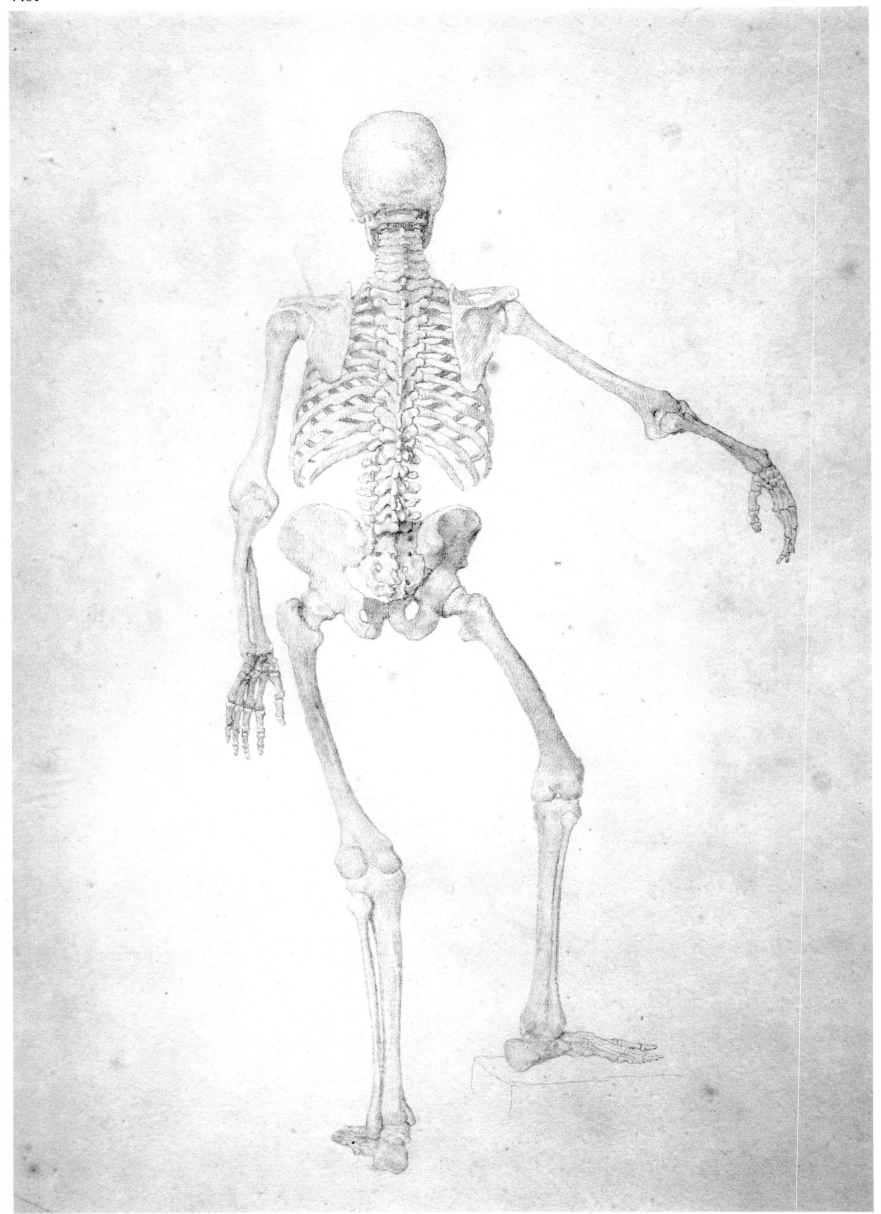

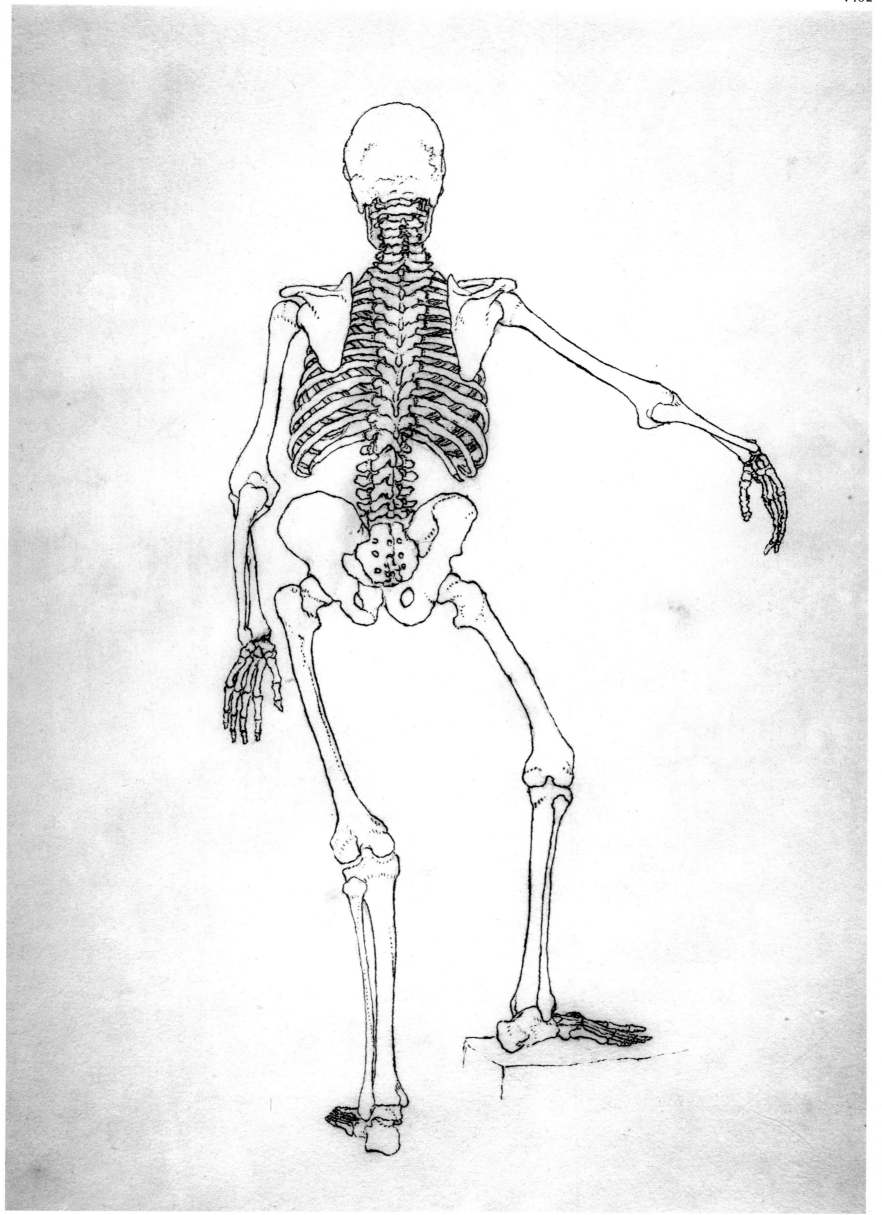

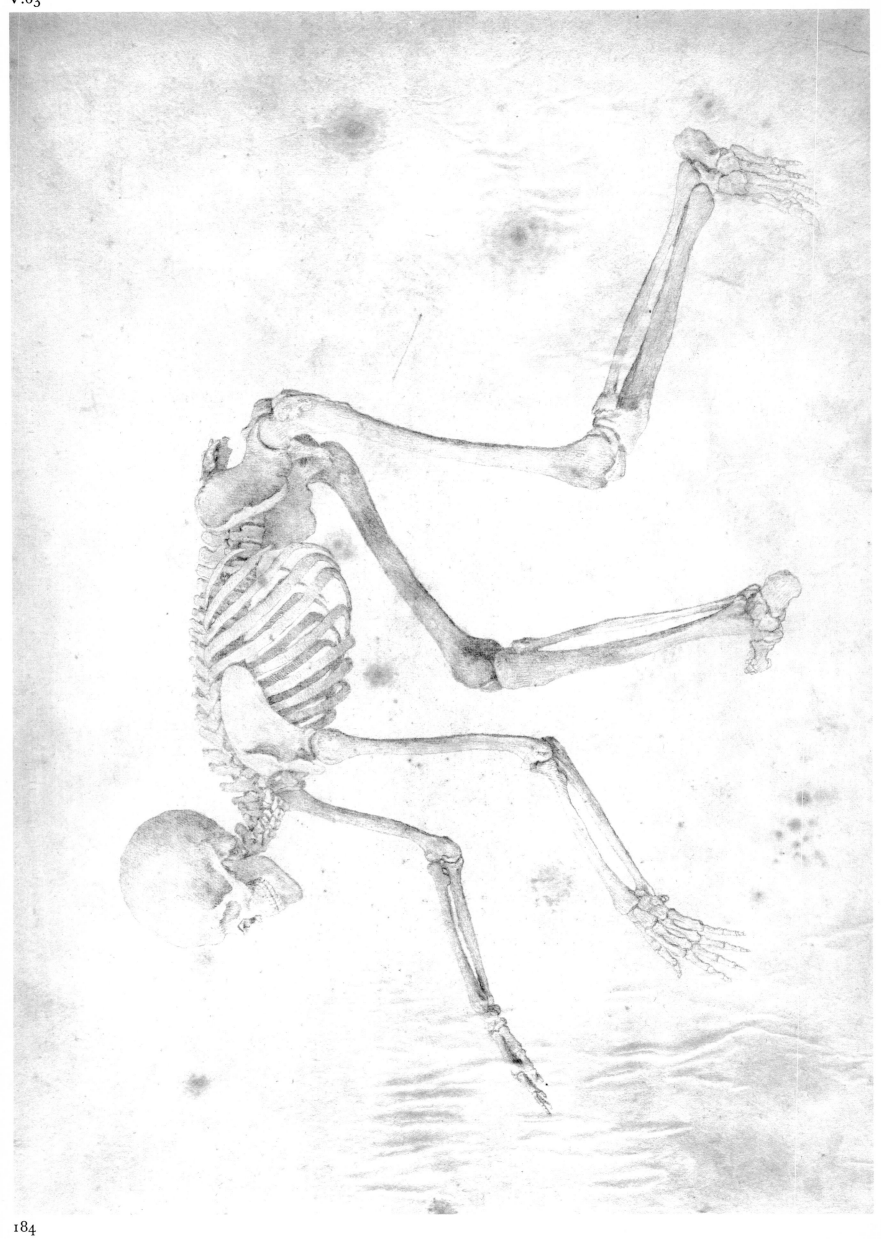

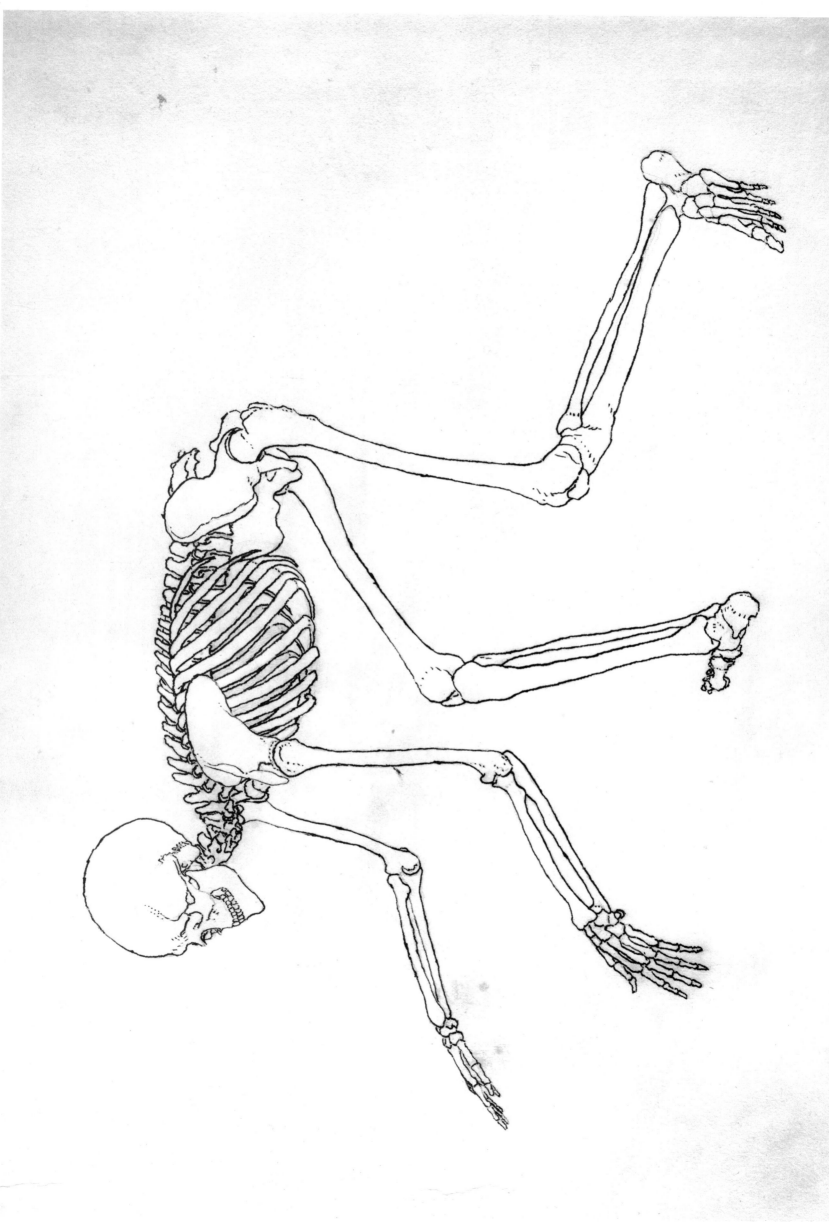

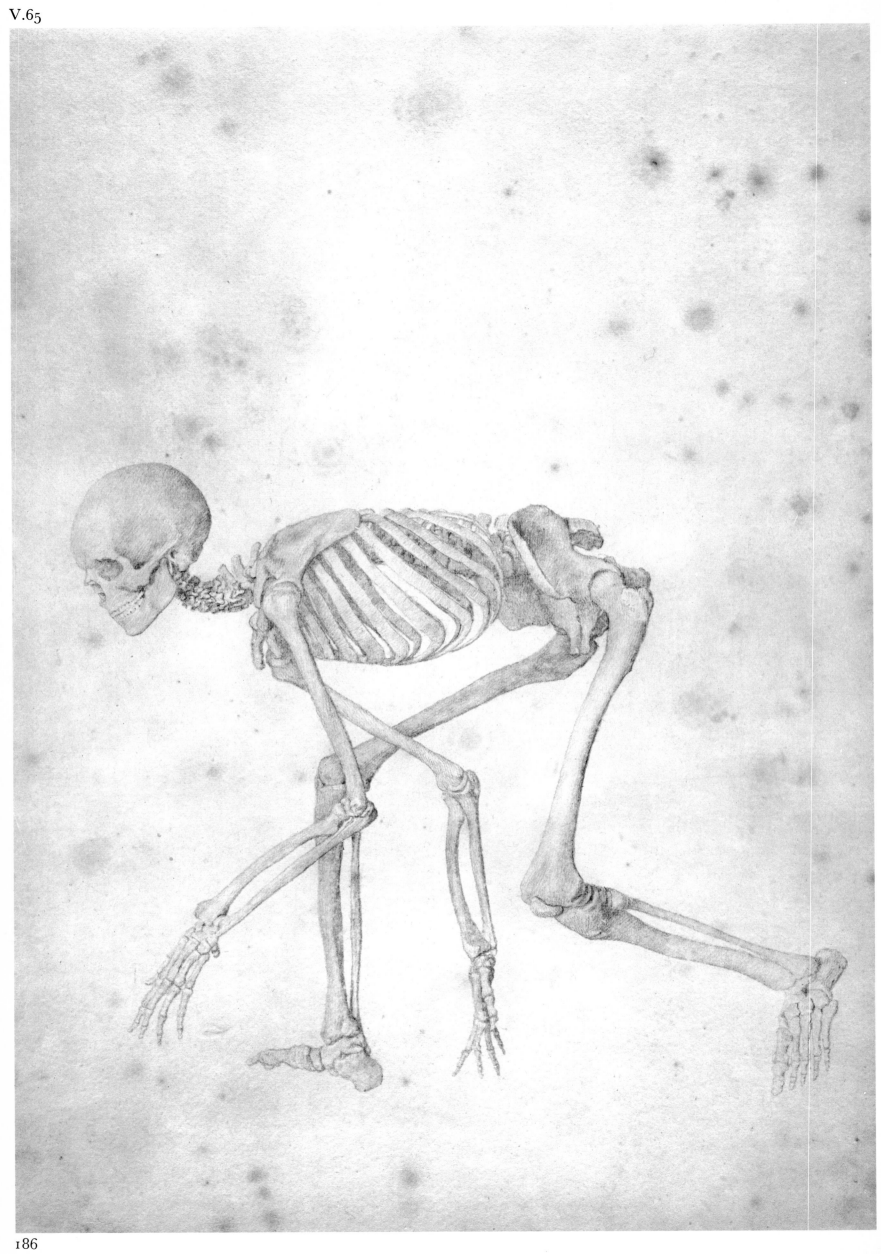

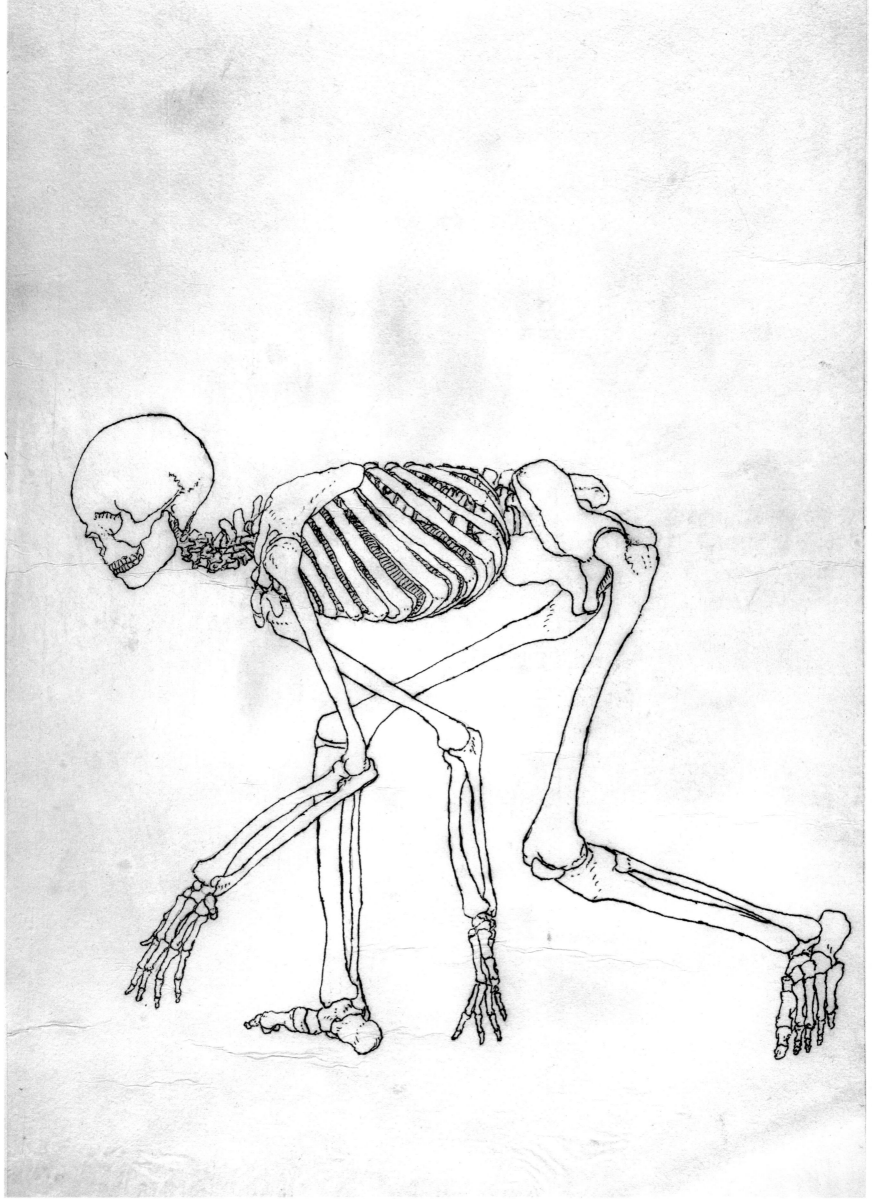

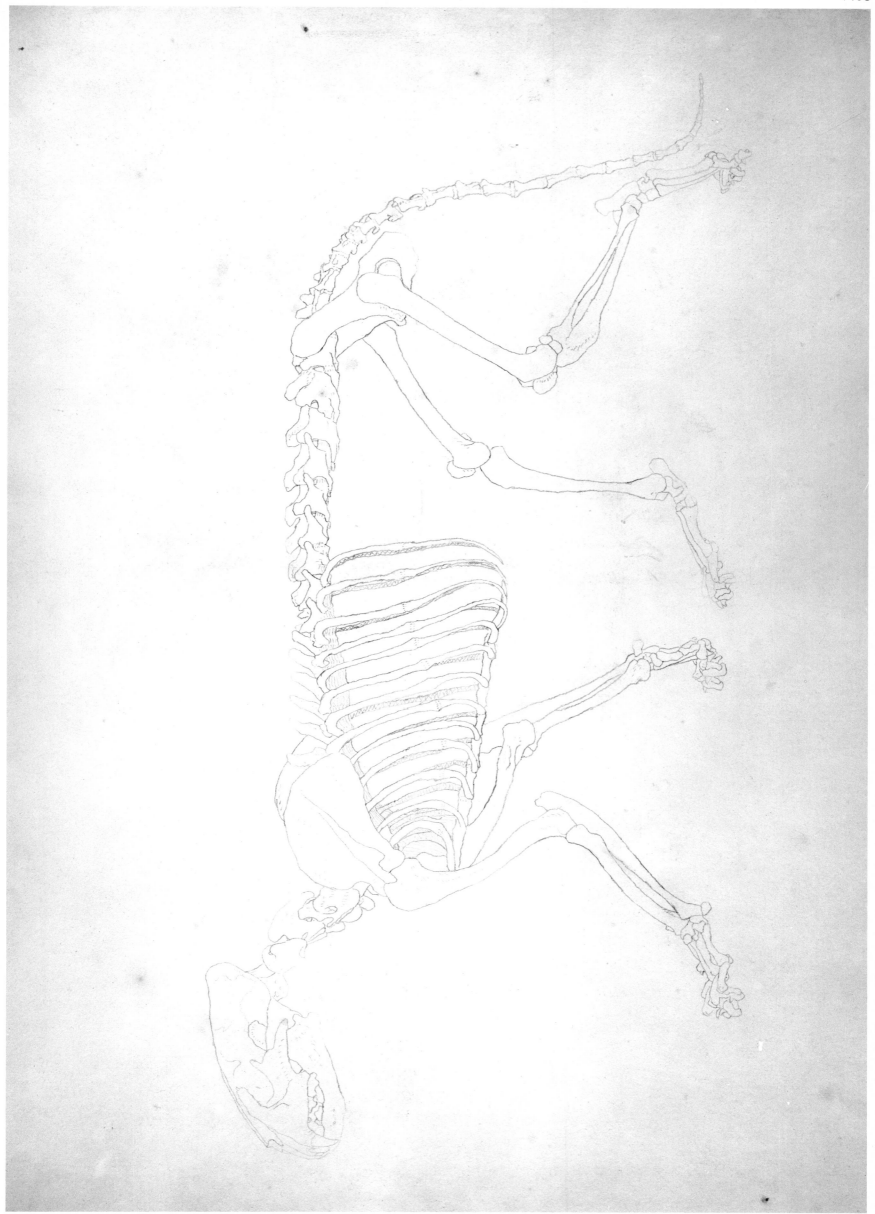

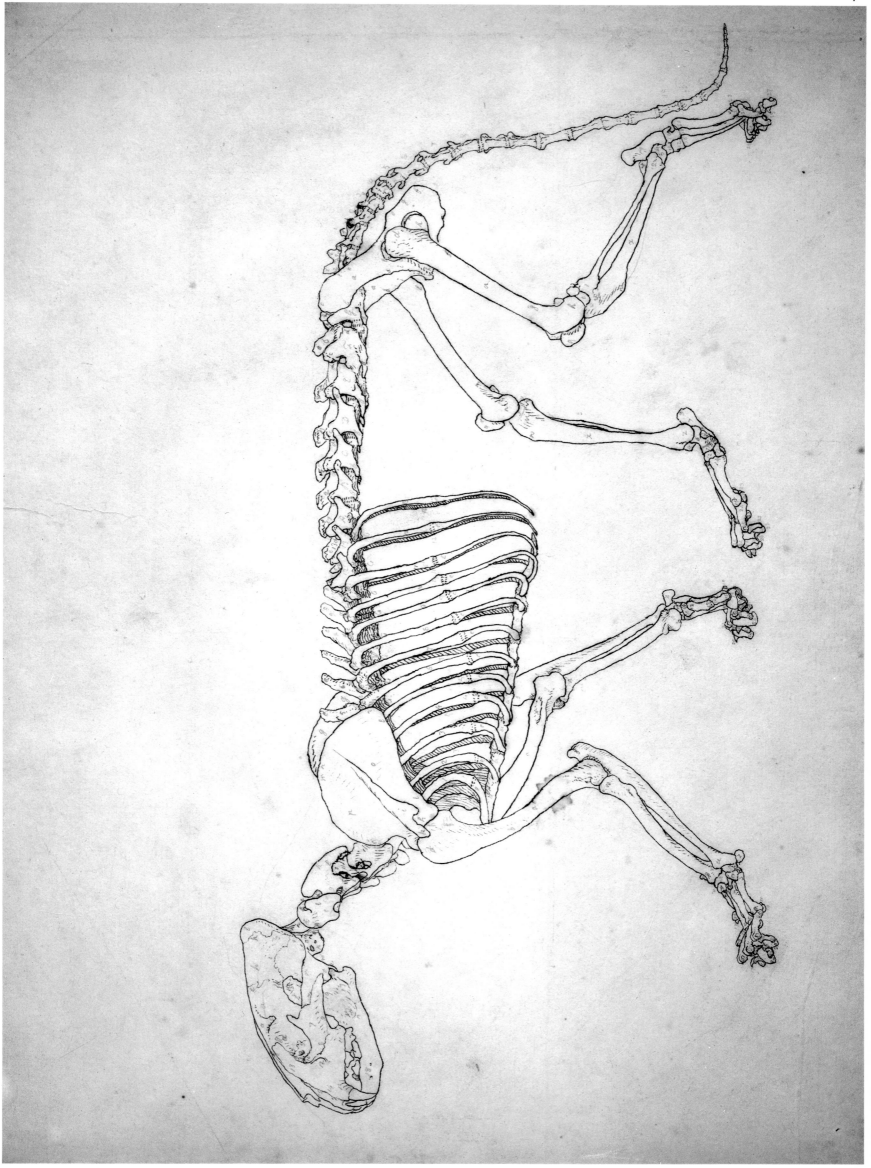

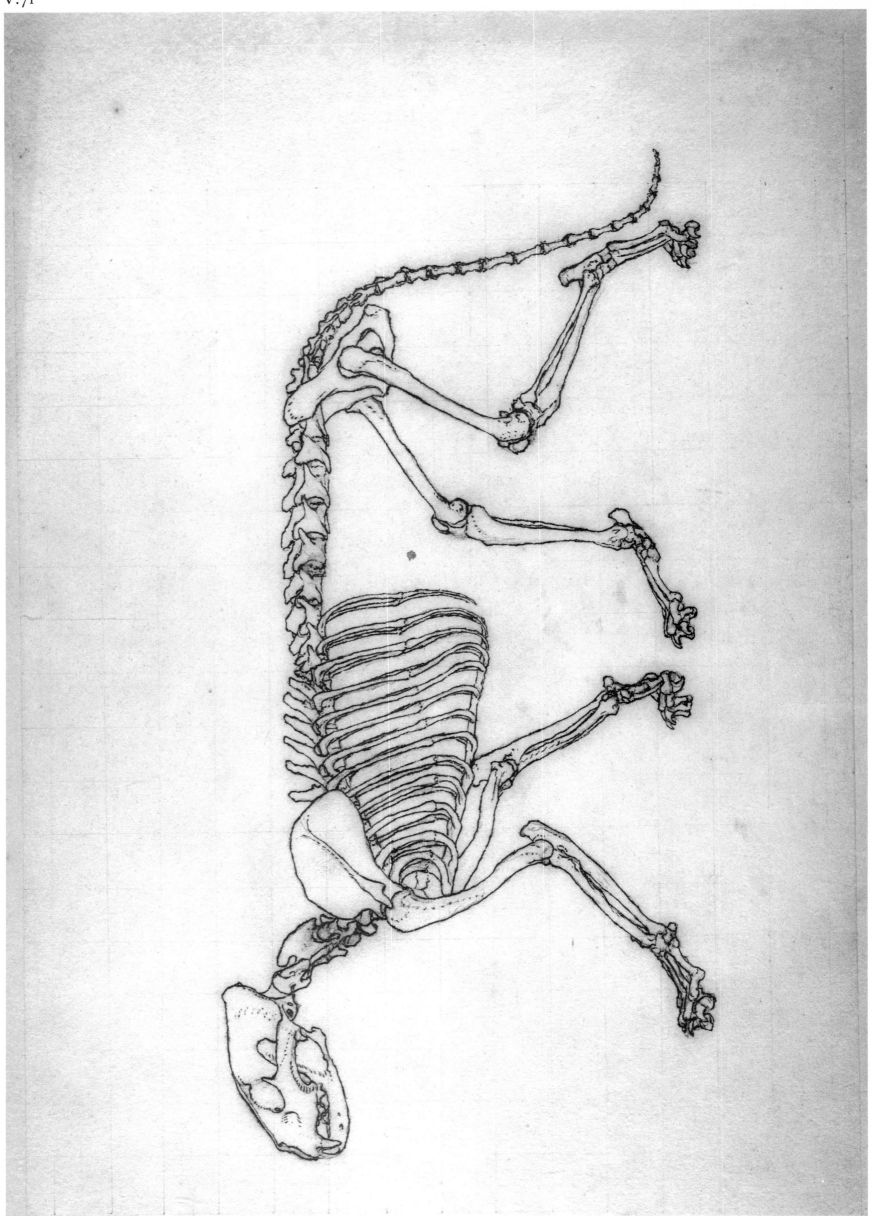

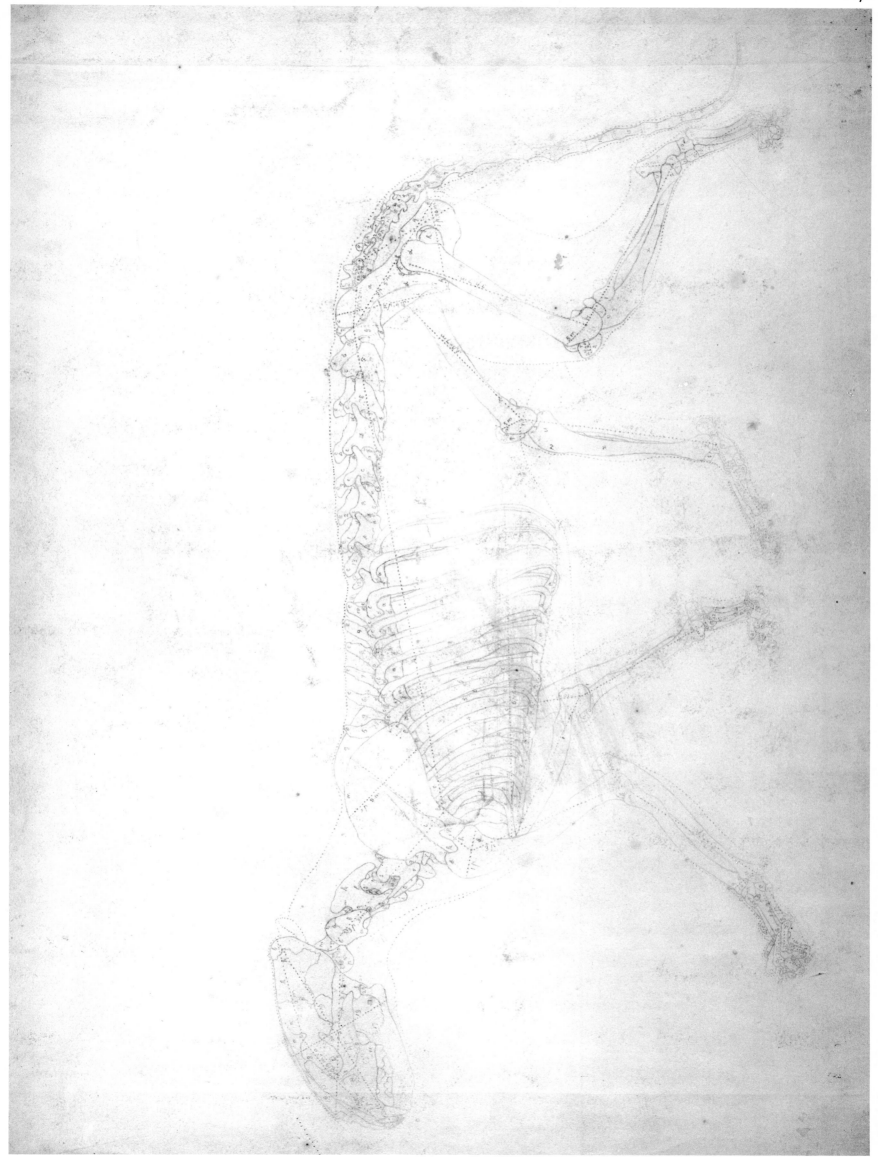

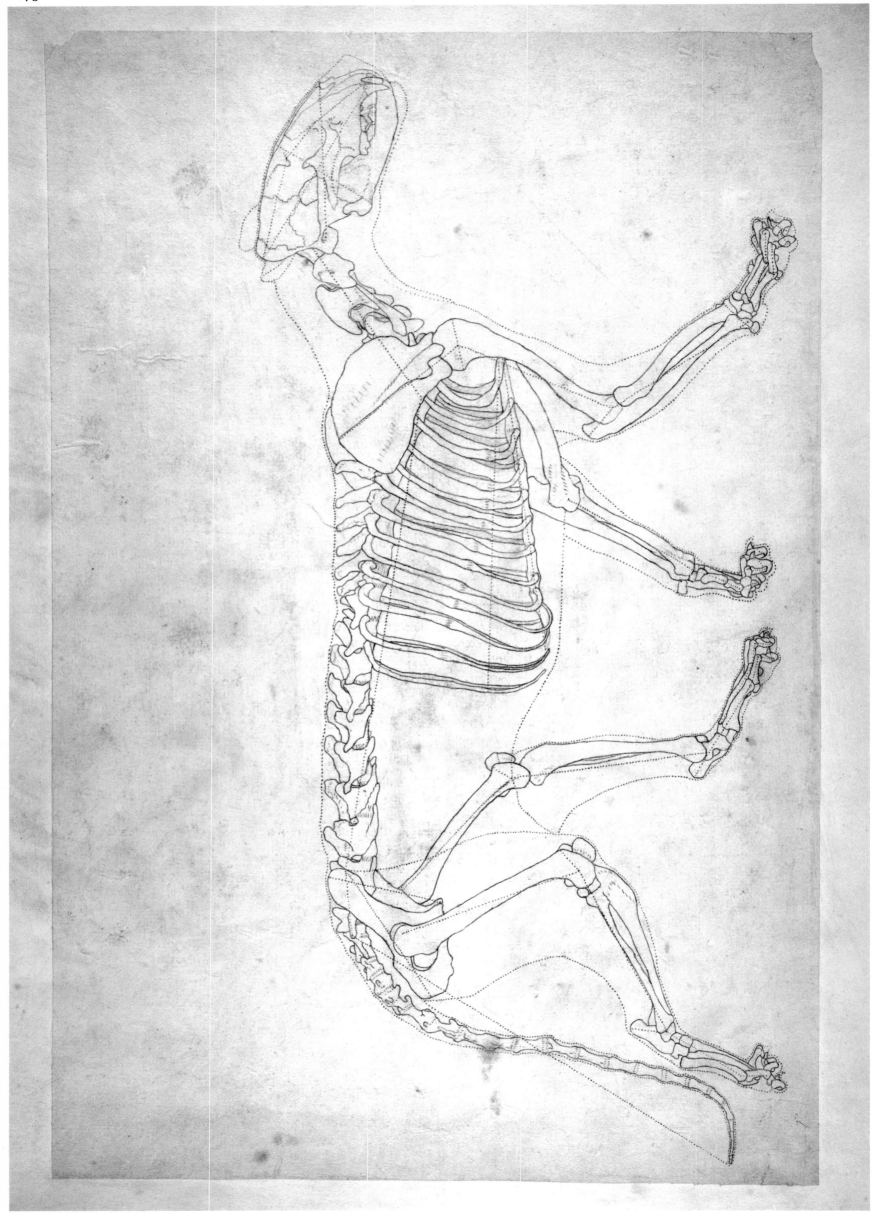

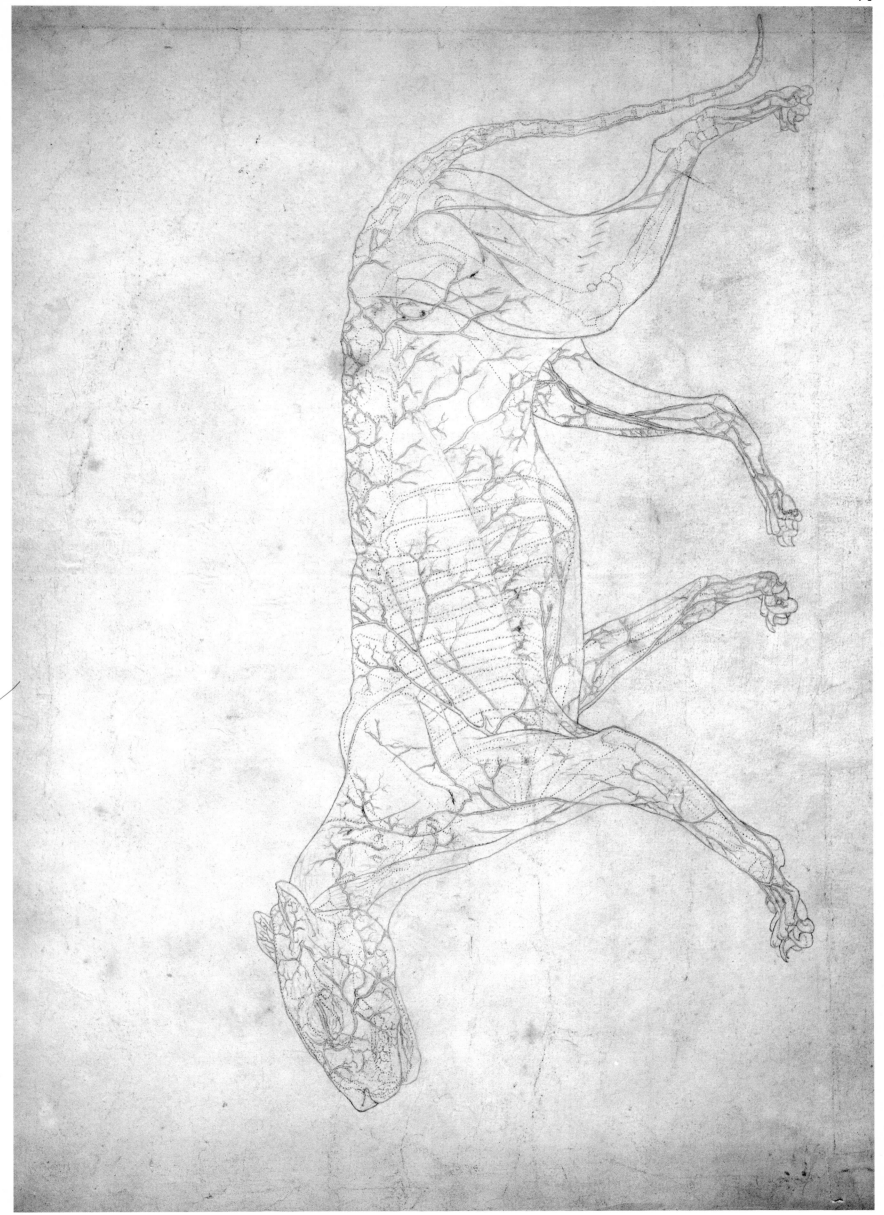

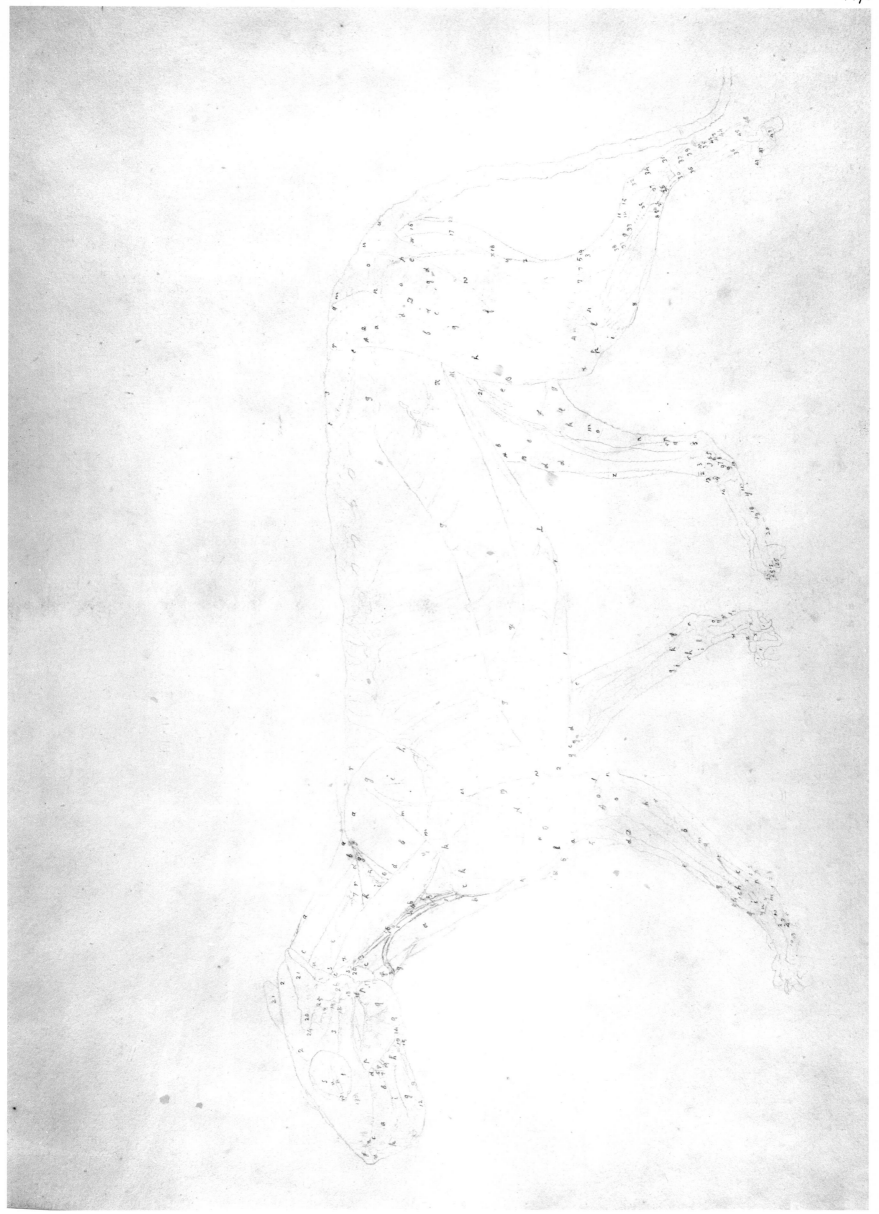

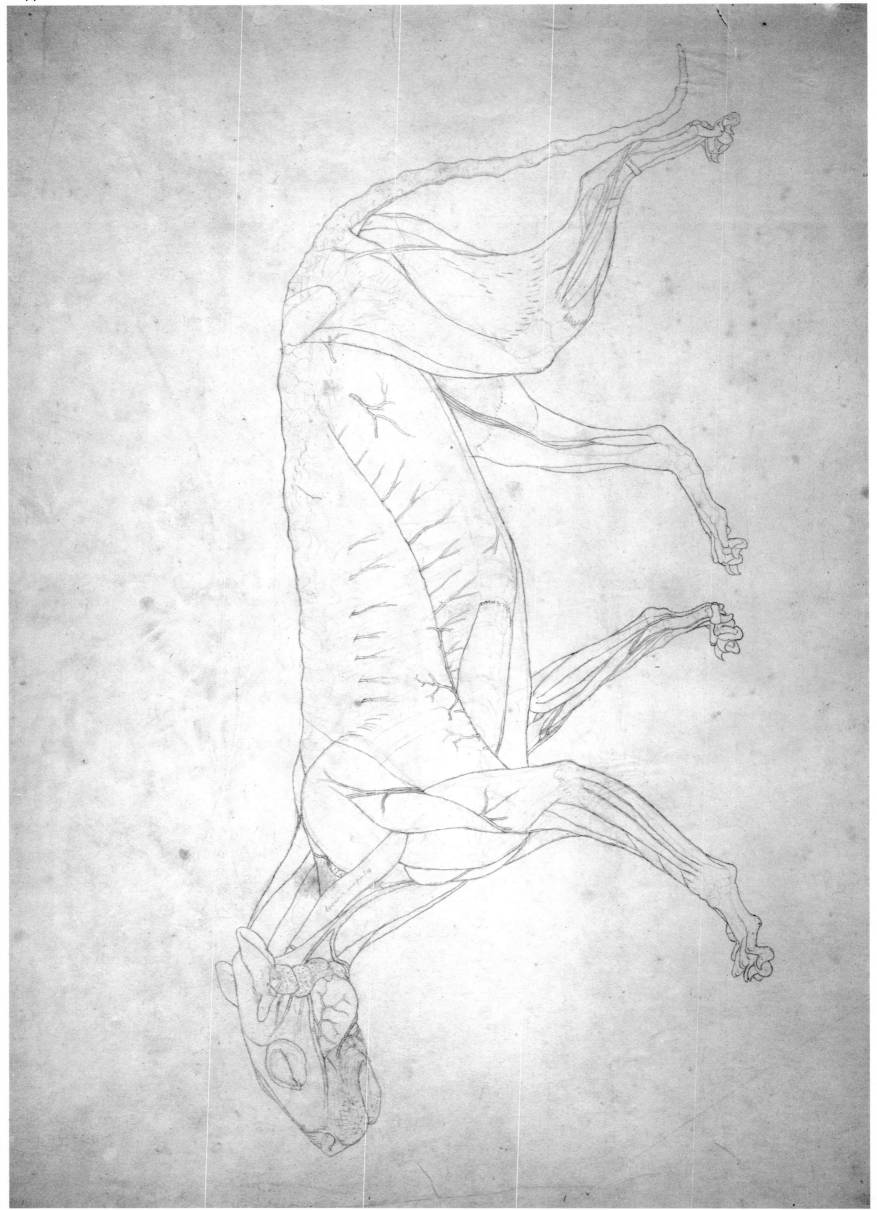

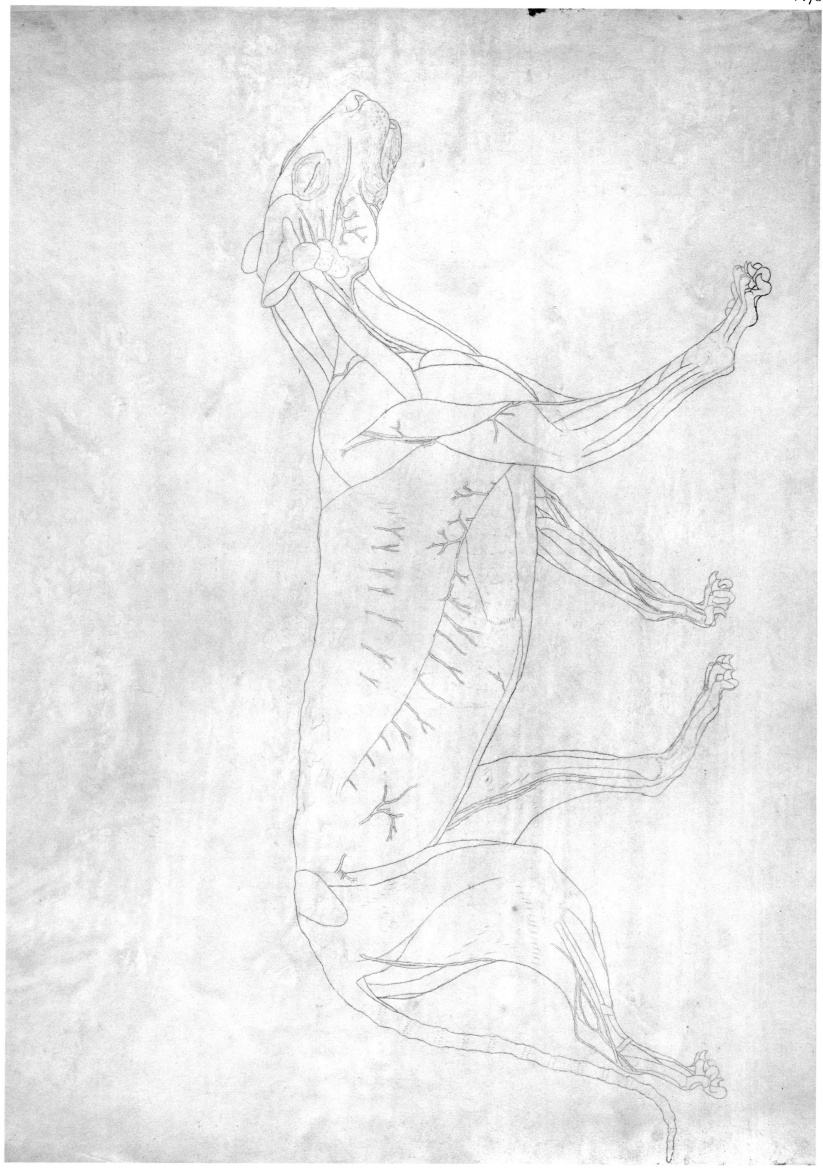

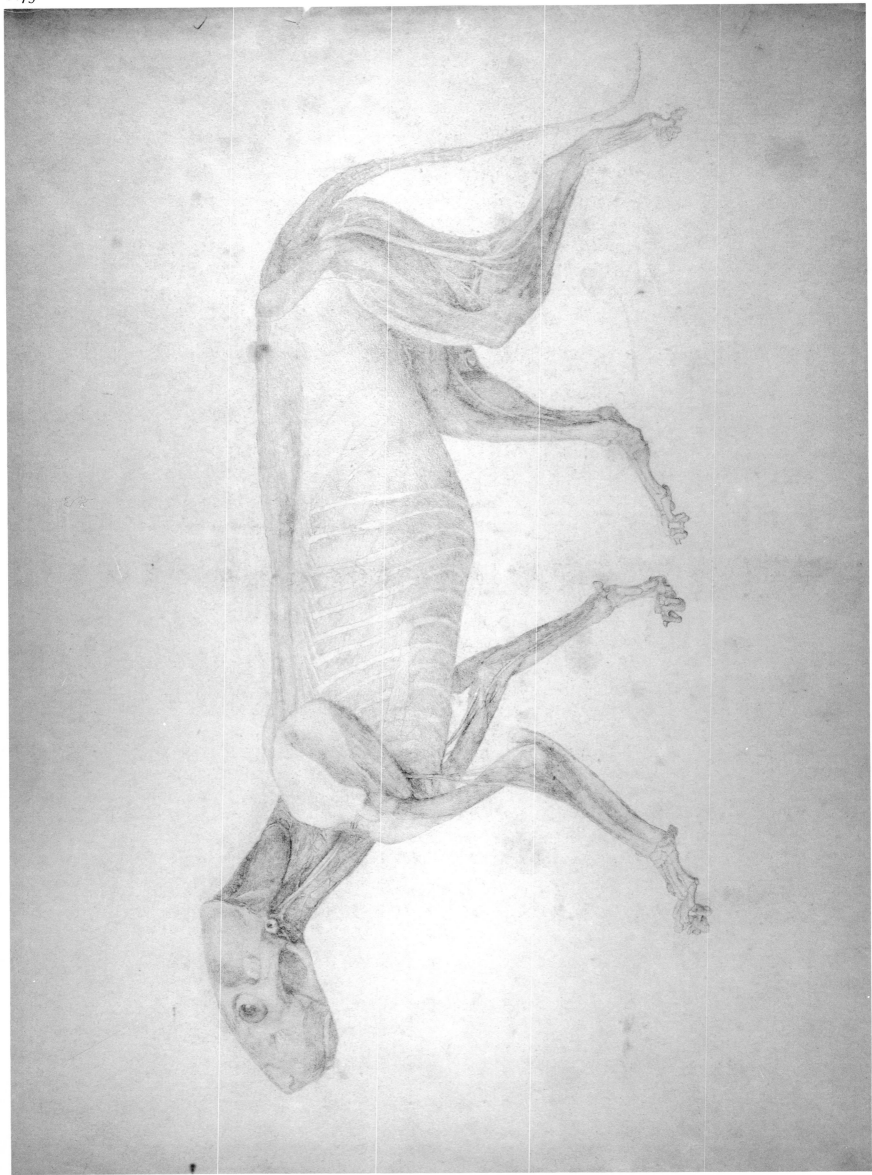

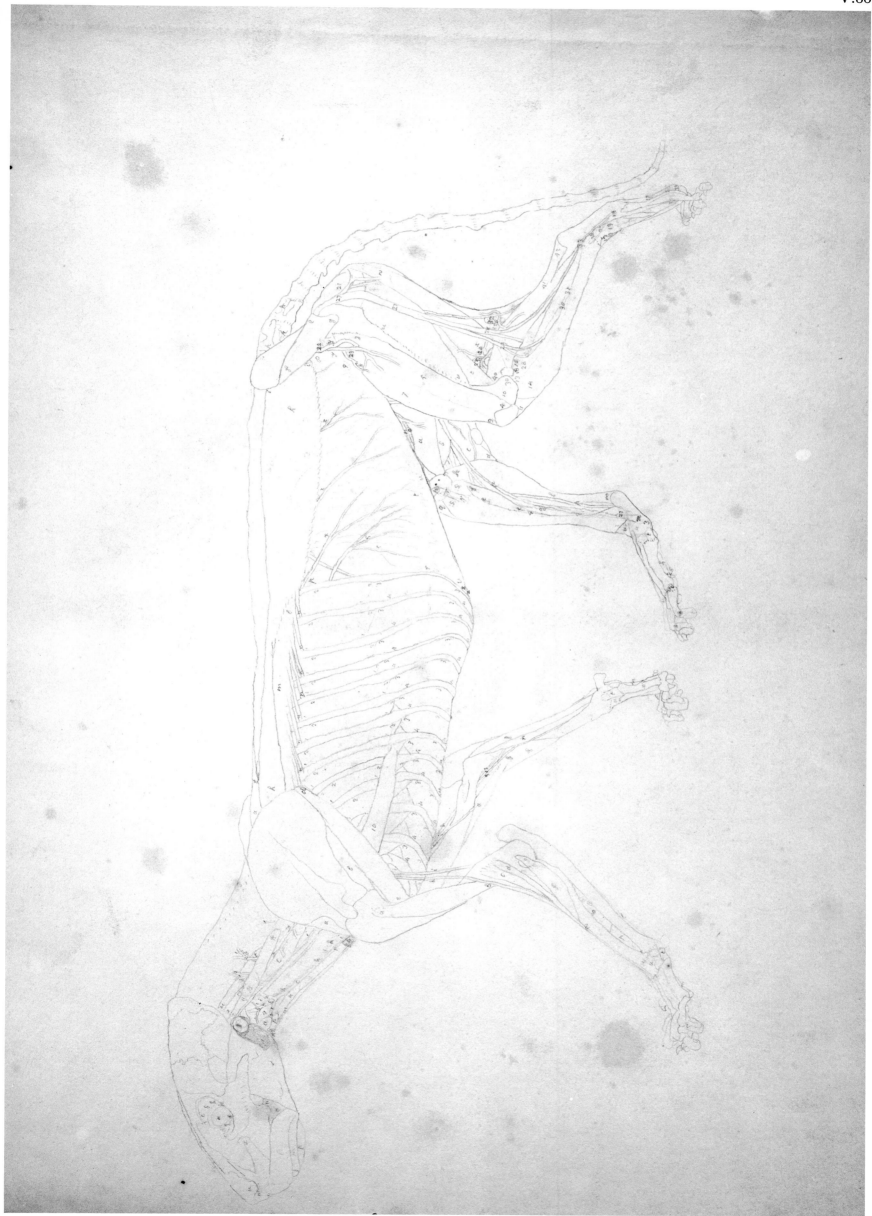

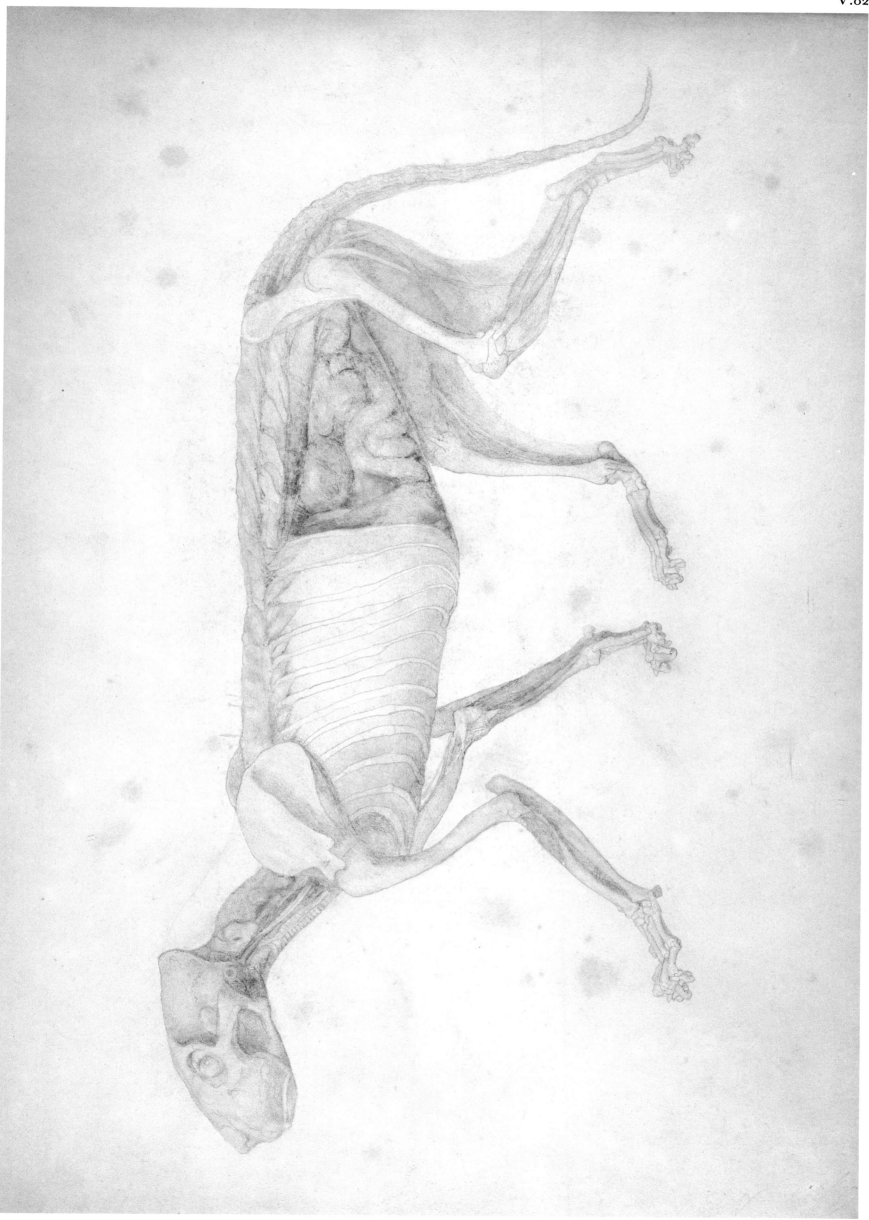

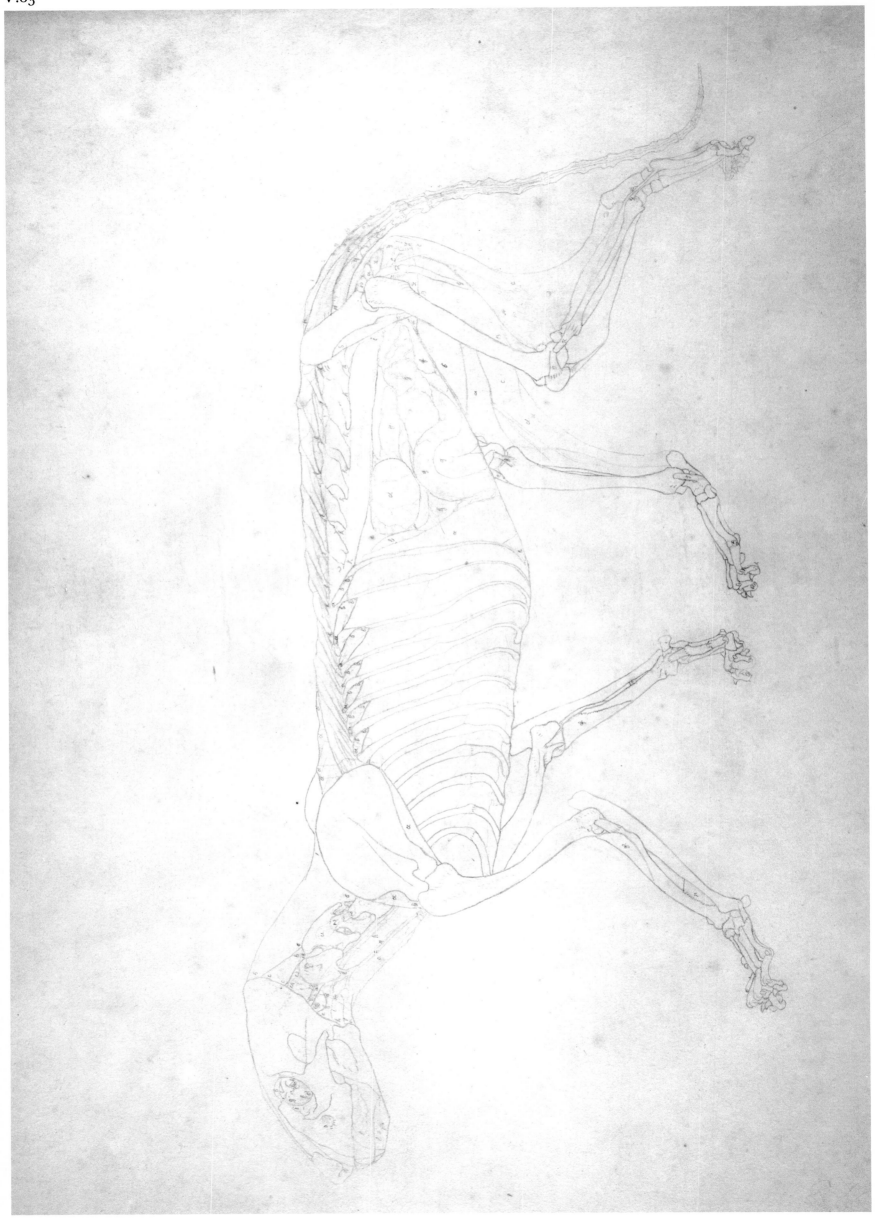

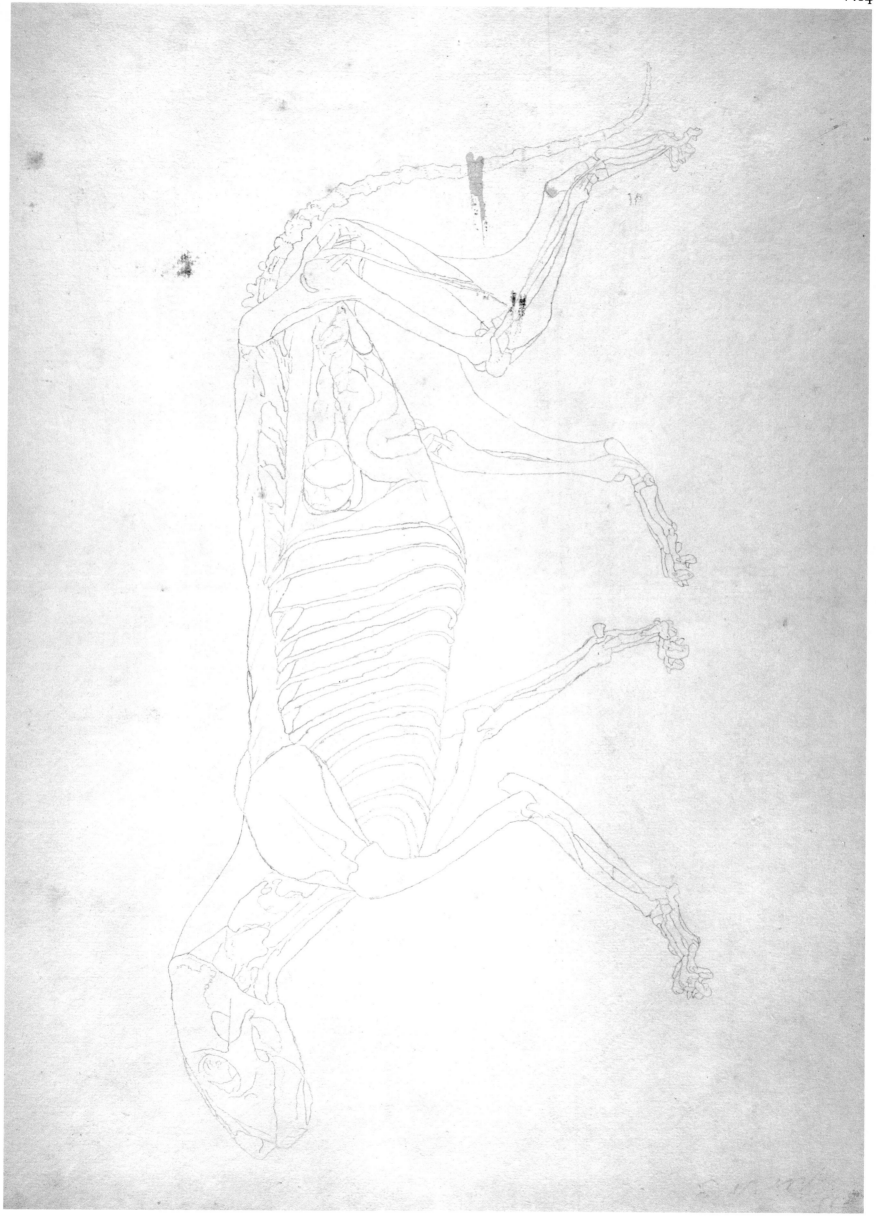

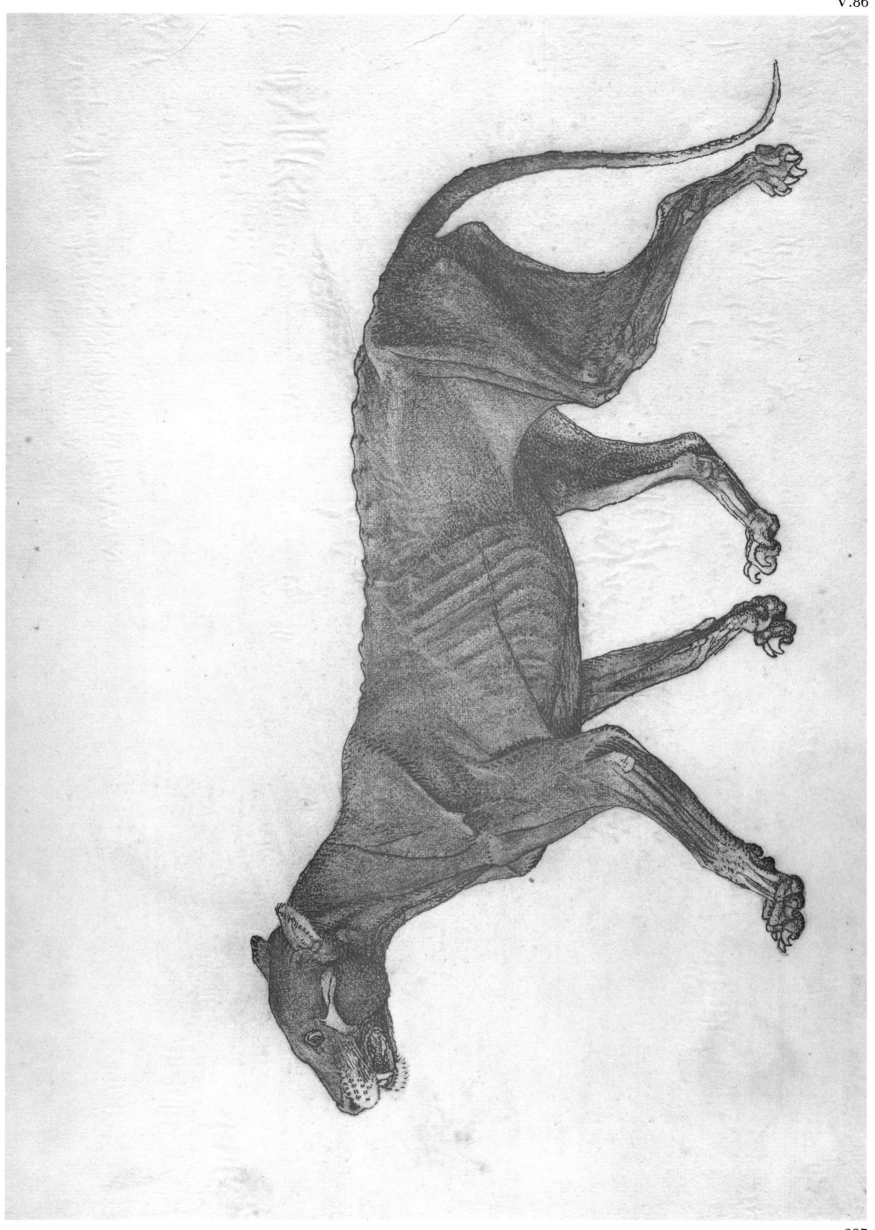

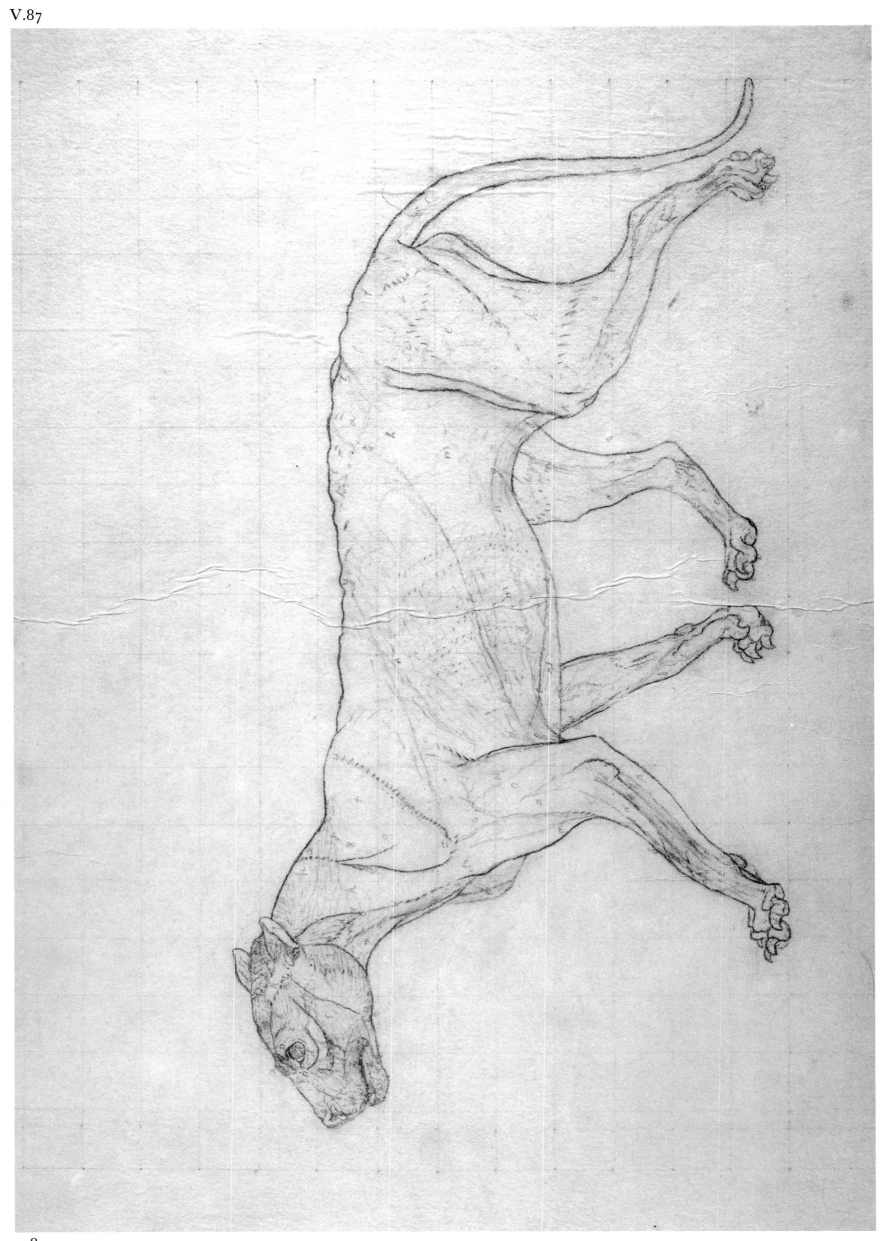

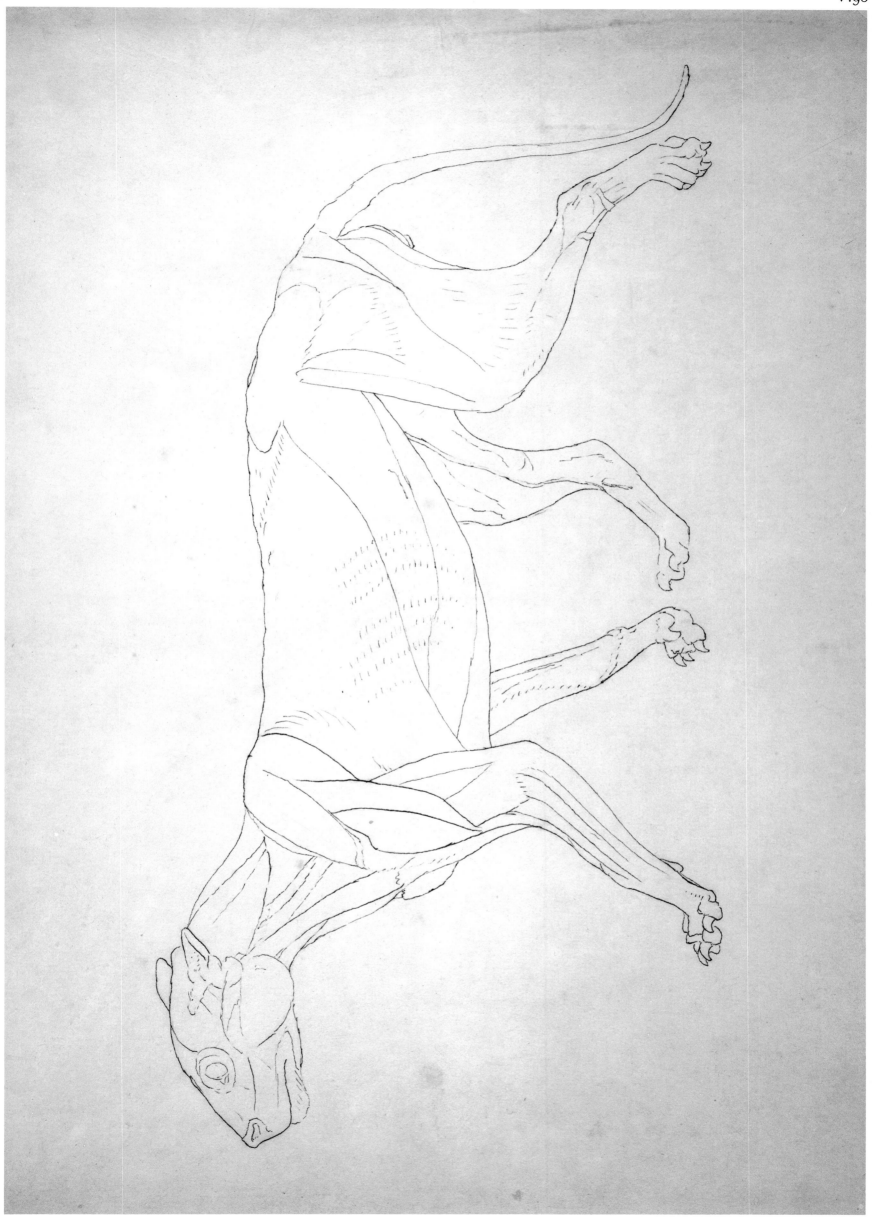

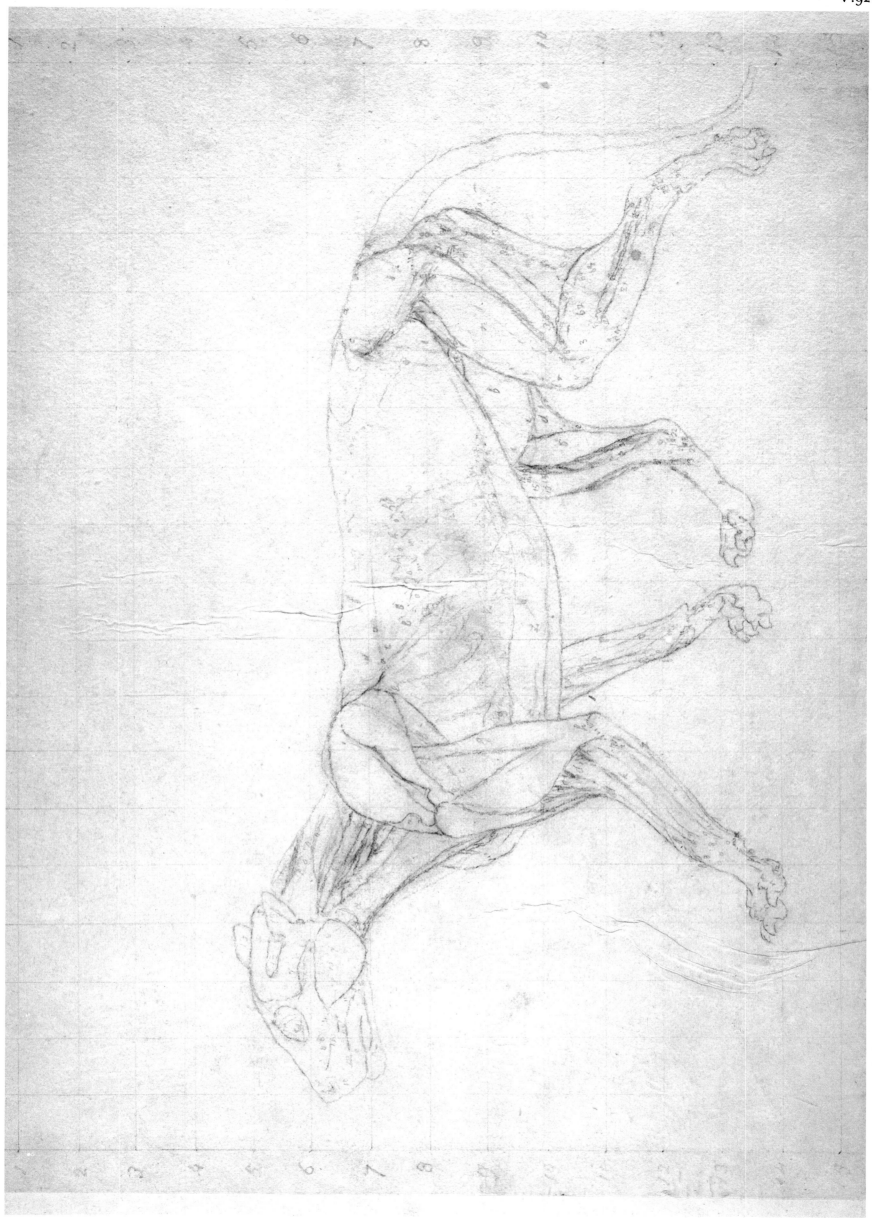

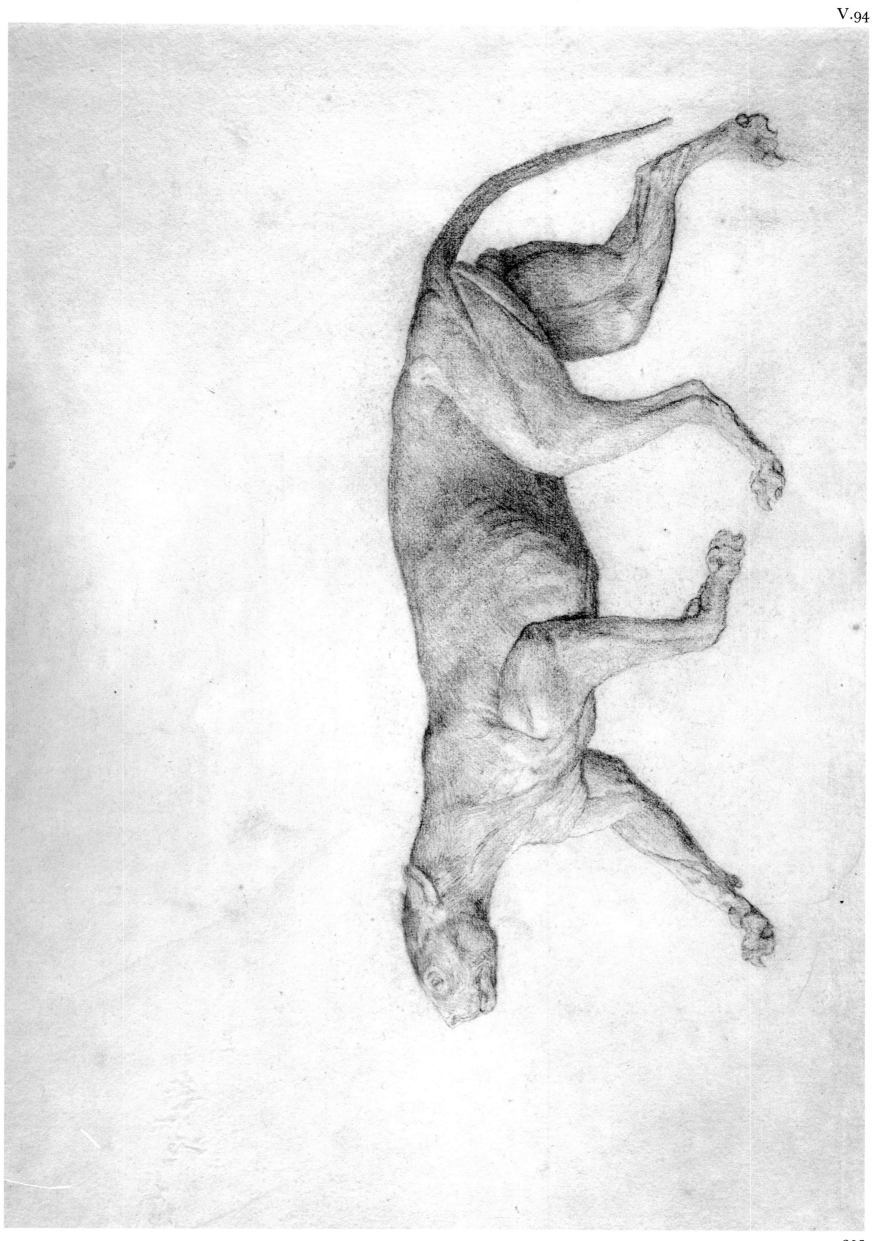

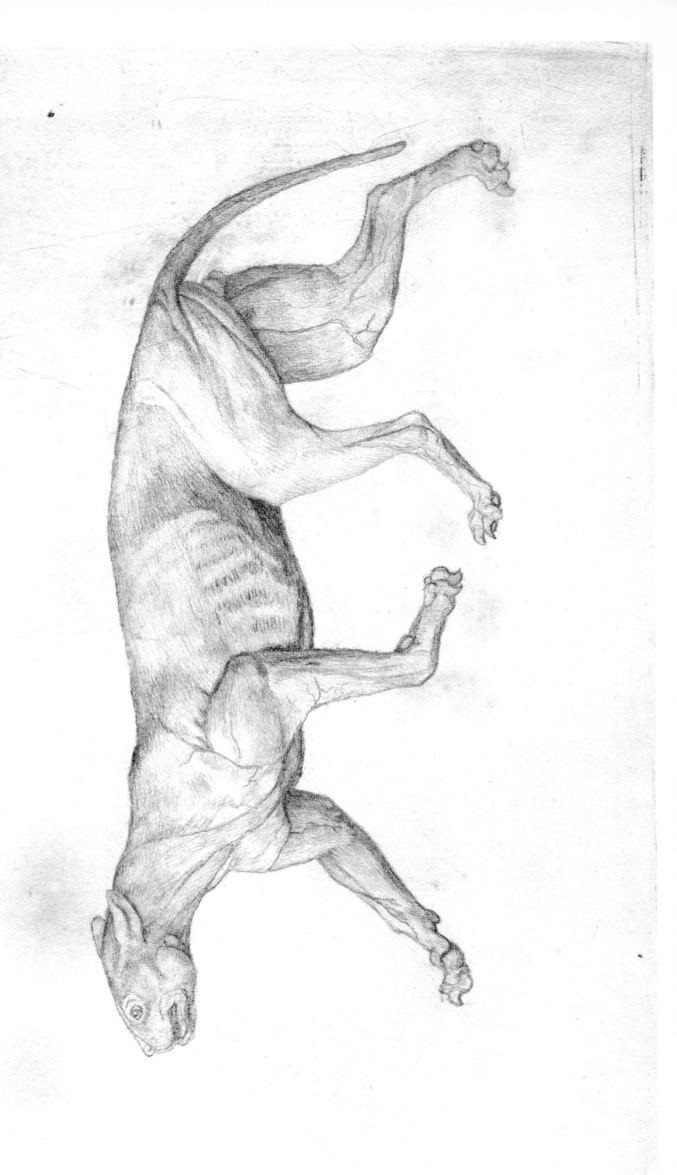

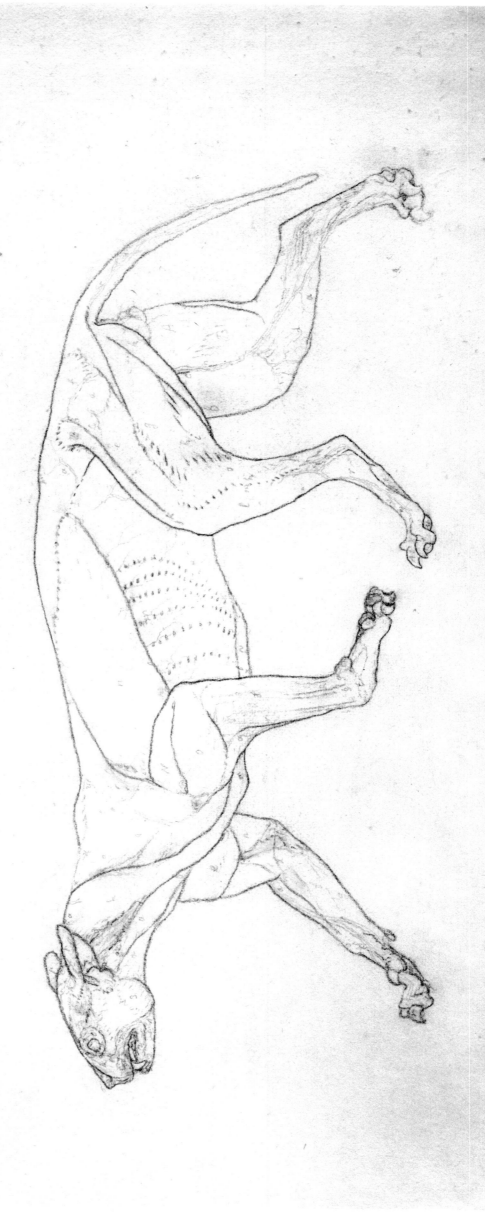

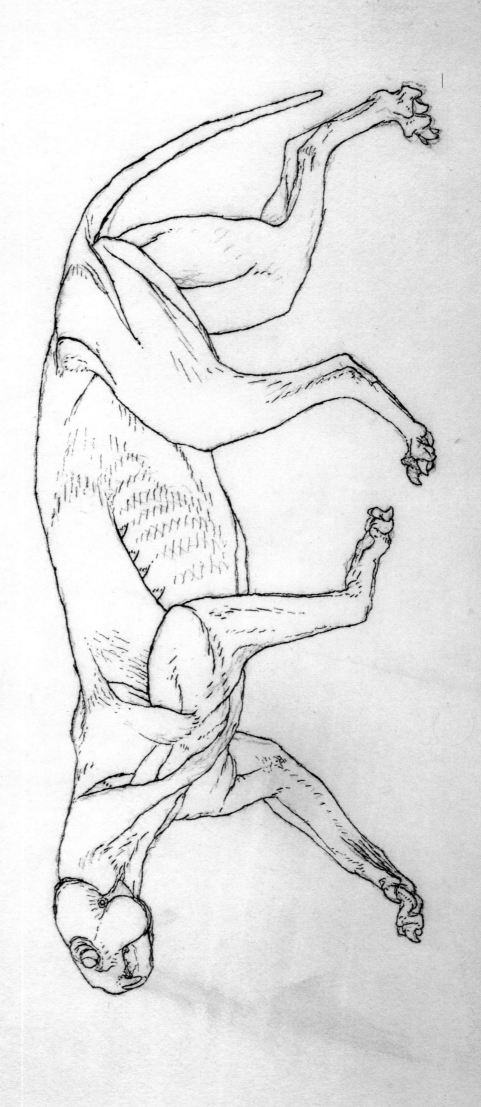

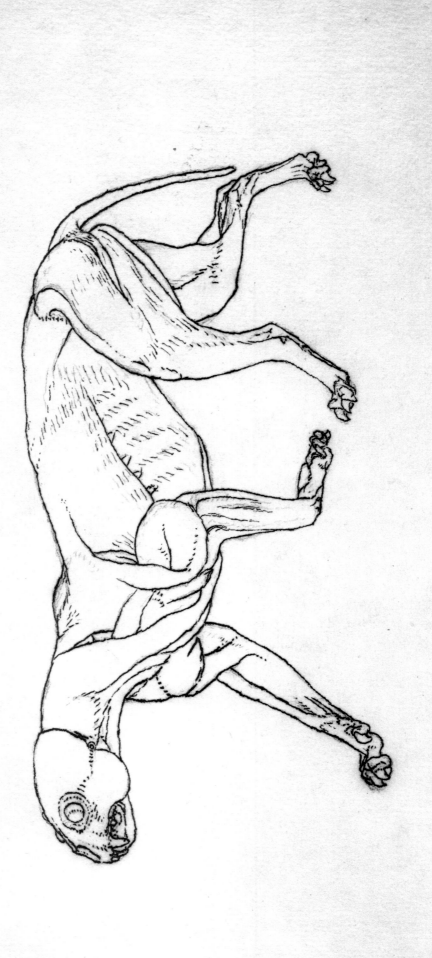

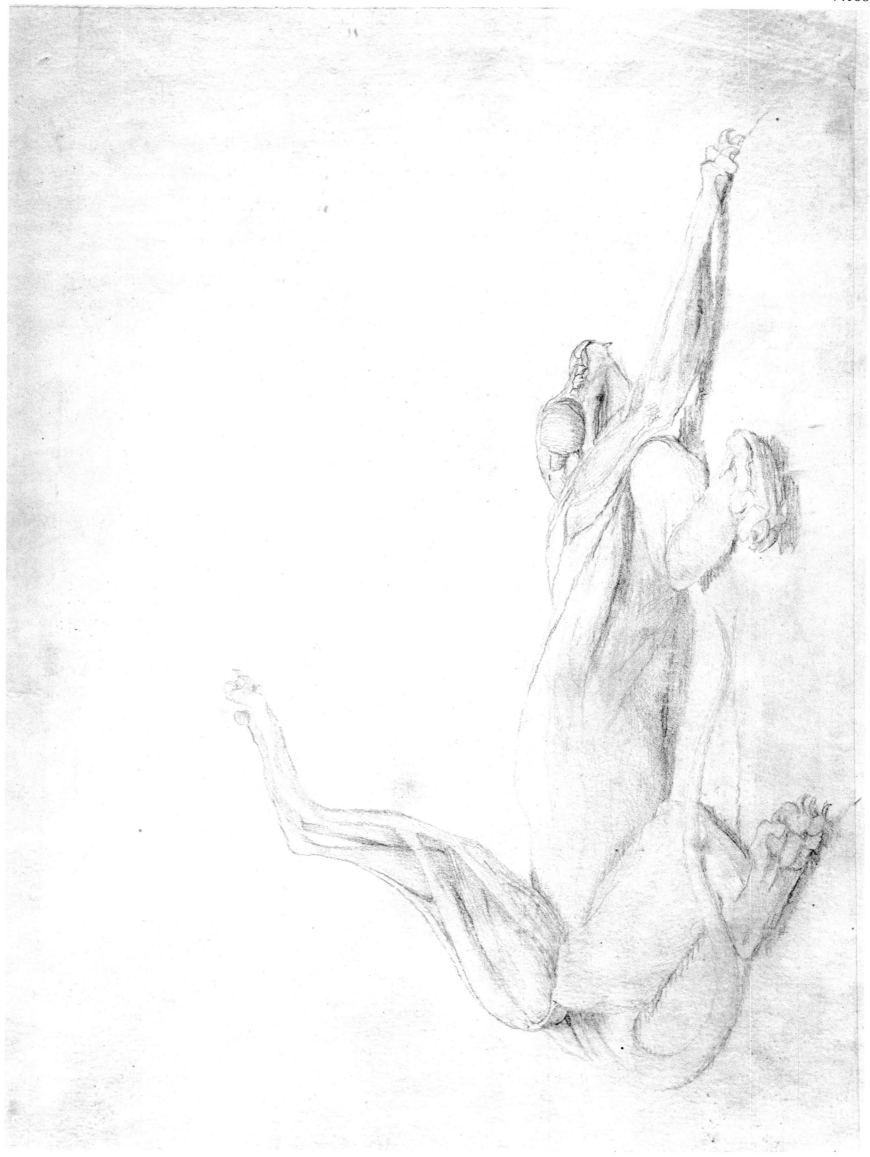

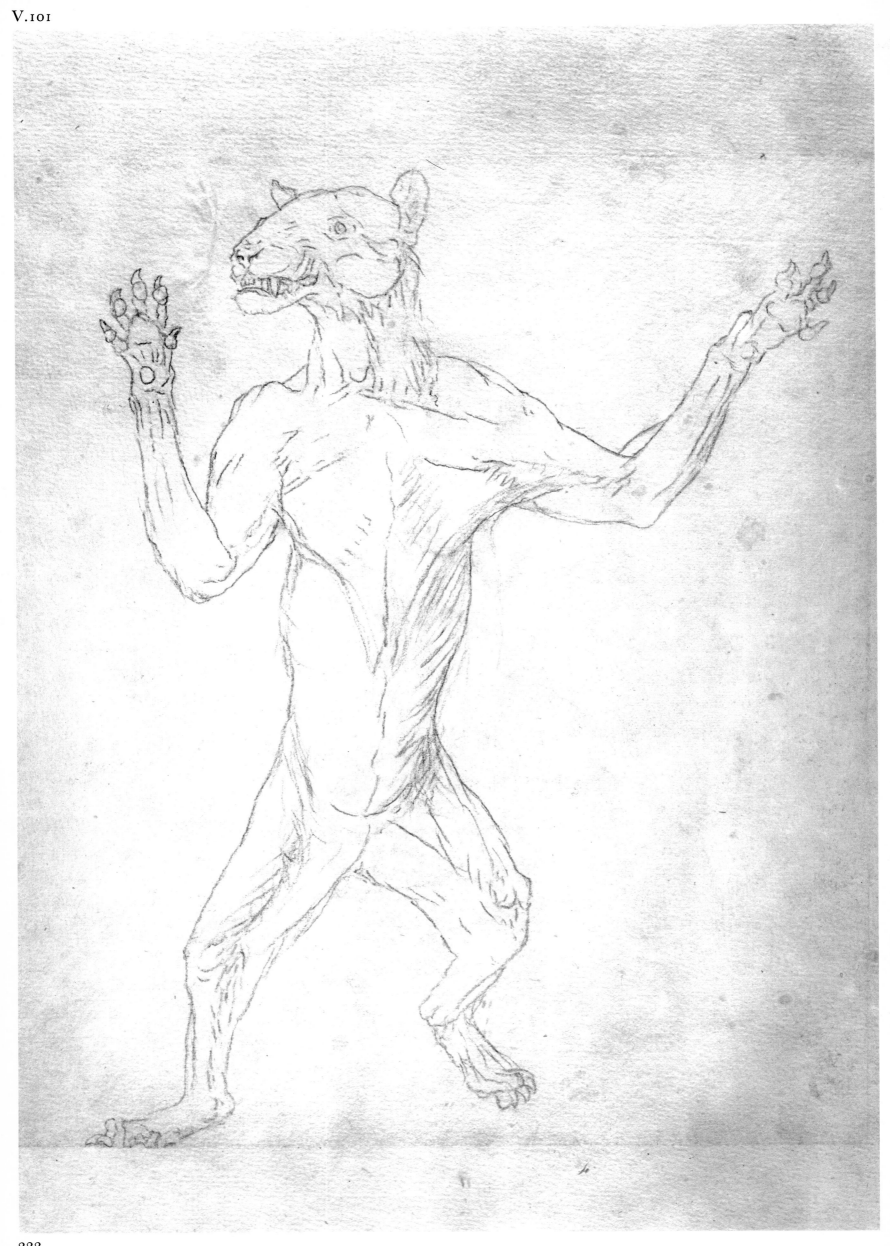

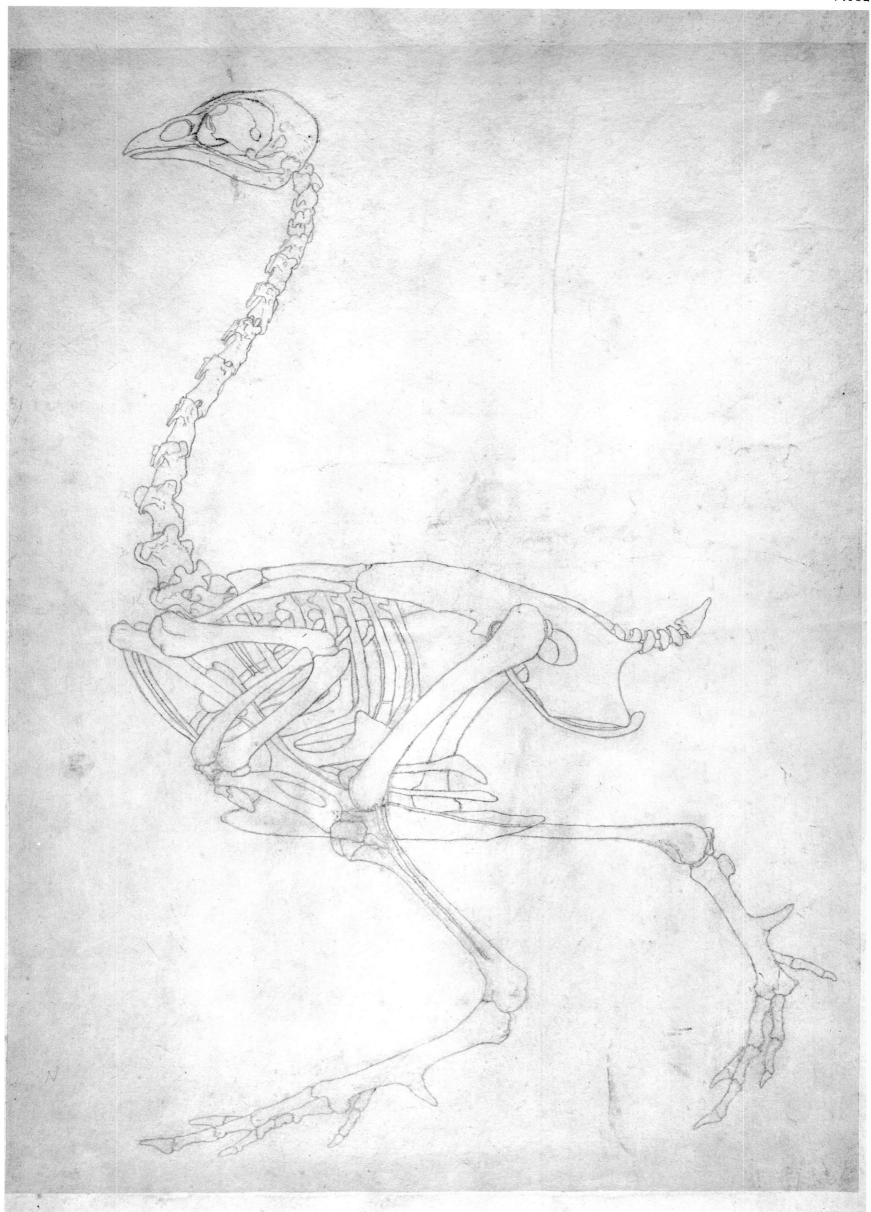

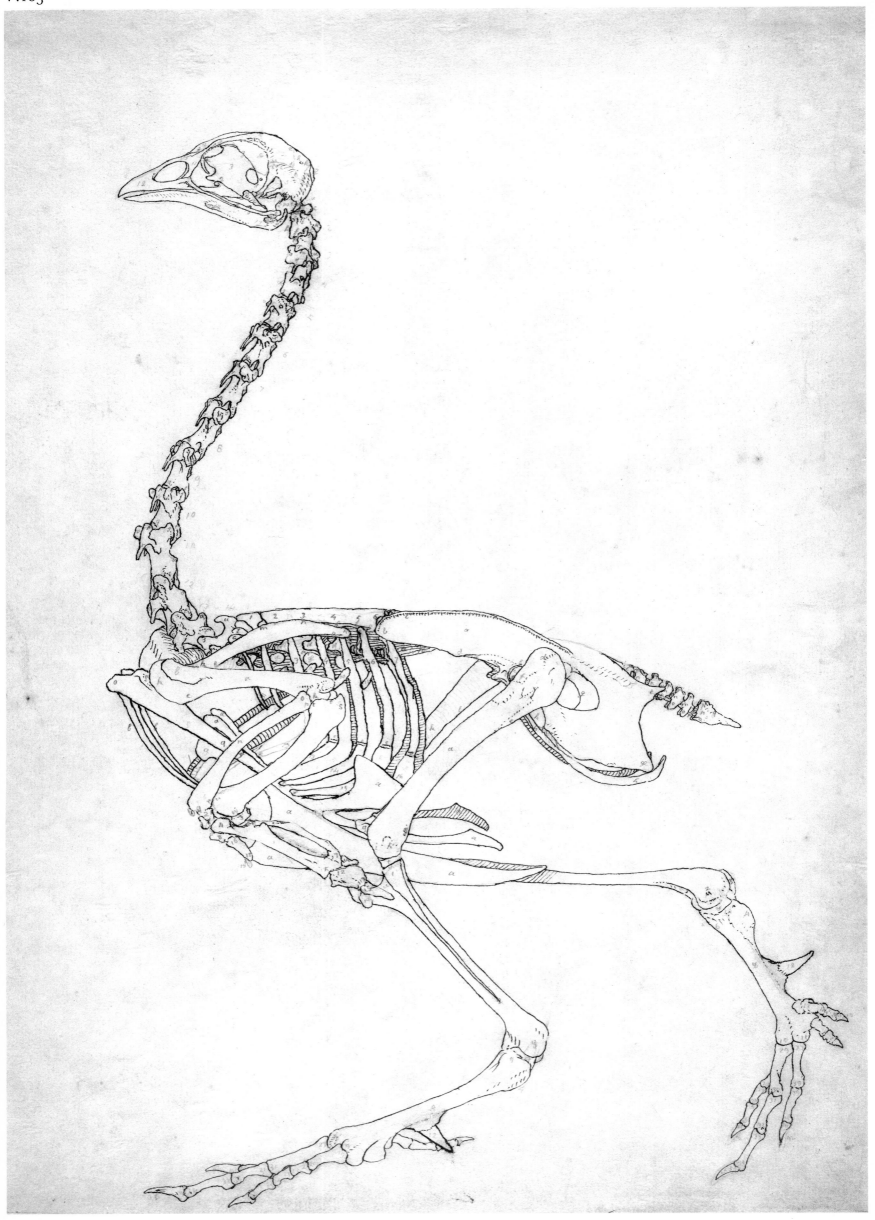

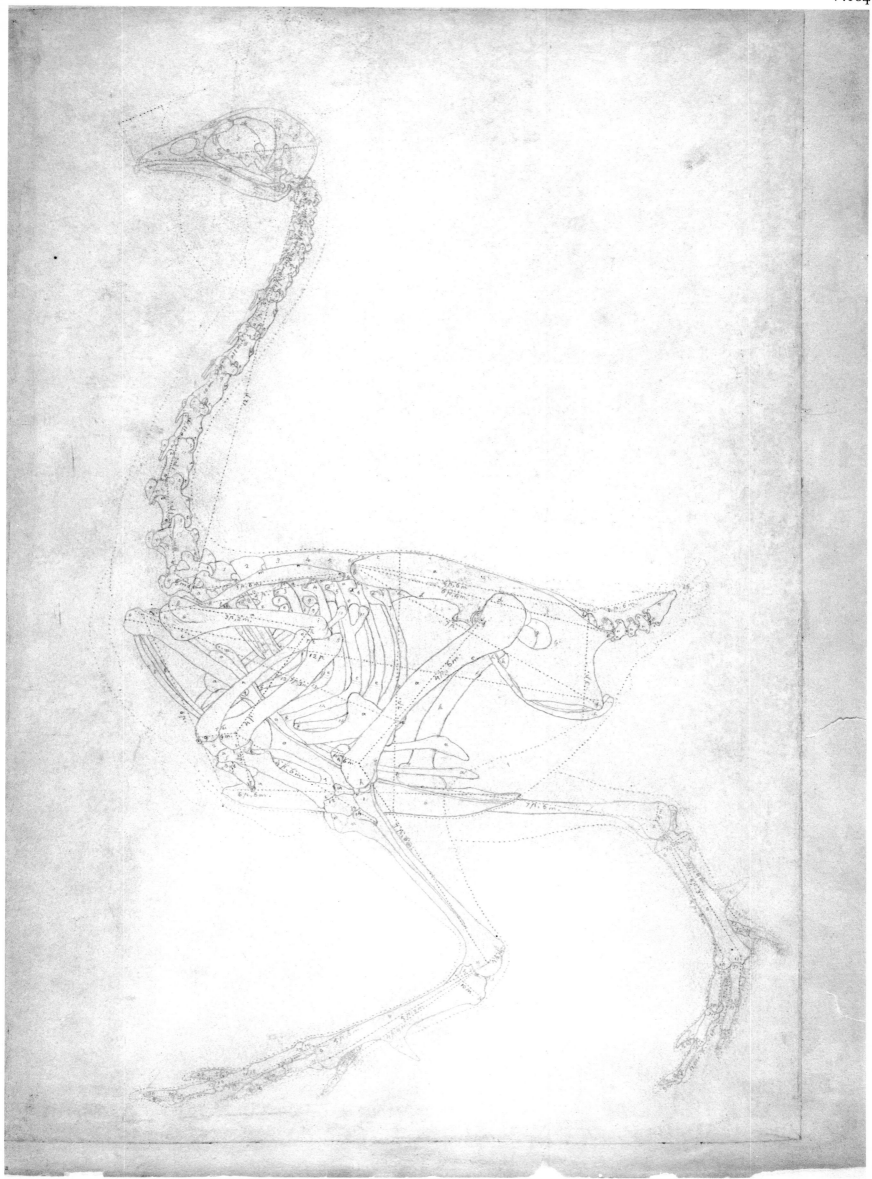

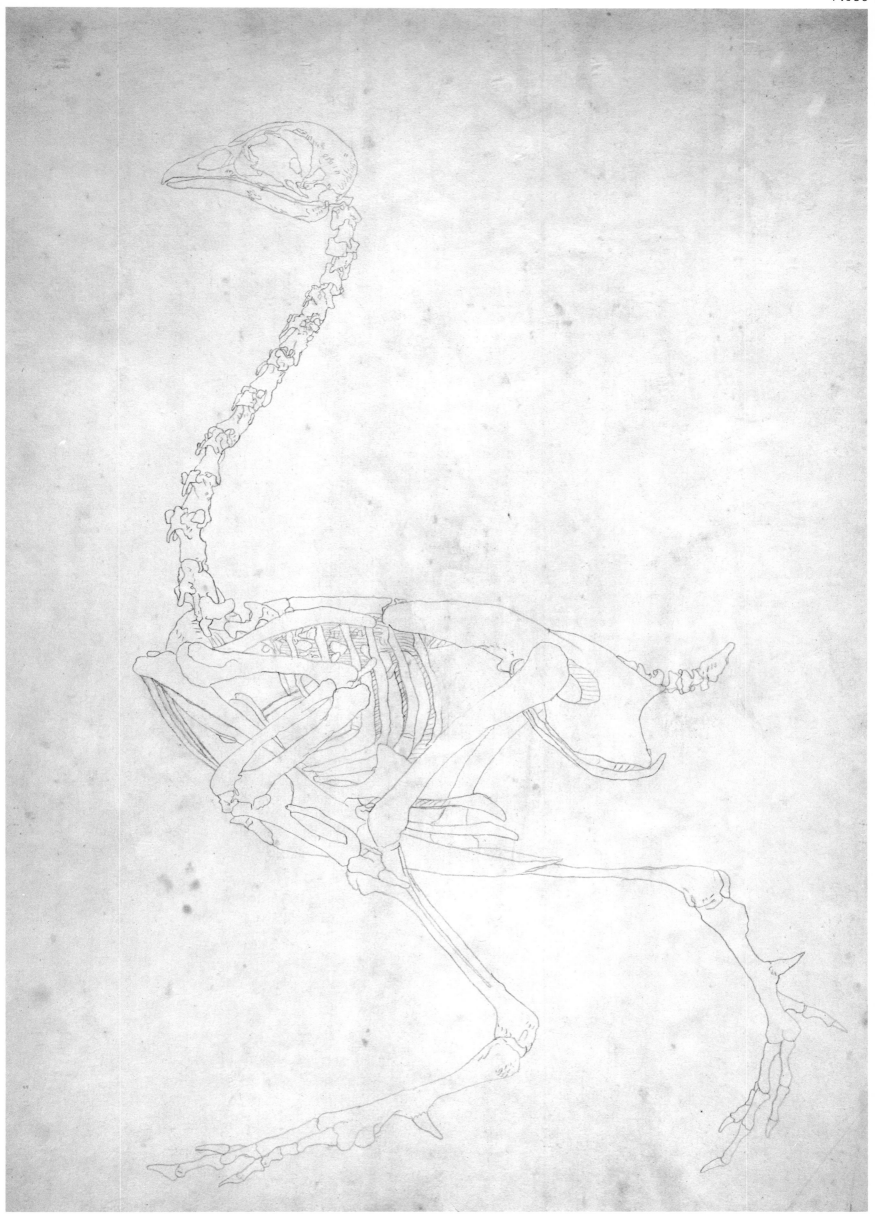

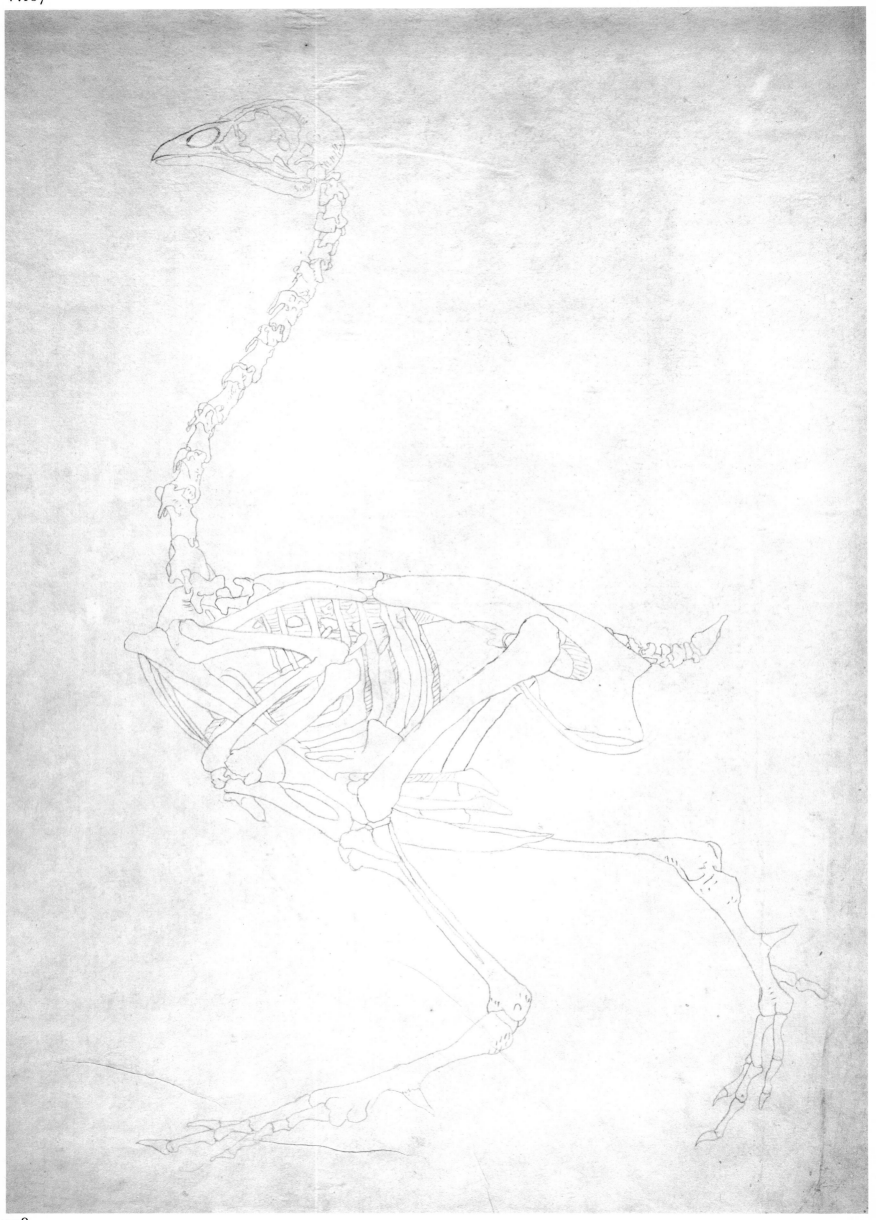

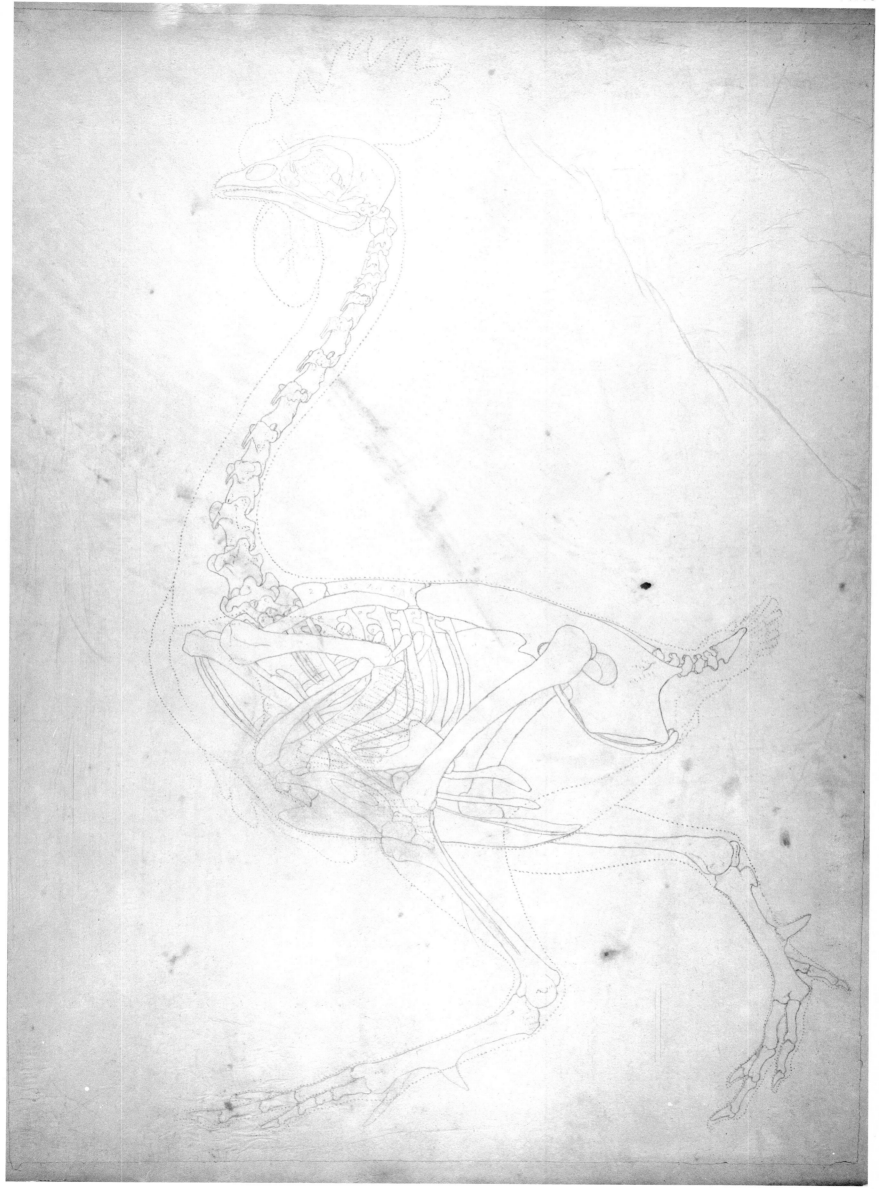

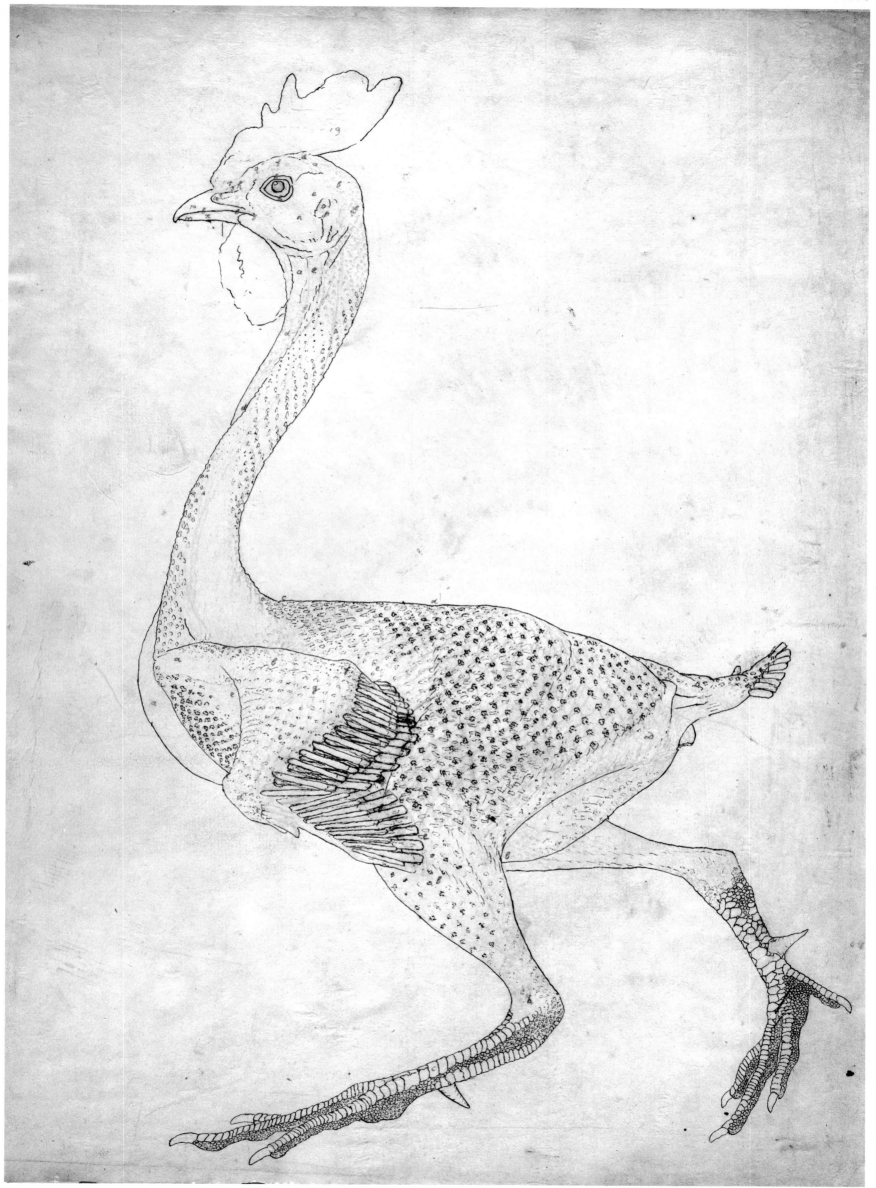

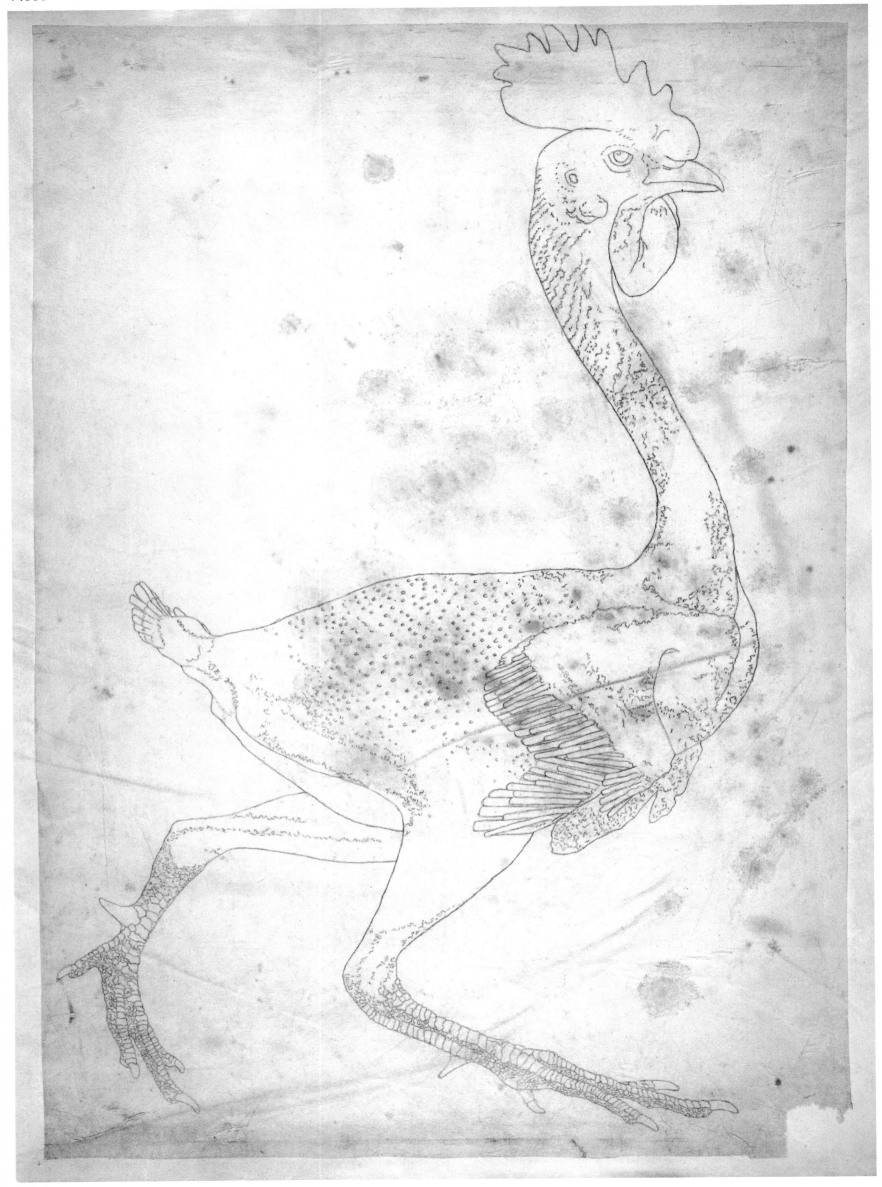

233

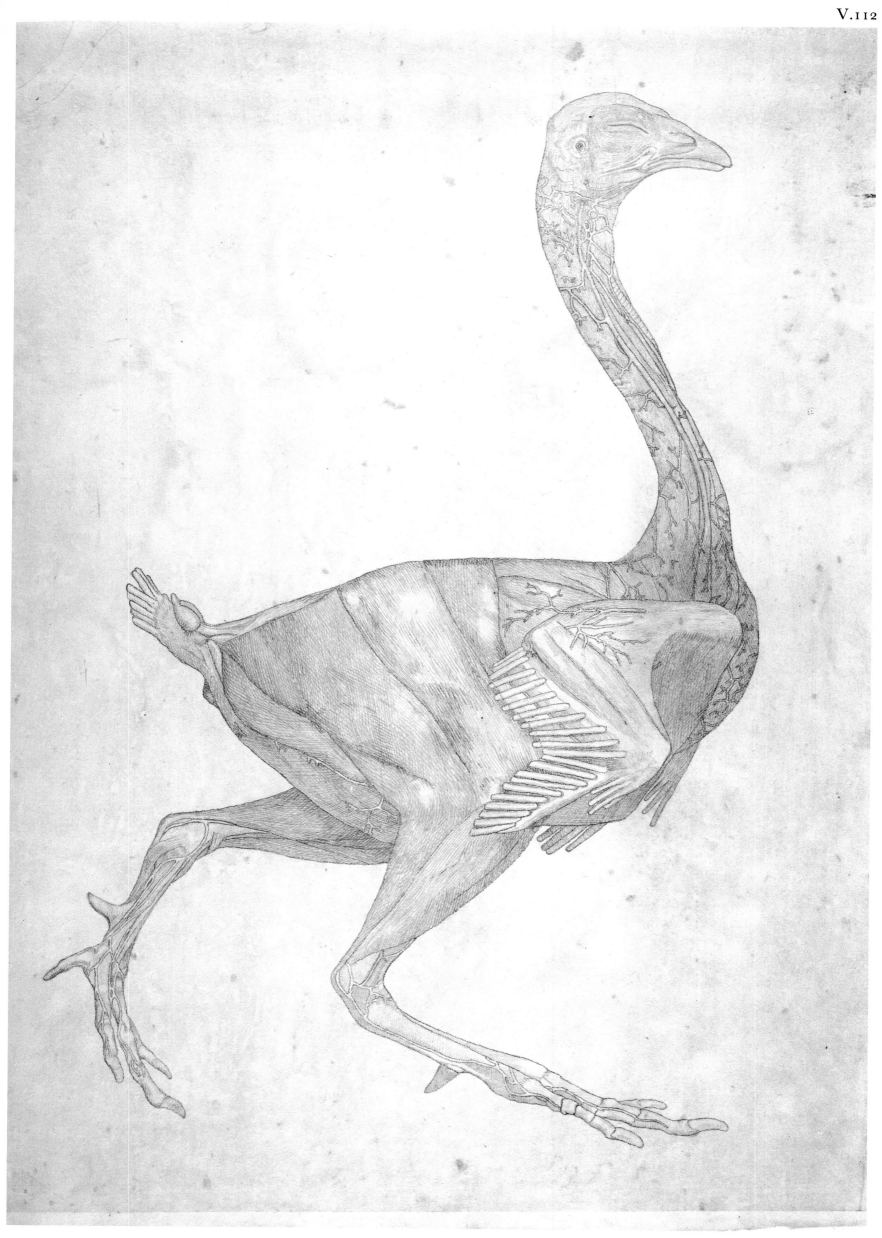

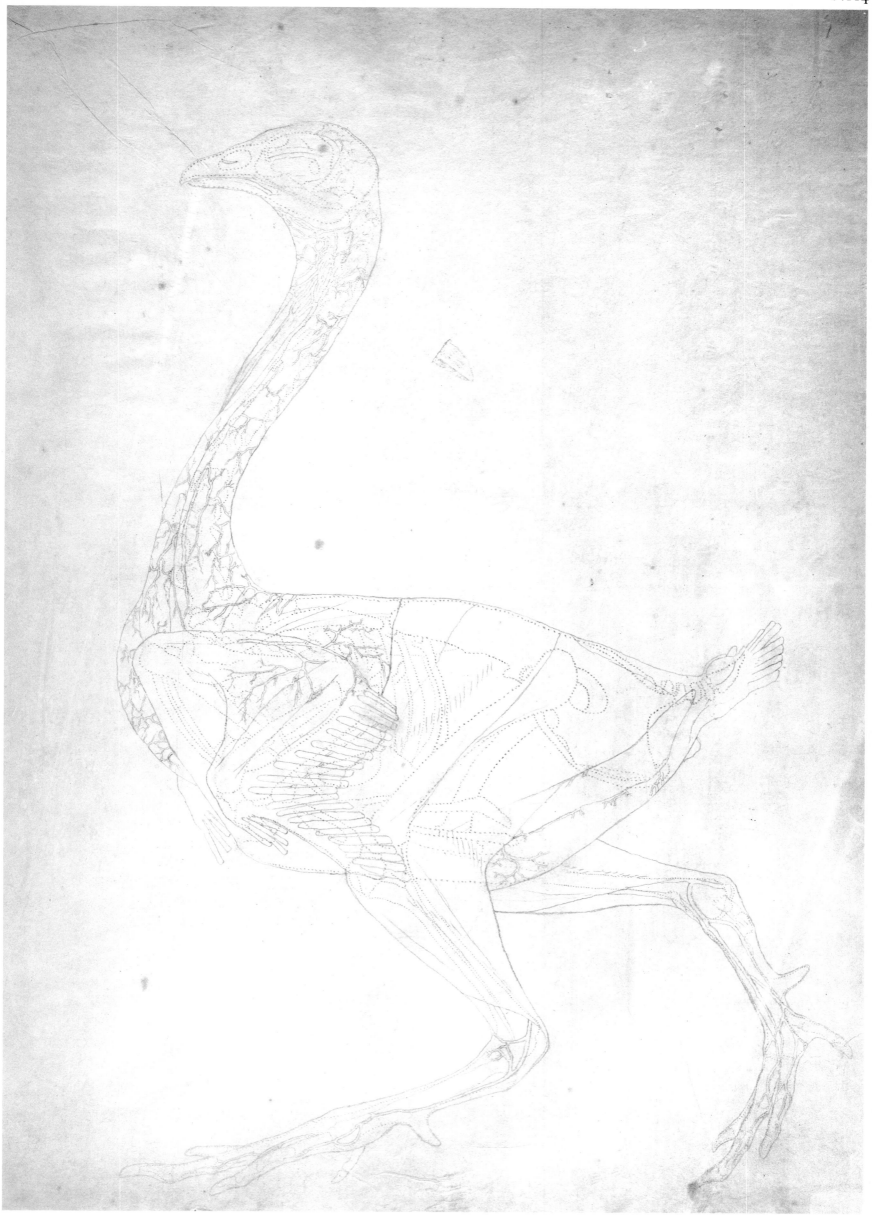

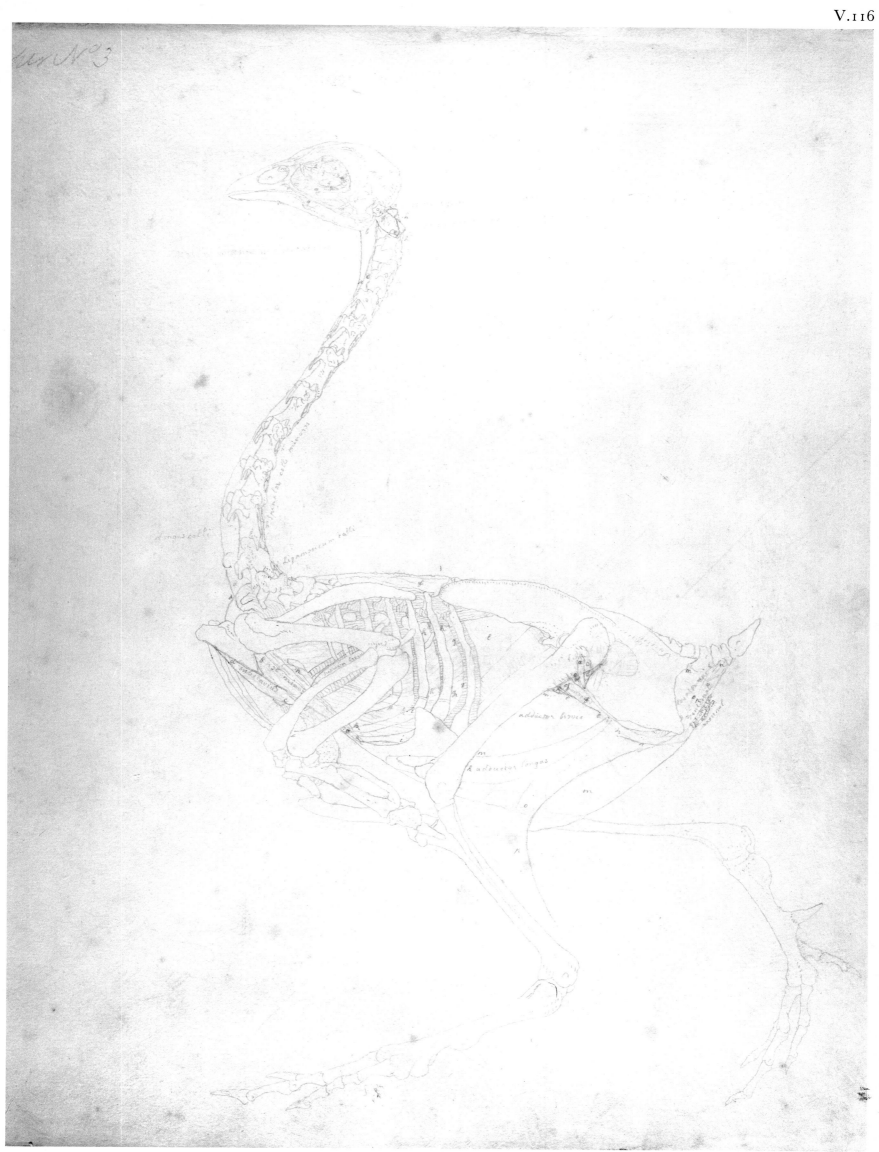

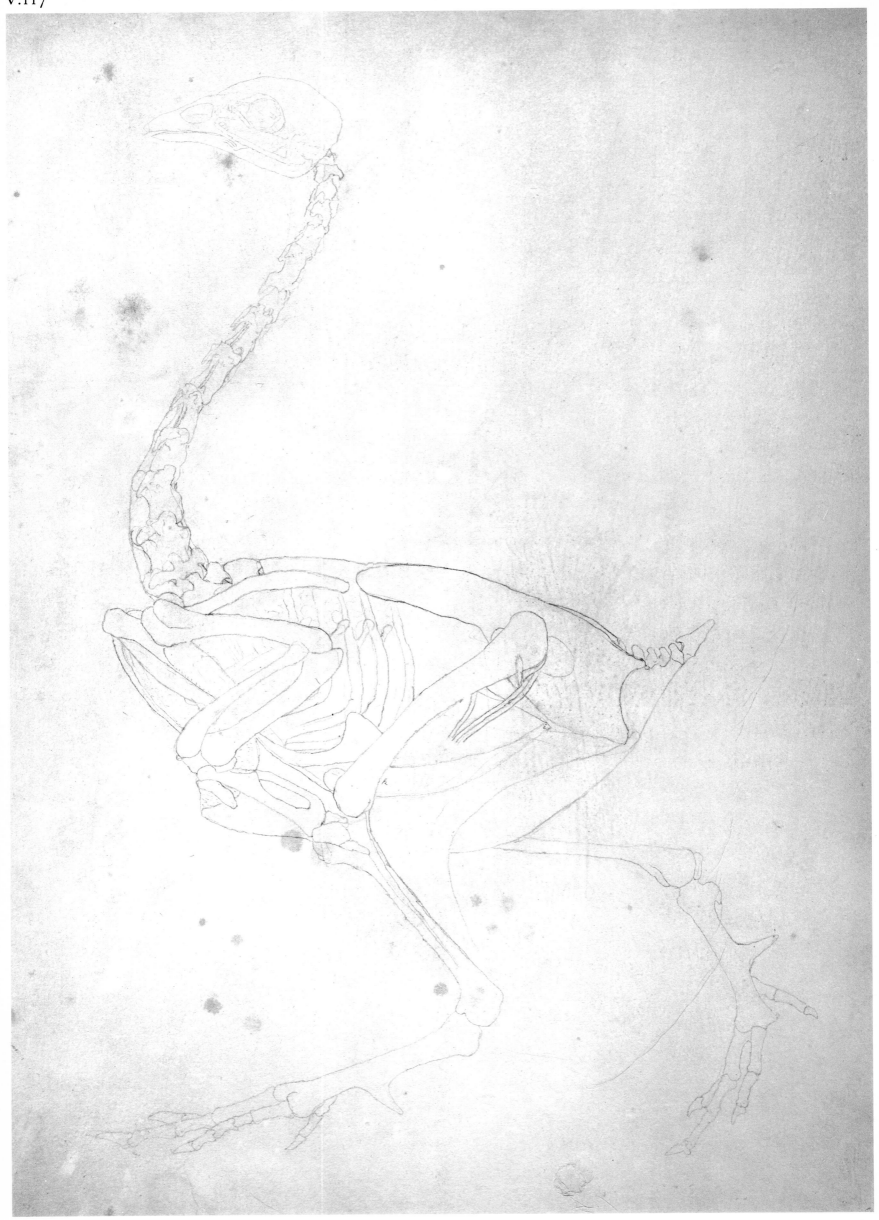

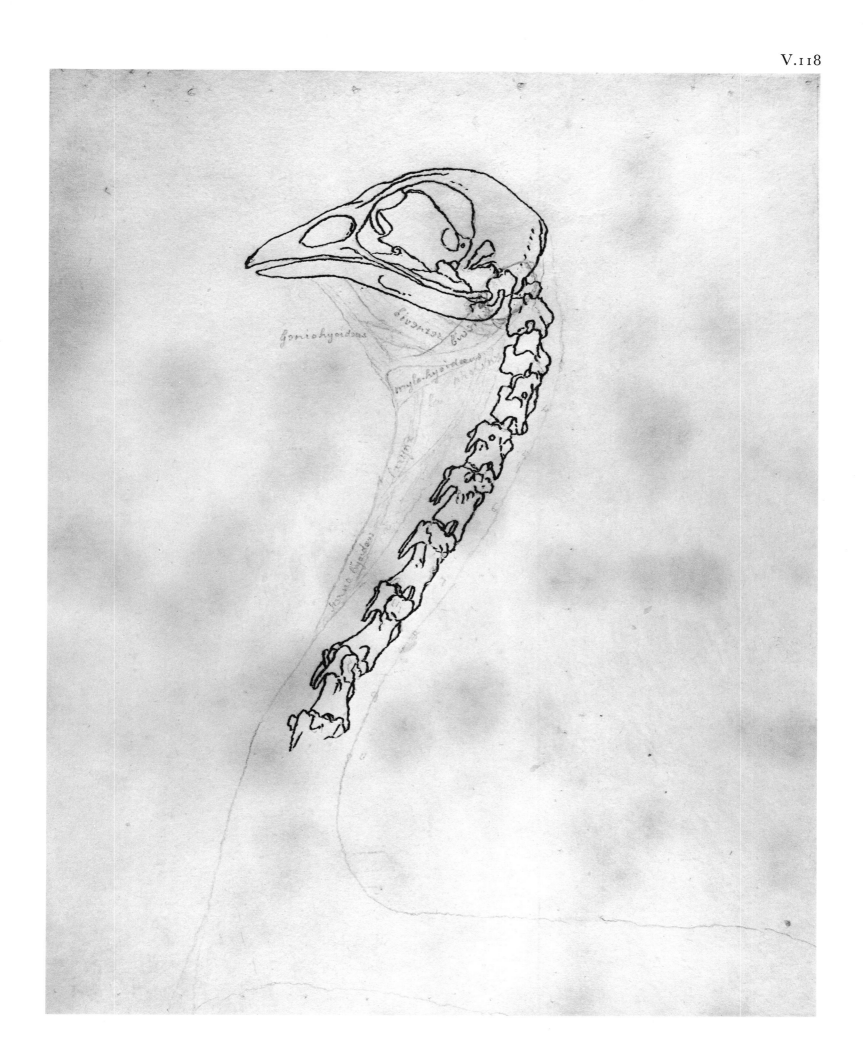

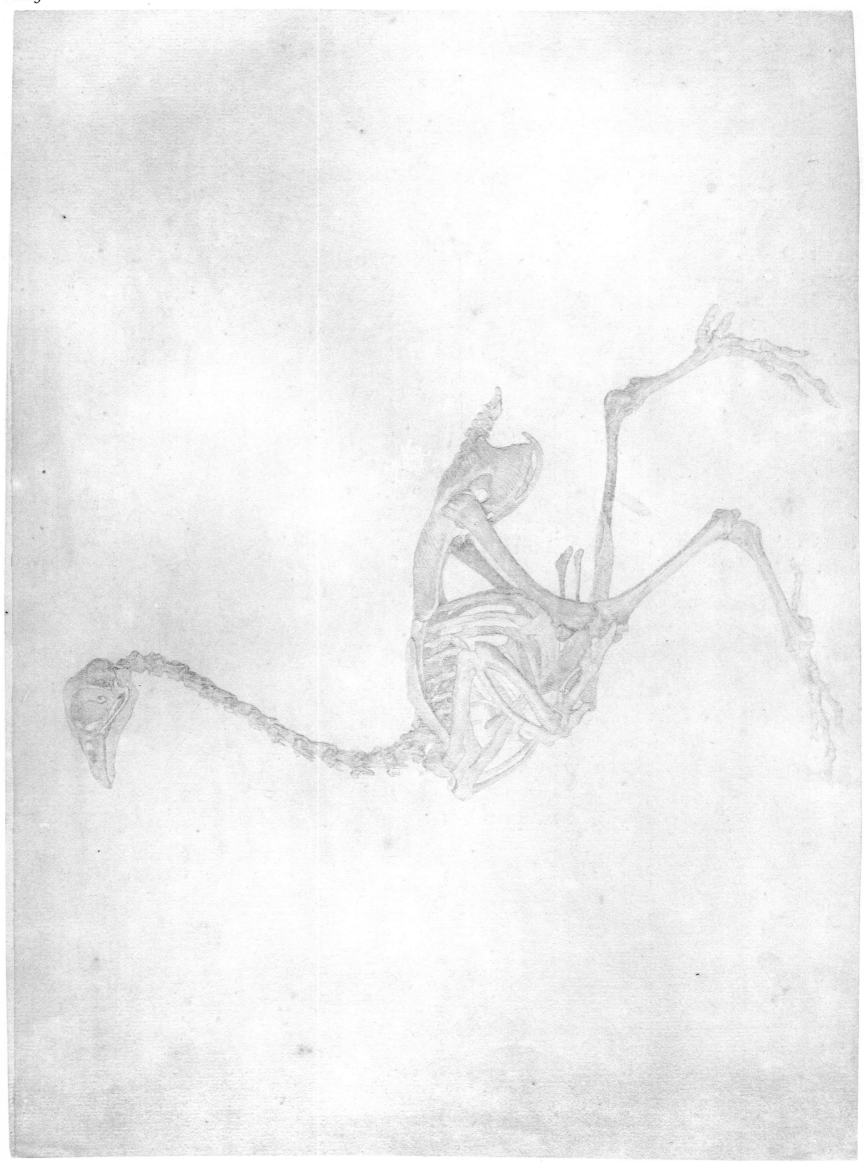

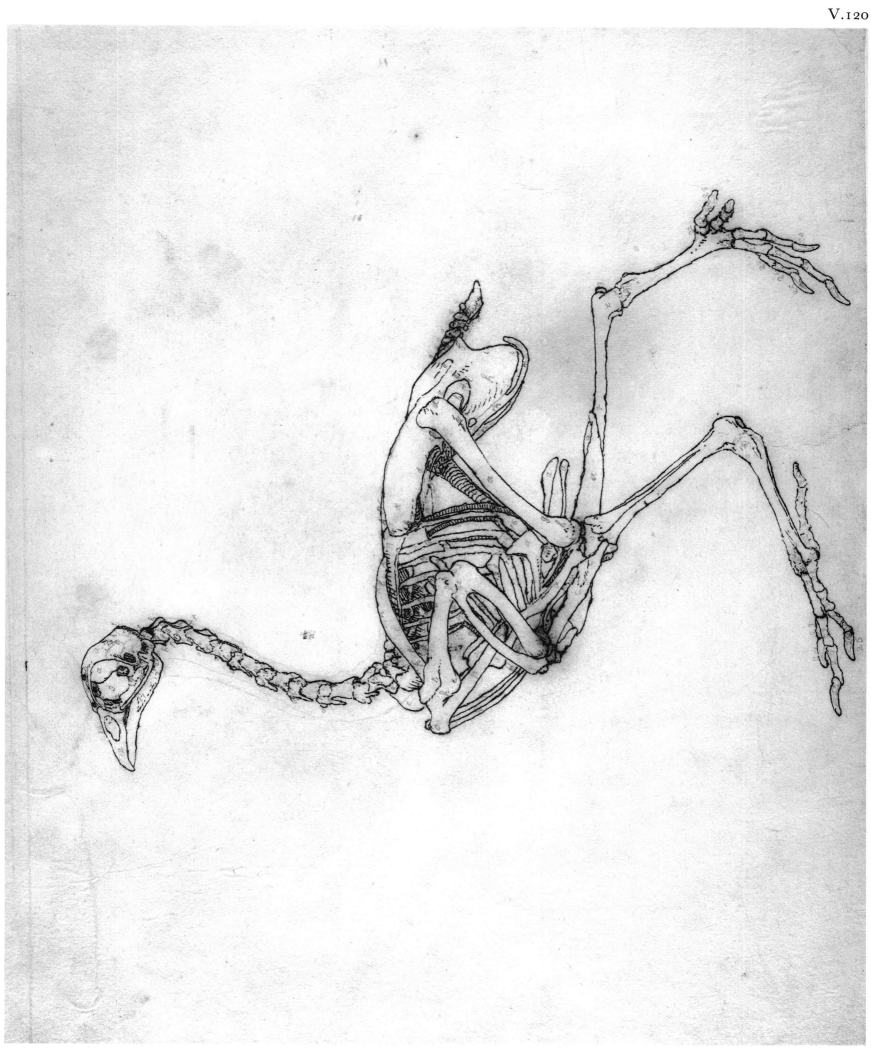

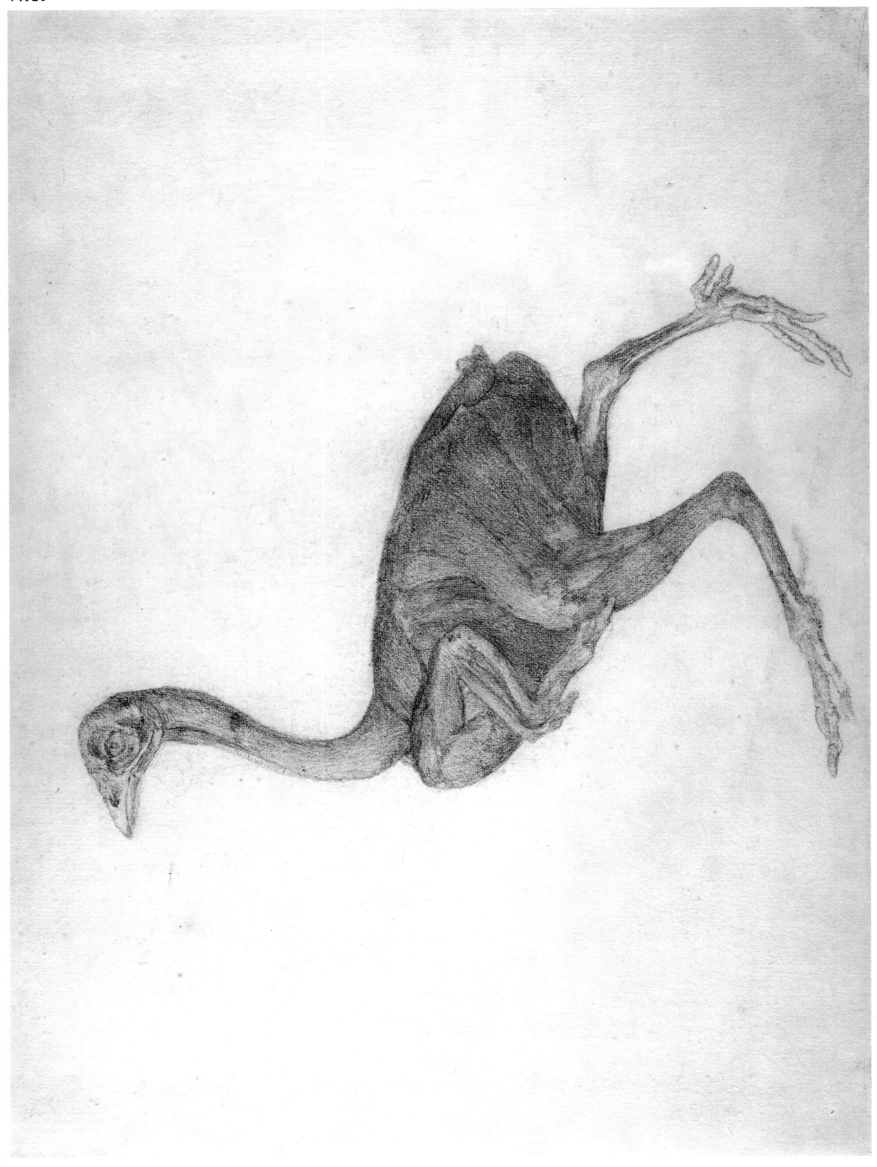

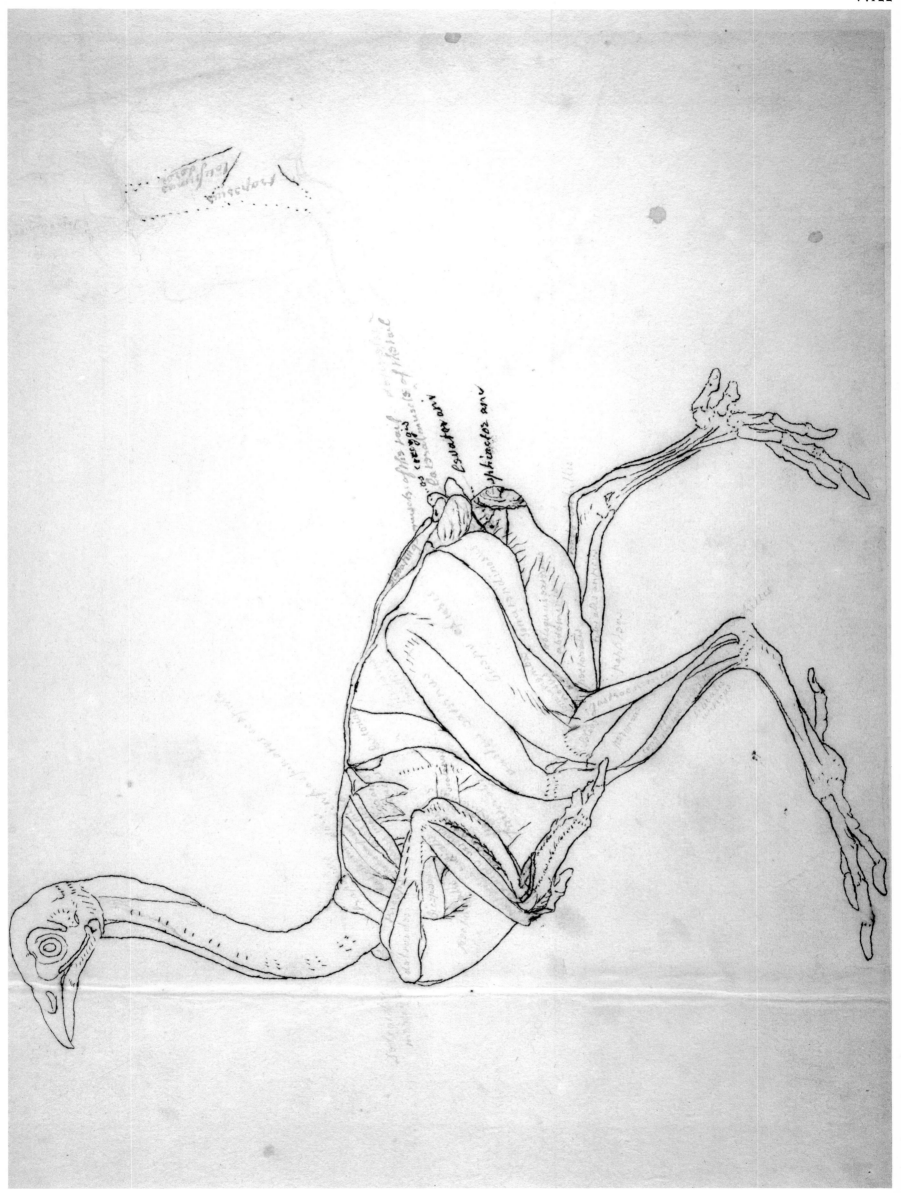

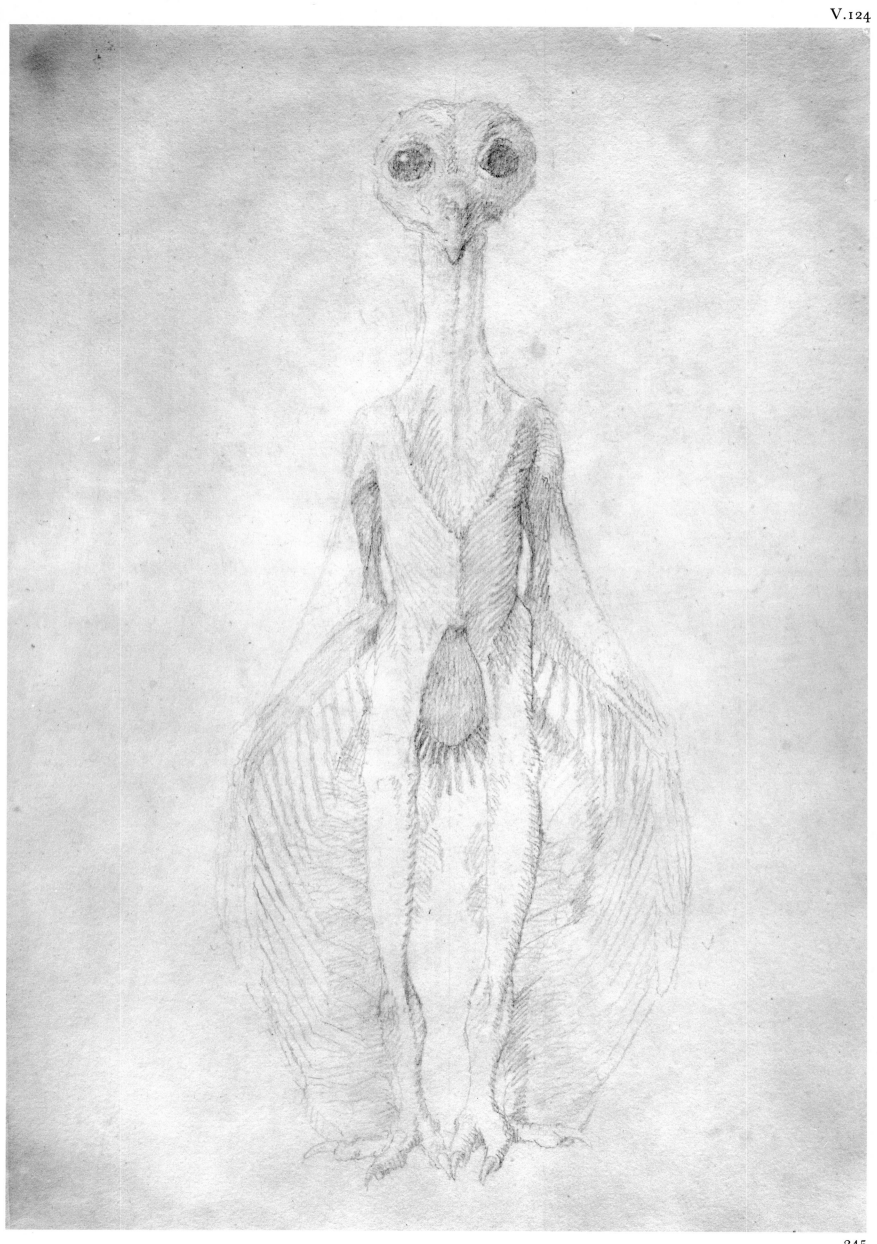

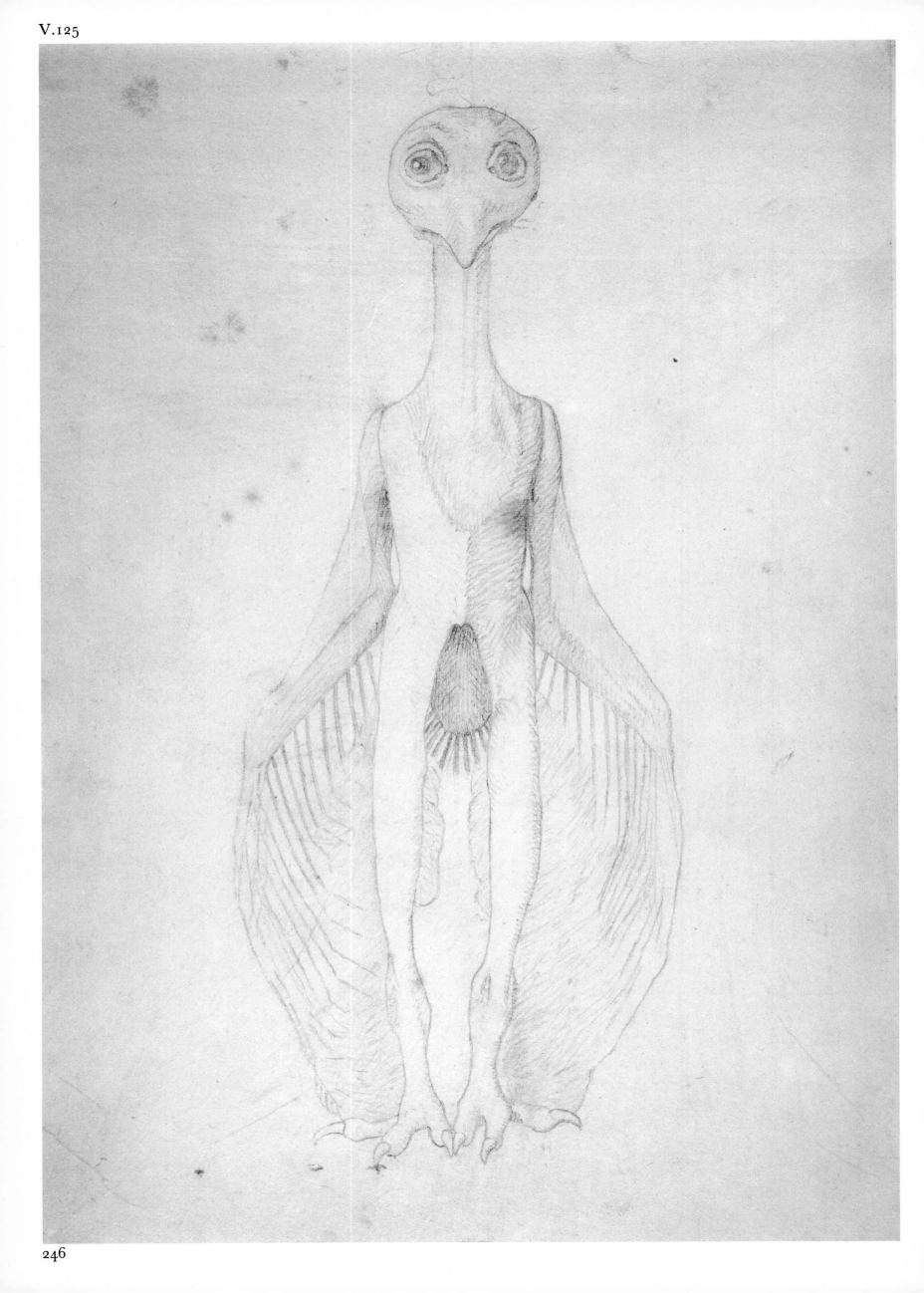

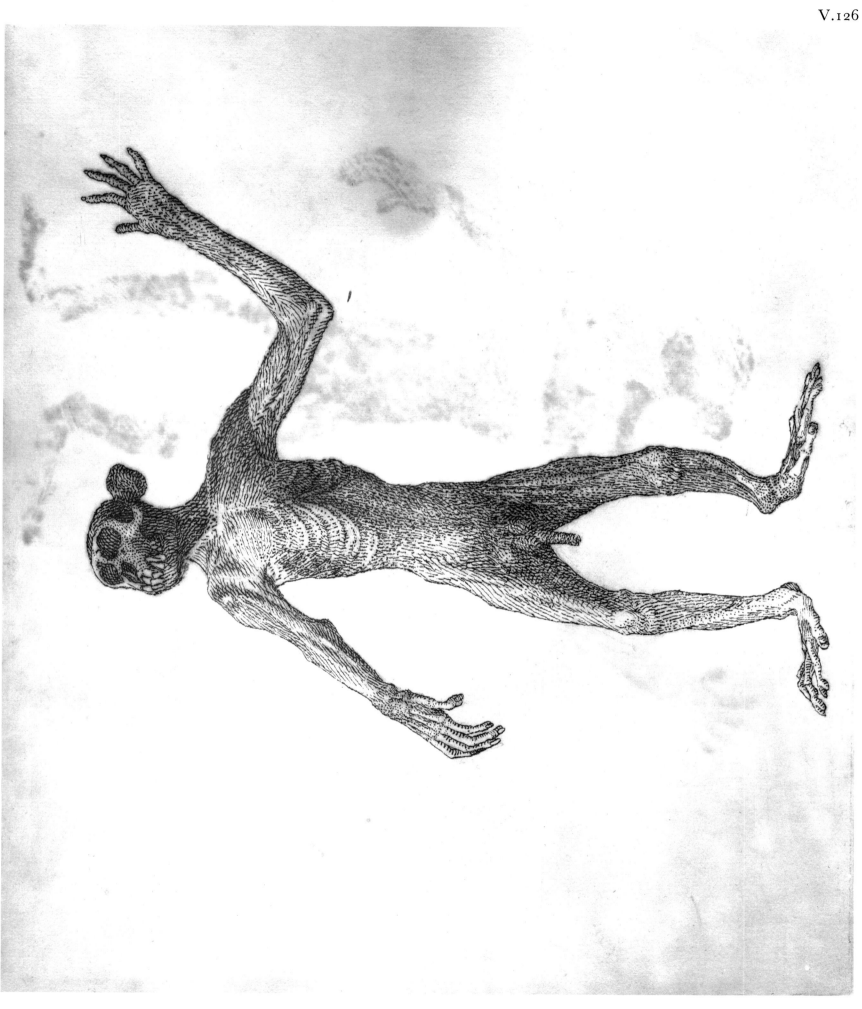

VI. Engravings for *A Comparative Anatomical Exposition of the Human Body with that of a Tiger and Common Fowl*, London, 1804–6

Although Stubbs intended this work to consist of thirty tables, only fifteen were actually published during his life, and this number was not exceeded in the posthumous publication of the work made by Edward Orme in 1817. The original publication made by Stubbs was issued in three parts, each consisting of five tables accompanied by their key figures, but without an explanatory text. The text had been prepared by Stubbs and a version of it appeared with Orme's edition, although this text does not correspond with the surviving manuscript at Worcester, Massachusetts. The tables differ in technique from that which Stubbs had previously used: he abandoned his former predominantly linear style for that of stipple engraving, producing a much more subtle transition in the depiction of light and shade and in the modelling of the forms. The size of the tables in this work is uniformly 20 by 15 inches in vertical plates and 15 by 20 inches in the horizontal engravings.

NOTES ON THE ENGRAVINGS

page 250 I. TABLE I
 HUMAN SKELETON, FRONTAL VIEW

Stipple engraving, 20 × 15 inches.
The skeleton used by Stubbs for the tables was obviously directly based on a single individual, and not idealised or generalised to fit some academic canon of proportion. The pelvic girdle is rather wider than average for a male skeleton and the feet notably small, although this is partly the result of the rather awkward foreshortening.

252 2. TABLE II
 HUMAN SKELETON, POSTERIOR VIEW

Stipple engraving, 20 × 15 inches.
This plate is remarkable for the skill with which Stubbs demonstrates the curvature of the spine, by the extraordinary accuracy of his observation of the relative positions of each vertebra and without any significant recourse to shading. The placement of the hands with their palms towards the spectator also displays the twisting of the radius over the ulna in the fore-arms.

254 3. TABLE III
 HUMAN SKELETON, LATERAL VIEW

Stipple engraving, 20 × 15 inches.
The choice of a running posture, unusual in anatomical illustration of the human skeleton, served to emphasise the comparison between man and the tiger and fowl, and also allowed the inner sides of

the limbs to be exposed. From this position the feet do not seem so disproportionately small as in the frontal view.

4. TABLE IV 256
 TIGER SKELETON, LATERAL VIEW

Stipple engraving, 15 × 20 inches.
Stubbs chose to show the tiger walking rather than running, although he did studies of a leopard in the latter posture. The position of the spine in the lumbar region is rather flattened.

5. TABLE V 258
 FOWL SKELETON, LATERAL VIEW

Stipple engraving, 20 × 15 inches.
The fowl like the tiger is shown walking; the position of the wings folded downwards tends to obscure the complex structure of the thoracic skeleton. Here Stubbs was obviously showing a preference for the most natural posture, even though it made extra demands on his skill in producing a clear exposition of the parts.

6. TABLE VI 260
 HUMAN BODY, FRONTAL VIEW

Stipple engraving, 20 × 15 inches.
In this table Stubbs's choice of an unidealised individual is even more apparent. The head seems small in proportion to the body, the shoulders are sloping, and the hips are rather wide.

262 7. TABLE VII
 HUMAN BODY, POSTERIOR VIEW

Stipple engraving, 20 × 15 inches.
Like the other tables of the entire human body, this shows Stubbs's unemphatic naturalism, with no attempt to dramatise the muscularity of the subject.

264 8. TABLE VIII
 HUMAN BODY, LATERAL VIEW

Stipple engraving, 20 × 15 inches.
This table showing the naked body in action allows Stubbs to demonstrate some of the muscles of the limbs and trunk more clearly than in the two previous tables.

266 9. TABLE IX
 TIGER BODY, LATERAL VIEW

Stipple engraving, 15 × 20 inches.
The tiger with the skin removed to expose the superficial connective tissue and the surface blood vessels. It is not strictly comparable to the corresponding tables of the human and the fowl since the former is entire and the latter has been plucked but not skinned.

268 10. TABLE X
 FOWL BODY, LATERAL VIEW

Stipple engraving, 20 × 15 inches.
The fowl with feathers plucked except for the flight feathers of the wings and tail, which have been clipped and their quills left inserted in the skin. At the base of the tail the preen gland can be seen.

270 11. TABLE XI
 HUMAN BODY, FRONTAL VIEW

Stipple engraving, 20 × 15 inches.
This and the two following tables show the human body with the skin removed. These plates are comparable to the écorché figures that had been used for the teaching of anatomy to artists since the Renaissance; a splendid life-size example had been modelled by Stubbs's contemporary, Houdon, and was used in the Ecole des Beaux Arts in Paris.

12. TABLE XII HUMAN BODY,
 POSTERIOR VIEW

Stipple engraving, 20 × 15 inches.
The second table showing the skinned human body, with the muscles and their blood vessels exposed.

13. TABLE XIII
 HUMAN BODY, LATERAL VIEW

Stipple engraving, 20 × 15 inches.
The final table of the human body. The viewpoint gives a much clearer display of the groups of muscles than those of the two previous tables, which are obscured by the action of the figure.

14. TABLE XIV
 TIGER BODY, LATERAL VIEW 276

Stipple engraving, 15 × 20 inches.
Here the superficial connective tissue has been removed, clearly exposing the muscles and blood vessels. It is comparable to Table XIII of the human body.

15. TABLE XV
 FOWL BODY, LATERAL VIEW 278

Stipple engraving, 20 × 15 inches.
The last table in the series, showing the fowl with the skin removed. The wattles have been cut off the head, but the quills of the wings and tail feathers still remain inserted.

VI. Engravings for
A Comparative Anatomical Exposition of the Human Body with that of a Tiger and a Common Fowl,
London, 1804–6

TAB. 1.

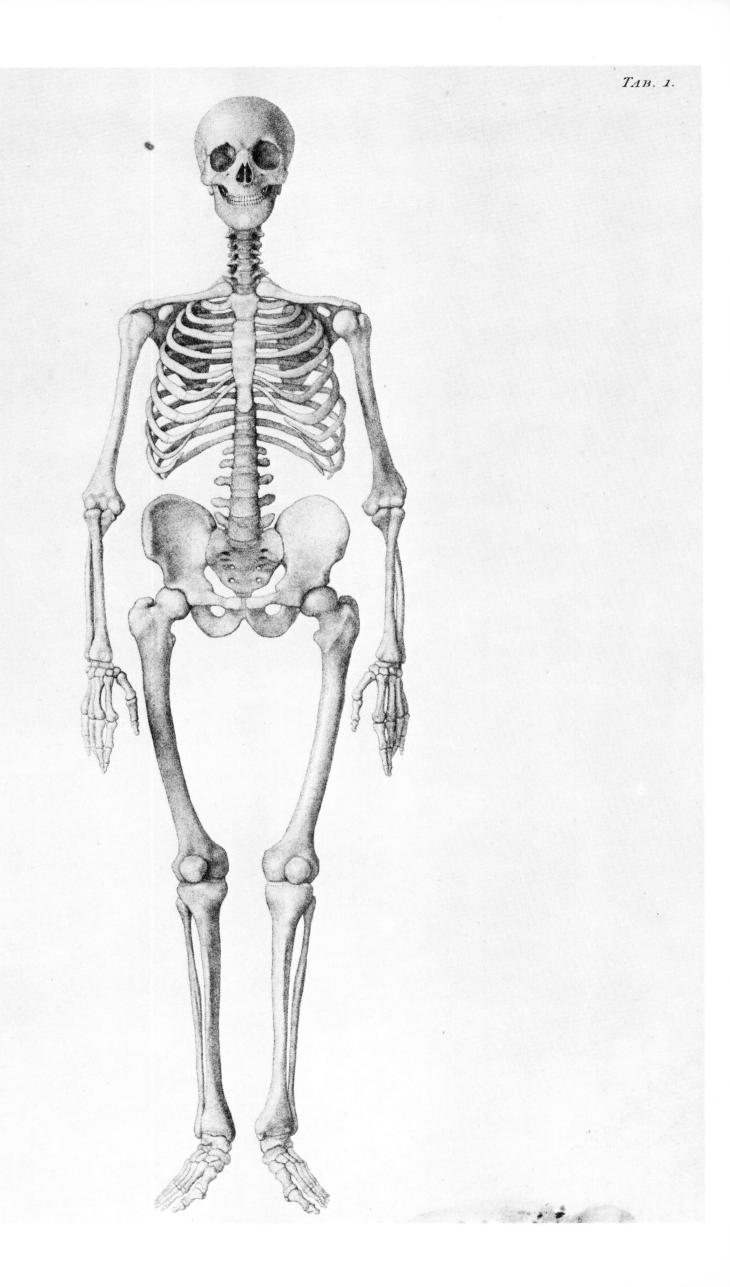

TAB. 1.

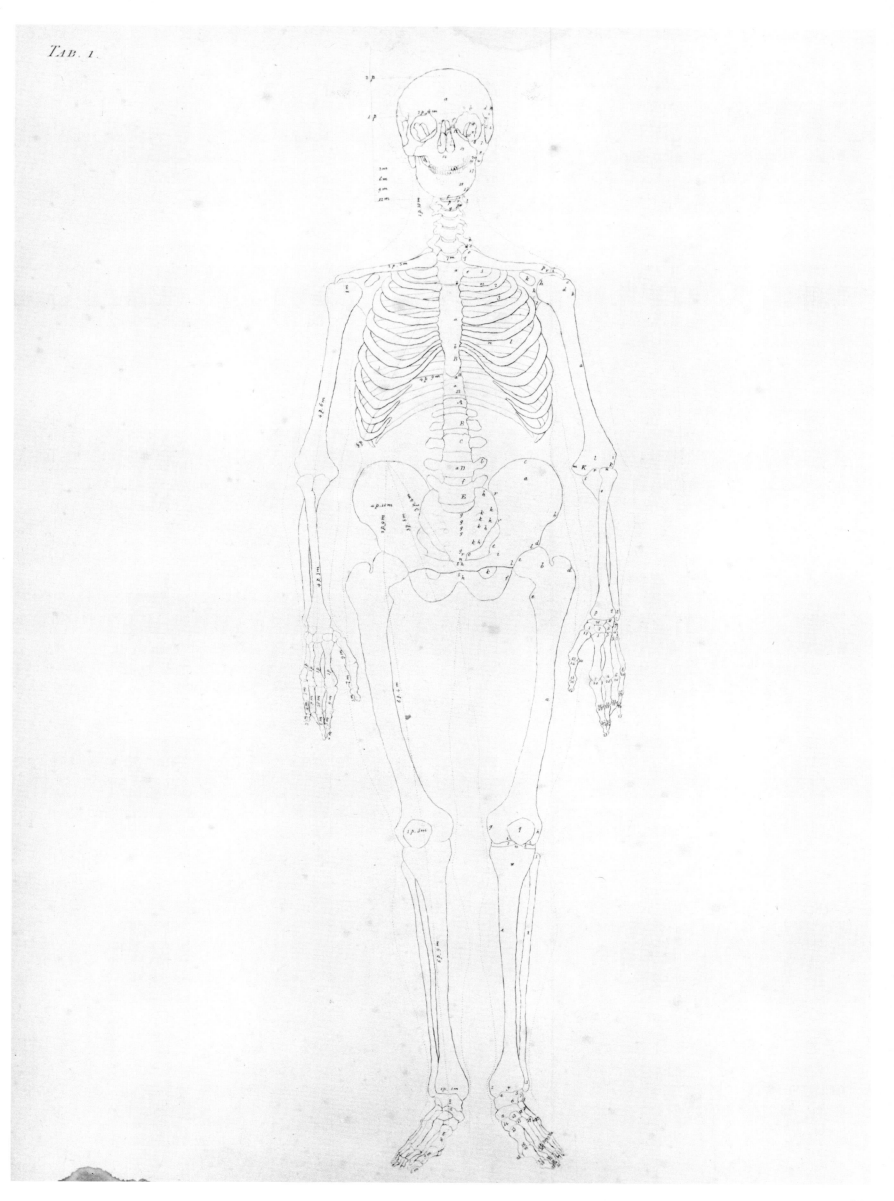

TAB. II.

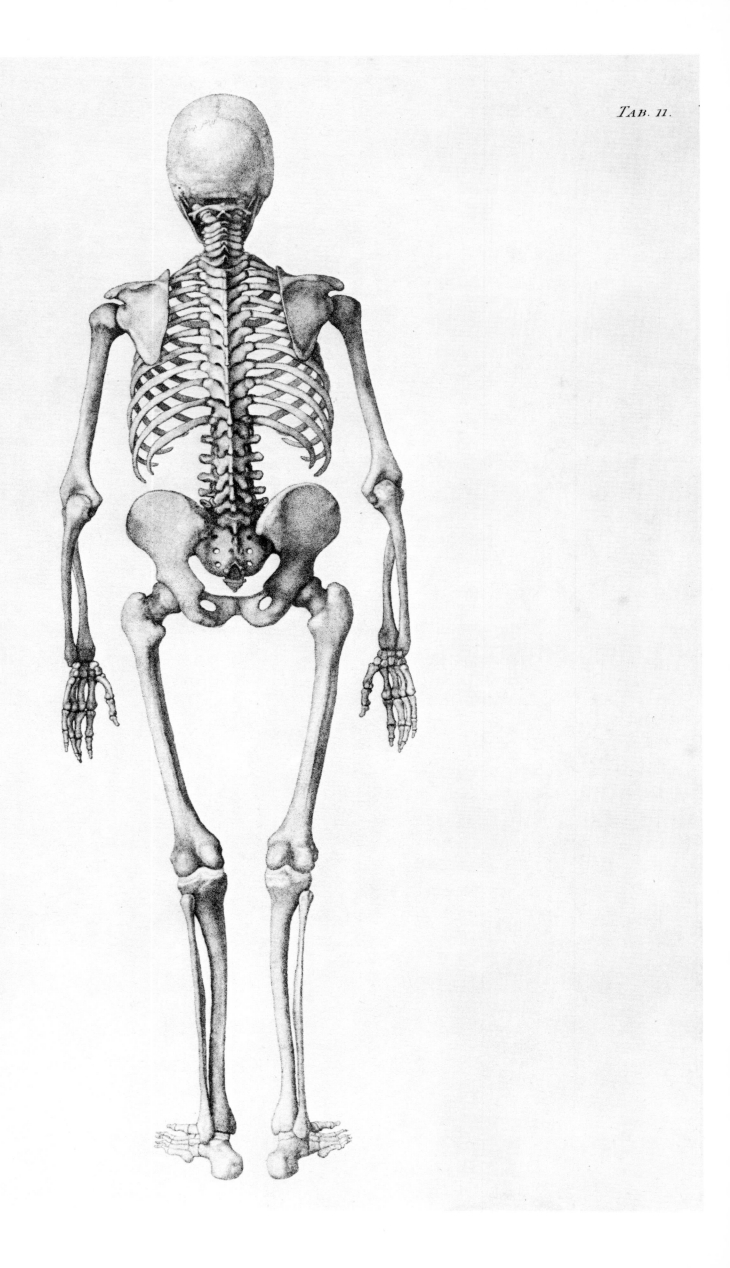

TAB. II.

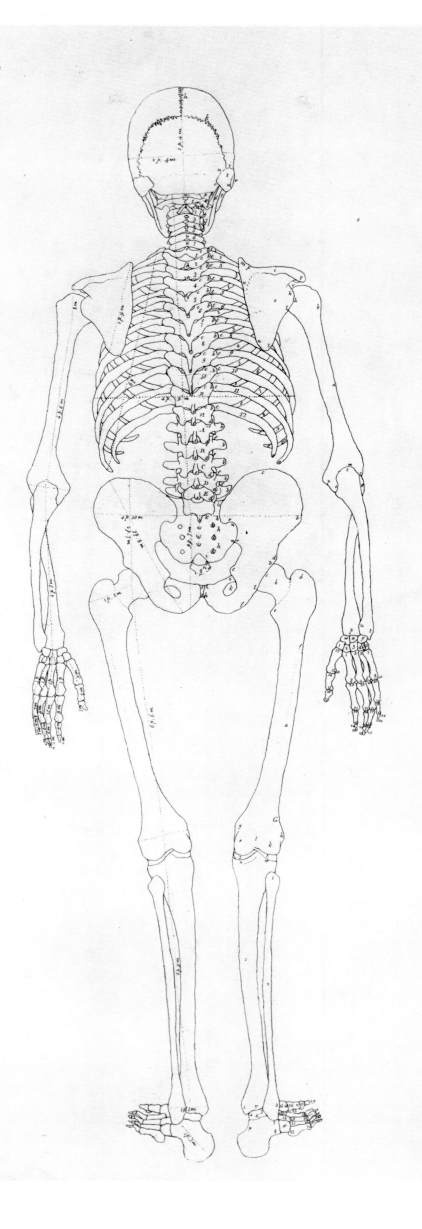

TAB. III.

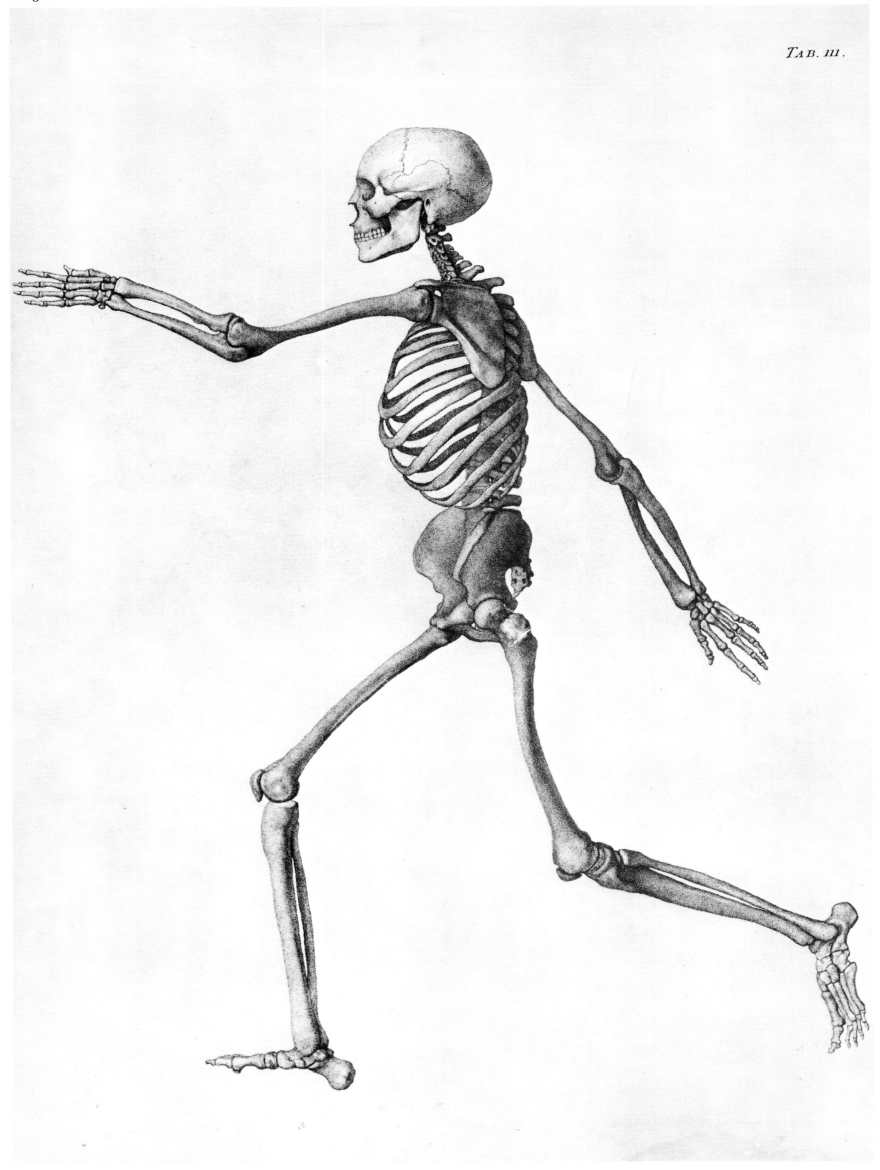

TAB. III.

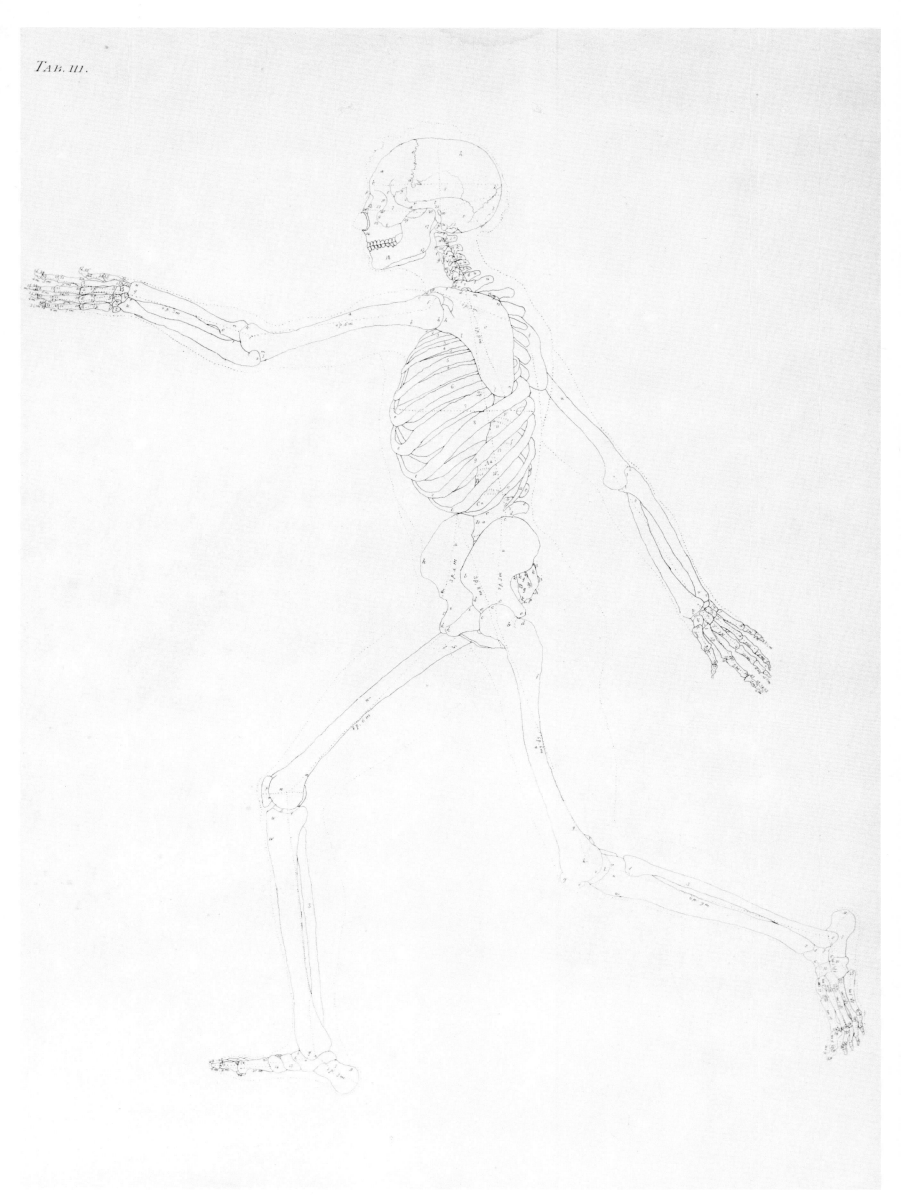

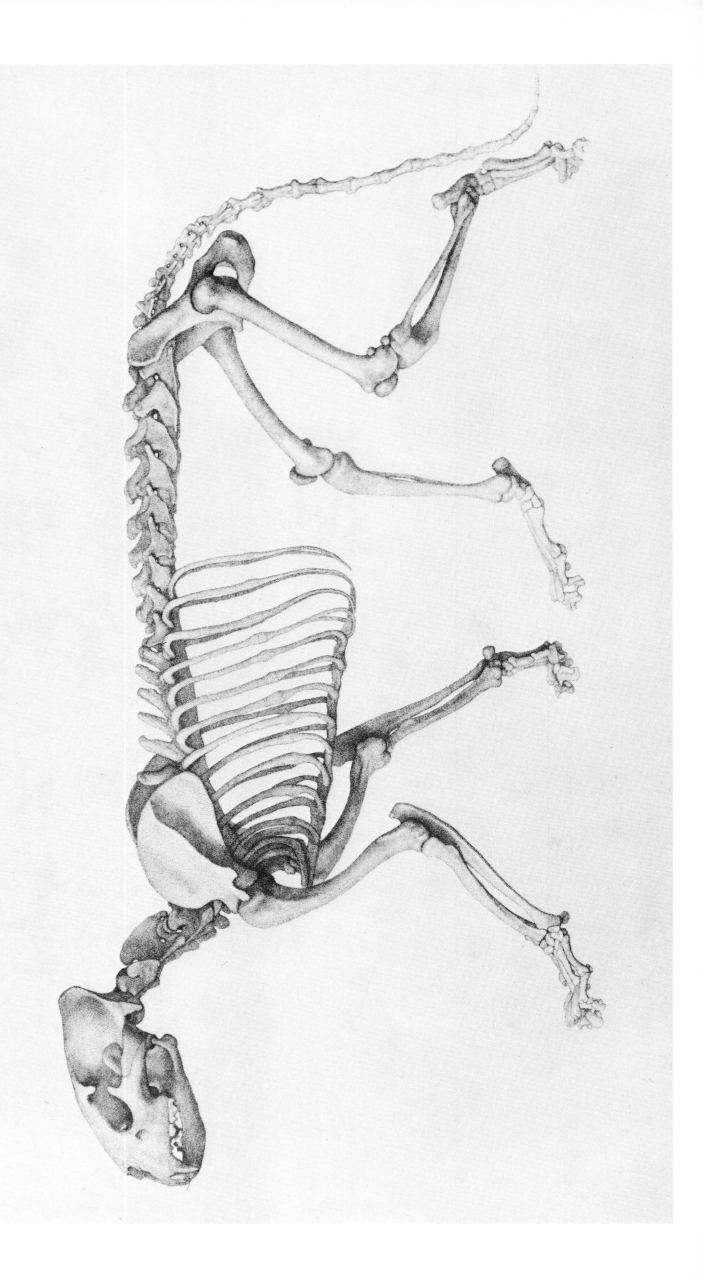

Tab. IV.

256

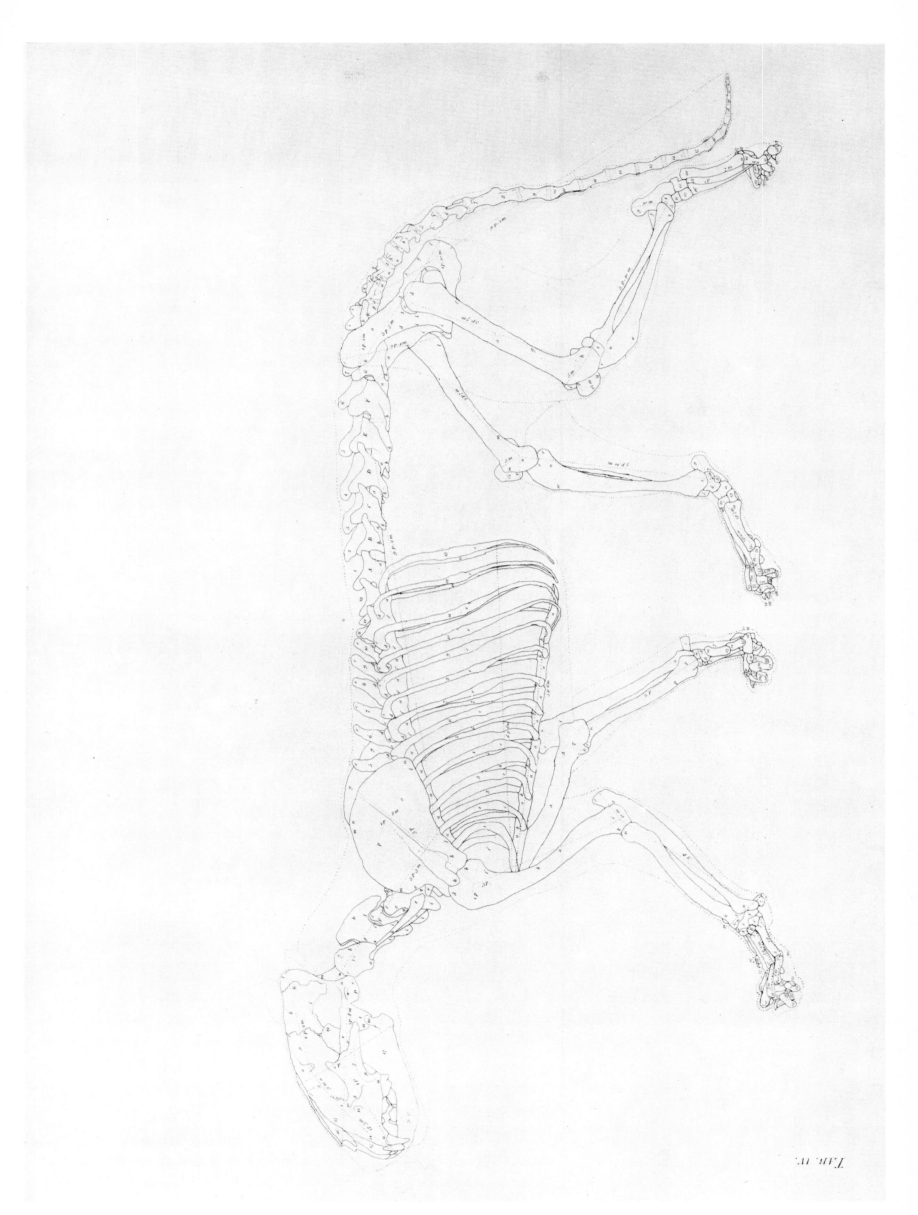

Tab. IV.

TAB. V.

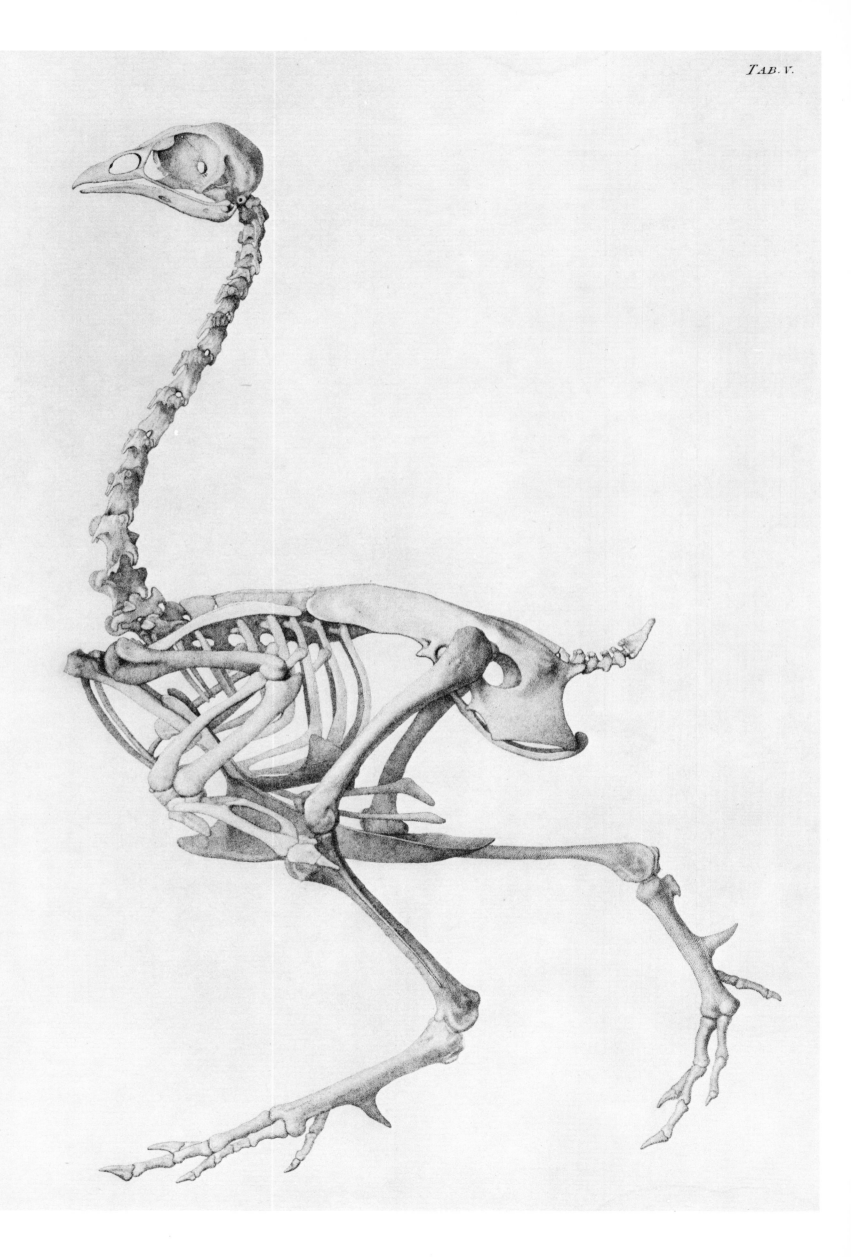

TAB. V.

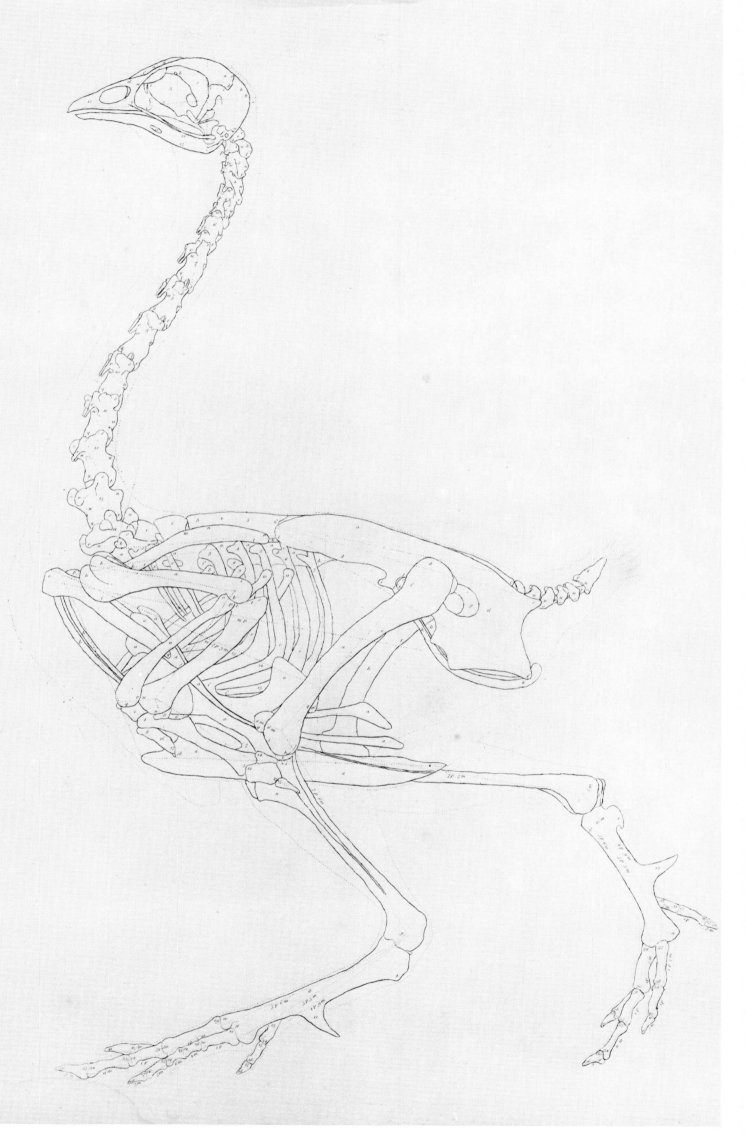

TAB. VI.

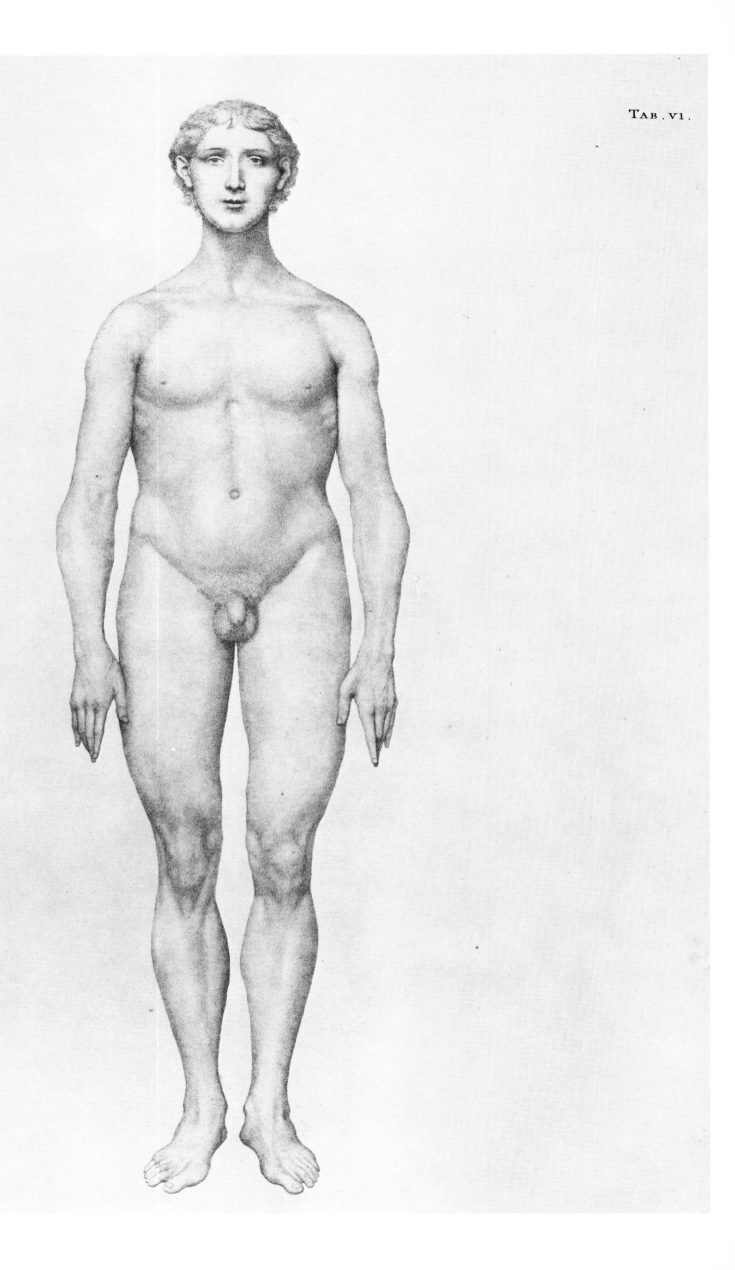

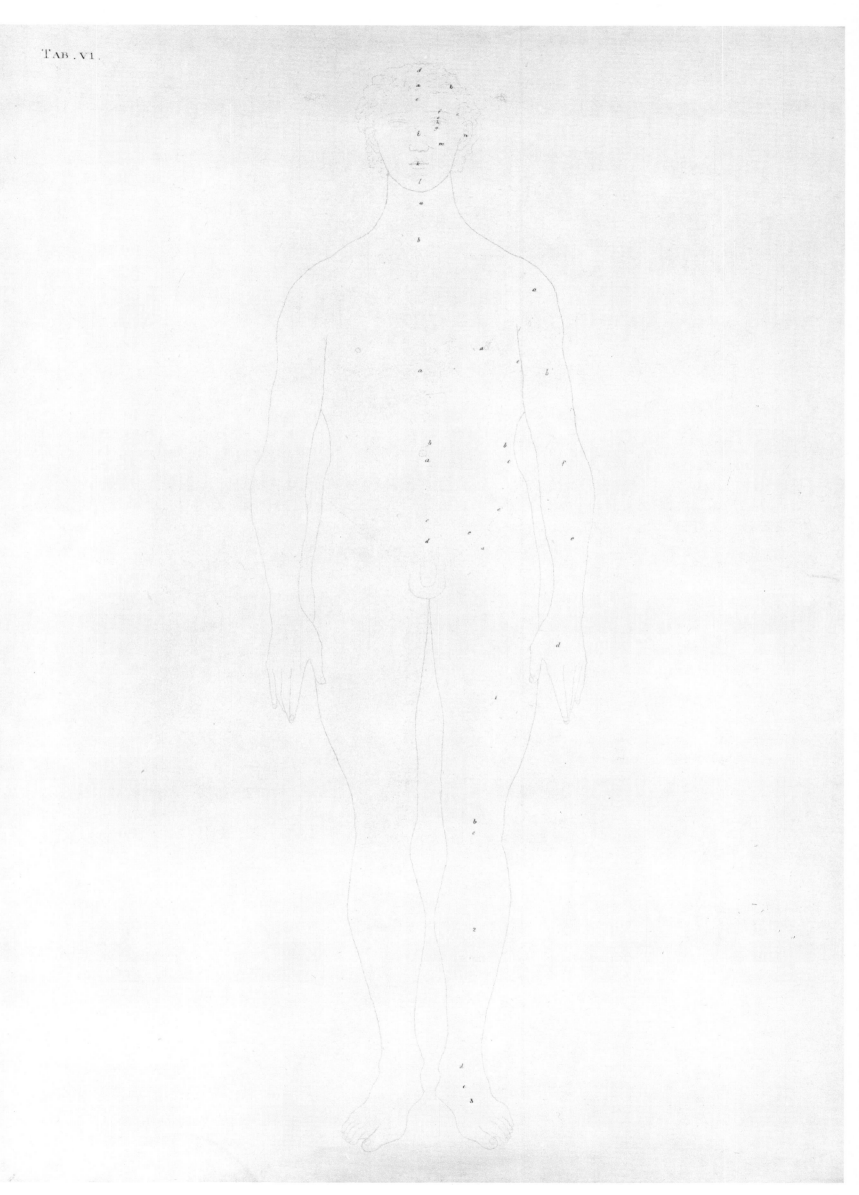

TAB. VII.

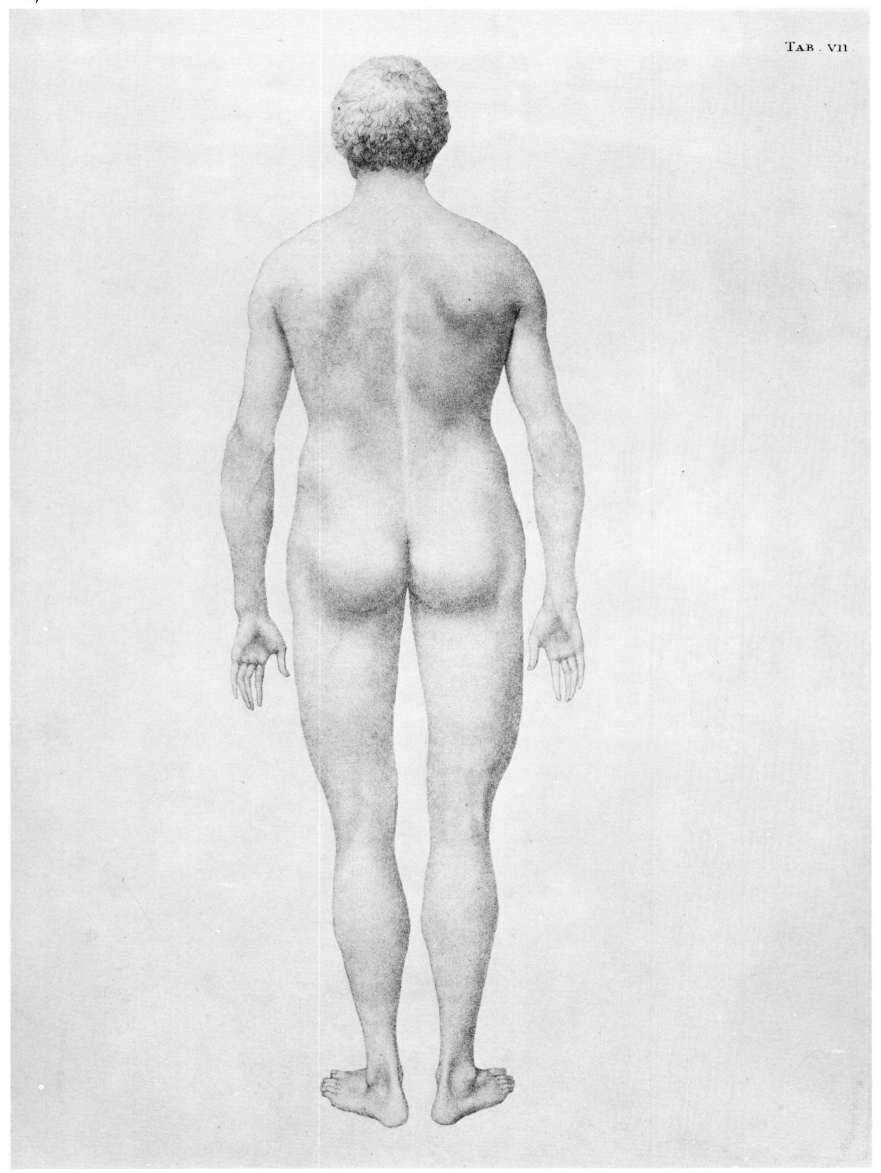

TAB VIII

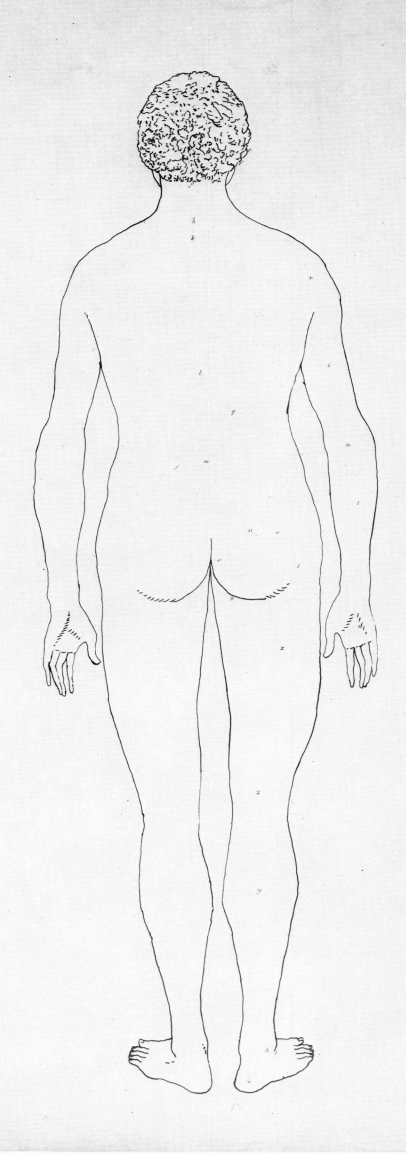

TAB. VIII.

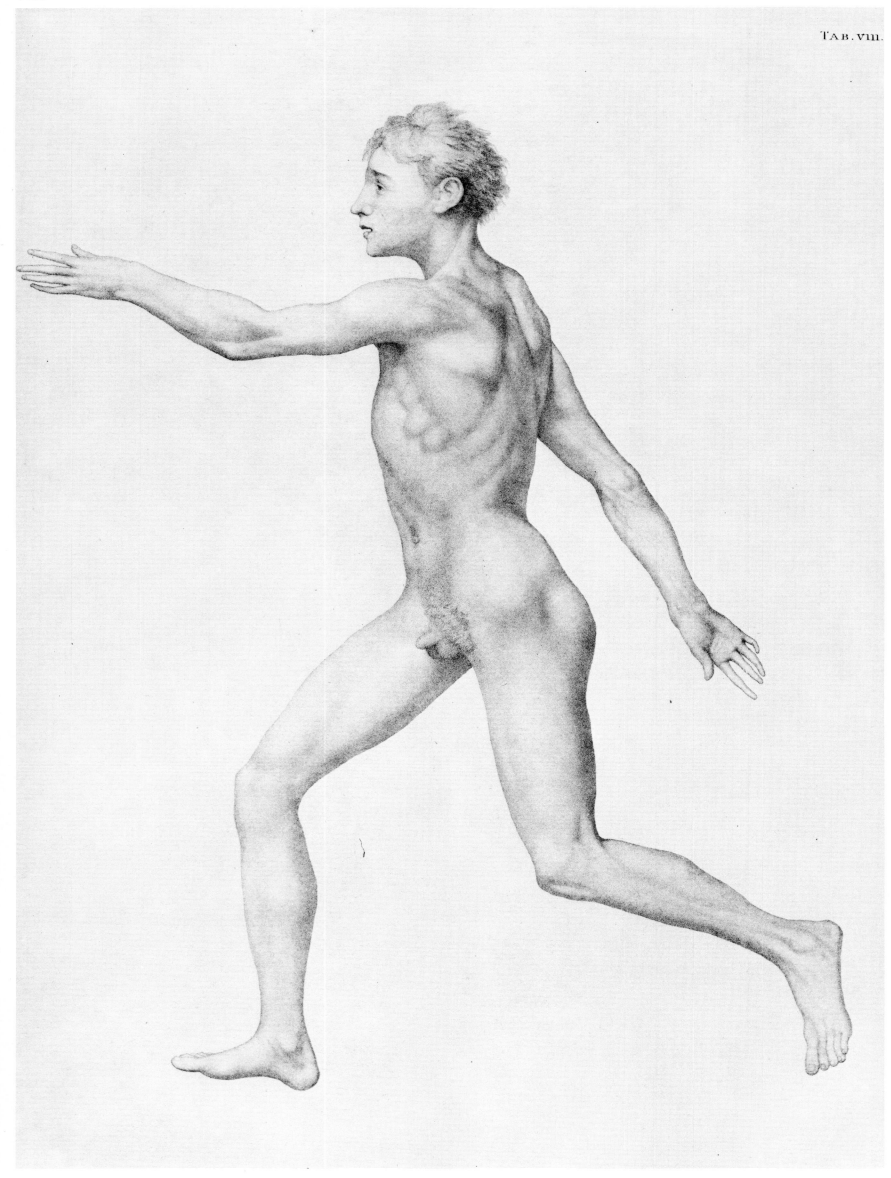

TAB. VII.

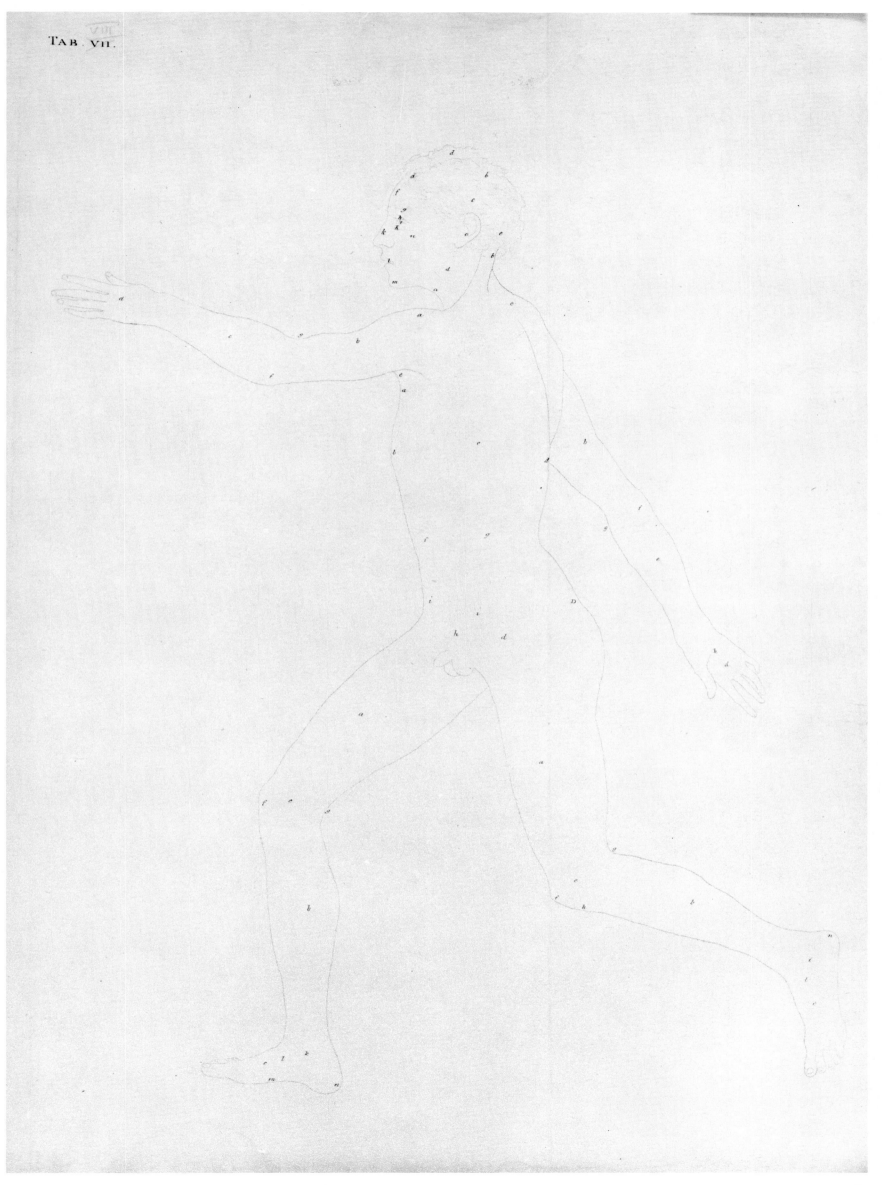

TAB. IX.

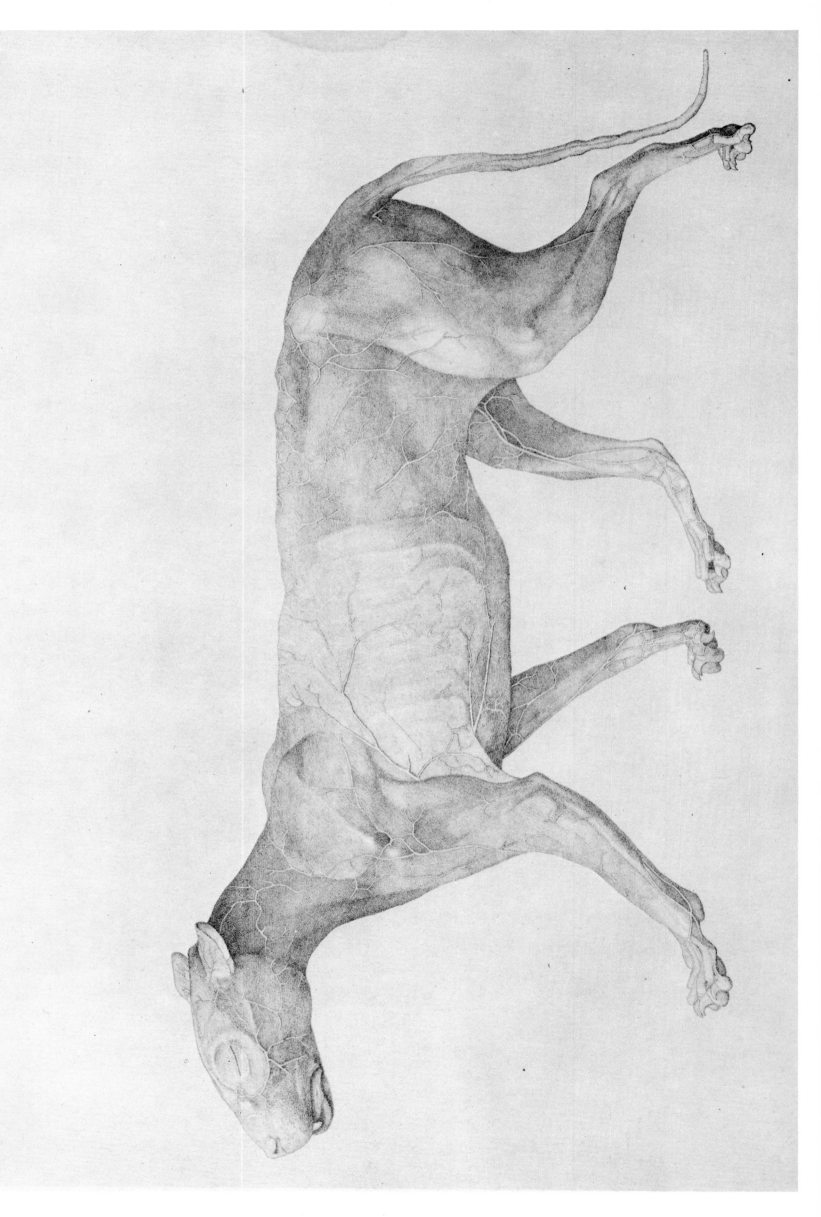

TAB IX

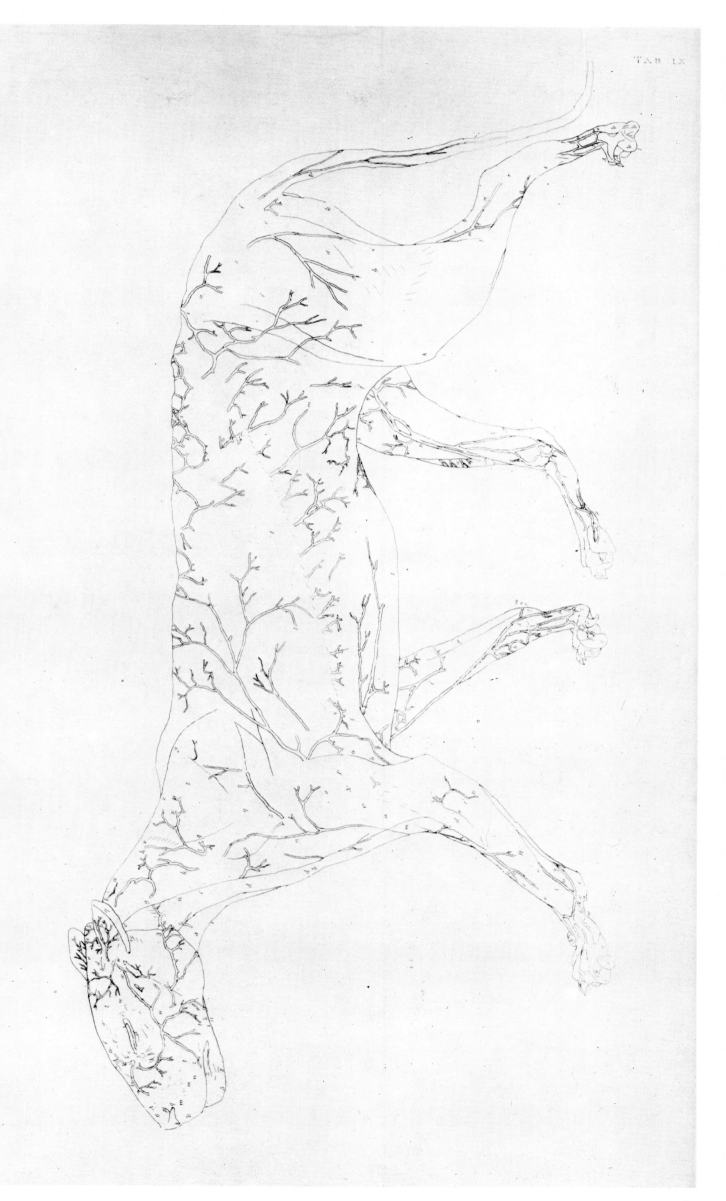

TAB. X.

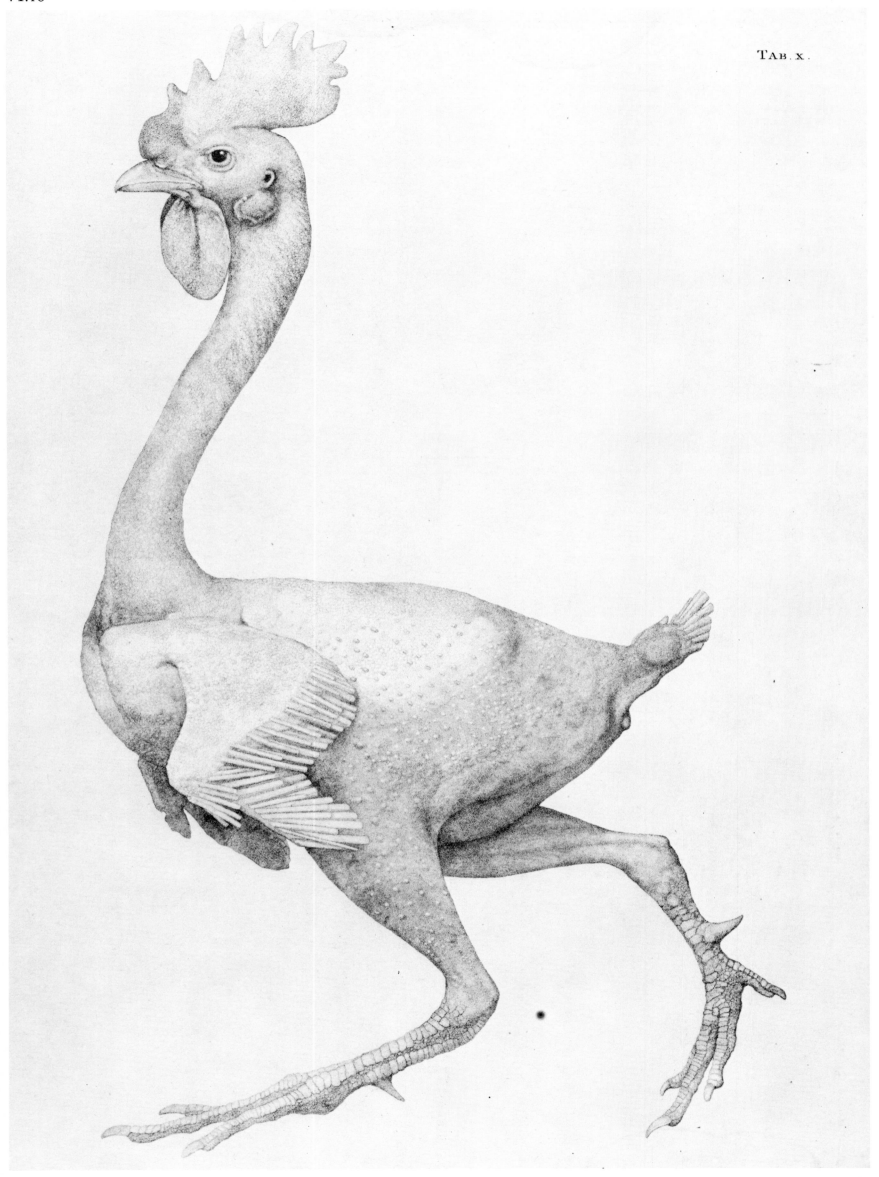

TAB. X.

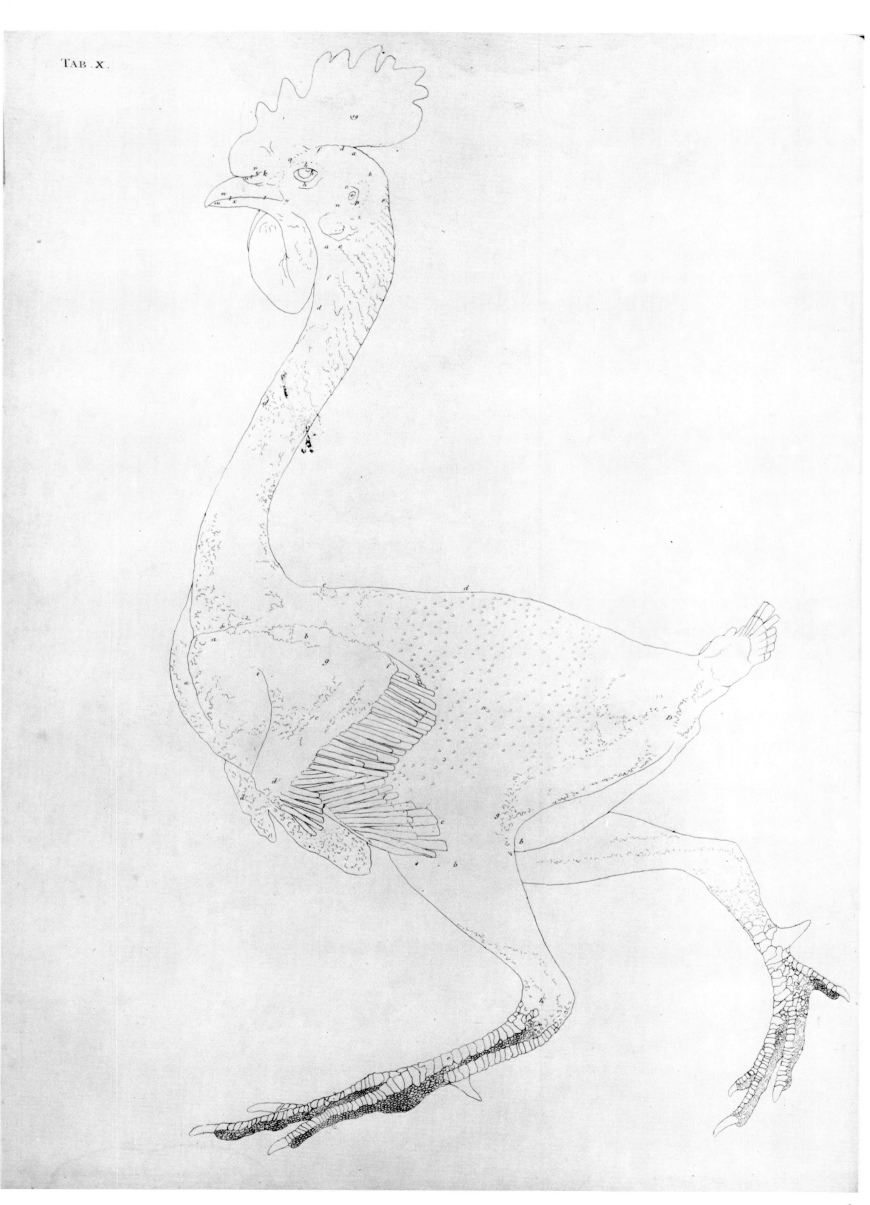

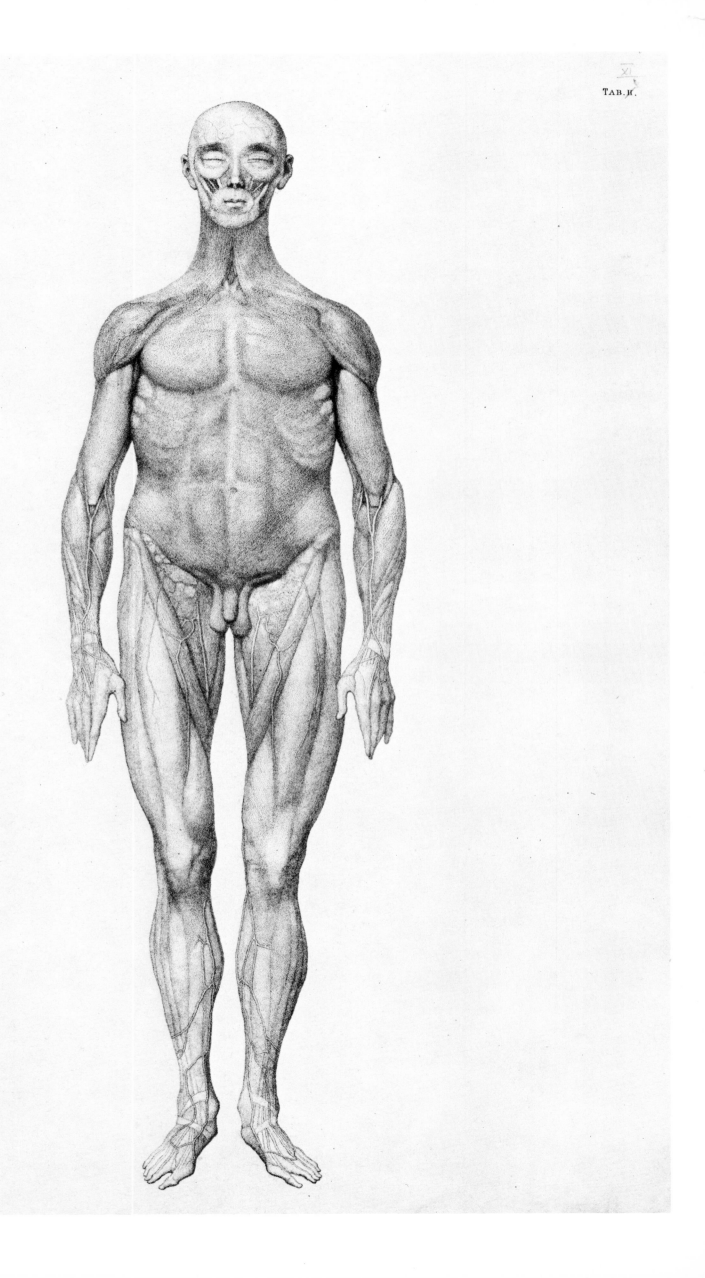

TAB. II.

TAB. II.

TAB. XII.

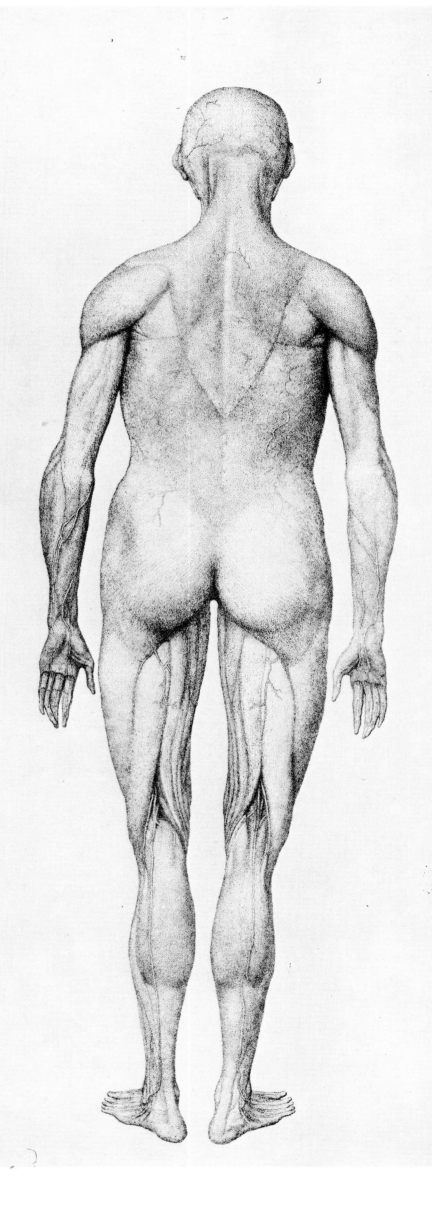

TAB. XII.

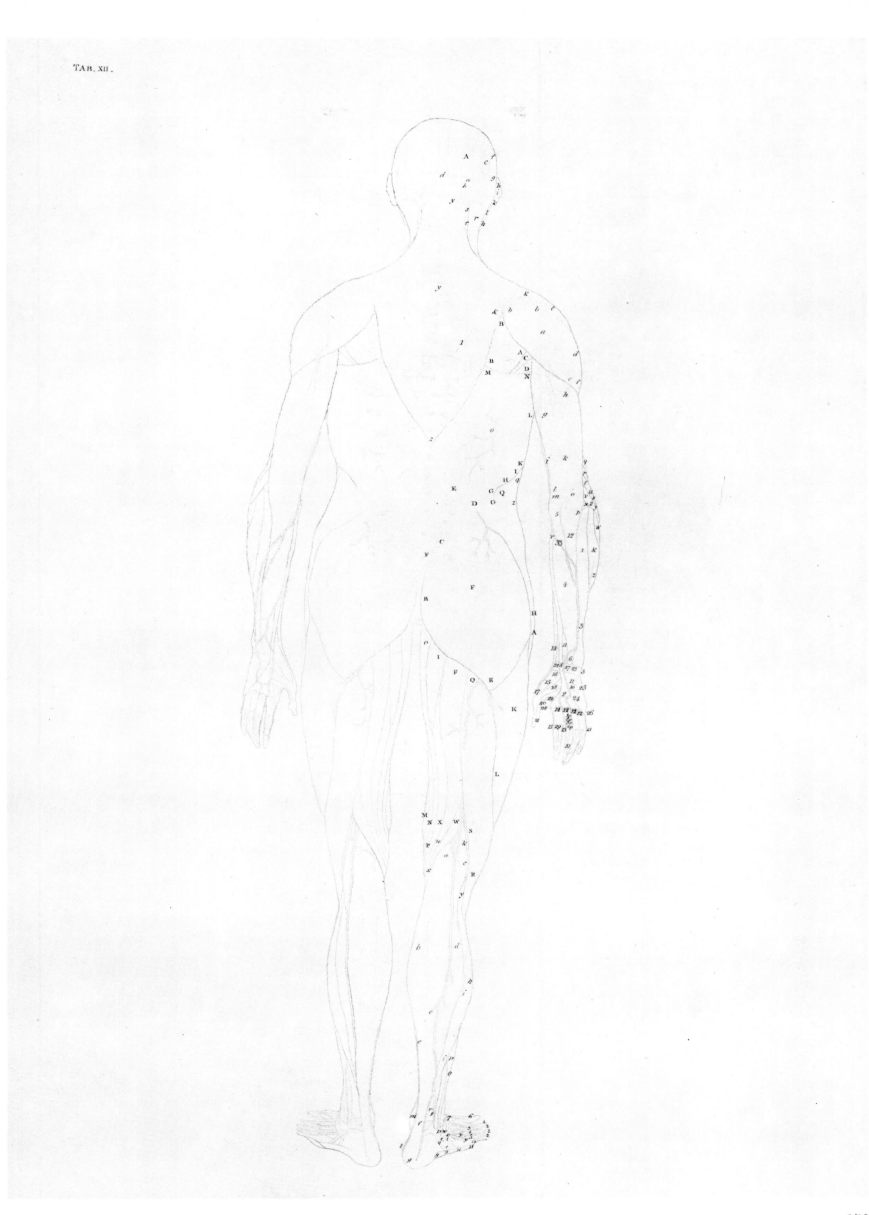

TAB. XIII.

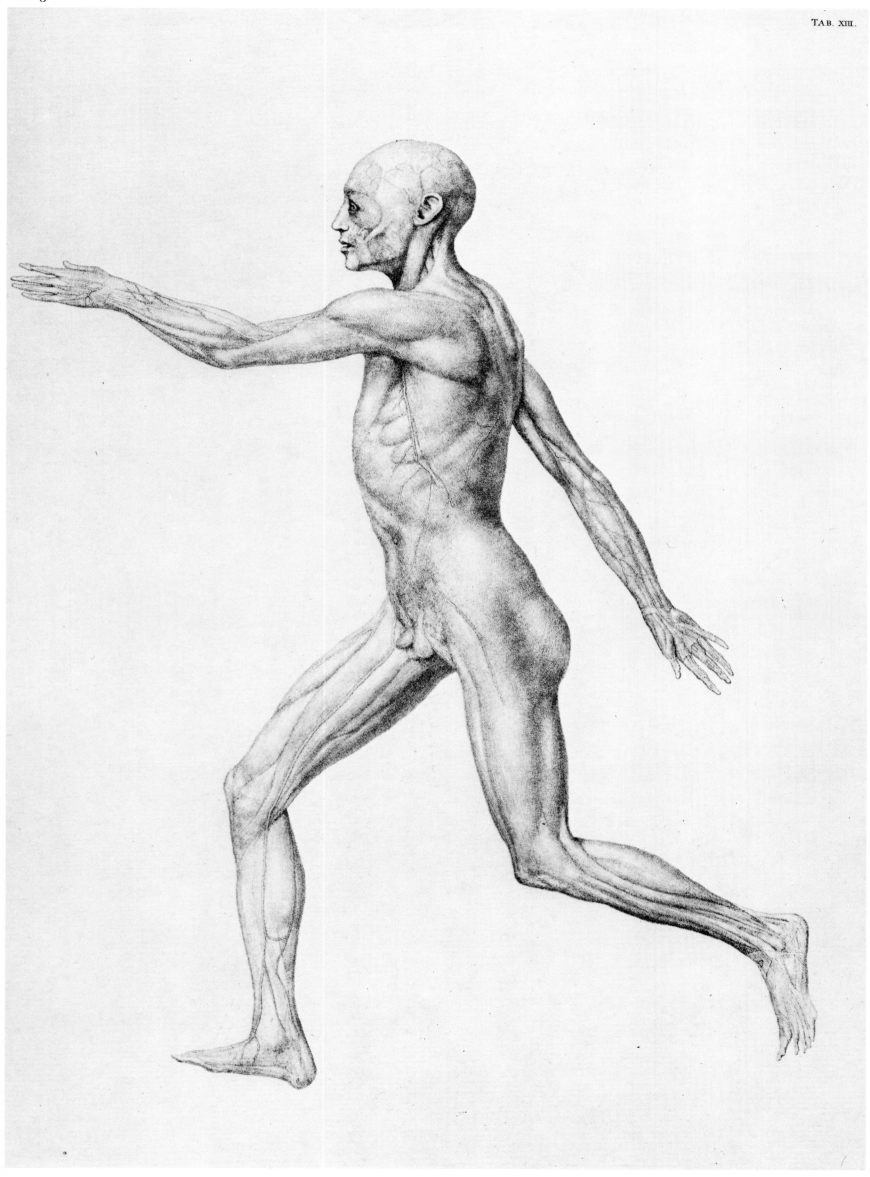

TAB. XIII.

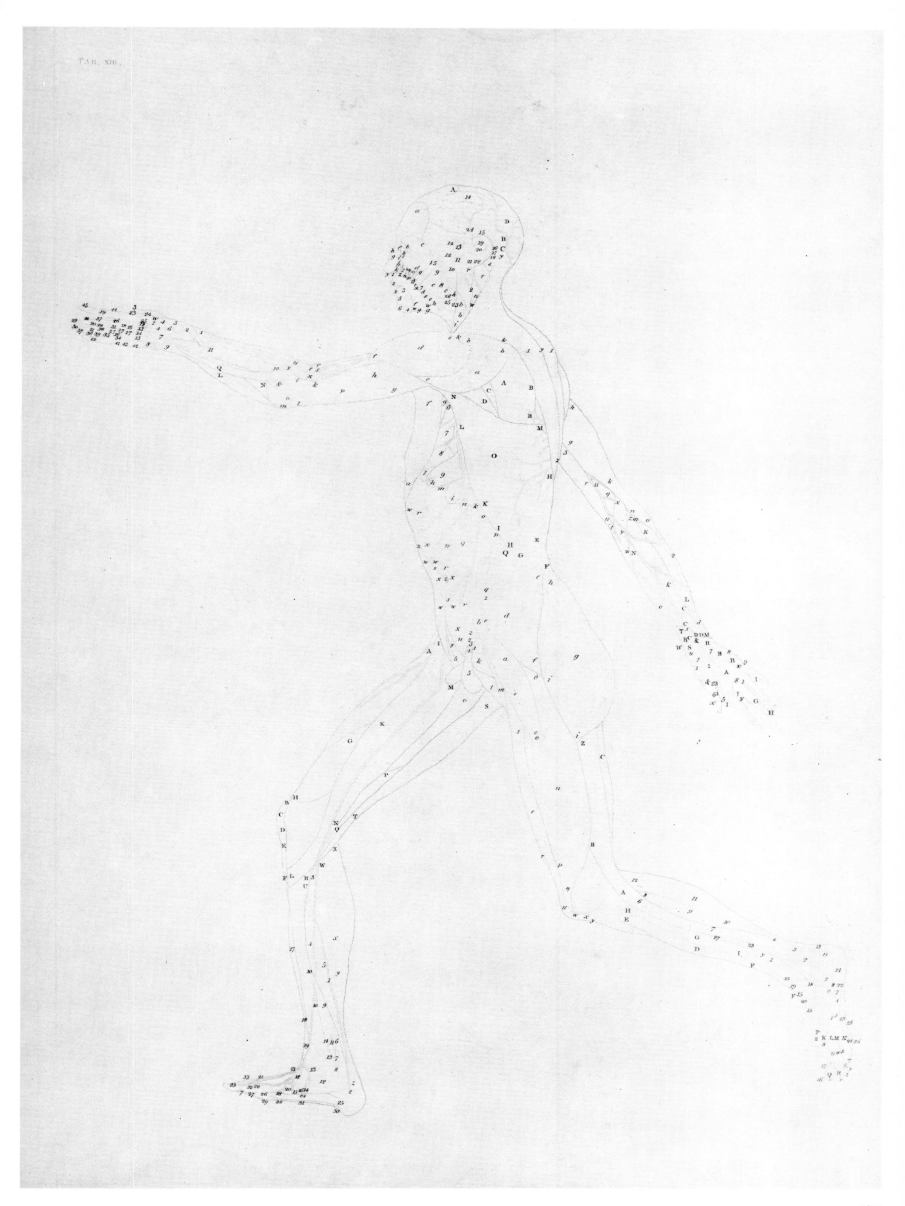

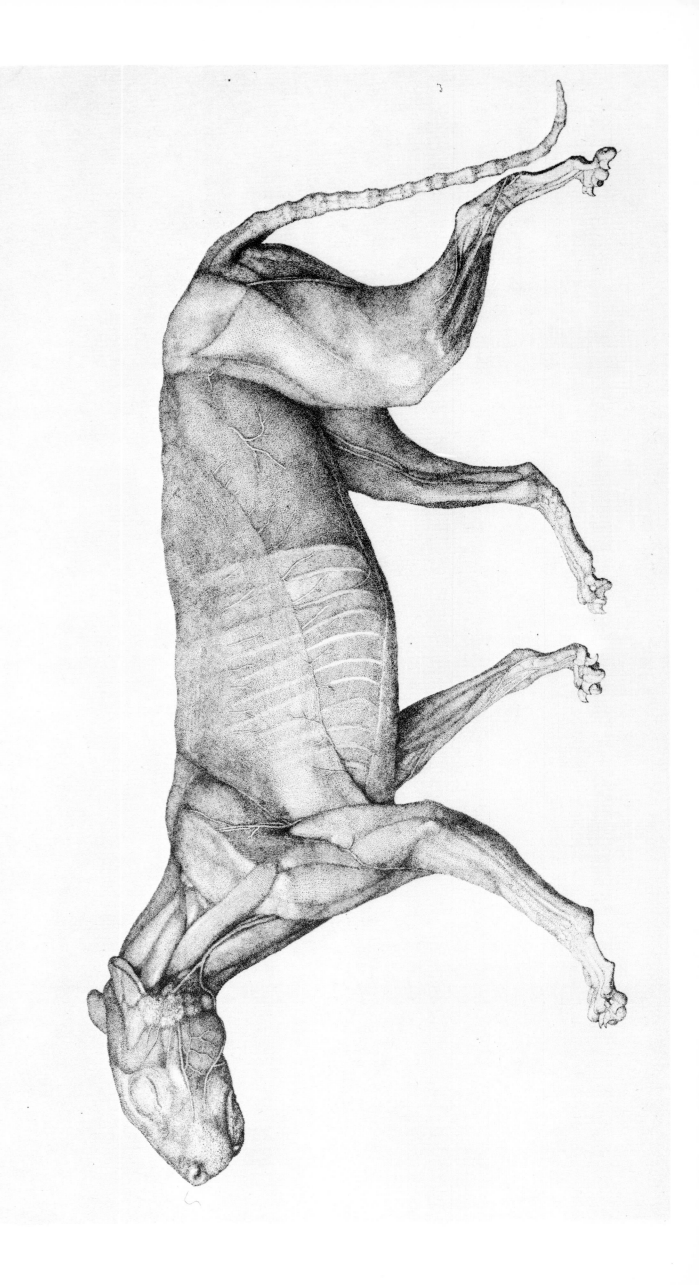

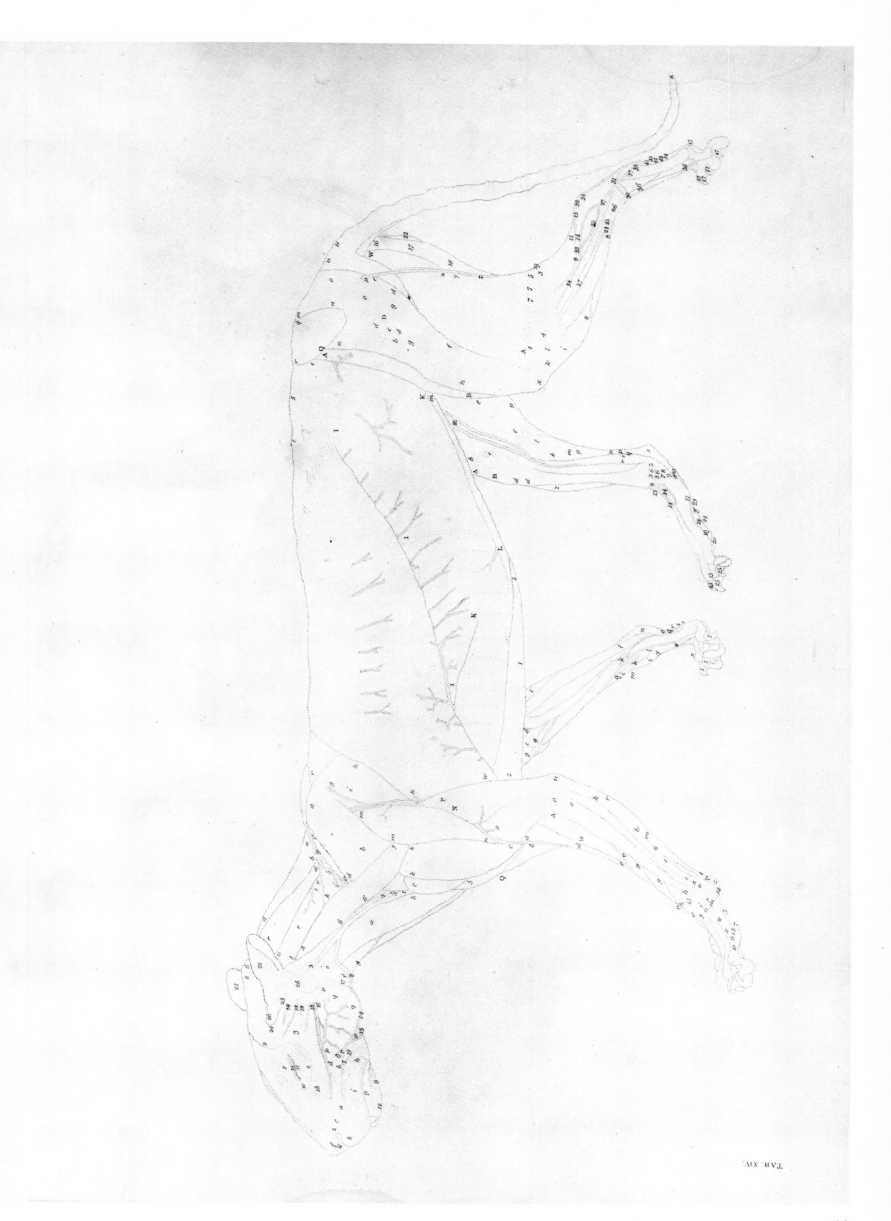

TAB. XIV.

TAB. XV.

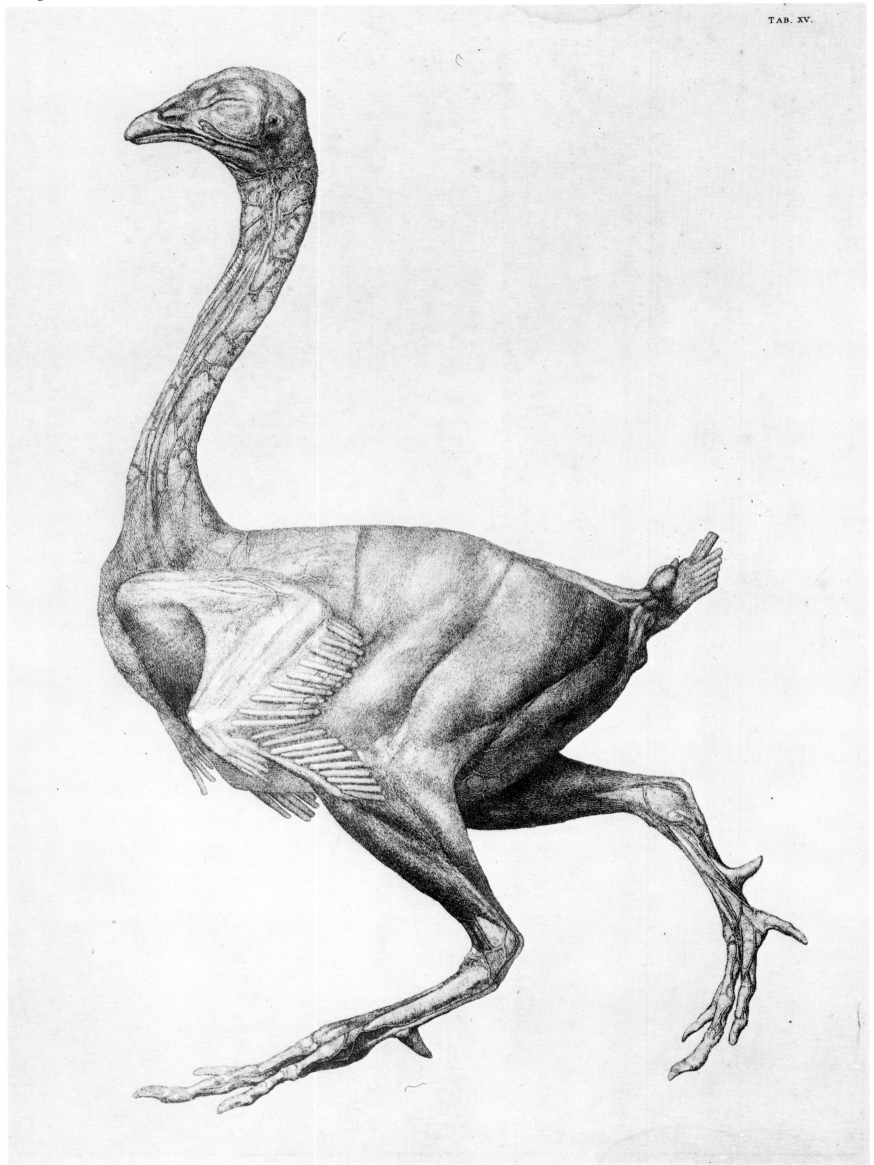

TAB. XV.

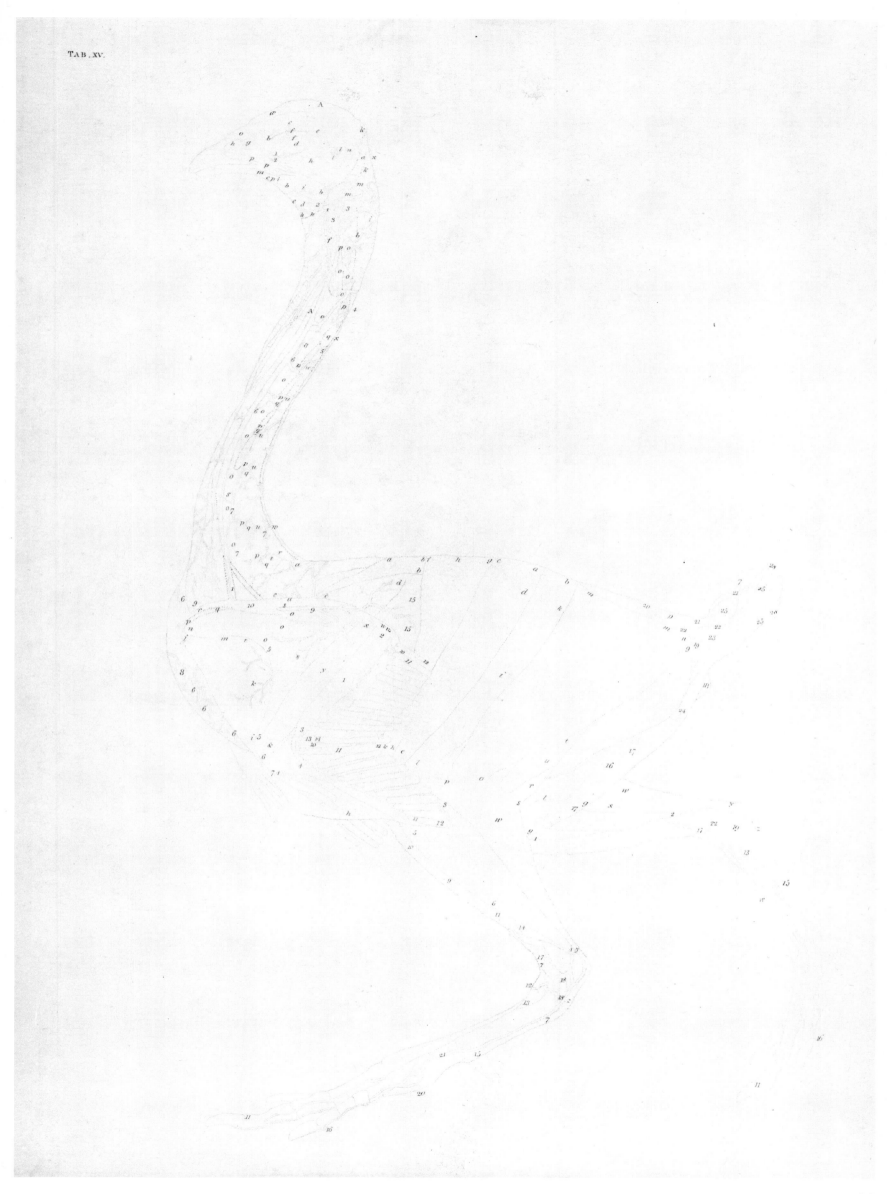

VII. Additional illustrations

This group of pictures is intended to illustrate some of the references in the text. It includes a group of the most important contemporary portraits of the artist and a number of figures illustrating the historical background of anatomical work up to Stubbs's time.

NOTES ON THE ILLUSTRATIONS

Frontispiece
GEORGE STUBBS,
SELF-PORTRAIT ON HORSEBACK

Enamel colours on an oval ceramic Wedgwood plaque, $36\frac{1}{2} \times 27\frac{1}{2}$ inches.
Signed 'Geo Stubbs pinxit 1782'. Lady Lever Art Gallery, Port Sunlight, Cheshire.
This self-portrait was long thought to represent Josiah Wedgwood, for whom Stubbs had painted four family portraits in 1780. Its true identity was established in 1957, making it the third known self-portrait of the artist.

page 283 1. GEORGE STUBBS,
SELF-PORTRAIT

Enamel colours on an oval ceramic Wedgwood plaque, 27×20 inches.
Dated 1781. National Portrait Gallery, London.
This is the most famous of the artist's self-portraits. It was commissioned by a Mrs Thorold and was acquired by the National Portrait Gallery in 1967.

284 2. GEORGE STUBBS,
STUDY FOR A SELF-PORTRAIT

Pencil on paper squared for transfer, oval, 12×9 inches.
Drawn between 1780 and 1781. The Mellon Collection, Washington, D.C.
This is a finished pencil study for the enamel self-portrait in the National Portrait Gallery.

285 3. GEORGE DANCE,
PORTRAIT OF GEORGE STUBBS

Pencil and watercolour on paper, 10×8 inches.
Signed and dated 'Geo Dance Feby. 8th. 1794'.
The Royal Academy, London. This is one of a number of portraits of his contemporaries made by the architect George Dance and, apart from his own self-portraits, is by far the finest of the contemporary records of Stubbs.

4. OZIAS HUMPHRY, 286
PORTRAIT OF GEORGE STUBBS

Pastel on paper, 23×19 inches.
The Walker Art Gallery, Liverpool.
Although this portrait is not dated, it is probably a contemporary likeness. Ozias Humphry compiled the manuscript Memoir of the life of George Stubbs, which is in the Picton Library at Liverpool and which is the largest source of contemporary information about the artist. The Memoir is composed of recollections of Stubbs's conversations and may have been in part dictated by him. It is annotated by Stubbs's companion Mary Spencer.

5. OZIAS HUMPHRY, 287
PORTRAIT OF GEORGE STUBBS

Ink and watercolour on paper, $20 \times 15\frac{3}{4}$ inches.
The National Portrait Gallery, London.
This is the second portrait made by Ozias Humphry (probably around 1795) and shows Stubbs holding an oval picture depicting horses drawing the chariot of Phaeton. This subject was used more than once by Stubbs and he modelled a Wedgwood plaque of the theme. The oval format of the work which Stubbs holds indicates that it was probably an enamel painting executed on a Wedgwood ceramic.

6. A DISSECTION 288

Miniature from an early fourteenth-century manuscript, $3 \times 4\frac{1}{2}$ inches.
The Bodleian Library, Oxford.
This manuscript illustration is the earliest-known depiction of a dissection. It shows the operator, who is a layman, being addressed by a physician and a monk. The body of a woman has been opened to expose the viscera. The kidneys, heart, lungs, and stomach are depicted lying beside the body, whilst the operator holds the liver in his hands.

7. LEONARDO DA VINCI, 289
A SHEET OF ANATOMICAL DRAWINGS

Pen and ink over red chalk on red, prepared paper, $11\frac{1}{4} \times 8\frac{1}{8}$ inches.
The Royal Library, Windsor.

This sheet of anatomical drawings (c.1504) shows three views of the leg muscles of a man and a comparison between the limb skeletons of a man and a horse. Two of the latter drawings show cords attached to the bones to indicate the position of the muscles.

290 8. LEONARDO DA VINCI,
 A DISSECTION OF A BEAR'S FOOT

Silver point, reinforced with ink, heightened with white, on grey-blue paper, $6\frac{3}{8} \times 5\frac{1}{2}$ inches.
The Royal Library, Windsor.
Drawn sometime between 1490 and 1493, this is one of the studies made by Leonardo of animal anatomy, and its implications of comparison with the homologous structures of man are evident.

291 9A & B. PIERRE BELON,
 A COMPARISON OF THE SKELETON OF A
 MAN AND A BIRD

Woodcuts, $11\frac{1}{4} \times 6\frac{1}{2}$ inches.
These plates are from Belon's *L'Histoire de la Nature des Oyseaux*, published in 1555. They represent the first printed comparison between a man and another animal. Belon has labelled the bones to illustrate the homologies between them. He accurately interpreted the structure of the limbs of the bird and shows an understanding of the nature of the elongated carpal and tarsal bones of the wings and legs respectively.

292 10. ANDREAS VESALIUS, PLATE VI OF
 DE HUMANI CORPORIS FABRICA, 1543

Woodcut, $14\frac{1}{2} \times 10\frac{1}{2}$ inches.
This celebrated work exerted a powerful influence on contemporary and subsequent anatomists due not only to the revolutionary observations made by Vesalius but also to the drama and beauty of the plates. Their legacy is obvious in Ruini's *Dell'Anotomia et dell'Infirmità del Cavallo* of 1598.

293 11. BARTHOLOMAEUS EUSTACCHI,
 TABLE XXXIII FROM TABULAE
 ANATOMICAE, 1714.

Engraving, $11 \times 7\frac{1}{4}$ inches.
Although these tables were only published in 1714, they had in fact been engraved in 1552. They are less striking than those of Vesalius, but though they lack his artistic achievement Eustacchi's tables are more accurate and contain a number of new anatomical discoveries.

294 12A, B, C, & D. CARLO RUINI,
295 FOUR TABLES FROM DELL'ANOTOMIA ET
 DELL'INFIRMITA DEL CAVALLO, 1598

Woodcuts, $10\frac{3}{4} \times 7\frac{3}{4}$ inches.
These tables from Ruini's anatomy are comparable

to the First Skeleton Table and Tables One, Seven, and Twelve of the Anatomical Tables from Stubbs's *Anatomy of the Horse*. Like Vesalius, Ruini employed woodcuts and he displayed the horse against a series of landscape backgrounds. Unlike Stubbs or Albinus, he did not use outline key figures but labelled the fully modelled plates. This work was consistently plagiarised up until the eighteenth century, and until Stubbs's *Anatomy* no attempt was made to conduct fresh dissections of the horse. This work is of importance as the first anatomical study of a horse and as the first work to be devoted to a single animal other than man.

13. G. MARKHAM, SKELETON OF A HORSE 296
 FROM MARKHAM'S MAISTER-PEECE, 1610

Woodcut, $5\frac{1}{4} \times 7\frac{1}{8}$ inches.
This illustrates the extraordinary quality of some works on the horse produced after Ruini's study. In this case the wild schematisation and the impossible arrangement of the pelvis must be attributed to Markham himself.

14. ANDREW SNAPE, 297
 TABLE XXXII FROM AN ANATOMY OF THE
 HORSE, 1683

Engraving, $10\frac{1}{2} \times 7\frac{1}{4}$ inches.
This is an example of the type of plagiarised anatomy based on Ruini. It is comparable to the third of the figures illustrated from Ruini's work shown above. The pose is reversed by the engraver who copied it. The landscape is altered and adorned by an irrelevant dragonfly. The worst defect is the deliberate schematisation of the muscles, destroying both the accuracy and the vitality of the representation.

15. ITALIAN SCHOOL, SEVENTEENTH 298
 CENTURY,
 ANATOMICAL STUDY OF A HORSE

Bronze, height $35\frac{1}{2}$ inches.
This sculpture is one of the earliest three-dimensional representations of equine anatomy. It is close in style to the numerous écorché studies of human anatomy used in academic teaching. This work was probably based on Ruini.

16. J. HOUBRAKEN (after C. de Moor) 299
 PORTRAIT OF BERNHARD SIEGFRIED
 ALBINUS

Engraving, Wellcome Foundation, London,
$8\frac{1}{2} \times 6\frac{1}{4}$ inches.
An eighteenth-century engraving after a contemporary portrait of the great Dutch anatomist, whose monumental works had such a profound influence on Stubbs's own method of presentation in *The Anatomy of the Horse* and the *Comparative Anatomical Exposition*.

VII. Additional
illustrations

17*A & B*. BERNHARD SIEGFRIED ALBINUS,
PLATE I AND ITS KEY FIGURE FROM
HISTORIA MUSCULORUM HOMINIS,
1734

Engravings, 8 × 5¼ inches.
Two plates from an early work on human muscles.
The book was quoted in the references which Burton
made in his *An Essay Towards a Complete New System of
Midwifery*. They were undoubtedly known to Stubbs
and used by him as a model for his subsequent
works, although their influence is not apparent in
the illustrations to Burton's own book. The plate
shows the dissection of the muscles of the hand.

301
302
303

18*A, B, & C*. BERNHARD SIEGFRIED ALBINUS
AND JAN WANDELAAR,
THREE TABLES FROM TABULAE SCELETI
ET MUSCULORUM CORPORIS
HUMANII, 1747

Engravings, 20½ × 14 inches.
These three plates illustrate the exquisite beauty and
craftsmanship of Albinus's great work on the human
anatomy. They lack the extravagant rhetoric of
Vesalius, and the use of engraving allowed a much
finer display of detail. Albinus deliberately included
elaborate backgrounds, which he believed en-
hanced the three-dimensional illusion he wished to
impart to the figures. The first two plates may be
compared to Tables I and XI of Stubbs's *Comparative
Anatomical Exposition*. The last plate shows a
rhinoceros, an earlier specimen than the one
painted by Stubbs for John Hunter.

304

19. ALEXANDER READ,
TABLE I FROM ELEMENTS OF SURGERY, 1764

Engraving, 8 × 9 inches.
This shows a group of surgical instruments of a type
used at the time Stubbs was preparing *The Anatomy
of the Horse*. They are remarkably similar to the
instruments used for dissection today, although
solid scalpels have been largely replaced by those
with disposable blades.

305

20. GEORGE STUBBS,
PORTRAIT OF JOSIAH WEDGWOOD

Enamel colours on an oval ceramic Wedgwood
plaque, 20 × 16 inches.
Signed 'Geo: Stubbs pinxit 1780', Wedgwood
Museum, Barlaston, Staffs.
This portrait was not commissioned by the sitter
but was probably painted by Stubbs from a drawing
made at Etruria, where he worked on the group
portrait of the Wedgwood family. It seems to have
remained in his studio until his death.

21. SIR JOSHUA REYNOLDS,
PORTRAIT OF JOHN HUNTER

306

Oil on canvas, 48 × 38½ inches.
Unsigned, painted in 1786. The Royal College of
Surgeons of England, London.
This portrait of John Hunter, which was commis-
sioned by the sitter, shows him in his study. Propped
open on the table is a book showing illustrations of
the comparative anatomy of the skull and the hand.
Above, on a shelf, is a jar containing a preparation
of lungs. Above can be seen part of the skeleton of a
giant, possibly that of Byrne, the Irish giant whose
body Hunter obtained and secretly prepared.

22. GEORGE STUBBS,
AN INDIAN RHINOCEROS

307

Oil on canvas, 27½ × 36½ inches.
The Royal College of Surgeons of England, London.
This painting of the Rhinoceros unicornis was
commissioned by John Hunter in 1772 and is one of
a group of six animal paintings which Stubbs
executed for John and William Hunter. The
rhinoceros was exhibited in Pidcock's Menagerie in
the Strand, from which Stubbs was able to make
the first really accurate representation of the animal.
In the sale of Stubbs's studio work in 1807, nine
drawings of the same animal were recorded, one
of these is now in the collection of Basil Taylor.

23. *A, B, & C*. GEORGE STUBBS,
THREE STUDIES OF LEMURS

308
309
310

Pencil on paper, 7¾ × 12, 7¾ × 10⅛, and 7¾ × 12½
inches respectively.
The British Museum, London.
These drawings were commissioned, between 1770
and 1773, by Sir Joseph Banks and bequeathed by
him to the British Museum. The name 'Lemur
murinus' and the signature are not in Stubbs's hand,
but were probably added by Banks.

24. GEORGE STUBBS,
A RACEHORSE IN ACTION

311

Pencil on paper, 6¾ × 10½ inches.
The Mellon Collection, Washington, D.C.
This remarkable drawing is of unknown date and
cannot be directly related to the other anatomical
studies surviving at the Royal Academy. The animal
is shown with the skin removed, emphasising the
action of the muscles. It is comparable with the
First Anatomical Table of *The Anatomy of the Horse*.
In some parts of the body the outline of the skeleton
can be seen beneath the muscles. The drawing may
have been made for one of the paintings of racehorses
in action. It may have a source in Stubbs's interests
in comparative anatomy.

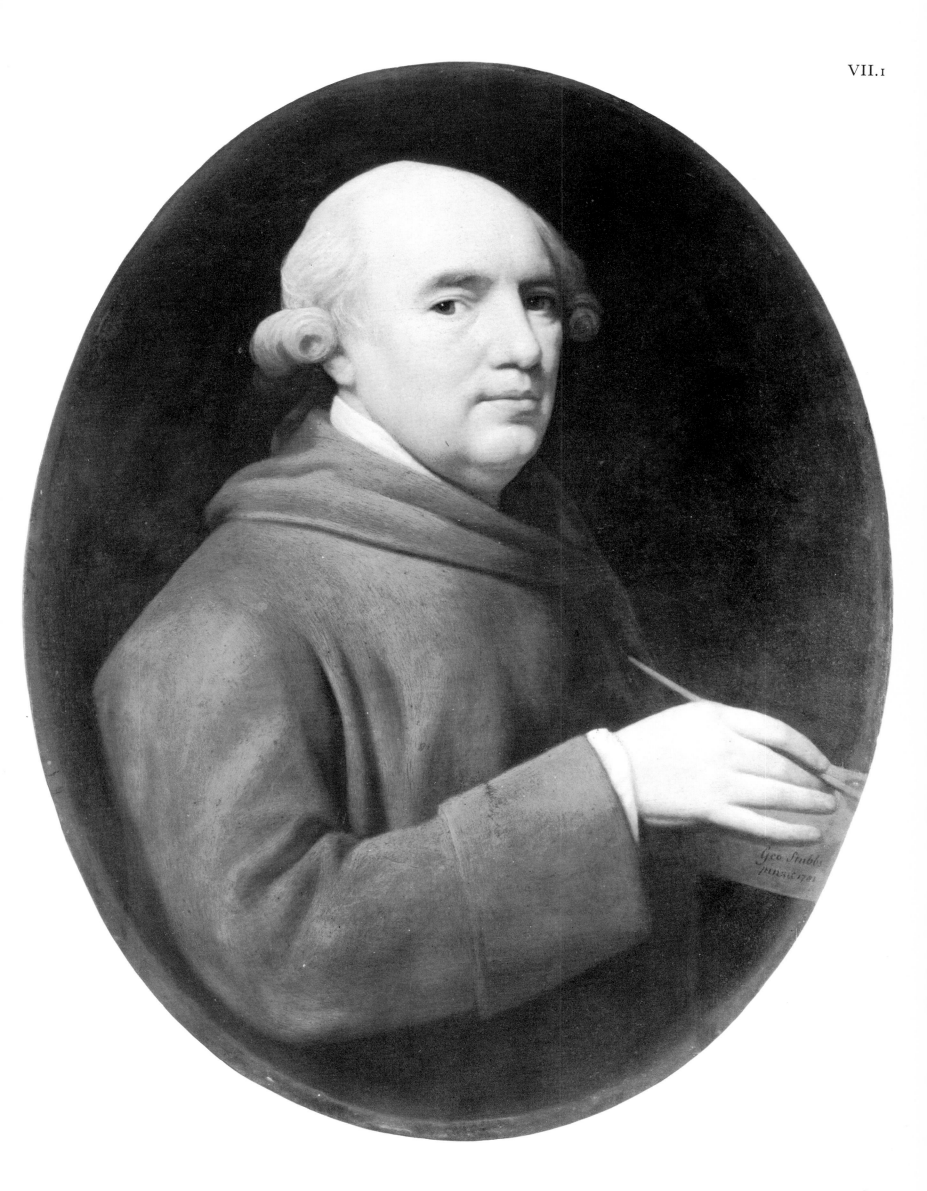

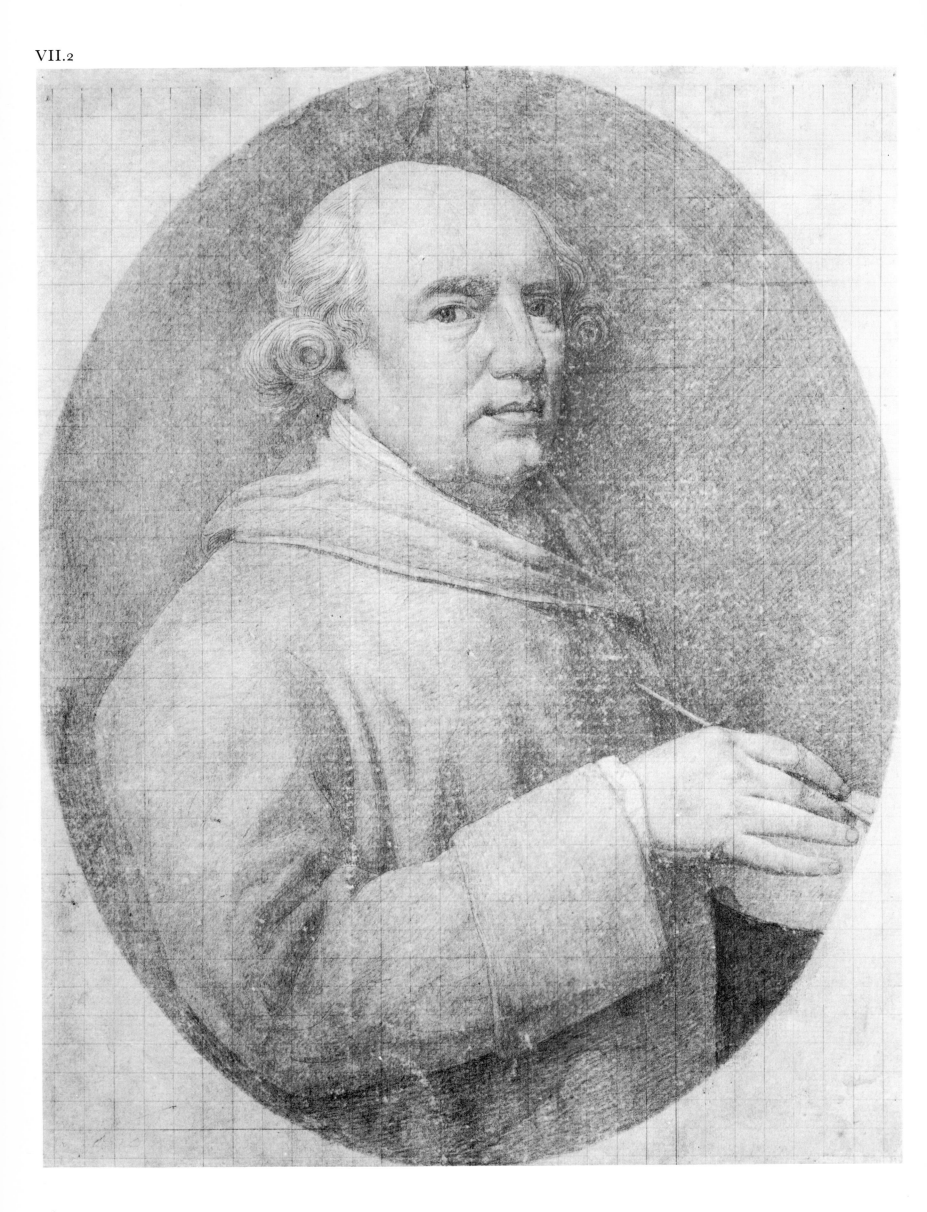

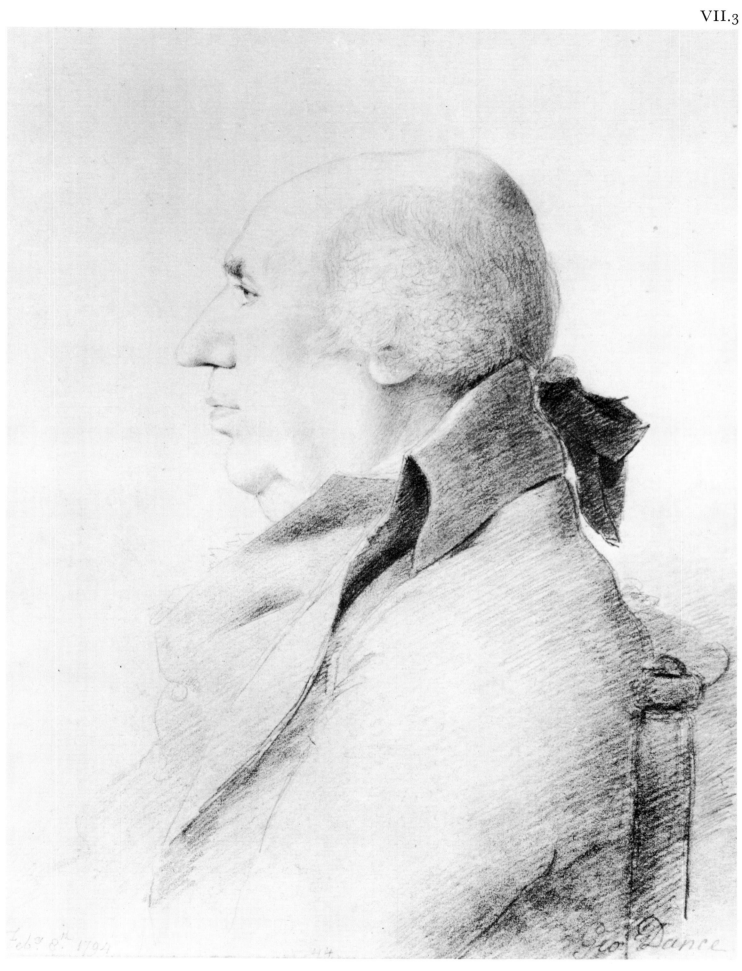

Feb.y 9.th 1794 44 Geo Dance

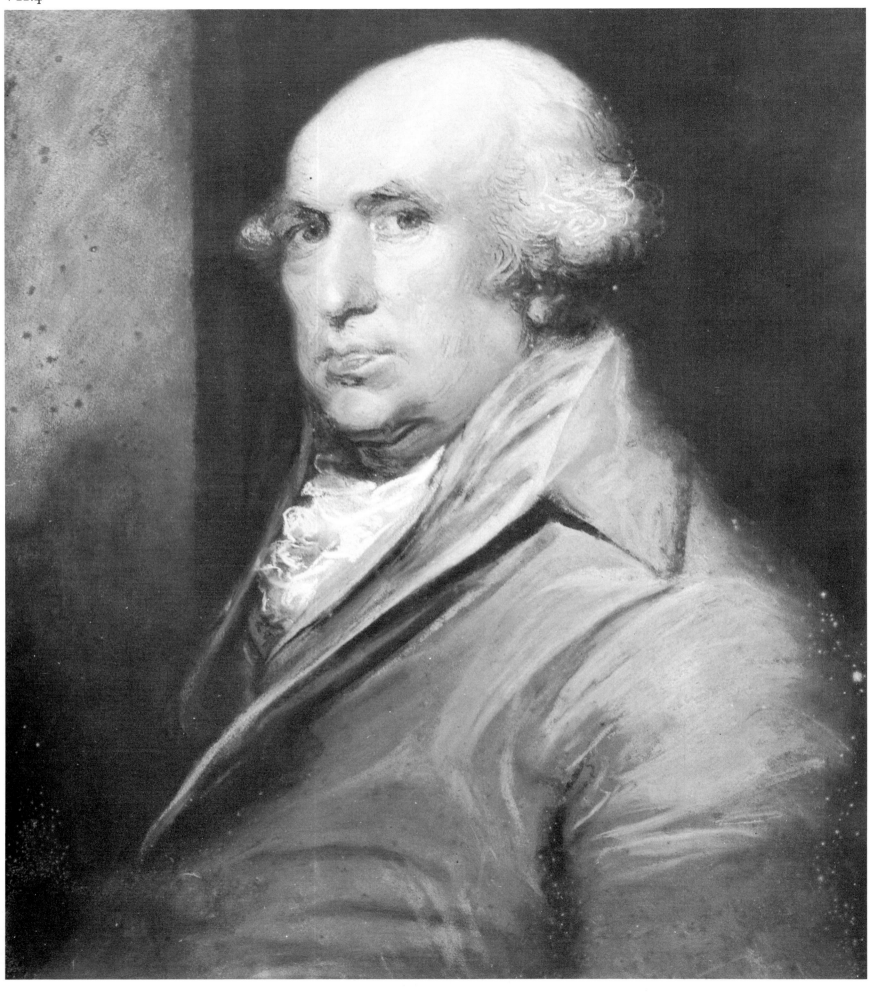

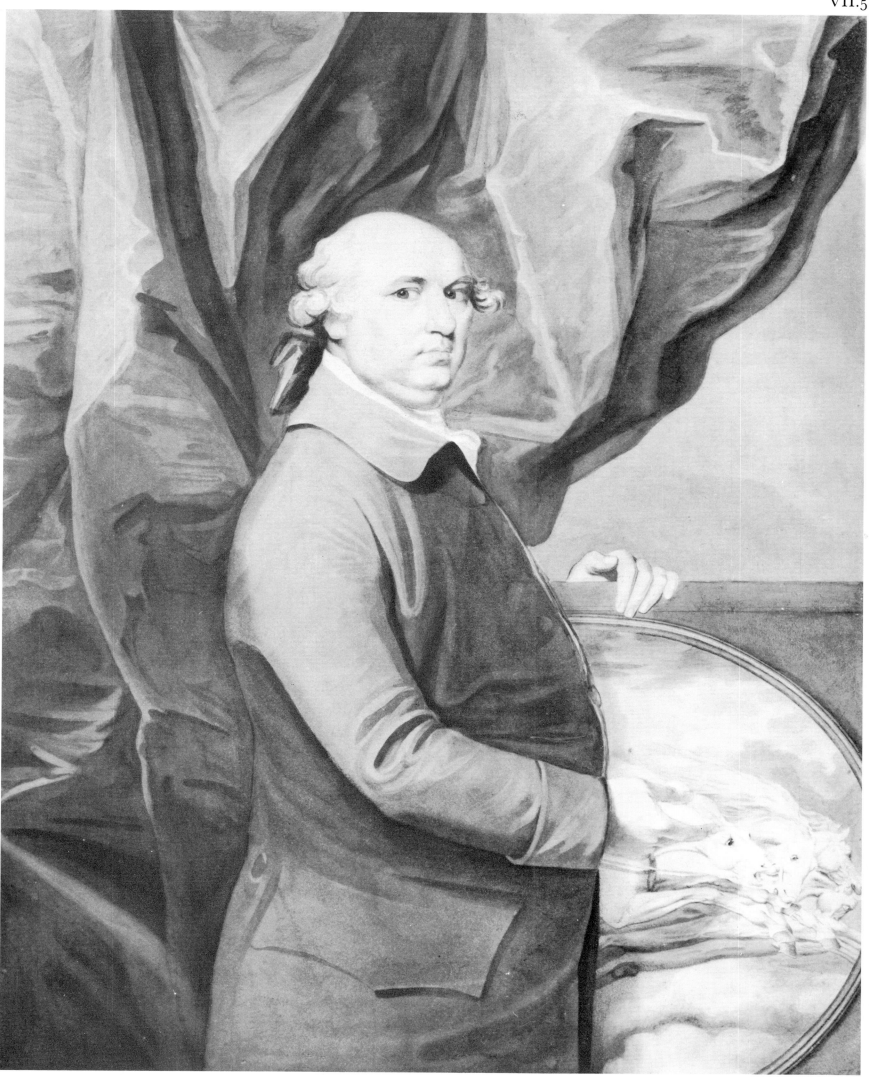

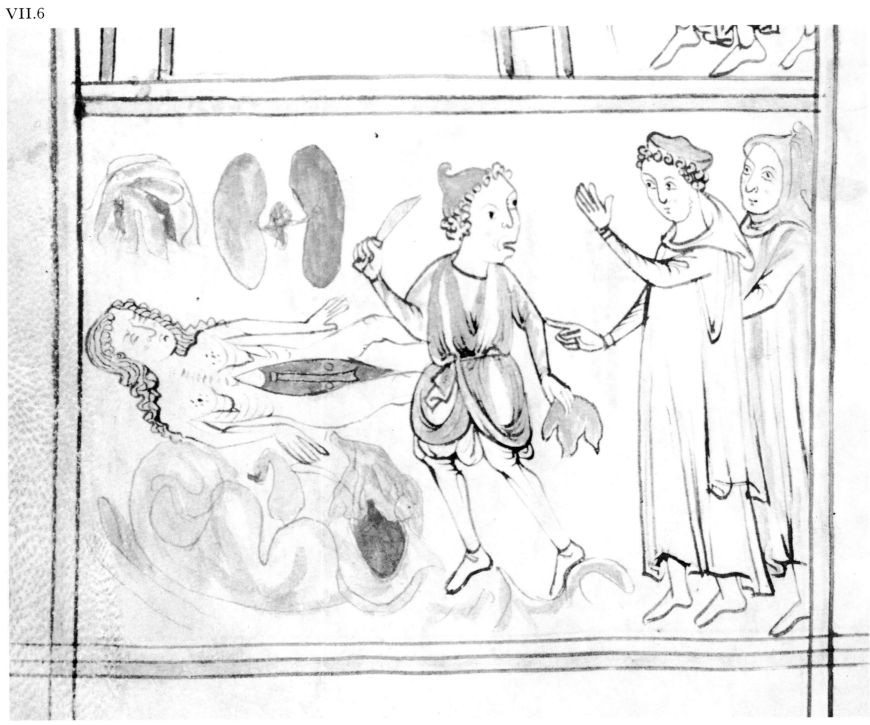

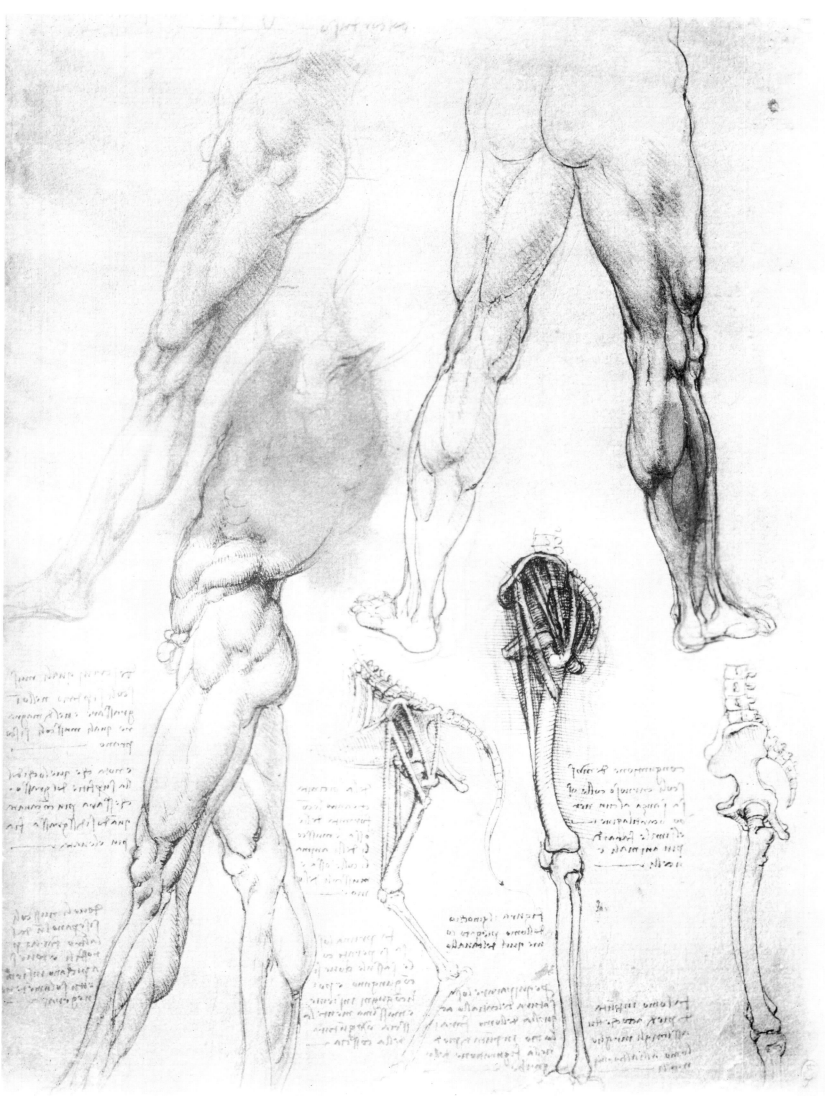

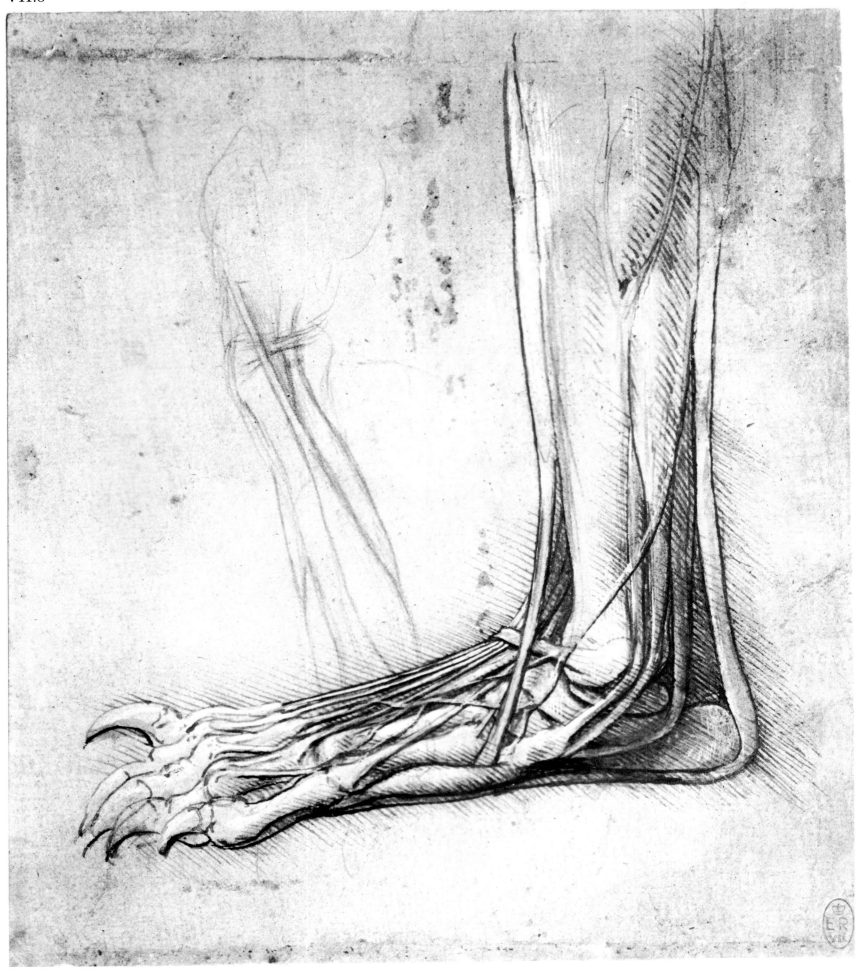

LIVRE I. DE LA NATVRE

Portraict de l'amas des os humains, mis en comparaison de l'anatomie de ceux des oyseaux, faisant que les lettres d'icelle se raporteront à ceste cy pour faire apparoistre combien l'affinité est grande des vns aux autres.

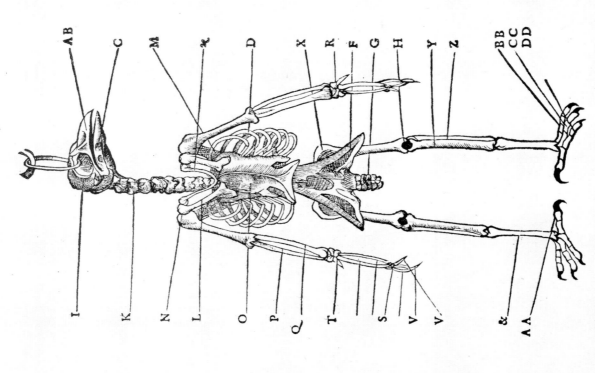

DES OYSEAVX, PAR P. BELON.

La comparaison du susdit portraict des os humains monstre combien cestuy cy qui est d'vn oyseau, en est prochain.

Portraict des os de l'oyseau.

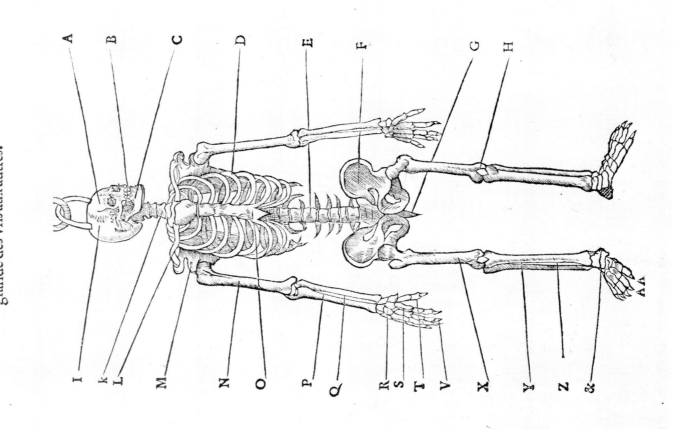

A B Les Oyseaux n'ont dents ne leures, mais ont le bec tranchant fort ou foible, plus ou moins selon l'affaire qu'ils ont eu à mettre en pieces ce dont ils viuent.

M Deux pallerons longs & estroicts, vn en chascun costé.

✗ L'os qu'on nomme la Lunette ou Fourchette n'est trouué en aucun autre animal, hors mis en l'oyseau.

D Six costes, attachées au coffre de l'estomach par deuant, & aux six vertebres du dos par derriere.

F Les deux os des hanches sont longs, car il n'y a aucunes vertebres au dessoubs des costes.

G Six os felets au cropion.

H La rouelle du genoil.

I Les sutures du test n'apparoissent gueres sinon qu'il soit bouilly.

k Douze vertebres au col, & six au dos.

d iii

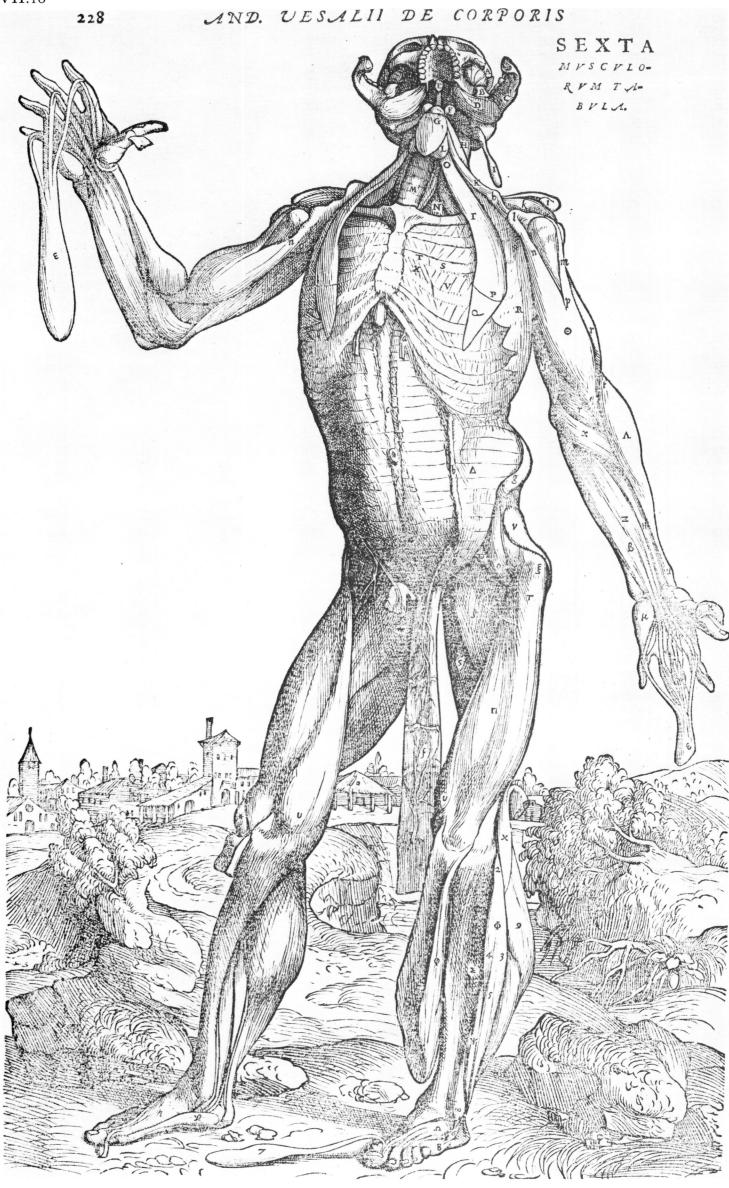

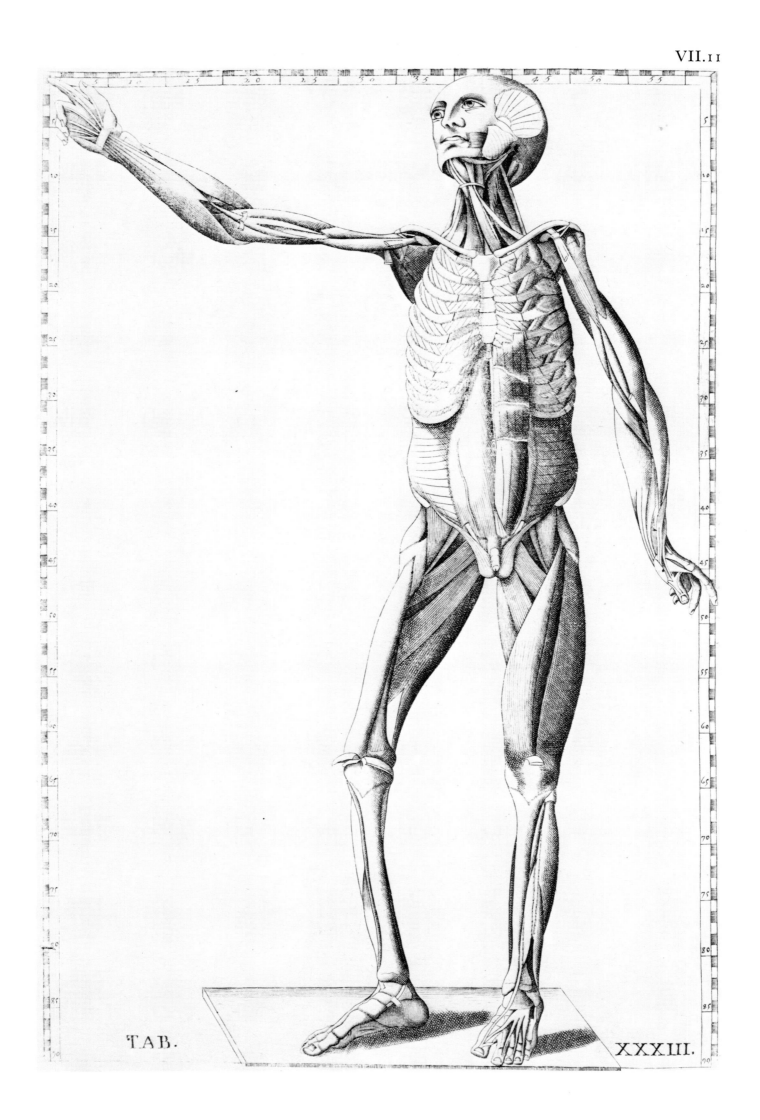

TAB.

XXXIII.

Tauola V. del Lib. V.

243

Q 4

235

Tauola I. del Lib. V.

VII.
12D

247

Tauola V. del Lib. V.

VII.
12C

245

Tauola V. del Lib. V.

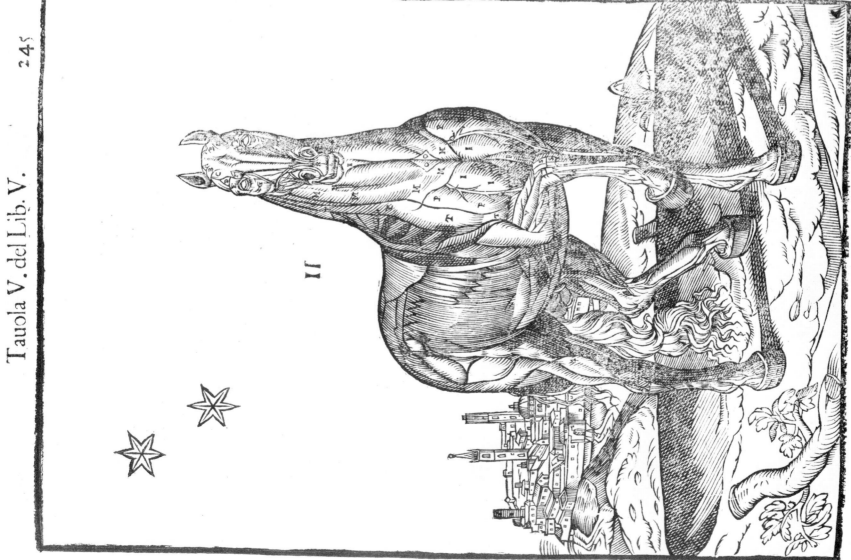

R 3

TAB XXXII

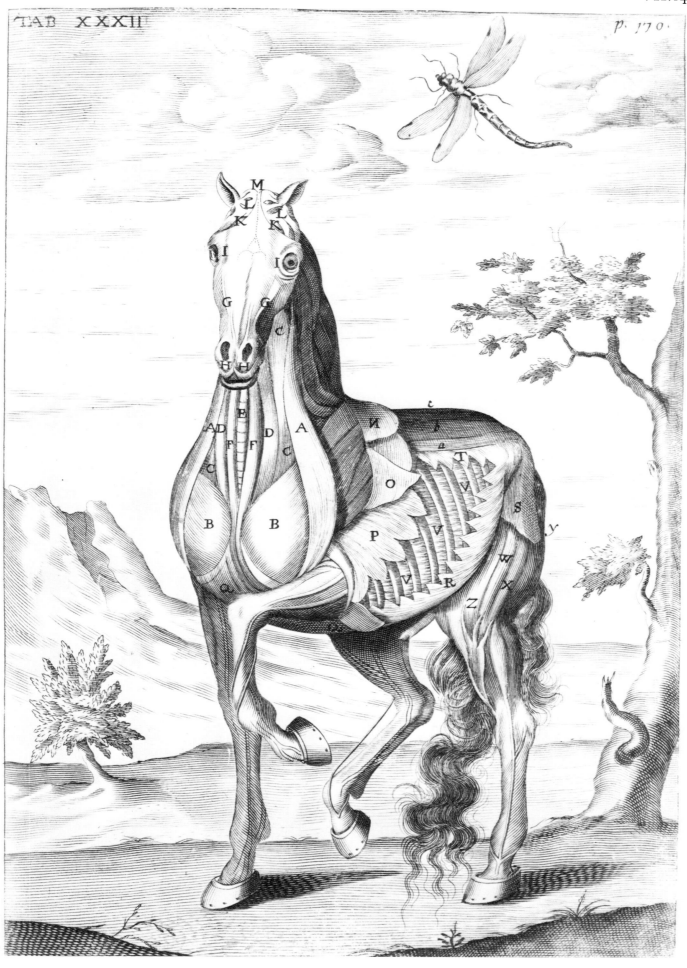

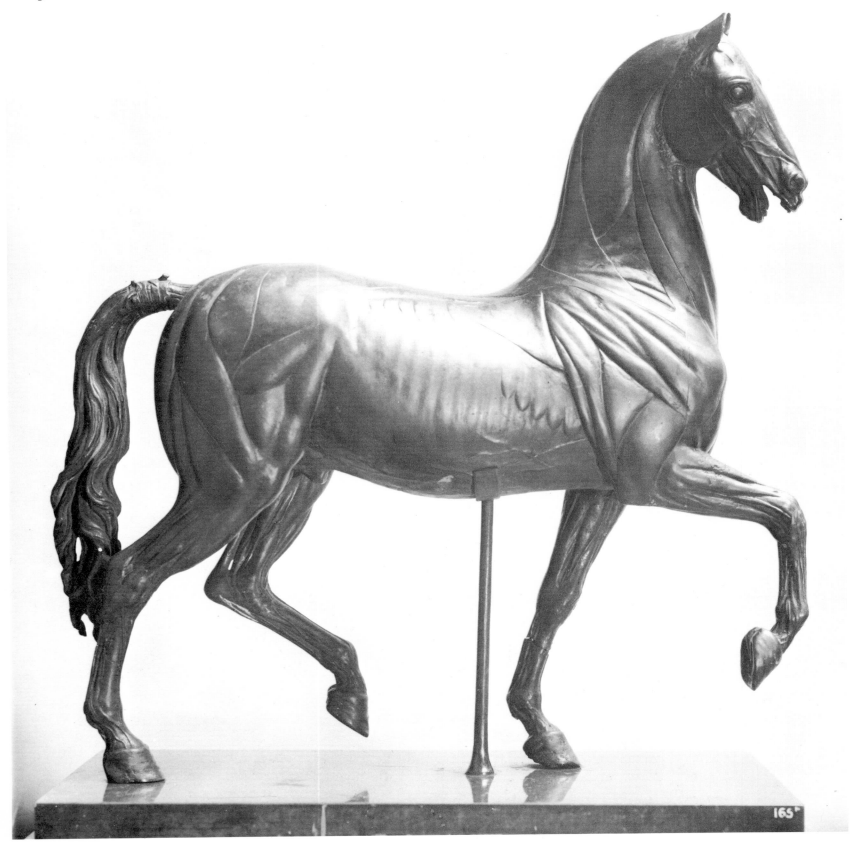

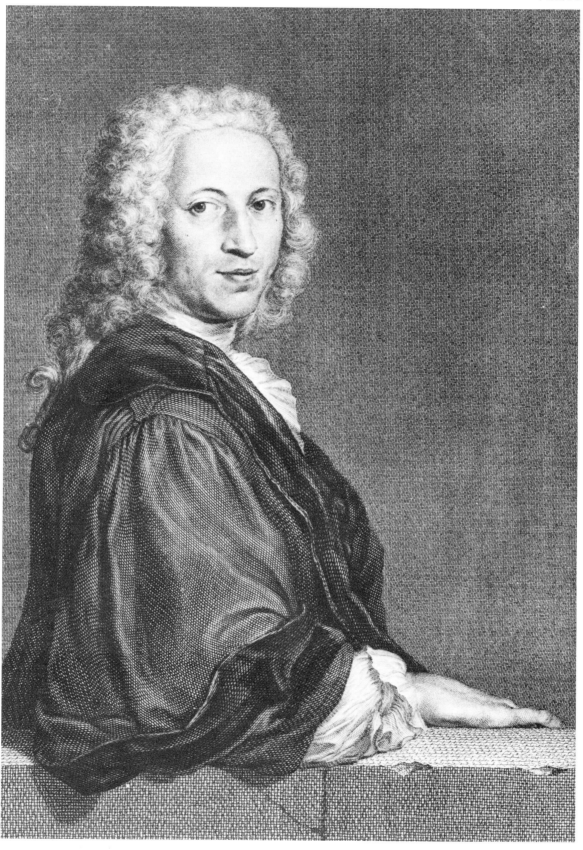

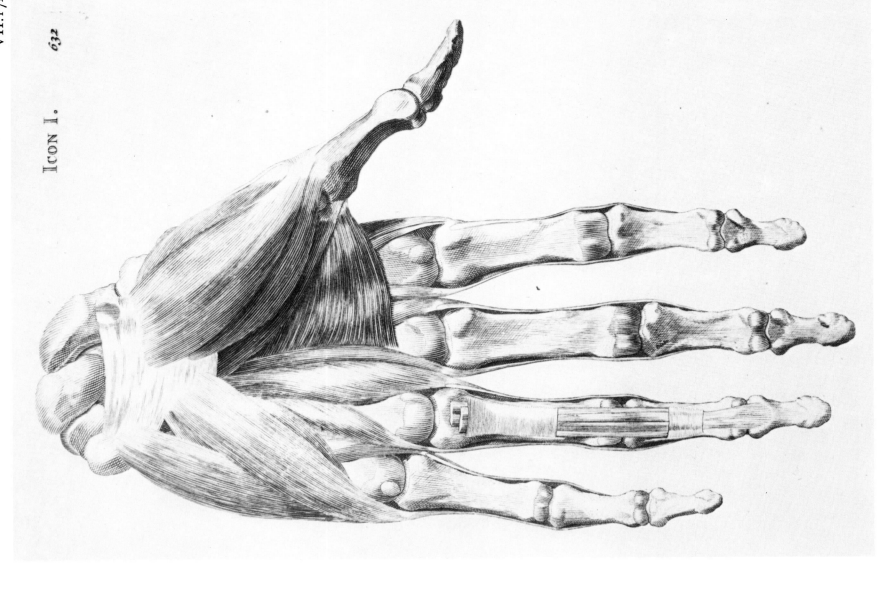

ICON I.

632

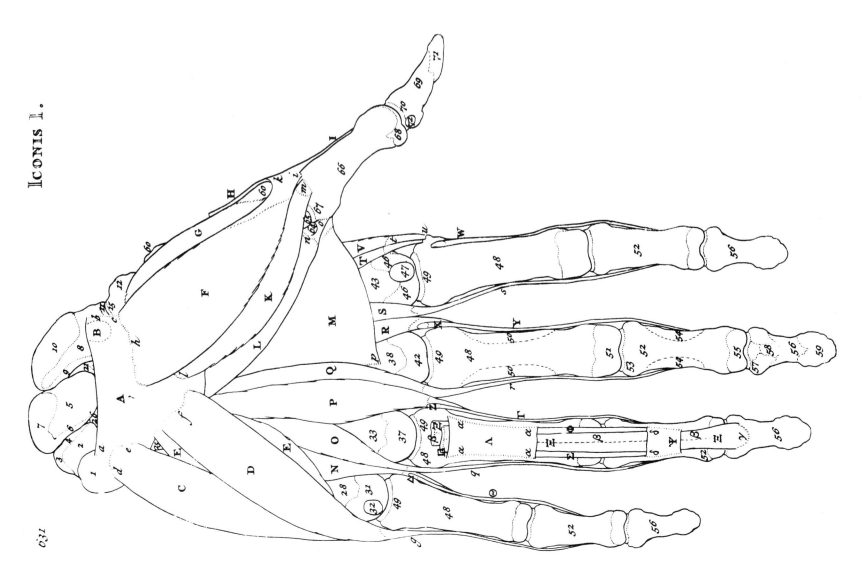

ICONIS I.

631

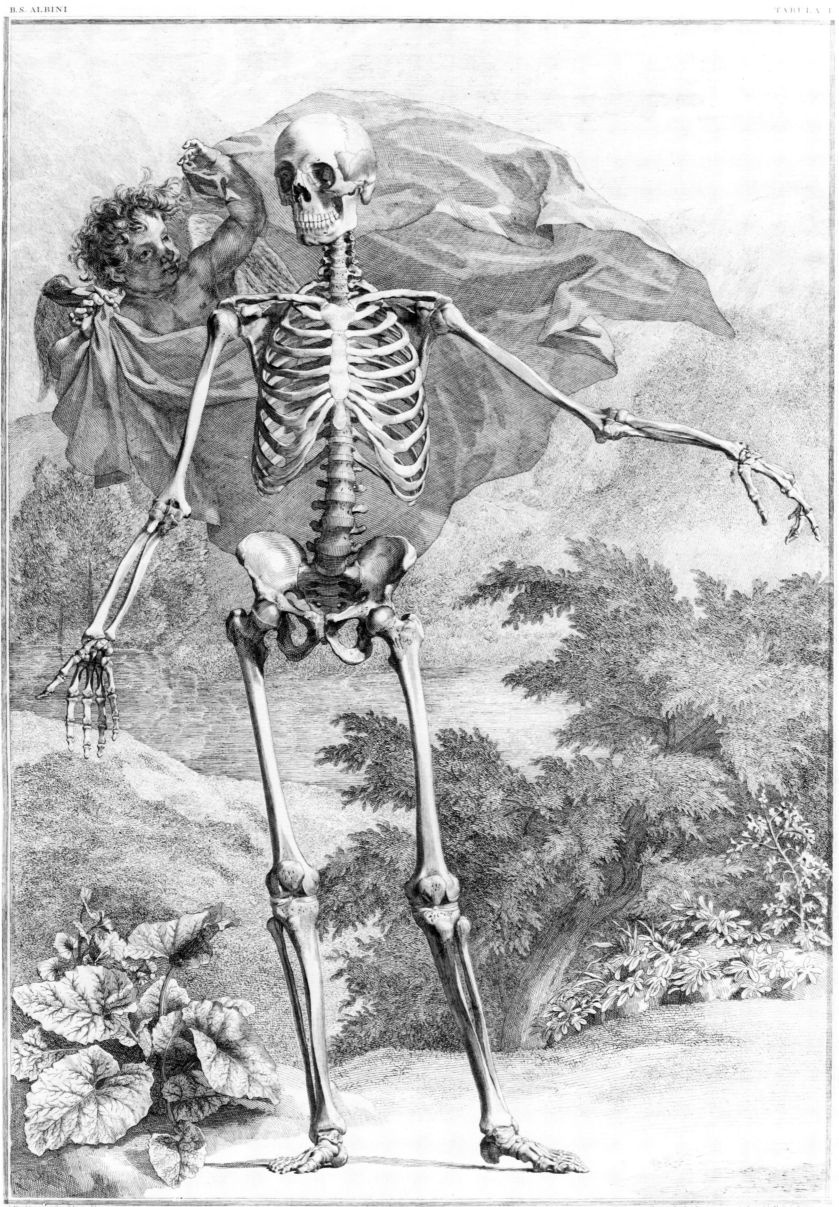

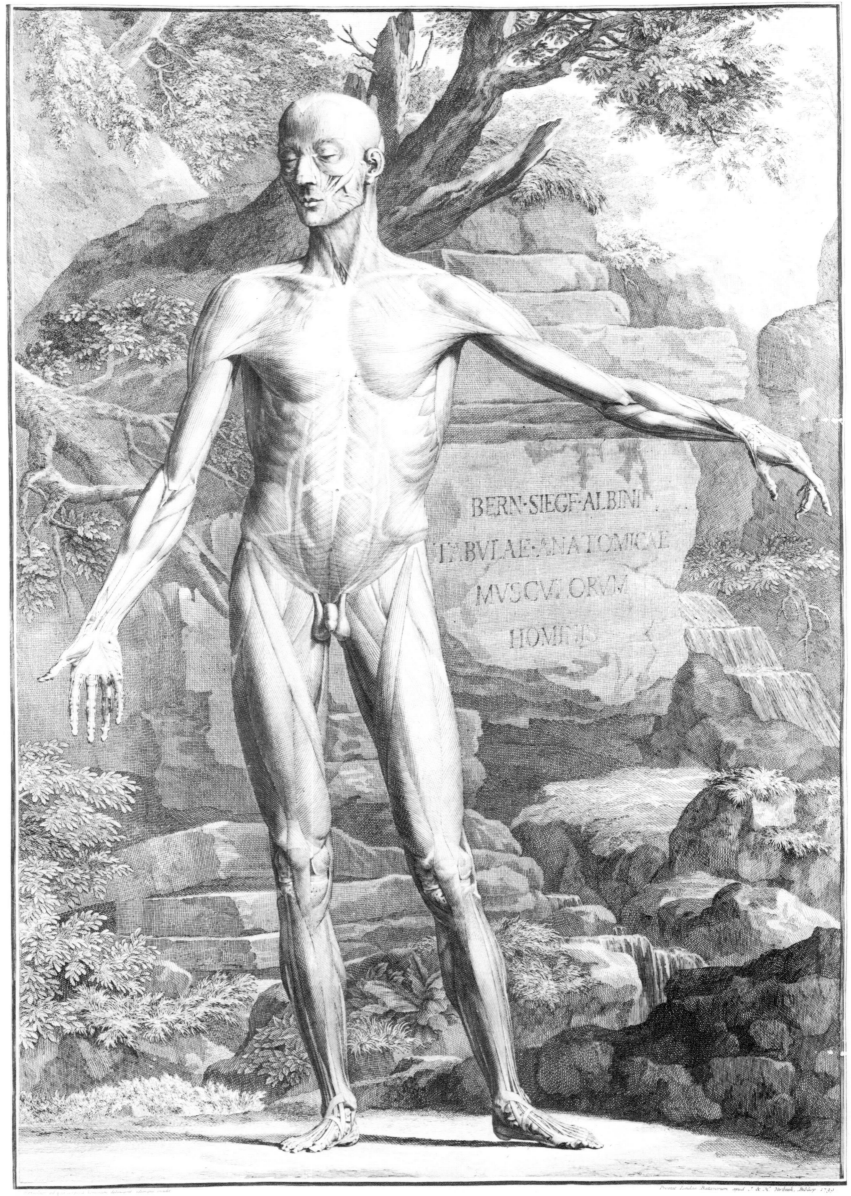

BERN·SIEGF·ALBINI
TABVLAE·ANATOMICAE
MVSCVLORVM
HOMINIS

TAB. I.

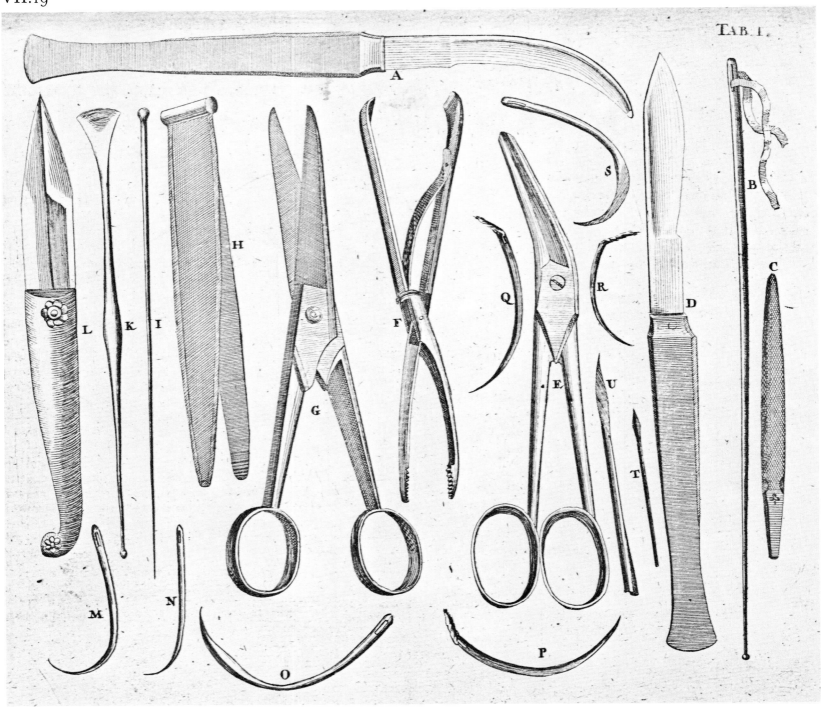

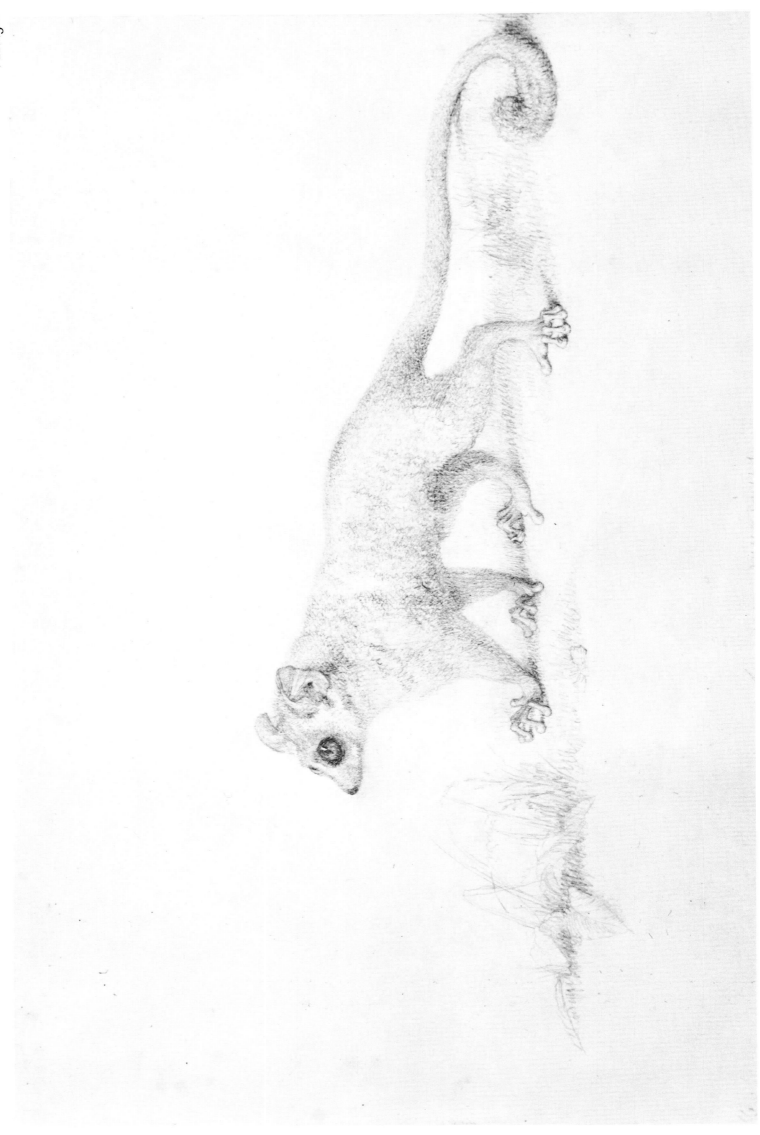

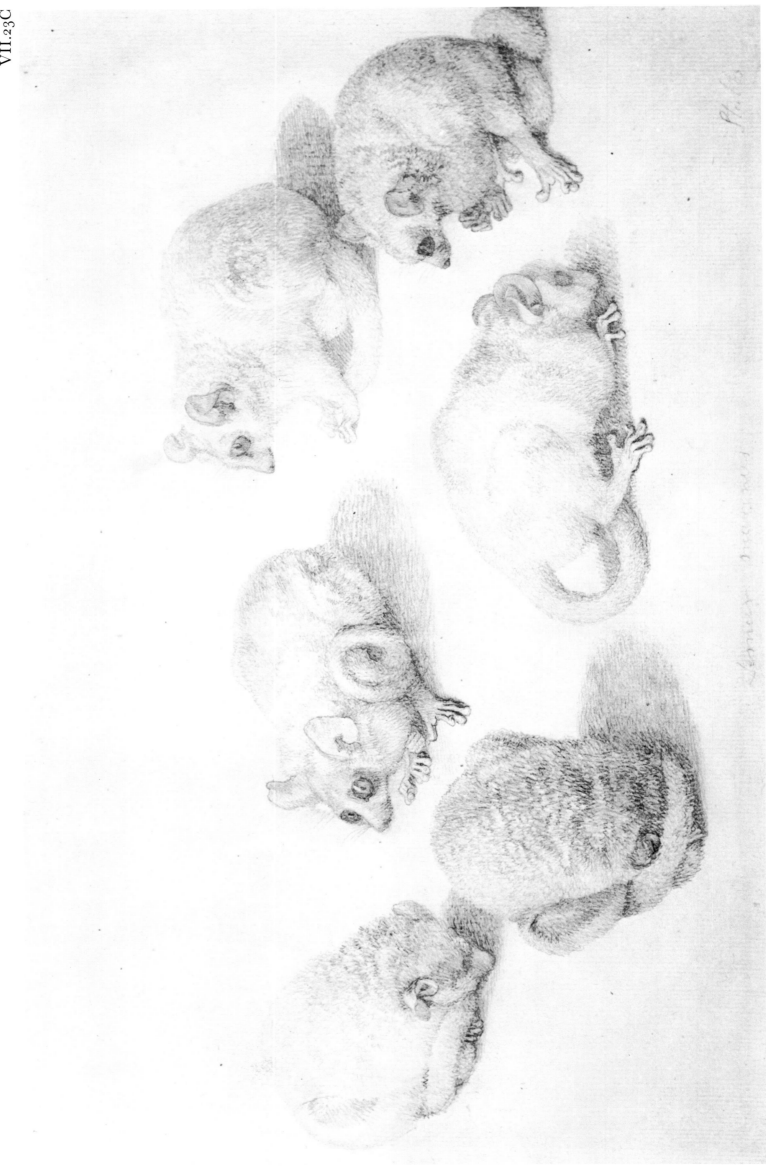

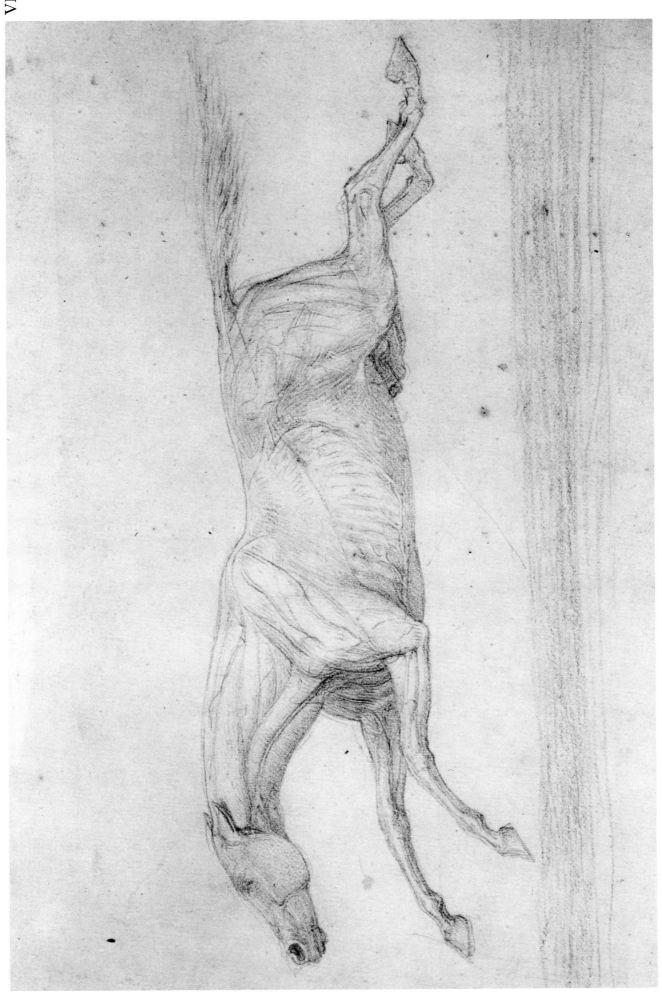

Bibliography

BOOKS, ARTICLES, AND CATALOGUES DEALING WITH GEORGE STUBBS

1. OZIAS HUMPHRY, 'Memoir of the Life of George Stubbs', manuscript, Picton Library, Liverpool.
2. *The Gentleman's Magazine*, October 1806, pp. 768–9.
3. *The Sporting Magazine*, May 1808, pp. 55–7.
4. JOSEPH MAYER, *Notes for a Memoir of George Stubbs*, privately printed, Liverpool, 1876.
5. WALTER GILBEY, *Life of George Stubbs R.A.*, privately printed, London, 1898.
6. WALTER SHAW SPARROW, *George Stubbs and Ben Marshall*, Cassell & Co., London, 1929.
7. GEOFFREY GRIGSON, 'George Stubbs, 1724–1806', *Signature*, April 1938, pp. 15–32.
8. *George Stubbs 1724–1806*, Walker Art Gallery Catalogue, 1951.
9. ELLIS K. WATERHOUSE, *Painting in Britain 1530–1790*, pp. 207–10, Pelican History of Art, London, 1953.
10. *George Stubbs 1724–1806*, Whitechapel Gallery Catalogue, London, 1957.
11. NEIL MCKENDRICK, 'Josiah Wedgwood and George Stubbs', *History Today*, August 1957, pp. 504–14.
12. *George Stubbs. Rediscovered Anatomical Drawings*, Arts Council Catalogue, 1958.
13. BASIL TAYLOR, 'George Stubbs, the Lion and Horse Theme', *The Burlington Magazine*, February 1965, pp. 81–6.
14. ANNE FINER and GEORGE SAVAGE, *The Selected Letters of Josiah Wedgwood*, pp. 233–61 Cory, Adams and Mackay, London, 1965.
15. R. B. FOUNTAIN, 'George Stubbs as an Anatomist', *The Proceedings of The Royal Society of Medicine*, pp. 639–46, London, July 1968.
16. *The Prints of George Stubbs*, Mellon Foundation Catalogue, London, 1969.
17. BASIL TAYLOR, *Stubbs*, Phaidon Press, London, 1971.
18. CONSTANCE-ANNE PARKER, *Mr Stubbs the Horse Painter*, J. A. Allen & Co., London, 1971.
19. STELLA A. WALKER, *Sporting Art: England 1700–1900*, Studio Vista, London, 1973.

ANATOMICAL AND GENERAL WORKS PROVIDING A BACKGROUND TO THIS STUDY

1. ANDREAS VESALIUS, *De Humani Corporis Fabrica*, Basle, 1543.
2. PIERRE BELON, *L'Histoire de la Nature des Oyseaux*, Paris, 1555.
3. CARLO RUINI, *Dell' Anotomia et dell' Infirmità del Cavallo*, Bologna, 1598.
4. G. MARKHAM, *Markham's Maister-Peece*, London, 1610.
5. ANDREW SNAPE, *An Anatomy of the Horse*, London, 1683.
6. BARTHOLOMAEUS EUSTACCHI, *Tabulae Anatomicae*, Rome, 1714.
7. J. DE SAUNIER, *La Parfaite Connoissance des Chevaux*, La Haye, 1734.
8. BERNHARD SIEGFRIED ALBINUS, *Historia Musculorum Hominis*, Leyden, 1734.
9. WILLIAM CAVENDISH, *A General History of Horsemanship*, London, 1743.
10. BERNHARD SIEGFRIED ALBINUS, *Tabulae Sceleti et Musculorum Corporis Humani*, Leyden, 1747.
11. BERNHARD SIEGFRIED ALBINUS, *Tables of the Skeleton and Muscles of the Human Body*, London, 1749.
12. ALEXANDER READ, *Elements of Surgery*, London, 1746.
13. ERIK NORDENSKIOLD, *The History of Biology*, Knopf, New York, 1928.
14. A. S. TURBERVILLE, *English Men and Manners in the Eighteenth Century*, O.U.P., London, 1929.
15. A. S. TURBERVILLE, *Johnson's England*, O.U.P., London, 1933.
16. DOUGLAS GUTHRIE, *A History of Medicine*, Nelson, London, 1945.
17. J. M. OPPENHEIMER, *New Aspects of John and William Hunter*, Heinemann, London, 1946.
18. F. J. COLE, *A History of Comparative Anatomy*, Macmillan, London, 1949.
19. J. B. SAUNDERS and C. D. O'MALLEY, *Vesalius*, World Publishing Co., New York, 1950.
20. SAMUEL W. LAMBERT, *Three Vesalian Essays*, Macmillan, New York, 1952.
21. J. B. SAUNDERS and C. D. O'MALLEY, *Leonardo da Vinci on the Human Body*, Henry Schuman, New York, 1952.
22. BASIL WILLIAMS, *Oxford History of England*, Volume XI, O.U.P., London, 1952.
23. BENJAMIN FARRINGTON, *Greek Science*, Pelican Books, London, 1953.
24. PAUL HAZARD, *European Thought in the Eighteenth Century*, Hollis and Carter, London, 1954.
25. CHARLES SINGER, *A Short History of Anatomy and Physiology*, Dover, New York, 1957.
26. GEORGE SARTON, *Six Wings*, The Bodley Head, London, 1957.
27. CHARLES SINGER, *A Short History of Scientific Ideas to 1900*, O.U.P., London, 1959.
28. STEVEN WATSON, *Oxford History of England*, Volume XII, O.U.P., London, 1960.
29. L. P. PUGH, *From Farriery to Veterinary Medicine*, Heffers, Cambridge, 1962.
30. ROBERT E. SCHOFIELD, *The Lunar Society of Birmingham*, O.U.P., London, 1963.
31. C. D. O'MALLEY, *Andreas Vesalius of Brussels*, University of California Press, Berkeley, 1964.

Appendix 1. The introduction to the English edition of 1749 of Albinus's *Table of the Skeleton and Muscles of the Human Body*

AN

ACCOUNT of the WORK.

Imagine it will not be difagreeable to the reader, to explain to him in what manner thofe figures were conftructed, by which means he will be rendered the more capable to judge of them. And in order to this, I fhall not only mention thofe things which fucceeded according to my wifh, but alfo thofe obftacles which I met with in this work; that thereby he may the more eafily underftand what is to be avoided, and what is to be obferved, in a work of this nature. Firft then, I fet out with planning the mufcles, and was extremely defirous to have them exactly expreffed in the figures, not only fingly, but in the order in which they lie with one another, and this laft I thought the moft proper to begin with. But as a great many of the mufcles are placed behind others, it was neceffary to divide them into certain claffes, the firft of which contains thofe which lie immediately under the teguments, the fecond thofe next to them, and fo of the reft. Wherefore I wanted not only that the members fhould be kept in the fame pofition while the figures of thefe different claffes were a taking off, but that thefe claffes fhould be exactly continued into one another, and by this means, that they might all appear the fame as they do in the body when put in the fame light and pofition. With this view, I expofed thefe claffes of mufcles before the ingraver, in the fame method as moft other anatomifts have done before, and he did them as well as he poffibly could. But the chief impediment in the way was this; that as in drawing the firft claffes, fome both of the mufcles and bones were only expreffed in part, but fuller expreffed in the next, after the firft mufcles, which covered them before, were removed; he could not poffibly draw thofe parts of them in the firft claffes (which by being firft expofed, were firft to be taken off) in fuch a manner, as that at the fame time they fhould be continued directly into the following, and after they were thus continued, preferve their proper fituations as they do in the body. But although afterwards, as the inner claffes explained what was to be done, the figures of the outer ones were accordingly mended, and all the figures were tolerably well done, and difcovered a great deal of fkill in the ingraver, yet I was not fufficiently pleafed with them, becaufe things were neither connected in them fo well as I could wifh, nor were they diftinctly, nor elegantly enough defigned; and they were quite different from thofe which I had planned in my own mind. This I was convinced of upon trial in fome parts which I examined, *viz.* the belly, breaft, arms, and face. And from this I difcovered what was to be done, in order to amend what I thought was deficient. I obferved that in drawing, as the firft order of mufcles fufficiently difplayed the figure of the limbs in general, they could be well enough expreffed by the ingraver in fuch a manner, as juftly to reprefent the figure of thefe parts; but that after the external mufcles were removed, the further he proceeded amongft the internal, the figure of the parts growing more and more imperfect, was of lefs affiftance to him in drawing thefe parts, and he was obliged to accommodate them to the firft, as the bafis. And he muft fucceed ftill worfe in the bones and fkeleton, becaufe the order in which they lie, though it bears a refemblance to the figure of the human body in general, yet at the fame time it differs confiderably from it. But unlefs the fkeleton, to which the mufcles are affixed, was juftly drawn, the mufcles themfelves could never be right reprefented. I underftood befides, that every thing that was done muft be very unfatisfactory, unlefs the proper dimenfions of the different parts were carefully marked. But here there were great difficulties to be overcome. For, in the firft place, the parts muft all be accurately meafured, and afterwards their dimenfions marked in the figures. Befides, fuppofing this could be ever fo well done, yet there were other obftacles hardly to be furmounted. To be fure it is very evident, that whatever is the pofition of the body or limb, the fame it muft be reprefented in the figure, provided the dimenfions of the parts are accurately marked. But there are fome parts which can be put into proper pofitions and meafured; fuch as the head, arms, hands, legs, and feet: and others which cannot; as the trunk, and neck. By this means it muft happen, that thefe laft muft be expreffed in an improper pofition, unlefs it be left to the fkill of the ingraver to correct, which I did not chufe to do, for fear of a miftake, as he could not demonftrate to me that he was fure of doing it right. And provided they could all have been put into proper pofitions, yet if upon fearching and handling the mufcles, or from any other caufe, the firft pofition of the part fhould in the leaft be changed, it appeared hardly poffible to replace it in fuch a manner, as that every thing fhould exactly correfpond to thofe which had been before taken off. Befides, as was fufficiently evident, one and the fame body could never do for the whole, and others would either not correfpond, or, if they fhould, could they be put fo exactly into the fame fituation, as that all the dimenfions could be accurately expreffed. Hence it appeared plain, that what I wanted was fomething more than even the beft anatomifts trouble their heads about, it being ufual for them to make only random figures of the parts, without confidering either the orders, dimenfions, continuations, or connexions of them with one another. Which figures although they may be ufeful, nay extremely ufeful, yet they are deficient in many things which ought to be fupplied, and render them perfect; which in every thing is the hardeft to be done. But why need I infift any longer on this fubject? It appeared very evident, that I muft purfue another method, and either drop intirely my intended fcheme, or find out fome certain rule by which to make my figure. And as human bodies, though they differ from one another in a great many things, yet agree in the whole; I muft pitch upon fomething that is common to them all, as the bafis or foundation to build my figures upon. And this is the fkeleton: which being a part of the body, and lying below the mufcles, the figures of it ought firft to be taken off, as a certain and natural direction for the others. It was proper therefore to begin with the figures of the fkeleton, and to thefe the figures of the mufcles were to refer. For the figures of the fkeleton being firft conftructed, as in moft men at leaft, of whatever fize or make, the mufcles are connected and pofited with the bones almoft in the fame manner, and in the fame places; it muft confequently happen, that the mufcles may be referred to thefe figures, even in other bodies, very different from one another, provided they are not deformed, if they are ingraved as belonging to the figures of the bones in thefe bodies. There likewife occurred to me another ufe of the above rule, *viz.* that by the figures of the mufcles being conftructed in this manner, a great many of the mufcles themfelves could be found out by them in the living fubject, and the fituations of almoft all of them. For in the firft place, by the affiftance of the figures of the fkeleton, it would be no difficult matter to know a great part of the bones in the living body, and fuch of them as could not be thoroughly difcovered, their fituations and pofitions might be clearly underftood, or fufficient hints given in order to difcover them; and thefe being once known, and examined, we fhould have it in our power to judge how the mufcles are fituated with refpect to the bones, as in the figures. And befides, the figures of the fkeleton and mufcles being conftructed, the figures of the vifcera might be referred to them; and to thefe, after they were conftructed, the figures of the arteries, veins, nerves, &c. might likewife be referred. For as architects, having firft laid a certain foundation, upon it build the edifice, together with all its parts; fo we may confider the mufcles connected to the fkeleton, as to the foundation; the vifcera, and other parts in their proper fituations: then the nerves, veins, and arteries, properly difpofed, and whatever elfe is neceffary towards the conftruction of the human fabrick. It is by far the beft way then for art to imitate this method, which nature has pointed out. And this has made me difcover, that *Euftachius* in his tables has followed a plan of fomewhat the fame nature.

Leaving therefore thefe firft rudiments, as fufficient only to difcover and teach what was to be done, I immediately fet about contriving the figures of the fkeleton. And in order to make them good as a foundation for the others, it was requifite they fhould be accurate, and reprefent the fkeleton from which they were taken to the life. But that every part of the bones might appear diftinct in the figures, it was neceffary they fhould be cleaned as carefully as poffible, and therefore feparated from one another; and how to join them again accurately was the difficulty. Neither was it poffible to be certain that they were right joined together again, unlefs by comparing them with the natural ftate; and how this could be done, was not eafily determined. Befides if it was, it might eafily be conjectured, that though they fhould be conjoined again naturally in general, yet it could not be done with that exactnefs which I wifhed for, fo as to make the other parts accurately correfpond. Add to this, that by cleaning the cartilages of the joints fufficiently, they muft either be deftroyed, or at leaft very much hurt; and therefore when they are joined again, the articulations will not be fo fit as they were before. And the more deficient that the former figures of fkeletons were in this refpect, I thought myfelf obliged to be at the more pains to find a remedy for it. After ruminating for fome time about a proper method, it came into my head, that the readieft way of effecting what I defired, was to prepare a frefh fkeleton in fuch a manner, as to leave the ligaments of the joints intirely whole; and after an exact figure had been taken of it in that fhape, to cut and remove the ligaments, and fo have thofe parts which were hid by them added to the figure. And this method feemed to be extremely natural. But I forefaw in my mind, that it would be a very laborious tafk, to make a fkeleton of that kind; and a difficult matter, after it was prepared, to keep it in proper order. Befides I was afraid, left, as the taking a Draught of fuch a fkeleton would require a confiderable time, in the mean while, partly by the drying of the cartilages and ligaments, and partly by putrefying, it fhould be very much fpoilt, and I myfelf mortified. Wherefore I thought proper to try it firft in feparate members of the fkeleton, in fome of which it fucceeded well enough; as in the hands, feet, and joint of the thigh. In others again I met with much more difficulty; as the ribs, and back-bone; but however there were hopes of overcoming thefe obftacles. Encouraged therefore by the fuccefs which I met with, about the latter end of the year 1725, happening to meet with a proper fubject, I prepared a fkeleton, fuch as I have mentioned above. But the ligaments being naturally weak, and adhering but loofely to the bones, it required a good deal of fkill to manage it, fo as to keep the bones in their proper pofitions. To dry the ligaments, fo as to render the fkeleton rigid, was not proper to be done, for fear of disfiguring the conjunctions of feveral of the bones, and fpoiling the cartilaginous crufts of the joints; nor, if it had been proper, ought it to be attempted, till the fkeleton was firft put into fuch a pofition, as I intended it fhould be in when the figure was to be taken of it. In order to this then, I proceeded in the following method. As the feet were not able to fupport the trunk, becaufe they were neither ftiff, nor could the pelvis reft firmly enough upon the heads of the offa femoris, I determined firft to fupport the lower part of the trunk in fuch a manner, as I could incline it a little which ever way I pleafed, if there was occafion for it. For this purpofe I ordered a tripod to be made,

[a]

AN ACCOUNT OF THE WORK.

with the feet at a moderate diftance from one another, and from the top of it, at that part where the feet are joined together, there rifes an iron ftalk, which foon divides into three branches, bended at a moderate diftance from each other, one of which is fhorter than the other two, which are of an equal length; but all of them towards the top for the length of a cubit bended firft outwards, in order to fupport whatever is laid upon them; and then upwards, to keep what is laid from falling off. The whole tripod is higher, than to allow the feet of the fkeleton to reach quite to the bottom of it, and therefore to the table upon which it is placed; while the inferior part of the trunk refts upon it. This tripod I put upon a low table, whereby the lower part of the fkeleton, and efpecially the feet, might more eafily be drawn; for if I had placed it upon the ground, it would have obliged the ingraver to ftoop too much, in order to get a right view of thofe parts. I then placed the lower part of the trunk upon the tripod, fo as that the cartilaginous conjunction of the offa pubis fhould reft upon the top of the fhorteft branch and the lower parts of the ilia, before the os facrum, upon thofe of the two longeft; having taken care before to have thofe branches bent in fuch a manner as to receive and keep firm thefe parts of the trunk, and that the fhorteft branch fhould be only as much fhorter than the others, as I chufed to place the lower part of the conjunction of the offa pubis below the lower parts of the ilia, which refted upon the longer ones. Having laid this firm foundation, the trunk was firft to be raifed, together with the neck and head. But I thought proper to begin with the trunk, as being ftronger and firmer than the neck and head. To this purpofe then I tied a cord to the upper part of the fpine, where it is firm and lefs flexible, and pulling it up ftreight to the ceiling of the room, I paffed it through a ring which I had fixed into the ceiling, and then faftened the end of it to a hook which was drove into the wall. By drawing this cord I raifed the trunk as much as I could, but in fuch a manner as to let the lower part of it reft upon the tripod. Afterwards I took another cord and paffed it under each of the cheek bones, one end of it under the right, and the other under the left, and the middle drawn towards the hind head near the neck, and then tied the two extremities over the head in form of a loop. Then to this loop I tied another cord, which I drew up to the ceiling, as I did the one from the fpine before, paffed it through another ring, and faftened it to a hook. This cord I drew as tight as I could, fo as not to flacken the one that was fixed to the fpine; and thus both the trunk, neck, and head, were raifed up, but they could not be made fo erect as not to decline a little. Therefore having tied feveral cords to the trunk, I drew them out in all directions to the walls of the chamber, and faftened them to hooks which I drove in on purpofe, and by means of thefe cords, I kept the trunk every where equally firm. But as I had tied the two firft cords, by which the trunk and head were erected, to the firmeft part of the trunk, that is the fpine, fo I tied the other cords likewife to the fame bone, being the bafis as it were of the trunk, and whofe motions the ribs follow. The reafon why I tied them to the upper part of the fpine was, that thereby I might command the whole fpine the better. And I tied them immediately below the neck, becaufe the backbone in that part is very firm; for if I had tied them to the neck, as its joints are very moveable, they would have render'd it crooked. The fixing of the trunk being finifhed in this manner, I proceeded next to that of the arms. To this end I tied a cord round the conjunction of the clavicle with the upper procefs of the fcapula, and with that I raifed it up as much as was requifite, fufpending the whole arm by this means to the ceiling; while by other cords running acrofs, I kept the fcapula firm, fo as neither to incline too much backwards nor forwards. Having fecured both the arms firm in this manner, I tied a cord to the lower part of the right radius, and by means of it, kept the whole arm at a proper diftance from the trunk. Then I tied another cord to the lower part of the left os humeri, and with the help of it I raifed the left arm up. Another cord I faftened to the ulna of the left arm, and with that I made the wrift incline gently downwards. The feet and legs I made firm in the following manner. The right leg I placed ftreight, fo as to fupport the trunk; but as the heel did not touch the table upon which the tripod was placed, I thruft in a bit of board between it and the table, fo thick as juft to make the foot ftand firm, and at the fame time not to raife the pelvis from the tripod, by pufhing the leg too high up. Then I put under the reft of the foot boards of an equal thicknefs, fo as to make it ftand firm and even. Next I tied a cord round the lower part of the thigh-bone, and faftening it to the wall backwards, made firm the knee. In much the fame manner, I fixed the left leg and foot; only the knee was a little bended, the heel lifted up, and it refted gently upon the extremity of the foot, on that part which is near the root of the great toe. Thus having finifhed the fixing of the fkeleton in general, the next thing to be done, was to render the pofition perfect. And this I did partly both by inclining, and raifing, the pelvis; partly by tightening, and flackening, the cords, and increafing the number of them; and partly by pieces of board, paper, pafteboard, &c. which it is not neceffary to mention in particular. I next looked out for a thin man, of the fame fize with my fkeleton, and making him ftand naked in the fame pofition, I compared the fkeleton with him, efpecially the hip-bone, fpine, thorax, fcapulæ, and clavicles; becaufe if thefe parts were put into proper pofitions, there would not be any great difficulty in the reft. Having corrected thofe things which wanted to be corrected, according to the method above explained, I examined the fkeleton carefully for fome days after, and by making fmall alterations, by means of tightening or flackening the cords, and otherwife, as I faw occafion, I tried whether it could not be ftill rendered more compleat. And after I had done this, I compared it again

with the naked man, that in cafe I had erred through exceffive carefulnefs, I might then correct it.

As foon as I had finifhed the pofition of the fkeleton, my next care was to have an exact figure made of it. I forefaw that the figure would be very incorrect, and difappoint my defign, if it was taken off by merely viewing the original, as ingravers commonly do. For it muft neceffarily happen, that the ingraver muft err, and therefore would neither make fuch a figure of the fkeleton as I wifhed for, nor fuch a one as I could not only hope to be, but abfolutely confide in, as a proper foundation for drawing the mufcles upon. But to meafure the whole fkeleton, and mark out the pofition, fize, and figure of every part, was an infinite tafk, nor could it poffibly be done without fome certain infallible rule to direct the ingraver. It was an eafy matter indeed to confine the view by the help of a certain quadrate, compofed of four wooden rulers formed into a quadrangle, having the intermediate fpace as large as the fkeleton, and the whole equally divided into little fquares, all of the fame fize, by means of fmall cords ftretched out between. This being placed right before the fkeleton, and the plate upon which the figure of the fkeleton was to be drawn, divided by lines, in the fame manner as the quadrate was by the cords, the ingraver, in order to draw the fkeleton, was to find out a proper place for viewing it through the quadrate, by means of a fixed hole, and not very large; which by applying his eye to, he could fee what parts of the fkeleton anfwered to certain cords of the quadrate, and in what manner; and accordingly make them correfpond with the fame lines of the plate. But here arofe another difficulty. For in order that the ingraver might fee every part of the fkeleton properly and diftinctly, it was neceffary that he fhould not be at too great a diftance from it. I wanted however that he fhould view it at a diftance little lefs than forty rhenifh feet, as we call them; left he fhould fee feveral of its parts too obliquely. But it was impoffible at that diftance to fee the fmall parts diftinctly. Wherefore, that the ingraver might be placed as near the fkeleton as was neceffary, and in the mean time have the fame view of it as at the diftance of forty feet, excepting the obfcurity occafioned by that diftance, I contrived the following method. I placed the quadrate before defcribed, and which I call the larger one, right before the fkeleton fo, as that the cords touched the moft eminent part of the fkeleton. Before this, at the diftance of four feet, I placed another of the fame kind, only the fquare fpaces made lefs; upon which account I call it the leffer quadrate. Thefe fpaces I made a tenth part lefs in this than in the other; becaufe the diftance of four feet was juft a tenth part of that, which I defigned it fhould be viewed at. I placed then thefe quadrates in fuch a manner, as that the corded part of each fhould be equally diftant from each other, that they fhould ftand perpendicular, and the cords of the one, correfpond to thofe of the other, the center of both being oppofite the middle of the left breaft of the fkeleton. Thefe things being thus ordered, the ingraver placing himfelf in the moft proper fituation near the fkeleton, for viewing it, endeavoured to make fome point where the cords of the leffer quadrate decuffated one another, coincide to the eye with the correfponding decuffating point in the cords of the greater one; and that part of the fkeleton which was directly behind thefe points, he drew upon his plate, at the point of decuffation of the lines of it, correfponding with the decuffating points of the quadrates; for I had divided the plate into fquares by crofs and ftreight lines, as I had divided the larger quadrate by cords. And in this manner proceeding through all the decuffating points of the cords, behind which any part of the fkeleton was obferved, he drew the parts of the fkeleton marked by thefe at the correfponding decuffating points of the lines of the plate. Afterwards he could continue in the plate thofe parts of the fkeleton which intervened between the points, fo as upon account of the fmallnefs of the fpaces not to err remarkably, at leaft not fo much as to deferve to be cenfured. According to this method then (which as it anfwered the intention, fo it occafioned an incredible deal of trouble to the ingraver) a fore view of the fkeleton was firft drawn as it ftood. It was drawn then with the ligaments keeping the joints tight. Afterwards the ligaments being fo far cut, and the joints fo far opened, as was neceffary for viewing the articulations of the bones, the ingraver added thefe to the figure. Then having untied the little cords which kept firm the fkeleton, as well as the two ropes by which it was kept erect, one of them going from the upper part of the fpine, and the other from the head, to be faftened to the ceiling, I turned it about together with the tripod, fo as to have the back part of it drawn; which was done in the fame manner as the other. The ligaments of the joints I cut, fo, as that although they were divided in the fore part, yet they were fufficiently entire to keep the joints together, and to preferve the fkeleton in a proper order, till a fide view was taken of it; and this was done the fame way as the other two, as foon as the back view was finifhed.

In the mean time, while thefe three figures of the fkeleton were a drawing, though the greateft application poffible was given, as they could not be finifhed in lefs than three months, it was neceffary to take care, that the fkeleton fhould not fuffer from drying or putrefaction, nor we hindered from going on from the fame caufes. Sometimes then, when it dried too much, I moiftened it with water, and cutting the ligaments, poured it into the joints, in order to preferve the cartilaginous crufts; and again, when the putrefaction was to be checked, I fprinkled it with vinegar; wrapped it up in the night time with paper, and cloths dipped in the fame liquor; and poured fome of the fame wherever there was room for it. During the time that the firft figure was a taking off, a hard froft coming on, the whole fkeleton was frozen, which was the beft thing that could happen both for keeping it firm, and preventing the putrefaction. And if that figure could

have

AN ACCOUNT OF THE WORK.

have been finished before the thaw came, upon untying the cords, I could easily have turned the skeleton, quite rigid with the frost, in order to the drawing of the second figure. But the thaw coming on sooner than I could have wished, it both began sooner to spoil, and gave me a great deal of more trouble. It was hurt likewise by the fire, which we were obliged to have always when the naked man stood; for he neither could nor would stand without it.

In these three figures, the posture of the skeleton, together with the position and connexion of all the bones, were accurately expressed; but their figure and outward appearance only in general. For the remains of the ligaments were an obstruction to this, besides other things which the bones could not easily be cleared from. And indeed though they could have been perfectly cleared, it would not have been well judged to have taken up the time in doing it, especially as they would have required a great deal, and I could do it afterwards at my leisure, and have figures taken of them. Having then taken down the skeleton, my next task was to clean the bones very neatly, so as that nothing about them might be spoil'd. After I had cleaned them, I deferred having the figures of the skeleton finished from them, till I had figures of each of them ingraved separately of the natural size. I put it off upon this account too, that, by making of these figures, the ingraver might prepare himself for drawing the others, when I had a mind to have them done. Having finished these, I returned again to the figures of the skeleton in the year thirty-three. The first thing I took care of was, to reduce them from the natural size to that which you see in the cuts. Then the ingraver, having examined all the bones in that position in which they stood in the figures, supplied whatever he found deficient in the figures, and amended whatever he thought done with less accuracy. And now I began to be confirmed in my design of publishing, which was my chief intention in taking so much pains about those figures, provided they all answered to my mind; and I was desirous to have them ingraved, as I hoped it would make them appear still more elegant. They were ingraved, and chiefly after the bones themselves, that so they might be both more perfect and neat.

They shew the skeleton standing in an erect posture, and proper attitude. The limbs I have put into such attitudes and positions, as that the order and connexion of both the bones and muscles may in general appear to the most advantage; and, if I was to proceed, even the bowels themselves, as also the arteries, veins, nerves, &c. The posture of the first and second is the same; the first representing a fore view of the skeleton, and the second a hind one. These two figures answer to each other; by which means you have a view all round the skeleton. The third figure is added to give a fuller view of the side; upon which account the posture of this is different from that of the others. But, with regard to the postures of each, the following particulars are to be taken notice of: The skeleton in the first and second figures stands firm upon the right foot, resting but very gently upon the left. The right foot rests upon the heel, and upon the anterior heads of all the bones of the metatarsus, especially of that which belongs to the great toe, the sesamoid bones in the mean time intervening. The toes are bended downwards, as it were to catch hold of the ground; and by this it stands the firmer. The extremity of the foot is turned outwards, as it naturally is in that posture, when the foot stands most firm. The right knee is strait. The patella rests upon the hollow in the middle between the condyles of the femur, in the same situation as it naturally has when the knee is strait, and itself pulled up by the rectus, vasti, and crureous muscles. The leg is inclined a little outwards over the extremity of the foot, the joint of the ankle, with the heel-bone, being a little bended. Hence the extremity of the foot rests full upon the ground, and the heel is in the same perpendicular line with the head; by which means the position is rendered more firm. This is likewise assisted by the thigh-bone being gently inclined the same way; and at the same time corresponding with the tibia in such a manner as to form a kind of angle with it, but a very obtuse one, and obtuse at that part mentioned above. The left foot, which is turned from the right sideways, and a little forwards, rests only, and very gently, upon the anterior head of the metatarsal bone of the great toe, by means of the sesamoid bones. The left knee is moderately bent, and the patella is situated in the hollow made for it between the condyles of the femur. Thus the right foot alone sustains the weight of the pelvis, which is situated obliquely, the left side being lowest, because the left foot is turned farther out than the right, and yet touches the ground. And because the left foot is likewise stretched a little forwards, so the left side of the pelvis is inclined forwards likewise a little more than the right. The trunk above the pelvis is turned towards the right, just enough to keep up the equilibrium. The whole spine then is bended towards the right. It is likewise twisted as it were a very little towards the left, excepting only the neck; so that though the left side of the pelvis is inclined a little more forwards than the right, yet the thorax may nevertheless be directed strait forwards. The neck on the contrary is turned towards the right, and the atlas with the head inclined the same way, as much as was necessary to give the face a gentle direction to that side. Further, the position of the pelvis is such, as that the whole upper brim is placed obliquely, chiefly indeed upwards, but likewise remarkably forwards. Wherefore the os sacrum descending from the loins is directed a little backwards, and from it the coccyx is inclined forwards, and bended the same way. The loins above the os sacrum are first remarkably crooked, then presently become straiter, incline gently backwards, and are hollow towards the back part; by which means they support the thorax the better. The spine of the back, inclining likewise backwards, is gently bended at its upper part, but contrary from that of the loins; and hence the thorax is prevented from inclining too much forwards. The neck rises from the back moderately bend-

ed, and supports the head so, as that the face may be sufficiently prominent forwards. The thorax with the spine is bended a little to the right. Hence the ribs on the right side are placed nigher together; the upper ones inclined a little downwards, and the lower ones upwards. On the other hand those on the left side are at a greater distance from one another; the upper ones inclining upwards, and the lower ones downwards. Wherefore the thorax externally according to its whole length is prominent on the left side; and in the right, below the middle, moderately hollow. Hence the lower ribs of the right side, by being more erect, have their anterior extremities more distant from the spine than those of the left. The right arm is almost pendulous, only a very little raised; whereby the position of the scapula is strait, and that of the clavicle almost quite transverse. But the scapula is pressed a little backwards, and together with it the clavicle, where it supports the scapula; by which means the chest is more openly exposed. The left arm again is raised up higher; whereby the clavicle, at that part upon which the upper process of the scapula rests, rises up together with that bone; and the scapula is a little turned, in such a manner, as that its lower angle is directed to the left side. The right elbow is streight, as also the radius and ulna; and the hand on the same side hangs open. The left elbow again is a little bent, the radius turned round the ulna as much as possible, and the hand turned with it. So much for the postures of the first and second figures.

In the third table the figure is in a walking position. This likewise stands on the right foot, the left only touching the ground with the extremity of the great toe; upon which account it is a little bended upwards, as in walking, when we want to bring the hind foot forwards. Farther, the right foot rests upon the heel, and the anterior extremity of the metatarsal bone of the great toe, by means of the intervening sesamoid bones; and upon these it chiefly stands, as also upon the anterior extremities of the metatarsal bones of the little toes. The right knee is streight, like that of the first figure, with the patella raised up in the same manner, and for the same reason, so as its lower part only rests upon the hollow between the condyles of the femur, and its upper part upon the thigh-bone above that hollow. The left knee is a little bent; and therefore the patella of this rests with its upper part in the hollow between the condyles. Hence its point is directed towards that eminence of the tibia, to which the ligament that goes to the patella is inserted. The pelvis, the same way as in the first and second figures, is supported entirely upon the right foot; and the left side of it is lower than the other. The spine above the pelvis is turned a little to the right side; whereby the thorax in its fore part is somewhat inclined the same way. The position of the face is more direct; both because the neck is more bended forwards, and besides the atlas with the head is turned considerably that way. The upper brim of the pelvis is directed upwards and forwards, the same as in the other figures; and the os coccygis with the lower part of the sacrum bended forwards. The loins immediately above the os sacrum are remarkably crooked, but presently become streighter, are gently inclined backwards, and hollow on the back part. The back-bone above the loins inclines also backwards, is gently bended at top, and hollow on the fore part. Above this rises the neck, bended a little forwards. The left arm is lifted up, whereby the scapula is somewhat turned, so that its upper part is directed a little backwards, and its lower angle forwards. But as the right arm hangs down, and is likewise turned backwards, hence the basis of the right scapula is kept at some distance from the ribs, especially at its lower angle. But I have explained the position of the figures sufficiently; for what remains in all of them may easily be understood only by viewing them. All the joints are large, and very well adapted, their cartilaginous crusts having been carefully preserved.

I proceed next to explain what sort of skeleton I made use of, to have the figures taken from. I chused it of that age in which the bones are arrived at their full growth and firmness; that is, when the epiphyses are plainly continued into the bones, of which they are a part; nor can the bones be said to be compleat before. It was of the male sex, of a middle stature, and very well proportioned; of the most perfect kind, without any blemish or deformity, either as to the bones themselves, or their connexions with one another. And as skeletons differ from one another, not only as to the age, sex, stature and perfection of the bones, but likewise in the marks of strength, beauty, and make of the whole; I made choice of one that might discover signs both of strength and agility; the whole of it elegant, and at the same time not too delicate; so as neither to shew a juvenile or feminine roundness and slenderness, nor on the contrary an unpolished roughness and clumsiness; in short, all the parts of it beautiful and pleasing to the eye. For as I wanted to shew an example of nature, I chused to take it from the best pattern of nature. But as even those skeletons, which may be reckoned the best, are different from one another, and I intended only to exhibit one of them; I proposed that that one should be an example for the others. And I cannot help congratulating my good fortune in this respect, for happening upon a body, which as it promised, so likewise it contained such a skeleton as I wanted. Yet however it was not altogether so perfect, but something occurred in it less compleat than one could wish. As therefore painters, when they draw a handsome face, if there happens to be any blemish in it, mend it in the picture, thereby to render the likeness the more beautiful; so those things which were less perfect, were mended in the figures, and were done in such a manner as to exhibit more perfect patterns; care being taken at the same time that they should be alto ether just. This then is the manner and history of the figures of the skeleton. From which, I think, it may easily be understood, that by this method it is possible to express the perfection of nature, at least to come

[b]

AN ACCOUNT OF THE WORK.

very near it: but it is not possible to produce any skeleton so perfect as these figures represent; at least, it is plain that it cannot be done so easily. For where is the anatomist, who, after having cleaned the bones perfectly well, and consequently has cleared away all the ligaments with which they are connected, and partly covered, preserving at the same time the cartilaginous crusts of the joints, can propose to join them together again in such a manner, as that the whole shall be perfectly just and elegant?

After these figures were drawn, I farther intended, as soon as they should be ingraved, to add the muscles to them; and, pushed on both by a love of the work, and an earnest inclination to improve anatomy, to try if I could perfect what I had conceived in my mind. Neither did I set out upon this unprovided. And indeed, as there is a great number of muscles intimately blended with other parts of the body; and as a great many difficulties must frequently occur, if you want to examine them all, not superficially, but fully and accurately; as they differ greatly and frequently from one another in different bodies; as very few bodies are proper subjects for one who is in search of the most perfect in its kind; while at the same time it was requisite that the ingraving should be retarded as little as possible: therefore it was absolutely necessary, to provide every thing for the work that I possibly could. From the time then that the first draughts of the skeleton were taken off, every year, with the consent of my pupils, and whenever an opportunity offered besides, I traced the muscles carefully, in order to observe their position, connexion, figure, thickness, and substance. And, according as more and more bodies occurred, either confirmed what I had before observed, or added whatever I found to be different. In this manner I proceeded every year. And as it is always better to present things to the view, if possible, than to trust to descriptions of them, I was at pains to preserve all of them I could, in order that I might be assisted by them afterwards. I took care especially to preserve in a proper liquor, that they might receive no damage, the bones and other parts to which the muscles are connected, whether they are said to arise from, or be inserted into them, together with the extremities of these muscles joined to them, and these all picked from the best subjects, which therefore I could consult whenever there was occasion. And as I had now a great number of scattered observations, I began to digest them, that I might have every thing in readiness. Which being done, I intended to compose from them a history of the muscles, making choice chiefly of those which I found the most frequently, and which I thought answered most the intention of nature. And though I designed to insert nothing into that history, but what the book of nature presented to me, yet I thought it convenient to consult the books of anatomists, and not only those of the best, but likewise of others which I could purchase; that I might be informed if I had passed over any thing, which was remarked by them, worthy to be taken notice of. And even since that system of myology has been published, I have not neglected to add whatever improvements dissections have since suggested to me.

Thus prepared, and with firmer resolution, and more sanguine hope, I began to add the muscles to the figures of the skeleton in the year thirty-eight. For this purpose it was proper to use the out-line figures only; for those which were ingraved were not so fit, upon account of the shades rendering obscure whatever should be added. But here I observed a fault in making the plates of the skeleton, which ought to be prevented. Ingravers, in order to take off a figure done upon paper, and ingrave it upon a copper-plate, first of all dawb the opposite side of the paper with powder of cerufs, then they lay that side of it carefully upon the plate, fitting it to it according as the position of the figure requires, and then they fasten it. Afterwards by drawing a needle along the lines of the figure, and impressing them gently, and just enough upon the plate, they order it so, that when the paper is removed, the lines appear upon the plate, by the impression made in the cerufs. But after the figure is finished, when the plate is ingraved, it happens that what was represented on the right, in the figure upon the paper, is ingraved on the left upon the plate, and vice versâ. If therefore any certain order of the muscles should be added to the out-line figures of the skeleton ingraved upon paper, and these again laid upon a copper-plate in order to be ingraved, according to the method above-mentioned; the right and left orders of the muscles would not answer to the right and left sides of the skeleton. This was easily corrected by ingraving the out-line figure of the skeleton upon a plate, in the usual way, and then having taken an impression of it upon paper (which I shall call the original) taking an impression of this upon another paper, so as to have a figure directly contrary to the other with respect to the sides, or right and left; and so using this contrary one (which I shall call the copy) to draw the muscles upon; and these being drawn, it was laid upon the copper plate, and so ingraved; and thus the figure which was cast off from this plate, was contrary to the copy, and therefore answered to the original, which was wanted. But here I was retarded by another obstacle. In order that the figures may be well ingraved, it is necessary that the paper should be sufficiently macerated. But when the sheets thus wetted, viz. the original and the copy, are put into the press together, it happens that being squeezed between two cylinders (which kind of press the ingravers always make use of) they are not only pressed, but likewise extended; by which means the figures are rendered so much larger, that when the sheets are afterwards dried, they do not contract to their just dimensions. Wherefore, if I had used such copies of the skeleton to draw the muscles upon, the figures of the muscles would have been too large in proportion to those of the skeleton. To prevent this, I ordered dry paper to be used both for the originals, and for the copies; by which means they were indeed faintly and imperfectly ingraved, especially the copies, but however not so

much, but they answered my purpose. But before I observed that fault of the copies which were ingraved upon wet paper, the second classes of the muscles were added to a copy of that kind of the figure of the skeleton; and hence it happens, that the out-line figures of the posterior layers of the muscles are rather somewhat larger than they ought to be. But this I could well enough dispense with in these figures, seeing they were only ingraved for the sake of the others which are shaded, and shew nothing but the bare out-lines together with the marks. But I corrected it in the shaded figures before they were ingraved; for these were all ingraved after the others, and all the out-line figures were transposed upon the copper-plates, which the shaded figures belonging to them were to be ingraved upon. And I corrected it in this manner. I took care that the paper made use of for the originals of the out-line figures, upon which the posterior layers of the muscles were to be ingraved, should be dry: but that used for the copies I ordered to be wetted. By this means the paper of the original figure, which was dry, was not extended by the force of the press, and therefore the size of the copy immediately after it was ingraved, as well as that of the original, was the same with the size of the figure upon the copper-plate, with which the original was stamped. But the paper of the copy being wetted, contracted itself upon drying, and consequently the figure which was stamped upon it. Wherefore, by repeated experiments, I found at last what maceration was exactly sufficient for the paper upon which the copies were to be ingraved, so that, after they were cast off, it should contract itself just enough to render the figure of a proper dimension. And these copies which I had corrected after this manner, I made use of for the posterior classes of the muscles, which were to be transposed upon the copper-plates for ingraving the shaded figures. Hence however I know, that when the cuts were quite ingraved, and ready to be published, though the figures in all the copper-places were of an equal size, it was scarce possible but in the cuts they must be more or less inequal: For as the paper upon which they are ingraved is of a looser or firmer texture, and as it is more or less softened by means of the maceration, so it contracts itself more or less after it is dried.

The muscles appear connected to the out line copies of the skeleton, in the same manner as they are to the skeleton in the dead Subject. And likewise the other parts to which muscles belong, as well as to the skeleton; as the os hyoides, the larynx, the tongue, &c. are connected the same way to the figures of the skeleton, and the muscles connected to them again. At the same time I added the history of the muscles, together with remarks, which were subjoined after it was published; having recourse every now and then to those observations above mentioned, which I had formerly put in writing, concerning the muscles. Nor was there any thing taken but from bodies themselves. And wherever they manifestly and remarkably differed from what I had more frequently observed in others, those things were supplied from other bodies. And as this succeeded according to my mind, though it retarded the work, there arose a new difficulty. It was downright impossible for me to draw the figures of most part of the muscles from one and the same body, and far less those of them all: on the contrary it was very evident, that it would require some years, and a great many bodies must be made use of for the purpose. It is very true, that the muscles of any of these bodies might well enough be adapted to the figures of the skeleton; but as some bodies are more brawny or fleshy than others, nor could I hope having it in my power to get the others exactly like the first, it was a hard matter to contrive how muscles taken from subjects differing in that respect, and compared with one another, should be modified into a proper equality, and proportion with one another. This could not possibly be effected by means of the skeleton only. Therefore, besides it, there was some other certain standard to be found out; for to depend upon the judgment alone, was neither quite safe, nor did I at all approve of it. The chief thing to be done was to look out for large and thick muscles, especially for those of the trunk and neck, and most of all, the extremities. I endeavoured then all I could to draw the external class of the muscles of the trunk, neck, and extremities, all from the first body, within which were to be placed those taken from other bodies, at the same time adapted to the figure of the skeleton; and these too I took from bodies as like the first as possible. But, in drawing the external classes of the muscles, it was difficult to find out the proper position of them with respect to the skeleton, because the most part of the skeleton was covered by them. Although then a great deal of care was taken, yet afterwards, as the inner classes, by the skeleton's being more exposed in them, shewed what was to be done, the external classes were to be corrected. For to connect the muscles accurately with the figures of the skeleton, I must have done them all separately, and if so, I could not easily have placed them in proper order with one another. In order to this, it was proper to begin with the external, which upon doing I found very difficult, as I just now mentioned, to place them justly with respect to the skeleton, which was almost quite covered with them; and it was likewise no easy matter to draw those properly, which lie in a great measure concealed under others. Both these difficulties were then got over, by beginning with the external class first, and so proceeding from that to the more internal, and again afterwards correcting the external, according as the internal shewed what was to be done.

Great care was taken in raising and exposing the muscles, that they should not be spoil'd. In order to prevent this, I used bodies that were fattish, whenever such were requisite, in which the muscles are preserved by the fat; and of this I take away no more than was quite necessary, that a right view might be had of the part that was to be drawn, leaving the rest untouched,

AN ACCOUNT OF THE WORK.

untouched, to preferve the mufcles not diffected. In many parts it was neceffary to trace and draw the mufcles at the fame time, efpecially thofe, which if I had attempted to diffect and expofe entirely, it would have been a very difficult matter, and next to impoffible, to have kept them from fpoiling: and I was frequently obliged to call in other helps befides. Thus, in order to draw the coracohyoideus mufcle, which is the thirty-fifth figure of the eleventh table, I firft laid bare the external part, and drew it, then afterwards the internal part of the beginning of it; to expofe which diftinctly, I diffected away the fat exceeding clean, without hurting the mufcle, leaving only what was neceffary to keep it from fhrinking, and at the fame time could not obftruct the figure. The concave and convex fides of the diaphragm, as they are reprefented in tables fourth, and fourteenth, cannot be feen both at one time in the body. For to have a view of the concave fide, the abdominal vifcera, which obftruct it, muft be removed; and for the convex again, the thorax muft be laid open. But if you pen the thorax, after having taken out the abdominal vifcera, or the abaumen, having firft emptied the thorax; in either cafe, the diaphragm becomes flaccid, and its figure is fpoiled. Wherefore, having emptied the abdomen of its contents, I firft expofed the convex fide of the diaphragm, and, as foon as that was drawn, I put them all in again, in order to fupport it; and then opening the thorax, I added the convex part of the figure; to finifh which I made ufe of another body, the thorax of which I opened firft, keeping the belly entire, whence the diaphragm was fupported by the abdominal vifcera. There were a great many other mufcles very troublefome to reprefent right; as thofe of the anus, and efpecially thofe of the pharynx, palate, uvula, and face. However, by means of contrivances of this kind, there are a great many things, if I am not miftaken, very juftly reprefented; fome of which can very hardly, and others not at all, be expofed fo plain in bodies themfelves. But it would take up too long a time to difcover, what and how many methods I made ufe of, to have every thing reprefented as perfect and diftinct as poffible.

The bodies which I ufed were thofe of adults, and fuch of them only as were moft proper for the purpofe. The mufcles again were fuch as moft frequently occur; only I picked out thofe that I judged the moft perfect, and in beft condition. But it would be an endlefs tafk to trace all thofe differences which appear in different bodies, in the fame manner as the features. And although, paffing over all trifling varieties, I had only taken notice of fuch as are remarkable, I fhould have found it no eafy matter to come to a clofe. Neither was it proper to infert many of thefe into a general fyftem of the mufcles, although they were even remarkable, and frequently occurred. Some of them however are inferted. There are a few mufcles inferted which rarely occur, as the pfoas parvus; and likewife a mufcle of the bladder, which I have very feldom feen. And altho' I have endeavoured to examine all the mufcles fully and accurately, and likewife to have them expreffed in the fame manner; yet I have neglected fome circumftances which appeared lefs material. For example, there are fome mufcles a little tendinous at their beginning, or extremity, which do not appear fo in the figures. Neither are there certain fiffures expreffed, through which the fmaller arteries, veins, and nerves penetrate, together with other things of the fame nature, which partly did not feem to be of any great confequence, and partly would render more or lefs obfcure the figure, and general fymmetry of the mufcles; befides that, I thought them lefs agreeable to that fimplicity which I endeavoured after. And certainly it is proper in things of that nature, when reafon requires it, always to confine ourfelves to certain bounds, not to be trefpaffed. Here the fituation, figure, fize, origin, infertion, cohefion, flefhy and tendinous nature, and the general courfe of the fibres, to which their direction might be referred, were the chief circumftances to be taken into confideration about the mufcles.

There are two kinds of tables, in which I have comprehended the whole work. The one contains the general connexion and difpofition of the mufcles all over the body; the other again contains the figures of each of them. The firft, the fame as the fkeleton, gives a fore, a back, and a fide view of the whole. And it exhibits the mufcles according to their different claffes: firft the moft external, then thofe next below, and fo forth; and the following is always a continuation of the preceding. But as the fore and back views of the body are always the fulleft, and by comparing thefe two together, you can generally guefs the fides; therefore the different claffes are exhibited before and behind. To thefe however I added the external clafs of the fide, that it might appear fuller and more diftinct, than can be conceived from comparing the fore and back parts together; and this the pofition of the mufcles feemed to require. This one at firft I thought would be fufficient, as from it the general difpofition of the mufcles there might be well enough underftood; efpecially if the claffes on the fore and back parts were compared, befides the figures of the fingle mufcles, if occafion required. But as fome of thofe which are fituated in the neck, and under the head, could not be better expofed, neither from before nor behind, nor in any other pofition; therefore there are fome claffes exhibited laterally. For the fame reafon I have added views of the mufcles in the fole of the foot, and in the cavity of the orbit. But as according to the various fituation and pofition of the parts, and the different view of them, the order of the mufcles is really different, or appears to be fo, and of this there is an infinite deal of variety; fo the figures may be multiplied to an infinite number. But I have made choice of that pofition which I thought the moft proper. And as it is impoffible to hit upon one where there is not fome part or other lefs confpicuous, I chofe that in which the mufcles in general are moft expofed. And of this fort there might ftill be a great many more figures. But as thofe few which I have given,

are, in my opinion, fufficient to fhew the order of the mufcles in general; and whatever more is required can eafily be fupplied by comparing the general figures with thofe of the fingle mufcles, therefore I thought it needlefs to add any more. Befides, I avoided too great a number, for fear of confufion. And it was much more difficult to reduce the mufcles in general to a few orders, with perfpicuity, than the multiplying of thofe could poffibly have been. But as in thofe general figures it is impoffible that the whole mufcles fhould appear, excepting a very few, it was neceffary to add compleat figures of each of them. And if I had multiplied the general figures fo, as that there fhould not be a mufcle in the whole body, that could not be found at full length in one or other of them; yet they could not all of them be known fo diftinctly, at leaft not fo eafily and readily, from thofe figures, as they are from the figures of the fingle mufcles, in which the proximity of other mufcles occafions no obfcurity. Further, the general figures ought not to be large, in order that they may be perufed at one view, and therefore fcarce larger than they are in thofe tables; for it is poffible for them to be too large to be conveniently infpected. This fize was proper for fufficiently expreffing moft part of the mufcles, even the fmall ones amongft them, as far as regards their general order and difpofition. The larger mufcles again, and even a great many of the fmall ones, might be plainly enough expreffed in the fame fize, fo as to be traced each of them diftinctly; but there were feveral which could not, either on account of their fmallnefs, or their fituation with regard to the neighbouring ones. The light and fhade too in the general ones could not fo eafily be expreffed with fimple lines, which are fitter for pointing out the courfe of the fibres, and with which the figures of the fingle mufcles are drawn, as they are with decuffated lines. It remained then that I fhould reduce the general figures to as few claffes as poffible, and make them as perfect as I poffibly could; and, befides them, exhibit the fingle mufcles feparately.

In drawing the figures of the fingle mufcles, I have followed the general ones wherever I could. And this I did, that the former might affift the latter, and make them be underftood; as well thofe things which, on account of the contiguous or incumbent parts, are either lefs compleat in the general ones, or plainly not confpicuous, as thofe which could not be fo well expreffed in them. By this means too the whole is better connected. But where the pofition which I borrowed from the general figures was not fufficient, I have added others in another pofition, fuch as I thought proper. There are fome mufcles in the general figures, whofe pofition is not fo proper as I could wifh, and fome, no part of which can be made to appear in the moft proper pofition. I could have multiplied the number of figures indeed, if I had wanted to exhibit every part of each of them, viz. externally, internally, and laterally, as there fhould be occafion. But I imagined it was better to take a little liberty here, and only exhibit thofe parts of them, which beft anfwered the intention of this work. The figures of the fingle mufcles are drawn twice as large as thofe of the general tables; by which means they are rendered fitter for expreffing every thing more fully and accurately, efpecially thofe which are only fmall. And although the large mufcles did not require that, yet I have obferved the fame rule in them, that fo there might be the fame proportion in all. But thofe mufcles which belong to the internal ear, being fo very fmall, are expreffed in the natural fize. They are all likewife figures of entire mufcles; except a few of maimed ones, which were obliged to be added, in order to expofe to view fome things remarkable. But as to their compofition, and thofe appearances which their internal ftructure exhibits to our view, I did not think proper to infert any thing in this volume, which is already fwelled to a fufficient bulk.

I have not only ftudied the correctnefs of the figures, but likewife the neatnefs and elegancy of them. For this end I employed an artift very fkilful, both in drawing and ingraving. And he happened to be one, which is very feldom the cafe, who was very fond of doing things in that way; which difpofition I encouraged, by giving him whatever he demanded for his trouble. For a great many years by-paft, he has worked for very few befides myfelf; and for thefe laft ten (moft part of which he has been wholly employed in thefe tables) almoft for me only. And he both drew and ingraved them all by my direction. In the firft place I endeavoured to make him underftand, as well as poffible, what was to be drawn; and I was conftantly with him, to direct him how every thing was to be done, affifting him in the drawing, and correcting what was drawn. And thus he was inftructed, directed, and as entirely ruled by me, as if he was a tool in my hands, and I made the figures myfelf. Afterwards too, when he came to ingrave them, there was a great deal of care required, left any thing fhould be done amifs in taking off the figures upon the copper plate; and frequently I had to advife him in what manner the parts were to be ingraved. And when after all this pains he happened to go wrong, I examined the figures after they were ingraved, and what faults I obferved he rubbed out, and corrected very exactly. For the chief care was, to exprefs every thing as correctly and diftinctly as poffible. The ingraver befides employed all his art, both in the out-lines of the figures, in the light and fhades, in the fymmetry of the parts, and in their different appearance. He ftudied dignity in the out-lines, diftinctnefs, force, grace, and harmony in the light and fhades, fo that every thing might appear full and diftinct; and at the fame time the whole figure, though compofed of feveral parts joined together, might no where be interrupted, further than nature has obferved in thofe parts; in the fymmetry, a certain harmony and equality, which ought to difcover itfelf amongft all the different parts; and in the outward appearance, the diftinction and difference between bone, flefh, tendon, cartilage, &c. in fhort, in the whole figures the greateft perfection. To the general

[c]

AN ACCOUNT OF THE WORK.

figures he has added ornaments, not only to fill up the empty spaces of the tables, and make them appear more agreeable; but likewise that by the shading of those ornaments upon the margins of the tables, the light and shades of the figures might be preserved, and heightened, and the figures themselves appear more raised or rounded; and though they are composed of several parts, and thereby consequently must be interrupted, that nevertheless they might seem to be entire. This required a considerable deal of skill; and though it was not easily done in any of the other tables, it was still more difficult in those of the skeleton. But whoever wants to examine how this is executed, will know it best by looking at the tables, at a proper distance, through his hand placed before the eye in the manner of a spy-glass, so that the surrounding light may not hinder the viewing them distinctly. And, I hope, to a person who observes them attentively, these ornaments will be found to have no bad effect, in making him discover less readily what is expressed in the figures themselves.

In order therefore that the beauty of the figures might not be hurt, it was proper not to add any marks to them, by which the several parts should be pointed out in the text. For besides that they would have bespotted the figures, so to speak, they would have obscured several things, and obliterated not a few, seeing many things are so small, that these marks would have covered them entirely, or almost so. Besides, of those of them which were to have been placed in the shades, the most part could not easily have been discerned, and several of them hardly at all. For this there is found a remedy, by adding the out line figures, and putting the marks to them: which has this advantage, that in the out-line figures the bounds and terminations of the different parts are very readily distinguished; and therefore they remove any doubt which might arise in the shaded ones, either from the smallness of the part, or the manner of the shades, or the ingraving, which cannot be prevented. But these marks are added to the figures of the single muscles, because they shew them almost all singly, and of larger dimensions, and themselves are ingraved all in one line; they could likewise be easily added, and easily discerned. Neither do they hurt those figures so much, seeing it was not necessary to be at so much pains about them. Besides, the bones, and other parts which are exhibited with the muscles, whereby you may know with what parts they are contiguous and connected, are only expressed in out-lines; not only because that was sufficient for the purpose, but that thereby the whole bodies, and terminations of the muscles, might appear the plainer. Neither are the muscles themselves, in these figures, drawn with less art than in the others, whether as to their limits, the light and shades, or the distinction of their tendinous and fleshy fibres. The manner too of ingraving is different in these, and they have this to recommend them, that they are expressed in simple lines,

without any cross ones; which simplicity was made use of, in order to point out the course of the fibres more distinctly. But this is only expressed in general; neither did I think it necessary to pursue the fibres minutely, and shew how they are compounded. For besides that this could only be done justly in part, I was of opinion, that the exact course of the fibres was rather to be looked for in the general system of figures.

For adding the marks I employed a skilful ingraver, who could do it with judgment; so as to put them in their proper places as exactly as possible, and answer both in size and fulness to those figures to which they were to be annexed; whereby they might both accurately point them out, and be conspicuous themselves, at the same time being no obstruction to any thing; and especially, that they should not obscure smaller parts too much. I took care too that the tables should be impressed as well as possible, which is of the greatest consequence for the elegance, force, and beauty of the figures, as every body versed in ingraving must know. Wherefore I both used the fittest paper, in which a great deal depends, and employed a very skilful and experienced workman. As to the explanations of the tables, they are short, in the form of an index; which I thought was sufficient: though those that belong to the single figures are a little fuller. The rest, the history of the muscles will explain.

This is all I have thought necessary to say concerning the nature of this work. Though he will best understand it, and he will find it no easy task neither, who engages in an affair of the same kind. It may possibly be thought, that I should have treated particularly of those things, which, besides such as have been inlarged upon by the best hands before me, they might expect I should explain, after all the pains, labour, and expence which I have been at, and which are indeed greater than can well be imagined. But as to such as love and cultivate this study, if they sufficiently consider what I have said above, they will readily understand what I intended. And if any one should sneeringly desire to know, in what, besides directing every thing according to the rules above mentioned, I differ either in the figures, descriptions, or any thing else, from former anatomists, or what I have either corrected, or added, although he may find it out upon making a comparison, I thought I might be allowed to pass that over. It is possible enough that I might have bestowed my labour, which in such a number of things was certainly very great, to a still better purpose. But whoever imagines, that that accuracy and perfection, which I have so earnestly endeavoured after, was needless and unnecessary, I would have him to consider, what the greatness and dignity of such a work required, besides a necessary usefulness. And I do not doubt but they will be less surprized, that I esteem these tables so much the more useful, not only the more just, but likewise the more beautiful, and more finished that they are found to be

THE

ANATOMY

OF THE

HORSE.

INCLUDING

A particular Defcription of the BONES, CARTILAGES, MUSCLES, FASCIAS, LIGAMENTS, NERVES, ARTERIES, VEINS, and GLANDS.

In Eighteen TABLES, all done from Nature.

By George Stubbs, Painter.

LONDON: Printed by J. PURSER, for the AUTHOR. 1766.

¹ANATOMY of the HORSE.

The Anatomical TABLE of the Skeleton of a HORSE explained.

Bones in the aaaabcdefg THE os fro forehead bone; *b* a smal which transmits an artery rve out of the orbit to al muscle; *c* a suture which joins the frontal bor the zygomatic, or jugal process of the temporal *de* the coronal suture; *d* a squamose, or scale-like *e* the part of it which makes a serrated or true f ommon to the frontal bone with the parietal bone iture common to the frontal and nasal bones; *g* a ommon to this bone with the os unguis.

hik The vertical, or parietal bor squamose suture, common to the parietal bone wi mporal bone; *k* the lambdoid suture, common to t tal bone with the occipital bone.

lmnoppq The occipital bone; *l* tal protuberance, which in this animal is very ogether with the internal spine, or protuberance, &rectly opposite to this, makes a strong body o t his place; betwixt *m* and *n* is a suture, which, ,a horses, is easily separated, but afterwards beco gtly united; *o* : process which makes a considerab on to the mammillary process of the temporal bo he condyloid process, which is incrusted with a i artilage.

rsstuwx Os temporis, or temporal bo he zygomatic, or jugal process of the temporal t the part which articulates with the lower jaw bo y a part which, in young horses, may be easily b ut afterwards becomes firmly united; it is distii by the name of os petrosa, or apophysis petrosa; ,ammill ary process; *w* the bony meatus, or entran he ear; *x* a suture common to the cheek bone, with gomatic process of the temporal bone.

yz The orbitary portion of the bone of the ; *y* a suture common to it with the os frontis; *z* a com on to it with the upper jaw bone.

1 2 3 4 5 6 Os unguis; *1* a small pro ce or roughness from whence arises the orbicular m f the

eye-lid; *2* a sinus or cavity belonging to the nasal canal; *3* a suture common to this bone with the cheek bone; *4* a suture common to this bone with the bone of the nose; *5* a suture common to this bone with the bone of the forehead; *6* a suture common to this bone with the upper jaw bone.

7 8 9 10 Os jugale, or cheek bone; *8 9* a suture formed by the union of this bone with the upper jaw bone; *10* a suture formed by the union of the orbitary part of this bone with the os unguis.

11 11 12 13 14 15 Os maxillæ superioris, or the upper jaw bone; *12* the foramen or hole of the channel *12* which passes along the bottom of the orbit of the eye; *13* a suture common to this bone with the bone of the nose; *14* a suture common to the anterior part of this bone *15*, and the posterior part *11 12 13*.

16 Os nasi

17 17 17 17 18 19 19 20 The lower mandible or jaw bone; at *17 17 17 17* are marked roughnesses, from which arise the tendinous parts of the masseter; *18* a hole out of which passes a nerve of the fifth pair and blood-vessels to the chin; *19 19* the coronal or acute process; *20* its condyle or head that is joined with the temporal bone.

21 A moveable cartilaginous plate which is interposed in the articulation of the lower jaw.

The Vertebræ of the Neck.

A Æ E a b b c d e The atlas or uppermost vertebra; *A Æ* the posterior and superior part of the left side of this vertebra, which articulates with the condyloid process of the occipital bone; *A* the anterior and superior part of the right side of the atlas, which articulates with the occipital bone as a large tubercle on the anterior part of this vertebra; *b b* the transverse processes; *c* the protuberance, tubercle, or inequality on the posterior part of this vertebra, which seems to be in the place of a spinal apophysis; *d* the posterior, and inferior part of the right side of this vertebra, which articulates with the second

vertebra; *e* the transverse hole through which a nerve and blood-vessels pass. *N. B.* This vertebra receives the articulating part of the occipital bone, as well as the superior articulating part of the second vertebra: the rest of the vertebræ in the inferior articulating parts of their bodies receive the superior articulating parts of the vertebra below, and have their superior articulating parts received by those above, so it is with the back and loins; *E* the superior and posterior holes.

fghiklmn 1 2 The epistrophæus or second vertebra of the neck; *f* the inferior part of the body which receives and is sustained by the third vertebra of the neck; *g* the superior part of its body, which is received by and sustains the atlas or first vertebra of the neck; *h* the anterior protuberance of the body of this vertebra; *i* the transverse process; *k* the spinal process; *l* the lower oblique process on the right side, which is covered with a smooth cartilage within the dotted lines; *m* the lower oblique process on the left side; at *1* is a hole where the vertebral artery goes in and comes out at *2*, called the transverse hole.

opqrstuwxy The third vertebra of the neck; *o* the anterior protuberance of the body of this vertebra; *p* is the superior part of the body of this vertebra, which is received into the inferior part of the body of the second vertebra; and *q* is the inferior which receives the superior part of the body of the fourth vertebra; *r* the transverse process; *s* the right upper oblique process; *t* the right lower oblique process; *u* the spinal process; *w* the transverse holes through which the vertebral arteries and veins of the neck pass; *x* the left upper oblique process; *y* the left lower oblique process seen thro' the large foramen or hole which contains the medulla spinalis, or spinal marrow.

N. B. This explanation may serve for the fourth, fifth, sixth, and seventh vertebra of the neck; only that the anterior portuberance is wanting in the sixth; but instead of that there is a process on each side which is obliquely placed a little more anteriorly than the transverse process

A but

but ascends obliquely outwards to join with it; it is marked *z*.

A continuation of the bones of the spine from the neck.

1 abcdefG The first or uppermost vertebra of the back; *a* the body; *b* the transverse process; *c* the upper oblique process; *d* the lower oblique process; *e* the spinal process; *f* the lower oblique process of the left side, seen through the large hole which contains the medulla spinalis; *G* the ligament interposed betwixt the bodies of the first and second vertebra of the back.

2 5 6 7 8 9 10 11 12 13 14 15 16 17 18 The vertebræ below the 1st, to the letters of which the explanation of the first will answer.

ABCDEF The six vertebræ of the loins; the explanation of the first vertebra of the back will answer to the vertebræ of the loins.

ggghiiiikllllmmmm The os sacrum or great bone of the spine; *ggg* the anterior part or body of this bone which, in young animals, is divided into as many bodies as there are spines in this bone, it being then like five vertebræ, whose transverse processes make the unequal rough part *h* of this bone; *iiiii* the five spines; *kkk* three inferior and anterior holes, which transmit the nerves on each side; *lll* posterior foramina or holes; these foramina, both anterior and posterior, answer to the foramina through which are seen, in this table, the oblique processes of the left side of the vertebræ both of the neck, back, and loins; the transverse processes of this bone being joined, make two holes, one anterior, the other posterior, of which there is but one in the neck, &c. the transverse processes not being joined; *mmmm* the parts of this bone made by the union of those parts which were oblique processes when it was divided into five vertebræ.

nopq The first bone of the coccyx or tail; *n* the body, *o* the transverse process, *p* the upper oblique process, which articulates with the os sacrum; there is no lower oblique process; *q* the spine; *r* the ligament interposed betwixt the bodies of the first and second bone of the tail, tying them together.

The same letters on the rest of the bones of the tail will answer to the explanation of the first, only it is to be observed, that there is but little appearance of any protuberating parts after four or five of the uppermost; and in the second the uppermost oblique process forms no articulation with the first, there being no lower oblique process, on any other of these bones as observed before: the spinal process of the second bone of the tail is double, arising from the sides of the spinal channel,

but not rising high enough to meet over the medulla spinalis as those of the first do; it makes two small processes: these protuberating parts diminish so fast that after the fifth or sixth bone they almost disappear, and the bones below are of an oblong figure thickest towards their extremities.

There are 18 bones in the tail.

Bones in the thorax and shoulder-blades.

aaaaab The sternum or breast bone, of which the parts *a a a a a* are bony, the rest, *b* is chiefly cartilaginous, or ligamentous, by which the bony parts are connected together.

1 c d e The first rib; *c* the head by which it is articulated with the transverse process of the first or uppermost vertebra of the back; *d* the anterior or former part of the said head which is connected to the bodies of the seventh vertebra of the neck and first of the back; *e* the cartilaginous end by which it is continued to the sternum.

This explanation will serve for the rest of the ribs, but it is to be observed, that the eight superior ribs only are connected to the sternum, the others are called false ribs.

1 2 3 4 5 6 7 8 9 10 11 12 13 14 15 16 17 18 Shew the external side of the ribs on the right side, and internal on the left side.

fg The inner side of the left scapula or shoulder-blade.

hiklmmnopq The right scapula; *h* it's neck; *i* it's spine; *k* the coracoid apophysis, or epiphysis; *ll* it's inferior costa; *mm* it's superior costa; *nn* its basis; *o* fossa sub-spinalis; *p* fossa supra-spinalis; *q* a cartilaginous continuation of the scapula.

Bones in the right upper limb.

abcdefghikKlm The humerus or bone of the arm; *b* denotes a protuberance into which the teres minor is inserted; *cdefgh* the upper head; *cde* three protuberances which form two sinuses or grooves which are pretty deep and incrusted with a smooth cartilage; they serve to confine the heads of the biceps muscle from sliping sideways; but by their smooth cartilaginous incrustation they suffer them to slide easily up and down; *the heads of this muscle are united over the middle protuberance d and the place of their union is covered with fleshy fibres*: *h* the part of the head which is joined to the cavity of the scapula, covered with a smooth cartilaginous crust; *i* the external condyle of the lower head; *kK* the head covered with a smooth cartilage with which the radius is articulated; *K* the double articular eminence; *l* the anterior fossula or sinus that receives the upper head of the radius

when the cub s much as it can be; *m* the posterior sinus w es the olecranon of the ulna when the cubit is e much as it can be.

nopqr Th *n o* the upper head; *o* a protuberance into wh ndon of the biceps muscle of the arm and brac inserted; *pqr* the lower head of this bone; *p* a sinus or groove through which goes the tende extensor carpi radialis; *q* a sinus through whi e tendon of the extensor digitorum communis; s through which goes the tendon which is anal the tendon of the extensor minimi digiti.

sttuu Th *s* the olecranon or elbow; *tt* the part which a with the humerus; *uu* the lower part, which mall and in aged horses becomes one bone with th

wxyz 2 ones of the carpus; *w* os scaphoides or navicular lunare; *y* os cuneiforme; *z* os pisiforme or orb (the bone called trapezium, which articulates w thumb is not in the horse; and the bone which it called the trapezoid, cubical, or least of the gular bones of the wrist, is not seen on this limb in le; but on the left upper limb in this table is mark 2 os magnum or the great round-headed bone wrist; 3 the unciform or hook-like bone of the

4 5 6 7 etacarpal bones in this animal called the shank-bone hich that marked 4 5 is equal to two of the metacarones joined together, *viz.* that of the middle fing d that of the ring finger; 4 the upper head by wh articulates with the carpus; 5 the lower head, in th e incrusted with a smooth cartilage; 6 7 an imperfec acarpal bone in the place of that in the human skel which belongs to the little finger; 6 he upper head which it articulates with the unciform bone of the carp 7 the lower head, which is very small, and (the b of the little finger being wanting) forms no articulation

10 11 bones which are always to be found in this joint; h bones are called sesamoid bones in the human skel and are frequently found in the first joint of the inc and little finger, and in the joints of th thumb; t serve to throw the bending tendons farthe from the are of motion in this joint and form a prope groove for em to slide in.

12 13 bone which is equal to the bones of the pha langes of e middle and ring finger in the human skeleton in a hors this is called the great pastern.

14 15 he bone of the second phalanx of the finge or the lit pastern or coronary bone.

16 The bone of the third phalanx, in a horfe called the coffin bone.

17 A fefamoid bone lying over the pofterior part of the articulation of the coffin bone with the coronary bone, or the two laft phalanges of the fingers.

In the left upper limb.

cde The os humeri; *cde* three protuberances which form two finufes or grooves which are pretty deep and incrufted with a fmooth cartilage.

op the radius; *o* a protuberance in the upper head into which the biceps mufcle of the arm and brachialis internus are inferted; *p* denotes a finus or groove in the lower head in which the tendon of the extenfor carpi radialis lies.

uu A fmall part of the ulna which in aged horfes becomes one bone with the radius, but in young ones is joined to it by ligaments.

wxz 1 2 The bones of the carpus; *w* os fphenoides or naviculare; *x* os lunare; *z* os pififorme or orbiculare; 1 os trapezium; 2 os magnum, or the great round-headed bone of the wrift.

4 5 8 9 the fhank or metacarpal bones; 4 5 is equal to the metacarpal bones of the middle and ring fingers joined together; 4 the head by which it articulates with the bones of the carpus; 5 the lower head incrufted with a fmooth cartilage; 8 9 an imperfect metacarpal bone in the place of that which belongs to the fore-finger in the human fkeleton; 8 the upper head by which it articulates with the trapezoid bone of the carpus; 9 the lower head which is very fmall, and the bones of the fore-finger being wanting it forms no articulation.

10 11 12 13 14 15 16 17 The three bones of the finger, or the great paftern; the little paftern or coronary bone and coffin bone with the three fefamoid bones which will all anfwer to the explanation on the right upper limb in this table.

In the pelvis.

abcdefgghiiklll The right os innominatum or bafon bone including three others; *abcd* the os ilium, hip, or flank bone; *bc* the fpine; *b* the anterior part of the fpine; *c* the pofterior part; *d* the protuberance from which arifes the rectus mufcle of the leg; *efgg* the os ifchium, or hich bone; *e* the acute procefs; *f* the tubercle of the ifchium; *gg* the pofterior notch for the paffage of the internal obturator mufcle; *hii* the os pubis; *ii* the

fpine or ridge of the os pubis; *k* the great foramen of the ifchium and pubis; *lll* the external margin of the acetabulum.

aabccdfhiikll The left os innominatum, which will anfwer to the explanation of the right os innominatum, with this difference only, that the left fhews the external view and this the internal view.

In the lower limbs.

abccdefghi The right femur or thigh bone; *a* the body or middle of this bone; *bccdde* the upper extremity, of which, *b* is the neck; *cc* the head incrufted with a fmooth cartilage where it is jointed into the acetabulum; *dd* the great trochanter or fpoke; *e* the lefs trochanter or fpoke; *f* a very prominent part of the linea afpera, into which the external glutæus is inferted along with a part of the fafcia lata; *g* a large foffa or notch, out of and from the borders of which the external head of the gemellus, and the plantaris mufcles arife; *hi* the lower extremity; *h* the outer condyle of the lower head, which at *i* is covered with a fmooth cartilaginous cruft.

klmnopppp The left femur or thigh bone; *l* the lefs trochanter; *m* a roughnefs from which arifes the internal head of the gemellus; *n* the inner condyle; *o* the outer condyle; *pppp* the fmooth cartilaginous cruft which covers the part of this lower head where it is jointed to the tibia and patella.

qqqrr The patellæ or knee-pan bones; *rr* that part which is covered with a fmooth cartilaginous cruft which forms part of the joint at the knee.

ss The inner fimilunar cartilages which are interpofed in the joints of the knees.

tt The outer fimilunar cartilages in the joints of the knees.

uvwxyuvwxy The tibiæ or greater bones of the legs; *u* the upper head; *v* that part of the upper head which, belonging to the joint of the knee, is covered with a fmooth cartilaginous cruft; *w* a protuberance in which terminate the anterior ligaments which come from the patella and tie it to the tibia; *y* the lower head of the right tibia; *z* the lower head of the left tibia.

1 2 1 The fibulæ or fmall bones of the legs; 1 the upper head; 2 the lower extremity which ends here almoft in a point.

3 4 5 4 5 6 The aftragali or cockal bones; 4 5 the

part which forms the juncture with the bone of the leg covered with a fmooth cartilaginous cruft.

7 7 8 9 The calcanei or heel-bones; 8 the projecting part that fuftains the aftragalus; 9 the tubercle into which is inferted the tendon of the gemellus, and to which the tendon of the plantaris is attached by ligaments.

10 The cubical bone of the tarfus or ancle.

11 11 The navicular bones of the tarfus.

12 12 The middle cuneiform bones of the tarfus.

13 The lefs cuneiform bone of the tarfus.

N.B. What are called the great cuneiform bones of the tarfus in the human fkeleton are (as well as the bones of the great toe) wanting in this animal.

14 15 16 17 14 15 16 18 19 The bones of the metatarfus or inftep; 14 15 a bone which is equal to the metatarfal bones of the fecond and third little toes both together in the human fkeleton; 14 the upper head which articulates with the three lower bones of the tarfus; 15 the lower head, in this place covered with a fmooth cartilaginous cruft, where it articulates with the upper head of the bone of the firft phalanx or order of the fmall toes; 16 17 an imperfect metatarfal bone in the place of that which, in the human fkeleton, belongs to the little toe; 16 the upper head, by which it articulates with the cubical bone of the tarfus; 17 the lower head which is very fmall, and (the bones of the little toe being wanting) forms no articulation; 18 19 an imperfect metatarfal bone in the place of that which, in the human fkeleton, belongs to the firft of the fmall toes; 18 the upper head by which it articulates with the lefs cuneiform bone of the tarfus; 19 the lower head which is very fmall, and (the bones of the firft of the fmall toes being wanting) forms no articulation.

20 21 20 21 Bones which are always to be found in thefe joints, two in each, fuch are called fefamoid bones in the human fkeleton; they ferve, in this joint, to throw the bending tendons farther from the center of motion, and form a proper groove for them to flide in.

22 23 24 22 23 24 The bones which are in the places of the three phalanges, or orders of bones of the fmall toes in the human fkeleton: with farriers the firft are called the great pafterns, the fecond the little pafterns, or coronary bones, the third the coffin bones.

25 25 Sefamoid bones lying over the pofterior parts of the articulations of the coffin bones, with the coronary bones.

B The

The fecond Anatomical TABLE of the Skeleton of a HORSE explained.

In the Head.

Aaabbccddeeffgg THE os frontis, or forehead bone divided into two by the continuation A of the fagittal or longitudinal future; *bb* the fuperciliary foramina, or holes tranfmitting each a fmall artery and nerve, out of the orbit, to the frontal mufcles; *cc* futures which conjoin the frontal bone with the zygomatic or jugal procefses of the temporal bones; *dd* futures common to the os frontis with the temporal bones, which are fquamofe parts of the coronal future; *ee* thofe parts of the coronal future which make a true future, and are common to the frontal bone with the parietal bones; *ff* futures common to the frontal and nafal bones; *gg* futures common to the frontal bone with the offa unguis.

hhiikkl The vertical or parietal bones; *ii* the fquamofe or fcale-like futures, which are formed by the conjunction of the parietal with the temporal bones; *kk* the lambdoide future formed by the conjunction of the parietal bones with the occipital bone; *l* the fagittal or longitudinal future, formed by the union of the two parietal bones.

mnn The occipital bone; *m* the large protuberance which is marked *l* in table the firft, and which, in a horfe, is called the nole bone; *nn* appendixes or additions to the lambdoid future formed by the union of the occipital bone with the temporal bones.

oooppqrr The temporal bones; *oooo* the zygomatic or jugal procefses of the temporal bones; *r* futures common to the zygomatic procefses of the temporal bones with the offa jugalia or cheek bones.

ssttuu The offa nafi, or bones of the nofe; betwixt *s* and *s* is a future common to the two nafal bones; *tt* futures common to the nafal bones with the offa unguis; *uu* futures common to the nafal bones with the upper jaw bones.

wwxxyyzz The offa unguis; *x* futures common to the offa unguis with the offa jugalia; *yy* futures common to the offa unguis with the offa maxillaria, or great bones of the upper jaw; *zz* fmall protuberances or roughneffes, from which arife the orbicular mufcles of the eye-lids.

1 1 2 2 3 3 The offa jugalia, or cheek bones; 3 3 futures formed by the union of the cheek bones with the upper jaw bones.

4 4 5 5 6 6 7 7 8 8 9 The offa maxillaria, or great bones of the upper jaw; 5 5 the foramina, or holes of the channels, which pafs along the bottoms of the orbits of the eyes; 6 6 parts of the upper jaw bones which belong to

the bottoms of the noftrils and arch of the palate; 7 7 8 8 9 the anterior parts, which are joined to the pofterior parts of thefe bones by futures marked 14 in table the firft of the fkeleton; 7 7 parts belonging to the bottoms of the noftrils and to the arch of the palate; 9 a future common to the upper jaw bones.

10 11 12 13 14 15 The fix dentes incifores, cutting teeth, or nippers, of the upper jaw.

16 16 18 18 Maxilla inferior, the lower mandible or jaw bone; 18 18 the coronoid apophyfis.

In the Spine.

aa The tranfverfe procefses of the atlas, or uppermoft vertebra of the neck.

1 *d* The tranfverfe procefs of the fifth vertebra of the neck.

2 *bcddefg* The fixth vertebra of the neck; *b* the anterior and lower part of the body of this vertebra, which receives the fuperior part of the body of the feventh vertebra; *c* the fuperior part of the body of this vertebra, which is received by the fourth vertebra; *dd* the tranfverfe procefs; *e* the anterior oblique procefs which is peculiar to this vertebra, and marked *z* & in table the firft, *f* the upper oblique procefs; *g* the lower oblique procefs.

3 *bcdfg* The feventh or laft vertebra of the neck; 3 the body; *b* the anterior protuberance of the body of this vertebra, *c* the head or upper part of the body of this vertebra, which articulates with the vertebra above it; *d* the tranfverfe procefs; *f* the upper oblique procefs; *g* the lower oblique procefs.

hhhhiikk &c. ll&c The vertebræ of the back; *hhhh* the bodies; *i* the upper oblique procefs of the firft vertebra of the back; thofe of the reft are not feen in this table; *kk&c.* the tranfverfe procefses; *ll&c* the fpinal procefses.

1 *mnop* The firft vertebra of the loins; *m* the upper oblique procefs; *n* the lower oblique procefs; *p* the tranfverfe procefs; *o* the fpinal procefs.

The fame explanation will do for all thofe of the loins.

qrrrr The os facrum, or great bone of the fpine; *q* the upper oblique procefs, by which it articulates with the lower oblique procefs of the loweft vertebra of the loins; *rrrr* the fpinal procefses.

ssss The bones of the tail.

In the Thorax and Shoulder-blades.

aaaaa The fternum, or breaft bone, of which the

parts *aaaaa* are bony, the reft *b* is chiefly cartilaginous or ligamentous and connects the bony parts together.

C The enfiform cartilage.

1 *cde* The firft rib on the right fide; *c* the head, by which it is articulated with the tranfverfe procefs of the firft or uppermoft vertebra of the back; *d* the anterior or former part of the faid head which is connected to the bodies of the feventh vertebra of the neck, and firft of the back; *e* the cartilaginous end by which it is continued to the fternum.——This explanation will ferve for the reft of the ribs on both fides, which are figured according to their order from the firft or uppermoft.

fghiikkllmno, *fghkkp* the fcapulæ, or fhoulder blades; *f* the neck; *g* the fpine; *h* the coracoide or crow's-bill procefs; *ii* the inferior cofta; *kk* the fuperior cofta; *ll* the bafis; *m* foffa fub-fpinalis; *n* foffa fupra-fpinalis; *o* a cartilaginous continuation of the bafis fcapulæ; *p* the internal and concave fide of the left fcapula.

In the Pelvis.

abcddddeeeeff The innominate or bafon bones, including three others; *abc* the os illium or flank bone; *b* the anterior part of it's fpine; *c* the pofterior part of it's fpine; *dddd* part of the ifchion or hich bone, feen betwixt the ribs; *eeee* part of the os pubis, feen alfo betwixt the ribs; *ff* the foraminæ or holes of thefe bones, feen likewife betwixt the ribs.

In the upper Limbs.

abcdefghiklmn, *abcdehiklmn* the humeri, or bones of the arm; *b* denotes a protuberance into which the teres minor is inferted; *cdefgh* the upper head; *cde* three protuberances which form two finufes or grooves, which are incrufted with a fmooth cartilage; they ferve to confine the heads of the biceps mufcle of the arm from fliping fideways, but fuffer them eafily to flide up and down; *h* that part of the head which is covered with a fmooth cartilaginous cruft, and articulates with the fcapula; *i* the external condyle of the lower head; *kl* the lower head covered with a fmooth cartilage with which the radius is articulated; *k* the round articular eminence; *l* the double articular eminence; *m* the anterior foffula or finus that receives the upper head of the radius when the cubit is bent as much as it can be; *n* the internal condyle.

opq, *opqrr* The radii, or radius of each arm; *o* a protuberance in the upper head, into which the biceps and

321

and brachialis are inserted ; *p* denotes a sinus, or groove, in the lower head, through which goes the tendon of the extensor carpi radialis ; *q* a sinus, through which goes the tendon of the extensor digitorum communis ; *r r* a smooth cartilaginous incrustation of the lower head, where it articulates with the bones of the carpus.

s s The olecranons of the ulnæ.

wxy 1 2 3 1*u*2*u*3*u wtxty* The bones of the carpus; *wt* os scaphoides, or naviculare ; *t* the part which articulates with the radius, covered with a smooth cartilaginous incrustation ; *xt* os lunare, or the lunar bone of the carpus, or wrist ; *t* the part incrusted with a smooth cartilage by which it articulates with the radius ; *y* the cuneiform or wedge-like bone of the carpus ; 1 *u* the trapezoid, cubical, or least of the multangular bones of the carpus, at *u* incrusted with a smooth cartilage for it's articulation with the navicular bone of the carpus ; 2 *u* os magnum, or the great round-headed bone of the wrist ; *u* the part which articulates with the os magnum and os lunare, incrusted with a smooth cartilage ; 3 *u* the unciform or hook-like bone of the wrist, at *u* incrusted with a smooth cartilage, by which it articulates with the lunar and cuneiform bones of the carpus : these cartilaginous incrustations do not appear in the left carpus, the joint being fully extended.

45678, 45689 The metacarpal bones, called, in the skeleton of a horse, the shank bones ; 4 5 the shank bone which is equal to the metacarpal bone of the middle-finger, and that of the ring-finger both together ; 4 the upper head ; 5 the lower head, incrusted, in this place, with a smooth cartilage for it's articulation with the great pattern or first phalanx of the fingers ; 6 7 an imperfect metacarpal bone, in the place of that which, in the human

skeleton, belongs to the little-finger ; 6 the upper head by which it articulates with the unciform bone of the carpus ; 7 the lower head which is very small, and (the bones of the little-finger being wanting) forms no articulation ; 8 9 an imperfect metacarpal bone in the place of that which, in the human skeleton, belongs to the index or first finger ; 8 the upper head, by which it articulates with the trapezoid bone of the carpus ; 9 the lower head, which is very small, and, (the bones of the first-finger being wanting) forms no articulation.

10 11 Sesamoid bones.

12 13, 12 13 Bones which are equal to the bones of the first phalanges of the middle and ring-fingers in the human skeleton : in a horse these are called the great pasterns.

14 15, 14 15 bones of the second phalanges ; the little pasterns or coronary bones.

16 16 The bones of the third phalanges or coffin bones.

17 A sesamoid bone, lying over the posterior part of the articulation of the coronary bone with the coffin bone, or the two last phalanges.

In the lower Limbs.

abcde, aff The thigh bones ; *a* the greater trochanter or spoke ; *b* the less trochanter ; *c* the protuberating part of the linea aspera, into which the external glutæus is inserted along with a part of the musculus fascia lata ; *d* the outer condyle ; *e* the inner condyle ; *ff* the anterior part of the lower head of the right femur covered with a smooth cartilage for it's articulation with the patella, and it's internal-anterior and internal-lateral ligaments.

g, gg The patellæ or knee-pan bones.

h The outer semi-lunar cartilage in the joint of the knee.

iklm, im The tibiæ, or great bones of the legs ; *kl* the upper head ; *k* a protuberance, into which is fixed the anterior ligaments of the patella ; *l* that part which belongs to the joint of the knee and is covered with a smooth cartilage ; *m* the lower head, which articulates with the bones of the tarsus.

M The fibula.

nopp, nop The astragali, or cockal bones ; *no* the part which forms the juncture with the bone of the leg, covered with a smooth cartilaginous crust.

qr The os calcis, or heel bone ; *r* the projecting part that sustains the astragalus.

s The cuboid, or cubical bone of the tarsus.

tt The navicular bones of the tarsus.

uu The middle cuneiform bones of the tarsus.

w The small cuneiform bone of the tarsus.

xyz&, xyz& The metatarsal, or instep bones ; *xy* a bone which is equal to the metatarsal bones, of the second and third small toes both together in the human skeleton ; *x* the upper head, which articulates with the three lower bones of the tarsus ; *y* the lower head, which, in this place is incrusted with a smooth cartilage, and articulates with the upper head of the first phalanx or order of the small toes ; *z&z&* the imperfect metatarsal bones.

1 1 The bones which are equal to the first phalanges of the second and third small toes, in the skeleton of a horse these are called the great pasterns.

2 2 The bones of the second phalanges, called in the horse the little pasterns or coronary bones.

3 3 The bones of the third phalanges, or coffin bones.

4 4 The sesamoid bones, lying over the posterior part of the articulation of the coronary bone with the coffin bone, or the two last phalanges.

C The

The third Anatomical TABLE of the Skeleton of a HORSE explained.

In the Head.

A A **T**HAT part of the os frontis which helps to form the orbit of the eye.

abbc The occipital bone, of which *a b b* is that which, in the skeleton of a horse, is called the nole bone ; *c* a future common to this bone with the os sphenoides.

def The temporal bone ; *d* the zygomatic or jugal process ; *e* a future common to the temporal bone with the os sphenoides ; *f* the bony meatus or entrance of the ear.

ghhGG Ossa palati ; *g* the orbitary part ; betwixt *g* and A is a future common to this bone with the orbitary part of the frontal bone ; *hh* the portia palatina, or part which compleats the arch of the palate ; betwixt *h* and *h* is a future formed by the union of these two bones.

iikllmmnn Os sphenoides ; *ii* denote roughnesses into which the anterior recti muscles of the head are inserted ; *mm* the pterygoid apophyses ; *ln*, *ln* the large lateral processes of the multiform or sphenoidal bone.

pq Os jugale or cheek bone ; betwixt *p* and *d* is a future common to this bone with the zygomatic process of the temporal bone ; *q* a future common to this bone with the upper jaw bone.

rrstuw, tw The ossa maxillaria, or great bones of the upper jaw ; *rrst* the posterior part of this bone ; *s* the jugal apophysis ; *t* the apophysis palatina of the posterior part of this bone ; betwixt *t* and *t* is a future formed by the union of these two bones ; *uw* the anterior part of this bone ; betwixt *r* and *u* is a future, formed by the union of the anterior with the posterior part of this bone ; *w* a process belonging to the anterior part of this bone, which helps to form the arch of the palate.

xy Os vomer ; *y* that part which forms the posterior part of the septum narium.

1 2 2 *zz* Os ethmoides ; 1 the part which helps to form the orbit ; 2 the labyrinth of the nostrils ; *z* conchæ narium superiores, the upper turbinated, or spongy bone, or the upper shell of the nostrils.

&& Conchæ narium inferiores, the lower turbinated or spongy bones, or the inferior spongy laminæ of the nose.

333 Dentes molares, or grinding teeth of the upper jaw.

4 One of the canini of the upper jaw.

5 One of the dentes incisores, cutting teeth, or nippers of the upper jaw.

6 6 7 8 Maxilla inferior, or the lower mandible, or

jaw bone ; 8 it's condyle or head, by which the mandible is articulated to the temporal bone.

9 Dentes incisores, the cutting teeth, or nippers of the lower jaw.

In the Spine.

abbcde The atlas, or uppermost vertebra of the neck ; *a* the protuberance, tubercle, or inequality on the posterior part of this vertebra, which seems to be in the place of a spinal apophysis ; *b b* the transverse process ; *c* the superior and posterior process ; *d* the transverse hole ; *e a* large tubercle on the anterior part of this vertebra.

fgghhiikl The epistrophæus, or second vertebra of the neck ; *f* the spinal process ; at *gg* the spine is divided into two, and continued to the lower oblique processes ; *hh* the lower oblique processes ; *ii* the transverse processes ; *k* the superior part of it's body, which is received by, and sustains the atlas ; *l* the transverse hole.

kllmmnnp The third vertebra of the neck ; *k* the spinal process ; *ll* the upper oblique processes ; *mm* the lower oblique processes ; *nn* the transverse processes ; *p* the internal side of the body of this vertebra ----This explanation will serve for those of the neck which are below this ; only it is to be observed, that *o* marks the upper part of the body of the fifth vertebra, where it articulates with the fourth at *p* ; *r* denotes the anterior oblique process of the sixth vertebra, and *qq* those parts of the oblique processes which are incrusted with smooth cartilages.

rr&css&ctt&c The vertebræ of the back ; *rr&c* the spinal processes ; *ss&c* the bodies ; *tt&c* the ligaments interposed betwixt the bodies of the vertebræ, tying them to each other.

uu&cwwxx&cyyzz&c The vertebræ of the loins ; *uu&c* the spinal processes ; *www* the bodies ; *xx&c* the transverse processes ; *yy* the ligaments interposed betwixt the bodies of the vertebræ, tying them to each other ; *z z&c* the openings betwixt the transverse processes through which the nerves come from the medulla spinalis.

1 1 1 1 1 2 2 2 2 2 3 3 3 3 3 4 4 &c 5 5 5 5 The os sacrum, or great bone of the spine ; 1 1 1 1 1 the rough part, composed of the transverse processes of this bone ; 2 2 2 2 2 the spinal processes ; 3 3 3 3 3 the anterior part, which, in a young horse, is divided into as many bodies as there are spines, betwixt which, in the parts 5 5 5 5, are bony lines that were formerly ligaments.

66&c77&c88&c99&c The bones of the coccyx or

tail ; 6 6 &c the transverse processes ; 7 7 &c the spinal processes ; 8 8 &c the bodies ; 9 9 &c the ligaments interposed betwixt the bodies of the bones of the tail.

In the Thorax and Shoulder-blades.

aa The sternum.

b The ensiform cartilage.

cc&c dd&cee&cff&cgg&c The ribs ; *cc&c* the parts by which they articulate with the bodies of the vertebræ ; *dd&c* the cartilages by which they are continued to the sternum, eight on each side ; *ee&c* the external side of the ribs ; *ff&c* the internal side of the ribs ; *gg&c* the cartilages of the false ribs which are ten on each side.

hiikl The right scapula ; *h* it's spine ; *ii* it's basis ; *k* a cartilaginous continuation of its basis ; *l* it's fossa subspinalis.

mmno The internal side of the left scapula ; *n* the coracoide apophysis ; *o* a small part of its neck.

In the Pelvis.

abcdefgghhhhii, A*bcfghh* The innominate or bason bones, including three others ; *abcd* the os illium on the right side ; *bc* its spine ; *d* a protuberance, from which arises the rectus muscle of the leg ; *ef* the os ischium or hich bone ; *e* the acute process ; *f* the tubercle ; *gg* the os pubis ; *hhhh* the great foramen of the ischium and pubis ; *ii* the external margin of the acetabulum.

In the upper Limbs.

abcd, A The humeri or bones of the arm ; *ab* the upper head ; *b* the part of the head which is joined to the cavity of the scapula, covered with a smooth cartilaginous crust ; *c* a protuberance into which the teres minor is inserted ; *d* the external condyle of the lower head ; A a small part of the head of the right humerus.

efgg, g The ulnæ ; *e* the olecranon ; *f* the part which articulates with the humerus ; *gg* the lower part of the ulna, which, in aged horses, becomes one bone with the radius.

hiklmnop, klmnop the radii ; *hi* the upper head of the radius ; *klmno* the lower head ; *k* a sinus, through which goes the tendon of the extensor minimi digiti in the human body ; *m* the part which articulates with the os sphenoides, or naviculare, incrusted with a smooth cartilage ; *n* the part which articulates with the os pisiforme or orbiculare, incrusted with a smooth cartilage ; *o* a sinus which

which receives the os lunare when this joint is bent as much as it can be.

P *pqrstuwxyz*, P *pqrstuwxyz* The bones of the carpus; P os pififorme or orbiculare; *pq* os fphenoides or naviculare; *p* the part covered with a fmooth cartilage for it's articulation with the radius; *r* os lunare; *s* os cuneiforme; *tu* os trapezium; *t* the cartilaginous incruftation by which it articulates with the os fphenoides; *wx* os magnum, or the great round-headed bone of the wrift; *w* the round head covered with a fmooth cartilage for it's articulation with the os lunare; *yz* the unciform or hook-like bone of the wrift; *y* the fmooth cartilaginous incruftation for it's articulation with the cuneiform or wedge-like bones of the wrift.

1 2 2 3 4 5 6 7, 1 3 4 5 6 7 The metacarpal bones; 1 2 2 3 a bone which is equal to the metacarpal bones of the middle and ring-fingers both together in the human fkeleton; 1 the head, by which it articulates with the three lower bones of the carpus; 2 2 3 the lower head, incrufted with a fmooth cartilage for it's articulation with the offa fefamoidea; 4 5 an imperfect metacarpal bone in the place of that which, in the human fkeleton, belongs to the fore-finger; 4 the upper head, which articulates with the os trapezium; 5 the lower head, which is very fmall, and (the bones of the fore-finger being wanting) forms no articulation; 6 7 an imperfect metacarpal bone in the place of that which, in the human fkeleton, belongs to the little finger; 6 the upper head, by which it articulates with the hook-like bone of the carpus; 7 the lower head, which is very fmall, and (the bones of the little finger being wanting) forms no articulation.

8 9 8 9 Offa fefamoidea, two bones which are always to be found in this joint; they ferve to throw the bending tendons farther from the center of motion in this joint, and form a proper groove for them to flide in.

1 0 1 0 The bones of the firft phalanges or order of bones in the fingers, in the horfe called the great pafterns.

1 1 1 1 The bones of the fecond phalanges, called in the horfe, the little pafterns or coronary bones.

1 2 1 2 The bones of the third phalanges, or the coffin bones.

1 3 1 3 Sefamoid bones, lying over the pofterior parts of the articulations of the coffin bones with the coronary bones, or the two laft phalanges of the fingers.

In the lower limbs.

abcddefghik, *acddefghik* Offa femorum, or the thigh bones; *b* the head, incrufted with a fmooth cartilage for its articulation with the acetabulum; *c* the lefs trochanter; *dd* the great trochanter; *e* a very prominent part of the linea afpera, into which the external glutæus is inferted along with part of the fafcia lata; *f* a large foffa or notch, out of and from the borders of which, the external head of the gemellus and the plantaris mufcles arife; *g* a roughnefs from which arifes the internal head of the gemellus; *h* the outer condyle of the lower head, covered with a fmooth cartilage; *ik* the inner condyle, at *i* incrufted with a fmooth cartilage.

ll The patellæ, or knee-pan bones.

mm The outer femi-lunar cartilages, which are interpofed in the joints of the knees.

nn The inner femi-lunar cartilages, which are interpofed in the joints of the knees.

opqr, *opqr* The tibiæ, or great bones of the legs; *op* the upper head; *r* the lower head.

st, *st* The fibulæ, or fmall bones of the legs; *s* the upper head; *t* the lower extremity which ends here almoft in a point.

uwxxyz& 1, *uwxxyz&* 1 The bones of the tarfus.

uw uw The calcanei, or heel bones.

xx xx The aftragali, or cockal bones.

yy The cubical bones of the tarfus.

zz The navicular bones of the tarfus.

& & The middle cuneiform bones of the tarfus.

1 1 The lefs cuneiform bones of the tarfus.

2 3 4 5 6 7, 2 3 4 5 6 7 The bones of the metatarfus, or inftep; 2 3 a bone which is equal to the metatarfal bones of the fecond and third little toes, both together, in the human fkeleton; 2 the upper head, which articulates with the three lower bones of the tarfus; 3 the lower head, covered with a fmooth cartilaginous cruft; 4 5 an imperfect metatarfal bone, in the place of that, in the human fkeleton, which belongs to the firft of the fmall toes; 4 the upper head, by which it articulates with the lefs cuneiform bone of the tarfus; 5 the lower head, which is very fmall, and (the bones of the firft of the fmall toes being wanting) forms no articulation; 6 7 an imperfect metatarfal bone in the place of that which, in the human fkeleton, belongs to the little toe; 6 the upper head, by which it articulates with the cubical bone of the tarfus; 7 the lower head, which is very fmall, and (the bones of the little toe being wanting) forms no articulation.

8 9 8 9 Offa fefamoidea, they are bones which are always to be found in thefe joints, two in each, they ferve to throw the bending tendons farther from the center of motion, and form a proper groove for them to flide in.

1 0 1 0 1 1 1 1 1 2 1 2 The bones which are in the places of the three phalanges or orders of bones in the human fkeleton : with farriers the firft are called the great pafterns; the fecond the little pafterns or coronary bones; and the third the coffin bones.

1 3 1 3 Sefamoid bones lying over the pofterior parts of the articulations of the coffin bones, with the coronary bones.

D The

The ANATOMY of the HORSE.

The firft Anatomical TABLE of the Mufcles, Fafcias, Ligaments, Nerves, Arteries, Veins, Glands, and Cartilages of a HORSE explained.

In the Head.

A A*a* EPICRANIUS, or mufcle of the fcalp; A A the tendinous expanfion that goes to the elevator of the upper lip and wing of the nofe; *a* the flefhy part which runs over a part of the orbicular mufcle of the eye-lid, and is inferted into the external fkin.

bcde The orbicular mufcle of the eye-lid; *e* the origin of the fibres from the ligament by which the conjunction of the eye-lids, in the great canthus, is tied to the nafal part of the os unguis.

fg The corrugator of the eye-brow; *f* it's origin; at *g* it is inferted into the fkin.

hikllmno The elevator of the upper lip and corner of the mouth; *ik* its origin from the epicranius; *ll* that part which is expanded under the dilator of the noftril and mouth; *m* the part which runs over the dilator of the noftril and mouth, and is inferted into the corner of the mouth; *n* the place where it divides for the paffage of the dilator of the noftril and mouth; at *o* it arifes from the bone near the inner angle of the eye.

pq The lateral dilator of the noftril and upper lip.

rstuwx Zygomaticus; *t* it's infertion into the orbicularis of the mouth; *wx* it's origin from the orbicularis of the eye; this mufcle, in action, pulls down the inferior part of the orbicular mufcle of the eye, as well as raifes the corner of the mouth (and the epicranius raifes the fuperior part of it:) it is a very thin mufcle.

zz&BC The orbicular mufcle of the mouth; B fibres which intermix with the fibres of the nafal mufcles of the upper lip; C fibres which run over the glands of the lip towards the infertion of the elevators of the chin.

1 2 The depreffor of the lower lip.

3 4 Part of the latiffimus colli, which at 4 is inferted into the lower jaw bone.

5 The elevators of the chin where they are inferted into the fkin, the fibres of which are intermixed with the fat of the chin.

6 The anterior dilator of the noftril.

7 The tendon of the long nafal mufcle of the upper lip.

8 Septum marium.

9 The vena angularis, which is a branch of the external-anterior jugular vein here protuberating; it runs to the great or internal angle of the orbit, fending branches on each fide to the mufcles and integuments; it fends out a branch through the lateral cartilages of the nofe, which is diftributed to the nares, and another, which runs down in a winding courfe to the upper lip.

1 0 A branch of the vena temporalis.

1 1 Arteria angularis.

1 2 Branches of the nervus maxillaris inferior, they are branches of the third branch of the fifth pair.

Mufcles of the outer Ear.

abbcdee Retrahens; *cdee* the upper or anterior part of the retrahens feen through the origens; this part is inferted tendinous into the ear, a little below the infertion of its middle part; *bb* the middle part of the retrahens, inferted into the external ear in the middle of it's convexity, about one third part of the way from the root of the ear to the tip; *a* the inferior or pofterior part of the retrahens, coming from its origin under the middle part to be inferted into the pofterior fide of the convex part of the ear lower than the medius near the infertion of the lateral depreffor *no*.

cdeedh The fuperior-anterior mufcle through which is feen the origens; *ee* the place where it joins it's fellow, having no origin from the bone; *d* it's infertion into the cartilage; *h* a part of it which runs over the cartilage, and is inferted near *h* into the outer ear.

gi Mufcles that run from the anterior cartilage *k*, to the external ear.

k The anterior cartilage of the outer ear.

l The lateral cartilage of the anterior cartilage of the outer ear; it arifes above the orbit of the eye, and is inferted into the anterior cartilage of the outer ear.

m A mufcle arifing under *l*, which is inferted at the inferior angle of the opening of the ear, anteriorly, with *i*.

no The lateral depreffor of the outer ear, arifing at *n*, from the quadratus colli it is inferted, clofe by the mufcle *m*, into the lower angle of the opening of the ear pofteriorly.

p The outer ear.

In the Neck.

3 4 *aabcdd* Latiffimus colli, or quadratus of the neck; *b* it's origin from the fternum, a little below the top; 4 it's infertion into the lower jaw bone; *c* a membranous part going over the jugular vein, from which the flefhy fibres of the lateral depreffor of the ear arifes; *dd* the edge by which it is attached to that part of the fafcia of the fuperior part of the trapezius which runs over the external furface of the levator humeri proprius.

fghiiklmn Levator humeri proprius; *g* that part which arifes tendinous from the proceffus maftoideus; *h* the part which arifes by thin flefhy fibres from the tendino-membranous part of the trapezius, or fends a membranous tendon to the ridge of the occiput; *l* the portion which lies under fome of the part *fghiik*, and arifes from the tranfverfe proceffes of the four uppermoft vertebræ of the neck near their extremities; it's origin is the fame with the angularis called levator fcapulæ proprius in the human body; *m* the end near it's infertion into the humerus between the biceps and brachiæus internus. The part *lm* may be called levator humeri proprius; the part *fghiik* mufculus ad levatorem acceffois, being a diftinct mufcle till it comes to be joined or inferted into the levator humeri proprius, juft below the opening where the nerve comes out marked 6.

opqqrstuwxxx The upper part of the trapezius; *op* the origin of the flefhy part; *p* the thickeft part; *qq* a part which, in this fubject, is thin, but flefhy; the flefhy fibres are inclofed betwixt two fafciæ; the external fafcia runs over the levator humeri proprius, and is attached to the edge of the quadratus colli, it fends off a great number of fmall white tendinous threads which run acrofs or interfect the fibres of the levator humeri proprius, and firmly adhere to it; the internal fafcia goes

on

on the internal furface of the levator humeri propius; *rr* in this line the carnous fibres end, but are covered, in this fubject, by fome of the fibres of the membrana carnofa; *s* a tendinous part; *t* a thin tendinous part, under which may be feen part of the ferratus major anticus; *u* the beginning of the tendon of the carnous fibres marked *ii* of the levator humeri proprius; or a continuation of the tendon of the trapezius; *xxx* the origin of the trapezius from the Ligament of the neck.---The flefhy fibres of this mufcle run in the fame direction, and are joined in with the levator humeri proprius, it is inferted along with part of the levator humeri into the fafcia, which covers the extending mufcles on the cubit, and into the tendinous furface of the infra fpinatus.

yyz& The inferior part of the trapezius; *yy* the origin; *&* its infertion; from *z* to *y* it is attached to the latiffimus dorfi by white threads of tendinous fibres, which interfect the tendinous and carnous fibres both of it and the latiffimus dorfi, and firmly adhere to both; thefe tendinous threads run from the continuation of the ligamentum colli towards this lower angle of the mufcle, fo that it makes a fort of double tendon for the trapezius to lie in at *z*.

cddv The jugular vein protuberating.

Upon the neck are feen branches of the cervical nerves, veins, and arteries, which go to the integuments.

In the Shoulder and Trunk.

abcddeefgghiiikllmnoooooooppqrs Membrana carnofa; *a* the thickeft flefhy part; *b* the thick flefhy parts running upon the extenfors of the cubit, becomes tendinous at *c*, and goes to be inferted with the latiffimus dorfi and teres major into the humerus; *dd* fome of the thick flefhy part going over the mufcles of the cubit and tending towards the cubit, forms the membranous tendon *q*, under which may be feen fome branches of nerves and blood-veffels which are difperfed in the flefhy pannicle; *ee* the pofterior and inferior beginning of the flefhy fibres which arife rather thin but increafe in thicknefs gradually as they advance towards the part *a*; *f* a flefhy part which runs into the duplicature of this membrane, *&c.* as it goes towards the thigh; at *gg* it is flefhy, but little more than a membrane, being very thin; *h* a membranous part which runs over the penis; *iiii* the tendinomembranous part which runs over the loins, part of the back, and part of the abdomen; *k* the membranous part which helps to form the duplicature; *ll* a feint appearance of the outline of the latiffimus dorfi; the part *m* is about as thick as the part *n* and the latiffimus dorfi both together; *ooooooo* the part where the carnous fibres of

the fuperior portion of this mufcle, or flefhy pannicle, begin to arife, which are but very thin, and all tend towards the cubit, fome of which difapper at, or are inferted into the membranous tendon *q* and appear again at or arife from the fame at *pp*, then running towards the mufcles on the cubit become a meer membrane as they pafs over the juncture of the elbow, and are fo fpread over the mufcles, *&c.* below, adhereing, in fome places, to the edges of the tendons, and in others, to the edges of the ligaments which bind down the mufcles to keep them in their proper fituations.

ttuwxyy Pectoralis; *tt* it's origin from the aponeurofis of the external oblique mufcle of the abdomen, this part is inferted into the head of the os humeri internally; *x* a part arifing from about two thirds of the inferior part of the fternum, which ends in a fafcia defcending down the mufcle, on the infide the cubit; *yy* the part arifing from the fuperior part of the fternum, for about one third of it's length, and running in a tranfverfe direction over the inferior part, it is inferted along with the levator humeri proprius, by a flat membranous tendon, into the humerus, betwixt the biceps and brachiæus internus.

z A large vein which branches in the flefhy part of the membrana-carnofa.

The blood-veffels and nerves marked on the thorax are thofe diftributed to the integuments which are taken off, the nerves come from the nervi dorfales or coftales and nervi lumbares, the arteries from the arteriæ intercoftales inferiores, and the exteriæ lumbares, and the veins from the venæ intercoftales and venæ lumbares.

& The tail.

Mufcles, &c. in the upper Limb or Extremity, as they appear under the Membrana-carnofa, with Remarks where it is principally attached.

abb Extenfor carpi-radialis; *a* the flefhy part; *b* the tendon, the lower part of which runs under the tendon of the mufcle *cc*, which is analogous to the extenfors of the thumb, and under a ligament common to it and the extenfor communis digitorum *tte*.

deefgh Extenfor ulnaris & digitorum communis; *d* the flefhy part fhewing itfelf under the membrane *ee*; *fg* the tendon which goes under the ligament at *e*, and giving a flip *f* to the tendon *ii* of the extenfor, analogous to the extenfor minimi digiti; *h* the tendon, fending fibres laterally over the ligament *m*.

iii Extenfor minimi digiti, to which the carnous membrane is attached at *ik*, and fends tendinous fibres over it in the direction as marked.

n The bone, which is an imperfect metacarpal bone, to which this membrane is attached.

o A fort of fpungy, fatty fubftance, probably a production of the membrana adipofa, lying over the protuberating part of this joint to preferve the bending tendons from bruifes when this part.touches the ground.

pq Flexor carpi ulnaris; at *p* the flefhy fibres appear under the membrane, and alfo under its own tendinous furface; *q* tendinous fibres going off from this mufcle to intermix with the ligaments of this articulation.

Rr Flexor digitorum profundus; *R* the flefhy part appearing under the tendinous furface of this mufcle as well as the carnous membrane.

s The tendon of the fublimis.

Tt The inter-mufcular ligament to the part of which the carnous membrane has fome adhefion.

u Marks the ligaments arifing at *u* from the orbicular bone and running obliquely downwards and forwards.

ww Ligamentous fibres which come from the infide of the radius and run over the bending tendons to be inferted into the bone *n*, and join in with the carnous membrane.

xx Vena plantaris externa.

y Nervus plantaris externus.

z A fmall nerve coming from under the ligaments on the other fide the carpus, and defcending in an oblique manner to join the nervus plantaris externus.

The carnous membrane joins in with the membranous expanfion which is fent down the cubit by part of the pectoralis, and with other membranous productions from the ligaments, forms a fort of ligament, inclofing the tendons of the extending mufcles, and confines them in their proper places. This ligament is inferted into the upper part of the firft bone of the finger.

The ligament arifing at *u* runs down to join the tendon *i* a little below *f*, running over the tendon *i* till it comes to it's infertion near the edge of that tendon next the tendon *f*; the part *ufw* fends the principal part under the tendon *efg* to be inferted into the metacarpal bone at *bf*, the part which runs over that tendon, or thofe tendons, joins in with the membranous production of the pectoral mufcle and carnous membrane.

& The hoof.

In the lower or pofterior Limb.

abcdefghikKlmnopqrstuwxyz& Fafcia lata, and mufculus faciæ latæ, with the membrana carnofa, and expanfions of the mufcles; *a* the part which is a continuation of the tendon of the latiffimus dorfi, which arifes free from the mufcle glutæus medius, which lies under it;

b the

b the origin of the mufculus fafciæ latæ from the fpine of the illium.

c The anterior flefhy part; *d* the pofterior flefhy part; *e* the tendon.

f The part under which the glutæus externus lies and from which it has a flefhy origin; this part is much thicker or ftronger than the part *a*.

ghi The part under which the biceps tibiæ lies; this mufcle in it's fuperior part, arifes from the fafcia lata.

k The femi-tendinofus lying under the faid fafcia, from which it alfo arifes in the fuperior part.

K The patella with it's external lateral ligament which binds it to the os femoris, and it's inferior anterior ligament, which binds it to the tibia, protuberating under the fafciæ.

l The extenfor longus digitorum; *m* peroneus; *n* flexor digitorum pedis; *o* Gemellus.

p Tendons formed by thefe fafciæ and expanfions to join in with the extenfors of the tarfus.

q Nerves expanded upon thefe fafciæ, or fent off to the external parts, as the adipofe membrane and cutis. They are branches of the fciatic nerve.

r A fort of tendon formed by the fefafciæ, &c. which may probably affift the extenfor digitorum when the tarfus is extended.

s The tendon of the extenfor digiti.

t The tendons of the flexors.

u The interoffeus, &c.

ww Veins arifing from under the hoof, called venæ plantares, they run into the vena tibialis pofterior.

x Nervus plantaris externus.

y A ligament fent off by the interoffeus, &c. and the capfula of the fetlock joint to join and bind down the tendon of the extenfor digitorum pedis.

About *z* thefe fafciæ have an attachment as they pafs over the tendon and ligaments.

& A fort of fpungy, fatty fubftance, probably a production of the membrana adipofa, lying over the protuberating part of this joint to preferve the bending tendons from bruifes when the fetlock touches the ground.

The fafcial membrano-tendinous expanfions, &c. cover all thefe mufcles, ligaments, blood-veffels, nerves, &c. forming a pretty ftrong coat over them; the mufcles, &c. only making their appearance by protuberating under them, which they will do even when they are covered by the external fkin.

A The hoof.

Mufcles, &c. protuberating under the membrana carnofa in the left upper limb, viz. on the cubit, carpus, metacarpus and extremity of the limb.

ab Extenfor carpi radialis; *a* the flefhy part; *b* the tendon.

c The tendon of the mufcle which is analogous to the extenfor of the thumb.

d Biceps cubiti.

e Pectoralis.

f Flexor digitorum.

g Flexor carpi radialis.

h Sublimis.

i Profundus.

k The tendon of the extenfor ulnaris & digitorum communis.

l A fort of fpungy, fatty fubftance, probably a production of the membrana adipofa.

m vena cephalica.

n Vena plantaris interna.

o Nervus plantaris internus.

p Interoffeus, &c.

q A ligament coming from the interoffeus and inferted into the extending tendon.

r The hoof.

Mufcles, &c. in the internal View of the left lower Limb, as they appear through or protuberate under the fafcias which cover them.

a The flefhy part of the tibialis anticus.

b The flefhy part of the fartorius.

c The tendon of the extenfor digitorum pedis.

d A ligament coming from the interoffeus, and joining with the tendon of the extenfor digitorum pedis.

e The interoffeus, &c. arifing from the upper part of the metatarfal bones and fome of the tarfal bones, and is inferted into the fefamoid bones, and firft bone of the toe on each fide, and fends off the part *d* to the tendon of the extenfor digitorum pedis.

ff The tendon of the plantaris.

g A tendon formed by the femi-tendinofus, biceps cruris, &c. to go to the heel.

Betwixt *fg* and *h* are formed, by the expanfions of the mufcles on the infide of the thigh, two or three flat tendons like thofe marked *p* on the external fide of the leg in this table.

The direction of the tendinous fibres of the fafcia are here marked as they run over the infide of the leg, &c. about *h* they are pretty ftrong (under which the vena faphæna is fcarcely difcernable) forming a ftrong tendinous fafcia, which joins in with the tendon of the extenfor digitorum pedis at *k*.

l A fort of fatty, fpungy, glandular fubftance, lying immediately under the fkin, probably a production of the membrana adipofa lying over the protuberating part of this joint to preferve the bending tendons from bruifes when the fetlock touches the ground.

m Vena faphæna.

n Branches of the vena faphæna.

o Vena plantaris interna, or a continuation of the vena faphæna.

p Nervus plantaris internus.

q A branch of the nervus cruralis.

r The hoof.

The second Anatomical TABLE of the Muscles, Fascias, Ligaments, Nerves, Arteries, Veins, Glands, and Cartilages of a HORSE explained.

In the Head.

abcd THE lateral dilator of the nostril and upper lip, *bc* it's insertion into the upper lip and nostril ; *d* it's origin.

f The anterior dilator of the nostril.

ghik The orbicular muscle of the mouth ; *g* the part belonging to the lower lip ; *h* the corner of the mouth ; *i* the part belonging to the upper lip ; *k* fibres which tend upwards to the insertion of the nasal muscles of the upper lip.

lmno The long nasal muscle of the upper lip ; *lmn* the fleshy part ; *m* it's origin ; at *n* the tendon begins ; *o* the tendon.

ppq The masseter.

r 8 8 Buccinator.

st The broad ligaments of the eye-lids, which are membranous elongations formed by the union of the periostium of the orbits, and pericranium along both edges of each orbit.

uuw The ciliaris muscle ; *w* it's origin.

xy A muscle belonging, in part, to the alæ narium *z*, but chiefly to the concha narium inferior ; *x* its insertion into the alæ narium ; *y* it's origin, by a small tendon from the bone along the nasal muscle of the upper lip ; below *x* it passes under the alæ narium to the inside of the nostril, and is there inserted into the concha narium inferior.

z Alæ narium.

& Septum narium.

2 2 3 The temporal muscle ; 3 it's insertion into the coronary process of the under jaw bone.

4 4 Muscular fibres which extend and draw outwards the pituitary membrane 5.

5 Membrana pituitaria.

6 7 7 A muscle called caninus, or elevator of the corner of the mouth, arising from the upper jaw bone under the muscle *xy*, and inserted at 7 7 into the buccinator.

9 10 The depressor of the lower lip ; it arises along with the buccinator, and is almost divided into two muscles, one superior, the other inferior, for the passage of nerves and blood-vessels to the lower lip ; the superior arises tendinous and is inserted fleshy into the lower lip laterally ; the inferior arises fleshy, and is inserted tendinous nearer the middle of the lower lip.

1 2 The elevator of the chin.

1 3 A nerve going to the alæ narium.

1 4 Vena jugularis which is a branch of the vena jugularis externa anterior.

1 5 Arteria angularis.

1 6 A branch of the vena temporalis.

1 7 1 7 Two valves, in a branch of the jugular vein.

1 8 Branches of the nervus maxillaris inferior. They are branches of the third branch of the fifth pair of nerves.

1 9 The salivary duct.

2 0 The anterior cartilage of the outer ear.

2 1 The outer ear.

2 2 2 3 A muscle arising from the anterior cartilage at 2 2, and inserted at 2 3 into the outer ear.

2 4 A muscle which arises by two fleshy heads from the internal surface of the anterior cartilage, and is inserted into the lower convex part of the external ear near the root, nearer the posterior edge than the anterior. It assists the posterior part of the retrahens in action.

2 5 A muscle which is a sort of antagonist to that marked 2 4, it arises from the ridge of the occiput under the retrahens, and is inserted into the ear at 2 5. It helps to turn the opening of the ear forwards.

2 6 2 6 2 6 *c* The parotid gland.

In the Neck.

abc Sterno mastoidæus, or sterno maxillaris ; it arises from the top of the sternum at *b*, and is inserted by a flat tendon into the lower jaw bone, under the parotid gland at, or near, *c*, is likewise inserted into the root of the processus mastoidæus by a flat tendon.

d The spungy, fatty substance of the mane cut directly down the middle, and the left side remaining on to shew it's thickness.

e Ligamentum colli.

ff Caracohyoidæus ; it arises from the upper and internal side of the humerus, betwixt the insertions of the subscapularis and teres major by a flat membranous tendon ; it begins to be fleshy as it comes from under the serratus minor anticus, and is inserted into the os hyoides.

g Sternohyoidæus.

hi Transversalis ; *h* the tendinous part ; *i* a fleshy part.

kl The tendon of the trachelomastoidæus ; *l* a fascia or membranous part.

mm Rectus internus major capitis ; *m* it's lowest origin from the transverse process of the fourth vertebra of the neck, and the part *p* of the longus colli, which origin is sometimes continued down almost as low as the lower part of the transverse process of the fifth.

oooo Inter-transversales minores colli ; they run from the transverse process of one vertebra to the transverse process of the next to it.

pq Longus colli.

rstuw Splenius ; *r* the part coming from the origin of this muscle, which is from the expansion common to it, and the serratus minor posticus, &c. It arises tendinous from the ligamentum colli under the rhomboides, and fleshy about the superior part of the neck.

At *s* it is inserted into, or attached to the transversalis ; at *t* to the tendon of the trachelomastoidæus ; *u* the part which goes to be inserted into the occiput. It is also inserted into the transverse processes of the fifth, fourth, and third vertebæ of the neck, by flat, strong tendons which run on the internal side of the muscle : it is externally fleshy within a minute or two of these insertions.

x Sternothyroidæus.

y Hyothyroidæus.

z Cricothyroidæus.

& The lower constrictor of the pharinx.

1 1 Vena jugularis communis.

2 Vena jugularis externa anterior.

3 Vena jugularis externa, posterior, or superior.

4 Part of the carotid artery, or carotis communis.

5 Glandulæ claviculares, or axillares (in this animal, as there are no clavicles) or cervicales inferiores or thoracicæ superiores lymphaticæ. They are lymphatic glands.

6 6 6 6, Branches of the cervical nerves accompanied with arteries which are distributed to the musculus levator humeri proprius, &c. and integuments.

7 Branches of the cervical arteries and veins coming out of the splenius to go to the trapezius and integuments.

Muscles in the Neck and Trunk, which are inserted into the Scapula.

aab Rhomboides ; *a a* the origin from the ligamentum colli : it has another origin from the superior spines of the vertebræ of the back : *b* it's insertion, or the part going to be inserted into the scapula.

F *cdef* Serratus

cdef Serratus minor anticus ; *cd* the fleshy part arising near *c* from the sternum, and part of the first rib, and from the cartilaginous endings of the second, third, and fourth ribs, near their joining to the sternum ; and is inserted into the superior costa near the basis scapulæ and tendinous surface of the supra-spinatus ; and is connected to the teres minor by the fascia *ef* which is sent from this muscle over the infra-spinatus scapulæ and supra-spinatus scapulæ to its outer edge.

It's flat tendon may be separated some part of the way to the basis and spine of the scapula from the tendinous surface of the supra-spinatus scapulæ.

ghiklop Serratus major anticus ; *g* part of it's insertion on the external part of the scapula ; the rest of it's insertion possesses about one half of the internal part of the scapula ; *h* the part which arises from the transverse process of the third vertebra of the neck ; *i* that from the fourth ; *k* that from the fifth ; *l* that from the sixth ; *o* it's origin from the seventh rib ; *p* from the eighth.

This muscle arises from the six superior ribs, also within about five minutes of the cartilages. It does not adhere to the intercostals as it passes over them ; but at the extremity of it's origin sends off a membranous tendon over the intercostals, towards the sternum : it arises all the way, from it's first beginning, from the external surface of the ribs up to the insertion of the tendons of the sacrolumbalis.

Muscles, &c. inserted into the humerus and cubit.

1 1 2 3 4 5 5 6 Pectoralis ; 1 1 it's origin from the linea alba abdominis ; 1 2 it's origin from the lower part of the sternum ; 3 it's origin from the superior part of the sternum ; the part 3 4, which is the superior part of this muscle, sends a flat membranous tendon in betwixt the biceps and levator humeri proprius, to which it is joined before it's insertion into the humerus ; 5 5 6 the flat tendon cut off at 5 5 ; the external part below this runs down the cubit.

abcdef Supra-spinatus scapulæ ; it continues it's origin from the scapula from *a* to about *b*, and is inserted at *c* into the head of the os humeri, and capsular ligament on the outside of the origin of the biceps cubiti ; and by the other half into the head and capsular ligament of the os humeri, or the inside of the origen of the biceps cubiti ; the lower part is covered by a tendinous fascia which runs from the supra-spinatus to the serratus minor anticus, and binds that muscle in it's place ; it is pretty strong at *d*, but stronger at *c*, below the protuberating part of the humerus ; at *ef* a fascia runs over this muscle from the serratus minor anticus to the teres minor.

hiklmn Infra-spinatus scapulæ ; from *h* to *i* are marked traces of the superior part of the trapezius's insertion on the surface of this muscle, it is attached to it at *i*, but strongly inserted into it near *h* ; *hk* marks the insertion of the superior part of the trapezius upon this muscle ; *l* the beginning of it's origin from the dorsum scapulæ, and the cartilage on the border of that bone ; *ikm* marks of the inferior outline of this muscle, where it is bounded by the teres minor, but not easily distinguished, by reason of the tendinous surface by which they are both covered and attached together ; *n* it's strongest tendon, by which it is strongly inserted into the protuberating part of the humerus under the tendinous expansion which goes from the teres minor to the lesser anterior saw muscle.

The lines upon this muscle mark the direction of some of the principal fibres of the tendinous covering.

opqq Teres minor ; *o* it's origin along with the triceps cubiti ; *p* it's insertion into the fascia arising from the humerus ; *qq* it's insertion into the humerus ; from *q* to *k* it sends off a fascia that connects it to the serratus minor anticus. The outline is much obscured by the fascia or tendinous covering of part of this muscle and the infra-spinatus with the supra-spinatus, which connects them. *kp* Marks the cutting off of the membranous tendon of the superior part of the trapezius, as *hk* marks it upon the infra-spinatus.

rrsttuw Latissimus dorsi ; *rrstt* it's flat tendon ; *rr* it's origin from the spinal processes of the back ; at *rs* this tendon is cut away from it's attachment to the fascia lata ; and at *rI* it is entirely cut away to uncover the glutæi ; *ttuw* the fleshy part ; *tt* the origin of the carnous fibres.

r, ru Mark the traces of the inferior part of the trapezius inclosed betwixt the tendon of this muscle, and a tendinous fascia which covers them both together ; the said fascia being cut off at *ru* and left on the latissimus dorsi leaves the marks of the trapezius very plain ; *tuu* shews the direction of the fibres of the tendinous fascia which connects this part of the muscle to the triceps cubiti : these fibres run over the infra-spinatus towards the insertion of the trapezius *hk* ; *w* the fleshy part going to be inserted into the humerus ; *sI* the aponeurosis which runs towards the obliquus descendens, and seems to be lost upon it, degenerating into a membrane.

In the Trunk.

IIIIKKKLM Obliquus externus, or descendens abdominis ; IIIII the place where the thickest carnous part ceases to arise from the ribs and begins to run over them without adhereing to them or the intercostals ; KKK the ending or insertion of the carnous part into the tendinous part ; L the linea alba or strong, broad aponeurosis, formed by this and the internal oblique muscle ; it is like a broad, strong ligament, much resembling that of the neck, forming a sort of rugæ which appear on it's external surface, running from above downwards : it has a communication with the serratus major anticus by an aponeurosis, which arises from that muscle ; it's first or superior origin is from the fifth rib, it arises tendinous from the back part of the insertions of the indentations of the saw muscle into the ribs, and, at it's origin receives the insertion of the lower part of the indentations of the saw muscle ; it arises from the posterior or inferior labeum or edge of the eighth rib, near all the way from I to the insertion of one of the indentations of the superior, or lesser, posterior serratus ; from the posterior labeum of the ninth, almost as high as where an indentation of the lesser serratus posticus is inserted in the superior or anterior labeum of the same rib ; it also arises from the tenth ; and, in this subject, opposite to the insertion of the serratus minor posticus, it arises from all the ribs below that from the part where the indentations of the serratus major posticus are inserted, or a little higher than that more externally, which is the case generally with the three or four last digitations, but most as they are the lowest and runs over the indentations of the saw muscle ; these digitations continue their origin from the ribs all the way down to the part marked IIIII and unite with the intercostal muscles in their passage ; this muscle has a communication with the latissimus dorsi by an aponeurosis, which is sent over it by that muscle ; I*r* marks the cutting away of the tendon of the latissimus dorsi to uncover the glutæi, &c. it is inserted into the os illium and os pubis and to it's fellow by the linea alba.

The blood-vessels and nerves which are marked on the thorax are those which were distributed to the parts taken off as the membrana-carnosa, &c. and integuments ; the nerves come from the nervi dorsales or costales and nervi lumbares ; the arteries from the arteriæ inter-costales inferiores and arteriæ lumbares ; the veins from the venæ intercostales and venæ lumbares.

In the right upper Limb.

NOP Triceps brachii ; N the head, which is called extensor longus major ; O the short head of the triceps, called the extensor brevis ; P the head called brachialis extensor longus minor. The short head O arises from the humerus, the other two from the scapula ; it's insertion is into the ancon.

QRS Biceps brachii, or caraco radialis ; Q the belly of

of the short head ; R the belly of the long head ; S the fascia of this muscle, which is sent down upon the muscles on the cubit.

a A b c d e e g h A fascia or strong membranous production lying over the extending muscles on the cubit ; *a A* it's origin from the edge of the triceps from the levator humeri proprius, and from the two protuberating parts of the humerus, betwixt which it is extended like a strong ligament, and gives origin to some of the fleshy fibres of the extensor carpi radialis ; it is inserted into the radius at *b c h* ; at *h h* into the ligament, and being expanded over all the extending muscles which lie on the cubit, is inserted into the internal side of that bone, all along the bounds of the bending muscles on that side ; there lies under it the extensor carpi radialis, of which *d* is the fleshy part ; *e e f* the tendon ; *b c* extensor digitorum communis ; *g* what is analogous to the extensors of the thumb.

This fascia is attached to the upper edge of the extensor digitorum communis, and may, perhaps, be properly called a flat tendon, arising common to this muscle, and the extensor carpi radialis, and sending an expansion not only over but also under them, and being attached to the bone on each side down to the carpus, and also to the ligaments that bind down the tendons, running over the carpus, it makes a continued case for them from their originations down to the carpus, confining them steady in their proper places. It communicates with the fascia of the biceps muscle, and with it is inserted into the tendon of the extensor carpi radialis.

f The tendon of the extensor carpi radialis inserted into the metacarpal bone.

i The tendon of the extensor digitorum communis going to its insertion into the coffin bone.

m n o o P p q r s t An expansion arising at *o o* from the articulating ligament, and at *n* from the olecranon : it receives an addition from the longus minor, and internal protuberance of the humerus, and expansion of the biceps muscle, then descends over the bending muscle down to the ligaments on the carpus, to which it is attached, as well as to the bones of the cubit on each side of the bounds of the bending muscles ; the different directions of it's fibres being marked as at *q, r, &c.* and it's insertion into the bone on the external side as at *P m b* ; it then runs into the ligaments. It gives rise to fleshy fibres of the muscle *m*, which is analogous to the extensor minimi digiti, all the way from the out-line *q m b* to the bone where the expansion is inserted. It has a strong insertion at *P* into that protuberating bone of the carpus called the

os pisiforme or orbiculare, and another betwixt the tendons *s r* of the flexor carpi ulnaris, besides it's conjunction with the ligaments on the carpus to which it is a considerable addition ; *t* a part of the expansion which appears like a number of small tendons.

At *z* a ligament arises which joins the tendon *m* near *m w*, and goes along with it to be inserted into the great pastern.

A slender ligament arises about P which covers the tendon *m* and then runs betwixt it and the tendon *i* to be inserted into the upper and anterior part of the great pastern.

h h P p u w x y z Ligaments which bind down the tendons lying upon the carpus.

16 *h h y y u* A ligament whose fibres run in a transverse direction over the anterior part of the carpus to which the carnous membrane adheres at *u* ; at 16 the ligament *h h y y* 16 adheres to the bursal ligament ; *x w* the insertions of the articular ligament ; betwixt *c* and *h* is a ligament proper to the extensor digitorum communis, inserted at two protuberating parts of the radius, one on each side the channel in which the tendon lies ; *p z w* a ligament, the fibres of which run in the upper part transverse, in the lower rather obliquely downwards, as it lies on the lateral or external part of the carpus, it was covered in table the first by the production of the membrana carnosa, and pectoralis, but rather the membrana carnosa, as it lies on the external part.

1 2 A ligament arising at 1 and inserted at 2 *w* ; it helps to bind down the projecting bone of the carpus, and serves as a stay to it when the flexor carpi ulnaris is in action : there is a large vein protuberating under it.

3 A ligament which helps to bind down the tendons of the sublimis and profundus.

4 The tendon of the profundus.

5 The tendon of the sublimis.

6 A vein arising from under the hoof called vena plantaris externa.

7 Nervus plantaris externus.

9 An articular ligament.

10 A ligament sent from the interosseus and inserted into the tendon of the extensor digiorum communis, which it binds down.

11 12 The horny part of the hoof ; 11 the superior part ; 12 the sole, or inferior part going under the coffin bone.

13 A substance resembling the villous surface of a mushroom arising from the coffin bone, received by the like arising from the hoof, which it mutually receives.

a b c c d d d D e f g g h i k l Musculus fascia lata ; *a* it's origin from the ilium ; *b* it's anterior fleshy belly ; D the posterior fleshy belly, over which the fascia lata sends a strong membrane, as well as under, so that it is received or contained in a duplicature of the fascia lata ; the fibres *d d d D e* arising from the superior or external fascia, and descending to be inserted into the inferior on it's external side ; the part *a b c* arises from the spine of the os ilium internally tendinous ; fleshy fibres arising from that flat internal tendon, and descending to be inserted chiefly into the inside of the bone in the angle *c d g g* ; the fleshy part in the superior angle *d* being thickest it gradually diminishes till it is lost in the line *g g* ; the dark colour of the fleshy fibres makes some appearance in this angle though the fascia is very strong, but not near so much as the part *a b g* because the covering of that is little more than a common membrane ; the line *a e* marks the place where the fascia lata is cut off before it passes betwixt this muscle and the glutæus externus to be inserted into the anterior costa of the os ilium ; *d e* marks the place where the production of the fascia lata, which is sent over this muscle, is cut off ; and *d d d* the place where it joins to the broad tendon of this muscle in which place it is cut off ; *e f* shews the place where the fascia lata is cut from it's conjunction with what may be called the broad tendon of this muscle ; *f g* marks the place where the fascia lata ceases to adhere to the tendon of this muscle, in order to pass down over the leg and foot ; at *h* the tendinous surface of the rectus cruris makes it's appearance through the tendon of this muscle ; *i k* shews the tendon or ligament which binds the patella to the tibia protuberating ; *l* the ligament which binds the patella to the external protuberance of the os femoris.

This muscle is inserted, by a strong tendon, into the tibia at *i*, adhering to the tendon of the anterior and middle part of the biceps muscle in it's way ; it's adhesion is all the way from *i* to the superior 4 where it has a little insertion into the patella.

m n o o p Glutæus externus ; *m* a fleshy origin from the ligament which runs betwixt the spinal and transverse processes of the os sacrum ; *m n* the place where the fascia lata is cut off from the production which it sends under this muscle, or from it's attachment to the tendinous surface of the internal part of this muscle, which arises from the ligament running betwixt the os sacrum and ischium ; and which receives first the insertion of those fleshy fibres which arise betwixt it and the ends of the spinal processes of the os sacrum from the same ligament, and then the

fibres

fibres *m n o o*, which arise from the fascia lata and descend obliquely inwards and downwards to be inserted into it ; *o o* the place where this muscle ceases to arise from the fascia lata and goes to be inserted at *p* into the lateral protuberance of the thigh bone ; it sends off a fascia over the posterior part of the thigh bone, which runs in a transverse direction, and into which the pyramidalis is inserted, or joins in with it before it's insertion into the superior or rather posterior part of this protuberance.

q Q r s t Glutæus medius ; *q r s* it's origin from the tendinous surface of the sacro lumbalis ; *s* it's origin from the ilium ; *q Q r s* the part which is covered by it's own proper membrane, and does not adhere to the tendon of the latissimus dorsi, &c. nor fascia lata ; *q Q t* the part which receives fleshy fibres from the fascia lata, going under the glutæus externus to be inserted into the great trochanter.

i k l u u w w x y z 3 4 4 5 7 7 8 8 9 11 Biceps cruris ; *u u w w* mark the superior or anterior head where it arises by carnous fibres from the fascia lata ; it's principal origin is from the ligaments which run from the spinal to the transverse processes of the os sacrum, and from thence to the tubercle of the ischium ; *w 5 y z* mark the inferior or posterior head, where it arises by carnous fibres from the fascia lata ; it's principal origin is from the tubercle of the ischium beginning at the extremity of that tubercle from the inferior angle, and continuing its origin by a flat strong tendon about six minutes along the inferior edge of that bone ; this tendon is continued down from the tubercle towards 5 betwixt *y* and *z*, from which, a little above *y*, the fleshy part *y 5 7 l* begin to arise ; but the fleshy part *x z 7* begins it's origin from the tubercle, and continues it down the said tendon ; *w w l 4* the fleshy part of the anterior head where it does not arise from the fascia lata, it is inserted into the patella and superior and anterior part of the tibia ; betwixt *p* and *w* are marked tendinous fibres which bind the anterior part of this muscle to the external glutæus ; and a little below that it is inserted into the thigh bone by a flat tendon, and by this insertion the anterior part of this muscle is kept from starting too much forwards, the fibres of this tendon or ligament running in almost a transverse direction ; the part *f 4 4 l w* lies under a fascia sent from the anterior part of the musculus fascia lata, to the tendon of the musculus fascia lata, which is cut off at *w f*, and on which the direction of its fibres are marked ; *x z 5 y w l 7 7* the fleshy part of the posterior head where it does not arise from the fascia lata ; *l i 8 8 9 3 7 7* the tendon of the posterior head which joins the tendon of the anterior head near the patella, and is likewise inserted at *i 8 8* into the anterior part of the tibia all the way down to the ligament common to the extensor

longus digitorum pedis, and tibialis anticus, and into part of the upper edge of that ligament and forms the tendon 11 with the fascia lata (which is cut off at 3 9) and is inserted into the os calcis ; 7 7 3 is the strongest part of the posterior tendon which is inserted into the os calcis.

15 The tendon of the plantaris.

16 17 17 18 19 Semi-tendinosus ; 16 it's origin from the ligament which runs betwixt the spines of the sacrum and the ischium, from the ligament betwixt the spinal and transverse processes of the os coccygis ; 16 17 17 marks the part which receives fleshy fibres from the fascia lata ; 18 the fleshy part which does not adhere to the fascia lata ; 19 the tendinous production which wraps over the gemellus to join in with the fascia lata and tendon of the biceps cruris ; the lines 16 17 betwixt this muscle and the biceps mark the fascia lata where it runs in betwixt these muscles ; the posterior of the two lines marks the cutting off of the part of the fascia which runs over the semi-tendinosus to the large adductor of the thigh : it's principal insertion is by a flat tendon into the superior and anterior part of the tibia internally, it is also attached to the plantaris near the bottom of it's fleshy part by a flat tendon or expansion.

22 The large adductor of the thigh.

24 25 25 26 27 30 31 32 33 34 Ligaments which bind down the tendons, &c. on the tarsus, the inferior and anterior part of the leg or tibia, and the superior part of the metatarsus laterally and anteriorly ; 24 25 25 a strong ligament common to the tendon of the extensor longus digitorum pedis and tibialis anticus ; at 24 it falls off to be very thin, but continues to receive some origin of tendinous fibres from the tibia for some way upwards, which run internally till they are lost in the tendinous expansion of the biceps muscle, &c. which is inserted into the upper internal edge of this ligament pretty strongly, but falls away to little or nothing in it's way towards the external lateral part of this ligament ; from 24 downwards this ligament strengthens as it descends towards 25 25, where it is thick and strong : it's origin on the external lateral part of the tibia is marked 25 33 : there is another strong ligament marked 26 proper to the tendon of the extensor longus digitorum pedis, which shews itself under the common membranous ligament 27 which covers it, and the articular ligament as well as blood-vessels, &c. upon the tarsus, and is attached to the ligament 24 25 25 ; at 25 25 ; at 30 are marked the directions of tendinous fibres, in this ligament, which arise from the bones of the tarsus and descend obliquely inwards and downwards ; 31 marks fibres arising from the splint bone, or a bone of the metatarsus, and running transversely over the anterior

part of the metatarsus joins in with the part 30 ; it is inserted into the superior and anterior part of the metatarsal bone ; 34 marks some little appearance, by protuberation, of a ligament common to the tendon 37, and the blood-vessels marked 14 ; 32 marks a ligament proper to the said tendon 37, it's origin and insertion being both from the tibia.

35 A ligament which binds down the tendons of the flexors.

36 36 Extensor longus digitorum pedis.

37 37 Peroneus anticus.

38 Flexor digitorum pedis.

39 A branch of the arteria tibialis anterior.

40 Plantaris.

41 Flexor digitorum pedis.

42 46 Vena plantaris externa.

43 Nervus plantaris externus.

44 The interosseus, &c.

45 A ligament sent from the interosseus, &c. by which the tendon of the extensor longus digitorum pedis 36 is bound down, otherwise it would start from the bone when the fetlock joint gives much way.

47 48 The horny part of the hoof ; 47 the superior part ; 48 the sole, or inferior part going under the coffin bone.

49 A substance resembling the villous surface of a mushroom arising from the coffin bone, received by the like arising from the hoof, which it mutually receives.

a The tendon of the rectus cruris.

b Vastus internus.

c d Sartorius

e e f Gracilis.

g h k l Semi-tendinosus ; *g* the fleshy part ; *k l* the tendon which is inserted into the tibia at *k* ; at *l* it sends off a tendon to the gemellus, to which, at *o*, the fasciæ are attached.

m m m Gemellus ; *m* a fleshy part ; under *n* lies the tendon over which the tendon of the plantaris is twisted.

n A tendon formed by that going off from the semitendinosus at *l*, and by another tendinous fascia.

o p q r s The fasciæ which are inserted into the os calcis gemellus and plantaris ; *o* the place where the fascia lata is cut off ; *p* the part going to be inserted into the os calcis on the external side, the part *q* joins with the part *r* to be inserted into the os calcis at *s*.

t u u w x The tendon of the plantaris coming from under the fasciæ and twisting over the gemellus at *t* ; *w* a part which it sends off to the os calcis, which makes a sort of ligament

ligament to bind in the tendon of the flexor digitorum pedis; it is spread a little upon the ligament 8 9 9 and inserted into it near it's origin from the os calcis about 8.

y The tendon of the flexor digitorum pedis lying under the thin ligament marked 35 on the right leg in this table; the bounds of it are here marked though it falls off gradually into nothing more than a common membrane, and is insensibly lost as it descends from about *y*; the lowest part of it's insertion into the splint bone is about *y*, but is here hid by the blood vessel.

z 1 The tibialis anticus appearing under the fascia.

2 3 3 The ligament marked 24 25 25 33 36 in this table of the right leg; 3 3 it's insertion into the tibia.

4 The ligament marked 30 on the right lower limb in this table.

5 A ligament which covers the tendon of the tibialis posticus arising from the posterior and inferior part, or internal inferior angle, and inserting itself into the articular ligament 9 9.

6 6 7 A ligament arising at 7 from the astragalus, and inserted at 6 6 into a cartilage lying under the tendon of the flexor digitorum pedis, which, assisted by another ligament on the other side the limb, confines it in it's place. These ligaments seem to be a part of the fascia which covers the muscles on the external side of the limb, which (passing under the tendon of the flexor digitorum pedis) forms a cartilaginous substance as it passes and is a smooth proper bed for that tendon to slide upon.

8 9 9 A strong ligament which binds the os calcis to the astragalus, os naviculare, ossa cuneiformia, and splint-bone, arising from a protuberance about 8, and inserted into the other bones of the tarsus and metatarsus about 9 9.

9 9 The articular ligament which binds the tibia to the bones of the tarsus.

10 11 A ligament running over the tendon of the plantaris, inserted into the ligament 8 9 9, and splint-bone. It is marked 35 on the right leg in this table.

12 12 12 A sort of ligamentous fascia betwixt which and the bursal ligament the mucilaginous glands are contained.

13 The ligament proper to the tendon of the extensor longus digitorum pedis, marked 26 in the right limb in this table.

14 15 16 17 The tendon of the extensor digitorum, at 14 going to be inserted into the last bone of the toe, or coffin bone: it receives the ligament 19 at the part 16, and the ligament 20 at the part 17; and, in it's passage down the toe, it adheres to the bursal ligaments under 21 and 20. It is marked 5 in table the first.

18 Interosseus, &c.

19 The ligament marked *d* in table the first. It arises from the interosseus, &c. and is inserted into the tendon of the extensor longus digitorum pedis, and binds it down.

20 A ligament which arises from the internal-lateral and inferior part of the first bone of the toe, and is inserted into the tendon of the flexor digitorum pedis, and binds it to this side, as 46 on the right lower limb, doth the same tendon to the other side.

21 Vena sapphena.
22 Nervus sciaticus internus.
23 Nervus plantaris internus.
24 Vena plantaris interna.
25 26 The horny part of the hoof; 25 the superior part; 26 the sole or inferior part going under the coffin bone.

27 A substance resembling the villous surface of a mushroom arising from the coffin bone, received by the like arising from the hoof, which it mutually receives.

In the left upper Limb.

c Part of the biceps which sends an expansion over the bending muscles lying upon the cubit.

def The expansion marked *mnoopPqrsst* on the left upper limb in this table.

gg The fascia marked *a* A *b c d e e g h* on the left upper limb in this table.

h The tendon of the muscle which is analogous to the extending muscles of the thumb, marked *g* on the right upper limb in this table.

iiklm The ligament marked 16 *hhyyu* on the left upper limb in this table: the articular ligament appears under this: from *k* to *l* this ligament communicates with the fascia *d e f*.

no A ligament arising at *n*, and inserted, about *o*, like the ligament marked 1 2 on the right upper limb in this table.

p The ligament marked 3 on the right upper limb in this table. It is a continuation of the ligaments marked *n o* on the right, and 1 2 on the left upper limb in this table, it is here something thinner than the ligaments *n o* and 1 2, but as it descends down the limb is soon insensibly lost in a membrane.

q The tendon of the profundus.
r The tendon of the sublimis.
s A vein arising from under the hoof, called vena plantaris interna.
t Nervus plantaris internus.
wx The tendon of the extensor digitorum communis; *w* the part which is sent off from the principal tendon to be inserted into the superior and internal part of the great pastern; *x* the principal tendon inserted into the coffin bone, but in it's way is attached to the coronary bone on it's anterior and superior part.

y A ligament which arises from the interosseus, &c. and is inserted into the tendon of the extensor digitorum communis, which it binds down.

z The interosseus, &c.

1 2 The horny part of the hoof; 1 the superior part; 2 the sole or inferior part going under the coffin bone.

3 A substance resembling the villous surface of a mushroom arising from the hoof, received by the like arising from the coffin bone, which it mutually receives.

H The

The third Anatomical Table of the Muscles, Fascias, Ligaments, Nerves, Arteries, Veins, Glands, and Cartilages of a Horse explained.

In the Head.

ab THE elevator of the upper eye-lid, so thin and transparent that the dark coloured part appears through at *a*, and the white at *b*.

c The lachrymal gland.
d The under eye-lid.
ee The tarsi ligamentum cilliare, or cilliar edges.
f Alæ narium.
ghii A muscle arising by a small tendon at *h*, and by a flat membranous tendon at *i i*; it is inserted near *g* into the pituitary membrane which covers the concha narium inferior: it has another insertion into the alæ narium.
k The septum narium.
mmn Caninus or elevator of the corner of the mouth; *m m* it's insertion from the corner of the mouth along the buccinator.
oo Orbicularis oris.
pqr The depressor of the lower lip.
ss Buccinator.
t The anterior dilator of the nostril.
u The elevator of the chin.
w The masseter.

1 Vena jugularis externa, posterior or superior; in a branch of which at
2 2 Are two valves, anastomasing between the anterior and posterior external branches of the jugularis.
3 Vena temporalis.
4 Vena angularis.
5 Arteria angularis.
6 7 8 Nervus maxillaris superioris; the second branch of the fifth pair of nerves; 7 branches going to the upper lip; 8 a branch which goes to the long nasal muscle of the upper lip.
9 Branches of the nervus maxillaris inferioris; they are branches of the third branch of the fifth pair of nerves; they communicate with the nervus maxillaris superioris.
10 Glandulæ labiales, part of which are cut away to shew something of the spreading of the nerves of the lip.
11 The salivary duct.
12 The anterior cartilage of the outer ear.
13 The outer ear.

In the Neck.

abcde Caracohyoidæus; *b* the part coming from it's origin at the upper and internal side of the humerus, betwixt the insertions of the sub-scapularis and teres major, by a flat membranous tendon, beginning to be fleshy as it comes from under the seratus minor anticus; *c* fibres which run towards the angle *d*, attached to the rectus anticus major, and having an origin by a flat tendon along with the insertion of that muscle from the os sphenoides; *a* fibres which intersect the wind-pipe, going from the part *c d* towards *e*, to be inserted into the os hyoides.

fg Sternohyoidæus arises at *f* from the middle tendon of the sternohyoideus, and goes, at *g*, along with the caracohyoideus to be inserted into the os hyoides.

hik Sternothyroidæus; *h* it's middle tendon; *i* the fleshy part coming from it's origin at the superior and internal part of the sternum, it runs close along with it's fellow a little higher than the part *h*, where it is tendinous, from whence it goes to be inserted at *k* into the thyroid cartilage about 3 minutes from it's fellow.

l Part of the carotid artery; at *l* goes off a branch to the sternothyroidæus.

m Nerves of the eighth pair.
n The thyroid gland.
oooo Glandulæ lymphaticæ.
q The lower constrictor of the pharinx.
r Hyothyroidæus.
s Cricothyroidæus.
t Cricoarytenoidæus posticus.
u The inferior maxillary gland.
wxy Rectus internus major capitis, or rectus anticus longus; *w* it's origin from the transverse process of the third vertebra of the neck; *x* it's origin from the transverse process of the fourth vertebra, and a part of the scalenus. It is inserted into the os sphænoides.

ABCDEFGH Transversalis cervicis; A B the superior part, which arises from the third, fourth, fifth, sixth and seventh oblique processes of the neck, and two uppermost of the back, viz. the lower oblique process of the third, and upper oblique process of the fourth, and so of the rest: it is inserted into the transverse process of the first vertebra of the neck. CDEFGH the inferior part which arises from the transverse processes of eight of the superior vertebræ of the back, and is inserted into the transverse processes of the four inferior vertebræ of the neck, partly fleshy, but chiefly by broad thin tendons, as at DEFGH. Between the superior part

A B and D the inter-transversales appear. At the extremity of it's origin it is spread out about three inches by a flat tendon expanded from it's first origin, from the eighth transverse process, to the broad tendon of the complexus to which it is strongly attached, and from the whole breadth of which fleshy fibres arise.

IKL Trachelo-mastoidæus, complexus minor, or mastoidæus lateralis; I the tendon, going to be inserted into the root of the processus mastoidæus; KL the fleshy part arising from the oblique processes of the third, fourth, fifth, sixth, and seventh vertebræ of the neck, the uppermost of the back, and transverse processes of the second and third vertebræ of the back.

MOOPPPQST Complexus; M shews some external appearance of the principal tendon towards which the fleshy fibres are directed as marked PP, &c. OO tendinous lines by which the carnous fibres PP, &c. are intersected; Q a tendinous origin from the ligamentum colli; S the part going to be inserted by a strong round tendon into the occiput near the insertion of it's fellow; at T are marked the directions of some tendinous threads which attach it to the ligamentum colli.

It begins it's origin from the upper oblique process of the third vertebra of the neck and continues it's origin from all the oblique processes of the neck below that, and from the upper oblique process of the first vertebra of the back, and, by a pretty strong flat tendon, from the transverse process of the second and third vertebræ of the back, from the last of which the tendon is reflected from the transverse process to the top of the spinal process of the same vertebra, and makes a communication betwixt this part of the muscle and that arising from the third, fourth, fifth, sixth and seventh spinal processes.

U U Obliquus capitis inferior.
W W Obliquus capitis superior.
X Y Longus colli.
1 1 1 1 1 2 2 2 2 2 Branches of the cervical arteries and veins.
3 Part of the jugular vein.

Muscles on the Shoulder.

ab The subscapularis, which is outwardly tendinous; at *a* is marked a membranous tendon, from which the supra spinatus receives some part of it's origin; *b* marks a tendinous slip sent from this muscle which leaves it about

327

about *a*, and is inferted into the caracoid procefs a little below *b*.

cdeeefgh Triceps extenfor cubiti; *c d e e e* the head, which is called extenfor longus major, arifing at *e e e* from the inferior cofta fcapulæ; *c* marks the Traces of the teres minor; at *d* are left fome ftrong tendinous threads belonging to the infra-fpinatus fcapulæ which adhere to this mufcle; the marks of the infra-fpinatus appear all the way from *d* to the humerus; *f* the origin of that part called extenfor brevis from the humerus; *g* the head called brachialis externus longus minor.

iiklmn Biceps brachii, or rather caraco radialis; *i i* the tendon arifing from the fcapula; *k* a flefhy part lying upon the tendon; *l* the belly of the long head; *m* the belly of the fhort head; *n* the aponeurofis arifing from this mufcle, which it fends to the tendinous fafcia or covering of the cubit.

o Nervus cubitalis.
p Nervus radialis.
q Nervus mufculus cutaneus.
r Nervus medianus.
s Branches of the arteria and vena axillaris.
t A branch from the anteria axillaris.

In the Trunk.

aabbbcd Serratus minor pofticus; *a a* the beginning of it's flefhy fibres; *b b b* the flat tendons by which it is inferted into the ribs; *a a c* the flefhy part; *d* the flat tendon by which it arifes. In this fubject this mufcle runs flefhy under the ferratus major pofticus, and is inferted into the twelfth, thirteenth, and fourteenth ribs. It's firft or fuperior infertion is into the fifth rib.

eefghh, &c. Serratus major pofticus; *eefg* it's broad tendon; from *g* to *f* is marked the place where the tendon of the latiffimus dorfi is cut off from it's infertion with this tendon into the fafcia lata; *e e h h*, &c. the flefhy part; *e e* the beginning of the flefhy part; *h* it's infertion into the ribs which in fome fubjects is only into feven inferior ribs, as in this fubject, though, as here, it is more frequently inferted into eight.

l Serratus major anticus.

mm, &c. *nnnoo*, &c. *pp*, &c. *qq*, &c. *rr*, &c. Intercoftals; *kmi* mark the origin of the external oblique mufcle from the ribs, where they are defcribed by fhaken lines; the fame kind of lines alfo where they unite with the intercoftals, or arife from the tendinous covering of the intercoftals; *o o*, &c. mark the parts of the external intercoftals which are above and below the infertion and adhefion of the external oblique mufcle; *pp*, &c. fome appearances of the internal intercoftals : out of thefe places

come nerves and blood-veffels which go to the external oblique mufcle; *qq*, &c. fome flefhy fibres which arife partly tendinous but chiefly flefhy, and run in a tranfverfe direction from one rib to another. They belong to the internal intercoftals. *rr*, &c. Flefhy fibres which run in the fame direction of the external intercoftals from one cartilaginous ending of the ribs to another. Betwixt moft of the ribs there are marked blood-veffels and nerves, fome of which go to the external oblique mufcle, they are called intercoftales.

sstuuwxy Obliquus internus, or afcendens abdominis. It arifes at *s s* from the fpine of the ilium tendinous and flefhy, it's origin is continued to the ligamentum fallopii, from which it arifes, and from the fymphyfis of the os pubis: it is inferted into the cartilage of the loweft rib tendinous and flefhy, and into the cartilaginous endings of the ribs as far as the cartilago enfiformis; *sstuuw* the flefhy part ending at *uu*: the nerves and blood-veffels which are feen on this part of the mufcle pafs to and from the external oblique mufcle and parts which are taken off; *x y* the flat tendon; that part of the tendon which runs over the rectus is cut off from *t* to *y*.

z Rectus abdomini: it arifes from the os pubis, and is inferted into the cartilago enfiformis and into the cartilages of the third, fourth, fifth, fixth, feventh, eighth and ninth ribs, and into the fternum betwixt the cartilages of the third and fourth ribs; there are flefhy fibres arifing from the firft rib which join it at it's origin from the fternum. This is called a diftinct mufcle and named mufculus in fummo thorace fitus.

The blood-veffels and nerves which are marked on the thorax are thofe which were diftributed to the parts taken off, as the obliquus externus, latiffimus dorfi, membrana carnofa, &c. and integuments; the nerves come from the nervi dorfales or coftales, and nervi lumbares; the arteries from the arteriæ intercoftales inferiores, and the arteriæ lumbares, the veins from the venæ intercoftales and venæ lumbares.

In the Cubit and right upper Extremity.

abcdd Extenfor carpi radialis; *a* it's origin from the fuperior protuberating part of the humerus; *b* the part which arifes flefhy from the fafcia which is extended betwixt the two external protuberating parts of the os humeri; it arifes above the part *b* and ligament or fafcia from the external ridge of the external condyle all the way up as far as the brachialis internus does not cover, but it's moft confiderable origin is from the anterior part of the external condyle of the os humeri, from which place it continues it's origin into the great cavity on the anterior

and inferior part of the os humeri; from whence it arifes by a very ftrong tendon firmly adhering to the tendon of the extenfor digitorum communis; *a b c* the flefhy part; *d d* the tendon inferted into the metacarpal bone, at *d* adhering to the burfal ligament a little before it reaches the lower bone of the carpus, or about three minutes from it's infertion into the metacarpal bone; *c* marks the place where the fafcia, proper to the extending mufcles on the cubit, is cut off from the fafcia of the biceps mufcle *n c*, which it joins to be inferted along with it into the tendon of the extenfor carpi radialis.

The origin of this mufcle is as extenfive as the originations of the long fupinator and radialis longus and brevis, and may be called a combination of all three in one, which is affifted by the biceps, the fafcia of which is like a ftrong flat tendon, inferted into the tendon of this mufcle.

f The mufcle which is analogous to the extenfors of the thumb in the human body; *f* the flefhy part arifing from the lateral part and ridge of the radius; *g* the tendon going to be inferted into the falfe metacarpal bone or loft in the ligament inferted into that bone, or rather attached to it before it's infertion. It is a combination of the abductor policis manus, extenfor longus, and extenfor brevis pollicis manus and indicator.

hiklmn Extenfor digitorum communis; *h* it's origin from the external condyle of the humerus; *i* the origin it receives from the fafcia which is extended betwixt the two external protuberating parts of the os humeri : it is a ftrong membranous tendon; *h l* it's origin from the upper and lateral part of the radius; *k* the flefhy belly; *m n* the tendon; *n* the part inferted into the coffin bone; *m* the tendon which it fends off to the tendon of the extenfor minimi digiti; it's principal origin is by a flat ftrong tendon from the lateral anterior and lower part of the os humeri, from the cavity above the articulation under the extenfor carpi radialis, to the tendon of which it adheres for about three minutes from it's beginning, as well as to the burfal ligament which lies under it.

ooo Ligamentous fafcias.

pqrs Extenfor minimi digiti; *p* the part arifing from the fuperior part of the radius. It has an origin from the ulna. The part marked with fhaken lines from *p* to *q* receives a flefhy beginning from the vagina or cafe which binds together the bending mufcles on the cubit. *r s* It's tendon which is joined by the flip from the extenfor digitorum communis *m*, to be inferted at *s* into the firft bone of the finger.

tuwxyz Flexor carpi ulnaris; *t* the origin of it's external head from the external protuberance of the os humeri pofteriorly; *u* the internal head which arifes from the

I internal

internal protuberance of the os humeri : it is inferted into the external falfe metacarpal bone a little below *w*, and at *x* into the pififorme bone; *y* the tendon; *z* the flefhy parts.

1 2 3 The profundus arifes by four diftinct heads, 3 is the common tendon of the four heads; the head 1 arifes from the internal protuberance of the os humeri pofteriorly under, and in common with the fublimis, with which it feems to be confounded, in fome degree, all the way down the flefhy part till it comes to the tendon where the four heads unite, and then the profundus and fublimis make two diftinct tendons; the next head arifes under that from the fame protuberance by a fmall flattifh tendon, it foon fwells into a round flefhy belly, then gradually tapering becomes a round tendon, joins in with the tendon of the firft defcribed head a little above the projecting pififorme bone of the carpus; the next head, marked 2, arifes flefhy from the ancon near it's extremity and foon becoming a fmall long tendon joins in as the former; the fourth head arifes flefhy from the flat pofterior part of the radius about it's middle, and firft becoming tendinous joins in with the other heads about the fame place.

There is a ftrong tendinous ligament arifing from the projecting pififorme bone, and another of the carpal bones inferted into the tendon of the profundus : it arifes from all the internal face of the carpus : there is fuch a ligament arifing from the internal edge of the radius, which is inferted into the fublimis about the fame place, where the four tendons of the profundus unite.

5 Interoffeus, &c.
6 A ligament from the interoffeus to the tendon of the extenfor digitorum communis.
8 8 The burfal ligament belonging to the anterior part of this joint.
9 The articular ligament.
10 The tendon of the fublimis.
11 Nervus plantaris externus.
12 Vena plantaris externa.
13 The villous covering of the coffin bone is here left on to fhew it's thicknefs.

In the right lower Limb.

aaabbcdd Glutæus medius; *aaa* it's origin from the facro-lumbalis; *b b b* an origin from the fafcia lata; *c* an origin from the line of the ilium; below *b b b* it is covered by the glutæus externus and biceps cruris; *d d* it's infertion into the great trochanter. It's origin is continued from *c* to the pofterior part of the fpine, and all that fpace of the

ilium which lies betwixt the fpine and the glutæus internus partly tendinous but chiefly flefhy, and from the ligament which goes betwixt the ilium and the tranfverfe procefles of the os facrum.

e Iliacus internus arifes flefhy from all the internal cavity of the os ilium and infide of it's anterior fpine; it is joined by the pfoas magnus and with it inferted into the leffer trochanter. They feem, to me, to be but one mufcle.

f Large arteries and veins which go to the mufculus membranofus, and in betwixt the rectus and vaftus externus. They are part of the firft ramus of the pudica communis.

ghiik Rectus cruris; *g* the part coming from it's origin from the external or pofterior part of the inferior fpine of the ilium by one tendon, and by another from the anterior part of the fame fpine; *h* it's flefhy belly; *k* it's infertion into the patella.

nopqrrs Vaftus externus; *o* it's origin from the pofterior part of the great trochanter; *p* an origin from the anterior fide: they are both externally tendinous; *r r* it's infertion into the patella; *r s* it's infertion into the lateral ligament of the patella; *n* it's principal flefhy part; *q* the thin flefhy part which goes to the lateral ligament, and over which the anterior part of the biceps goes to be inferted into the patella at *r r u u*.

rruuw The infertions of the anterior part of the biceps; *r r u u* that into the patella; *w* that into the tibia.

yz The inferior ligament of the patella, inferted at *y* into the patella, and at *z* into the tibia.

1 2 The lateral ligament of the patella, inferted at 1 into the patella, and at 2 into the os femoris.

3 4 The burfal or capfular ligament of the knee.

5 The place where the tendon of the glutæus externus is cut off from it's infertion.

6 The place where the expanfion is cut off which it fends to the pyramidalis.

8 8 8 8 The ligament which runs from the fpinal to the tranfverfe procefles of the os facrum, upon which is marked the flefhy origin of the biceps.

8 8 9 10 The ligament which runs from the tranfverfe procefles of the os facrum to the ifchium, on which is marked the flefhy origin of the biceps cruris.

8 9 Shews the place where the fafcia lata is cut off betwixt the biceps and femi-tendinofus.

9 9 11 The origin of the biceps from the tubercle of the ifchium; 9 9 that from the end; 9 11 that from the inferior edge, where there is a little of the flat tendon left on to fhew it's breadth.

12 13 14 15 16 Blood-veffels; 12 an artery; 13 a

vein, the branches of which, 15 and 16, run to the femi-tendinofus, the branches 14 to the biceps. The artery is a branch of the firft ramus of the pudica communis, which is a branch of the internal iliaca or hypogaftrica; the vein is a branch of the vena hypogaftrica.

18 Blood-veffels which go to the femi-tendinofus; the fuperior is an artery, the other a vein.

19 20 21 22 23 24 25 30 Extenfor longus digitorum pedis; 19 an origin from, or an attachment to, the tibia; 20 it's origin from the femoris along with the tendon of the tibialis anticus infeperably joined to that ftrong tendon; 22 23 24 25 it's tendon running under the ligament 26; 21 it's flefhy belly; at 22 it is joined by the tendon of the peroneus; at 23 it is joined by a ligament from the interoffeus, &c. which binds it down to the great paftern; the principal part of the tendon 24 goes to be inferted into the coffin bone, where it is joined by the tendon of the peroneus; it fends off a flip to be inferted into the firft bone of the toe or great paftern at 30.

26 A ligament which binds down the tendon of the extenfor longus digitorum pedis.

27 Extenfor brevis digitorum pedis.

28 29 The tibialis anticus; 28 it's origin from the fuperior and anterior part of the tibia; it arifes alfo by a very ftrong tendon from the inferior part of the os femoris, and is inferted into the bones of the tarfus and metatarfus. It is more fully explained in table the eighth.

31 31 32 33 Semi-membranofus arifing tendinous, and at it's origin attached to the origin of the biceps at 31 31; at 33 it is joined in with the femi-tendinofus, and is with it inferted into the tibia.

34 35 The inferior part of the femi-tendinofus cut off at 34; at 35 it fends off an expanfion attached to the tendinous ligament which lies over the gemellus, and covers fome blood-veffels and nerves which pafs over the gemellus, and run down the leg: it is alfo inferted by a flat tendon or expanfion into the plantaris near the bottom of the flefhy part, through which expanfion there is an opening for the paffage of a large nerve. It's principal infertion is by a flat tendon into the fuperior and anterior part of the tibia internally.

15 36 36 37 38 39 39 40 The large adductor of the thigh; 15 36 36 fhew the flefhy origin of the femi-tendinofus from the flat tendon of this mufcle or ligament running from the facrum and coccygis to the ifchium; 15 39 mark the place where the femi-tendinofus ceafes to arife from this tendon or ligament on this fide, and where the flefhy fibres of this mufcle begin to arife on the other fide of the tendon; at 37 and 38 the furface

is

is tendinous, but strongest about 37, where tendinous fibres run as marked in a transverse direction from the ligament or fascia lata ; 39 39 the place where the expansion is cut off which is sent from the fascia lata before it runs in betwixt the biceps and semi-tendinosus ; 40 the external fleshy part of this muscle. The fascia sending off an expansion before it goes in betwixt the biceps and semi-tendinosus, which is fixed to the large adductor of the thigh at 39 39, and this fascia being attached to the edge of the broad tendon of this muscle or running over it, as at 37, makes a compleat case for the semi-tendinosus above the process of the ischium, which keeps it firmly in it's place. This muscle arises from the ligament running from the sacrum and coccyx to the ischium ; it's principal origin is from the tubercle of the ischium ; it is inserted by a strong tendon into the internal condyle of the humerus behind the origin of the articular ligament and a little below it, and by a flat tendon into the articular ligament and tendon of the semi-tendinosus. It joins in with the long adductor near it's insertion.

50 51 52 53 Peronæus ; 50 it's origin from the upper part of the fibula and articular ligament 54 ; 51 it's fleshy belly ; 52 53 it's tendon joining in with the long extensor of the toes at 53, part of which is inserted into the great pastern along with part of that tendon at 30.

58 59 Flexor digitorum ; 58 the fleshy part ; 59 the tendon.

60 60 61 62 62 63 64 Gemellus ; 60 60 a sort of flat tendon which may be easily separated from the muscle to which it only adheres by it's external edge : it runs over the surface of the muscle and joins in with the fascias sent from the semi-tendinosus, &c. which joins in both above and below, and by that means makes a case for the tendon of the gemellus and plantaris ; 61 the externally tendinous origin of the external head of the gemellus ; 62 62 the fleshy parts ; 63 the fleshy part under the expansion 60 ; 64 the tendons of the external and internal head of the gemellus ; that upon which the 6 lies is the tendon of the internal head, and that which the 4 lies on is the tendon of the external head ; the tendon 60 wraps over it a little above 6 to be inserted more internally into the os calcis ; so that these three tendons, along with that of the plantaris, are twisted like a rope.

68 69 The tendon of the plantaris, wraping over the tendon of the gemellus at 68. This muscle arises under the external head of the gemellus (in which it is in a manner wrapt up) out of the large fossa or notch in the os femoris : above the external condyle on the external side of it's fleshy belly the gemellus is attached to it by fleshy fibres ; at 68 it runs over the end of the os calcis, where

it is bound on each side by ligaments which prevent it's slipping either way ; at 69 it divides to be inserted on each side of the inferior part of the great pastern posteriorly, and to give passage to the tendon of the flexor digitorum pedis, to which tendon it serves as a ligament to confine it to the great pastern when the fetlock joint is bent, and by that means it receives assistance from that tendon in bending the fetlock joint. This is analogous to the plantaris and short flexor of the toes in the human body, viz. the part above 68 to the plantaris, and the part below to the short flexor of the toes.

70 71 71 Articular ligaments ; 70 that which binds the tibia to the bones of the tarsus ; 71 71 that which binds the os calcis to the splint bone.

72 A capsular ligament.

74 75 Interosseus, &c. it arises from some of the tarsal bones and the upper part of the metatarsal bones, and is inserted into the sesamoid bones and great pastern on each side ; it sends off the ligament 75 and another on the other side to bind down the tendon of the extensor digitorum pedis. This is of a ligamentous nature, but supplies the places of the interosseus, the short flexor, adductor, and abductor of the great toe, the abductor and short flexor proper to the little toe, and a ligament which arises from the calcaneum and belongs to the cuboid bone, but sends off an excursion which joins the origins of the short flexors of the little toe in the human body : the ligamentous aponeurosis 75 is sent partly from the interosseus, &c. and partly from the capsula of the fetlock joint to the tendon of the extensor digitorum pedis.

76 Arteria tibialis anterior.

77 A vein from the biceps cruris on which appears a valve. It is a branch of the obturatrix. It is accompanied with a nerve.

81 A large vein, on which several valves are marked.

82 A nerve which accompanies the vein 81 to go under the fascia 35, and which is marked 9 in the first table. It is a branch of the large crural nerve.

83 Nerves going to the tibialis anticus. They are some of the small siatic ramus.

84 The external nervus plantaris.

85 The external vena plantaris.

86 A substance which resembles the villous surface of a mushroom, marked 13 and 3 in table the second, is here left to shew it's thickness or depth : it is the same on all the feet.

In the internal Side of the left lower Limb.

A a The tendinous surface of the rectus cruris, inserted at A into the patella.

b b c 12 Vastus internus, inserted at b b into the patella ; at A a into the rectus ; and at 12 into the ligament 13 14.

d The long adductor of the thigh.

e A flat tendon or fascia from the large adductor of the thigh.

f g Gemellus ; f the fleshy belly, the external surface of which is tendinous at f ; the tendon of this internal head wraps over the tendon of the plantaris to go to the external side of the heel : g the tendon of the external head.

h The tendon of the solæus.

l m n n p r The tendon of the plantaris ; l the part marked t in table the second ; m the part marked u in table the second ; n n the part marked s, the part marked q r in table the second, being here cut off at p ; the part marked w in table the second is cut off in this place ; r the tendon on this side going to it's insertion into the first bone of the toe.

u w x y z 30 The extensor digitorum pedis ; u the fleshy part, marked 21 on the right limb in this table ; w the part marked 22 on the right limb in this table ; x the part marked 24 in this table on the right lower limb, and 14 in table the second on the left limb ; y the part marked 16 in table the second ; z the part marked 17 in table the second. It has an insertion at 30 into the great pastern with part of the tendon of the peronæus.

z The ligament marked 20 in table the second.

1 2 3 Tibialis anticus.

6 Popliteus ; externally tendinous, particularly near it's insertion.

7 Tibialis posticus.

8 8 Flexor digitorum pedis.

9 10 The bursal ligament.

11 The intermuscular ligament marked 26 on the left limb in this table.

12 13 14 The internal anterior ligament which binds the patella to the tibia.

15 15 15 A membranous covering of the bursal ligament, betwixt which and the bursal ligament are contained the mucilaginous glands of this joint.

16 The internal articular ligament which connects the os femoris to the tibia.

18 18 The articular ligament which binds the tibia to the bones of the tarsus.

22 23 23 The ligament marked 8 9 9 in table the second. It is a strong ligament which binds the os calcis to the astragalus, os naviculare, ossa cuneiformia and splint bone, arising from a protuberance about 22 and inserted into the other bones of the tarsus and metatarsus about 23 23.

K 25 A

25 A nerve called sciaticus internus.

26 The ligament marked 19 in table the second.

27 Interosseus, &c. marked 18 in table the second.

28 Nervus plantaris internus. It is a branch of the nervus sciatica-tibialis.

29 Vena plantaris interna.

36 The villous covering of the coffin bone, is here left on to shew it's thickness.

In the internal Side of the left upper Limb.

a b c Extensor carpi radialis, marked a b c d d on the right upper limb in this table ; a the fleshy belly ; b c the tendon ; c it's insertion into the metacarpal bone.

d A ligamentous fascia.

e Profundus.

f g The muscle which is analogous to the extensors of the thumb, marked f g on the left upper limb in this table.

h The tendon of the extensor digitorum communis.

i Nervus medianus.

k Arteria brachialis, or the humeral artery.

l l m m The bursal ligament on the anterior part of this juncture.

n Flexor carpi radialis.

o Sublimis.

p Flexor carpi ulnaris.

q Interosseus, &c. It arises from the bones of the car-

pus and upper part of the metacarpal bones, is inserted into the sesamoid bones and great pastern on each side, and sends off the ligament r on this side to the tendon of the extensor digitorum, which it binds down. It is of a ligamentous nature, but supplies the places of the interossei manus and abductors of the fore finger, little finger, and short abductor of the thumb, with the adductors of the thumb and little finger.

s Vena cephalica.

t Vena plantaris interna.

u Nervus plantaris internus.

w The villous covering of the coffin bone is here left on to shew it's thickness.

The fourth Anatomical TABLE of the Muscles, Fascias, Ligaments, Nerves, Arteries, Veins, Glands, and Cartilages of a HORSE explained.

In the Head.

a b THE globe or ball of the eye ; a the pupil ; b the white of the eye, or tunica scleratica, covered with the albuginea or tendons of the streight muscles only, and not covered with the tunica adnata or conjunctiva.

c One of the lachrymal glands placed in the great canthus of the eye, called caruncula lachrymalis and glandula lachrymalis inferior.

d The semi-lunar fold, formed by the conjunctiva.

e Attollens.

f Deprimens.

g Adducens.

h Abducens.

i Obliquus superior.

k Obliquus inferior.

l The trochlea.

m m n n o Caninus, or the elevator of the corner of the mouth ; m m it's origin ; n n it's insertion into the orbicularis oris ; n o it's insertion into the buccinator.

p p Orbicularis oris, or the orbicular muscle of the mouth.

q r The glandulous membrane which lines the inside of the lips ; q that of the lower lip ; r that of the upper lip, the glands of which are called glandulæ buccales.

s The elevator of the chin.

t u The short nasal muscle of the upper lip.

w w Buccinator ; it arises from three different places ; the superior fibres arise from the alvioli of the upper jaw ; the middle fibres from the ligamentum inter maxillares, and the inferior from the lower jaw : it is inserted into the

glandulous membrane of the inside of the cheek and lips, and into the orbicularis oris.

x The anterior dilator of the nostril.

y The pituitary membrane on the inside of the alæ narium.

z The salivary duct.

1 Vena jugularis externa posterior or superior.

2 Vena temporalis.

3 Arteria angularis.

4 Vena angularis.

5 Nervus superciliaris, the ramus superior, or frontalis : it is the most considerable of the three rami of the nervus orbitarius commonly called ophthalmicus, which is the first branch of the fifth pair of nerves : it passes through the foramen superciliare, is spent on the musculus frontalis, orbicularis and integuments.

6 7 8 9 The second branch of the fifth pair of nerves called nervus maxillaris superior ; 7 a branch which goes to the long nasal muscle of the upper lip ; 8 a branch which goes to the inside of the nares towards the top of the nose ; 9 branches which go to the upper lip.

10 The anterior cartilage of the outer ear.

11 The ear.

In the Neck.

a Glandula thyroides.

b b c c d d e f f f The carotid artery : it sends branches at b b to the glandula thyroides ; d d branches which give off ramifications to the sterno thyroidæus ; e branches which go to the caracohyoidæus ; f f f branches going to the aspera arteria : these branches of arteries are all accompanied with veins.

g An artery and vein running over the gula.

h h The third branch of the eighth pair of nerves.

i i i i OEsophagus.

k k Trachea arteria, aspera arteria, or wind-pipe.

l m n Sternothyroidæus ; m the thick fleshy part near it's origin at the superior, and internal part of the sternum ; l it's middle tendon ; n it's insertion into the thyroid cartilage.

o p Crycothyroidæus ; p it's origin from the crycoide cartilage ; o it's thyroidal insertion.

q q The lower constrictor of the pharynx.

r Hyo-thyroidæus, or thyro-hyoidæus.

s The lower, and anterior part of the thyroid cartilage.

t u Rectus capitis posticus major ; t it's origin from the spine or ridge of the lower oblique process of the second vertebra of the neck.

w x Rectus capitis posticus minor, or rather medius ; w the part coming from it's origin at the spine of the second vertebra of the neck : it begins it's origin at the root of the spine of the oblique process, just where the rectus major ceases to arise, and continues it's origin about three minutes up the spine or ridge ; x the part going to be inserted by a tendon, short and broad, into the occiput, wraping over the surface of the intervertebralis.

y z Obliquus capitis superior : y it's fleshy origin, which is pretty deep, from the broad transverse process of the atlas ; z it's insertion into the occiput.

A B Obliquus capitis inferior ; A it's origin from all the length of the spine of the oblique process of the second vertebra of the neck above A, where it runs under the

the rectus capitis posticus longus: it is externally tendinous: it arises from all the posterior part of that vertebra which the intervertebralis does not cover: B it's insertion into the anterior part of the broad transverse process of the atlas which the intervertebralis does not cover.

CDEFGHIK Longus colli; CHDEF the parts arising from the transverse processes of the third, fourth, fifth, and sixth vertebræ of the neck: H the part which is inserted into the anterior part of the body and transverse processes of the second vertebra, as CDEF run in part to be inserted into the anterior parts of the transverse processes and bodies of the vertebræ above them, as well as join the part I, which goes to be inserted into the anterior part of the body of the first vertebra; the part H may be divided into a distinct muscle, or nearly so, and probably the parts DEF may be so too; I K the part inserted into the anterior oblique process of the sixth vertebra; I the tendon; K a fleshy part. It's inferior origin is from the anterior lateral part of the body of the last vertebra of the neck, and the five uppermost of the back.

LL, &c. MM, &c. Intertransversarii posteriores colli; LL, &c. their insertions into the transverse processes of the vertebræ of the neck; MM, &c. their origins from the roots of the oblique processes, and the part betwixt them and the transverse processes. For each insertion there seems to be an origin from the lower oblique process of the vertebra below it, and the upper oblique process; or it rather seems to be at the root of the upper oblique process, and almost down to the lower oblique process of that vertebra, and betwixt the oblique and transverse processes where the intervertebralis does not cover. The lowest origin is from the first transverse of the back, part of which is inserted into the transverse process of the seventh vertebra of the neck.

NNN Intervertebrales appearing betwixt the originations of the intertransversarii posteriores colli: they arise from the ascending oblique processes of the five inferior vertebræ of the neck, and from the space betwixt the oblique processes of the uppermost vertebræ of the back: they are each of them inserted into the lateral parts of the bodies of the vertebra above their origin.

OOOOPQ The multifidæ of the spine, arising at OOOOP from the descending oblique processes of the vertebræ of the neck, partly externally tendinous, as marked at OOOO; the part O, from the descending process of the third vertebra, is wholly inserted into the spine of the descending process of the second vertebra of the neck, and the external part marked OO of the two vertebræ below that; so that there are originations from three different vertebræ which unite in their insertions in-

to one: the short parts, or those originations which are nighest their insertions, arise most internally, and those of a middling length, arise betwixt the long ones and short ones: the longest fibres, or those which arise most externally, have their insertions nighest the spinal processes, or their fellows on the other side; and the short ones nighest the oblique processes: those of a middling length have their insertions betwixt the two.

RTU Spinalis cervicis; R it's origin from the second spine of the back, which origin is continued for about one third of the way down that spine towards it's root: it arises also from the third spine or the ligamentum colli: near R it communicates with the semi-spinalis dorsi: T the part going to be inserted into the spinal process of the fourth vertebra of the neck; it is also inserted into the fifth spinal process; U the part going to be inserted into the spinal process of the sixth vertebra of the neck by a strong flat tendon: there is also a part under this which arises from the spine of the first vertebra of the back, from it's tip about half way down to it's root, and goes to be inserted into the spine of the seventh vertebra of the neck: it has an origination also from the ligament that goes from the spine of the second vertebra of the back to the first for it's whole length, which is inserted into the spines of the neck.

This might be called interspinalis dorsi et cervicis, because it's situation is entirely amongst the spines arising from those of the back to be inserted into those of the neck.

1 1 1 1 Branches of the cervical nerves.
2 2 Branches of the cervical arteries.
3 3 Branches of the cervical veins.
4 Part of the jugular vein.
5 Ligamentum colli.

In the Shoulder.

ab Sub-scapularis.
def Teres major; d it's origin from the inferior costa of the scapula; e a part externally tendinous, going to be inserted into the humerus betwixt the brachialis externus and caraco brachialis; f a part covered with communicating tendinous fibres, by which it and the fifth head of the extensor of the cubit are joined.

ghiikklm Longus minor, or the fifth extensor of the cubit; dg it's origin from the inferior angle of the scapula, and tendinous surface of the teres major; h shews some remaining fleshy fibres where the longus major was attached to it's flat tendon; ghiik it's flat tendon from which the fleshy part iil arises at ii, and runs towards the tendon m to be inserted into the inside of the ancon;

k shews the out-line of the tendon of the latissimus dorsi and membrana carnosa, which is inseparably joined to the teres major, and makes with it but one tendon, though the fibres from this muscle, in some measure, intersect those of the teres major, and are inserted into the humerus, making the upper angle of the tendon along with the upper part of the teres major. The fibres which come from the anterior part of the latissimus dorsi are inserted the highest (being intersected by the posterior part which runs over the inferior angle of the scapula) going to their insertion with the lower part of the tendon of the teres major.

no Brachialis externus; arises from the upper part of the os humeri betwixt the beginning of the brachialis internus and the tendons of the teres major; o the part where it begins to be tendinous and goes to be inserted into the extremity of the ancon.

ppq The inferior part of the serratus major anticus.
r Nervus cubitalis.
s Nervus radialis.
t Nervus musculo-cutaneus.
u Nervus medianus.
w Branches of the arteria and vena axillaris.

Muscles, &c. on the Trunk.

1 1, &c. 2 2, &c. The external intercostals; they arise at 1 1, &c. from the inferior edge and a little of the outside of each rib, the last excepted; they are a little tendinous, and descending obliquely downwards, are inserted at 2 2, &c. into the upper edge and a little of the outside of each rib, the first excepted.

3 3, &c. 4 4, &c. The internal intercostals: they arise at 3 3, &c. from the superior edge of the bony part of each rib except the first, not covering any of the outside, and from the edges of the cartilages of the ribs and a considerable part of the outside of them; they are chiefly externally tendinous, but partly fleshy, and ascending obliquely upwards, and forwards are inserted into the lower edge of the bony part of each rib, and into the edges and part of the outside of their cartilages, the last rib excepted.

5 5 5 5 5 Branches of the nervi costales, lying upon the transversales, which go to the abdominal muscles and integuments.

The nerves and blood-vessels which are marked on the thorax are those which were distributed to the parts taken off, as the obliquus internus and externus, latissimus dorsi, membrana carnosa, &c. and integuments; the nerves come from the nervi dorsales, and nervi lumbares; the arteries from the arteriæ intercostales infe-
L riores,

riores, and arteriæ lumbares, the veins from the venæ intercostales and venæ lumbares.

aabccdeeff The semi-spinalis and spinalis dorsi; aabeff semi-spinalis dorsi, which arises fleshy from all that space of the tendinous surface of the longissimus-dorsi that lies betwixt it's out-line marked a a, and the dotted out-line marked b d of the spinalis dorsi which lies under it, and then running over it's strong tendinous surface marked with dotted lines; b d e e communicates with it's fleshy fibres, and with them goes to be inserted into the spinal apophysis ff; it communicates with the spinalis cervicis, and is inserted under that part of it, R, which arises from the spine of the third vertebra of the back, or from the ligamentum colli: betwixt those two spines it sends a strong tendon also down to the spine of the first vertebra of the back; c c d spinalis dorsi, which arises by a strong ligamentous tendon under the semi-spinalis marked with dotted lines b d e e, which sends off fleshy fibres communicating with the semi-spinalis, and are inserted with it into the spines of the back ff; it is also inserted into the inferior ridge of the second spine of the back, which insertion is continued about half way down from the end towards the root, and into the spine of the first dorsal vertebra, beginning it's tendinous and fleshy insertion near the end, below the insertion of the tendon of the semi-spinalis, and continuing it for about half the length of that spine along it's inferior ridge: it's principal or strongest insertion is by a short, strong, roundish tendon into the spine of the seventh vertebra of the neck, which is the only part appearing as at c c d, the rest being under the scapula and semi-spinalis dorsi.

The semi-spinalis seems to make it's insertions into the extremities, or very near them, of the ten superior spines of the back, and the spinalis makes it's insertions all the way from the insertion of the semi-spinalis along their inferior ridges down to the insertions of the multifidæ spinæ, which is half the length of the seven uppermost, the insertion then diminishes till it comes almost to a point in the tenth spine: it's origin is entirely tendinous from the eleventh, twelfth, thirteenth, fourteenth, fifteenth, and sixteenth spinal processes of the back.

ghhiikkk Longissimus dorsi; g the tendon inserted into the transverse process of the seventh vertebra of the neck: it is inserted by distinct flat tendons into the transverse processes of the vertebræ of the back; the lateral part of it is inserted into the lower convex edge of all that part of the ribs that lies betwixt the sacro-lumbalis and elevators of the ribs, tendinous and fleshy; or it is inserted into the rib of those that appear from under the sacro-lumbalis and elevators of the ribs, (which are about

seven,) at it's protuberating part, where it joins to the vertebra, and then the insertion becomes in each rib gradually broader, partly tendinous, and partly fleshy, till it comes to the last rib, where it is about nine minutes broad: it is also inserted into all the transverse processes of the vertebræ of the loins the whole length of their inferior edges: it's externally tendinous part, near the spines, is very thick, but diminishing as it advances towards the sacro-lumbalis. The fleshy part h h appears through the tendinous surface of this muscle; it arises from the spine of the last vertebra of the loins, and from the three uppermost spines of the sacrum strongly tendinous, as well as from the superior posterior edge of the ilium i i, and fleshy from the inside of the ligament k k k, which is a very strong one, especially near the ilium; at b it arises fleshy from all the anterior side of the ilium which is behind the transverse process of the os sacrum.

lmnn, &c. o Sacro-lumbalis; l the part that arises from, or with, the longissimus dorsi by a small tendon: in this subject it receives originations by flat tendons about half the breadth of the muscle from the superior edge of all the ribs except two or three of the uppermost; and is inserted, by distinct flat tendons, into the inferior edge of all the ribs except two or three of the lowest; and into the transverse process of the seventh vertebra of the neck, as at o; n n, &c. mark it's insertions into the ribs, each tendon running upon the surface of the muscle over about three ribs below it's insertion; m the part externally fleshy.

Ppqrstu Transversalis abdominis; pp the part coming from it's origin from the transverse processes of the three or four uppermost vertebræ of the loins; at P it is joined by a tendinous origin from the spine of the ilium; p r it's origin from the lowest rib, which is continued down all the length of the inferior edge of the bony part of the rib from r to it's conjunction with the vertebra; Ppqrst it's fleshy part; u it's tendon which is inserted into the ensiform cartilage and linea alba. It is more fully explained in table the fourteenth.

w Arteria epigastrica, or the internal branch of the external iliaca.
xxx Branches of the nervi lumbares which go to the abdominal muscles and integuments.
yy The external branch of the outer iliaca in two ramifications, accompanied by the external branch of the outer iliac vein in two ramifications.
z Mammaria interna.

In the right lower Limb.

effg The iliacus internus; ff it's origin from the

ilium; at g it is tendinous on the surface; at e g it has an origin from the fascia lata: it joins in with the psoas magnus from it's origin, and is with it inserted into the little trochanter of the thigh bone. --- They seem to be but one muscle.

hikkkll Glutæus internus; h it's origin from the ilium, externally tendinous, inwardly fleshy; it is externally fleshy at i; at kkk are tendinous lines. It is inserted into the great trochanter at lkkkl.

pqqrst The large adductor of the thigh; p the flat tendon by which it arises from the ligament running from the sacrum and coccyx to the ischium; qq the beginning of the fleshy part on this side, externally tendinous; r the external fleshy part; s the place where it's thick belly begins to diminish, conforming to the belly of the gemellus; it is inserted by a strong tendon into the internal condyle of the os femoris behind the origin of the articular ligament and a little below it.

uw The gracilis; u the fleshy part; w the tendon.
xy Musculus parvus in articulatione femoris situs; x the fleshy part; y the tendon.

1 1 1 2 2 3 4 5 6 Cruralis; 1 1 1 it's origin by small flat tendons externally, but internally fleshy; 2 2 the place where the tendinous surface begins to disappear; 3 4 it's insertion into the patella and lateral ligament; at 3 it is partly divided for the reception of blood-vessels; and it's origin at 6 is confounded with the two vastii.

7 8 9 Vastus internus; 8 it's origin along with the cruralis from the femoris; 9 it's tendinous insertion into the patella; it has a fleshy insertion about half way up the femur into the external tendinous surface on the internal side of the cruralis; or these two may be joined together, and called but one penniform muscle, the tendon spoken of receiving the fleshy insertions of the vastus internus on one side, and on the other of that part of the cruralis marked 1 1 1 2 2 5 3; and the part 3 4 6 only may be called cruralis, being distinct from the patella up to the part 6, where, at it's origin, it is confounded with the fleshy fibres of the two vastii, the origin of these muscles, except 3 4 6 is from the upper part of the thigh bone, and continued down that bone to 6.

10 The lateral ligament of the external side of the patella which binds that bone to the external condyle of the os femoris.

11 The middle or anterior ligament of the patella which binds that bone to the tibia.

12 The lateral ligament of the internal side of the patella which binds that bone to the tibia.

13 13 The bursal ligament of the knee, betwixt which and

and that marked 34 in table the third, lie the mucilaginous glands.

14 14 15 16 17 18 19 20 Tibialis anticus; 14 14 it's origin from the superior and anterior part of the tibia; 15 it's tendinous origin from the inferior part of the os femoris: this is a very strong tendon, into which the fleshy part, which arises from the tibia at 14 14, begins to be inserted, after running down about one third of the length of the tibia; soon after which insertion fleshy fibres run from this, obliquely downwards and inwards, to be inserted into a flat tendon, which is a continuation of what may be called the proper and inferior tendon of the tibialis anticus marked 20: the internal or posterior part of this muscle, which is externally tendinous, makes a fleshy body much thicker than, or about twice as thick as, the anterior fleshy part: the superior part, running from the tibia obliquely downwards and outwards, and then from the external posterior surface obliquely downwards, is also inserted into the middle tendon: it ceases to be fleshy about the bottom of the tibia, where the internal or posterior tendon and middle tendon form the tendon 20, which is inserted into the ossa cuneiformia and metatarsal bone; the part 19 into the os cuboides, it divides for the passage of some blood-vessels and then unites again; and the part 18 into the ossa cuneiformia posteriorly running over the internal articular ligament as far back as the posterior edge of the splint bone.

23 24 25 25 26 26 27 27 Flexor digitorum pedis; 23 it's tendinous and fleshy origin from the fibula and articular ligament, and from the superior and posterior part of the tibia, which origination is continued near half the way down that bone from a considerable roughness; the protuberating parts of which give rise to the four or five tendinous parts composing this muscle: they intermix with the carnous part in this manner, the fibres descend obliquely downwards from the fascia 26 26 27 27 to be inserted into the tendon which lies next it; and that tendon receives the carnous fibres descending from the tendinous part which is next to it more internally; and that tendon sends fibres obliquely downwards to the next which is still more internal, and so on of the rest; one receiving fleshy fibres from each side, and that next it sending them off to each side, the external fascia only excepted, which sends fleshy fibres to this muscle only inwards, being the cover of this muscle: this fascia on the external side, where it is marked 26 26, gives origin to the fleshy fibres of the peronæus: it is joined by the fascia which arises from the internal posterior edge of the tibia when that fascia has run over the tibialis posticus, which it serves to bind down in it's proper place. There is some part of

17 17 18 The internal lateral ligament, which binds the patella to the os femoris; 18 it's origin from the os femoris; 17 17 it's insertion into the patella.

19 19 20 The internal lateral ligament, which binds the patella to the tibia; 20 it's origin from the tibia; 19 19 it's insertion into the patella. --- This is marked 12 on the left limb in this table.

21 22 The external lateral or anterior ligament, which binds the patella to the tibia, marked 11 on the left limb in this table; 21 it's origin from the tibia; 22 it's insertion into the patella.

23 24 The internal, lateral, articular ligament, which binds the tibia to the os femoris.

25 25 The bursal ligament of the knee, with some few of the mucilaginous glands left on which lie betwixt this ligament and that marked 15 15 15 15 in table the third.

26 Interosseus, &c.

27 28 An articular ligament.

34 The articular ligament of the fetlock joint.

35 The bursal ligament. This is a strong thick ligament, and about this place almost cartilaginous. To this the tendon of the extensor digitorum is strongly attached.

36 A bursal ligament.

37 An articular ligament.

the origin seen at 28 from betwixt the tibia and fibula: 27 27 The origin of the fascia which covers this muscle, which is strong and tendinous near it's origin, from the articular ligament, and fibula, or rather from the articular ligament which runs from the external condyle of the humerus all the way down the external side of the tibia, and by which the fibula is attached to the tibia, as well as by a ligament which arises from the external edge of the tibia and descends obliquely downwards to be inserted into the fibula; 24 the external part of this muscle where the fleshy fibres may be seen through the fascia; 25 25 the tendon.

28 29 Poplitæus; 28 the tendon arising under the articular ligament.

30 The articular ligament, which runs all the way down the fibula, and to the bottom of the tibia.

31 An articular ligament.

32 A ligament which binds the os calcis to the splint bone.

33 An articular ligament.

34 Arteria sciatica, accompanied with a vein.

35 35 Branches of the arteria glutæa, accompanied with veins and nerves.

36 A branch of the arteria obturatrix, accompanied with a vein.

37 A branch of the arteria obturatrix.

38 A branch of the vena cruralis, in which appear some valves.

39 A branch of the arteria poplitæa.

51 A branch of the vena poplitæa.

52 Arteria poplitæa.

53 Vena poplitæa, in which appears a valve.

54 Nerves going to the tibialis anticus. They are rami of the small sciatic branch.

55 Arteria tibialis anterior.

56 Vena tibialis anterior, in which appear some valves.

57 Glandula poplitæa, commonly called the pope's eye.

58 Vena saphæna.

59 The outer cartilage belonging to the coffin bone.

60 The inner cartilage belonging to the coffin bone.

40 41 42 42 43 44 45 49 The plantaris; 40 it's origin from the os femoris; 41 a place where the gemellus is attached to it by fleshy fibres; 42 42 the tendon inserted at 43 into the first bone of the toe; 49 a ligament arising from the os calcis and inserted into this tendon, which keeps it steady upon the end of that bone; 44 a ligament arising from the first bone of the toe, and inserted into this tendon; the ligament 45, which arises from the sesamoid bone, is not attached to it but runs over it, and serves as well as the ligament 44 to prevent it's starting from those bones when the joint is bent.

38 An articular ligament.

39 Branches of the vena tibialis anterior.

40 A nerve called sciaticus internus.

41 The inner cartilage belonging to the coffin bone.

In the right upper Limb.

abc Brachialis internus. It arises at *a* from the neck of the humerus, and the internal lower part of the scapula; *c* the part which goes to be inserted into the radius a little below the insertion of the biceps and more internally.

deffghi Flexor digitorum profundus; *de* the first or largest head, explained in table the third, with the other three heads of this muscle; *d* the fleshy part; *e* the tendinous part; *g h* the third described head; *g* the fleshy part; *h* the tendon; *i* the last described head, appearing here a little; *ff* the common tendon, inserted into the coffin bone.---See table fourteen for a fuller explanation.

k A ligament which runs down the small end of the ulna, to be inserted into the ligament or bones of the carpus, and to which the fascia is inserted on this side, which covers the bending muscles on the cubit.

lm Flexor digitorum sublimis; *l* a little of the fleshy part; *m* the tendon inserted into the great pastern.

The insertion 43 is but half of it's tendon, it being divided, and the other half inserted into the internal posterior edge of the same bone, leaving, by that division, a passage for the flexor digitorum pedis, which is seen at 25 lying betwixt the tendon of the plantaris and the bone.

46 A capsular ligament.

47 An articular ligament.

48 A capsular ligament.

49 A ligament which binds the tendon of the plantaris to the os calcis, and may be called part of the origin of the short flexor of the toes.

50 An articular ligament.

In the left lower Limb.

a Arteria cruralis.

b Vena cruralis.

hhi Poplitæus; *hh* it's insertion into the tibia externally tendinous; *i* the fleshy part coming from it's origin from the external condyle of the femoris which is marked 28 on the left limb in this table.

kllmnop Plantaris; *k* the fleshy belly; *llmn* the tendon; *o* a ligament arising from the os calcis and inserted into the tendon *m* of the plantaris, which it confines in it's place; it's fellow is marked 49 on the left limb in this table. This ligament may be called part of the origin of the short flexor of the toes; *n* it's insertion into the first bone of the toe; the external insertion is marked 43 on the right lower limb in this table; betwixt these insertions the tendon of the flexor digitorum pedis runs down to it's insertion into the coffin bone; *p* a ligament arising from the first bone of the toe and inserted into the tendon.

q A ligament which arises from one sesamoid bone and runs over the tendon of the plantaris to be inserted into the other, and serves to bind down that tendon.

1 2 3 Tibialis posticus; 1 the fleshy belly; 2 3 the tendon inserted into the tendon of the flexor digitorum pedis.

4 Flexor digitorum pedis, marked 23 24 25 25 26 26 27 27 27 on the right limb in this table.

10 11 12 13 15 16 Tibialis anticus; 10 the fleshy part marked 14 on the left limb in this table; 11 the part marked 16; 12 the part marked 19; 13 the part marked 18; and 15 is one tendon of the fleshy part of this muscle, inserted into the ossa cuneiformia posteriorly running over the internal articular ligament as far back as the posterior edge of the splint bone; the part 16 is inserted into the superior and anterior edge of the metatarsal bone; the part marked 13 runs under the tendon 15 to it's insertion into the ossa cuneiformia.

M 17 17 18 The

nnnn Articular ligaments.

ooo Bursal ligaments.

p Vena cephalica.

q Interosseus, &c.

r The outer cartilage belonging to the coffin bone.

In the left upper Limb.

abc Brachialis internus, made a little concave at *b* by the biceps; *c* it's insertion into the radius.

d Nervus medianus.

e Arteria brachialis.

f Vena brachialis.

g Vena cephalica.

i Flexor carpi radialis.

lm Flexor digitorum sublimis; *l* the fleshy part; *m* the tendon.

nopp Flexor digitorum profundus; *n* the head marked *g h* on the right upper limb in this table; *pp* the tendon.

qqqq Articular ligaments.

rrr Bursal ligaments.

s Interosseus, &c.

t The inner cartilage belonging to the coffin bone.

The fifth Anatomical TABLE of the Muscles, Fascias, Ligaments, Nerves, Arteries, Veins, Glands, and Cartilages of a HORSE explained.

In the Head.

a MUSCULUS septimus oculi suspensorius, arises from the margin of the hole through which the optic nerve passes into the eye, and is inserted (being divided into several fleshy portions) into the lower or posterior part of the sclerotica below the termination of the other muscles.

b Obliquus superior.

c The trochlea.

d Obliquus inferior.

e Attolens.

f Deprimens.

g Adducens.

h Abducens.

i The semi-lunar fold, formed by the conjunctiva, which incloses a sort of gland, the internal part of which is a thick and firm glandular substance terminating in fat; the external or lunar edge is broad and very thin, of a cartilaginous nature, before which lies the caruncula lacrymalis, or glandula lacrymalis inferior.

k The optic nerve, where the eye is cut away.

llmnnooop The glandulous membrane of the inside of the lips and cheek; *ooo* the part in which the buccinator is inserted, which is thicker than the rest and more free from glands; *llmp* the glands called glandulæ labiales; they are thickest near the corners of the mouth and beginning of the upper lip; *nn* Glandulæ buccales.

q The elevator of the chin.

1 Vena angularis.

2 Arteria angularis.

3 Nervi maxillaris inferioris; they are the third branch of the fifth pair of nerves.

4 5 6 Nervi maxillaris superioris; they are branches of the third branch of the fifth pair of nerves; 4 branches which go to the upper lip; 5 a branch which goes to the inside of the nostril towards the tip of the nose; 6 a branch which goes to the long nasal muscle of the upper lip.

7 8 9 The cartilages of the nose; 7 the middle portion; it is a broad cartilaginous lamina, joined by a kind

of symphysis to the anterior edge of the middle lamina of the os ethmoides, to the anterior edge of the vomer, and to the anterior part of the groove formed by the ossa maxillaria, as far as the nasal spines of these bones: this lamina compleats the septum narium of which it forms the principal part; 8 the anterior lateral cartilage which forms the tip of the nose, or the superior anterior part of the nostril; 9 the posterior and inferior lateral cartilage, or rather bone, for in aged horses it seems to be perfect bone, which helps to form the inferior part of the nostrils.

10 The anterior cartilage of the outer ear.

11 The outer ear.

In the Neck.

a Rectus anticus brevis, or minor; *a* it's origin from the lateral part of the body, rather anteriorly, and from the root of the transverse process of the first vertebra of the neck. It is inserted into the occiput in it's anterior process or appendix, or to the edge of the bone adjoining to it.

d Cricoarytanoidæus lateralis.

e Cricoarytanoidæus 331

e Cricoarytanoidæus pofticus.

f A very fmall part of the arytenoidæus.

ghhhh OEfophagus; *g* the membrane bared by taking away the lower conftrictor of the pharynx, and freed a little from it's attachment to the thyroid cartilage *i* to fhew the infertion of the cricoarytanoidæus lateralis.

ik The thyroid cartilage; at the lower procefs, tied to the crycoid cartilage by the ligament *m*.

l The annular, or crycoid cartilage.

n The ligament by which the thyroid or fcutiform, and the crycoid or annular cartilages are tied one to the other in the anterior part.

m A ligament which ties the lower procefs of the thyroid or fcutiform cartilage to the crycoid cartilage.

ooo Trachea arteria, afpera arteria, or wind-pipe.

pp The carotid artery, or carotis communis.

1 Arteria carotis externa, or the external carotid.

2 Arteria carotis interna, or the internal carotid.

qq The trunk of the eighth pair of nerves.

3 A branch of the eighth pair of nerves.

4 Arteria cervicalis, or the cervical artery.

5 Vena cervicalis.

rs Rectus pofticus brevis, or internus; *r* it's origin from the atlas; *s* it's infertion into the occiput.

tu Intervertebralis; *t* it's origin from the afcending oblique procefs of the third vertebra; *u* it's infertion into the lateral part of the body of the fecond.

uw, &c. The five inferior intervertebrales, which anfwer to the fame explanation as the fuperior, only that the loweft arifes from the fpace betwixt the oblique procefles of the uppermoft vertebra of the back, and the reft arife from the fuperior oblique procefles only: their anterior and inferior flefhy parts feem to be confounded with the intertranfverfarii pofteriores colli, but their upper and pofterior parts are diftinct, the nerves and blood-veffels coming from betwixt the vertebræ to go to the back of the neck running betwixt them.

xxxxy The multifidus of the fpine arifing at *xxxx* from the defcending oblique procefles of the vertebræ of the neck, externally tendinous; *y* it's uppermoft infertion into the fpine of the defcending procefs of the fecond vertebra of the neck. This is more fully explained in tables the fourth and fourteenth.

z One of the fcalenæ, or rather the elevator of the firft rib arifing at *z* from the tranfverfe procefs of the feventh vertebra of the neck. It is inferted into the firft rib.

1 2 2 3 4 5 6 6, &c. 7 8 8, &c. Ligamentum colli; it is a double ligament; 1 the fuperior or pofterior part, which begins to diftinguifh itfelf about the fifteenth fpine of the back on the lateral part of it's extremity, by being broader than the extremity of the fpine; from which projecting part the inferior part of the trapezius begins about the fourteenth fpine; it diftinguifhes itfelf about this place alfo by a fmall groove or channel that is formed betwixt it and it's fellow; but it's origin is not to be abfolutely fixed in this place, becaufe in conjunction with the interfpinal ligaments it runs down the back and loins, and probably to the end of the tail, joining both fides together, they are on the fpinal procefs of the vertebræ of the back, about one minute broad, or rather more, then extending in breadth as they arife from the fuperior vertebræ till they come to the third fpinal procefs, where they are about four minutes broad, they leave their origin in two diftinct portions, joined only by an intervening ligament, the fibres of which run in a tranfverfe direction from one part to the other; there is a deep groove or channel continued betwixt them for about one part and fix minutes, as they afcend towards the occiput, as far as 2; then diminifhing in breadth, they become almoft round, and infert themfelves into the occiput at 5 about two minutes diameter lying both clofe together; 3 the part of the ligament arifing from the fpines of the fecond and third vertebræ of the back; 4 an intervening ligament, which joins the two origins of the ligamentum colli together; 666666 the infertions into the fpinal procefles of the fuperior vertebræ of the neck; 7 the interfpinal ligament betwixt the firft and fecond vertebræ of the neck; 8888 a ftrong communicative membrane which fills up the opening betwixt the infertions of this ligament, on which fome ftragling filaments of the ligament are expanded.

13 13 14 15 The capfular ligament of the articulation betwixt the head and firft vertebra of the neck; 13 13 the part inferted into the firft vertebra; above 14 it is inferted into the occiput; 15 it's infertion into the long procefs of the occipital bone, which feems to be a confiderable addition to the mamillary procefs of the temporal bone.

16 The capfular ligament of the articulation betwixt the firft and fecond vertebræ of the neck; the pofterior part covers the fpinal marrow, the lateral part covers the articulating part of the fecond vertebra of the neck, where it is covered with a fmooth cartilage.

17 17 17 17 Shew the capfular ligaments of the articulations of the five inferior vertebræ of the neck, made by their oblique procefles: they arife free from the bone juft at the extremity of the oblique procefles, and continue their origin round the articulating cartilages.

18 18, &c. The vertebral veins, arteries, and nerves of the neck.

19 Part of the jugular vein.

In the Trunk.

ab, &c. The elevators of the ribs; they arife at *a* externally tendinous, from the tranfverfe procefles of all the vertebræ of the back (except the laft) and from the laft of the neck, to be inferted into the fuperior edge of all the ribs, each being inferted into the rib immediately below it's origin, and running from it's origin in a radiated manner; the pofterior part, or that next the fpine, running to the upper part of the rib almoft tranfverfely; the anterior part, or that fartheft from the fpine, running in an oblique direction downwards, to be inferted into the rib about nine minutes from it's articulation with the vertebra, for about ten of the inferior ribs; then they diminifh in length gradually, 'till the length of their infertion is but about fix minutes from their articulation at the uppermoft ribs.

cc, &c. *dd*, &c. Multifidi fpinæ; *cc*, &c. their tendinous originations from the tranfverfe procefles of the vertebræ of the back; *dd*, &c. their tendinous and flefhy infertions into the fpines of the back, loins, and facrum; their origins and infertions are both tendinous and flefhy, but at the external parts of the origins, from the extremities of the pofterior protuberances of the tranfverfe procefs, are the ftrongeft tendinous parts, the external tendon expanding itfelf as it advances towards the infertions, leaves it externally flefhy near the infertions; but upon fome of the fuperior fpines, particularly thofe which lie under the fcapula, it becomes externally tendinous near it's infertions; the infertions neareft the ends of the fpines are tendinous for the moft part, thofe of the loins forming a roundifh tendon about half a minute broad, and a quarter, or near it, thick.

ef The lateral mufcle of the tail arifing at *e* from the fpine of the laft vertebra but one of the loins; *f* the flefhy part; it goes to be inferted by a tendon into the oblique procefs of the third vertebra of the tail, and alfo into two or three of the lower ones, and then joins in with the elevating mufcles of the tail.

gg, &c. The inter-tranfverfe mufcles of the tail arifing from one vertebra, and inferted into the next, and fo on through the whole length of the tail. There are mufcles which arife from the upper or pofterior part of the tranfverfe procefles, and are inferted into the oblique procefles of the next but one or two below them.

h The ligament which runs over the fpines of the os facrum.

i The elevating mufcle of the tail, beginning its origin from the inferior or pofterior edge of the third fpinal procefs of the os facrum, which origin is continued from near the end of the fpine about half way towards it's root, it's origin

N

origin is continued flefhy from the fides, edges and interfpinal ligaments of the fpines of the facrum below that, from the whole length of the laft of them, and after paffing over one is inferted into the next oblique procefs, or next but one, below.

k The depreffing mufcle of the tail, beginning it's origin from under the tranfverfe procefs of the third vertebra of the facrum, and continuing from the tranfverfe procefles of thofe below from the whole breadths of them, and the inter-tranfverfe ligaments. The flefhy fibres are inferted into the bodies of the vertebræ or bones of the tail.

lll The lungs appearing through the pleura.

mmmnnn The diaphragm appearing through the pleura; *mmm* the flefhy part; *nnn* the tendinous part.

oo, &c. Nervi intercoftales.

pp, &c. Arteriæ intercoftales.

q The inteftines, feen through the peritonæum.

In the right lower Limb.

abc Mufculus parvus in articulatione femoris fitus; *a* it's round flefhy belly; *b* the flat tendon by which it arifes over the tendon of the rectus cruris; *c* the flat tendon by which it is inferted into the os femoris.

def The head of the rectus, left on to fhew how that mufcle arifes from the os innominatum, being hid in table the third under the glutæus medius, and glutæus internus, and in table the fourth under the glutæus internus; *d* it's origin from the external or pofterior part of the inferior fpine of the ilium, covered at *b* by the thin flat tendon of the mufculus parvus in articulatione femoris fitus; *e* it's origin from the anterior part of the inferior fpine of the ilium; *f* the place where the mufcle is cut off.

iiklo Iliacus internus; *ii* the anterior part arifing from the fpine of the ilium; *kl* pofterior part arifing at *kl* from the fafcia lata; *o* the tendon, inferted into the leffer trochanter; at *l* a fafcia arifes which runs over the pofterior part of this mufcle.

mnnoo Levator ani, coming from it's origin from the acute procefs of the ifchium near *m*; it is inferted at *nn* into the tranfverfe procefles of the fecond, third and fourth bones of the tail, and at *oo* into the internal fphincter ani.

p The internal fphincter ani.

ss The infertion of the pectinæus into the os femoris.

tu Sartorius; *t* the flefhy part, or rather the mufcle, which is flat and flefhy; *u* being only a fafcia by which the mufcle is confined in it's proper place.

T A fort of fafcia under which thefe nerves and blood-veffels lie, and to which they are attached as well as the neighbouring mufcles, and by that means kept in their proper places. The nerves and blood-veffels are marked as protuberating under it and feen through it.

wxx The gracilis; *w* the flefhy part; *xx* the fafcia by which it is confined in it's proper place.

z Part of the adductor of the thigh, arifing at *z* from the ifchium; it is inferted externally tendinous into the os femoris.

1 2 3 Obturator internus with the gemini; 1 the inferior of the gemini, arifing from the ifchium; 2 the tendon of the obturator internus coming from the infide of the ifchium; 3 the fuperior of the gemini going to it's infertion with the tendon of the obturator internus, and the other gemini into the internal lateral part of the great trochanter.

4 A tendinous fafcia arifing at 4 from the point of a little protuberance of the ifchium, which fpreading and defcending is attached to the adductor magnus; it ferves to bind down the tendon of the obturator internus, obliging it to lie in a concave form pofteriorly: it is a guard for the nerve which accompanies it (lying partly over it) preventing it's being over braced by that tendon's ftarting from the bone, by bringing itfelf into a ftreight line when in action.

10 11 11 The burfal ligament of the hip joint arifing at 10 from the os innominatum, at 11 11 from the neck of the os femoris.

13 13 Mark where the burfal ligament had it's origin from the os femoris, which inferts itfelf into the patella and tibia.

14 A ligament which binds the cartilage 15 to the tibia; behind 14 the top of the tibia is incrufted with a fmooth cartilage, which ferves the tendon of the popliteus to flide upon.

15 The outer femi-lunar cartilage in the joint of the knee.

18 19 The articular ligament of the knee; 18 it's origin from the os femoris; 19 it's infertion into the fibula.

20 A ligament which binds the fibula to the tibia.

21 The external lateral ligament which binds the patella to the os femoris.

22 The internal lateral ligament which binds the patella to the tibia.

23 The anterior ligament which binds the patella to the tibia.

24 Part of the tendon of the gemellus, which is inferted into the os calcis, cut off at 24.

25 A ftrong ligament which binds the os calcis to the fplint bone.

26 26 26 26 The external articular ligaments of the foot.

27 A ligament running from the aftragalus to the metatarfal bone.

28 Interoffeus, &c.

29 Iliaca minor.

30 Arteria glutæa.

31 Pudica communis.

32 32 Arteria obturatrix.

33 Arteria cruralis.

34 Vena cruralis.

35 Nervus cruralis.

36 Arteria poplitæa.

37 Vena poplitæa.

38 The outer cartilage belonging to the coffin bone.

39 The inner cartilage belonging to the coffin bone.

In the internal Side of the left lower Limb.

1 The internal lateral ligament of the patella, which binds that bone to the os femoris.

2 The internal lateral ligament of the patella, which binds that bone to the tibia, marked 22 on the right limb in this table.

3 The anterior ligament, which binds the patella to the tibia, marked 23 on the right limb in this table.

4 The internal articular ligament of the knee joint.

5 A ligament which binds the os calcis to the aftragalus and os naviculare.

6 6 6 6 The internal articular ligaments of the foot.

7 A ligament which runs from the aftragalus to the metatarfal bone, marked 27 on the right lower limb in this table.

8 Part of the tendon of the gemellus, which is inferted into the os calcis, cut off at 8.

9 Interoffeus, &c.

10 Arteria cruralis.

11 Vena cruralis.

12 The inner femi-lunar cartilage in the joint of the knee.

13 The outer femi-lunar cartilage in the joint of the knee.

14 The inner cartilage belonging to the coffin bone.

Mufcles, &c. on the right upper limb.

aab Subfcapularis; *b* it's infertion into the humerus.

c Interoffeus, &c.

ddd Ligaments which bind the orbicular bone to the radius, the bones of the carpus, and metacarpal bone.

eeee Articular ligaments.

f Nervus cubitalis.

g Nervus axillaris.

h Nervus radialis.

i Nervus

i Nervus musculo-cutaneus.
kk Nervus medianus.
ll Arteria axillares.
m Vena axillares.
n Vena cephalica.

o The outer cartilage belonging to the coffin bone.
p The inner cartilage belonging to the coffin bone.
In the internal Side of the left upper Limb.
aaaa Articular ligaments.
b Interosseus, &c.

c Nervus medianus.
d Arteria brachialis, or the humeral artery.
e Vena brachialis, or the humeral vein.
f Vena cephalica.
g The inner cartilage belonging to the coffin bone.

The sixth Anatomical TABLE of the Muscles, Fascias, Ligaments, Nerves, Arteries, Veins, Glands, and Cartilages of a HORSE, viewed in front, explained.

In the Head.

aabaab THE anterior muscles of the anterior cartilage: they arise under the epicranius thick and fleshy, and are inserted into the anterior angle of the anterior cartilage of the outer ear.

cc The lateral muscles of the anterior cartilage of the outer ear: they arise from above the orbits of the eyes; and are inserted into the anterior cartilages of the external ear.

dd The origenes. Their origin is, probably, from the epicranius; as they are not connected to the bone: they are inserted into the anterior cartilage.

ee The insertion of the middle parts of the retrahens, which is about one third of the way from the root of the ear to the tip; and about the middle of it's convexity.

ff Muscles which run from the anterior cartilage to the external ear.

hh Muscles which arise from under the lateral muscles *cc* in this table, and are inserted at the inferior angles of the openings of the ears anteriorly.

i The lateral depressor of the outer ear; arising from the quadratus colli, and inserted close by the lateral muscle of the anterior cartilage *c* in this table into the inferior angle of the opening of the ear posteriorly.

kkK The epicranius, or muscle of the scalp; K the tendinous expansion that goes to the elevators of the upper lip, and wings of the nose; *kk* the fleshy parts which run over part of the orbicular muscles of the eye-lids, and are inserted into the external skin.

lllₐmlllₐm The orbicular muscles of the eye-lids; ₐ the origin of the fibres from the ligament, by which the conjunction of the eye-lids in the great canthus is tied to the nasal part of the os unguis.

LL The corrugators of the eye-brows.

nnNN₄₄nnN The elevator of the upper lip and corner of the mouth: about the inner angle of the eye it arises from the bone: from *n* to *n* it arises from the epicranius; N N that part which is expanded under the dilator of the nostril and mouth; ₄₄ the part which runs over the dilator of the nostril and mouth, and is inserted

into the corner of the mouth.---- The part ₄₄ is the elevator of the upper lip; the part N N the elevator of the alæ nasi and upper lip.

o₃₅o₃ The zygomatici; ₃₅ it's origin from the orbicular muscle of the eye-lid; *o* the part which goes to be inserted into the corner of the mouth.

p The lateral dilators of the upper-lip and nostrils.

qqqr The orbicular muscle of the mouth; *r* fibres which intermix with the fibres of the long nasal muscles of the upper lip.

ss Part of the latissimus colli, which is inserted into the lower jaw bone.

tuu The tendons of the long nasal muscles of the upper lip; *t* the union of the tendons.

ww The anterior dilators of the nostrils.

xx Part of the membrana pituitaria, which lines the whole internal nares, the cellular convolutions, the conchæ, the sides of the septum narium, and, by an uninterrupted continuation, the inner surface of the sinus frontalis and maxillaris, and of the ductus lacrymalis, palati, and sphenoidalis: it is likewise continued down from the nares to the pharynx.

In the Neck, Breast, Shoulders and Trunk.

abcdefghss The quadratus genæ latissimus colli, or broad muscle of the neck; *a* it's origin from the sternum, a little below the top; *b* it's origin from the proper, or inverting membranes of the pectoral muscle, or from the membranous continuation of the membrana carnosa; over that muscle at *c* the fleshy parts of each side recede from each other; and are united only by the tendinous expansion *d*, which becomes fleshy again, or gives rise to fleshy fibres at *e*; *f* the part under which the jugular vein protuberates; *g* the part under which the sterno-mastoideus, or rather sterno-maxillaris, protuberates; *h* a part which runs over the levator humeri proprius; at *ss* it runs over the lower jaw, and is, about the lower *s*, inserted into that bone.

ikll The proper elevator of the humerus; *i* that

part which arises tendinous from the processus mastoideus, and by a tendinous membrane from the ridge of the occiput: this part alone may be called levator humeri proprius; and the part *k*, which lies partly under it and arises from the transverse processes of the four uppermost vertebræ of the neck, may be called musculus ad levatorem accessoris, being a distinct muscle 'till it comes to be joined with or inserted into the levator humeri proprius, just below the opening where the nerve *m* comes out; *ll* the part which goes to be inserted into the humerus along with the transverse or superior part of the pectoralis between the biceps, and brachiæus internus. ---- The part arising from the processus mastoideus, and ridge of the occiput is the anterior and superior part of the trapezius: it has the coracohyoideus strongly attached to it, which it confines in it's proper situation agreeable to the curvature of the neck.

mm Nerves.

nnoppqqr The pectoral muscle; *nno* the superior part which arises from the superior part of the sternum for about one third of it's length, and running in a transverse direction over the inferior part is inserted along with the levator humeri proprius by a flat membranous tendon into the humerus, betwixt the biceps and brachiæus internus; *ppqq* the part of this muscle which arises from the anterior and inferior part of the sternum for about two thirds of it's length, and runs down upon the muscles lying on the inside of the cubit; a little below *qq* it ceases to be fleshy; *r* the part which arises from the aponeurosis of the external oblique muscle of the abdomen, and is inserted into the head of the os humeri internally.

s Some of the superior parts of the trapezius. In this view none of the inferior parts can be seen.

ttuwwxxyyyzzzz&c&c&c Membrana carnosa; *tt* the posterior and inferior origin of the fleshy fibres; *u* the thickest part of this fleshy pannicle going to be inserted along with the latissimus dorsi and teres major into the humerus; *ww* large branches of veins which are spread in this mus-

O cle;

cle; *xx* the origin of the superior portion of the carnous fibres of this muscle, which are but very thin, all tending towards the cubit, and becoming a meer membrane as they pass the juncture of the elbow, are thus expanded over the muscles, &c. below, adhering in some places to the edges of the muscular ligaments or those ligaments which bind down the tendons of the muscles to keep them in their proper places; *yyyzzzz* the posterior and inferior tendino-membranous part which runs over the loins, back, and part of the abdomen; the parts lying under which protuberate, as the serratus major posticus at *yyy*, and the ribs at &c&c; it then goes down the lower limbs with, or is lost in the fascia of the latissimus dorsi, fascia lata, and other membranous expansions which are spread upon the muscles, &c. of the lower limbs.

In the upper Limb.

abbcdefghiiikkk The membranous continua-

tion of the fleshy pannicle down the upper limb, as it covers the muscles, &c. which lie upon that limb; *abb* the extensor carpi radialis; *a* the fleshy belly; *bb* the tendon; *c* the tendon of a muscle which is analogous to a combination of the abductor policis manus, extensor longus, and brevis policis manus, and indicator in the human body: it arises from the lateral part and ridge of the radius, and (in a horse, the thumb and fore-finger being wanting,) is inserted into the imperfect metacarpal bone of the fore-finger, or lost in the ligaments inserted into that bone, or rather attached to them before their insertion: *def* extensor digitorum communis; *d* the fleshy belly; *ef* the tendon; *g* extensor carpi radialis; *h* flexor carpi ulnaris; at *iii* this membranous expansion goes under the hoof; *kkk* vena cephalica, which arises from under the hoof, and falls into the jugularis externa, on the radius it is called vena radialis, and below that, vena plantaris.

l The hoof.

In the lower Limbs.

ABCDabcdeghhiik The membranous continuation of the fleshy pannicle down the lower limbs along with the fascia lata, &c. as they cover the muscles, &c which lie upon those limbs; A the musculus fascia lata protuberating; B vastus externus; C the patella; D the anterior ligament which binds the patella to the tibia; *a* the fleshy part of the tibialis anticus, making it's appearance through the fasciæ that cover it; *bcd* the extensor longus digitorum pedis; *b* the fleshy belly; *cd* the tendon; *e* a sort of tendon formed by these fasciæ, which joins with the tendon of the extensor longus digitorum pedis; *g* the fleshy belly of the peroneus; *hh* a branch of the crural vein, called vena saphæna, or saphæna major; *iik* the tendon of the plantaris;

l The hoof.

The seventh Anatomical TABLE of the Muscles, Fascias, Ligaments, Nerves, Arteries, Veins, Glands, and Cartilages of a HORSE, viewed in front, explained.

In the Head.

a THE anterior dilator of the nostril.

bcdd The lateral dilator of the nostril and upper lip; *c* it's origin; *dd* the part which is inserted into the nostril.

efgh The long nasal muscle of the upper lip; *f* it's origin; *g* it's tendon, where it unites with it's fellow; *h* it's insertion into the upper lip.

kk Ales naris.

lmno A muscle arising by a small tendon along with the long nasal muscle of the upper lip at *m*; *n* it's insertion by a small portion into the wing of the nose; *o* the principal part going to be inserted into the concha narium inferior.

p Part of the membrana pituitaria which lies upon the opening of the nares. See table six, *x*.

P Musculus caninus, or the elevator of the corner of the mouth.

QQQ The orbicular muscle of the mouth.

qrr Musculus ciliaris; *q* it's origin.

st The broad ligament of the eye-lids, which are membranous elongations formed by the union of the periostium of the orbit and pericranium, along both edges of each orbit.

uw The ball of the eye; *u* the pupil; *w* the iris.

xxy The temporal muscle; *xx* it's origin; *y* it's insertion into the coronary process of the under jaw bone.

z The masseter.

1 Arteria angularis.

2 Vena angularis.

3 The salivary duct.

4 Branches of the nervus maxillaris inferior: they are branches of the third branch of the fifth pair of nerves: they are accompanied with an artery from the temporal artery which communicates with the arteria angularis.

In the Ear.

ab A muscle arising at *a* from the anterior cartilage, and inserted at *b* into the external ear.

c A muscle which arises by two fleshy heads from the internal surface of the anterior cartilage, and is inserted into the lower convex part of the external ear near the root, nearer the posterior edge than the anterior: it assists the posterior part of the retrahens in action.

d A muscle which is a sort of antagonist to *c*; it arises from the ridge of the occiput under the retrahens, and is inserted into the ear at *d*: it helps to turn the opening of the ear forwards.

f The anterior cartilage of the outer ear.

g The outer ear.

In the Neck.

abc Sterno-mastoideus, or sterno-maxillaris, because it arises at *a* from the top of the sternum, and is inserted tendinous into the lower jaw bone under the parotid gland, and by a continuation of the same flat tendon into the root of the processus mastoideus.

dd Caracohyoideus arises from the upper and internal side of the humerus, betwixt the insertions of the subscapularis and teres major by a flat membranous tendon, and is inserted into the os hyoides; it has a strong attachment to the anterior part of the levator humeri proprius, or rather the anterior part of the trapesius, by which it is confined in it's proper place, being prevented forming a streight line when the neck is curved.

ee Longus colli.

ff Scaleni.

gh Inter-transversalis minor colli.

iklm Serratus major anticus; *i* the part which arises from the transverse processes of the third and fourth vertebræ of the neck; *k* that from the fifth, *l* that from the sixth, *m* that from the seventh: it is inserted into the scapula. Betwixt these parts are marked arteries and nerves which go to the parts lying over them.

nnoo The jugular veins; at *oo* are valves.

p Glandulæ cervicales inferiores. See table second, 5.

In the Shoulders and Trunk.

abc Serratus minor anticus arises from the sternum and part of the first rib, and from the cartilaginous endings of the second, third, and fourth ribs near their joining to the sternum : it is inserted into the superior costa near the basis of the scapula and tendinous surface of the supra-spinatus ; and is connected to the teres minor by a fascia, which is sent from this muscle over the infra and supra-spinatus scapulæ to it's outer edge. It's flat tendon may be separated, some part of the way, to the basis and spine of the scapula, from the tendinous surface of the supra-spinatus scapulæ.

ddeeffggh Pectoralis ; *ddee* the superior part arising from the sternum at *dd*, which is, at *ee*, going to be inserted, by a flat membranous tendon, along with the levator humeri proprius into the humerus, together with or betwixt the biceps and brachiæus internus ; *ffgg* the part of this muscle which arises from the anterior part of the sternum at *ff*, thence running towards the muscles lying on the cubit ceases to be fleshy about *gg*, and sends a membranous tendon or fascia down the muscles on the inside the cubit, which is joined by the membrana carnosa ; *h* the part which arises from the aponeurosis of the external oblique muscle of the abdomen, and is inserted into the head of the os humeri internally.

ikklmn Supra-spinatus scapulæ ; *kk* it's origin from the spine of the scapula ; *l* it's insertion into the head of the os humeri and capsular ligament on the inside of the biceps cubiti ; *m* it's insertion into the head of the os humeri and capsular ligament on the outside of the biceps cubiti.

opq Infra-spinatus scapulæ ; *q* the tendon by which it is inserted into the protuberating part of the humerus.

r Teres minor.

ssttuw Latissimus dorsi ; *ss* the aponeurosis, or tendon of this muscle ; *tt* the origin of it's fleshy fibres ; *u* a fleshy part of this muscle, which runs over the inferior angle of the scapula ; *w* the fleshy part going to be inserted into the humerus.---The serratus major posticus protuberates a little under the aponeurosis of this muscle.

x Coraco-radialis.

yz Triceps brachii ; *y* the head, called extensor longus ; *z* extensor brevis.

1 1 1, &c. *2 2 2*, &c. *3 3 4 4 4 5 6 6* Obliquus externus, or descendens abdomenis ; it's superior origin is from the fifth rib : about *1 1 1*, &c. it begins it's origin from the ribs and intercostals, and continues it down to about *2 2 2*, &c. where it ceases to adhere to them ; *4 4 4* the fleshy part which does not adhere to the ribs, and intercostals ; *3 3* mark the fleshy fibres arising from

the fascia lata ; *5* the fleshy part of this muscle which lies over the abdomen ; *6 6* part of it's insertion into the spine of the ilium.---Upon this muscle are marked a great many small branches from the intercostal arteries which go to the membrana carnosa and integuments.

7 7 Longissimus dorsi.

In the upper Limbs.

aabcdefghi A fascia or strong membranous production, lying over the extending muscles which are upon the cubit : *aa* it's origin from the two external protuberating parts of the humerus, from the levator humeri proprius, from the trapezius, and from the anterior edge of the triceps : it is expanded like a strong ligament betwixt the two protuberating parts of the humerus, and gives origin to some of the fleshy fibres of the extensor carpi radialis ; it is inserted into the radius on each side of the extending muscles, and into the muscular ligaments on the carpus ; it makes a continued case for the extending muscles from their originations down to the carpus, and confines them steady in their proper places ; there lies protuberating under it, at *abcdef*, the extensor carpi radialis, of which *bcd* mark the fleshy part ; *ef* the tendinous, which is inserted at *f* into the metacarpal bone ; at *g* the muscle protuberates, which is analogous to the extensors of the thumb in the human body, and at *hi* the extensor digitorum communis of which *h* is the fleshy part ; *i* the tendon.

klm The tendon *i* inserted at *k* into the coffin bone ; at *lm* into the great pastern or first bone of the finger.

nn Ligaments which confine the tendon of the extensor digitorum communis down to the great pastern, which is analogous to the first bone of the finger in the human subject : they are sent from the interosseus, &c.

op An expansion which arises from the external articular ligament betwixt the humerus and cubit and from the olecranon ; it receives an addition from the longus minor and then descends over the bending muscles to form the ligaments on the carpus to which it is attached, as well as to the bones of the cubit on each side of the bounds of the bending muscles ; there lies protuberating under it at *o*, the flexor carpi radialis ; and at *p* flexor carpi ulnaris.---- It forms the ligament which binds down the tendons of the bending muscles on the carpus, and descends more than half way down the splint bones, then degenerates into a membrane, and joins the ligament which arises from the sesamoid bones.

qr Vena cephalica : it arises from under the hoof and falls into the jugularis.

ss Vena plantaris.

t Nerves which go to the integuments.

u A ligament proper to the tendon of the extensor digitorum communis, inserted, at two protuberating parts of the radius, on each side the channel in which the tendon lies.

wxyy A ligament whose fibres run in a transverse direction over the anterior part of the carpus, to which the carnous membrane adheres at *w*, and the bursal ligament which lies under it about *x* : it seems to arise from the fascia which covers the bending muscles on the cubit, and the articular ligaments protuberating under it at *yy*.

zz The articular ligaments of the fetlock joint.

& A substance resembling the villous surface of a mushroom, arising from the coffin bone, received by the like substance arising from the hoof, which it mutually receives.

In the lower Limbs.

a Part of the gluteus externus.

bbbcd Gluteus medius ; *bbb* it's origin from the tendinous surface of the sacro-lumbalis ; *c* it's origin from the ilium.

cfghik Musculus fascia lata ; *e* the posterior fleshy belly ; *f* the fleshy part lying betwixt the two fleshy bellies ; *ghik* the broad tendon ; at *g* it is covered by the fascia lata, which, in this place, is inseparably united with it, but ceases to adhere to it betwixt *g* and *h*, where it is cut off ; at *i* the tendon of this muscle is inserted into the tibia ; at *gh* the vastus externus protuberates ; at *k* the patella ; and betwixt *k* and *i* is the external anterior ligament which binds the patella to the tibia.

lmnopqrssst Biceps cruris ; *lm* the anterior fleshy part, which is inserted into the patella near *m*, and by a strong tendon *mn* into the tibia at *n* ; the part *m* lies under the flat tendon of the middle part *o*, which joins the flat tendon of the musculus fascia lata ; *o* the middle part of this muscle going to be inserted into the anterior and superior ridge of the tibia, and the tendon of the anterior part running from the patella to *i* ; *pqrssst* the tendon of the posterior part of this muscle, which is inserted at *sss* into the anterior ridge of the tibia, and under which protuberates, at *p*, the extensor longus.

uuuwwxz 1 2 2 The tendon of the extensor longus digitorum pedis, of which *p* is the fleshy belly ; and *uuuwwx* the tendon inserted at *u* into the coffin bone, and at *ww* into the great pastern or first bone of the toe ; *x* at the place where the fasciæ are cut off which join in with this tendon ; at *q* the tibialis anticus protuberates under the tendon of the biceps cruris, of which *q* is the fleshy part, and *z 1* the tendons protuberating under the ligaments ; at *r* the peroneus protuberates, of which *r* is the fleshy part, and *22* the tendon which joins in with the long extensor of the foot.

P 3 Extensor

5 Extensor brevis digitorum pedis arises tendinous from the upper part of the anterior protuberance that stands forwards from the calcaneum, and soon becoming fleshy is inserted fleshy and tendinous into the tendon of the long extensor digitorum pedis a little above that tendon's being joined by the peroneus.

4 A ligament common to the extensor longus digitorum pedis and tibialis anticus ; it receives a little of the insertion of the biceps cruris into it's superior edge internally ; the part *4* is the strongest part of it : it arises from the tibia close to the insertion of the flat tendon of the biceps with which it is united : it's fibres run obliquely downwards and outwards from the internal edge of the tibia to the external.

5 A ligament proper to the extensor longus digitorum pedis protuberating under the membranous ligament.

6 A ligament common to the extensor longus digitorum pedis with the tendon of the peroneus : it arises from the

bones of the tarsus and splint bone, and is inserted into the anterior and superior part of the metatarsal bone, and running membranous over the ligament *5* joins the ligament *4* ; it's tendinous fibres run chiefly transverse, but some scattered irregular tendinous stripes from about *7* run obliquely downwards and inwards : there is an expansion running to this from the fascia which covers the flexor digitorum over the peroneus which compleats a case for that muscle.

7 A ligament which binds down the tendon of the peroneus ; it runs from the tibia to the os calcis : it is marked *3 4* in table the second.

8 8 A sort of ligamentous fascia, betwixt which and the bursal ligament the mucilaginous glands are contained ; it is attached above, to the ligament *4*, and below, to the ligament *6*, on the inside to the articular ligament.

9 10 10 Interosseus, &c. it is like a strong ligament arising from the upper part of the metatarsal bones, and

some of the tarsal bones, and is inserted into the sesamoid bones and first bone of the toe on each side, and sends off the ligaments *10 10* to the tendon of the extensor longus digitorum pedis.

11 The tendon of the flexor digitorum pedis.

12 12 The tendon of the plantaris.

13 13 Vena saphæna.

14 Vena plantaris externa.

15 Vena plantaris interna, or a continuation of the vena saphæna.

16 The vena plantaris arising from under the hoof.

17 The tendon of the gemellus, or tendo achilles, inserting itself into the os calcis, covered by the fasciæ which are inserted into the os calcis.

18 Tibialis posticus.

19 A substance resembling the villous surface of a mushroom, arising from the coffin bone, received by the like substance arising from the hoof, which it mutually receives.

The eighth Anatomical TABLE of the Muscles, Fascias, Ligaments, Nerves, Arteries, Veins, Glands, and Cartilages of a HORSE, viewed in front, explained.

In the Head.

a THE anterior dilator of the nostril ; the superior part is inserted into the superior edge of the alæ nasi, the middle part *a* into the cartilage, and the lower part into the anterior edge of the nostril below the anterior lateral cartilage, and above the posterior and inferior lateral cartilage.

bcD A muscle which arises by a small tendon along with the long nasal muscles of the upper lip, and from the musculus canini, or is attached to it by a membranous tendon which runs over the nerves *1 1 2 3* : it is inserted into the wing of the nostril, but chiefly into the concha narium, or pituitary membrane which incloses the concha narium inferior ; *b* it's origin ; *c* the fleshy part which goes to be inserted into the concha narium ; at *D* those few fibres are cut away which were inserted into the wing of the nose ; it is inserted into the alæ nasi fleshy all the length of it's inferior edge.

dd Orbicularis oris.

e Canini, the elevators of the corners of the mouth.

f The masseter.

ggh The temporal muscle ; *gg* it's origin ; *h* it's insertion into the coronary process of the under jaw bone.

i Part of the membrana pituitaris. See table the sixth *x*.

K The alæ narium.

kl The eye-ball ; *k* the pupil, *l* the iris.

mnn Musculus ciliaris ; *m* it's origin.

o The elevator of the eye-lid, so thin and transparent that the white part of the eye is seen through it, and the tunica adnata, or conjunctiva, which lies under it, as well as the tendon of the streight muscles of the eye.

1 1 2 9 Nervus maxillaris superior, the second branch of the fifth pair of nerves ; *1 1* branches going to the upper lip ; *2* a branch which goes to the inside of the nostril towards the tip of the nose ; *9* a branch which goes to the long nasal muscle of the upper lip.

3 Branches of the nervus maxillaris inferior ; they are branches of the third branch of the fifth pair of nerves ; and accompanied with an artery from the temporal artery which communicates with the arteria angularis ; the nerve also communicates with the nervus maxillaris superior.

4 Arteria angularis.

5 Vena angularis.

6 The salivary duct.

7 The anterior cartilage of the outer ear.

8 The outer ear.

In the Neck.

ab Sterno-thyroideus ; *a* it's origin from the sternum internally ; it's insertion is into the thyroid cartilage.

cd Caracohyoideus ; *c* the flat membranous tendon

coming from it's origin from the upper and internal side of the humerus, betwixt the insertions of the subscapularis and teres major : it is inserted into the os hyoides : *d* the fleshy part : it is attached to the anterior part of the trapezius, which prevents it's starting into a right line when the neck is curved : it has an attachment to the rectus anticus major, or an origin by a flat tendon along with it's insertion from the os sphenoides.

f Scalenus ; it arises from the transverse processes of the fifth, sixth, and seventh vertebræ of the neck, and is inserted into the first rib.

gg The inferior part of the transversalis cervicis : it arises from the transverse processes of eight of the superior vertebræ of the back, and from the fascia betwixt that and the broad tendon of the complexus, &c. by fleshy fibres : it is inserted into the transverse processes of the four inferior vertebræ of the neck partly fleshy, but chiefly by broad thin tendons, as *gg*.

h The superior part of the transversalis cervicis, which arises from the third, fourth, fifth, sixth, and seventh oblique processes of the neck, and the two uppermost of the back, viz. beginning at the lower oblique process of the third and at the uppermost of the fourth, and so of the rest. It is inserted into the transverse process of the first vertebra.

i Part of the trachelo-mastoidæus, complexus minor, or mastoidæus lateralis, which arises from the oblique processes

ceffes of the third, fourth, fifth, fixth, and feventh vertebræ of the neck, the uppermoft of the back, and tranfverfe proceffes of the fecond and third vertebræ of the back. It is inferted tendinous into the root of the proceffus maftoidæus.

k Arteria carotis.

l Part of the jugular vein.

In the Trunk.

aabc Mufculus in fummo thorace fitus, arifes at *aa* from the firft rib, and is inferted into the fternum about the root of the cartilage of the fourth rib; at *b* the edge *c* joins in with the rectus abdominis of which this mufcle feems to be a continuation.

ffgghhiii Serratus minor pofticus; *ffgg* the broad tendon by which it arifes, cut off at *ff* to fhew the gluteus medius; *gghh* the flefhy part, beginning at *gg*; *iii* the flat tendons by which it is inferted into the ribs: it's firft infertion is into the fifth rib. In fome fubjects this mufcle runs flefhy under the ferratus major pofticus, and is inferted into the ribs from the fifth to the fourteenth.

FFG The ferratus minor anticus arifing from the fternum and cartilages of the four fuperior ribs at FF.

kkllmm, &c. Serratus major pofticus; *kkll* it's broad tendon, cut from the tendon of the latiffimus dorfi at *kk*; *llmm*, &c. the flefhy part, inferted into the ribs at *mm*, &c. it is, in fome fubjects, inferted into eight inferior ribs, in others only into feven.

H Supra-fpinatus fcapulæ.

I Infra-fpinatus fcapulæ.

nop Longiffimus dorfi; *n* the ftrong thick part of it's tendinous furface; *o* the thin part of it's tendinous furface, through which the flefhy fibres make fome appearance; *p* it's fuperior tendon, inferted into the tranfverfe procefs of the feventh vertebra of the neck.

qrst Sacro lumbalis; *q* the part arifing by a fmall tendon along with the longiffimus dorfi; *r* it's uppermoft infertion into the tranfverfe procefs of the feventh vertebra of the neck; *s* it's infertion into the firft rib; *t* that into the fecond.

yy, &c. *zz*, &c. 1 1, &c. 2 2, &c. The external intercoftals; *yy*, &c. *zz*, &c. the anterior part over which the external oblique mufcle of the abdomen runs without adhering; *zz*, &c. 1 1, &c. the part to which the external oblique mufcle adheres, which is about as extenfive as it's origin from the ribs; 2 2, &c. the parts which lie above the adhefion of the oblique mufcle of the abdomen.

3 3, &c. Flefhy fibres which arife partly externally, ten-dinous, but chiefly flefhy, and run in a tranfverfe direction from one rib to another.

4 4, &c. Parts of the internal intercoftals.

5 5 6 6 7 Obliquus internus, or afcendens abdominis; 5 5 it's origin from the fpine of the ilium, tendinous, and flefhy: it's origin is continued to the ligamentum fallopii; it is alfo continued from the faid ligament and fymphifis of the os pubis: 6 6 it's infertion into the cartilage of the loweft rib partly tendinous: it is likewife inferted into the cartilaginous endings of the ribs as far as the cartilago enfiformis.

8 9 9 Some appearance of the tranfverfalis abdominis.

10 10, &c. Some branches of the nervi lumbares.

1 1 A branch of the external branch of the outer iliac artery, accompanied by 1 2.

1 2 A branch of the external branch of the outer iliac vein.

1 3 1 3, &c. Branches of the arteriæ intercoftales inferiores.

1 4 1 4, &c. Branches of the arteriæ intercoftales fuperiores.

1 5 1 5, &c. Branches of the arteriæ lumbares.

In the Shoulders and upper Limbs.

A Nervus mufculo-cutancus.

B Nervus medianus.

C Nervus cubitalis.

D Nervus radialis.

E Nervus axillaris.

F Vena axillaris.

abc Subfcapularis, which is outwardly tendinous; *a* marks the place where the membranous tendon is cut off, by which the fupra-fpinatus receives fome origin from the furface of this mufcle; *b* marks a tendinous flip fent from this mufcle which leaves it about *c*, and is inferted into the proceffus coracoides: it ferves to guard fome nerves which pafs under it.

de The internal part of the pectoralis, coming at *d* from it's origin from the aponeurofis of the external oblique mufcle of the abdomen; *e* it's infertion into the head of the os humeri.

fgh Triceps brachii; *f* the head called extenfor longus, arifing from the inferior cofta of the fcapula; *g* the head called extenfor brevis, arifing from the humerus and expanfion which covers the extending mufcles on the cubit; *h* the part going to be inferted into the ancon.

iklmn Biceps brachii, or rather coraco-radialis; *i* it's origin from the proceffus coracoides fcapulæ; *k* a flefhy part lying upon the tendon; *l* the external belly; *m* the internal belly; *n* the aponeurofis arifing from this mufcle

which it fends to the tendinous fafcia, or covering of the cubit, and tendon of the extenfor carpi radialis.

o Part of the brachialis internus: it arifes from the neck of the humerus and internal lower part of the fcapula; and is inferted into the radius a little below the infertion of the coraco-radialis, but more internally.

pqrstuwxy Extenfor carpi radialis; *p* it's origin from the fuperior external protuberating part of the humerus; *q* fome of the part which arifes flefhy from the fafcia which is extended betwixt the two external protuberating parts of the os humeri: it arifes above the part *q*, and ligament or fafcia from the external ridge of the external condyle all the way up as far as the brachialis internus does not cover: but it's moft confiderable origin is from the anterior part of the external condyle of the humerus; from which place it continues it's origin into the great cavity on the anterior and inferior part of that bone, from whence it arifes by a very ftrong tendon, firmly adhering to the tendon of the extenfor digitorum communis. ---- The origin of this mufcle is as extenfive as the originations of the long fupinator, radialis longus and brevis in the human body: it appears to be a combination of all the three; it is affifted by the biceps, the fafcia of which is like a ftrong flat tendon inferted into this mufcle; *rst* the flefhy part; *uwx* the tendon inferted into the metacarpal bone at *w*; about *x* it adheres to the burfal ligament; *y* marks the place where the fafcia, proper to the extending mufcles on the cubit, is cut off from the fafcia of the biceps mufcle *ny*, which it joins, to be inferted, along with it, into the tendon of this extenfor carpi radialis.

zz A ligamentous fafcia.

1 2 2 3 4 5 6 6 Extenfor digitorum communis; 1 the flefhy belly which arifes from the external condyle of the humerus, the upper and lateral part of the radius and fafcia which covers the extending mufcles on the cubit; but it's principal origin is by a ftrong flat tendon from the anterior part of the external condyle of the humerus; from which place it continues it's origin into the great cavity on the anterior and inferior part of that bone called it's anterior foffula above it's articulation with the radius; it lies under the extenfor carpi radialis, to the tendon of which it adheres for about three minutes from it's beginning as well as to the burfal ligament which lies under it: 2 2 3 4 5 6 6 the tendon; 3 the part which is inferted into the coffin bone; 4 the infertion of a flip of this tendon, along with the tendon of the extenfor minimi digiti, into the great paftern, externally; 5 the infertion of a flip of this tendon into the great paftern internally; 6 6 the infertions of the ligaments into this tendon, which bind it down to the great paftern.

Q 7 7 8 The

7 7 8 The mufcle which is analogous to the extenfors of the thumb in the human body; 7 7 the flefhy part arifing from the lateral part and ridge of the radius; 8 the tendon going to be inferted into the internal fplint: it is a combination of the abductor pollicis manus, extenfor longus and brevis, pollicis manus, and indicator.

9 Flexor carpi radialis, arifes from the inner condyle of the humerus and is inferted into the internal fplint bone.

10 Flexor carpi ulnaris internus; that part of it which arifes from the internal protuberance of the humerus.

1 2 Vena cephalica, it arifes from under the hoof (where it is called vena plantaris) and falls into the jugularis.

1 3 1 3 The burfal ligament, belonging to the anterior part of this joint.

1 4 1 4 The articular ligaments of the carpus.

1 5 1 5 The articular ligaments of the fetlock joint.

1 6 Vena plantaris.

In the lower Limbs.

abbbcd Gluteus medius; *bbb* it's origin from the tendinous furface of the facro-lumbalis; *c* it's origin from the ilium; near *d* it is inferted into the great trochanter of the thigh bone.

efG Vaftus externus; *e* it's principal flefhy part, inferted at *f* into the patella; G the thin flefhy part, inferted into the external lateral ligament of the patella.

ghik Tibialis anticus; *g* it's origin from the fuperior, and anterior part of the tibia; it arifes alfo by a very ftrong tendon from the inferior part of the os femoris into which the flefhy part, arifing from the tibia about *g*, is inferted, having firft run down about one third of the

length of the tibia, after which infertion flefhy fibres arife from the tibia and run obliquely downwards and inwards: the internal furface of this mufcle, which is externally tendinous and arifes from the tibia, fends off flefhy fibres obliquely downwards and outwards, which form a belly about twice as thick as thofe from the external tendon, which they meet, and with it form the tendon *h*, which is inferted into the fuperior and anterior edge of the metatarfal bone, and into the offa cuneiforma: the external tendinous furface of this mufcle, which arifes from the os femoris, divides about the bottom of the tibia into two parts *i* and *k*, which ferve as ligaments to keep the tendon *h* from ftarting from the tibia when this joint is bent: the part *i* is inferted into the leffer cuneiform bones of the tarfus, pofteriorly running over the internal articular ligament as far back as the pofterior edge of the fplint bone; and the part *k* is inferted into the os cuboides: it divides for the paffage of fome veffels, and then unites again.

lmnnopqrstt Extenfor longus digitorum pedis; *l* it's origin from the os femoris along with the ftrong tendon of the tibialis anticus, to which it is infeparably joined near it's origin: it arifes alfo from the tibia: *m* it's flefhy belly; *nn* it's tendon, joined at *o* by the tendon of the peroneus; with part of which it fends off a flip to be inferted into the firft bone of the toe, or great paftern at *p*; at *q* it is joined by the fafciæ, which are here cut off, and fends with them a flip which is inferted into the great paftern at *r*; *s* the principal part of the tendon going to be inferted into the coffin bone; *tt* the infertions of the

ligaments into this tendon, which bind it down to the great paftern.

uu Extenfor brevis digitorum pedis.

wxx Peroneus; it arifes from the external articular ligament, which runs from the external condyle of the femoris down the fibula, and from the fafcia or tendinous covering of the flexor digitorum pedis; *w* it's flefhy belly; *xx* it's tendon, which joins in at *o* with the tendon of the extenfor longus digitorum pedis.

y Tibialis pofticus, arifes from the external fide of the pofterior part of the head of the tibia, and from the tendinous furface of the flexor digitorum pedis; the tendon of which mufcle it joins in with, after running through a groove on the internal fide of the heel.

z The tendon of the gemellus.

& The tendon of the plantaris.

1 Arteria tibialis anterior.

2 Vena faphæna.

3 Vena plantaris externa.

4 Vena plantaris interna.

5 A ligament proper to the extenfor longus digitorum pedis.

6 6 A burfal ligament.

7 8 Articular ligaments.

9 The interoffeus, &c. it is like a ftrong ligament arifing from fome of the tarfal bones, and the upper part of the metatarfal bones; and is inferted into the fefamoid bones of the fetlock joint, and upper parts of the great paftern on each fide, and fends off the ligaments 10 10 to the tendon of the extenfor longus digitorum.

The ninth Anatomical TABLE of the Mufcles, Fafcias, Ligaments, Nerves, Arteries, Veins, Glands, and Cartilages of a HORSE, viewed in front, explained.

In the Head.

a THE anterior dilator of the noftril.

ef The fhort nafal mufcle of the upper lip.

gg The orbicular mufcle of the mouth.

hhhiik Caninus, or the elevator of the corner of the mouth; *hhh* it's origin from the upper jaw bone; *ii* it's infertion into the buccinator; *ik* it's infertion into the orbicularis oris.

llm Part of the buccinator; it arifes from three different places: the fuperior fibres arife from the alveoli of the upper jaw; the middle fibres from the ligamentum inter maxillaris, and the inferior ones from the lower jaw:

it is inferted into the glandulous membrane of the infide of the check and lips; and at *m* into the orbicularis oris.

nop The globe, bulb, or ball of the eye; *n* the pupil; *o* the iris; *p* the white of the eye, or tunica fclerotica, covered with the albuginea, or tendons of the ftreight mufcles only.

q One of the lachrymal glands placed in the great canthus of the eye, called caruncula lachrymalis, and glandula lachrymalis inferior.

r The femi-lunar fold, formed by the conjunctiva.

s Attollens; it arifes from the bottom of the orbit near the foramen opticum, from the elongation of the

dura-mater by a fhort narrow tendon, and is inferted into the tunica fclerotica forming the albuginea.

t Deprimens; it arifes and is inferted as the attollens, only the attollens is on the fuperior, and the deprimens on the inferior part of the globe.

u Adducens; it has it's origin betwixt the attollens and deprimens, and is inferted betwixt them lying on the internal fide of the globe: it's tendon is joined by the attollens above, and deprimens below; and on the external fide of the globe, thofe two mufcles are joined in like manner before they reach the cornea, by the abducens; thefe four ftreight mufcles altogether forming the tunica albuginea

335

ginea, are inserted into the tunica sclerotica near the edge of the cornea lucida.

w Obliquus inferior.

xyz Nervi maxillares superiores; they are branches of the third branch of the fifth pair of nerves; *x* branches which go to the upper lip; *y* a branch which goes to the inside of the nostril towards the tip of the nose; *z* a branch which goes to the long nasal muscle of the upper lip.

1 Arteria angularis.
2 Vena angularis.
3 The anterior cartilage of the outer ear.
4 The outer ear.

In the Neck.

ab Sterno-thyroideus, arising at *a* from the superior and internal part of the sternum fleshy, it becomes tendinous in about half it's ascent up the wind-pipe, from which tendon the sterno-hyoideus arises; it soon becomes fleshy again and is inserted into the thyroid cartilage.

c Trachea arteria, asperia arteria, or wind-pipe.

defgh Longus colli; *d* the part which comes from it's inferior origin, which is from the lateral parts of the bodies of the five uppermost vertebræ of the back and the lowest of the neck, and from the transverse processes of the sixth, fifth, fourth, and third vertebræ of the neck; it is inserted at *g* into the anterior oblique process of the sixth vertebra of the neck, and into the bodies of the fifth, fourth, third, and second, laterally, near the transverse processes, and into the anterior eminence or tubercle of the body of the first vertebra of the neck.

iikk Inter-transversarii posteriores colli; they arise from the roots of the oblique processes, and betwixt them and the transverse processes; also from the posterior part of the transverse processes of the four inferior vertebræ of the neck, and the uppermost of the back: they are inserted into all the transverse processes of the neck, except the first and last, though the obliquus capitis inferior seems to be a muscle of the same kind.

m Nerves coming from betwixt the sixth and seventh vertebræ of the neck, betwixt that and the first of the back, and betwixt the first and second of the back: they form the brachial nerves.

n Arteria carotis.
o Part of the vena jugularis.
p Part of the vena cephalica, where it falls into the jugularis.

In the Trunk.

a Semi-spinalis dorsi, arises fleshy from the tendinous surface of the longissimus dorsi: it is inserted into the spines of the ten superior vertebræ of the back: and communicates with the spinalis cervicis as well as the fleshy fibres of the spinalis dorsi, before it's insertion into the superior parts of the spines, the spinalis dorsi being inserted below it.

bbccdefgh Longissimus dorsi; it arises at *bb* from the posterior spine of the ilium, and at *cc* by a strong aponeurosis from the three uppermost spinal processes of the os sacrum, from all those of the loins and seven or eight of the back; this aponeurosis, or tendinous surface, is very strong near the spines as at *d*, but diminishes in thickness so as to shew the carnous fibres through at *e*: it arises also fleshy from the inside of the ligament which binds the posterior part of the ilium to the transverse processes of the os sacrum, and from all the anterior side of the ilium which is behind the transverse processes of the os sacrum, and is inserted into the whole length of the inferior edges of the transverse processes of all the vertebræ of the loins, into the inferior or lower convex edges of about seven of the inferior ribs, betwixt their articulations and the sacrolumbalis; the insertion into the lowest is about nine minutes broad, the insertions into those above, diminish gradually in breadth 'till they come to the seventh or eighth, where they end in a point: the sacro-lumbalis in those above lying close up to the transverse processes of the vertebræ of the back. It is inserted, by distinct tendons, into all the transverse processes of all the vertebræ of the back, and ligaments of the true ribs, and at *g* into the transverse process of the seventh vertebra of the neck; *bbfh* shew the carnous origin of the gluteus medius from the tendinous surface of this muscle.

ikkllllllllL Sacro-lumbalis; *i* the part which, in this subject, arises from or along with the longissimus dorsi; it receives origins from the superior edges of all the ribs, except two or three of the uppermost, by flat tendons about half the breadth of the muscle, and is inserted, by distinct flat tendons, into the lower convex edges of all the ribs except two or three of the lowest, as at *llllll*, and into the transverse process of the seventh vertebra of the neck at L: each of these tendons run upon the surface of the muscle, going over about three ribs below it's insertion.

noopppp Levatores costarum; *noo* that which arises at *n* from the transverse process of the seventh vertebra of the neck, being inserted into the first rib at *oo*; it is sometimes called one of the scaleni: *ppp* those which arise from the transverse processes of the back, and the neighbouring ligaments, each being inserted into the back part of the outside of the rib below it's origin.

qqrr, &c. The external intercostals; they arise at *qq*

from the inferior edge, and a little of the outside of each rib, the last excepted, are a little tendinous, and, descending obliquely downwards, are inserted at *rr* into the upper edge and from a small portion of the outside of each rib, the first excepted.

sstt, &c. The internal intercostals, they arise at *ss* from the superior edge only of the bony part of each rib, except the first, not covering any of the outside, and from the edges of the cartilages of the ribs, and a considerable part of the outside of the cartilages: they are, chiefly externally, tendinous, but partly fleshy, and ascending obliquely upwards, and forwards, are inserted into the lower edges of the bony parts of the ribs, and into the edges and part of the outsides of their cartilages, the last excepted.

uuwwxyy Transversalis abdominis; the part *uu* arises from the inside of the ribs below the triangularis of the sternum and diaphragm by fleshy digitations; the part *ww* arises tendinous from the transverse processes of the three or four uppermost vertebræ of the loins, by an aponeurosis, or tendinous plain, and fleshy from the internal labeum of the crista of the ilium, and a great part of the ligamentum fallopii, or tendinous margin of the internal obliquus of the abdomen, and is inserted into the ensiform cartilage, and linea alba, adhering to the posterior plate of the aponeurosis of the internal oblique muscle of the abdomen at it's first passing under the rectus. The lower part of the aponeurosis of the transversalis is separated from the upper in a transverse direction, from the edge of the rectus to the linea alba, about half way betwixt the navel and synchondrosis of the pubis, the upper part going behind the rectus, and the lower before it and the pyramidalis, if there is any; at *x*, from the spine of the ilium, arises an aponeurosis common to this muscle, with the lower posterior serratus and internal obliquus, cut off at *xi*, where it joins the serratus, and *yy* where it joins the internal obliquus.

z The elevating muscle of the tail.
1 The lateral muscle of the tail.
2 2 The inter-transversal muscles of the tail.
3 The depressing muscle of the tail.

The origins and insertions of the muscles of the tail are shewn in the next table.

4 Branches of the nervi lumbares, coming out of the sacro lumbaris, which run under the gluteus medius to go to the integuments.

5 5, &c. Branches of the nervi costales, lying upon the transversales, which go to the abdominal muscles and integuments.

R 6 Branches

6 Branches of the nervi lumbares which go to the abdominal muscles and integuments.

7 Small arteries coming out of the sacro-lumbalis to go to the gluteus medius.

8 8 Arteries from the intercostales inferiores.

9 9, &c. Branches of the arteriæ intercostales superiores.

10 The external Branch of the outer iliac artery in two ramifications, accompanied by 11.

11 The external branch of the outer iliac vein, in two ramifications.

In the Shoulders and upper Limbs.

abcde Sub-scapularis; it arises from all that space of the inner or concave side of the scapula, betwixt the insertion of the serratus major anticus and near it's neck, and from this situation it has it's name: it is thick and made up of several penniform portions: *a* the part above the superior costa of the scapula, where there is yet remaining a part of the flat tendon by which the supra-spinatus receives some origin from the tendinous surface of this muscle; *b* the part below the inferior costa of the scapula, which is externally tendinous; *c* marks a tendinous slip sent from this muscle, which leaves it about *d*, and is inserted into the processus coracoides; it serves to guard some nerves which pass under it: this muscle is inserted at *e* into the head of the os humeri, which insertion is continued down to the insertion of the teres major.

fgh Teres major; *f* it's origin from the inferior costa of the scapula; *g* the part which is externally tendinous, going to be inserted into the humerus.

ikllmno Longus minor; *iklln* it's broad tendon by which it begins, at *i* from the inferior angle of the scapula, and at *ik* from the tendinous surface of the teres major; *ll* the beginning of it's fleshy fibres, which become tendinous again at *m*, and are inserted into the inside of the ancon; at *n* may be seen, through the flat tendon of this muscle, the tendons of the membrana carnosa and latissimus dorsi, going to their insertions into the humerus, along with the teres major, to the tendon of which muscle they are inseparably joined; but before their insertion their fibres intersect each other in this manner, viz. the tendinous fibres from that part of the latissimus dorsi which lies over the inferior angle of the scapula, are inserted along with the inferior angle of the tendon of the teres major, running over the fibres of the inferior angle of the teres major and those of the membrana carnosa, which are inserted along with the superior angle of that tendon; at *o* are left some

of the carnous fibres of the longus major, which was attached to, or received some origin from the flat tendon of this muscle.

pq Coraco brachialis; *p* it's origin from the processus coracoides of the scapula; *q* it's insertion into the humerus.

rs Brachialis internus; *r* the part which arises from the neck of the humerus, and the internal lower part of the scapula; and is inserted at *s* into the radius a little below the insertion of the coraco radialis and more internally.

t Flexor carpi radialis; it arises from the inner condyle of the humerus, and is inserted into the internal splint bone.

u The first head of the profundus or perforans.
w Nervus musculus cutaneus.
x Nervus medianus.
y Nervus cubitalis.
zz Nervus radialis.
1 Nervus axillaris.
2 Arteria axillaris.
3 Vena axillaris.
4 Arteria brachialis, or the humeral artery.
5 Vena cephalica.
6 6, &c. Bursal ligaments.
7 7, &c. Articular ligaments.
8 8 Cartilages belonging to the coffin bone.

In the lower Limbs.

aab Iliacus internus; *aa* Part of it's origin which is continued from all, or most of the inside of the os ilium, which lies before the transverse processes of the loins and sacrum, and has some origin from that part of the fascia lata which lies betwixt it and the glutei: it joins in with the psoas magnus from it's origin, and is, with it, inserted into the little trochanter of the thigh bone; they seem to be but one muscle.

ccdefghi Tibialis anticus; *cc* it's origin from the superior and anterior part of the tibia; *d* the origin of it's strong tendon, *deghi*, from the inferior part of the femoris, to which, near it's origin, the tendon of the extensor longus digitorum pedis is inseparably attached; about *e* the superior part of the fleshy fibres, which arise at *cc*, are inserted into the inner side of this tendon, after which insertion, fleshy fibres run from the inner side of this tendon obliquely downwards, and inwards, and are met by fleshy fibres arising from the tendinous covering of the internal side of this muscle, which run obliquely downwards and

outwards; this fleshy part is about twice as thick as that from the outside tendon, and with it forms the principal tendon *f*, by which it is inserted into the superior and anterior edge of the metatarsal bone, and into the ossa cuneiformia: *g* the place where the external tendon divides, and is inserted, by the part *h*, into the less cuneiform bone of the tarsus, posteriorly running over the internal articular ligament as far back as the posterior edge of the internal splint bone, and by the part *i* into the os cuboides; at *i* this part divides for the passage of some blood-vessels, and then unites again.

kl Flexor digitorum pedis.

1 1 Arteria tibialis anterior.

2 Vena tibialis anterior, in which appear some valves: it is covered by a thin fleshy part of the tibialis from about 1 upwards.

3 The external anterior ligament of the patella, which binds that bone to the tibia.

4 The external lateral ligament, which binds the patella to the external condyle of the os femoris.

5 The external articular ligament, which binds the os femoris to the fibula, and tibia: it runs all the way down the fibula, and to the bottom of the tibia.

6 A bursal ligament, upon which lie mucilaginous glands.

7 The external articular ligament of the tarsus.

8 The internal articular ligament of the tarsus.

9 9 The articular ligaments of the fetlock joint.

10 10 The articular ligaments of the great pastern with the coronary bone.

11 11 The articular ligaments of the coronary bone with the coffin bone.

12 12 12 12 The anterior part of the bursal ligament of the tarsus.

13 13 The anterior part of the bursal ligament of the fetlock joint.

14 14 The anterior part of the bursal ligament of the articulation of the great pastern with the coronary bone.

15 The anterior part of the bursal ligament of the articulation of the coronary bone with the coffin bone.

16 17 Interosseus, &c. it is like a strong ligament arising from some of the tarsal bones, and the upper part of the metatarsal bones, and is inserted into the sesamoid bones, and upper part of the great pasterns; on each side at 17 17 are cut off small ligaments, which were inserted into the tendon of the extensor longus digitorum pedis.

18 18 Cartilages belonging to the coffin bone.

The

The tenth Anatomical TABLE of the Muſcles, Faſcias, Ligaments, Nerves, Arteries, Veins, Glands, and Cartilages of a HORSE, viewed in front, explained.

In the Head.

ab THE glandulous membrane of the inſide of the lips; *a* glandulæ labiales; *b* glandulæ buccales.

c The concha narium inferior, covered by the pituitary membrane.

defg The four recti muſcles, or muſculi recti of the eye; of which *d* is called attollens, *e* deprimens, *f* adducens, and *g* abducens: theſe muſcles ariſe from the bottom of the orbit near the foramen opticum, in the elongation of the dura-mater, by ſhort narrow tendons, in the ſame order as they are inſerted into the tunica ſclerotica, near and at the edge of the cornea lucida; the flat tendons, before they reach the cornea lucida, join and form the tunica albuginea, or white of the eye.

h Obliquus inferior.

i Muſculus ſeptimus occuli ſuſpenſorius, ariſes from the margin of the foramen opticum, and is inſerted (being divided into ſeveral fleſhy portions) into the poſterior part of the ſclerotica, below the terminations of the muſculi recti.

k Arteria angularis.

l Vena angularis.

m The middle portion of the cartilage of the noſe: it is a broad cartilaginous lamina, joined by a kind of ſymphyſis to the anterior edge of the middle lamina of the os ethmoides, to the anterior edge of the vomer, and to the anterior part of the groove formed by the oſſa maxillaria, as far as the naſal ſpines of theſe bones: this lamina compleats the ſeptum narium, of which it forms the principal part.

no The part *o* is but a continuation of the part *n*, which, both together, form the lateral cartilage of the noſe: they are continuations of the middle cartilages.

pqr Nervi maxillares ſuperiores; they are branches of the third branch of the fifth pair; *p* branches which go to the upper lip; *q* a branch which goes to the inſide of the noſtril towards the tip of the noſe; *r* a branch which goes to the long naſal muſcle of the upper lip.

s The anterior cartilage of the outer ear.

t The outer ear.

In the Neck and Trunk.

ab Inter-vertebrales; they ariſe from the aſcending proceſſes, and form the ſpace between the oblique proceſſes of the uppermoſt vertebræ of the back: they are inſerted into the lateral part of the body of the vertebra above it's origin.

cc, &c. *dd,* &c. The multifidus of the ſpine; *cc* the origins from the upper part of the tranſverſe proceſſes of the vertebræ of the back, and from the oblique aſcending proceſſes of the loins, and ſacrum; *dd,* &c. the inſertions into the ſpinal proceſſes of the ſacrum, loins, and back.

e The elevating muſcle of the tail, beginning it's origin from the inferior or poſterior edge of the third ſpinal proceſs of the os ſacrum, which origin is continued from near the end of the ſpine, about half way towards it's root: it's origin is continued fleſhy from the ſides and edges, and interſpinal ligaments of the ſpines of the ſacrum, below that from the whole length of the laſt of them, and is inſerted into the firſt and ſecond oblique proceſſes of the os coccygis by two tendons; it then begins to ariſe from the ſpinal proceſſes of the coccyx, and after paſſing over one, or two, is inſerted into the next, or next but one below that: This ſeems to be a continuation of the multifidus of the ſpine.

fgh The lateral muſcles of the tail or coccyx: *fg* the tendon by which it ariſes, at *f,* from this ſpine of the loweſt vertebra but one of the loins; *h* the fleſhy part: it is inſerted tendinous into the oblique proceſs of the coccyx or tail, and into two or three below that, and then joins in with the elevating muſcle of the tail.

i The inter-tranſverſe muſcles of the tail, ariſing from the tranſverſe proceſs of one vertebra of the coccyx or tail, and inſerted into that of the next, and ſo on through the whole length of the tail.

There are muſcles which ariſe from the upper, or poſterior part of the tranſverſe proceſſes, and are inſerted into the oblique proceſſes of the next but one or two below them; they are like the inter-tranſverſales poſteriores of the neck.

k The depreſſing muſcle of the tail, which begins it's origin from under the tranſverſe proceſs of the third vertebra of the ſacrum, and continues it from the whole length of the tranſverſe proceſſes of the ſacrum below that, and from the inter-tranſverſe ligaments, and ſo on down the tail almoſt to the laſt, and is inſerted into the bodies of the bones of the tail.

ll, &c. The elevators of the ribs.

m Arteria cervicalis.

n The vertebral vein and artery of the neck.

o Arteria carotis communis.

p The trunk of the eighth pair of nerves.

q Part of the jugular vein.

r Arteria mammaris interna.

In the Shoulders and upper Limbs.

1 2 3 4 4 Sub-ſcapularis; it ariſes from all that ſpace of the inner or concave ſide of the ſcapula, between the inſertion of the ſerratus major anticus, and near it's neck: from this ſituation it has it's name, it is thick and fleſhy, made up of ſeveral penniform portions; 1 the part above the ſuperior coſta of the ſcapula, which is externally tendinous; 2 marks a tendinous ſlip ſent from this muſcle, which leaves it about 3, and is inſerted into the proceſſus coracoides; ſome nerves and blood-veſſels paſs under it: this muſcle is inſerted, at 4 4, into the head of the os humeri.

5 Nervus muſculo-cutaneus.

6 Nervus medianus.

7 Nervus cubitalis.

8 Nervus radialis.

9 Nervus axillaris.

10 Arteria axillaris.

11 Vena axillaris.

12 Arteria brachialis, or the humeral artery.

13 Vena cephalica.

14 Vena plantaris

16 16 Ligaments which bind together the bones of the carpus.

17 17, &c. Articular ligaments.

18 18 Cartilages belonging to the coffin bone.

In the lower Limbs.

aa Iliacus internus; *aa* part of it's origin which is continued from all, or moſt of the inſide of, the os ilium, which lies before the tranſverſe proceſſes of the loins and ſacrum, and has ſome origin from the poſterior part of the anterior ſpine of the ilium, and that part of the faſcia lata which lies betwixt it and the glutei: it joins in with the pſoas magnus from it's origin, and is, with it, inſerted into the little trochanter of the thigh bone.

S *b* Interoſſeus,

b Interoſſeus, &c.

c Vena tibialis anterior.

d Vena ſaphena.

ee Vena plantaris externa and vena plantaris interna.

f A ligament which runs from the aſtragalus to the metatarſal bone.

gg, &c. Articular ligaments.

h The outer ſemi-lunar cartilage in the joint of the knee.

ii Cartilages belonging to the coffin bone.

The eleventh Anatomical TABLE of the Muſcles, Faſcias, Ligaments, Nerves, Arteries, Veins, Glands, and Cartilages of a HORSE, viewed poſteriorly, explained.

In the Head.

A THE outer ear.

ab Muſcles running from the anterior cartilage to the external ear.

1 2 Retrahens; the poſterior part 1 ariſes under the part 2, and is inſerted into the ear near the inferior muſcle of the outer ear, or the depreſſor; the part 2 ariſes from the ligamentum colli and occiput, and is inſerted into the convex part of the outer ear.

c The ſuperior lateral muſcle of the outer ear, which ariſes under the lateral muſcle of the anterior cartilage, and is inſerted into the inferior angles of the openings of the ears anteriorly.

d The lateral muſcle of the anterior cartilage of the outer ear, which ariſes from above the orbit of the eye, and is inſerted into the anterior cartilage.

3 The inferior lateral muſcle or depreſſor of the outer ear: it ariſes from the quadratus colli, and is inſerted cloſe by the lower angle of the opening of the ear poſteriorly.

e The orbicular muſcle of the eye-lids, which ariſes from the ligament by which the conjunction of the eye-lids, in the great canthus, is tied to the naſal part of the os unguis.

4 4 5 6 Part of the latiſſimus colli, inſerted about 5 into the lower jaw; at 6 the parotid gland protuberates under the latiſſimus colli.

f The globe, or ball of the eye.

gh Depreſſors of the lower lip, chiefly covered by the quadratus colli.

iii The orbicular muſcle of the mouth.

k The elevators of the chin, where they are inſerted into the ſkin, the fibres of which are intermixed with the fat of the chin.

l Caninus, or the elevator of the corner of the mouth.

m Zygomaticus; it's origin is from the orbicularis of the eye; and it's inſertion into the orbicularis of the mouth.

n The lateral dilators of the noſtril and upper lip.

o The digaſtrick muſcle of the lower jaw; the quadratus colli covers this part, and immediately under it the mylohyeideus lies.

p The inferior maxillary glands.

q Vena angularis, a branch of the external jugular vein.

In the Neck, Shoulders, and Trunk.

abc Levator humeri proprius; *a* the portion which ariſes, under the part *b,* from the tranſverſe proceſſes of the four uppermoſt vertebræ of the neck; *b* the part which ariſes from the proceſſus maſtoideus, tendinous, and by a tendinous membrane from the pole bone or ridge of the occiput: theſe two heads unite before they paſs over the head of the humerus, and are inſerted into that bone along with the tranſverſe or ſuperior part of the pectoralis, between the biceps and brachiæus internus: the firſt part hath the ſame origin as the angularis, called levator ſcapulæ proprius in the human body; the ſecond has it's origin much like the anterior and ſuperior part of the trapezius, which, in the human body is inſerted into the clavicle, but the clavicle being wanting in a horſe it is inſerted into the humerus, and the angularis into it.

def The ſuperior part of the trapezius, under which, at *d,* the ſplenius protuberates; at *e* the ſerratus major anticus; at *f* the rhomboides.---To this muſcle the part, as above, called levator humeri, which ariſes from the bones of the head, belongs.

g The mane.

hikllmmnnopq Membrana carnoſa; *h* the inferior part of the trapezius lying under the membranous part of this fleſhy pannicle; *i* the ſuperior fleſhy part; *k* a membranous part; *llm* the poſterior fleſhy part, which begins at *ll;* *nnoq* the poſterior membranous part lies over the obliquus deſcendens, linea alba abdominis and part of the ſerratus major poſticus; *p* a large vein, which is ſpread in the fleſhy part of this pannicle. It is attached to the upper edge of the ſuperior part of the pectoralis, and the lower edge of the inferior part; ſo that they, together, ſurround the whole limb from the top of the ſhoulder to the bottom of the fore feet: it's lower part goes with the lower part of the pectoralis to be inſerted into the humerus, and it's upper part with the upper part of the pectoralis down the fore limb: it may be called the moſt exter-

nal part of the pectoralis, or fleſhy membrane; and that part of the pectoralis, marked *ffgg* in table the ſeventh, may be called the external part of the pectoralis; the part marked *ddee* the middle; and the part marked *h* the internal part: the internal part is inſerted at the top of the humerus, the middle part as low as the bottom, and into the faſcia of the coraco-radialis; and the external part runs, with part of this fleſhy membrane, down the fore limb.

r The tail.

In the upper Extremities, or anterior Limbs.

abcdDefghiklmn The membranous continuation of the fleſhy pannicle down the upper limbs, with the muſcles, &c. protuberating under it; *a* extenſor carpi radialis; *b* extenſor digitorum communis; *cdD* flexor carpi ulnaris; *c* the external head, from the external protuberance of the os humeri poſteriorly; *d* the internal head, ariſing from the internal protuberance of the os humeri; *D* the tendon; *e* the third deſcribed head, in table the third, of the profundus; *g* The middle part of the pectoralis, which ſends a membranous expanſion down this limb along with the expanſion of the membrana carnoſa; *i* a ſort of ſpungy fatty ſubſtance, probably a production of the membrana adepoſa, lying over the protuberating part of this joint to preſerve the bending tendons from bruiſes when this part touches the ground, &c.

k The internal and external vena plantaris; *kl* the external branch from the baſilica.

mn The tendons of the ſublimis and profundus.

op Ligamentous fibres which come from the inſide of the radius, and are inſerted into the external metacarpal bone; they protuberate at *o* and join in with the carnous membrane about *p.*

qr The horny part of the hoof; *q* the ſuperior part; *r* the ſole or inferior part lying under the coffin bone.

In the lower or poſterior Limbs.

ABabcdefghiklmnopqrstuvwxyz& The membranous continuation

337

continuation of the flefhy pannicle down the inferior, lower, or pofterior limbs, with the mufculus fafciæ latæ; the fafciæ latæ, and other expanfions of the mufcles, with the mufcles, &c. protuberating under them : A the large adductor of the thigh; B gracilis; *a* the gluteus medius lying under the carnous membrane, and continuation of the tendon of the latiffimus dorfi; *b* the origin of the mufculus fafciæ latæ from the fpine of the ilium; *c* the anterior flefhy part; *d* the pofterior flefhy part; *e* the tendinous furface into which the carnous fibres of the flefhy bellies *c* and *d* are inferted internally : *f* the gluteus externus protuberating a little; *g h i* the biceps cruris, or biceps tibia; *g* the anterior part; *h* the middle

part; *i* the pofterior part; *k* the femi-tendinofus; K the patella; *l* the extenfor longus digitorum pedis; *m* peroneus; *n* flexor digitorum pedis; *o* gemellus; *p* tendons formed by thefe fafciæ and expanfions to join in with the extenfors of the tarfus : about *p* and *q* there are feen branches of veins which terminate the faphæna minor in cutaneous ramifications; *q* nerves expanded upon thefe fafciæ, or fent off to the external parts (as the adipofe membrane and cutis); they are branches of the fciatic nerve; *r* a fort of tendon formed by thefe fafciæ, which may probably affift the extenfor digitorum when the tarfus is extended; *t* the tendons of the flexors; *u* the interof-

feus, &c. *w w* veins arifing from under the hoof, which are branches of the vena tibialis pofterior, from which the faphæna is derived; they are called venæ plantares; *x* a large nerve, called the external plantaris; *y* nervus plantaris internus; at *z* thefe fafciæ have an attachment to the tendons and ligaments as they pafs over them; *&* a fort of fpungy fatty fubftance, probably a production of the membrana adipofa, lying over the protuberating part of this joint to preferve the bending tendons from bruifes, when it touches the ground, &c.

1 2 The horny part of the hoof; 1 the fuperior part; 2 the fole or inferior part lying under the coffin bone.

The twelfth Anatomical T A B L E of the Mufcles, Fafcias, Ligaments, Nerves, Arteries, Veins, Glands, and Cartilages of a H o r s e, viewed pofteriorly, explained.

In the Head.

a THE lateral dilator of the noftril.

bb Mufculi canini.

cdde The orbicular mufcle of the mouth.

fgh The depreffor of the lower lip; it arifes along with the buccinator, and is almoft divided into two mufcles, one fuperior the other inferior, for the paffage of nerves and blood-veffels to the lower lip; *f* the fuperior part, which arifes tendinous, and is inferted flefhy into the lower lip laterally; *g h* the inferior part, which arifes flefhy, and is inferted tendinous into the lower lip near the middle; *g* the flefhy belly; *h* the tendon.

i Buccinator.

k The maffeter.

l Mylohyoideus; it arifes from the lower jaw near the fockets of the dentes molares, and fomething more anteriorly, and is inferted into the os hyoides.

mm The parotid gland.

n The inferior maxillary gland.

o Branches of the nervus maxillaris inferior : they are branches of the third branch of the fifth pair of nerves : and accompanied with an artery from the temporal artery, which communicates with the arteria angularis.

p Arteria angularis.

q Vena angularis.

r The falivary duct.

st Vena temporalis.

u The outer ear.

In the Neck.

abcd Coraco-hyoideus coming, at *a*, from it's origin at the upper and internal fide of the humerus, betwixt

the infertions of the fub-fcapularis and teres major by a flat membranous tendon : it begins to be flefhy at *a* as it comes from under the ferratus minor anticus; *c* it's infertion into the os hyoides : it has a ftrong attachment to the anterior part of the levator humeri or trapezius, near the whole length of it's flefhy part, and the upper part marked *d* in table the third is attached to the rectus anticus longus, or internus major capitis, or it arifes from the os fphenoides, by a flat tendon, clofe to the infertion of that mufcle.

e Sterno-hyoideus; it arifes from the middle tendon of the fterno-thyroideus, and goes to be inferted into the os hyoides along with the coraco-hyoideus.

fg Sterno-maftoideus, or fterno-maxillaris; it arifes from the top of the fternum, and is inferted, tendinous, into the lower jaw bone; at *f* it's tendon protuberates under the parotid gland; it is alfo inferted, by a continuation of the fame flat tendon, into the root of the proceffus maftoideus.

hh Rectus internus major capitis.

ii Inter-tranfverfales minores colli; they run from the tranfverfe procefs of one vertebra to the tranfverfe procefs of the next to it.

k The tendon of the trachelo-maftoideus.

lmnop Splenius; *l* the part coming from the origin of this mufcle, which is from the expanfion, common to it and the ferratus minor pofticus, &c. it arifes tendinous from the ligamentum colli, under the rhomboides, and flefhy about the fuperior part of the neck; at *m* it is attached to the tendon of the trachelo-maftoideus, at *n* to the tranfverfalis : it is likewife inferted into the fifth,

fourth, and third tranfverfe proceffes of the vertebræ of the neck by flat ftrong tendons, which run on the internal fide of the mufcle : *p* the part which goes to be inferted into the occiput.

qqrs Rhomboides; *qq* it's origin from the ligamentum colli; *q r* it's origin from the fuperior fpines of the vertebræ of the back; *s* the part going to be inferted into the fcapula.

t Ligamentum colli.

uwxyz Serratus major anticus; *u w x y* it's origination from the third, fourth, fifth, and fixth tranfverfe proceffes of the vertebræ of the neck; *z* that part which is inferted into the external part of the fcapula.

1 Vena jugularis communis.

2 Vena jugularis externa anterior.

3 Vena jugularis externa pofterior, or fuperior.

4 Arteries coming out of the fplenius to go to the trapezius and integuments.

5 Arteries accompanied with branches of the cervical nerves, which go to the levator humeri proprius and integuments.

In the Shoulder and Trunk.

abcd Infra-fpinatus fcapulæ; *b* it's origin from the dorfum fcapulæ, and the cartilage on the border of that bone; *c* it's ftrong tendon, by which it is inferted into the protuberating part of the humerus, under the tendinous expanfion which goes from the teres minor to the leffer anterior faw mufcle; *d* a part of the carnous infertion of this mufcle below that protuberating part of the os humeri.

T *effgh* Teres

effgh Teres minor; at *ff* it fends off a fafcia, which connects it to the ferratus minor anticus; from *f* to *h* it is inferted into the humerus, and at *g* into the fafcia which runs over the extending mufcles on the cubit.

ik Latiffimus dorfi; *i* the part which lies upon the ribs; *k* the part which runs over the inferior angle of the fcapula.

IK Triceps brachii; I the part called extenfor longus; K extenfor brevis.

L Part of the pectoralis, which fends an expanfion down the infide of the cubit.

llmmnnopp Obliquus externus abdominis; *llmm* the part which arifes from the ribs, and intercoftals; *mmnn* the flefhy part which runs over the ribs and intercoftals; *o* the flefhy part lying over the abdomen; *pp* the ftrong broad aponeurofis of this mufcle.

q The elevating mufcle of the tail, beginning it's origin from the inferior or pofterior edge of the third fpinal procefs of the os facrum, which origin is continued from near the end of the fpine about half way towards it's root, being flefhy from the fides, and edges, and internal ligaments of the fpines of the facrum, and below that from the whole length of the laft of them. It is inferted into the firft and fecond oblique proceffes of the os coccygis by two tendons; it then begins to arife from the fpinal proceffes of the coccygis and after paffing over one or two tendons, is inferted into the next or next but one below that, and fo on to the end of the tail.

r The lateral mufcle of the tail, or os coccygis; it arifes tendinous from the fpine of the laft vertebra but one of the loins, which tendon is marked *eee* in table the fifth, and the flefhy part *f*; it is inferted tendinous into the oblique procefs of the third vertebra of the tail, and alfo into two, or three, below that, and then joins in with the elevating mufcle of the tail.

s The inter-tranfverfe mufcles of the tail, arifing from the tranfverfe procefs of one bone of the tail, and inferted into that of the next, and fo on through the whole length of the tail. --- There are mufcles which arife from the upper, or pofterior part of the tranfverfe proceffes, and are inferted into the oblique proceffes of the next but one or two below.

t The depreffing mufcle of the tail, beginning it's origin from under the tranfverfe procefs of the third vertebra of the facrum, and continuing it from the whole length of the tranfverfe proceffes of the os facrum below that, and from the inter-tranfverfe ligaments, and fo on down the tail : it is inferted into the bodies of the bones of the tail.

uu Sphincter externus ani.

w Acceleratores penis.

In the upper Limbs.

aa The extenfor digitorum communis, protuberating under the fafcia which covers the extending mufcles on the cubit.

ABCDG *bcddeffg* An expanfion which arifes from the articular ligament A, and from the olecranon C : it receives an addition from the longus minor, and internal protuberance of the humerus and expanfion of the biceps mufcle, or coraco-radialis, then defcends over the bending mufcles of the cubit down to the ligaments on the carpus, to which it is attached as well as to the bones of the cubit on each fide of the bounds of the bending mufcles : *ff* it's attachment to the continuation of the ulna, or ligament from the ulna, which runs down towards the carpus, or to the radius near them; it has a ftrong attachment to the os pififorme, or orbiculare betwixt *d* and *f*, and another betwixt the tendons of the flexor carpi ulnaris *d e*; betwixt *f* and *f* it appears like a number of fmall tendons; there lies protuberating under it at D the tendon of the mufcle, which is analogous to the extenfor minimi digiti in the human body : at B *bcdde* the flexor carpi ulnaris; B *b* the external head arifing by the tendon B from the external protuberance of the os humeri pofteriorly; *c* the internal head arifing from the internal protuberance of the os humeri; G *dde* the tendon which divides into two a little below G, and is inferted, by the part *dd*, into the fplint bone; and by the part *e* into the os pififorme or orbiculare; *g* the third defcribed head in table the third of the profundus, of which *h h* is the tendon.

E The tendon of a mufcle which is analogous to the extenfor of the thumb in the human body.

h h The tendon of the profundus.

ikk The tendon of the fublimis going to be inferted, near *kk* (where it divides for the paffage of the profundus,) into the great paftern, or bone of the firft order of the finger.

ll Nervus plantaris externus and nervus plantaris internus.

L Vena cephalica; it falls into the jugular vein.

mm Vena plantaris externa and vena plantaris interna.

op The external articular ligament.

qr The internal articular ligament.

st A ligament which runs from the os orbiculare to the radius, and external articular ligament over the tendon *dd* of the flexor carpi ulnaris.

uw A ligament running from the orbicular bone of the carpus to the falfe metacarpal bone : it ferves as a ftay to that bone when the flexor carpi ulnaris is in action : there is a large vein protuberating under it which is a branch of the vena cephalica.

uxy A ligament which binds down the tendons of the fublimis and profundus running from the orbicular bone of the carpus to the articular ligament, &c. to the upper part of which the expanfion of the bending mufcles on the cubit makes a confiderable addition : the part *u x* runs from the orbicular bone to the internal falfe metacarpal bone, and ferves as a ftay to it when the flexor carpi ulnaris is in action.

z A ligament which helps to bind down the tendon of the fublimis and profundus : it is fixed to the fplint bones on each fide : it is a continuation of the expanfion which covers the bending mufcles on the cubit.

1 A ligament inferted into the fefamoid bones, running over the tendons of the fublimis and profundus, which ferves to prevent the tendons from ftarting from thofe bones when the joint is bent.

2 A ligament arifing from the upper part of the great paftern on each fide the tendons of the fublimis and profundus : it is attached to the tendon of the fublimis about 2, and ferves, as well as the ligament 1, to confine the bending tendons to the bone when the joint is bent.

3 A ligament which binds the tendon of the profundus to the coronary bone when it is in action.

4 4 5 5 The interoffeus : it is like a ftrong ligament arifing from the bones of the carpus and upper part of the metacarpal bones : it is inferted into the fefamoid bones, and great paftern on each fide, and fends off the ligaments 5 5 to the tendon of the extenfor digitorum communis, which it keeps from ftarting when the joint is in motion.

6 A fubftance refembling the villous furface of a mufhroom.

In the lower Limbs.

aaabcd Gluteus externus: *b* a flefhy origin from a ligament which runs betwixt the fpinal, and tranfverfe proceffes of the os facrum; *b d* the place where the fafcia lata is cut off from the production, which it fends under this mufcle, or from it's attachment to the tendinous furface of the internal part of this mufcle arifing from the ligament which runs betwixt the os facrum and ifchium, and receives firft the infertion of thofe flefhy fibres which arife betwixt it and the ends of the fpinal proceffes of the os facrum from the fame ligament, and then the fibres *a a a*, which arife from the fafcia lata, and defcend obliquely inwards and downwards to be inferted into it: *c* the place where this mufcle ceafes to arife from the fafcia lata, and goes to be inferted into the lateral protuberance of the thigh bone: it fends off a fafcia over the pofterior part of the thigh bone, which runs in a tranfverfe direction, and into which the pyramidalis is inferted, or joined

in

in with before it's infertion into the fuperior and pofterior part of this protuberance.

efffg Gluteus medius; *e* the part which arifes from the tendinous furface of the facro-lumbalis, and does not adhere to the fafcia lata; *fff* the part which receives flefhy fibres from the fafcia lata; *g* it's origin from the ilium: it goes under the gluteus externus to be inferted into the great trochanter.

hikLlllmnnoop Mufculus fafcia lata; *h* it's origin from the ilium; *i* it's anterior flefhy belly; L the pofterior flefhy belly, over which the fafcia lata fends a ftrong membrane, as well as under; fo that it is received or contained in a duplicature of the fafcia lata; the fibres L*lllm* arifing from the fuperior or external fafcia and defcending to be inferted into the inferior; the part *hik* arifes from the fpine of the os ilium internally tendinous: flefhy fibres arifing from that flat internal tendon, and defcending to be inferted chiefly into the infide of the fafcia; *kloo* the flefhy part in the fuperior angle; *l* being thickeft, it gradually diminifhes till it is loft in the line *oo*; the dark colour of the flefhy fibres make fome appearance through the fafcia in this angle, though it is very thick, but not near fo much as the part *hio*, becaufe the covering of that is only (or little more than) a common membrane; the line *hm* marks the place where the fafcia lata is cut off before it paffes betwixt this mufcle and the gluteus externus, to be inferted into the anterior cofta of the os ilium; *lm* marks the place where the production of the fafcia lata, which is fent over this mufcle, is cut off; and *lll* the place where it joins the broad tendon of this mufcle, in which place it is cut off; *nn* marks the place where the fafcia lata ceafes to adhere to the broad tendon of this mufcle, in order to pafs down over the leg and foot; at *p* the tendinous furface of the rectus cruris makes it's appearance through the tendon of this mufcle. ---- This mufcle is inferted by a ftrong tendon into the upper and anterior part of the tibia, adhering to the tendon of the anterior, and middle part of the biceps mufcle all the way from the patella to it's infertion into the tibia.

O P P The large adductor of the thigh; P P the place where the fafcia lata is cut off, which confines this part of the mufcle in it's place.

qrrsstuwxyz 1 2 3 4 4 5 6 7 8 9 10 11 12 13 Biceps cruris; *qrr* mark the fuperior, or anterior head where it arifes by carnous fibres, from the fafcia lata: it's principal origin is from the ligaments which run from the fpinal proceffes to the tranfverfe proceffes of the os facrum, and from thence to the tubercle of the ifchium: *sstuw* mark the inferior or pofterior head, where it arifes by carnous

fibres from the fafcia lata: it's principal origin is from the tubercle of the ifchium, beginning at the extremity of that tubercle from the inferior angle, and continuing it's origin, by a flat ftrong tendon, about fix minutes along the inferior edge of that bone; this tendon is continued down from the tubercle towards *su* betwixt *t* and *w*, from which, a little above *t*, the flefhy fibres *sstz* 1 4 4 begin to arife; but the flefhy part *uwx* 2 4 5 begins it's origin from the tubercle, and continues it down the faid tendon; *rry* the flefhy part of the anterior head where it does not arife from the fafcia lata; *z* the tendon by which it is inferted into the patella, and fuperior and anterior part of the tibia; the part *nry* lies under a fafcia fent from the anterior part of the pofterior head to the tendon of the mufculus fafcia lata; *x* 1 2 4 4 5 the flefhy part of the pofterior head, where it does not arife from the fafcia lata; 7 3 4 4 5 6 8 9 10 11 12 13 the tendon of the pofterior head, which joins the tendon of the anterior head near the patella, and is likewife inferted into the anterior part of the tibia all the way down to the ligament common to the extenfor longus digitorum pedis, and tibialis anticus, and into part of the upper edge of that ligament; 5 6 is the ftrongeft part of this tendon; it joins with a production of the fafcia lata, and is inferted into the os calcis; there lie protuberating under this tendon, at 9, the extenfor longus digitorum pedis, at 10 the peroneus, at 11 the flexor digitorum pedis, at 12 the foleus, and at 13 the gemellus.

14 15 15 16 17 Semi-tendinofus; 14 it's origin from the ligament running from the fpinal to the tranfverfe proceffes of the os facrum, and from thence to the ifchium; 14 15 15 mark the part where it receives carnous fibres from the fafcia lata; 15 15 16 the flefhy part where it does not arife from the fafcia lata; 17 the tendinous production which wraps over the gemellus to join in with the fafcia lata, and tendon of the biceps cruris: it fends off an expanfion which is attached to the tendinous ligament which lies over the gemellus, and covers fome blood-veffels and nerves which pafs over the gemellus and run down the leg, and are marked 14 in table the fecond at the heel: it is alfo inferted by a flat tendon, or expanfion, into the plantaris near the bottom of the flefhy part; through which expanfion there is an opening for the paffage of a large nerve: it's principal infertion is by a flat tendon into the fuperior and anterior part of the tibia internally, marked *k* on the left lower limb in table the fecond.

18 19 19 20 The gracilis: 19 19 the part coming from it's origin, which is from the edge of the inferior branch of the os pubis near the fymphyfis by a broad and very fhort tendon, from thence the flefhy fibres run down to the

internal condyle of the os femoris, where they terminate in a thin tendon, which afterwards degenerates into a kind of aponeurofis, and is inferted into the fore part of the infide of the head of the tibia; and from thence it is continued almoft to the bottom of that bone, and the pofterior part is attached to the tendinous furface of the flexor digitorum pedis.

21 7 8 A part of the fafcia lata, &c. which is left remaining, the reft being cut away before it's attachment to the tendons of the biceps, and femi-tendinofus: they cover the tendon of the gemellus, and are inferted into the inner fide of the os calcis with a tendinous production of the plantaris: thefe fafciæ are inferted into the edges of the principal tendon of the plantaris, but moft ftrongly into the external edge: the fafciæ, along with the tendinous production of the plantaris, being united, divide into two almoft equal parts (or if they are continued into each other it is by what is membranous;) the external is inferted into the external edge of the plantaris as it paffes over the calcaneum: the internal portion partly into the faid tendon oppofite to the other, but chiefly into the internal fide of the calcaneum clofe to the origin of the aponeurofis plantaris.

22 23 24 25 26 The tendon of the plantaris coming from under the tendons of the fafciæ and twifting over the tendon of the gemellus at 22; at 26 it divides for the paffage of the tendon of the flexor digitorum pedis. The part 22 23 belongs to that part which is analogous to the plantaris in the human body, and inferted into the heel; and the part 23 24 25 26 is analogous to the fhort flexor of the toes arifing from the heel or protuberance of the calcaneum, but in a horfe they are continued one into the other.

27 The tendon of the flexor digitorum pedis of which 11 is the flefhy portion, lying partly under the broad tendon of the biceps cruris.

28 29 The tendon of the peroneus, of which 10 is the flefhy part lying under the broad tendon of the biceps cruris.

30 The tendon of the extenfor longus digitorum pedis; of which 9 is the flefhy part lying under the broad tendon of the biceps cruris.

40 Extenfor brevis digitorum pedis.

41 42 Tibialis pofticus; 41 it's flefhy belly lying under the flat tendons of the fartorius and gracilis; 42 the tendon going to join in with the tendon of the flexor digitorum pedis.

43 Poplitæus, lying under the tendons of the fartorius and gracilis.

44 Some of the flefhy part of the flexor digitorum pedis, of which 27 is the tendon.

U 45 Nerves

45 Nerves which make fome appearance under the tendon of the biceps cruris, going to the tibialis anticus, &c. they are branches of the fmall fciatic ramus, or fciaticus externus, called likewife fciatico-peronæus.

46 The external nervus plantaris.

47 The internal nervus plantaris.

48 Arteria plantaris externa.

49 Vena plantaris externa.

50 Vena plantaris interna.

51 A ligament which runs from the tibia to the os calcis, it lies over the tendon of the peroneus.

52 52 The external articular ligament, which is inferted above into the tibia and below into the aftragalus, and os calcis.

53 A ligament which binds together the bones of the

tarfus and metatarfus inferted externally above into the os calcis, and below into the fplint or external imperfect metatarfal bone.

54 A burfal ligament.

55 A ftrong ligament which binds the os calcis to the aftragalus, os naviculare, offa cuneiformia, and fplint or imperfect metatarfal bone, marked 8 9 9 in table the fecond.

56 56 57 57 The interoffeus, &c. it is like a ftrong ligament arifing from the upper part of the metatarfal bones, and fome of the tarfal bones, and is inferted into the fefamoid bones, and firft bone of the toe; on each fide it fends off the ligaments 57 57 to the tendon of the extenfor digitorum pedis.

58 A ligament lying over the tendon of the plantaris:

it is inferted into the fefamoid bones on each fide of the tendon, to which bones it clofely confines the tendon when this joint is bent, but is not attached to it.

59 A ligament arifing from the firft bone of the toe on each fide, and inferted into the middle of the tendon of the plantaris, to which bone it confines the tendon, when this joint is bent.

60 A ligament which binds the tendon of the flexor digitorum pedis down to the fecond bone of the toe when this joint is bent.

61 A fubftance refembling the villous furface of a mufhroom, arifing from the coffin bone, received by the like fubftance arifing from the hoof, which it mutually receives.

The thirteenth Anatomical T A B L E of the Mufcles, Fafcias, Ligaments, Nerves, Arteries, Veins, Glands, and Cartilages of a H O R S E, viewed pofteriorly, explained.

In the Head.

a G LANDULÆ labiales.
bb Mufculus caninus.
cc Buccinator.

def The depreffor of the lower lip: it arifes along with the buccinator, and is almoft divided into two mufcles, one fuperior the other inferior, for the paffage of nerves and blood-veffels to the lower lip; *d* the fuperior part which arifes tendinous, and is inferted flefhy into the lower lip laterally; *ef* the inferior part which arifes flefhy and is inferted tendinous into the lower lip near the middle: *e* the flefhy belly; *f* the tendon. ---- The part *d* is the depreffor of the corner of the mouth, and the part *ef* the depreffor of the lower lip, but the part *d* is covered by the blood-veffels and nerves which go to the chin.

gggh The orbicular mufcle of the mouth.

ii The elevators of the chin.

k The eye-ball.

ll Mufculus ciliaris.

m Maffeter.

n Branches of the nervus maxillaris inferior: they are branches of the third branch of the fifth pair of nerves, and are accompanied with an artery from the temporal artery, which communicates with the arteria angularis.

oo Arteria angularis.

p Vena angularis.

q The falivary duct.

rs Vena temporalis.

t The outer ear.

In the Neck.

ab Coraco-hyoideus, coming at *a* from it's origin, at the upper and internal fide of the humerus, betwixt the infertions of the fub-fcapularis and teres major, by a flat membranous tendon: it begins to be flefhy as it comes from under the ferratus minor anticus: *b* it's infertion into the os hyoides: it is attached to the anterior part of the trapezius near it's whole length, and above that attachment to the rectus major capitis anterior; or has an origin along with the infertion of that mufcle from the os fphenoides by a flat tendon.

c Sterno-hyoideus: it arifes from the middle tendon of the fterno-thyroideus, and is inferted into the os hyoides along with the caraco-hyoideus.

d 5 Genio-hyoideus; 5 it's origin from the lower jaw, tendinous. --- It's infertion into the os hyoides is near *d*.

6 6 7 Diagaftricus; 7 the middle tendon; 6 6 it's two infertions into the lower jaw.

ee Obliquus capitis inferior, covered by the fafcia by which the complexus is attached to the tranfverfe proceffes of the firft and fecond vertebræ of the neck: it arifes from all the length of the fpine of the oblique procefs of the fecond vertebra of the neck, and from all the pofterior part of that vertebra which the inter-vertebralis does not cover, and is inferted into all or moft of the anterior part of the broad tranfverfe procefs of the atlafs, which the inter-vertebralis does not cover.

f Rectus internus major capitis, or rectus anticus

longus: it arifes from the tranfverfe proceffes of the third and fourth vertebræ of the neck, and from a part of the longus colli: it is inferted into the os fphenoides.

ghiklmnooo Tranfverfalis cervicis; *gh* the fuperior part, which arifes from the oblique proceffes of the third, fourth, fifth, fixth, and feventh vertebræ of the neck, and two of the uppermoft of the back, viz. the beginning of the lower oblique procefs of the third, and uppermoft of the fourth, and fo of the reft: it is inferted into the tranfverfe procefs of the firft vertebra of the neck; *iklmn* the inferior part; it arifes from the tranfverfe proceffes of eight of the fuperior vertebræ of the back, and from the fafcia betwixt that and the broad tendon of the complexus, &c. by flefhy fibres: at *klmn* it is inferted into the tranfverfe proceffes of the four inferior vertebræ of the neck, partly flefhy, but chiefly by broad thin tendons; at *ooo* the inter-tranfverfalis makes fome appearance.

pq Trachelo-maftoidæus, complexus minor, or maftoidæus lateralis; *p* the flefhy part: it arifes from the oblique proceffes of the third, fourth, fifth, fixth, and feventh vertebræ of the neck; the uppermoft of the back, and the tranfverfe proceffes of the fecond and third vertebræ of the back; *q* the tendon going to be inferted into the root of the proceffus maftoidæus.

R*rsstuwx* Complexus; it is attached by a fafcia to the tranfverfe proceffes of the firft and fecond vertebræ of the neck. It arifes from the oblique proceffes of the third vertebra of the neck, and from all thofe of the neck be-

low that, and from the upper oblique procefs of the firft vertebra of the back, and by a pretty ftrong, flat tendon from the fecond and third vertebræ of the back, from the laft of which the tendon is reflected to the fpinal procefs of the fame vertebra, which makes a communication betwixt this part of the mufcle and that arifing from the fpines of the third, fourth, fifth, fixth, and feventh vertebræ of the back; *r* flefhy fibres arifing from the broad tendon; at R it arifes tendinous from the ligamentum colli; *sstt* tendinous lines, by which the flefhy fibres are interfected, which advance towards the tendon *u*; *w* the part which is inferted, by a ftrong round tendon, into the occiput near it's fellow; at *x* are marked the directions of fome tendinous threads which attach it to the ligamentum colli.

yz Ligamentum colli; *z* the place where the rhomboides and the trapezius are cut from their origins.

1 Part of the vena jugularis communis.

2 Vena jugularis externa anterior.

3 Vena jugularis externa pofterior, or fuperior.

4 Branches of the cervical arteries and veins going to and coming from the fplenius trapezius and integuments.

In the Trunk.

aa, &c. The ferratus major pofticus, inferted into the ribs.

bbbcccc, &c. *dd*, &c. The external inter-coftals; *b* a part to which the external oblique mufcle does not adhere; *cc*, &c. the part to which the external oblique mufcle of the abdomen adheres, which is about as extenfive as it's origin from the ribs; *d* the part over which the external oblique mufcle of the abdomen runs without adhering.

eee, &c. Fibres which arife partly, externally, tendinous, but chiefly flefhy; and run in a tranfverfe direction from one rib to another.

ff, &c. Part of the internal inter-coftals.

gg, &c. Flefhy fibres which run in the fame direction as the external inter-coftals from one cartilaginous ending of the ribs to another.

hiiklmm Obliquus internus or afcendens abdominis; it arifes from the fpine of the ilium, tendinous, and flefhy, which origin is continued to the ligamentum fallopii, from which it arifes, and from the fymphyfis of the os pubis; it is inferted into the cartilage of the loweft rib, tendinous and flefhy, and into the cartilaginous endings of the ribs as far as the cartilago-enfiformis; *h* the flefhy part ending at *ii*; at *k* is an opening through which blood-veffels pafs to and from the external oblique mufcle; *l* the flat tendon; at *mm* that part of the tendon of this mufcle which runs over the rectus is cut off.

no Rectus abdominis, arifes from the os pubis and is inferted into the cartilago-enfiformis, and the cartilages of the tenth, ninth, eighth, feventh, fixth, fifth, fourth, and third ribs near the fternum; and into the fternum betwixt the roots of the cartilages of the third and fourth ribs. --- There are flefhy fibres arifing from the firft rib which join it at it's origin from the fternum, betwixt the cartilages of the third and fourth ribs. --- This is called a diftinct mufcle and named mufculus in fummo thorace fitus.

p The elevating mufcle of the tail.

q The lateral mufcle of the tail.

r The inter-tranfverfe mufcle of the tail.

s The depreffing mufcle of the tail.

For a more full explanation of the mufcles of the tail, fee table the 12th.

t The external fphincter ani.

u Acceleratores penis.

ww Glands.

--- The blood-veffels and nerves which are marked on the thorax, are thofe which were diftributed to the parts taken off, as the obliquus externus, latiffimus dorfi, membrana carnofa, &c. and integuments: the nerves come from the nervi dorfales, or coftales, and nervi lumbares; the arteries from the arteriæ inter-coftales inferiores, and the arteriæ lumbares; the veins from the venæ inter-coftales and venæ lumbares.

In the upper Limbs.

ABC Triceps brachii; A the part called extenfor longus; B extenfor brevis: the long head arifes from the inferior cofta of the fcapula, and the fhort head from the humerus, they are inferted into the ancon at C.

abc Extenfor digitorum communis; *a* the flefhy part which arifes from the external condyle of the humerus, the upper and lateral part of the radius and fafcia which covers the extending mufcles on the cubit, but it's principal origin is by a ftrong flat tendon from the anterior part of the external condyle of the humerus, from which place it continues it's origin into the anterior foffula, or finus, which receives the upper head of the radius when the cubit is bent: it lies under the extenfor carpi radialis, to the tendon of which it adheres for about three minutes from it's beginning, as well as to the burfal ligament which lies under it; *bc* the tendon which is chiefly inferted into the coffin bone: it fends the flip *c* to the tendon of the extenfor minimi digiti, to be along with it inferted into the anterior and fuperior part of the great paftern externally; and another flip which is inferted into the anterior and fuperior part of the great paftern internally: it

likewife fends a flat tendinous flip or aponeurofis to the os orbiculare, and another to the fuperior part of the metacarpal bone or internal articular ligament near it's infertion into that bone: thefe are analogous to thofe aponeurofifes in the human body, which bind the tendons of this mufcle together.

dd The tendon of the mufcle which is analogous to the extenfor minimi digiti in the human body, joined by the flip *c* of the extenfor digitorum communis: it arifes from the fuperior part of the radius, from the external part of the ulna for a confiderable way down that bone, and from the vagina or cafe which binds together the bending mufcles of the cubit, and is inferted along with the flip *c* into the anterior and fuperior part of the great paftern externally: this flip, which it receives, is analogous to the aponeurofis in the human body, which binds the tendons of the extenfor digitorum together: it fends a flip to the orbicular bone, to which, by that means, it is bound.

efghi Flexor carpi ulnaris: *e* the external head, arifing, by the tendon *e*, from the external protuberance of the os humeri pofteriorly: *f* the internal head, arifing from the internal protuberance of the os humeri: *g* the tendon which divides into two a little below *g*, and is inferted, by the part *h*, into the external fplint bone, and, by the part *i*, into the os pififorme or orbiculare. ---- Thefe heads are two diftinct mufcles, the one ulnaris externus, the other ulnaris internus; the tendon of the ulnaris externus only is divided, being inferted partly into the external fplint bone, and partly into the orbiculare.

Kklm The profundus: it arifes by four diftinct heads, the moft confiderable of which, marked K, arifes from the internal protuberance of the os humeri pofteriorly under and in common with the fublimis, with which it feems to be confounded, in fome degree, all the way down the flefhy part till it comes to the tendon, where the four heads unite, and then the profundus and fublimis make two diftinct tendons: the fecond head arifes under the firft, from the fame protuberance, by a fmall flatifh tendon, which foon fwells into a round flefhy belly, then, gradually tapering, becomes a round tendon, and joins in with the firft head a little above the orbicular bone of the carpus: the third head *k* arifes flefhy from the ancon near it's extremity, and foon becoming a fmall long tendon joins in with the firft and fecond heads about the fame place where they unite: the fourth head arifes flefhy from the flat pofterior part of the radius about it's middle, and (firft becoming tendinous) joins in with the heads about the fame place where they join with each other; *lm* the common tendon, which is inferted below *m* into the coffin bone. ---- It receives,

X from

from the pofterior part of the bones of the carpus, the infertion of what is analogous to the flexor brevis policis manus, and flexor parvus minimi digiti, in the human body.

N*no* The fublimis, which arifes from the internal protuberance of the os humeri pofteriorly, over and in common with the firft head of the profundus, with which it feems to be confounded, in fome degree, all the way down the flefhy part, till it comes near the orbicular bone of the carpus, where it makes a diftinct tendon *no*, which divides, near *o*, for the paffage of the profundus, and is inferted into the great paftern on each fide of that tendon, and ferves as a ligament to confine it to that bone when the joint is bent; N the flefhy part. ---- It receives, from the pofterior and internal part of the radius, the infertion of what is analogous to the flexor longus pollicis manus in the human body.

pp Nervus plantaris.

q Arteria plantaris.

s Vena cephalica; it falls into the jugular vein.

tt Vena plantaris externa, and vena plantaris interna.

u The burfal ligament, at the juncture of the humerus with the fcapula.

wx The external articular ligament of the carpus.

yz The internal articular ligament of the carpus.

1 2 A ligament running from the orbicular bone of the carpus to the fplint bone: it ferves as a ftay to that bone when the flexor carpi ulnaris is in action: there is a large branch of the vena cephalica protuberating under it.

3 3 4 4 Interoffeus, &c. it is like a ftrong ligament arifing from the bones of the carpus, and upper part of the metacarpal bones: it is inferted into the fefamoid bones and great paftern on each fide, and fends off the ligaments 4 4 to the tendon of the extenfor digitorum, which it keeps from ftarting when the fetlock joint gives way. ---- It fupplies the places of the interoffei manus, and abductors of the fore finger, little finger, and fhort abductors of the thumb, with the adductors of the thumb and little finger.

In the lower Limbs.

ab Iliacus internus; *a* it's origin from the fpine of the ilium: it arifes from the whole or fuperior half of the infide of the os ilium, and has fome origin from that part of the fafcia lata which lies betwixt it and the glutei: it is joined in with the pfoas magnus from it's origin, and with it inferted into the little trochanter of the thigh bone: they feem to be but one mufcle.

cddddefgh Gluteus medius; *c* the part which arifes from the tendinous furface of the facro-lumbalis, and does not adhere to the fafcia lata; *dddd* the part which re-

ceives flefhy fibres from the fafcia lata; *e* it's origin from the ilium, which is continued from this place to the pofterior part of the fpine, and all that fpace of the os ilium which lies betwixt the fpine and the gluteus internus, partly tendinous, but chiefly flefhy; and from the ligament which goes between the ilium and the tranfverfe proceffes of the os facrum; *f* the part which lies under the gluteus externus and biceps cruris; *ggh* it's infertion into the great trochanter.

AAB Gluteus externus; AA the flefhy part; B a flat tendon.

C Gluteus medius.

D Pyramidalis.

E Mufculus fafcia lata.

F Sartorius.

iklmn GH Pyramidalis, arifes from the os facrum and the ligament betwixt that and the ifchium: it is, for a confiderable way, infeparably joined to the gluteus medius, and inferted at *k* into the back part of the great trochanter: it receives an expanfion from the gluteus externus: G the infertion of it's flat tendon H.

o Triceps fecundus; it arifes from the ifchium, and is inferted into the linea afpera of the thigh bone, and near it's infertion is attached to the large adductor.

qrst Triceps tertius, the large adductor of the thigh, or adductor magnus; it arifes from the ligament running from the facrum and coccyx to the ifchium; which ligament is probably nothing more than the flat tendon of this mufcle, to the pofterior edge of which the fafcia lata is joined, and to the anterior edge of the ligament running betwixt the os facrum and the ifchium: it's principal origin is from the tubercle of the ifchium: it is inferted by a ftrong tendon into the internal condyle of the humerus, behind the origin of the articular ligament and a little below it, and by a flat tendon into the articular ligament and tendon of the femi-tendinofus: it joins in with the long adductor near it's infertion.

uuw Gracilis: it arifes from the edge of the inferior branch of the os pubis, near the fymphyfis, by a broad and very fhort tendon; from thence the flefhy fibres run down to the internal condyle of the os femoris, where they terminate in a thin tendon, which afterwards degenerates into a kind of aponeurofis, and is inferted into the fore part of the infide of the head of the tibia.

xyyz The inferior part of the femi-tendinofus: the upper part is cut off at *x*: the origin, by carnous fibres from the broad tendon of the adductor magnus, is fhewn at *s*: the tendinous production which wraps over the gemellus to join in with the fafcia lata and tendon of the biceps cruris is cut off at *yy*: it fends off an expan-

fion which is attached to the tendinous ligament which lies over the gemellus and covers fome nerves and blood-veffels which pafs over the gemellus and run down the leg; they are marked 14 in table the fecond: it is alfo inferted by a flat tendon or expanfion into the plantaris near the bottom of the flefhy part; through which expanfion there is an opening for the paffage of a large nerve marked 67 in table the third on the left lower limb; it's principal infertion is by a flat tendon into the fuperior and anterior part of the tibia internally.

1 2 3 Semi-membranofus; 2 it's origin from the tubercle of the ifchium: at it's origin it is attached to the fhort head of the biceps cruris; about 3 it joins in with the femi-tendinofus, and is with it inferted into the tibia.

4 5 6 7 7 8 Vaftus externus; 4 it's origin from the pofterior part of the great trochanter; 5 the part which arifes from the infide: they are both externally tendinous: it's origin is continued flefhy along the infide of the femoris for about two-thirds of it's length downwards; 6 the flefhy belly; 7 7 it's infertion into the patella; 7 8 it's infertion into the lateral ligament of the patella: it is likewife inferted into the tendon of the rectus.

9 Rectus cruris: it arifes from the external or pofterior part of the inferior fpine of the ilium by one tendon, and by another from the anterior part of the fame fpine; thefe tendons foon unite and form a large flefhy belly, which defcends to be inferted into the patella.

10 11 12 12 13 14 15 16 The gemellus; 10 it's external head, which arifes out of and from the borders of a large foffa or notch in the os femoris, a little above the external condyle, at 10 externally tendinous; 11 it's internal head, which arifes from a roughnefs on the lower and pofterior part of the os femoris a little above the internal condyle: 12 12 a fort of flat tendon, which may be eafily feparated from the mufcle, only adhering to it by it's external edge; it's internal edge joins the fafcia of the femi-tendinofus, &c. it runs over the furface of the mufcle, and joins in with the fafcia fent from the femi-tendinofus, &c. which joins it both above and below, and by that means makes a cafe for the tendons of the gemellus and plantaris; 13 the external flefhy part; 14 the external flefhy part lying under the expanfion of the femi-tendinofus, &c. 15 the tendon formed by part of the external head; 16 the tendon of the internal head, formed by the internal head and part of the external head: thefe tendons, 15 and 16, are both together inferted into the os calcis.

17 At 17 is marked the cutting off of the fafcia from the femi-tendinofus.

18 19 The folæus, it arifes from the external articular ligament

ligament of the knee, and is inserted into the fasciæ or tendinous parts of the gemellus 12 12 a little below 19, or attached to them and inserted with them into the os calcis: the fasciæ from the biceps, semi-tendinosus, gracilis, &c. with the tendinous part, marked 12 12 in this table, communicate with or are attached to each other, and are inserted partly into the os calcis on the inside of the principal tendon of the gemellus, with which, at their insertion, they are confounded, and are partly inserted on each edge of the tendon of the plantaris as it runs over the os calcis: their lateral parts are joined posteriorly by a ligamentous membrane, marked 22 23 24 in table the twelfth.

20 21 22 The tendon of the plantaris: this muscle arises under the external head of the gemellus (in which it is in a manner wraped up) out of the large fossa, or notch, in the os femoris: above the external condyle, on the external side of it's fleshy belly, the gemellus is attached to it by fleshy fibres; at 20 it runs over the end of the os calcis, where it is bound on each side by ligaments which prevent it's flipping to either side; at 21 it divides to be inserted on each fide of the inferior part of the great pastern posteriorly, and to give passage to the tendon of the flexor digitorum pedis, to which tendon it serves as a ligament to confine it to the great pastern when the fetlock joint is bent, and by that means it receives assistance from that tendon in bending the fetlock joint. ---- This is analogous to the plantaris and short flexor of the toes in the human body, viz. the part above 20 to the plantaris, and the part below 20 to the short flexor of the toes.

23 25 25 25 26 Flexor digitorum pedis; 23 the fleshy belly, externally tendinous, which arises tendinous and fleshy from the fibula and articular ligament which runs from the external condyle of the os femoris to and down that bone, and from the posterior part of the tibia, tendinous and fleshy, which origination is continued near half the way down that bone from a considerable roughness, the protuberating parts of which give rise to the four or five tendinous parts of which this muscle is composed; 25 25 25 26 the tendon, inserted at 26 into the coffin bone.

27 27 28 29 Peronæus; it arises from the upper part of the fibula and articular ligament, which runs from the external condyle of the os femoris down the fibula: it has an origin from the tendinous surface of the flexor digitorum pedis, near all the length of the fleshy part of that muscle; 28 29 it's tendon, which is inserted into the tendon of

the long extensor of the toes at 29, part of which is afterwards inserted into the great pastern on it's superior and anterior portions externally.

30 31 Extensor longus digitorum pedis; it arises along with the strong tendon of the tibialis anticus, to which it is inseparably joined near it's origin: it arises also from the tibia; 30 it's fleshy belly; 31 it's tendon, at 29 joined by the tendon of the peronæus, with part of which it sends off a slip to be inserted into the great pastern: on it's superior and anterior part externally it sends another slip, with the fasciæ which join it, to be inserted into the superior and anterior part of the great pastern internally, but it's principal insertion is into the anterior and superior part of the coffin bone.

32 Extensor brevis digitorum pedis.

33 34 Tibialis posticus; it arises from the external side of the posterior part of the head of the tibia, and from the tendinous surface of the flexor digitorum pedis; 33 it's fleshy belly; 34 it's tendon, inserted into the tendon of the flexor digitorum.

35 35 Poplitæus; it arises tendinous from the external condyle of the os femoris under the articular ligament, and is inserted into the tibia at 35 35 externally tendinous.

36 36 Nervus sciaticus.

37 Nervus sciatico-cruralis.

38 Nervus poplitæus.

39 Nervus plantaris externus and nervus plantaris internus, which are branches of the nervus sciatico-tibialis.

40 A branch sent from the nervus sciaticus, which divides, one branch to go with the blood-vessels to the gluteus, another to the biceps cruris, and another to the semi-tendinosus, &c.

41 Nervus sciatico-peronæus.

42 42 Rami of the sciatico-peronæus; they run in betwixt the peronæus and long extensor of the toe, and are distributed to those muscles with the tibialis anticus and the neighbouring parts.

43 A Branch of the nervus sciatico-cruralis.

44 45 46 Branches of the arteria pudica communis which is a branch of the internal iliaca or hypogastrica; 45 a branch cut off where it enters the biceps cruris; 46 branches cut off, which pass through the fascia lata to go to the semi-tendinosus.

47 Arteries which go to the biceps cruris.

48 A branch of the arteria poplitæa which goes to the biceps cruris.

49 Arteria tibialis anterior.

50 Arteria plantaris externa.

51 52 53 Branches of the vena hypogastrica; at 52 a branch which comes from the biceps cruris; at 53 branches are cut off which come from the semi-tendinosus.

54 A branch of the vena poplitæa which comes from the biceps.

55 A branch of the vena obturatrix.

56 Vena plantaris externa and vena plantaris interna.

57 57 Glandula poplitæa, commonly called the pope's eye.

58 58 59 59 60 60 A ligament running from the spines of the os sacrum to it's transverse processes, and from thence to the tubercle of the ischium, from which the upper head of the biceps receives a fleshy origin; 59 59 59 60 60 shew the place where the fascia lata is cut off which runs betwixt the fascia lata and biceps cruris.

61 62 The external articular ligament, which is inserted above into the tibia and below into the astragalus and os calcis.

63 63 A ligament which binds together the bones of the tarsus and metatarsus, inserted externally above into the os calcis, and below into the external splint bone, and internally into the os cuboides.

64 A bursal ligament.

65 A strong ligament which binds the os calcis to the astragalus, or naviculare, ossa cuniformia, and the internal splint bone.

66 66 66 67 67 Interosseus, &c. it is like a strong ligament, arising from some of the tarsal bones, and the upper part of the metatarsal bones, and is inserted into the sesamoid bones and great pastern on each side: it sends off the parts 67 67 on each side to bind down the tendon of the extensor digitorum pedis. ---- This is of a ligamentous nature, but supplies the places of the interosseus, the short flexor, adductor and abductor of the great toe, the abductor and short flexor proper to the little toe, and a ligament which arises from the calcaneum and belongs to the cuboid bone; but sends off an excursion which joins the origins of the short flexor and interosseus of the little toe, both those of the interossei of the third of the small toes and that of the adductor of the great toe in the human body. The ligamentous aponeurosis 67 is sent partly from the interosseus, &c. and partly from the capsular of the fetlock joint to be inserted into the tendon of the extensor digitorum pedis.

The fourteenth Anatomical TABLE of the Muscles, Fascias, Ligaments, Nerves, Arteries, Veins, Glands, and Cartilages of a HORSE, viewed posteriorly, explained.

In the Head and Wind-pipe.

aaa THE orbicular muscle of the mouth.

bb Musculus caninus, or the elevators of the corner of the mouth and of the cheek: it arises from the upper jaw bone, and is inserted, at bb, into the orbicular muscle of the mouth and buccinator.

cd The buccinator: it arises in three different places: about d the superior fibres arise from the alveoli of the upper jaw: the middle fibres arise from the ligamentum inter-maxillaris, and the inferior from the lower jaw: it is inserted into the glandulous membrane of the inside of the cheek and lips, and at c into the orbicularis oris.

e The glandulæ buccales, or glandulous membrane which lines the inside of the lips.

fg The elevator of the chin.

h The globe, or ball of the eye.

n Arteria temporalis.

oo Arteria angularis.

p Vena angularis.

qrs Vena temporalis.

t An artery which goes to the glandulæ sublinguales.

u Glandulæ sublinguales.

wx Geniogloffus; w it's tendinous origin from the jaw bone; x it's insertion into the tongue: this insertion is continued from the os hyoides to near the tip of the tongue.

yz Hyothyreoideus; y it's origin from the thyroid cartilage; z it's insertion into the os hyoides.

1 1 2 The lower constrictor of the pharinx.

3 4 Hyogloffus; arising at 3 from the os hyoides, and inserted into the tongue near 4.

5 Part of the os hyoides.

6 The outer ear.

In the Neck.

abcdef Longus colli; a the part coming from it's inferior origin from the lateral parts of the bodies of the five uppermost vertebræ of the back, and the lowest of the neck; bcde it's originations from the transverse processes of the sixth, fifth, fourth, and third vertebræ of the neck: it is inserted at f into the anterior oblique process of the sixth vertebra of the neck: it is also inserted into the bodies of the fifth, fourth, third, and second laterally, near their transverse processes, and into the anterior eminence or tubercle of the body of the atlas.

gg, &c. hh, &c. Inter-transversarii posteriores colli; gg, &c. their originations from the roots of the oblique processes, and betwixt them and the transverse processes where the inter-vertebralis does not cover; hh, &c. their insertions into the sixth, fifth, fourth, third and second transverse processes of the vertebræ of the neck. ---- To divide these into distinct muscles there seems to be, for each insertion into the transverse processes, two originations, viz. one from the inferior part of the vertebra below the insertion, and the other from the upper part of the next to that. ---- The lowest origin is from the first vertebra of the back, part of which is inserted into the transverse process of the seventh vertebra of the neck.

ikll Obliquus capitis inferior; ik it's origin from all the length of the spine of the second vertebra of the neck; at k, where it runs under the rectus capitis posticus longus, it is externally tendinous; it arises from all the posterior part of that vertebra which the inter-vertebralis does not cover, and is inserted, at ll, into all or most of the broad transverse process of the atlas, which is not covered by the inter-vertebralis.

mn Obliquus capitis superior; m it's fleshy origin, which is pretty deep from the broad transverse process of the atlas; n it's insertion into the occiput.

op Rectus capitis posticus major; o it's origin from the ridge or spine of the lower oblique process of the second vertebra of the neck; p it's insertion into the occiput.

q Rectus capitis posticus minor, or rather medius: it arises from the root of the spine of the oblique process of the second vertebra of the neck above the origin of the rectus major; and continues it's origin for about three minutes up the spine, or ridge of this vertebra: it is inserted by a short and broad tendon into the occiput, wrapping over the surface of the intervertebralis.

rstuwwx The multifidæ of the spine, arising at rstu from the descending oblique processes of the vertebræ of the neck, partly, externally, tendinous; ww the insertion of the parts arising at stu, from the descending oblique processes of the fifth, fourth, and third vertebræ of the neck, viz. all that part which arises from the third vertebra u, the external and middle parts of the origin from the fourth vertebra t, and the external part of the origin from the fifth vertebra s. The inner part of the origin

from the fourth vertebra, and the middle part from the fifth vertebra, with the external part from the sixth vertebra r, are inserted into the spine of the third vertebra. ---- There are fibres inserted into the spine of the third vertebra, arising from three vertebræ below it; and in that manner it runs on down to the bottom of the spine.

yyy The inter-vertebralis appearing betwixt the originations of the inter-transversarii posteriores colli: they arise from the ascending oblique processes of the five inferior vertebræ of the neck, and from the space betwixt the oblique processes of the uppermost vertebra of the back; they are inserted each into the lateral parts of the bodies of the vertebræ above their origin respectively.

1 1 Branches of the cervical nerves.

2 Branches of the cervical arteries.

3 Branches of the cervical veins.

4 Part of the vena jugularis communis.

5 Vena jugularis externa anterior.

6 Vena jugularis externa posterior or superior.

7 8 9 10 Ligamentum colli; 8 the place where the trapezius and rhomboides are cut from their originations from this ligament; 9 the part which is inserted into the spines of the superior vertebræ; 10 the part which is inserted into the occiput.

In the Trunk.

a Semi-spinalis dorsi; it arises fleshy from the tendinous surface of the longissimus dorsi: and inserted into the spines of the ten superior vertebræ of the back: it communicates with the spinalis cervicis as well as the fleshy fibres of the spinalis dorsi before it's insertion, the spinalis dorsi being inserted below it.

bbcc, &c. The external inter-costals; they arise, at bb, from the inferior edge, and a little of the outside of each rib, the last excepted: they are a little tendinous, and, descending obliquely downwards, are inserted at cc into the upper edge and a little of the outside of each rib, the first excepted.

ddee, &c. The internal inter-costals; they arise at dd from the superior edge of the bony part of each rib, except the first, (not covering any of the outside,) and from the edges of the cartilages of the ribs, and a considerable part of the outside of them; they are chiefly, externally, tendinous, but partly fleshy, and ascending obliquely

upwards and forwards are infted into the lower edge of the bony part of each rib, an into the edges and part of the outfides of their cartilages, the laft rib excepted.

f The elevating mufcle of te tail.

g The lateral mufcle of the ail.

h The inter-tranfverfe mufc of the tail.

i The depreffing mufcle of te tail.

The mufcles of the tail aremore fully explained in table the twelfth.

kklmm Tranfverfalis abdomiis; *kk* the part which arifes from the infide of the rib below the triangularis of the fternum and the diaphragm, y flefhy digitations; the part *l* arifes from the three or far uppermoft tranfverfe proceffes of the vertebræ of theloins by an aponeurofis, and flefhy from the internal labiui of the crifta offis ilii, and a great part of the ligamentm fallopii, or tendinous margin of the internal obliquus c the abdomen; and is inferted into the enfiform cartilage and linea alba, adhering to the pofterior plate of the apneurofis of the internal oblique mufcle of the abdoma: at it's firft paffing under the rectus the lower part ofthe aponeurofis of the tranfverfalis is feparated from theupper in a tranfverfe direction from the edge of the reus to the linea alba, about half way betwixt the navel und fynchondrofis of the pubis, the upper part going behid the rectus and the lower before it and the pyramidalis.

oo, &c. Branches of the nervi cofales, lying upon the tranfverfalis, which go to the abdorinal mufcles and integuments.

p Branches of the nervi lumbares which go to the abdominal mufcles and integuments ling over the tranfverfalis.

qq, &c. Arteries from the intercoftalis inferior.

r The external branch of the oute iliac artery in two ramifications, accompanied by *s*.

s The external branch of the oute iliac vein in two ramifications.

t The external fphincter ani.

u Acceleratores penis.

In the upper Limbs.

abc Brachialis internus; *a* the part vhich arifes from the neck of the humerus; *b* the part whicl arifes from the internal lower part of the fcapula; at *c* it is going to be inferted into the radius a little below the coraco-radialis and more internally.

defghi Profundus, or perforans; it arifes by four diftinct heads, the firft, or moft confiderable, of which is that marked *de* in this table: it arifes from the internal protuberance of the humerus, pofteriorly, under, and in common with the fublimis, with which it feems to be confounded, in fome degree, all the way down the flefhy part, till it comes to the tendon where the four heads unite, and then the profundus and fublimis make two diftinct tendons: it is tendinous at *d*: the fecond head arifes under the firft, from the fame protuberance, by a fmall flattifh tendon, which foon fwells into a round flefhy belly, then tapering gradually becomes a round tendon, and joins in with the firft head a little above the orbicular bone of the carpus: the third head *f* arifes flefhy from the ancon near it's extremity, and foon becomes a fmall round tendon; *g* joins in with the firft and fecond heads about *g*, where they unite; the fourth head arifes flefhy from the flat pofterior part of the radius, about it's middle (firft becoming tendinous) and then joins in with the other heads about the fame place where they join in with each other: they all together form the common tendon *hi*, which is inferted, at *i*, into the coffin bone. ---- It receives, from the pofterior part of the bones of the carpus, the infertion of what is analogous to the flexor brevis pollicis manus, and flexor parvus minimi digiti in the human body.

klmnn The fublimis or perforatus; it arifes from the internal protuberance of the os humeri, pofteriorly, over, and in common with the firft head of the profundus, with which it feems to be confounded, in fome degree, all the way down the flefhy part, 'till it comes near the orbicular bone of the carpus, where it makes a diftinct tendon *lmnn*, which divides at *m* for the profundus, and is inferted on each fide of the great paftern, as at *n* and *n*: it ferves as a ligament to confine the tendon of the profundus to that bone when the joint is bent. ---- This mufcle receives from the pofterior and internal part of the radius, the infertion of what is analogous to the flexor longus pollicis manus in the human body.

o A ligament which binds down the bending tendons, explained in table the twelfth.

pq Flexor carpi radialis; it arifes from the internal protuberance of the os humeri, and is inferted at *q* into the fplint bone.

rr Interoffeus, &c. it arifes from the bones of the carpus and metacarpus, and is inferted, at *rr*, into the offa fefamoida.

s Nervus radialis.

t Vena cephalica: below the carpus it is called vena plantaris.

uu Ligaments which bind the orbicular bone to the radius, the bones of the carpus and metacarpal bone.

ww, &c. Articular ligaments.

xx The cartilages belonging to the coffin bone.

In the lower Limbs.

abbc Iliacus internus; *a* part of it's origin from the pofterior part of the anterior fpine, and fome marks of it's origin from the fafcia lata; *bb* it's origin from the anterior part of the anterior fpine of the ilium, which is continued from all, or moft part, of the infide of the ilium, which lies before the pfoas magnus from it's origin, and is, with it, inferted into the little trochanter of the thigh bone: they feem to be but one mufcle.

deeffgg Gluteus internus; *dee* it's origin from all that part of the outfide of the ilium which is below the origin of the gluteus medius, running between the anterior inferior fpine, and the great pofterior finus: it is likewife fixed in the edge of that finus in the fpine of the ifchium, and in the orbicular ligament of the joint of the hip: it is inferted, at *ff*, into the anterior part of the upper edge of the great trochanter: it is externally tendinous at *d*, and there are tendinous fibres running through it at *gg*.

hi Obturator internus; it arifes from the internal labium of all the anterior half of the foramen ovale a little diftance from the neighbouring part of the obturator ligament, and alfo both above and below the foramen: it likewife arifes from the upper half of the infide of the os ifchium, from the upper oblique notch in the foramen ovale, to the fuperior part of the great pofterior finus of the os ilium; at *h* it comes out of the pelvis through the pofterior notch of the ifchium; and at *i* is inferted into the great trochanter.

kl Gemini; the upper part of which, *k*, arifes from the acute procefs or fpine of the ifchium, near the finus or notch through which the obturator internus bends itfelf, and is inferted, at *k*, into the great trochanter along with the obturator internus, and the other of the gemini, *l*, which arifes from the pofterior edge of the finus, through which the obturator internus bends itfelf, and from the outer part of the tubercle near the lower part of that finus, and is inferted along with the tendon of the obturator internus, at *l*, into the great trochanter.

m Obturator externus; it arifes from the outer or anterior fide of the os pubis, at the edge of that hole next the fmall ramus of the ifchium, and a little to the neighbouring parts of the obturator ligament, and is inferted, at *m*, into the great trochanter.

n Quadratus; it arifes from the outer edge, or the obtufe line which runs from under the acetabulum towards the lower part of the tuberofity of the ifchium; and is inferted, at *n*, into the oblong eminence of the
Z thigh

thigh bone, which ftands out partly from the pofterior fide of the trochanter major, and partly below the fame.

opqqrst Adductor magnus femoris, or triceps femoris; *o* the firft part, or triceps primus; *pqq* the fecond part, or triceps fecundus; *rst* the third part, or triceps tertius; it begins it's origin from the outer part of the anterior edge of the os pubis near it's fynchondrofis, from whence it continues to arife as far as the tubercle of the ifchium; from the tubercle of the ifchium at *s* and fafcia lata at *r*; and is inferted the firft part at *o*, and the fecond at *qq*, into the linea afpera in fome meafure externally tendinous, and into the internal condyle of the femoris by a ftrong tendon behind the origin of the articular ligament, and a little below it.

uwx Gracilis; it arifes from the edge of the inferior branch of the os pubis near the fymphyfis by a broad, and very fhort tendon; from thence the flefhy fibres run down to the internal condyle of the os femoris, where they terminate in a thin tendon, which afterwards degenerates into a kind of aponeurofis *x*, and is inferted into the fore part of the infide of the head of the tibia.

y The tendon of the mufculus parvus, in articulatione femoris fitus; it arifes by a flat tendon over the pofterior tendon of the rectus, from a little above the edge of the acetabulum, and foon becoming a round flefhy belly dwindles again into a fmall flat tendon, which is inferted into the thigh bone at *y*.

122345 Cruralis, or cruræus; *11* it's origin, from the anterior and outer part of the thigh bone, externally tendinous, being by fmall flat tendons, which difappear at *22*, but inwardly flefhy: it is inferted into the patella at *34*, and into the external lateral ligament, at *45*, by a flat tendon or fafcia; at *3* it is partly divided for the reception of blood-veffels.

67810 Vaftus internus; *6* the part arifing from the upper part of the thigh bone, which origin is continued almoft down to the inner condyle, or from about half the length of the mufcle, by flefhy fibres, from all that fpace between the origin of the cruræus and the infertion of the adductor magnus femoris: from all this extent the fibres run obliquely downwards and outwards, and are inferted, at *77*, into the tendinous furface of the cruræus, and at *8* into the patella; *6778* fhew the impreffion made on this mufcle by the rectus cruris; *10* fhews the external furface of the internal fide of this mufcle on the left fide.

11 Interoffeus, &c.

A Sartorius.

B Triceps fecundus.

C Tranfverfus penis.

E One of the gemini.

F Obturator internus.

1213 1415 16 17 18 19 20 21 Plantaris; *12* it's origin out of the large foffa, or notch, of the os femoris; *13 14* it's belly; at *13* flefhy fibres are attached to the tendinous furface of this mufcle; *15 16 17 18 19 20 21* the tendon, which, about *15*, begins to wrap over the tendon of the gemellus; at *16* and *17* it is attached to the os calcis by ligaments, which are inferted into it in thofe places; and at *18* to the great paftern by a ligament inferted into it there; at *19* it divides for the paffage of the tendon of the flexor digitorum pedis; at *20* and *21* it is inferted into the great paftern. ---- The parts *16* and *17* may be called parts of the origin of the fhort flexors of the toes; the part above *16* and *17* being analogous to the plantaris, and the part below to the fhort flexors of the toes in the human body; one being inferted into the calcaneum, and the other arifing from it; but, in a horfe, one is like a continuation of the other, attached to the calcaneum on each fide.

22 23 23 Poplitæus; at *22* it arifes, tendinous, from the external condyle of the os femoris, under the articular ligament, and near *23 23* it is inferted externally tendinous into the tibia.

24 25 26 Tibialis pofticus; *24* it's origin from the external fide of the pofterior part of the head of the tibia: it arifes alfo from the tendinous furface of the flexor digitorum pedis; *25* it's flefhy belly; *26* it's tendon inferted into the tendon of the flexor digitorum pedis.

27 28 29 30 31 31 flexor longus digitorum pedis; *27* it's origin from the fibula and the ligament which runs from the external condyle of the os femoris, to and down that bone, tendinous and flefhy, and from the pofterior part of the tibia, tendinous and flefhy; which origination is continued near half the way down that bone from a confiderable roughnefs, the protuberating parts giving rife to the tendinous parts of which this mufcle is compofed; *28* the flefhy belly, externally tendinous; *29 30 31 1* the tendon by which it ends, beginning at *29*, comig from under the plantaris at *30*, and inferted into the coffin bone at *31 31*. ----- This mufcle is analogous to both the flexor longus digitorum pedis, and flexo longus pollicis pedis in the human body: it receives an addition from the os calcis and offa cuneiforma, whih is analogous to a mufcular head in the human body, hich confifts of two portions diftinct from the beginning, both arifing from the calcaneum, and inferted into th tendon of the long flexor of the toes before it divides foon after which the lumbricales arife from the tendos into which it is divided.

32 32 Branches f the arteria glutæa, accompanied with veins and nervs.

33 The large ciatic nerve, which, on the thigh, is called fciatico-cruris.

34 A branch ofthe arteria cruralis.

35 Arteria poptæa.

36 Arteria obtratrix.

37 Nerves goig to the tibialis anticus; they are rami of the fmall fiatic ranch.

38 Nervus fciitico-tibialis internus.

40 40, &c. Aticular ligaments.

41 41 The catilages belonging to the coffin bone.

The fifteenth Anatomical TABLE of the Muscles, Fascias, Ligaments, Nerves, Arteries, Veins, Glands, and Cartilages o a HORSE, viewed posteriorly, explained.

In the Head and Neck.

a STYLOGLOSSUS.
 b Stylopharingæus.
 c Stylohyoidæus.
 d Hyoglossus; arises from the os hyoides, and is inserted into the tongue.
 e Pterygoidæus internus.
 f Pterygoidæus externus.
 g The middle constrictor of the pharinx.
 h The superior constrictor of the pharinx.
 i Crico-arytænoideus.
 k The posterior or inferior lateral cartilage.
 l The elevator of the chin.
 L The outer ear.
 mn, &c. Inter-vertebrales; *m*, &c. their origins from the ascending oblique processes of the five inferior vertebræ of the neck: the lowest origin is from the space betwixt the oblique processes of the uppermost vertebra of the back; *n*, &c. their insertions into the lateral parts of the bodies of each vertebra above their origins.
 opqqqqqr Ligamentum colli; the part *p* arises from the spines of the second and third vertebræ of the back, and the part *o* from most of the spines of the back below them; the part *p* is inserted, at *qqqqq*, into the spines of the five superior vertebræ of the neck, and the part *o* is inserted into the occiput at *r*.

In the Trunk.

 aa Multifidi spinæ.
 b The ligament which runs over the spines of the os sacrum.
 c The elevating muscles of the tail.
 d The lateral muscle of the tail.
 ee The inter-transverse muscles of the tail.
 f The depressing muscle of the tail.
 The muscles of the tail are more fully explained in table the twelfth.

In the upper Limbs.

 aabccdd Interosseus; arising at *b* from the os magnum or great round headed bone of the carpus, and, at *cc*, from the upper part of the metacarpal bone; it is fleshy at *aa*, and inserted, at *dd*, into the sesamoid bones.
 e Vena cephalica; below the carpus it is called vena plantaris.

 g Vena brachialis.
 f Arteria brachialis.
 h Nervus medianus.
 iii Ligaments which bind the orbicular bone to the radis, the bones of the carpus, and metacarpal bone.
 kk, &c. Articular ligaments.
 lll Ligaments which bind the sesamoid bones to the great pasterns.
 mm Cartilages belonging to the coffin bone.
 n A cartilaginous ligament which ties the two sesamoid bones together.

In the lower Limbs.

 ABBC Iliacus internus; A part of it's origin from the posterior part of the anterior spine, with some marks of it's origin from the fascia lata; B B it's origin from the anterior part of the anterior spine of the ilium, which is continued from all or most part of the inside of the ilium which lies before the transverse processes of the vertebræ of the loins and sacrum: it joins in with the psoas magnus from it's origin, and is with it inserted into the little trohanter of the thigh bone: they seem to be but one muscle.
 aa Gemini.
 bc Obturator internus.
 dee Obturator externus; *d* the fleshy part; *ee* the tendon.
 fg Quadratus; *f* it's origin; *g* it's insertion.
 hi Pectineus; *h* part of it's origin; *i* it's insertion externally tendinous.
 k Part of the sartorius.
 K Triceps secundus.
 lmmn Gracilis; *l* part of it's origin; *lmm* it's fleshy part; *n* it's flat tendon.
 op Musculus parvus in articulatione femoris situs; *o* it's origin; *p* it's insertion.
 qrs The origin of the rectus; *q* it's internal origin; *r* it's external origin; *s* the place where it is cut off.
 t The external sphincter ani.
 uw The internal sphincter ani, attached, at *u*, to the bodies of the second, third, and fourth bones of the tail.
 xyz Levator ani, arising near *x* (where it is tendinous), from the acute process of the ischium; it is in-

serted, at *y*, into the transverse processes of the second, third, and fourth bones of the tail; and at *z* into the internal sphincter ani.
 1 Transversus penis.
 2 Acceleratores penis.
 3 One of the erectores penis.
 4 Arteria sacra.
 5 Iliaca minor.
 6 Arteria glutæa; of which 7 is a branch.
 8 Arteria sciatica.
 9 Pudica communis.
 10 Arteria obturatrix.
 11 Arteria cruralis, of which 12 is a branch.
 13 Arteria poplitea.
 14 Vena poplitea.
 15 Arteria tibialis posterior.
 16 Arteria peronæa posterior.
 17 17 The large sciatic nerve, which on the thigh is called sciatico-cruralis.
 18 Nervus sciatico-tibialis internus.
 19 19 Nervus plantaris externus and nervus plantaris internus. ---- They are branches of the sciatico-cruralis internus.
 20 A ligament which binds the fibula to the tibia.
 21 A strong ligament, which binds the os calcis to the splint bone.
 22 Ligaments which bind the bones of the tarsus together.
 23 24 24 Interosseus, &c. 23 it's origin from the tarsal and metatarsal bones; 24 24 it's insertions into the sesamoid bones and upper part of the great pastern on each side. It sends off a small ligament on each side to the tendon of the extensor longus digitorum pedis. ---- This is of a ligamentous nature, but supplies the places of the interosseus, the short flexor, adductor and abductor of the great toe, the abductor and short flexor proper to the little toe, and a ligament which arises from the calcaneum.
 25 A cartilaginous ligament, which ties the two sesamoid bones together.
 26 27 27 27 Ligaments which bind the sesamoid bones to the great pastern.
 28 28 Cartilages belonging to the coffin bone.
 29 29, &c. Articular ligaments.

F I N I S.

A a

Tab: 7 of the Anatomy of the Human Body viewed anteriorly.

591.4
S93
v.4

486

The seventh Anatomical Table of the Muscles,
Fascias, Ligaments, Nerves, Arteries, Veins, Glands,
and Cartilages of the Human Body Explained.

The muscles in the Head viewed anteriorly.

a b, The corrugator of the eye-brow, or superciliaris; b, it's origin from the os frontis. The musculi superciliares are fleshy fasciculi situated behind the supercilia, and behind the inferior portion of the musculi frontales from the root of the nose to above one half of each superciliary arch; they are strongly inserted, partly in the synarthrosis of the os nasi with the os frontis where they come very near the proper muscles of the nose, and partly in a small neighbouring portion of the orbit; from thence they first run up a little, and afterwards more or less in the direction of the eye-brows; they are made up of several small fasciculi of oblique fibres, all fixed by one end in the manner already said, and by the other partly in the lower extremity of the muscles by which they are covered, and, partly in the skin of the supercilia. This last portion is easily confounded with a portion of the musculus orbicularis palpebrarum.

c d e, The levator palpebræ superioris; this is a very thin muscle, situated in the orbit above and along the rectus superior oculi; it is fixed to the bottom of the orbit, by a small narrow tendon, near the foramen opticum, between the posterior insertions of the rectus superior, and obliquus superior; from thence it's fleshy fibres c, run forward on the rectus, increasing gradually in breadth and terminate by a very broad aponeurosis d, in the tarsus e, of the superior palpebra.

f f f, The membranous part of the eye-lids, or palpebræ and membrana conjunctiva; the palpebra are a kind of veils or curtains placed transversely above and below the anterior portion of the globe of the eye, and accordingly there are two eye-lids to each eye, one superior, the other inferior; the superior is the largest and most moveable in man; the inferior the smallest and least moveable; they both unite at each side of the globe, and the places of their union are termed angles, one large and internal which is next the nose, the other small or external which is next the temples. The palpebra are made up of common and proper parts; the common parts are the skin, epidermis, and membrana adiposa; the proper parts are the muscles, the tarsi, the puncta or foramina lacrymalia, the membrana conjunctiva, the glandula lacrymalis, and the particular ligaments which sustain the tarsi. The tarsi and ligaments are in some mea-

L'Anatomie du Tigre.

Explication de la Premiere table Anatomique
des
Muscles, bandes, ligamens, nerfs, artères, veines, glandes, Et cartilages d'un Tigre.

Les muscles &c. dans la tête regardés de côté latéral.

A A a, Epicrane, ou muscle du pericrane; A A, l'expansion tendineuse qui va gagner le releveur de la lèvre superieure & de l'aile du nez; a, portion charnue qui règne le long d'une partie du muscle orbiculaire de la paupiere, & a son insertion dans le tegument externe.

b c d e, Le muscle orbiculaire de la paupiere, e, l'origine des fibres, du ligament, par lequel la conjonctive des paupieres dans le grand canthus, est attachée à la portion nasale de l'os unguis.

f g, Le corrugateur du Sourcil; g, son insertion dans la peau.

h i k l l m n o, Le releveur de la lèvre superieure, & du coin de la bouche; i k, son origine de l'epicrane; à l, il nait de l'os près de l'angle interne de l'œil; m m n, son insertion dans le muscle orbiculaire de la bouche, & dans la peau.

p q, Le dilatateur lateral du naseau & de la lèvre superieure;

r s u u v x, Zygomatique; t t, son insertion dans l'orbiculaire de la bouche; v x, son insertion dans le cartilage anterieur de l'oreille externe; l'office de ce muscle est d'abaisser le cartilage anterieur de l'oreille externe, aussi bien que de faire monter le coin de la bouche.

z z & B C, Le muscle orbiculaire de la bouche; B, fibres qui se mêlent à celles des muscles nasaux de la lèvre superieure; C, fibres qui se mêlent a celles des muscles du menton.

1 2, L'abaisseur de la lèvre inferieure.

3 4, Portion du très large du cou qui, à 4, a son